WOMEN *and* SPORTS *in the* UNITED STATES

Jaime Schultz | Jean O'Reilly | Susan K. Cahn | EDITORS

WOMEN *and* SPORTS *in the* UNITED STATES

A Documentary Reader | SECOND EDITION

Dartmouth College Press *Hanover, New Hampshire*

Dartmouth College Press
An imprint of University Press of New England
www.upne.com
© 2019 Trustees of Dartmouth College
All rights reserved
Manufactured in the United States of America
Designed by Mindy Basinger Hill
Typeset in Minion Pro

For permission to reproduce any of the material in this book, contact Permissions,
University Press of New England, One Court Street, Suite 250, Lebanon NH 03766; or
visit www.upne.com

Library of Congress Cataloging-in-Publication Data
Names: Schultz, Jaime, editor. | O'Reilly, Jean, editor. | Cahn, Susan K., editor.
Title: Women and sports in the United States : a documentary reader / Jaime Schultz,
 Jean O'Reilly, and Susan K. Cahn, editors.
Description: Second Edition. | Hanover, New Hampshire : Dartmouth College Press,
 [2018] | Previous edition: 2007, with Jean O'Reilly as principal editor. | Includes
 bibliographical references and index.
Identifiers: LCCN 2018036635 | ISBN 9781512603200 (Paperback)
Classification: LCC GV709.18.U6 074 2018 | DDC 796.082—dc23
LC record available at https://lccn.loc.gov/2018036635

CONTENTS

xi Acknowledgments

xiii Introduction

1 PART I *The Importance of Sport*

3 Benefits: Why Sports Participation for Girls and Women |
WOMEN'S SPORTS FOUNDATION | 2016

8 Climbing through the Glass Ceiling | CHUCK TANOWITZ | 2015

11 I Am Woman, See Me (Sweat)! Older Women and Sport |
MAUREEN M. SMITH | 2016

23 Illini Paralympian Is Racing to Help Russian Adoptees |
SEAN HAMMOND | 2013

28 Women's Soccer Is a Feminist Issue | MAGGIE MERTENS | 2015

34 Sport Has Huge Potential to Empower Women and Girls |
LAKSHMI PURI | 2016

39 PART II *Biological and Physical Considerations*

41 Women in the Water: They Love to Flounder but Few
Become Good Swimmers | ANONYMOUS, *NEW YORK TIMES* | 1895

43 Sport, Physical Training, and Womanhood | STEPHAN K. WESTMANN | 1939

46 Does the Menstrual Cycle Affect Sporting Performance? | JAMES MCINTOSH | 2015

52 Position Statement on Girls and Women in Sports | LYLE MICHELI, ANGELA SMITH, FRANCISCO BIOSCA, AND PATRICIA SANGENIS, WITH MARK JENKINS | 2002

57 Girls Suffer Sports Concussions at a Higher Rate Than Boys. Why Is That Overlooked? | MARJORIE A. SNYDER | 2015

86 Women's Sport: What Everyone Needs to Know | JAIME SCHULTZ | 2018

65 Female Athletes Dope, Too | IAN MCMAHAN | 2016

67 PART III *Psychological Issues*

69 Mental Health and Well-Being | E. J. STAUROWSKY, M. J. DESOUSA, K. E. MILLER, D. SABO, S. SHAKIB, N. THEBERGE, P. VELIZ, A. WEAVER, AND N. WILLIAMS | 2015

103 Sports Participation and Positive Correlates in African American, Latino, and White Girls | SUSAN C. DUNCAN, LISA A. STRYCKER, AND NIGEL R. CHAUMETON | 2015

120 The Pressure of Pulling Your Own Weight in Rowing | D'ARCY MAINE | 2017

125 Shouts from the Stands: A Letter to USA Swimming about Gender Stereotypes | KELSEY THERIAULT | 2015

129 Trends in Gender-related Research in Sport and Exercise Psychology | NICOLE M. LAVOI | 2011

139 PART IV *Sex, Gender, and the Rules of Inclusion*

141 Is Gender Segregation in Sports Necessary? | ALICE SANDERS | 2016

147 Wimbledon Has Sent Me a Message: I'm Only a Second-Class Champion | VENUS WILLIAMS | 2006

150 So What If Some Female Olympians Have High Testosterone? | JAIME SCHULTZ | 2016

155 Hyperandrogenism and Women versus Women versus Men in Sport: A Q&A with Joanna Harper | ROSS TUCKER | 2016

165 On the Team: Equal Opportunity for Transgender Student Athletes | PAT GRIFFIN AND HELEN J. CARROLL | 2010

177 PART V *Athletes Performing Masculinities and Femininities*

179 All-American Girls Professional Baseball League Rules of Conduct, 1943–1954 | ALL-AMERICAN GIRLS PROFESSIONAL BASEBALL LEAGUE

181 Debunking the "Throw like a Girl" Myth | JENN SAVEDGE | 2015

182 Playing "Too Womany" and the Problem of Masculinity in Sport | JOANNA L. GROSSMAN AND DEBORAH L. BRAKE | 2013

188 Living the Paradox: Female Athletes Negotiate Femininity and Muscularity | VIKKI KRANE, PRECILLA Y. L. CHOI, SHANNON M. BAIRD, CHRISTINE M. AIMAR, AND KERRIE J. KAUER | 2004

207 Something to Cheer About? | JAIME SCHULTZ | 2014

221 PART VI *Sexualities and Sport*

224 Women in Sports Should Look Beautiful | PAUL GALLICO | 1936

226 Athletes and Magazine Spreads: Does Sexy Mean Selling Out? | LAURA PAPPANO | 2012

230 2012 Harvard Men's Soccer Team Produced Sexually Explicit "Scouting Report" on Female Recruits | C. RAMSEY FAHS | 2016

234 Stronger Together | KELSEY CLAYMAN, BROOKE DICKENS, ALIKA KEENE, EMILY MOSBACHER, LAUREN VARELA, AND HALEY WASHBURN | 2016

234 Changing the Game: Homophobia, Sexism, and Lesbians in Sport | PAT GRIFFIN | 1992

254 Gag Orders on Sexuality | ALLIE GRASGREEN | 2013

258 Devastating Report Details Toxic Culture That Led to the Worst Sex Abuse Scandal in U.S. Sports | LINDSAY GIBBS | 2017

263 PART VII *Intersections of Race, Ethnicity, and Gender*

266 "Cinderellas" of Sport: Black Women in Track and Field | SUSAN CAHN | 2003

284 One-Legged Leotards and Tiger-Striped Fingernails: Florence Griffith-Joyner and the Representation of Black Femininity | LINDSAY PARKS PIEPER | 2015

290 Finishing Last: Girls of Color and School Sports Opportunities | NATIONAL WOMEN'S LAW CENTER AND POVERTY AND RACE RESEARCH ACTION COUNCIL | 2015

312 America's Painful Journey from Prejudice to Greatness in Women's Gymnastics | CELISA CALACAL AND LINDSAY GIBBS | 2016

319 *All about Eve* on Ice: Creating a New Olympic Rivalry between Blonde Girls, Just in Time | ANDI ZEISLER | 2014

323 Media Fail to Give *Real* First Asian American Olympic Gold Medalist Her Due | DEVIN ISRAEL CABANILLA | 2016

325 On the Rez | IAN FRAZIER | 2001

335 PART VIII *Women, Sport, and the Media*

337 Women Play Sport, but Not on TV: A Longitudinal Study of Televised News Media | CHERYL COOKY, MICHAEL A. MESSNER, AND ROBIN H. HEXTRUM | 2013

347 Depicting the Sporting Body: The Intersection of Gender, Race, and Disability in Women's Sport/Fitness Magazines | MARIE HARDIN, SUSAN LYNN, AND KRISTIE WALSDORF | 2006

363 How to Talk about Female Olympians without Being a Regressive Creep: A Handy Guide | LINDY WEST | 2016

395 Breaking: Women in Hijab Play Sports | SHIREEN AHMED | 2016

369 Women in Sports Media Face Unrelenting Sexism in Challenges to Their Expertise and Opinions | JULIE DICARO | 2016

373 PART IX *Current Status and Recommendations for the Future*

376 Title IX and Athletics: Leveling the Playing Field Leads to Long-Term Success | NATIONAL COALITION FOR WOMEN AND GIRLS IN EDUCATION | 2017

390 Forty-Five Years of Title IX: The Status of Women in Intercollegiate Athletics | AMY S. WILSON | 2017

399 Girls' Participation in Physical Activities and Sports: Benefits, Patterns, Influences, and Ways Forward | R. BAILEY, I. WELLARD, AND H. DISMORE | 2005

401 Women in the Olympic and Paralympic Games: An Analysis of Participation, Leadership, and Media Coverage | E. J. HOUGHTON, L. P. PIEPER, AND M. M. SMITH | 2017

415 Strategies for Change | FEMINIST MAJORITY FOUNDATION | 1995

419 Index

ACKNOWLEDGEMENTS

This book would not have come into being without the assistance of a number of people and institutions. Our editors, Phyllis Deutsch and Richard Pult, and the staff and freelancers (especially Kara Caputo, Rachel Shields Ebersole, and Amanda Dupuis) at the University Press of New England have been tremendously helpful and supportive over the years in which this project took shape. We thank Dr. Amy Wilson, NCAA director of inclusion (Gender Equity and LGBT), and Dr. Maureen M. Smith, author of the "Women in the Olympic Games" survey for the Women's Sports Foundation, for generously sharing their research. We also are grateful for the work of research assistants Katrina Sinclair and Paulina Rodriguez Burciaga, and for the financial help provided by the University at Buffalo's College of Arts and Sciences Subvention Fund. Our friends and colleagues—Nicolaas Geenen, Abigail Gillard, Pamela Grundy, Ian and Natasha Jentle, Donald Levy, John Manning, Patrick McDevitt, Brian and Patricia O'Reilly, Sydney and Terry Plum, Don Sabo, Mary Turco, Jacqueline Wood, and many others—have been most generous in their advice, and this anthology is better for their suggestions.

We offer this book as a gesture of our deepest gratitude to Shane and Barbara O'Reilly; to Nella Bee and Sylvie Schef, two budding athletic girls; and to Tandy Hamilton, whose midlife athletic blossoming serves as a reminder of why sports matter in women's lives.

INTRODUCTION

In the 1950s a typical American women's intercollegiate basketball game would have occurred on a rare "playday" or "sportsday" in which students, ordinarily limited to intramural competitions on their own campus, came together for a single competitive game between schools. Such events took place in a congenial atmosphere in which sports(wo)manship and sociability held equal weight with winning and losing. There were no records kept, set, or broken because, according to the prevailing mentality, statistics did not matter. What mattered was playing the game and extending that opportunity to as many players as possible. The majority of teams played by the old half-court rules and each team's players wore the same color "pinnies" or vests. Physical educators coached the teams and kept spectators to a minimum, and after the game the players met for refreshments before returning home.

This format of women's athletics developed as a result of two influences: an almost complete disregard for girls and women in the larger male-dominated sports world and a firmly held philosophy among female physical educators that highly competitive sport benefited the few skilled female athletes and neglected the majority of students. It was a philosophy that advocated "play for play's sake" and not the quest for victory or the development of elite talent. As a result—with anomalous exceptions like the quadrennial Olympic Games, fan-crazy Iowa girls' basketball, and several historically black colleges—women operated in most settings, from recreational to school leagues to colleges, entirely under the radar of big-time sport.

Today across the country sold-out basketball games at universities such as Connecticut, Tennessee, and Stanford attract thousands of spectators who watch teams of nationally and internationally recruited athletes battle it out on the

hardwood. The athletes enjoy athletic scholarships and team budgets with formerly unthinkable expenditures for air travel, hotels, meals, uniforms, shoes, and salaries for multiple coaches. Moreover, today's athletic accounts consist of not only an expense column but also a revenue column that includes profits made from ticket sales and television contracts. This spectacular transformation in the funding and prominence of women's sport highlights the personal and physical power of young women coming of age in an era of entitlement, in which the right to compete and receive equitable resources with men's sport is rarely disputed.

Many observers attribute the sea change in U.S. women's sport in colleges, high schools, and recreational leagues to a congressional act: Title IX of the Education Amendments of 1972. Title IX prohibits sex discrimination in any educational institution that receives federal financial assistance, which includes nearly every private and public school in the country. And yet Title IX has not been a magic bullet capable of eradicating bias against women's sport. In the first edition of this book, we wrote about nine-year-old Natasha Dennis, who, in 1990, played soccer so well that the father of a girl on the opposing team charged onto the field, accused Natasha of being a boy, and demanded that she and some of her teammates be hauled into a bathroom to verify their sex.[1] Twenty-seven years later, Milagros "Mili" Hernandez experienced something similar. Organizers of a 2017 Nebraska state soccer tournament suspended the eight-year-old athlete and her Azzuri-Cachorros Chicas teammates because Mili had short hair. The officials thought she was a boy, even though her father produced documents to the contrary.[2] Girls not only have to play soccer a certain way, but it seems they must also look a certain way to escape suspicion that they must really be boys.

The powerful gender connotations of sport are not surprising given its historical roots and development in Western societies. For centuries sport has been a site of male recreation, camaraderie, and competition, as well as an arena in which boys and men learn and display their masculine prowess. In this capacity the sports world has served as an important proving ground for masculinity, thus making it unwelcoming to female participants. Consequently women consistently meet institutional and ideological roadblocks that discourage their involvement. These obstacles take many forms, from observers responding to women's athletic pursuits with scorn and denigration to school administrators providing paltry resources to women's sport being ignored altogether—especially through limited coverage in the national media. Typically the impediments have been even greater for girls and women of color and those from working-class backgrounds, who are often unable to attend well-funded high schools, enroll in college, or join country clubs, or simply lack leisure time and money. American

women's sporting experiences have historically been affected by multiple and intersecting axes of power.

But apparent disadvantages sometimes work in the athletes' favor. In some cases—such as African American women in track and field or southern white mill workers playing basketball in popular textile leagues—being a member of a racial, ethnic, working-class, or regional enclave allowed for a positive sporting tradition unimpeded by professionals and journalists who assailed competitive sport for women. Despite widespread discouragement in the dominant culture, a faction of women from diverse ethnic, racial, religious, and class backgrounds consistently sought out athletic opportunities, taking advantage of school, municipal, religious, and elite amateur and professional programs whenever they were available. The history of women's sport is not, therefore, a history of discrimination so extensive as to stifle all interest in competitive athletics, but rather an uneven patchwork of avid female participation set within a broader framework of pervasive discrimination, ranging from explicit prohibitions against female athleticism to implicit discouragement, ridicule, and simple lack of opportunity. The story of the rise of women's sport is thus one of hidden opportunities and breakout performances in a culture of pervasive but gradually lessening discouragement of female athletes. This tension between prohibition and possibility is especially evident if we look at the history of women's sport over the last century.

The tension between male prerogative and female interest in sport sharpened in the early twentieth century as women began to reject the physically confining ideal of the staid, domestic, and pious Victorian lady. At the end of the nineteenth century, for example, the introduction of the safety bicycle triggered a profound change in women's attitudes toward physical activity, social etiquette, and fashion. First in Europe and later in the United States, the mass appeal of the bicycle to women stemmed not only from the ease with which one could learn to ride but also from the opportunities it presented for freedom of movement. In 1892, at the age of fifty-three, American feminist Frances Willard discovered this. Three years later she published *A Wheel within a Wheel: How I Learned to Ride the Bicycle,* a celebration of her improved health, tenacity, and general attitude, and a clarion call for all women to benefit from this marvelous form of transport. And well they might benefit: in an age in which most middle-class women labored daily under the physical restrictions of heavy skirts and petticoats, tight corsets, elaborate hairdos, and unwieldy hats, the bicycle made physical movement that much faster and easier. Unchaperoned cycling excursions became both possible and popular, as distances difficult to cover on foot could be negotiated quickly and independently on a bicycle. The mass appeal of the bicycle in the 1890s also began to change women's attitudes

toward fashion, as more and more women rejected their corsets and cumbersome frocks in favor of the bicycle-friendly "rational outfit" of lightly corseted or uncorseted bodices worn with divided skirts or bloomers made of comparatively lightweight material.

In the 1910s popular magazines praised the new phenomenon of the modern athletic girl who loved outdoor activities. Excitement about this feminine ideal reflected both the growing popularity of sport in American society and a shift in the prevailing gender order. Earlier, Victorians commended women for their domestic roles as mothers and wives while simultaneously praising their purity and frailty. This view faded before the robust image of the turn-of-the-century New Woman, noted for her bold, adventurous spirit and her eagerness to engage in public activities, including business, education, politics, and physical culture. The prominence of modernism was often symbolized through the figure of the physically liberated young woman emancipated by bold new styles of dress, liberal sexual mores, and a heightened interest in sport. By the 1920s white female tennis players and aquatic champions rivaled movie stars for celebrity status as the popular press and advertisers featured them in stories and photos celebrating modern womanhood. In the face of racial segregation, African American women became cultural heroes and inspired "race pride" while competing in organizations such as the American Tennis Association and at historically black colleges and universities.

Girls and women's sport blossomed through the efforts of recreation leaders and physical educators who believed that athletic activity was an important part of physical and social development. In urban working-class neighborhoods, service-based groups such as the Young Women's Christian Association and the Catholic Youth Organization, along with newly formed municipal parks and recreation departments, organized sport for girls and women. Young working women also found opportunities in industrial leagues sponsored by businesses interested in promoting goodwill within the workforce and local community. Concurrently, middle-class women seized upon an array of opportunities in high school and college athletic programs, which featured extensive intramural offerings and a growing number of interscholastic basketball, baseball, field hockey, and track competitions. The popularity of such endeavors prompted the Amateur Athletic Union (AAU) to establish national championships in women's swimming, track and field, and basketball in the 1920s. The capstone of women's new athletic freedom came during the international Olympic Games of the 1920s, during which women competed for medals in skating, swimming and diving, and track-and-field events, though competitors were overwhelmingly white.

The enthusiasm for women's sport did not go unchallenged. Critics viewed athletics as an inherently masculine activity. Thus, women could succeed only by sacrificing what was seen as their natural femininity for masculine qualities of body and mind. Opponents also complained that vigorous athletic activity exposed the female body to public view and damaged a woman's reproductive organs, threatening her chances for future motherhood. They warned that aggressive physical competition unleashed physical, sexual, and emotional passions that put girls at risk of bodily injury, sexual impropriety, and nervous collapse.

These critics succeeded in limiting women's athletic opportunities. Forced into a defensive posture, female physical educators adopted a philosophy of moderation that sought to stamp out all interscholastic sports. Under this policy, educators also modified the rules of girls' athletic games to reduce physical strain and contain competitive impulses. These anti-competition impulses temporarily banned women from certain athletic events. For example, following the addition of women's track and field to the Olympic program in 1928, the International Olympic Committee (IOC) banned women from running races of more than 200 meters. These policies, although not universally adopted, predominated until the 1960s, restricting girls' and women's competitive opportunities and sending a message that "real sport" was an activity suited only to boys and men.

Contending forces for and against women's competitive sport created a complex legacy. Certain athletes, such as tennis player Helen Wills, aviator Bessie Coleman, swimmer Eleanor Holm, and multisport competitor Ora Washington, created a positive image of liberated, assertive, and alluring new womanhood, whereas the great masses of girls and women found only limited opportunities for athletic competition and were as likely to reap scorn as to earn praise if they pursued athletic excellence or passions. These contradictions persisted in the 1930s and 1940s as softball and basketball gained great popularity. A girl who first played on a neighborhood sandlot might then join a team through her local recreation program and in her late teens or twenties play for an adult team sponsored by her employer or some other local business. The most skilled women joined semiprofessional teams that competed regionally before traveling to national tournaments. However, the assumption that physical ability and success were fundamentally masculine continued to plague the best athletes.

This mixed reception is best illustrated by two high profile events in these decades: the 1932 Olympic performance of Babe Didrikson and the establishment of the All-American Girls Professional Baseball League (AAGPBL) in the early 1940s. A working-class woman from Texas, the eighteen-year-old Mildred "Babe" Didrikson (later Zaharias) took Los Angeles by storm at the 1932 Olympic Games, winning two gold medals and a silver in track-and-field events (she

should have won three golds, as she tied for first and set a new world record in the high jump, but officials voided the medal on the grounds that she used an improper technique). Didrikson's astounding abilities made her a national celebrity. Yet appreciation for her prowess went hand in hand with more derisive comments about her appearance, personality, and sexuality. Critics called Didrikson a "man-girl" and a "muscle moll." Criticism of track and field athletes as manly women gained enough momentum to affect participation in the sport: track, once almost as popular as tennis and swimming, fell to such a marginal position that by the 1940s and 1950s most predominantly white schools and communities simply stopped offering it to girls. Athletes from historically black schools, colleges, and universities, such Tennessee State University and Tuskegee Institute, filled the void to register outstanding AAU and Olympic performances in the pre–Title IX era.

Softball, by contrast, grew in popularity throughout the Depression and war years. In 1942, enterprising Midwestern businessmen launched a professional women's softball league, which they quickly converted to baseball. The AAGPBL operated for twelve seasons, from 1943 to 1954, and thrived in midsized cities such as Rockford, Illinois, and South Bend, Indiana. National and local media covered the league and players who were thrilled at the chance to get paid for playing the game they loved best. Yet the league's male directors never trusted that athletic skill could by itself guarantee large crowds and financial success. They conceived of their product as a dramatic contrast between feminine girls and masculine skill, and required players to wear pastel-colored short-skirted uniforms, keep their hair long, and attend preseason charm and beauty classes. Such policies sent a mixed message to the athletes and the public: athletic skills were essentially masculine with femininity existing outside, and in contrast to, sport. Moreover, AAGPBL's ideal feminine ballplayer was white, as league organizers refused to sign African American players. The men's Negro National League hired Toni Stone, Connie Morgan, and Mamie "Peanut" Johnson in the early 1950s, but a staggering number of women of color were left without athletic opportunities.

In a conservative post–World War II climate that emphasized family, marriage, and conventional femininity, the popularity of women's sport suffered further decline. Little League programs, restricted to boys, sprouted everywhere, crowding out informal sandlot and playground teams once open to the determined tomboy. In high schools and colleges, women's intramural activities vastly outnumbered more competitive interscholastic and intercollegiate events, while in municipal settings women's recreation programs emphasized activities such as "beauty culture" and crafts instead of athletic contests. As the number of playing opportunities declined, girls and women who continued to seek high-

level competition faced stereotypes of female athletes as ugly, unnatural, and masculine. Even more damaging were insinuations that linked women's sports with lesbianism. Such condemnation was a powerful form of social control that dissuaded athletic involvement no matter one's sexuality.

Yet even amid the chilly climate of the 1950s and early 1960s, a more progressive view began to gain momentum. In the field of physical education, a younger generation of professionals pressed conservative leaders to relax their stand against competition. This approach took institutional form in 1966 with the founding of the Commission on Intercollegiate Athletics for Women, renamed the Association for Intercollegiate Athletics for Women (AIAW) in 1971, which governed and promoted intercollegiate tournaments and championships for women. The organization became the sole sponsor and chief advocate of women's intercollegiate athletics in the 1970s.

The nationwide fitness campaign initiated through John F. Kennedy's President's Council on Physical Fitness encouraged younger girls to enjoy athletic pursuits. These subtle shifts in the 1960s opened the door for the dramatic changes of the 1970s and 1980s, when feminist movements took up the cause of gender equity in education, women's health, the workplace, and sport. Feminists, women's sport advocates, and a burgeoning fitness industry happy to profit from women's new athleticism combined to radically alter ideas about female physicality and encourage a view of liberation that valued strong, fit bodies capable of casting off the restraints that had marked women's inferior status for too long. In this age of change, female athletes successfully challenged the belief that sport is a male preserve, advancing instead the idea that athletic play is a human endeavor appropriate for all.

This view gained legal support through Title IX of the Education Amendments of 1972. Outlawing gender discrimination in education, the law had an enormous—and unanticipated—influence on sport. At the time of its passage, fewer than 300,000 girls played high school sports in the few states that provided interscholastic programs. Forty-five years later, nearly three and a half million girls played high school sports and more than 200,000 went on to compete in intercollegiate athletics, to become 43.5 percent of all Division I, II, and III athletes represented by the National Collegiate Athletic Association (NCAA)—not equal, but it was progress. The NCAA, which defeated the AIAW in a struggle to govern women's sport in the early 1980s, has made a public commitment to continued improvement in those statistics, with the goal of full equity under the standards set by Title IX.

As with school-based sport, women have also advanced in professional and Olympic ranks. The prodigious changes in both the number and the skill level of highly competitive female athletes have permanently altered longstanding

patterns of discrimination and the corresponding belief in female athletic inferiority. The transformation of elite-level sports has affected every level of participation. Schoolgirls report that athleticism is a source of popularity, and the tomboy epithet no longer discourages young female athletes. Parents express a similar attitude, with a vast majority now maintaining that sports are equally as important for girls as for boys. Municipal and independent youth athletic programs, which are not subject to Title IX, have followed the path of educational institutions and created a host of opportunities for girls in soccer, swimming, softball, and volleyball, as well as the chance to compete in formerly all-boys organizations, such as Little League. Interest levels are equally high among adult women, whether for those who compete nationally and internationally or for the much larger number who take up physical activities geared toward health, recreation, or enjoyment.

Still, inequalities persist. This is perhaps most apparent when it comes to pay and the allocation of financial resources. For example, in 2016 five female team members filed a wage-discrimination action against the U.S. Soccer Federation with the Equal Employment Opportunity Commission. In the complaint, the women pointed out that their team had generated nearly $20 million more revenue than the men's team in the previous season, yet the federation paid the women about a quarter of what the men earned. The U.S. Women's National Team had won three World Cups since FIFA first held the women's tournament in 1992; American men have never advanced past the quarterfinals since the Cup's advent in 1930.[3] The list of disparities between the two teams was long.

After more than a year of negotiating, U.S. Soccer agreed to increase women's pay and bonuses and improve their travel arrangements and hotel accommodations, though the terms still are not equal to what the men receive. Inspired by their soccer-playing comrades, members of hockey's U.S. Women's National Team successfully threatened to boycott the 2017 International Ice Hockey Federation Women's World Championship, forcing USA Hockey to improve its financial arrangements with female athletes. During the dispute the players received support from unions representing the NHL, NFL, NBA, and Major League Baseball and from sixteen U.S. senators.[4]

Are things starting to shift in women's favor? Yes and no. Men still vastly outearn women members of the U.S. national hockey teams. And men can supplement their stipends by playing in the NHL, where the minimum salary is more than half a million dollars. Women can play in the National Women's Hockey League, established in 2015, but salaries there ranged between $10,000 and $26,000—that is, until the middle of the 2016 season, when league officials announced they would slash all wages in half due to low attendance.[5] In soccer,

conversely, players in the National Women's Soccer League saw their minimum salaries *double* from $7,200 in 2016 to roughly $15,000 in 2017. Although this is a tremendous gain, it still is not a living wage. Most players must take on other jobs, live with host families, or play in overseas leagues to make ends meet. The minimum salary for the U.S. men's professional league, Major League Soccer, is $60,000.[6] The salary gap widens in professional basketball: in 2016 the league minimum for players in the NBA was $525,000; it was $38,000 in the WNBA.[7] As a result more than half of WNBA players take their talents overseas in the off-season or, in the case of superstar Diana Taurasi, miss an entire WNBA season in favor of more lucrative contracts in other countries.

Pay discrepancy is only slightly better in individual sports than in team sports. The Ladies Professional Golf Association granted players on the 2015 tour a total of $61.6 million in prize money. That same year, the PGA awarded $320 million to male golfers.[8] Even in tennis, the most lucrative sport for women, men earn more. Male athletes also receive more commercial endorsements and media attention, both of which exacerbate the inequity. At the administrative and coaching levels, men vastly outnumber women and typically earn much more in analogous positions.

As women strive for equality in sport as well as in education and employment, they raise a critical question that has both legal and policy implications: what constitutes equity? So far the abolition of sex discrimination has been defined in terms of equitable but not identical allocation of resources and opportunities. Thus, football teams can continue, with rare exception, to be all male and to far outspend any girls' or women's sports offered at the high school or college level, as long as female athletes have roughly equivalent opportunities to compete and receive scholarships proportional to their levels of participation. Yet the exact meanings of *equity* and *equality* remain loosely defined and hotly debated.

Some feminist critics have come at the issue from a different angle, valuing sport but asking if girls and women want to follow the same path as male competitive athletics, given their history of corruption, violence, and commercialism. Responding to the prevalence of eating disorders and serious injuries in sports such as gymnastics and figure skating, the emphasis on competitive success over participation and pleasure, and a system that rewards winning at the expense of healthy, cooperative learning and well-rounded physical and emotional development, some advocates of women's sport have begun exploring "partnership models" (sometimes called female sport models) that encourage mutual respect, the building of skills, and shared enjoyment at all levels of ability.

We can expect the struggle over gender equity and the cultural meaning of sport to continue for some time in the courts and on the playing fields. In the

meantime increased participation among girls and women will generate an expanded sense of entitlement to the many benefits of sport, such as physical strength, athletic skill, and the pleasure and confidence it can bring to body and mind. And the meaning of sport will continue to affect and be affected by the larger culture's definitions of—and conflicts over—womanhood and manhood, power and equality.

Women and Sports in the United States presents a selection of essays and documents designed to help readers explore conflicting interpretations of gender and sport in the past, present, and projected future. With this goal in mind, we have organized the book to assist readers in developing both historical knowledge and analytical insight into contemporary sport and gender relations. By focusing on major themes that have shaped the contours of sport in the past and present, each part explores a central issue—a persistent area of conflict and change—of women's sport, through historical and contemporary readings. Most sections include scholarly essays that provide important information and analytical frameworks coupled with journalistic material, research reports, opinion pieces, personal narratives of athletes and journalists, and legal or organizational documents. We chose material based on its range of coverage, diverse viewpoints, interpretive insights, and for the pleasures and challenges we hope it provides.

Part 1, "The Importance of Sport," emphasizes the different ways that sport matters in the lives of girls and women. It matters physically, socially, and psychologically. And it matters—it should matter—regardless of one's age, race, ethnicity, religion, (dis)ability, sexuality, gender identity, or social class. Yet many girls and women do not have access to sport, have been turned away from it, or think that it is of little consequence to their lives and livelihoods. For these reasons, and a host of others, sport is an important feminist issue. At the same time, the importance of sport is that it is never just about sport.

Part 2, "Biological and Physical Considerations," addresses the mythologies that have held women back from sport. For example, the myth of female frailty, an ideology rooted in gender, class, race, ethnicity, occupation, and geography, has long been used against those who hoped to engage in athletic pursuits.[9] Those who opposed participation argued that women were simply too weak, too delicate, too vulnerable to engage in such vigorous activity. Menstruation, that "eternal wound" within a woman's body, served as evidence that women were unsuited for sport.[10] Women's breasts, as one journalist wrote in the 1895 article "Women in the Water," prevented them from becoming proficient swimmers. A century later, CBS sports analyst Ben Wright likewise remarked that women golfers "are handicapped by having boobs."[11] But female athletes have continually disproved these antiquated notions, pushing both themselves and the boundaries of sport and gender.

In the process of showing that women can indeed push themselves to go higher, move faster, and be stronger, there have been some negative repercussions, including catastrophic injuries and the use of performance-enhancing drugs. Ultimately, the major theme of part 2 is that the notable biological and physical differences between male and female athletes must be considered in the context of the time and place in which these differences are pronounced and understood.

Certainly sport is a physical pursuit, but we should not overlook its psychological aspects, as the essays in part 3 attest. Research shows that sport participation confers a variety of psychological benefits on girls and women across racial and ethnic lines: improved body image, higher levels of self-esteem, and lower levels of anxiety and depression than their sedentary peers. At the same time, due to pressures to maintain certain body types, female athletes show elevated risks of pathogenic weight control behaviors. Part 3, "Psychological Issues," ends with a look at gender-related trends in the field of sport and exercise psychology.

Parts 2 and 3 consider some of the physical and psychological differences between male and female athletes, but is sex segregation the best way to organize sport? If so, on what grounds should we determine sex? These are some of the questions explored in part 4, "Sex, Gender, and the Rules of Inclusion." Outside of sport there are few social outlets that mandate separating girls from boys or women from men. But some critics doubt that separate can ever be equal and instead propose alternative sex-integrated models. Both segregation and integration, however, are premised on a binary model of sex, that is, that there are two opposite and mutually exclusive sexual categories: male and female. The truth is that human sex is not so neat or easily divisible, as stories of intersex, hyperandrogenic, and trans athletes tell us. While organizations struggle with how (and whether) to determine and maintain sexual categories in sport, they raise important questions about equity, identity, and power.

These same questions, with slightly different inflections, play out in part 5, "Athletes Performing Masculinities and Femininities." The historical associations between masculinity and sport can present challenges for female athletes. When Phillip K. Wrigley established the All-American Girls Professional Baseball League in 1943, the tension between sport's masculine history and the overtly feminine athletes was a major selling point for Midwestern audiences. Thus, as one sees in the league's rules of conduct, the players were required to perform an emphasized version of (white) femininity through their clothing, hairstyles, and comportment. Although the women were proficient athletes, the insult "you throw like a girl" persists, particularly as a way to disparage boys and men. The idea of playing "too womany" is a variation on this theme. But what does this say about our perceptions of girls and women as athletes? Why do such

beliefs persist, even when women's presence in sport is now taken for granted? Athletic skill, strength, and muscularity continue to be the hallmarks of ideal masculinity. Even when these attributes are celebrated in women's sport, they too often come cloaked in the vestiges of idealized femininity—whether the skirts worn by AAGPBL members or the sparkly hair ties donned by contemporary softball players.

We continue discussions of sex and gender in part 6 by focusing more specifically on matters of sexuality in women's sport. We start with two articles that discuss the significance of heterosexuality and hypersexuality in sport. Does an emphasis on an athlete's beauty or sex appeal undercut the legitimacy of her accomplishments, as well as the legitimacy of women's sport in general, or does it encourage spectatorship and fandom, which women's sport so desperately needs to stay afloat? No matter where one comes down in this debate, we find undeniable evidence of the problems with sexualizing women athletes in the selections concerning the 2012 Harvard men's soccer team, which issued a "scouting report" on the incoming women players that compared their bodies and described them in numerical and sexually explicit terms. An investigation uncovered this report several years later, and it is clear that this was something of an annual tradition among the male players; similar actions unquestionably go on at schools and universities across the country. Hurt, frustrated, angry, and disgusted with the men they thought were their teammates, six women subjected to that report responded in an open letter, reminding us that "'locker room talk' is not an excuse because this is not limited to athletic teams. The whole world is the locker room." The uses of conventional femininity and heterosexuality to sell women's sport are also manifestations of sexual prejudice, as scholar and activist Pat Griffin shows in her 1992 landmark article "Changing the Game: Homophobia, Sexism, and Lesbians in Sport." More than two decades later, it is clear that homophobia remains a significant problem. Finally, part 6 ends with a disturbingly important article on the prevalence of sexual abuse in sport.

Although this book is about women in sport, it is important to note that not all women share the same identities or experiences. In part 7, we consider the ways that race and ethnicity intersect with sex and gender to influence sport participation. We begin with two essays that attend to the ways that African American women negotiate their femininity and sexuality in the context of track and field's supposed "masculine" attributes.

Although Title IX has improved the participation of white and middle-class women in sport, it has not always affected girls and women of color in the same ways. And women of color who are able break into traditionally "white" sports, such as gymnastics, figure skating, and swimming and diving, encounter

continued manifestations of prejudice. Those confronted with bigotry react in a variety of ways. We end this part with a reaction from Oglala Sioux basketball star SuAnne Marie Big Crow, born and raised on the Pine Ridge reservation in South Dakota. As opposing fans spewed racial hatred at Pine Ridge's high school girls' basketball team, Big Crow performed, as Ian Frazier describes, "one of the coolest and bravest deeds I have ever heard of." The readings in part 7 highlight the ways in which race and ethnicity intersect with sex to produce differential experiences for women in sport and, simultaneously, draw attention to issues of white privilege.

These differential experiences tend to play out in the ways that the media represents (or does not represent) female athletes. Part 8, "Women, Sport, and the Media" includes two academic surveys. Considering some of these scholars' findings, specifically as they played out in the 2016 Rio Olympics, Lindy West offers a "handy guide" for how a journalist can "talk about female Olympians without being a regressive creep." Sadly, it is advice from which many people, both inside and outside the media, could benefit. Shireen Ahmed takes on the gendered Islamophobia prevalent in media coverage of Muslim women athletes. In the process, Ahmed notes that "almost 90 percent of sportswriters are white, straight, able-bodied men. Therein lies much of the problem." This also poses a problem for women sportswriters, who must deal with their own varieties of regressive creeps, especially on social media, as Julie DiCaro discusses in the last article in part 8.

More than ten years after the publication of the first edition of *Women and Sports in the United States: A Documentary Reader,* what has changed? What remains the same? And what work is needed to make sport a safe, encouraging, competitive, positive, and inclusive space for all? To address these questions, we end this book with "Current Status and Recommendations for the Future," a section devoted to the state of women in sport, assessed through reports about youth and scholastic sport, intercollegiate athletics, and the Olympic Games.

We hope that this book encourages critical thinking and lively discussion about why sport matters to humans and in particular what the experience of sport contributes to the lives of girls and women. Is it worth fighting for? If it is, what do we seek to achieve?

Notes

1. Gary Libman, "Kicking Up a Storm," *Los Angeles Times* (November 8, 1990), E1, 14, 16.
2. "Short-Haired Girl Mistaken for Boy, Barred from Soccer Tournament Finals,"

NPR, June 6, 2017, www.npr.org/sections/thetwo-way/2017/06/06/531754229/short
-haired-girl-mistaken-for-boy-told-she-can-t-play-soccer.

3. Louisa Thomas, "Equal Pay for Equal Play: The Case for the Women's Soccer
Team," *New Yorker,* May 27, 2016, www.newyorker.com/culture/cultural-comment/
the-case-for-equal-pay-in-womens-sports.

4. Travis Waldron, "U.S. Women's Hockey Players Reach Deal to End Fair Pay
Boycott," *Huffington Post,* March 28, 2017, www.huffingtonpost.com/entry/us
-womens-hockey-pay-deal_us_58d13577e4b00705db52b7fa.

5. Seth Berkman, "Pay Cuts Jolt Women's Pro League and Leave Its Future
Uncertain," *New York Times,* November 22, 2016, www.nytimes.com/2016/11/22/
sports/hockey/nwhl-pay-cut-salary.html?mcubz=1.

6. Meg Linehan, "NWSL Minimum Salary to Double for Fifth Season," Excelle
Sports, January 26, 2017, www.excellesports.com/news/nwsl-minimum-salary-double
-fifth-season.

7. John Walter, "Taking a Closer Look at the Gender Pay Gap in Sports," *Newsweek,*
April 1, 2016, www.newsweek.com/womens-soccer-suit-underscores-sports-gender
-pay-gap-443137.

8. Ibid.

9. Nancy Theberge, "Women's Athletics and the Myth of Female Frailty," *Women: A
Feminist Perspective* 4 (1989): 507–522.

10. Patricia Anne Vertinsky, *The Eternally Wounded Woman: Women, Doctors,
and Exercise in the Late Nineteenth Century* (Manchester, UK: Manchester University
Press, 1990).

11. Richard Sandomir, "CBS Pulls Wright off the Air," *New York Times,* January 10,
1996, B9.

PART I *The Importance of Sport*

This first part addresses why sport matters and, particularly, why sport matters to girls and women. As the included report from the Women's Sports Foundation explains, sport offers a number of physical, psychological, and social benefits. The lessons that athletes learn translate to other areas of achievement, such as education and the workplace. It has always been important to promote sport for boys and men and for too long girls and women missed out.

As the next three readings demonstrate, sport is important to everyone—regardless of age, impairment, or ability. In "Climbing through the Glass Ceiling," Chuck Tanowitz describes taking his ten-year-old daughter to watch her idols compete at a national rock-climbing championship. The significance of young girls—of anyone, really—watching highly skilled female athletes at peak performance cannot be overstated. These athletes demolish sexist stereotypes as they inspire the next generation to push the boundaries of human potential.

Older athletes also challenge stereotypes, as Maureen M. Smith examines in "I Am Woman, See Me (Sweat)!" Historically, women over the age of 60 were considered in terms of their "physical frailty," rather than their physical competence. In reviewing the sport sociology literature and weighing it against the experiences of three groups of physically active women, Smith argues there needs to be more study devoted to this increasingly vibrant population. In addition, there should be more opportunities for aging women to be physically active. As Smith maintains, "If you offer it, older women will participate."

In the same way, we need more sporting opportunities for girls and women with physical, intellectual, or sensory impairments, as the story of track star

Tatyana McFadden makes clear. McFadden, who races in a wheelchair and earned her seventeenth Paralympic medal at the 2016 Games in Rio, had to develop her skills without the benefit of a high school team. When she sought to compete, the coach dismissed her by explaining, "There's clubs for kids like you." McFadden's subsequent lawsuit against the school helped pave the way for a 2013 national law mandating that schools must provide athletic opportunities for students with impairments. This is important. Approximately nine out of every one hundred U.S. families have a child with an impairment that interferes with sport and exercise, yet few are able to find viable athletic outlets, despite the law that resulted from McFadden's efforts.[1]

Clearly, sport is important for all girls and women, and yet, as several of the readings in this section point out, they still lack opportunities, funding, and media coverage. As Maggie Mertens asserts, sport is a "feminist issue." Even so, Mertens continues, feminist organizations and media outlets too often view women's sport as "frivolous." This is a mistake, for sport is "an institution of massive cultural significance and an area rife with 'serious' issues, such as sexual violence, pay inequality, and a lack of women in leadership positions."

Finally, the remarks from UN Assistant Secretary-General and UN Women Deputy Executive Director Lakshmi Puri reiterate some important themes raised in this part. Like Mertens, Puri notes some of the problems that continue to plague girls' and women's sport. And, as with the McFadden article, Puri asserts that "it's not just about sports." We thus close this part by considering some of the international implications of sport—as a path toward gender equality, female empowerment, and the eradication of poverty and gender-based violence.

Note

1. Michael L. Williams, "Accommodating Disabled Students into Athletic Programs," *National Federation of State High School Associations,* July 27, 2014, www. nfhs.org/articles/accommodating-disabled-students-into-athletic-programs.

BENEFITS *Why Sports Participation for Girls and Women*

Women's Sports Foundation | 2016

A Matter of Health and Well-Being

Founded in 1974 by Billie Jean King, the Foundation is dedicated to advancing the lives of girls and women through sports and physical activity. That's what the Foundation does, but the "why" is most important. Although there is a federal law that mandates equal participation opportunities for male and female students in secondary and post-secondary institutions of higher education, the real reason we want equal opportunity for our daughters to play sports is so they too can derive the psychological, physiological and sociological benefits of sports participation. Sport has been one of the most important socio-cultural learning experiences for boys and men for many years. Those same benefits should be afforded our daughters. It is important for all of us to know that:

- High school girls who play sports are less likely to be involved in an unintended pregnancy; more likely to get better grades in school and more likely to graduate than girls who do not play sports.

- As little as four hours of exercise a week may reduce a teenage girl's risk of breast cancer by up to 60%; breast cancer is a disease that afflicts one out of every eight American women. (Journal of the National Cancer Institute, 1994)
- Forty percent of women over the age of 50 suffer from osteoporosis (brittle bones). (Osteoporosis, 1996) None of us should want our daughters to repeat the experiences of generations of women—our mothers and grandmothers—who were not permitted to play sports or encouraged to participate in weight-bearing exercises that are necessary to establishing bone mass.
- Girls and women who play sports have higher levels of confidence and self-esteem and lower levels of depression.
- Girls and women who play sports have a more positive body image and experience higher states of psychological well-being than girls and women who do not play sports.
- Sport is where boys have traditionally learned about teamwork, goal-setting, the pursuit of excellence in performance and other achievement-oriented behaviors—critical skills necessary for success in the workplace. In an economic environment where the quality of our children's lives will be dependent on two-income families, our daughters cannot be less prepared for the highly competitive workplace than our sons. It is no accident that 80% of the female executives at Fortune 500 companies identified themselves as former "tomboys"—having played sports.

Women without Sports Experience
Are Disadvantaged in the Work Setting

The existing American business model is a male model of organizational structure and human relationships. Males learn the rules of human organizations and interactions from sport. Sport is one of the most important socio-cultural learning environments in our society and, until quite recently, has been reserved for boys and men. This is not to say that the male model of business or organizations is the preferred model. In fact, women are bringing new strengths to business and organizations that are based on their skills in group process, preference for cooperation models and sensitivity to human needs. Eventually, as women rise to executive positions, the organizational models of business will reflect more female characteristics and become androgynous.

Right now, however, women who don't know the written and unwritten rules of sport are at a disadvantage in understanding business models of organization

based on sport. How important is it that our daughters learn the same rules as our sons? It's critical. The most important of those rules are:

1. *Teams are chosen based on people's strengths and competencies rather than who is liked or disliked.* This seems like such a simple concept, yet women have traditionally learned to pick their friends and emphasize human relationships rather than skill competencies.

2. *Successful players are skilled in practicing the illusion of confidence.* Boys are taught at an early age and through their participation in sport that it is not acceptable to show fear. When you get up to bat or play any game, it is important to act confident and not to let your teammates know you are afraid, nervous or have a weakness—even if you are not confident. Employees who are skilled at practicing the illusion of confidence— calmness under pressure, acting sure of self and abilities, etc.—get to play the most important positions and are more likely to be starters. People who are practicing the illusion of confidence make everything look easy and don't need constant reinforcement or support.

3. *Errors are expected of people who are trying to do new things. The most important thing is never make the same mistake twice.* Errors are acknowledged immediately by each player and players are expected to fix their errors and not dwell on them or take criticism of errors personally. During a game is not the time to have a long conversation about what you should do or how you might correct an error. That is something you do during practice before or after the game.

4. *Loyalty to your teammates is very important.* Many women don't understand it when a man who is not doing his job is protected rather than dismissed. Boys learn from sports that every person on the team has a role to play. Even the players who sit the bench are positive forces on the team as long as they are good sports and encourage teammates who play. Players who are satisfied sitting the bench and waiting their turn to play are valued because they promote team harmony by not complaining. Not everyone can be a successful player. Few men will criticize their teammates. They will always promote the strength of their teammates and not mention weaknesses. Women who don't play sports are much more critical of each other and much more likely to point out a teammate's weaknesses if asked to do so. When women do this in business organizations, they are perceived as disloyal. This is not to say that we must tolerate incompetence. What is important is how we do it. If we have an incompetent employee, then good teammates need to find a position he or she

can play or trade that player to another team. This means that we need to help relocate employees we no longer wish to keep.

5. *"I will" equals "I can."* Boys playing sports are taught that being "good at a position" is a function of the will to achieve and working on the basic skills required for that position. They also learn that you need to play the position in order to become adept at that position. Thus, boys grow up thinking that they can achieve anything they commit themselves to achieving. It is not [because of] an inflated ego or an accident that men apply for jobs for which we may think them underqualified. It is simply that they have been trained to believe that they "can" meet a new challenge of a new position and can learn by doing. Women, on the other hand, believe that advancing to a new position requires certification, classroom training, degrees or something tangible that says "I am qualified," in addition to being confident that they can meet the demands of a new position. If they haven't played sports, they haven't had as much experience with the trial-and-error method of learning new skills and positions and are less likely to be as confident as their male counterparts about trying something new.

6. *In a hierarchical organization, your boss (the head coach) gives the orders and the employees (players) follow the head coach's instructions.* Men's organizations are very hierarchical in nature. When playing the game in the business setting, the coach is all powerful and players follow orders. If a player has a better idea, he or she gets to the coach in an informal setting and persuades the coach to consider that idea. The idea then becomes the coach's idea and is carried into the business setting. Women's organizations are more decentralized and collegial. Women are much more likely to bring a group together, ask everyone to present their ideas and then come up with an idea or direction that has the support of the majority of the group. It may be unrealistic to expect organizations led by men who have been trained in hierarchical organizations to adopt problem-solving or decision-making models preferred by women. It may be equally unrealistic to expect your coach to understand when you speak up to disagree during team meetings. It is important for our sons and daughters to learn about the differences in how men and women create different decision-making and problem-solving organizations, and how to operate successfully in each environment.

7. *Winning and losing has nothing to do with your worth as a person.* In sports and in organizations, sometimes you win and sometimes you lose. Sport gives you experience so you learn to win graciously and accept defeat without blowing the experience out of proportion. You learn

to separate the outcome of a game or your performance in one game from your worth as a person. A bad practice does not make you a bad person. This is a critically important lesson for all workers.

8. *Pressure, deadlines and competition are fun.* In sports and in organizations, pressure, deadlines and competition are commonplace. Sport gives players the experience of dealing with these realities and learning to enjoy and conquer their challenges. When there are only two seconds left on the clock, your team is one point down, and you go up for the jump shot, you learn what pressure, deadlines and competition are all about and how they can be perceived as exhilarating and fun rather than scary and distasteful. The bottom line is that most organizations want to hire people who enjoy and excel in competitive environments. If we don't give sports to women, we don't allow them to learn how to handle these challenges.

9. *When you are too tired to take one more step, you know you can.* Ultimately, participation in sports teaches players all about the work ethic: that hard work, repetition and constant practice are the keys to successful performance. Athletes know that no matter how tired they are, they can tap into a reservoir of stamina, strength and good thinking—even under the most difficult of circumstances—and continue to compete successfully.

10. *Perfection is sequential attention to detail.* In sports and in business, being exceptional is leaving no detail unattended to. Every athlete has a precise checklist of details involved in every skill from throwing a curve ball to shooting a jump shot. The more you study your opponent and prepare for a game, the more successful you are. Great players are students of their game, and great students are always learning.

Girls and Women Need Encouragement and Aspirational Role Models

Many people think that girls are not as interested in sport as boys. Women's Sports Foundation research shows that boys and girls between the ages of 6 and 9—and their parents—are equally interested in sports participation. However, by the age of 14, girls drop out of sport at a rate that is six times greater than boys. Girls and women simply do not receive the same positive reinforcement about their sports participation. Boys receive balls, gloves and sports equipment by the age of 2. They see their images on television as sportsmen, they see their photos in the sports section and know from their parents and friends that they are expected to play sports.

Even though our daughters are not as likely to be discouraged from playing sports as they were 10 years ago, they simply aren't encouraged to the same extent as little boys. As a result, they enter organized sport two years later than little boys and are, therefore, less likely to have the skills necessary for early success experiences. If a child is unskilled, he or she is unlikely to have fun. It's no fun to strike three times in row. The no. 1 reason why boys and girls play sports is because it's "fun."

We must do a better job of supporting our daughters' sports participation. For Christmas and birthdays, we must find books about girls in sports, give gifts of sports equipment and sports lessons. We need to take our sons and daughters to see women playing sports so they grow up appreciating and respecting the sports skills of women and so our daughters see images of themselves excelling in sports—because she is not going to see those images on television or in the newspapers. It's no accident that girls' sports participation in Olympic sports increases significantly following the Olympic Games, one of the few times that coverage of women's sports is equal to that of men's sports. Aspirational role models drive youth demand for sports. This top to bottom synergy has not yet become commonplace in women's sports because of limited college and professional sports opportunities and television coverage.

However, the trend is clear: the increased participation and success of female athletes at the Olympic Games, increased television coverage of women's college sports, new women's professional sports leagues and the participation increases of females in all sports and all age levels.

CLIMBING THROUGH THE GLASS CEILING

Chuck Tanowitz | 2015

From *Medium*, July 7, 2015, https://medium.com/@ctanowitz/climbing-through-the-glass-ceiling-4f4403137f01. Reprinted with permission.

America is on the women's sports bandwagon again thanks to a spectacular victory by the American women in the World Cup. This was as exciting a game as has ever happened in sports. The fact that women played mattered less than the athleticism clearly apparent on the field.

As Dave Zirin at the *Nation* points out it's silly to try to defend "women's sports" since it's been defended before and will be defended again.[1] But for those of us with daughters, this does matter quite a bit.

For me it has to do with the world of climbing and a sweet, tough 11-year-old girl who not only climbs, but also plays a solid game of soccer, much like her current favorite player, Alex Morgan.

Not long ago I was sitting on the padded floor at Central Rock Gym in Watertown, Mass. My daughter, shaking with excitement, sat next to me as we waited for the 23 competing athletes to enter. I looked at the huge rock wall in front of us, camera phones clicked and the emcee kept the crowd at this sold-out event warmed up and cheering.

The stakes were high—this was the national championship. And as the athletes walked out, I counted 12 women and 11 men, some barely older than the 10-year-old girl cheering beside me. They waved to the crowd and took in our adoration; their bodies looked as if they'd been chiseled from the stone which the climbing walls resembled.

It was then that I realized: I had no idea who the men were, but I knew a good number of the women. For the first time I approached a sport entirely by knowing the women first.

My daughter's bedroom looks like that of most other girls her age. She has her stuffed animals, pictures of friends, an iPad seemingly always at the ready and a pink wall filled with posters. Of course there's Taylor Swift and her copy of Van Gogh's Starry Night, but filling in the blanks are photos of rock climbers.

A prominent space is held for Sasha DiGiulian, a social media phenom who is known as one of the best in the world.[2] She is sponsored by big names like Adidas and boasts thousands of followers on Instagram and Facebook. She inspires not just my daughter, but thousands of others.[3] There is also Delaney Miller, a 19-year-old who turned out to be the winner that night at Central Rock Gym, and Meagan Martin, who was among the top female contenders on American Ninja Warrior. All these women are on YouTube and, believe me, their climbs get watched.

Missing from the night, but there in my daughter's heart, was Ashima Shiraishi, a 13-year-old girl from New York whose age and stature belie her abilities. Her TEDX Teen Talk, in which she laments her struggles with homework even as notes that she climbs until her fingers are bloodied, has been viewed more than thirty-six thousand times.[4] My daughter counted for at least a few of those.

But rock climbing seems like the anomaly.

Women's sports have consistently struggled to gain spectators. Tennis and golf have likely made the most progress, pay women about as much as men and have similar levels of spectators.[5] But the norm for women's sports is cases

like women's basketball, which not only struggles to get a foothold, but also becomes the butt of jokes.

Flip on ESPN at any given moment and try to catch some highlights of women's basketball. You can't. But you can easily catch coverage of men's professional and college teams. This isn't just speculation. According to the Women's Sport and Fitness Foundation, as reported in the *Economist*, women's sports received 7% of the coverage of men's sports on commercial television in 2013.[6]

Here in Boston, the Krafts are talking about building a soccer stadium just for the Revolution using public land.[7] Meanwhile, the Boston Breakers, our own women's professional team, will play at Harvard. Not at Harvard Stadium, where they played to mostly empty stands last year, but at a smaller soccer stadium designed for college soccer.[8]

The problem isn't the women on the field and it isn't team management; they're just responding to economic demand. The problem is us. We look at the men first and then just assume that the women's games are an inferior experience.

Sitting in that rock gym with the men and women climbing side by side, it was clear that the women aren't inferior climbers. In fact, the women seemed to outlast the men on the wall and gain the biggest cheers.

We weren't watching men and women, we were watching highly trained athletes building up on physical strength and using expertise that has taken them hundreds or thousands of hours to acquire. These are people at the top of their game.

In truth, we need both men and women on the professional level because they inspire our sons and daughters differently.

A day after the competition, as she thought about her upcoming climbing session, my daughter turned to me and said, "I can't wait to get to the bouldering wall. I feel inspired!"

She never could feel that way if the only athletes she had to watch were the men.

Notes

Links in the original online version of this article have been turned into endnotes.

1. David Zirin, "Why I'm Done Defending Women's Sports," *Nation*, July 6, 2015, www.thenation.com/article/why-im-done-defending-womens-sports.

2. Clare Malone, "Selling Rock Climbing in the Social-Media Era," *New Yorker*, March 30, 2015, www.newyorker.com/news/sporting-scene/selling-rock-climbing-in-the-social-media-era.

3. Rebecca Ruiz, "21 Women Whose Instagram Photos Will Amaze and Inspire You," *Mashable*, March 8, 2015, http://mashable.com/2015/03/08/instagram-amazing-women.

4. Ashima Shiraishi, "Just Climb through It," TEDx Teen, October 21, 2014, https://www.youtube.com/watch?v=dIz7n7KWlZY.

5. Nikhil Sonnad, "The Most Female-Friendly of All Spectator Sports: Tennis," *Atlantic*, July 25, 2014, www.theatlantic.com/entertainment/archive/2014/06/if-you-care-about-equal-pay-for-women-tennis-is-the-sport-for-you/373371.

6. "Why Professional Women's Sport Is Less Popular Than Men's," *Economist*, July 28, 2104, www.economist.com/blogs/economist-explains/2014/07/economist-explains-19.

7. Mary Moore, "Kraft Soccer Stadium Push Complicates Boston 2024 Plan for Widett Circle," *Boston Business Journal*, March 25, 2015, www.bizjournals.com/boston/news/2015/03/25/kraft-soccer-stadium-push-complicates-boston-2024.html.

8. Shira Springer, "Why Do Fans Ignore Women's Pro Sports?" *Boston Globe*, September 24, 2014, www.bostonglobe.com/magazine/2014/09/23/why-fans-ignore-women-pro-sports/A37CAUWxMvocvF5xkkAe1J/story.html.

I AM WOMAN, SEE ME (SWEAT)!

Older Women and Sport

Maureen M. Smith | 2016

From *Kinesiology Review* 5, no. 1 (February 2016): 75–80, doi:10.1123/kr.2015–0055. Copyright © Human Kinetics, Inc. Reprinted with permission. Bracketed insertions are part of the original publication.

"For the first time in history, the proportion of adults age 60 and older is growing faster than any other age," according to the National Academy of Kinesiology (NAK) 2015 conference program. The rise in the population of 60-year-olds points to an increasing number of older women engaged in various forms of sport. As a result, these older women and their sporting exploits will contribute to the growing body of literature examining the sporting experiences of older women, and perhaps serve as a model for younger women who hope to stay active in the second half of their lives. Of importance in thinking about this subject is how we define older women and the concomitant stereotypes, ideas, and expectations American society attaches to this growing legion of "older women" in the sporting arena. If the emphasis on the proportion of adults age

60 and older is any indication, the age 60 appears to be entering the realm of "older adult." This arbitrary age marker is news to me, as I'm not sure we have general consensus as a society as to what it means to be older and, as a result, how we think (and feel) about growing and being older. This is especially important in sport and exercise, two spaces that privilege and value youth in significant and meaningful ways.

Barbara Ainsworth, in organizing this special issue and the various presentations at the NAK 2015 meeting, communicated her intention to examine the broader topic of older adults and physical activity from Bronfenbrenner's (2010) social ecological model. Bronfenbrenner's model is particularly helpful in reminding scholars about the various influences on individual lives and pursuits, especially scholars who might not normally give much thought to issues of access, role of the family, economics, institutional support or lack thereof, and so on. In sport sociology, these are issues we consider on a daily basis and our theories operate with assumptions of racism and sexism, as well as class inequity issues (Coakley, 2015; Sage & Eitzen, 2015). Exercise, sport, physical activity—these are so much more than one's physical body moving through physical space, more than telomeres and heart rates, more than muscles, bones, and systems. Movers are thinking, feeling, remembering beings. One element Bronfenbrenner does not take into account with his model is the passage of time, that is, historical context, which Mills (1959) included in his sociological imagination. For example, one cannot examine an older woman and her physical activity simply in her present condition and in her present moment of time; one must also consider her past experiences. Moreover, Bronfenbrenner's model does not consider the intersectional identities of individuals. Thus, the model does not consider, for example, the ways one's race and class intersect with one another and allow for varied experiences based on these intersections (Crenshaw, 1989).

In this article, I provide a brief overview of recent work in sport sociology examining the experiences of older women in sport. I provide a brief American perspective on this trend and highlight three groups of older women in sport and physical activity that serve as examples of possibilities and models, and conclude with considerations as to how programs of kinesiology might consider the experiences of older female athletes from a perspective that considers the "sociological imagination."

Before examining the literature examining older women in sport, it may be helpful to remind the reader of the current historical context related to older adults. This article's title suggests that older women as a group are marginalized in American society, much less the sporting arena, hence the "See Me Sweat." When it comes to "seeing" women in American society, we are a bit schizophrenic in the ways we perceive and portray, as well as how we study, this

segment of our population. This is particularly true in thinking about women as physical movers. Grant and O'Brien Cousins (2001, p. 238) contend, "In the course of quantifying physical performance, functional capabilities, and psychological characteristics of the aged, the ineffable and less tangible are either suppressed or absent," and consequently "the central character [i.e., the older adult] is hidden from the text." The literature on aging adults overwhelmingly examines this group as physical specimens, with little consideration for their enjoyment of movement or their desire to hone their skills. Instead, they are reduced to statistics that warn us of their physical deficiencies.

The manuscript title's reference to 1970s icon Helen Reddy and her feminist anthem, "I Am Woman, Hear Me Roar," is first a play on words—we need to actually see (read value) women—and the sweat aspect is reliant on first being seen, though seeing older women (or women of any age, for that matter) sweat also conjures images that bring a new set of issues with which to contend (Kane, 2011, 2013). Sport, including physical activity and exercise, is a gendered activity; our cultural expectations and ideologies around both gender and sport are ones that do not celebrate or value women in the same ways, be it financially, physically, emotionally, and so on. Moreover, our educational, cultural, political, and other social institutions over time have contributed to these ideologies, making it challenging to accurately think about older women in sport without giving attention to the gender of the participants. Therefore, this focused attention on women is largely in response to the institutionalized ways they have been marginalized and sometimes excluded in sport (Coakley, 2015; Sage & Eitzen, 2015).

An example of a prominent woman in American society at this historical moment will help illustrate these points in ways that might be further applied to women in the sport setting. Hillary Clinton, one of the current contenders running for the democratic nomination for president, is 68 years old. Her age and status as a grandmother are both viewed as weaknesses, whereas men of a similar age are not viewed in the same light (Sullivan, 2014). Moreover, the relationship Americans have with their politicians and the expectations we have of these politicians to have some sport credibility puts Clinton at a serious disadvantage (Coakley, 2015). She did not attend high school during a time period when organized sports were widely available for girls, nor was there social support for girls who wanted to (and did) engage in sport (unless that sport was considered female appropriate and the female athlete appeared feminine). How will Clinton communicate to American voters her fitness to be commander-in-chief without the requisite sporting experience? Her best bet will be as a fan, which is not nearly as prestigious (at least for women) as being a former athlete.

Most reviews of literature in sociology of sport studies that examine older

adults in sport include reference to the various stereotypes of aging adults, some positive and some negative, as well as mediated images of older adults, both in sport and in society (for example, see Atkinson & Herro, 2010; Grant, 2001; Hartmann-Tews, 2015; Hervik & Fasting, 2014; Pike, 2010; Pike, 2011a; Pike, 2011b). In news media and popular culture, there is a noticeable absence of images of older women in exercise and sport. A Google search using the keywords "older women and exercise" retrieved various images that pictured older women who appeared older than what I was expecting and doing activities that seemed to fulfill stereotypes of fragility. These images were almost exclusively of White women with gray hair doing basic movement patterns such as stretching. A Google search for "older adults and sports" was only slightly better. This absence of images of older women engaged in sport extends to older women commenting on sport, coaching sport, and writing about sport. While a similar argument might be made about older men in sport, there are still many models of manhood that affirm their masculinity and strength. Moreover, older men are still reporting and commenting on sport. Even older male sport fans are depicted. For example, on NFL Sundays, viewers are routinely exposed to older men's masculinity with Cialis ads, and their female partners are simply supportive and passively-engaged bathtub buddies. Recently, when the popular television series from the 1980s, "The Golden Girls" celebrated their 30-year anniversary, it reminded viewers of the ways older women have been portrayed in popular culture. This foursome of three women in their 50s and one 80-year-old portrayed older womanhood as a phase of life that was rooted in retirement and stereotypical attitudes about aging. The television series is one prominent example of the ways popular culture's definition of growing older has evolved since the show's initial airing in the 1980s. Blanche, Rose, and Dorothy were in their mid-50s, and that was considered "golden"?! And yet they were seen as older women, retired and engaged in volunteer work, and cementing the image of golden girls in stereotypical ways. To the point of older women's involvement in sport and exercise, the extent of their exercise was dancing and the ever-popular 1980s sport of aerobics in their Jane Fonda unitards and leggings.

Older Adults in Sport from a Sport Sociology Perspective

Several journals publish articles that address active aging from a sociological approach. The *Journal of Aging and Physical Activity* (JAPA) routinely publishes issues with around 15 articles per issue, with one or two of the set being sociological or maybe tangentially related. In the July 2015 issue, all 18 original research articles were focused on the physical dimensions of aging, such as cardiovascular

risk, gait speed, steps per day, step count accuracy, waist circumference, loss of muscle, and arm reach tests. In April, one article did examine racial segregation's impact on exercise (Armstrong-Brown, Eng, Hammond, Zimmer, & Bowling, 2015), and another looked at environmental barriers to movement in older adults in Taiwan (Chen, Matsuoka, & Tsai, 2015). The January 2015 issue featured an article titled "Impact of Psychosocial Factors on Functional Improvement in Latino Older Adults After Tai Chi Exercise" (Siu, Rajaram, & Padilla, 2015). However, a quick review of the journal's mission statement does reveal a focus on the physical dimensions of aging, with less emphasis on articles that might fall under the social science umbrella. Moreover, the few articles that consider the psychosocial aspects often approach the subjects using quantitative methods (though a special issue of JAPA was published in 2001 that highlighted qualitative research, and called for more work to be done).

Athletes of all ages participate in sport for a variety of reasons, and older women echo similar motives. Health and fitness benefits, enjoyment, accomplishment, socializing with others, and their love of the sport all appear as reasons to explain older women's engagement in sport. Yet, older adults are generally marginalized when we study sport, with not as much known about their experiences in sport, including the quality and meanings of their experiences. One notable contributor to this area of study in sport sociology is Rylee Dionigi, whose work has appeared in the *Journal of Aging and Physical Activity*, the *Sociology of Sport Journal*, and a number of leisure publications (Dionigi, 2005, 2006a, 2006b, 2010a, 2010b, 2010c, 2013). Dionigi (2006a) examined the motives and experiences of older adults in physically-demanding sports at senior sporting competitions, such as Masters Games and Senior Games. Like Grant and O'Brien Cousins (2001), she urged others to pursue qualitative methods in their approach to studying older athletes, and addressed the value of interviews and observations. Citing Jaffe and Miller (1994), who state the goal of qualitative research is "to understand social life by taking into account meaning, [and] the interpretive process of social actors," but also "cultural, social and situational contexts in which those processes occur" (p. 371), Dionigi's findings reveal the complexities and contradictions which frame older adult participation in sport. For example, there exists the belief that competition is for young athletes and sport for older adults is supposed to be fun. In her interviews with older athletes, she identified four themes: 1. "fun, friendship, and fitness"; 2. competition was important to participants; 3. "I'm out here, I can do this" (ideas about youthfulness); and finally, 4. use it or lose it (which is a theme that appears in other similar studies with masters athletes). In *Competing for Life: Older People, Sport and Ageing* (Dionigi, 2008), she argues that the "phenomenon of older people

competing in sport is a reflection of an ageist society which continues to value youthfulness over old age and reject multiple ways of ageing" (see Dionigi's university website at https://www.csu.edu.au/faculty/science/human/staff/profiles/associate-professor/rylee-dionigi).

In reading through her published works and her extensive vitae on the topic (also see Dionigi, Baker, & Horton, 2011; Dionigi & Gard, 2015; Dionigi, Horton, & Baker, 2010, 2013; Dionigi & Litchfield, 2013; Dionigi & O'Flynn, 2007; Horton, Dionigi, & Bellamy, 2013; Litchfield & Dionigi, 2012), one is quite impressed with her focus as well as her qualitative approach to her subject. For anyone in sport sociology interested in studying older adults in sport, Dionigi's work is a primer. Similarly, sport sociologist Elizabeth Pike in the United Kingdom has focused on the sporting experiences of masters athletes (Pike, 2010; Pike, 2011a; also see Pike, 2011b, 2015). Pike (2011a) builds on the work of Hastings, Kurth, Scholder, and Cyr (1995) regarding masters swimmers, which developed Stebbin's concept of serious leisure, and found the main reasons given for participating in masters swimming were sociability, achievement, fitness, skill development, enjoyment, and tension release. Pike contends that "we know very little" (2011a, p. 493) about the meaning and significance of exercise in later life. In her study on masters swimmers, who had an average age of 65, Pike identified three themes. The first was how swimming helped form the daily schedules of the swimmers, replacing work, and helping to structure retirement. These older adults (she included both men and women in her study) found that swimming was much easier to schedule into their days without the time demands of work, and swimming provided a space where they could develop new skills and engage in serious leisure and serious play. Female swimmers, however, still had the challenge of balancing domestic responsibilities with their swimming schedules. Pike's second theme was how access to economic capital enabled the consumption of social and corporeal capital through swimming (and helped dispel notion of dependent older adults). She writes about WOOPies (Well Off Older Persons) and GLAMs (Gray, Leisured, and Moneyed) and the access their financial capital provided in transportation issues, such as driving to meets and practice. Their swimming activities provided them community and prevented isolation. Pike comments that this third age of older adulthood resembles adolescence, a time period where new identities are created and social status and networking occur through swimming membership. Her third theme was how swimming was a form of resistance to the aging body (and in the process reproduced the privilege of youth). In this theme, swimmers spoke of their declining performances, as well as changes in their physical appearance. Their engagement in social comparison led some to see the aging process as part of losing their athletic self, and

they had to learn how to negotiate their aging bodies. One interesting note Pike included was the role of the British government, who offered free swimming to all citizens over age 60 as part of the Olympic legacy for the 2012 Olympic Summer Games. Her point is well taken, as is the work of Dionigi and others in this field—when it comes to aging adults and activity, many countries are far ahead of the United States in providing institutional and structural supports which allow for more opportunities for sport participation.

An American Response to Older Women in Sport

In thinking about the work of Dionigi and Pike, and other scholars who examine older adults, sometimes including women, much of the work has been focused on senior athletes around the globe, but with little examination of American participants. Older American female athletes are generally missing from much of the literature on senior athletes. However, the passage of Title IX in 1972 indicates that we should expect to see greater participation in organized sport by older women. A woman who has just turned 60 would have been born in 1955 and most likely graduated from high school in 1973, only one year after the landmark legislation. These 60-year-olds will be the first wave of women to have had some limited organized sport opportunities offered through their high schools, with the women following enjoying even greater opportunities and experiences, including collegiate teams. We know that early engagement in sport is a predictor of future involvement in sport, and thus these numbers should continue to grow for senior athletes.

A brief look at three different groups of older women engaged in various forms of organized sport and exercise merits inclusion to aid readers in recognizing the social dimensions of sport, as well as reminding us of the institutional and structural issues many women face in their efforts to engage in sport in the United States. In Richmond, California, great time, expense, and effort went into the renovation of the Richmond Plunge, a pre–World War II aquatics center. Richmond is an ethnically diverse city outside San Francisco. The Richmond Plunge hosts a variety of aquatics activities that range from water aerobics classes to masters swimming teams to recreational lap swimming. In addition to lap swimming, there is always a lane in each of the two pools for bathers to walk (so walking lanes rather than swimming lanes). The regular attendees at the water aerobics classes reflect the ethnic diversity of the city, and the women are in their 50s, 60s, and 70s. Their body sizes are quite varied, with many larger bodies among the participants. Some of the women swim laps before or after the class. Each class costs $4, and can be cheaper with a pool pass. In the locker

room, many of the women discuss their identities, telling each other "I'm not an exerciser," though clearly, to most observers, participation in a water aerobics class is exercise. Identifying and viewing themselves as athletes is not consistently part of their schemas, yet they are clearly enjoying themselves and are committed to the group and the activity.

The "Old Beaches" are a senior women's basketball team in Long Beach, California. To compete in tournaments with the team, one must be at least 50 years old. However, the team is open to 40-somethings in their regular twice-a-week practices on Wednesday evenings and Sunday afternoons. They charge $3 at each practice to cover the gym fees. The members are lesbian and heterosexual, with most working full-time in a variety of occupations. Many of the women socialize outside their "Old Beaches" practices and tournaments, including attending women's college and professional basketball games. In talking with these women, their love of the sport is clearly articulated and the practices and games provide them with organized opportunities to play a sport they love. Many, as a result of attending high school pre–Title IX, did not have the opportunity to play high school basketball, and this exclusion is one explanation they provide for their support of college and professional teams. They share stories of injuries and physical decline, yet their lack of talent rarely seems to be a deterrent in their participation.

Senior tennis for women in the United States offers numerous opportunities, though in some different ways than aquatics or basketball. The Berkeley Tennis Club (BTC) hosts several senior tennis teams. Their women's 9.0 team competes in local, regional, and national competitions in United States Tennis Association tournaments. The BTC and its members are reflective of an economically wealthy/healthy group, with some of the women retired and others still employed in professions that allow for their regular tennis matches. Monthly costs for the club exceed $140 and being a member of a team incurs additional costs. Few of these women played in high school, but were provided opportunities to play in other settings as youth, such as tennis clubs and parks and recreation offerings. Tennis has historically been a sport viewed as female appropriate, so the involvement of girls in tennis and later as women is evidence of the lifetime practice of movement espoused by many physical education programs. Some of these team members have been playing with and against each other for over 20 years, so tennis is a space for long-term friendships that provide great joy as well as annoyance. Tennis is an interesting sport for adults, with the United States Tennis Association (USTA) as the organizer of leagues and championships. With all their leagues, the USTA has had to consistently reorganize because there are more and more women playing tennis. For example, there had been an age

group for women 60 and older, with 70 as the next age group. As a result of more women playing, there is now a 55 seniors group, but not 60; the age categories continue to adjust to the increasing numbers of women entering senior tennis. Part of the experimentation with the age categories is also part of a deliberate effort to attract more women to the sport. Tennis teams and competitions are based on age and level, so an older athlete can begin their playing career at a later age and find parity in competition.

In all three examples, the experiences of women in sport settings reflect dynamic processes, as many women are discovering what sport participation means as they find increasingly more opportunities to engage in sport. This is a variation of the "if you build it, they will come" mantra. If you offer it, older women will participate. What is clear in talking and observing older women in a variety of sport and recreational settings is their enjoyment of movement and the need for more work to be done that values these experiences just as their heart rates, body fat, balance, and weight are valued.

America looks to schools and our educational system to organize and provide sport opportunities, and as a result, we've already lost many participants before they've graduated from high school. This means we need to figure out ways to bring these individuals back to exercise at some point, though how we do this is a challenge because once out of the school setting, we do not have social systems in place to support and provide similarly-organized opportunities. We are reliant on individualism and privatization to meet the needs of older adults in exercise and sport rather than organizing and providing social and community based programs (nationwide, this does occur in various communities in the United States, but it is inconsistent—urban/rural, and so on). This trend is also occurring at the youth sport level, and it remains unclear how this might play out in public schools as more teams are outside the school setting and more schools are removing physical education from their curriculum.

Conclusions

The good news is, at least according to some research, "60 is the new 40"—middle age now begins at 60 (Bogart, 2010; Shah, 2015)! This is great news, but will require many people (mostly those of us under 60) to adjust our ideas about what it means to be old and what it means to be active. For too long, older women have been hampered by societal stereotypes about their physical fragility and age-old ideas around women and sport participation. Moreover, many professionals in kinesiology have marginalized women in all age groups as participants in their studies because of the complications presented by women's menstrual cycles.

How fantastic would it be to read a newspaper headline cheering on the benefits of menopause in sport participation, or some other sort of celebratory findings that focus on the strengths and abilities of older women in sport rather than weaknesses and deficiencies?

The takeaway for the interdisciplinary field of kinesiology is partly in relationship to the training of our students, and how we might begin to help shift their perceptions about what it means to grow older and how we can be a part of developing exercise competence in women who haven't previously been engaged in sport, but also continue to provide healthy spaces for active athletes and movers. How can we aid them beyond seeing aging as a process to be delayed and dreaded? Rather, how can we communicate that this time period should be anticipated for new opportunities and identities as movers, for feeling good and competent in one's body, and for connecting to others in meaningful ways in a sport setting? Equally important, how can we craft public policy that provides for these sporting spaces for women, as integral to their healthy aging process? I'm hopeful that this new wave of 60-somethings—or are they 40-somethings?—uses their political and physical muscles to shape these conversations.

References

Armstrong-Brown, J., Eng, E., Hammond, W.P., Zimmer, C., & Bowling, J.M. (2015). Redefining racial residential segregation and its association with physical activity among African Americans 50 years and older: A mixed methods approach. *Journal of Aging and Physical Activity, 23*, 237–246. doi:10.1123/japa.2013–0069

Atkinson, J.L., & Herro, S.K. (2010). From the chartreuse kid to the wise old gnome: Age stereotypes as frames describing Andre Agassi at the U.S. Open. *Journal of Sport and Social Issues, 34*, 86–104. doi:10.1177/0193723509358966

Bogart, R. (2010, January 7). Is 60 the New 40? *Chicago Tribune*, http://www.chicagotribune.com/sns-health-60-new-40-story.html

Bronfenbrenner, U. (Ed.). (2010). *Making human beings human: Bioecological perspectives on human development.* Thousand Oaks, CA: SAGE Publications, Inc.

Chen, Y.-J., Matsuoka, R.H., & Tsai, K-C. (2015). Spatial measurement of mobility barriers: Improving the environment of community-dwelling older adults in Taiwan. *Journal of Aging and Physical Activity, 23*, 286–297. doi:10.1123/japa.2014 -0004

Coakley, J.J. (2015). *Sport and society: Issues and controversies,* 11th ed. New York, NY: Irwin/McGraw-Hill.

Crenshaw, K. (1989). *Demarginalizing the intersection of race and sex: A black feminist critique of antidiscrimination doctrine, feminist theory, and antiracist politics.* Chicago: University of Chicago Legal Forum.

Dionigi, R.A. (2005). A leisure pursuit that "goes against the grain": Older people and

competitive sport. *Annals of Leisure Research, 8*, 1–22. doi:10.1080/11745398.2005.10
600957

Dionigi, R.A. (2006a). Competitive sport and aging: The need for qualitative
sociological research. *Journal of Aging and Physical Activity, 14*, 365–379.

Dionigi, R.A. (2006b). Competitive sport as leisure in later life: Negotiations,
discourse, and aging. *Leisure Sciences, 28*, 181–196. doi:10.1080/01490400500484081

Dionigi, R.A. (2008*). Competing for life: Older people, sport and ageing.* Saarbücken,
Germany: VDM.

Dionigi, R.A. (2010a). Masters sport as a strategy for managing the aging process. In
J. Baker, S. Horton, & P. Weir (Eds.), *The masters athlete: Understanding the role of
sport and exercise in optimizing aging* (pp. 137–155). New York, NY: Routledge.

Dionigi, R.A. (2010b). Older athletes: Resisting and reinforcing discourses of sport
and aging. In S. Spickard Prettyman & B. Lampman (Eds.), *Learning culture
through sports: Perspectives on society and organized sports* (2nd ed., pp. 260–278).
Lanham, MD: Rowman & Littlefield Education.

Dionigi, R.A. (2010c). Older Sportswomen: Personal and cultural meanings of
resistance and conformity. *The International Journal of Interdisciplinary Social
Sciences, 5*, 395–407.

Dionigi, R.A. (2013). Older women and competitive sports: Resistance and
empowerment through leisure. In V.J. Freysinger, S.M. Shaw, K.A. Henderson, &
M.D. Bialeschki (Eds.), *Leisure, women, and gender* (pp. 167–176). State College, PA:
Venture Publishing.

Dionigi, R.A., Baker, J., & Horton, S. (2011). Older athletes' perceived benefits of
competition. *The International Journal of Sport and Society, 2*, 17–28.

Dionigi, R.A., & Gard, M. (Eds.). (2015). *Sport and physical activity across the lifespan:
Critical perspectives.* Basingstoke, UK: Palgrave Macmillan.

Dionigi, R.A., Horton, S., & Baker, J. (2010). Seniors in sport: The experiences and
practices of older World Masters Games competitors. *The International Journal of
Sport & Society, 1*, 55–68.

Dionigi, R.A., Horton, S., & Baker, J. (2013). Negotiations of the ageing process: Older
adults' stories of sports participation. *Sport Education and Society, 18*, 370–387. doi:
10.1080/13573322.2011.589832

Dionigi, R.A., & Litchfield, C. (2013). Rituals in Australian women's veteran's field
hockey. *The International Journal of Sport and Society, 3*, 171–189.

Dionigi, R., & O'Flynn, G. (2007). Performance discourses and old age: What does it
mean to be an older athlete? *Sociology of Sport Journal, 24*, 359–377.

Grant, B. (2001). You're never too old: Beliefs about physical activity and playing sport
later in life. *Ageing and Society, 21*, 777–798. doi:10.1017/S0144686X01008492

Grant, B., & O'Brien Cousins, S. (2001). Aging and physical activity: The promise of
qualitative research. *Journal of Aging and Physical Activity, 9*, 237–244.

Hartmann-Tews, I. (2015). Assessing the sociology of sport: On ageing, somatic
culture and gender. *International Review for the Sociology of Sport, 50*, 454–459.
doi:10.1177/1012690214563586

Hastings, D., Kurth, S., Scholder, M., & Cyr, D. (1995). Reasons for participating
in a serious leisure career: Comparison of Canadian and U.S. masters

swimmers. *International Review for the Sociology of Sport, 30,* 101–117. doi:10.1177/101269029503000106

Hervik, S.E., & Fasting, K. (2014). "It is passable, I suppose"—Adult Norwegian men's notions of their own bodies. *International Review for the Sociology of Sport.* Epub ahead of print.

Horton, S., Dionigi, R.A., & Bellamy, J. (2013). Canadian women aged 75 and over: Attitudes towards health related role models and female masters athletes. *The International Journal of Interdisciplinary Social and Community Studies, 7,* 33–47.

Jaffe, D., & Miller, E. (1994). Problematizing meaning. In A. Sankar & J.F. Gubrium (Eds.), *Qualitative methods in aging research* (pp. 51–66). Thousand Oaks, CA: Sage.

Kane, M.J. (2011). Sex sells sex, not women's sports. *The Nation Magazine, 293*(7), 28–29.

Kane, M.J. (2013). The better sportswomen get, the more the media ignore them. *Communication & Sport, 1,* 231–236. doi:10.1177/2167479513484579

Litchfield, C., & Dionigi, R.A. (2012). The meaning of sports participation in the lives of middle-aged and older women. *The International Journal of Interdisciplinary Social Sciences, 6,* 21–36.

Mills, C.W. (1959). *The sociological imagination.* London: Oxford University Press.

Pike, E. (2010). Growing old (dis)gracefully?: The gender/ageing/exercise nexus. In E. Kennedy & and P. Markula, P. (Eds.), *Women and exercise: The body, health and consumerism* (pp. 180–196). London, UK: Routledge.

Pike, E.C. (2011a). Aquatic antiques: Swimming off this mortal coil? *International Review for the Sociology of Sport, 47,* 492–510. doi:10.1177/1012690211399222

Pike, E.C. (2011b). The active aging agenda, old folk devils and a new moral panic. *Sociology of Sport Journal, 28,* 209–225.

Pike, E.C. (2015). Assessing the sociology of sport: On age and ability. *International Review for the Sociology of Sport, 50,* 570–574. doi:10.1177/1012690214550009

Sage, G.H., & Eitzen, D.S. (2015). Sociological Theories and Sport. In D.S. Eitzen (Ed.), *Sport in contemporary society: An anthology* (pp. 3–11). New York, NY: Oxford University Press.

Shah, Y. (2015, April 16). 60, Not 50, Is the New Middle Age, Study Says. *The Huffington Post.* http://www. huffingtonpost.com/2015/04/16/60-is-the-new-middle- age_n_7079006.html

Siu, K-C., Rajaram, S.S., & Padilla, C. (2015). Impact of psychosocial factors on functional improvement in Latino older adults after Tai Chi. *Journal of Aging and Physical Activity, 23,* 120–127. doi:10.1123/JAPA.2013–0164

Sullivan, M. (2014, February 22). On Campaign Trail, Missteps with Gender. *New York Times.* Available at http://www.nytimes.com/2014/02/23/opinion/sunday/on -campaign-trail-missteps-on-gender.html?_r=0

ILLINI PARALYMPIAN IS RACING TO HELP RUSSIAN ADOPTEES

Sean Hammond | 2013

From the *Daily Illini* (University of Illinois), February 19, 2013, https://dailyillini.com /uncategorized/2013/02/19/illini-paralympian-is-racing-to-help-russian-adoptees. Reprinted with permission.

On a 15-degree day in Cable, Wisc., Tatyana McFadden's fingers begin to go numb. She will later recall experiencing the worst pain she has ever felt in her hands, waiting for them to defrost, but for now she is just worried about finishing her race.

The race is a 5-kilometer cross-country ski at the Telemark Resort in a town of fewer than 1,000 people in northwest Wisconsin. On this day, Sunday, Jan. 13, McFadden is competing in the International Paralympic Committee's Nordic Skiing World Cup.

This is unfamiliar territory for McFadden. She hadn't tried the sport until 10 days ago.

McFadden has three Paralympic gold medals, she has an additional seven Paralympic medals—all from the summer games—and she is an eight-time world champion and four-time marathon winner. Yet McFadden, a full-time student at the University of Illinois, achieved all of this in a wheelchair, not strapped to a metal seat atop two skis, known as a "sit-ski," like she is now. If any Paralympic athlete could pick up a new sport and become one of the world's best in a matter of weeks, it would be McFadden.

But why is she here? What motivates the 23-year-old from Clarksville, Md., as she skis across artificial snow in sub-freezing Wisconsin?

The same thing that motivates as many as 20,000 protesters, on this very same day, nearly 5,000 miles away, as they march through the streets of Moscow.

On Dec. 28, Russian President Vladimir Putin signed a bill banning U.S. adoptions of Russian children. The law is named after a 1-year-old Russian boy named Dima Yakovlev, who died in 2008 after his adoptive American father left him in a locked car sitting in a hot parking lot. It is seen by many as a direct retaliation to the United States' Magnitsky Act. Enacted late last year, the law denies visas to Russians accused of human-rights violations.

According to the U.S. Department of State's most recent statistics, 962 Russian children were adopted by Americans in 2011. (Americans adopt more children from only two other countries: Ethiopia and China.) The Dima Yakovlev Law will put an abrupt end to that. The ban cuts deep for McFadden, who spent the first six years of her life in a Russian orphanage.

McFadden's journey began in St. Petersburg, Russia, where she was born in 1989 with a hole in her spine resulting in her paralyzation below the waist, a condition known as spina bifida. When operated on immediately, the condition is rarely life-threatening. But McFadden wasn't operated on for 32 days, and after her operation was complete, she was sent, like many unwanted and disabled children, to an orphanage.

The orphanage where McFadden lived is in a cluttered part of urban St. Petersburg. It has three floors; the top two are where the children stay. The upper floors have two large rooms, one where the kids can play and one lined with beds. On the first floor is a dirty, brown pool where McFadden liked to play as a child. She spent six years at the orphanage, which was so poor it couldn't even afford crayons. A wheelchair was out of the question, so McFadden walked on her hands.

When Debbie McFadden, commissioner of disabilities for the U.S. Health Department, visited Russia on a business trip in 1994, she had no intention of adopting a child. It was on the trip that she visited this three-story orphanage and was struck by the spirit and energy of Tatyana. She felt a connection with the little girl—strong enough to adopt her and bring her to the U.S.

For a 6-year-old girl who had seen little outside of her orphanage, the world suddenly seemed enormous. Debbie brought Tatyana from her orphanage to a hotel. Tatyana thought the hotel was America. When she really did reach America, Tatyana was so sick and anemic Debbie brought her to Johns Hopkins Hospital in Baltimore. Doctors told Debbie they didn't expect her to live more than a few months.

It was sport that helped Tatyana through her first years in America. Debbie enrolled her in anything she could: swimming, gymnastics, wheelchair basketball, wheelchair racing. Whenever Debbie tried to help her, Tatyana would say in Russian, "I can do it myself."

Debbie watched a passion grow as her daughter's health gradually improved. Tatyana fell in love with racing and became obsessed with becoming an Olympian. Without intending to, Debbie instilled a desire that would fuel one of the world's best athletes.

Tatyana has travelled all over the world, but of all the places she has been, nothing compares to the view she saw from an airplane of the white skyline of Athens.

The summer before her freshman year of high school, Tatyana competed in her first Paralympic Games in Athens. At 15, expectations were not high, but she left with a silver and a bronze medal in the 100-and 200-meter sprints, respectively. When she returned home, however, Tatyana found athletic success harder to come by.

After freshman orientation at Atholton High School in Howard County, Md., Tatyana returned home excited because she had been promised there were clubs for everyone at the school. Debbie asked her what club she wanted to join, but there was little doubt: She wanted to join the track and field team. When track season arrived, however, she was turned away, even though the sport didn't make cuts.

"They told her she couldn't be on the team," Debbie said. "[The coach] said things like, 'Handicapped kids can't be on the team, there's clubs for kids like you.' All the things that you just don't say."

Debbie thought Tatyana misunderstood her coach, but she had not. They let her join, but she was not given a uniform, and when she raced, the meet stopped and she raced down the track alone. Tatyana said the experience was humiliating and she knew something had to change. Debbie went to the school and begged them to give Tatyana a uniform. When the school refused, she threatened to sue. The school was unfazed, so the McFaddens filed suit for no damages.

The lawsuit took four years, Tatyana's entire high school career, but they eventually won in their county and state. Through the lawsuit, local media dubbed Tatyana the "Rosa Parks of disabilities," and she was young enough to ask Debbie who Rosa Parks was.

On Jan. 25, with the help of Tatyana's lawsuit and similar cases, it became national law that high schools have to include children with disabilities, give them uniforms and let them race alongside other athletes.

Debbie said the arguments used against Tatyana's case were the same arguments that were used against people of color and women. "It's not just about sports," she said. "It's not just about winning and losing. In high school, you're learning about sportsmanship and teamwork and fair play. Other kids are learning that disabled kids need to be included."

Tatyana continued with track in high school. And her sister, Hannah, younger than Tatyana by six years and an amputee, would eventually compete without the obstacles Tatyana faced. Athens would prove to be just the beginning for Tatyana athletically, just as her lawsuit would prove to be her beginning as an activist.

The Dima Yakovlev Law (officially known as Federal Law of Russian Federation No. 272-FZ) wasn't passed out of the blue. It was talked about for weeks. But

when it became apparent that it might actually become law, Tatyana became a vocal leader against it.

"She started telling me, 'They can't do this,'" Debbie said. "She said, '[Without adoption] I would have died.' And no Russian would have wanted her."

"I really wanted to be a voice of it," Tatyana said. "From my personal adoption experience, adoption was a positive thing and I believe it is a positive thing for all children."

Shortly before Christmas, Tatyana began fielding calls from reporters. At the same time, prospective parents across the country were waiting to find out if the child they were planning to adopt would ever make it to America. Tatyana decided to take action.

On Dec. 26, Tatyana and her cousin Carter McFadden, also a Russian adoptee, drove half an hour from Clarksville to the Russian embassy in Washington, D.C. They met with a group of about 15 people—Russians, adoptees and reporters—outside the embassy. It was cold, cloudy and sleeting. Debbie said they had with them a petition signed by 7,000 Americans and 134,000 Russians asking not to sign the adoption ban into law. One of the members of the group buzzed into the embassy and said, in Russian, that they were there to give a petition.

They did not get a response.

After 30 minutes, a security guard showed up and said she'd received word of an "unruly demonstration." Debbie stepped forward and told the guard it was not a riot; her daughter simply wanted to hand over a petition. When asked what she would do if the petition was not accepted, Debbie simply said she would go home.

Not long afterward, a Russian official stepped out through the gate with a large umbrella and asked Tatyana what she wanted. She replied: "Sir, I'm here to speak on behalf of all the orphans who don't have a voice. President Putin would be a hero to all of the children in the orphanages and people like myself if he wouldn't sign this law into effect. I'm giving you this petition in hopes that he will be our hero."

"Is that all?" the official asked.

"Yes," Tatyana said.

The official grabbed the petition and went inside, slamming the gate behind him. Tatyana said there are photos of her handing over the petition. The embassy later claimed it never received a petition.

"I just don't think that Putin understands the outcome for these children," Tatyana said. "It's a shameful thing that he [signed the bill]. The children were used as pawns between two countries. That's really sad."

Tatyana said she plans on adopting a child of her own someday. And while

adopting from other foreign countries is still a possibility, adopting from Russia was important to her.

"If you can't be with a family from your original country, then why can't you be with a family from somewhere else who can show you love and care and support?" she said.

Once Putin signed the bill, there was really very little anyone could do to change his decision. But that's when Tatyana had another idea.

After competing in the London Marathon in April 2011, McFadden went back to Russia and visited her orphanage.

The smell of cabbage cooking from the kitchen instantly brought back memories as soon as she walked through the door. She saw the pool where she used to play on the first floor. Seeing the dirty, brown water again, McFadden thought it was really rather disgusting. In all, the living conditions of the orphanage were not appealing.

She toured the building and visited with the children. There were 14 kids staying there at the time of her visit, all of which had disabilities.

She gave her medal from the 2010 New York Marathon to the orphanage, along with a monetary donation from her marathon winnings. The orphanage is not government-funded, and any money they can get goes toward medical supplies and new toys.

For McFadden, it was a way to thank the orphanage for taking care of her for the first six years of her life.

The trip was the only time McFadden has ever been back to Russia. But she doesn't expect it to be her last. In September, she cemented her name in the record books, winning gold medals at the London Paralympic Games in the 400-, 800- and 1,500-meter races. And while she still has her sights set on the 2016 games in Rio de Janeiro, a new ambition began forming in her mind. The 2014 Winter Paralympics will be held a little more than a year from now in—of all places—Sochi, Russia.

The possibility of competing in the Winter Games was on Tatyana's mind before the Dima Yakovlev Law was signed, but the adoption ban added more conviction and determination to her cause. Reaching the games would mean achieving an elite level in a new sport in less than a year and a half. But for McFadden, the only way to show the Russian people that children with disabilities belong is if she can reach the winter Olympics in the country in which she was born.

"I'll have a story to tell," she said. "It will be an honor to go because I identify

myself as a Russian-American. I'm never going to let my heritage go, and I just want them to see what happens when you bring up a child with a disability that was adopted. I want them to see that miracles can happen."

There have been multiple protests in Russia since the bill was signed, including the one on Jan. 13. Tatyana is hoping her presence in Sochi next year will send a message to Putin that the protests have not.

She finished the 5K on that day with a time of 15 minutes, 27 seconds—fast enough for fourth place. For McFadden, the race in Cable was her final event of the skiing season. She made the U.S. national team, but she is not a lock for Sochi. For the spring, her focus will turn to marathon training. But Sochi will always be in the back of her mind, and she will never forget the three-story orphanage in St. Petersburg.

She is hoping that a year from now Putin will have trouble ignoring her cause, and just maybe he will become the hero that she wishes him to be.

WOMEN'S SOCCER IS A FEMINIST ISSUE

Maggie Mertens | 2015

From the *Atlantic*, June 5, 2015, www.theatlantic.com/entertainment/archive/2015/06/womens-soccer-is-a-feminist-issue/394865. Copyright © 2015, Maggie Mertens, as first published by the *Atlantic*. Bracketed insertions are part of the original publication.

When I told my friends and family I'd be going to Brazil for the World Cup last year, they looked at me like I'd just won the lottery. In a sense, I had; I'd entered a lottery just to be able to purchase tickets. In Recife, I attended games at a brand-new stadium with a bright-green grass pitch, along with 40,000 other soccer fans from around the world. For months leading up to the event I saw news coverage on TV, in newspapers, and in magazines hyping Team USA, even though they had a virtually nonexistent chance of victory. By the time I left for Brazil, friends who I never knew to be soccer fans were telling me who their favorite players were, jealous that I would see "our boys" play against the tournament favorites, Germany.

This year, I'm going to the World Cup again. There was no lottery, and tickets were half the cost of the ones I bought last year, including a ticket to the final. (Which, last year, would have been nearly impossible to come by, not to men-

tion afford.) The games I'll attend this month will be played at a 32-year-old stadium with an artificial-turf field. Some of the games in the tournament will be played at a stadium with 10,000 seats, while the smallest stadium in Brazil seated 37,634. Even though this year Team USA are favorites to win, there's been little preview coverage of the tournament. When I tell people I'm going, most of them say, "There's a World Cup this year?" There is, only it's being played by women, not men.

Starting this month, millions of viewers will watch women's soccer on television, and even start to recognize players by their first names. Some might wonder why audiences only see these world-class players, like Abby Wambach, who holds the international goal-scoring record—for women and men—for a few weeks every two years at the World Cup or the Olympics. But most, even those who care about equality for women, won't consider how different these athletes' careers are compared to those of men who do the exact same thing for a living.

Today, the gap between men's and women's wages, the tiny fraction of female CEOs at Fortune 500 companies, and the lack of respect for Hollywood actresses and directors receive regular and impassioned coverage in both the mainstream and feminist media. The gender inequities in sports are just as vast as those faced by women in corporate offices and on movie sets, but for some reason they fail to incite the same level of outrage.

In 1978, in the midst of the second-wave feminist movement, Hollis Elkins, a professor of women's studies at the University of New Mexico, Albuquerque, published a paper that asked why the women's movement hadn't ever concerned itself with equality in sports. (This was six years after the passage of Title IX, which prohibited sex discrimination in federally funded schools, including in athletic departments.) Elkins died in 2013, but if she were alive today, she'd likely still be asking the same question.

Elkins laid out four main reasons why the women's movement was wary about involving itself in sports. One: Female athletes were perceived as either unconcerned with or hostile toward the women's movement. Two: Feminists didn't want to be "doubly damned" by "the suspicion of lesbianism" that both feminists and female athletes faced. Three: Sports was seen as a realm where men proved their manliness, negatively predisposing many feminists toward sports in general. And four: Sports was considered "frivolous." It wasn't seen as being as important as issues like the right to work, abortion, and equal pay.

In October of last year, the biggest names in women's soccer did something unprecedented: They sued the world soccer governing body.[1] A group of top international players including Wambach, Brazil's Marta, and Germany's Nadine Angerer filed a gender-discrimination lawsuit against the Canadian Soccer As-

sociation and FIFA citing the fact that this year's World Cup in Canada would be played on artificial turf instead of natural grass. All six prior women's World Cups, and all 20 men's, have been played on grass fields, because it's considered a superior playing surface. Simply by pointing to gender discrimination, the lawsuit did something female athletes don't usually do.

"There's a major fear of the explicit use of the term feminism to sell women's soccer," says Rachel Allison, a professor of sociology at Mississippi State University who has studied women's professional soccer. "The one major event that's broken that trend is the FIFA turf lawsuit."

When this explicitly feminist issue arose, it went unmentioned on websites such as *Jezebel, Everyday Feminism*, and *The Feminist Wire*. *Ms. Magazine*'s blog wrote one post on the issue with no follow-up, and *Feministing.com* posted one link to an outside story on the topic in a news roundup-type post.

This isn't the first time feminist issues in sports have gone relatively unnoticed by sites that focus on women's issues. In 2012, *Jezebel* and *Feministing* both lamented the folding of the Women's Professional Soccer league, though neither site had covered the league in any prior stories. And neither *Jezebel, Feministing, Everyday Feminism*, nor *The Feminist Wire* have ever run a story on the current women's league, the National Women's Soccer League. *Ms.* has published one blog post about an NWSL team, written by a fan.

"It's not like we never thought about sports stories," says Dodai Stewart, the former deputy editor of *Jezebel*. "If there were notable newsy things happening in the world of women's sports we would cover that. But it wasn't like we were existing for sports coverage. In the atmosphere we were in, it just didn't feel like, 'oh, this thing is lacking,' even though it was."

The problem is, sports media isn't covering women's sports either. In 2014, ESPN's *SportsCenter* dedicated 2 percent of its on-air time to covering women's sports, according to a study published this week in the journal *Communication & Sport*. The study found that three local Los Angeles news networks did slightly better, devoting 3.2 percent of their sports coverage to women athletes.[2]

Cheryl Cooky, one of the study's co-authors and a professor of women's studies at Purdue, says these numbers are actually lower than they were when this study began 25 years ago. But even this clearly unequal treatment is difficult for people to understand as sexist.

"There's still this cultural investment in the idea that sport is this space wherein talent and hard work is what matters, and things like race, gender and sexual orientation don't," Cooky says. The thinking goes that if women's sports were worthy of more coverage, they would receive it. But as Cooky points out, a lot of our perceptions of how interesting women's sports are come from the

media itself. "Men's sports are going to seem more exciting," she says. "They have higher production values, higher-quality coverage, and higher-quality commentary. . . . When you watch women's sports, and there are fewer camera angles, fewer cuts to shot, fewer instant replays, yeah, it's going to seem to be a slower game, [and] it's going to seem to be less exciting."

In Seattle, where I live, the men's professional soccer team, the Sounders, draws 44,000 fans on average to every home game. The women's professional soccer team, the Reign, draws 3,500. This disparity exists in a place where, while I was growing up, the majority of boys and girls I knew played on a soccer team, at a time when Brandi Chastain's game-winning penalty kick to win the 1999 women's World Cup was the most memorable sports moment any of us had been alive to see.

The Reign isn't lacking star power. U.S. national-team superstars Hope Solo and Megan Rapinoe are on its roster. To be fair, the Reign is only in its third season of existence. But the Seattle Sounders are only in their eighth year in the MLS, and by their third year, they were averaging 36,000 fans per game at CenturyLink Field, where the Seattle Seahawks play.

Kiana Coleman, co-founder of the Royal Guard, the main supporter group for the Seattle Reign, points to the dearth of media coverage.

"Most people, even soccer fans around here, don't even know the team exists," she says. "How would they? Women's soccer isn't on ESPN except for the World Cup. I've sent messages to [local news station] KING 5. . . . The Mariners could be in a deep, dark hole and they still don't cover the Reign. Last year, we [almost] never lost, and still nothing."

This disparity in coverage is gender inequality at work, says Cooky. "The media plays a huge role in building and sustaining audiences for sport and they do it very well for men's sports and they do it horribly for women's sports." The World Cup, when more Americans watch and get excited about women's soccer, proves her point.

It's a chicken and an egg problem, says Allison, the Mississippi State professor. "This huge media platform doesn't exist for the national league. So media often tells the women's league, you don't have the level of interest we need to make this successful. But that narrative falls apart when we see how they are able to do just that with the World Cup."

"When people find out you're a professional soccer player, they think it's awesome," says Jazmine Reeves, Rookie of the Year for the NWSL's Boston Breakers

in 2014. "But they think it's awesome because there are certain assumptions that go along with the life of being a professional athlete. And they don't realize that for us [women], it's kind of like the exact opposite."

Last year *The New York Times* ran an article on the tight financial circumstances many male professional soccer players face in the still-fledgling MLS. "Many in MLS Playing Largely for Love of the Game," read the headline. The minimum salary? $36,500.[3]

Reeves made $11,000 last season, more than the 2014 NWSL league minimum of $6,000, but less than a third of what her male peers were making. The team tried to offset her expenses, as it does with many players, by placing Reeves with a host family in Boston during the season so she wouldn't have to pay rent. "My host family was great, but at the same time, as an adult, you want to be able to pay for your own apartment," she says.

This season, the NWSL minimum went up to $6,842. The MLS minimum jumped to $60,000 thanks to a contract renegotiation. Still peanuts compared to male professional athletes in the MLB, NBA, or NFL, but at least it's a salary, not a four-figure joke.

"I never really thought about it until I was playing professionally," Reeves says. "Then I realized, wow, there's a team down the street from us playing in Gillette Stadium and we can't even get a consistent training field half the time. . . . You can't deny the fact that there's a pattern."

Reeves does see hope in the way one city embraced its female players. "I did not feel like a professional athlete until we went to Portland," she says. She likely won't be on the field to see NWSL's future, however. At the end of the season, at age 22, she retired from professional soccer to take a job with Amazon.

What Reeves felt during that game against the Portland Thorns was the effect of 14,383 fans dressed in Thorns red packing the same stadium where the MLS' Portland Timbers play. At their home games a rowdy crowd waves flags, sings songs and performs cheers led by Capos, fans who stand with their backs to the field the entire game simply to fire up the crowd. In other words, Reeves played in an environment very similar to the one most men's professional soccer teams experience.

In some ways Portland, where soccer scarves—often representing both the Timbers and the Thorns—hang from the walls and ceilings of bars across the city, is uniquely set up to support a women's soccer team. The Portland MLS and NWSL teams have the same ownership, a distinction shared by just one other of the nine NWSL teams in the league. And it helps that the Timbers are incredibly popular. The waiting list for Timbers season tickets is reportedly more than 10,000 strong. Providence Park, where the teams play, holds 22,000. Marketing the Thorns to these soccer-hungry fans is a no-brainer.

"When the [Thorns] team was announced people stepped up immediately and said we want to make sure the support for them is equal to that for the Timbers," says Kristen Gehrke, one of the leaders of the Rose City Riveters, the main Thorns supporter group.

But without a built-in MLS infrastructure that promises media, advertising, and audience support, the NWSL fan base in most cities has struggled. Not counting Portland, the average attendance in 2014 was a little less than 3,000, with many of those being families or youth-soccer players.

The Thorns prove that a deeper and more diverse fan base exists for women's soccer when male and female teams are treated more equally. Hours before the kickoff of a Thorns game against the Washington Spirit in Portland in May, Thorns jerseys could be spotted on the streets of the city. And though the stadium filled with many young soccer players and families early on, groups of 20- and 30-somethings of both genders filled many of the seats before the first whistle, as well as the bars near the stadium before and after the game.

So why, in 2015, is sports, a multi-billion dollar industry that so many take so seriously, still seen as a "frivolous" issue by many feminists, as Elkins suggested in 1978? There are a few small groups advocating for more women coaches and better treatment for women athletes. But according to Allison, "even in the academy, studying sports is often considered a less serious pursuit than studying the economy, or politics."

And that, says Cooky, is wrong. Feminists need to focus on sports because it's an institution of massive cultural significance and an area rife with "serious" issues, such as sexual violence, pay inequality, and a lack of women in leadership positions. "Who wouldn't want to do what they love and say that's their job?" says Reeves. "I'm not saying I would never play again, but I can't live off of what they gave me. I can't."

Notes

Links in the original online version of this article have been turned into endnotes.

1. Joe Prince-Wright, "Abby Wambach Leads Players' Lawsuit over Turf at 2015 World Cup," NBC Sports, October 2, 2014, http://soccer.nbcsports.com/2014/10/02 /abby-wambach-leads-players-lawsuit-over-turf-at-2015-world-cup.

2. Cheryl Cooky, Michael A. Messner, and Michela Musto, "'It's Dude Time!': A Quarter Century of Excluding Women's Sports in Televised News and Highlight Shows," *Communication and Sport* 3, no. 3 (2015): 261–287.

3. Andrew Keh, "Many in M.L.S. Playing Largely for Love of the Game," *New York Times,* October 26, 2014, www.nytimes.com/2014/10/27/sports/soccer/many-in-mls -playing-largely-for-love-of-the-game-.html.

SPORT HAS HUGE POTENTIAL

TO EMPOWER WOMEN AND GIRLS

Lakshmi Puri | 2016

Remarks by UN Assistant Secretary-General and Deputy Executive Director of UN Women Lakshmi Puri at "The Value of Hosting Mega Sport Events as a Social, Economic and Environmental Sustainable Development Tool" event on February 16, 2016. Reprinted with permission of UN Women, the UN organization dedicated to gender equality and the empowerment of women.

Secretary-General Mr. Ban Ki-moon,
Excellencies,
Distinguished delegates,
Colleagues and friends,

I am pleased to be part of this important discussion and I agree with the previous speakers that sport has enormous power to generate real social, economic and environmental change and contribute to sustainable development, social cohesion and even to challenge mind sets and prejudice.

Let me talk briefly about the contribution of sports to gender equality and in the context of the SDGs [sustainable development goals].

First, sport has huge potential to empower women and girls.

In many countries, it has been recognized that sport can be a force to amplify women's voices and tear down gender barriers and discrimination. Women in sport defy the misperception that they are weak or incapable. Every time they clear a hurdle or kick a ball, demonstrating not only physical strength, but also leadership and strategic thinking, they take a step towards gender equality.

There is good evidence that participation in sports can help break down gender stereotypes, improve girls' and women's self-esteem and contribute to the development of leadership skills.

Second, women and girls continue to face discrimination in access to sports as athletes and spectators, and inequalities in professional sports, media coverage, sports media and sponsorships.

Women are far more visible in sports today than at any previous point in history. The Olympics of the modern era started as an all-male event, with women making gradual inroads to compete in different disciplines. As such, women

competed for the first time at the 1900 Games in Paris. Of a total of 997 athletes, 22 women competed in five sports: tennis, sailing, croquet, equestrianism and golf. Incredibly enough, women were only allowed to run the marathon in the Olympics in [1984]. Also, with the addition of women's boxing to the Olympic programme, the 2012 Games in London were the first in which women competed in all the sports featured.

Interesting to note that since 1991, any new sport seeking to join the Olympic programme must have women's competitions. Yet even at mega events, women still face challenges. At the last FIFA Women's World Cup in 2015, women were required to play on artificial turf, which is often regarded as more physically punishing than natural grass. It is impossible to imagine a men's World Cup on this type of surface.

Media attention to women's sport in general is extremely low in comparison to men's. Just have a look at the sports section of The New York Times on any day of the week. Chances are there are no photos and no stories of women athletes. That has a very negative effect on sportswomen's salaries and the access to sponsorships, tournaments, leagues and the capacity of showcasing their capacity and skills.

Across professional sports, in fact, one of the most obvious and quantifiable manifestations of gender-based discrimination is that women athletes face a huge pay gap. The total pay-out for the Women's World Cup was 15 million United States dollars, compared with 576 million United States dollars for the last men's World Cup—nearly 40 times more for men. The exception is tennis, which since 2007 has awarded equal prize money at all four Grand Slam tournaments.

While sports events aim to promote values of fairness, there is also a dark side. Violence against women and girls occurs in all countries and happens in many situations, including in relation to sports events. Evidence from the UK suggests that domestic violence increases during World Cups or when the home team loses. Trafficking in women and children for sexual exploitation vastly increases during sporting "mega events" such as the Olympics and World Cups.

Thirdly, let me point to UN Women's work with sports organizations, especially the International Olympic Committee.

In Brazil, a joint UN Women and IOC [International Olympic Committee] programme works with the National Youth School Games and targets adolescents to advocate for the messages of equality and non-discrimination, non-violence, girls' empowerment and positive masculine traits among boys. The programme is reaching out to girls aged 12–14, using quality sports activities to build leadership skills. It aims to foster self-esteem, support positive and healthy decisions, and help prevent gender-based violence. The programme also engages boys

and girls aged 12–17 to challenge negative gender stereotypes and be partners for positive change.

Sport is an area in which we can leverage our partnerships and engagement with different audiences to teach everyone that gender-based violence has no place in it, on or off the field, anywhere in our lives, and that a future where all playing fields are truly level for all women and girls can be achieved. During the World Cup in Brazil, UN Women launched a mobile application, "Clique 180," to help women victims of violence access information and services.

Together with the UN system and as part of the Secretary-General's UNiTE to End Violence against Women campaign, UN Women promoted the distribution of stickers during the FIFA World Cup that read "The brave are not violent" to educate soccer fans about the responsibility men should take to end violence against women and to combat gender stereotypes.

UN Women has established a great partnership with the Valencia Club de Fútbol (VCF) through which we are working to change stereotypes [and] challenge misconceptions of masculinity, and VCF is becoming a gender equality champion and mobilizing resources for UN Women's mandate. We have been able to voice our gender equality message from a different speaker—a football club—and share the gender equality and women's empowerment message in a new way and with an audience not necessarily familiar with our work—the football stars, players and football fans. This is UN Women's first global partnership with a sports club and VCF is a key partner in the sports sector and industry to communicate the gender equality and women's empowerment agenda to its particular audience while contributing to the core resources of the organization. The partnership aims to promote gender equality and features the UN Women logo on players' jerseys, stadium banners and in the club's social media. It also includes special matches and soccer clinics all over the world. Together we are onside for gender equality.

Fourthly, mega sport events can be used to spread messages that support the 2030 Agenda, including its messages of a world free of poverty and free of violence.

Mega sports events bring billions of people together. These events have the potential to leave social and economic legacies. They can contribute to universal values of equality and non-discrimination, they can empower people and challenge long-seated stereotypes. This can be done through their enormous outreach, and the visibility of role models they create.

Let us remember today Cathy Templeton, who made a name for herself in the motorcycle racing world. In 1997, she said: "I am the first ever female AMA pro hill-climb racer. I'm rather excited by all the attention I am getting because

of this, but I'm also a little disappointed that it has taken so long for women to step into this position."

And we all are disappointed and can wait no longer.

It is our challenge to ensure the achievement of gender equality in the sports world. Mega sports events are also our opportunity to promote the values espoused in the 2030 Agenda and embodied in the 17 sustainable development goals.

This brings us back full circle to the fact that gender equality and women's empowerment are essential to the achievement of the SDGs.

Realizing gender equality in sports is therefore a great tool in the arsenal of sustainable development. Let sports empower all people, women and men, for a sustainable future for people and planet.

PART II *Biological and Physical Considerations*

Part 2 looks at several biological and physical considerations that have shaped women's involvement in sport—ideas rooted in both cultural mythology and scientific study. We begin with a pair of historical essays that address two biological characteristics that have been used to dissuade women from participating in sports: breasts and menstruation. The author of "Women in the Water" (1895) suggests that women can never be good swimmers because their breasts impede their ability to swim. Although countless swimmers have debunked this unreasonable notion, detractors to this day continue to cite women's breasts as an impediment to swimming and other sports. A century after the publication of "Women in the Water," for instance, CBS golf commentator Ben Wright remarked, "Women are handicapped by having boobs. It's not easy for them to keep their left arm straight. . . . Their boobs get in the way."[1]

In the second selection, an excerpt from the 1939 book *Sport, Physical Education, and Womanhood*, Dr. Stephan K. Westmann describes menstruation as a wound, a regularly occurring weakness in a woman's body that prevents her from participating in sports during her period and, even more, that ought to disqualify her from competitive sport altogether. More than three-quarters of a century later, Dr. James McIntosh attempts to set the record straight on the issue of menstruation (perhaps the "last taboo") and its relation to sports performance. The topic is still up for debate, he maintains, primarily because of the stubborn social stigma attached to discussing this natural process and its physiological effects. Although McIntosh points out that "there is plenty of

anecdotal evidence now that menstruation affects performance," that evidence is inconsistent and not grounded in clinical research.

The next article, a position statement from the International Olympic Committee (IOC) Medical Commission's working group on women in sport, reminds us that participation in sport provides tremendous benefits and, simultaneously, presents significant risks. Even so, the statement on "female injuries" should put to rest any lingering concerns about the potential damage that sport might do to women's reproductive organs or breasts. And on the topic of sex-specific risks, Marjorie A. Snyder discusses the current concern with sports-related concussions in "Girls Suffer Sports Concussions at a Higher Rate Than Boys. Why Is That Overlooked?" Although we have become accustomed to discussions about traumatic brain injuries in men's football, boxing, rugby, and other sports, researchers have not yet focused commensurate attention on women's sports, despite the fact that the injury rates are more prevalent among girls and women. The lack of research leaves women in certain high-risk sports, such as ice hockey and softball, without the important information and guidance they need to protect their health, safety, and well-being.

No exploration of biological imperatives and athletic performance would be complete without a look at the use of performance-enhancing drugs (PEDs). In an excerpt from *Women's Sport: What Everyone Needs to Know,* Jaime Schultz explains the most common forms of doping in sport and their effects on female athletes. She notes that according to the World Anti-Doping Agency, more than four times as many male athletes tested positive for PEDs as female athletes. However, in the final essay in this part, journalist Ian McMahan takes a critical view of this statistic to argue that "there is actually little basis for the argument that women are less likely to use PEDs."

Altogether, we hope this section demonstrates the impossibility of separating biological and physical "facts" from the broader culture in which they are researched, produced, understood, and put into practice.

Note

1. Chrisena Coleman, Bob Raissman, and Hank Gola, "TV Network Says Golf Flap a Bust: Backs Commentator on Remarks," *New York Daily News,* May 13, 1995, www.nydailynews.com/archives/news/tv-network-golf-flap-bust-backs-commentator-remarks-article-1.687427.

WOMEN IN THE WATER *They Love to Flounder but Few Become Good Swimmers*

Anonymous | 1895

From the *New York Times,* July 7, 1895.

The most popular counter at the moment in the shops is that where bathing suits are sold. A loiterer at one of them which served out the sort worn by women saw six purchases made the other day by as many women in ten minutes.

Yet all this water floundering among the sex produces few swimmers. It is the exception when a woman can swim at all; it is a marvel when she can take herself through the water for twenty yards, a distance that every boy in the country accomplishes before he is a dozen years old, or he is an abnormal boy. A writer in The Chicago Record comments on some of the reasons why a woman does not swim naturally and instinctively, as a boy does. To begin with, the boy never seems to have any instinctive awe of the water.

When fear is eliminated, good swimming is invariably the result. After all, it may be materially a question of strength, this marked difference in the ability of the sexes to swim. A boy jumps into unknown depths, trusting to his strength of muscle and sinew to pull him through. A woman has no such quality on which to depend. She knows her back is weak, her arms more like cotton than steel. It is this inherent consciousness of weakness that makes her shrink, although she couldn't probably define the reason of the feeling.

There is this peculiarity about a woman's swimming—she will either swim "dog" or "frog" fashion, the former being the easier, the latter the correct way.

A woman rarely, if ever, uses the overhand stroke to any advantage. There are women known to have done so, but they find it impossible to keep it up or make any progress. All men use it, to the exclusion of other methods. The arm in this stroke is brought backward, then over the head and plunged forward, the shoulder being entirely out of the water at each stroke. It is exactly as if one were pulling himself through the water by means of a taut rope.

I lately asked a physician why it was that women never made use of this stroke. He answered that these powerful strokes were made by means of the muscles across the chest. In a man these muscles are strongly developed, giving to the arms their whole strength. For a woman the bosom takes the place of these sinews, cutting off the means of her ever making this stroke of any use to her.

Again, a woman is rarely a good diver, even though she is an expert swimmer. Physicians explain that this is owing to her weak back. She does dive in a sort of fashion, standing on a slight eminence and gracefully inclining herself head downward into the water. Even this is indulged in by only a few. A woman dreads giving herself up to space in this inverted attitude, simply because her back may play her false or the blood rush to the brain.

The same writer has a sensible word to say about bathing suits. Women enter the race handicapped by the garments they wear. Flannel is the heaviest kind of cloth, and yet women cling to it as a bathing suit. A stockinet garment that comes from heel to shoulder, so that the weight is taken off the waist, is best. Over that a long Russian blouse of black wash silk or alpaca, loosely belted, and short sleeves. Then every muscle can work easily and naturally. The blouse throws off the water, remains light, and the swimmer has no extra weight.

Wear a suitable bathing suit, cultivate judgment, and there is no reason why any woman shouldn't swim.

SPORT, PHYSICAL TRAINING, AND WOMANHOOD

Stephan K. Westmann | 1939

Excerpted from Stephan K. Westmann, *Sport, Physical Training and Womanhood* (Baltimore: Williams and Wilkins, 1939).

What is menstruation? Nothing but the loss of the unfertilised ovum, preceded by regular periodical development of the uterine mucosa. When the histological development has passed its peak a wounded area, which is in the most sensitive part of a woman's body, is left. No sports*man* would ever dream of competing with a wound in his vital organs!

Many competitive sports necessitate sexual abstention for men while training. In women sexual cells grow, ripen and decay with the regular periodicity of changes in the moon. Menstruation takes place as a final phase, when the proliferative changes in the mucosa, preparing it for the lodgment of an ovum, have been brought to naught by lack of fertilisation. In my judgment this activity in the female body is sexual activity of the highest kind.

The complete ignorance of the trainer regarding the extreme sensitiveness and vulnerability of the female body at this period, and the misdirected ambition and lack of comprehension in the woman, allow her to train for competitive sports and to take part in them at this very time. Moreover, it must be remembered that during the period of menstruation women are in a condition of critical significance for their nerves and psychical well-being. The entire vegetative nervous system, particularly the parasympathetic vagus nerve, is in a state of increased sensitivity. By means of an increased flow of choline into the bloodstream, all nerves, especially the brain, are put in a state of hyperexcitability.

The danger to which a woman is exposed when she persists in taking an active part in sports during her period is aggravated by the fact that the competition for which she has entered is fixed for a date which cannot be altered. This tempts her to cast all reasonable considerations aside. A woman who has trained specially for a certain date, and is anxious to put herself to the test, will compete without regard for her bodily condition, and suffer injury as the result. Incidentally the results of competitions are worse during menstruation than at other times. This may be explained as follows:

We know that disinclination to take an active part in affairs creates hyper-aemia of the abdominal organs. Conversely, we can imagine that the presence of an increased amount of blood in the abdominal organs is connected with disinclination to be active. This theory is confirmed by practical observations. Also the decrease in the alkali reserve in the blood shortly before and at the beginning of menstruation is of great importance with regard to sports. By examining large numbers of women it has been found that before the onset of menstruation there is a period of depression—*i.e.*, lassitude—and a marked tendency toward dejection. At such a time activity in sport is most unsuitable. It is quite wrong to assume that the feeling of lassitude can be dissipated by sport. On the contrary, the lack of ability to compete with full vigour merely intensifies the feeling of inferiority already in existence, so that a mild degree of depression may be much increased.

It has been noted in many women that while they are actively engaged in sport the menstrual flow ceases altogether. I have myself treated eleven women competing in mild athletics and six swimmers, all of whom told me they had ceased to menstruate during the competitions. It is known that when amenor-rhea appears during training or a course of exercises it is a sign of overstrain. This implies a disturbance in the cyclic ripening of the ovum in the process of preparation for proliferation.

The delicate reaction of the endocrine glands to strain indicates an upset in balance between the hormones of the thyroid, pituitary, and ovary.

Too much activity in sports of a masculine character causes the female body to become more like that of a man. This holds good not only in regard to the outward appearance, but in regard to the genital organs, for they tend to decay. The monthly preparation for proliferation, which was previously normal, is disturbed, and may even cease altogether; the power to proliferate may be lost.

That overstrain in sports is the sole cause of it is shown by the fact that when masculine sports are stopped the woman's femininity may be restored and her period reappear, provided the trouble has not gone too far.

We know that at menstruation the blood flows at first into the uterine cavity. The uterus then empties itself by intermittent contractions. X-ray examina-tions prove that when the pressure within the uterus is slightly above normal an antiperistaltic wave traverses the uterus and Fallopian tubes. This provides an explanation, in a number of cases, of peritoneal shock caused by menstrual blood which has passed into the peritoneal cavity.

The sudden occurrence of oscillations in the pressure within the abdominal cavity may account for this. This theory enabled the author to explain two cases of severe shock which resembles acute peritonitis or a severe internal

haemorrhage. In each case the patients were indulging in competitive sports during menstruation, which brought on sudden and severe contraction of the abdominal muscles.

After stoppage of the menstrual flow the whole system continues to be affected. The loss of blood weakens many women more than they realise. The genital organs remain hyperaemic and the general circulation is not yet normal, so that not only during the period does the physical condition impose a handicap on activity in sport, but after it as well.

Later in the course of our argument we shall return to the discussion of different kinds of sport and their special dangers, when we are considering individual cases. Meanwhile let it be said, as a result of clinical experience, that *complete abstinence from activity in sport is absolutely imperative in the menstruating woman.*

Menstruation alone disqualifies a woman for competitive sport. [. . .]

The most important point for our discussion to decide is whether or not excessive participation in competitive sport influences the chief task of the female body—namely, reproduction with all its attendant functions.

Does sport, especially competitive sport, influence women in their desire to bear children? One must distinguish clearly between sports of a mild type and those which are actively competitive. Participation in sport does not diminish normal sexual desire in man or woman. It may, in fact, be said that the activity of the ductless glands can be stimulated by a properly regulated indulgence in sport.

Every man undergoing rigorous training to fit himself for a competition has to abstain from sexual intercourse. If he does not, his efficiency is reduced. This conclusion has been reached by questioning men, but so far no similar questioning of women has been reported. From my own observation I can state that there has been no decrease in sexual desire among women active in sports.

There is no doubt, however, that the desire to bear children has been seriously influenced, in the majority of cases, among women preparing themselves for competitions. What is more, in women already pregnant there is a lack of desire to continue their pregnancy, as the following case will show.

A well-known sportswoman consulted me with the sole purpose of having her pregnancy interrupted. Her only reason for desiring this was her wish to take part in a sporting event four weeks later. When I had refused her request she sought and found someone else to carry out what I had declined to do, and returned to me later suffering from inflammation of the Fallopian tubes.

So it is not altogether an exaggeration to say that there are sportswomen in whose uterus the ovum has very little moral standing!

On the evidence provided by this case and many other examples in the lit-

erature, it can be said that suppression of the desire to bear children, inspired by ambition to win the laurel wreath of victory, is a complete condemnation of competitive sports for women.

DOES THE MENSTRUAL CYCLE AFFECT SPORTING PERFORMANCE?

James McIntosh | 2015

From *Medical News Today*, MediLexicon, Intl., July 22, 2015; web, December 13, 2017, www.medicalnewstoday.com/articles/297154.php. Bracketed insertions are part of the original publication.

Participation in sports is often seen as the preserve of the young and fit. While the years from adolescence to young adulthood may be when bodies are at the peak of physical fitness, for women, this time happens to coincide with the years in which menstruation occurs.

Earlier this year, when British tennis player Heather Watson was defeated in the first round of the Australian Open, she attributed her performance to "girl things," causing her to experience dizziness, nausea and fatigue as she attempted to play.

Annabel Croft, a former tennis player, told the BBC that Watson's openness was "brave" and that "women do suffer in silence on this subject. It has always been a taboo subject."

Croft considers the impact of the menstrual cycle on sporting performance to be "the last taboo" in sports, yet others downplay its influence. British runner Paula Radcliffe currently holds the world record for the women's marathon and she broke the existing record at the start of her period.

"I broke the world record so it can't be that much of a hindrance," she told the BBC, "but undoubtedly that's why I had a cramped stomach in the final third of the race and didn't feel as comfortable as I could've done."

In this Spotlight, we investigate to what extent the menstrual cycle can affect sporting performance, as well as examining strategies for mitigating against its draining effects.

What Symptoms Are Caused by Menstruation?

Firstly, a brief recap of what the menstrual cycle involves. The cycle is a series of changes that a woman's body goes through each month preparing her for the possibility of pregnancy. An egg is released from the ovary and the lining of the uterus thickens (the luteal phase). If the egg is not fertilized before the end of the cycle, the lining of the uterus is shed through the vagina.

Alongside these changes, women can also be affected by premenstrual syndrome (PMS) manifesting in emotional, behavioral and physical symptoms. The American College of Obstetricians and Gynecologists believe that around 85% of menstruating women experience at least one symptom of PMS as part of their monthly cycle.

These symptoms have a lot of potential to disrupt a sportswoman's performance. In addition to the cramping that Radcliffe referred to, women can experience physical symptoms such as joint and muscle pain, headaches, weight gain and low energy levels.

The emotional and behavioral symptoms caused by PMS also appear disruptive to physical activity, especially at elite levels of competition when even the smallest margins can prove decisive. These include insomnia, poor concentration, irritability and appetite changes.

Currently, experts are unsure what causes PMS, but it is believed that changes in hormone levels and the neurotransmitter serotonin could play roles in the development of symptoms.

There is also a severe form of PMS known as premenstrual dysphoric disorder (PMDD) that has many disabling symptoms, such as panic attacks, feelings of despair, binge eating and a lack of interest in daily activities, alongside the physical symptoms of PMS.

But to what extent do menstruation and its associated symptoms have an effect on women's ability to participate in sporting activities? It is well documented that, for some women, PMS symptoms can be severe enough to force them to miss days of work, and so it stands to reason that they could also impair women's capacity for exercise.

However, getting regular exercise is often recommended as a step that women can take to alleviate PMS symptoms. Does this mean that sportswomen should be protected from the full extent of the condition?

Evidence of Menstruation Affecting Performance

Exercise physiologist Jason Karp, PhD, believes that fluctuating levels of the hormones progesterone and estrogen lead to physiological changes in the body

during menstruation and that these changes are exacerbated by exercise—particularly if it is intense.

Changes to the body during the luteal phase of the menstrual cycle also include increases in breathing and body temperature. "A higher body temperature during the luteal phase makes it harder to run in the heat, because you don't begin sweating to dissipate heat until you have reached a higher body temperature," Karp explains.

Increased breathing during the luteal phase also means that less oxygen is available for the muscles involved in exercise, he adds, as more oxygen is required by the muscles responsible for breathing.

In 2011, however, the *New York Times* ran an article on the menstrual cycle and athletic performance, citing a series of studies examining female rowers as proof that women should not be concerned with where they are in their cycle when it comes to sporting performance.

The researchers concluded that "normally menstruating female rowers and female rowers taking [oral contraceptive] pills should not be concerned about the timing of their menstrual cycle with regard to optimized sport-specific endurance performance."

Although the studies examined the performance of both competitive athletes and women that rowed for fun, their results are severely limited by the number of participants that were studied. One study involved a total of 15 rowers, the other just 11.

These studies are indicative of a lack of quality research in this area, meaning that experts are unable to speak with certainty about the full impact of menstruation on sport.

Dr. Susan White, the chief medical officer for Netball Australia, says that it is a difficult area to research: "The things that some women associate with the menstrual cycle, like fatigue or bloating or general lethargy, are hard to measure. And even if we could measure them, it's then difficult to say that it's just one or a combination of those symptoms and other internal or external factors that may affect performance."

She states that while world's best performances have been recorded at all stages of the menstrual cycle, one study conducted in Italy indicates that female soccer players may be more at risk from injury before and during their menstrual periods. "It is unclear whether it was because of physiological or psychological factors or a combination of them," she adds.

A Silent Psychological Battle

Although there is a lack of certainty from researchers as to the effects of the menstrual cycle, since Heather Watson raised the subject there have been plenty of other female athletes coming forward to share their experiences and describe how the menstrual cycle has affected their performances.

In a news conference, Czech tennis player Petra Kvitova agreed that "it's quite tough" to play at the start of the menstrual cycle. Former world number one Martina Navratilova also stated that her playing had been affected.

"You don't want to use it as an excuse," she told the BBC, "but it can affect some players in a big way. I never talked about it but it certainly was there."

Paula Radcliffe was able to set a world record while on her period. For Andu Bobby George, India's long jump champion, however, menstruation prevented her from succeeding.

"I was in top form in every other way, but the period made me feel weaker and there was nothing I could do about it," George told *Scroll.in*. "After the events, many people criticized my performance but this is not something I could ever tell them."

In India, menstruation is considered to be even more of a taboo than in the UK and the US. Some consider menstrual blood to be impure, some girls are not permitted to enter kitchens or sleep on mattresses during their period and it is estimated that 10% of girls believe that menstruation is a disease.

The fact that menstruation is a taboo subject can make participating in sport an anxious occasion, particularly when there is the potential for it to come into conflict with the rules of specific games. Some sporting uniforms such as the traditional whites of tennis and the tight trousers of horse-riding can leave women anxious about the possibility of "leaking," as Annabel Croft puts it.

Being a member of a sports team can certainly help with these concerns. Having colleagues with which to share worries who are affected by the same things can help erode the feeling of taboo that has a hold over most of society.

In fact, some teams such as the British Olympic hockey team monitor the menstrual cycles of their players. "It's something we didn't want to take chances on," coach Ben Rosenblatt told *The Guardian*. "You get to the final of an Olympics, you want to control every aspect of your performance."

Team member Hannah Macleod states the biggest comfort of this team monitoring is that team members do not have to suffer the menstrual cycle in silence.

The Conversation Continues

Aside from the social support being in a team provides, there are other options available to sportswomen to lessen the effects of menstruation if they are particularly affected by it.

Oral contraceptive pills and injections are taken by some athletes to either control when their periods occur or to stop them completely. However, some forms of medication are known to affect water retention and some contain ingredients that are banned, considered to be performance enhancing.

Ultimately, medication adds a further level of complexity to the already complicated world of elite level sports.

And just as women's sporting performance is affected differently by menstruation, the opinions of women on the subject vary just as much. Many agree that menstruation can affect performance, but that it should not be used to explain occasions when athletes are unsuccessful.

"It's personal to every athlete and by no means should it ever be used as an excuse but, at the same time, it does have an effect," says Anne Keovathong, a former British tennis player. Her career was marked by several knee injuries sustained during—and attributed by Keovathong to—menstruation.

Professional cyclist Inga Thompson told CNN that there was a risk of undermining women's sporting abilities through openness. "I feel very protective of our sport," she said. "You don't want to pull the 'girl card,' because we've fought so hard for equal representation."

It is clear that the taboo around menstruation and the battle for greater equality place sportswomen in a difficult position. There is plenty of anecdotal evidence now that menstruation affects performance, but a lack of clinical data to back it up and lend it authority.

Annabel Croft believes that Heather Watson has opened up a world debate about menstruation, making it easier for athletes to talk about and seek help with any problems they have in the future. Many will hope that this debate will extend to more robust clinical research, addressing the limitations that currently exist in elite sports.

References

Australian Sports Commission, Menstrual myth busting (www.ausport.gov.au/sportscoachmag/development_and_maturation2/menstrual_myth_busting), accessed 22 July 2015.

BBC, Curse or myth—do periods affect performance? (www.bbc.com/sport/tennis/30926244), accessed 21 July 2015.

BBC, Menstrual cycle "last taboo" for women in sport—Annabel Croft (www.bbc .com/sport/tennis/30908551), accessed 21 July 2015.

Daily Mail, Sport's last taboo? Czech star Petra Kvitova admits it's "difficult" for female players to compete while having their period (www.dailymail.co.uk/femail /article-3144279/Czech-star-Petra-Kvitova-admits-s-difficult-female-players -competing-having-period.html), accessed 22 July 2015.

The Guardian, Menstruation: the last great sporting taboo (www.theguardian.com /sport/shortcuts/2015/jan/21/menstruation-last-great-sporting-taboo), accessed 22 July 2015.

Human Kinetics news release (www.humankinetics.com/2012-releases/2012-releases /does-a-womans-menstrual-cycle-affect-her-running-performance), accessed 22 July 2015.

Mayo Clinic, Menstrual cycle: What's normal, what's not (www.mayoclinic.org /healthy-lifestyle/womens-health/in-depth/menstrual-cycle/art-20047186), accessed 21 July 2015.

Mayo Clinic, Premenstrual syndrome (PMS)—causes (www.mayoclinic.org/diseases -conditions/premenstrual-syndrome/symptoms-causes/syc-20376780), accessed 21 July 2015.

Mayo Clinic, Premenstrual syndrome (PMS)—symptoms (www.mayoclinic.org /diseases-conditions/premenstrual-syndrome/symptoms-causes/syc-20376780), accessed 21 July 2015.

No effect of menstrual cycle phase and oral contraceptive use on endurance performance in rowers, S. Vaiksaar et al., *Journal of Strength and Conditioning Research*, doi:10.1519/JSC.0b013e3181df7fd2, published online June 2011, abstract. www.mayoclinic.org/diseases-conditions/premenstrual-syndrome/symptoms -causes/syc-20376780.

No effect of menstrual cycle phase on fuel oxidation during exercise in rowers, S. Vaiksaar et al., *European Journal of Applied Physiology*, doi:10.1007/s00421-010 -1730-1, published online 19 November 2010, abstract. www.ncbi.nlm.nih.gov /pubmed/21088972.

Office on Women's Health, Premenstrual syndrome (PMS) fact sheet (www.womens health.gov/menstrual-cycle/premenstrual-syndrome), accessed 22 July 2015.

Scroll.in, As UK tennis player breaks silence on menstruation, Indian sportswomen speak out on taboo subject (http://scroll.in/article/703877/as-a-british-tennis -player-breaks-silence-on-menstruation-indian-sportswomen-speak-out-on -taboo-subject), accessed 22 July 2015.

USA Today, Indian women hear some crazy things about their periods (www .usatoday.com/story/news/world/2015/01/07/globalpost-indian-menstration -period/21383475), accessed 22 July 2015.

POSITION STATEMENT ON GIRLS AND WOMEN IN SPORTS

Lyle Micheli, Angela Smith, Francisco Biosca,
and Patricia Sangenis, with Mark Jenkins | 2002

This statement was produced by the IOC Medical Commission's Working Group Women in Sport during the congress Women and Sport, Lleida, Spain, April 18–20, 2002. Reprinted with permission.

Opportunities for girls and women to participate in sport have increased dramatically over the last quarter century. A generation ago, women competed in "ladylike" or "graceful" athletic endeavors such as tennis, diving, figure-skating, and gymnastics. Today they also engage in a wide variety of sports once considered the preserve of boys and men. Rugby and weightlifting are just two of the traditionally male sports in which women now compete ardently for world titles.

It is the position of the IOC Medical Commission that sport is for everyone. Girls and women should not be excluded from participation in athletic activity because of their gender. As with sports participation for all populations, the benefits for girls and women far outweigh any possible risks. The IOC Medical Commission encourages efforts to understand any possible special concerns of female athletes in order to develop and implement measures to reduce these athletes' injuries and enhance the quality of their participation.

Benefits of Sports Participation

The benefits of vigorous physical activity are well-understood, and have important implications for female participants. These benefits include physical and psychosocial components.

PHYSICAL BENEFITS

- Reduced risk of illnesses such as heart disease, hypertension, diabetes, and endometrial and breast cancer
- Improved muscle-to-fat ratio/body composition
- Stronger immune system with moderate physical activity
- Less menstrual discomfort
- Stronger bones and reduced risk of developing osteoporosis later in life

- Improved self-esteem, self-confidence, and perception of competence; better performance in academic settings
- Decreased risk of unwanted pregnancy
- Decreased risk of drug and alcohol abuse

Risks of Sports Participation

As with any competitive activity requiring strength, endurance, and daring, sport carries with it the risk of physical harm. It bears repeating, however, that the benefits of sport outweigh the risks. Put another way—given the perils of a sedentary lifestyle, which include a variety of chronic illnesses, the consequences of physical inactivity outweigh possible hazards involved in sports participation.

The two most common questions asked about the participation of girls and women in sports are:

- Are girls/women at greater risk of certain types of injuries?
- Do girls/women get injured more often?

"FEMALE" INJURIES?

Gender-specific injuries are rare, and concerns about female participation in sports are outdated and erroneous.

The female reproductive organs are better protected from serious athletic injury than the male organs. Serious sports injuries to the uterus or ovaries are extremely rare. Breast injuries, a commonly heard argument against girls' participation in vigorous sports, are among the rarest of all sports injuries, even when women play a full-contact sport such as rugby.

MORE INJURIES?

Acute injuries are caused by sudden trauma such as impact or a twist. Common acute sports injuries include bone fractures, ligament sprains, and muscle strains and contusions. Girls and women are not generally at greater risk of sustaining "acute" injuries compared to their male athlete counterparts. One exception may be anterior cruciate ligament (ACL) injuries.

Studies show that adolescent and college-aged female athletes—especially soccer and basketball players—are three to four times more likely to sustain an ACL injury than their male counterparts. The reasons for this are not fully understood, but are thought to encompass a complex combination of intrinsic and extrinsic risk factors, possibly including anatomical, hormonal, and conditioning differences. Some measures to reduce the number of ACL injuries

in female athletes include: 1) strengthening the leg muscles that stabilize the knee, especially the hamstrings; 2) improving aerobic conditioning to prevent fatigue-related missteps; 3) modifying the usual "cutting," or "side-stepping," maneuver from a two-step to a three-step motion so the knee is never fully extended; 4) performing sports that involve running and pivoting with the weight forward on the balls of the feet, emphasizing soft jump landings; and 5) educating coaches about the increased risk of ACL injuries in female athletes and enhancing the ability of coaches to evaluate female athletes' skills, conditioning, and readiness to participate.

Overuse injuries are caused by repetitive microtrauma to tissue. Common overuse injuries include stress fractures, tendonitis, and bursitis. Female athletes may be more susceptible to overuse sports injuries. Two apparent reasons for this are a lack of long-term preparation for vigorous sports training and not beginning sports training until the height of the growth spurt (typically between eleven and thirteen), a time when musculoskeletal injury incidence is generally greater for all children. The wider female pelvis and greater angulation of the female knee are related to increased incidence of kneecap problems, compared with boys/men. A rapid increase in training volume is the most frequent cause of overuse injuries, so it is important for girls and women beginning a sports or exercise program to only gradually increase the frequency, intensity, and/or duration of their activity regimen, especially if they have not been particularly active since early childhood.

Female athletes may be at a higher risk of stress fractures. The term "Female Athlete Triad" was coined to describe the most common chain of events leading to this type of injury:

1) Intense training plus disordered eating contribute to menstrual abnormalities, particularly when nutritional intake is insufficient to meet the energy needed for the training;
2) menstrual abnormalities are associated with decrease of the estrogen needed to build bones, which, coupled with a poor diet may lead to osteoporosis or decreased bone mineral content; and,
3) weaker bones are vulnerable to stress fractures related to the athlete's training schedule.

The Female Athlete Triad is most frequently seen in endurance runners and those who participate in activities such as gymnastics, figure-skating, and dance—sports where leanness is considered a virtue and therefore where, regrettably, disordered eating is endemic. Treatment of the Female Athlete Triad should be multidisciplinary, as the athlete with this condition will benefit from

the input of a sports psychologist and sports nutritionist familiar with the disorders as well as a sports medicine orthopedist and physiotherapist/athletic trainer.

The disproportionate incidence of overload injuries seen in female athletes may partly be a product of sociological factors that make girls' conditioning levels lower than boys'. As social attitudes change and girls begin to participate in sports and fitness activities regularly from a younger age, improved fitness levels should reduce this incidence. Additional gender-related risk factors include: "extrinsic" factors such as lack of knowledge on the part of coaches on appropriate training for girls and women, and "intrinsic" risk factors such as hormonal and tissue differences from boys/men, including but not limited to smaller bone architecture and different upper to lower body proportions in length and strength that appear throughout all populations and are not changed by training. Research into improved training methods for girls and women will continue to ameliorate discrepancies in injuries rates between the genders, though until then these discrepancies should not prevent or discourage female sports participation.

Recommendations to Minimize Injury Risk and Enhance Participation

Sport is becoming increasingly important in the lives of girls and women. The increasing number of competitive and recreational female athletes should be viewed positively. To perpetuate and accentuate the progress that has been made in this area in so many countries—and to inspire progress in countries where none has been made—the IOC Medical Commission makes the following recommendations:

SPORTS GOVERNING BODIES

- Should, in keeping with Rule 2, Paragraph 5 of the Olympic Charter, promote women in sport at all levels and in all structures, particularly in their executive bodies (including medical committees)
- Should encourage the participation of girls and women in their particular sport
- Should maintain injury and illness statistics pertaining to girls and women in their particular sport

PHYSICAL EDUCATORS, COACHES, AND OTHER EXERCISE AND HEALTH PROFESSIONALS

- Should take measures to improve their understanding of the special considerations of the female athlete

- Should focus on helping young female athletes (5–18) develop a broad range of skills through exposure to a variety of sports; sports specialization before age 10 is not desirable
- Should ensure that increases in training volume are not so great that they cause overuse injury

PARENTS

- Should encourage daughters to participate in sports and physical activity from a young age
- Should increase their understanding of the benefits and risks of sports for girls and women
- Should regularly remind themselves that the most important reason children play sports is for *fun*

RESEARCH

- Should focus on gathering epidemiological data on injury rates in order to develop effective injury prevention strategies

References

FIMS/WHO Ad Hoc Committee on Sports and Children—Micheli LJ (Chair), Armstrong N, Bar-Or O, Boreham C, Chan K, Eston R, Hills AP, Maffulli N, Malina RM, Nair NVK, Nevill A, Rowland T, Sharp C, Stanish WD, Tanner S. Sports and children: Consensus statement on organized sports for children. Bulletin of the World Health Organization. 1998; 76(5):445–447.

Clinics in Sports Medicine (The Young Athlete) Vol 19, No. 4, 2000.

U.S. Department of Health and Human Services. The Surgeon General's call to action to prevent and decrease overweight and obesity. (2001). Rockville, MD: U.S. Department of Health and Human Services, Public Health Service, Office of the Surgeon General; Available from: US GPO, Washington.

The President's Council on Physical Fitness and Sports Report—Physical Activity & Sport in the Lives of Young Girls: Physical & Mental Health Dimensions from an Interdisciplinary Approach. (1997). Washington DC: President's Council on Physical Fitness and Sports.

Wein D, Micheli LJ. Nutrition, Eating Disorders, & the Female Athlete Triad. In: Mostofsky DL, Zaichkowsky LD, eds. Medical and Psychological Aspects of Sport and Exercise. Morgantown, WV: Fitness Information Technology, Inc. 2002: 91–102.

Tofler IR, Stryer BK, Micheli LJ, Herman LR. Physical and emotional problems of elite female gymnasts. New Engl J Med. 1996; 335(4):281–283.

Omey ML, Micheli LJ, Gerbino PG 2nd. Idiopathic scoliosis and spondylolysis in the female athlete. Tips for treatment. Clin Orthop. 2000; (372):74–84.

Micheli LJ, Metzl JD, Di Canzio J, Zurakowski D. Anterior cruciate ligament reconstructive surgery in adolescent soccer and basketball players. Clin J Sport Med. 1999; 9(3):138–41

The Encyclopaedia of Sports Medicine Volume VIII: Women in Sport. Edited by Barbara L. Drinkwater. An IOC Medical Commission Publication in collaboration with the International Federation of Sports Medicine.

GIRLS SUFFER SPORTS CONCUSSIONS AT A HIGHER RATE THAN BOYS. WHY IS THAT OVERLOOKED?

Marjorie A. Snyder | 2015

In a study of collegiate athletes, the highest rate of concussions was reported not by male football players, but by female ice hockey players.

The flood of media attention highlighting damaged brains, dementia and suicides in retired NFL players has made concussions synonymous with football. That attention was greatly needed; the debilitating consequences of brain injuries in football players of all ages have been severely overlooked. But the focus of this controversy has been far too narrow. It's true that young players need better equipment and stricter safety standards on the gridiron. But in many of the most popular sports, boys aren't the ones most likely to be afflicted by concussions. Girls are.

Recent studies of high school and collegiate athletes have shown that girls and women suffer from concussions at higher rates than boys and men in similar sports—often significantly higher. For instance, in a recent analysis of college athletic injuries, female softball players experienced concussions at double the rate of male baseball players.[1] Women also experienced higher rates

of concussions than men in basketball and soccer. Across all sports in the study, the highest rate of concussions was reported not by male football players, but by female ice hockey players. In that sport, a woman experienced a concussion once every 1,100 games or practices—nearly three times the rate experienced in football. The gender disparity exists in high school sports, too. One study, analyzing concussion data for athletes in 25 high schools, found that in soccer, girls experienced concussions at twice the rate of boys.[2]

So why aren't girls getting as much attention? For one, female athletes haven't taken up the charge to the degree that professional football players have. More female role models need to share their stories and speak out on this issue, to put pressure on schools and leagues to make sports safer for girls and women.[3] Congress also can drive more action, by setting national guidelines on managing concussions in young athletes.

We also need more and better science on the gender differences in concussions. There is painfully little research on why female athletes are so susceptible to athletic brain injuries and how to better protect them. For instance, helmets are mandated in boys' lacrosse, but not in girls'. Without better science, debate rages over whether helmets would make girls less susceptible to concussions, or simply encourage them to be more aggressive on the field, making them more susceptible. And in ice hockey, it's hard to explain why girls are suffering a higher rate of concussions than boys even though intentional body checking is prohibited in the girls' game.

There are many possible explanations for why female athletes experience higher rates of concussions. The greatest attention has been directed to their head and neck size and musculature; researchers speculate that girls have smaller, weaker necks than boys, making their heads more susceptible to trauma.[4] Hormones also could play a role.[5] If a woman suffers a concussion in the premenstrual phase, when progesterone levels are high, there's an abrupt drop in the hormone. That could cause a kind of withdrawal that either contributes to or worsens symptoms like headache, nausea, dizziness and trouble concentrating.[6] This may be why women have more severe or longer-lasting symptoms than men, who have low pre-injury levels of progesterone.[7] It's also possible that, if girls feel the effects of concussions more severely, they are simply more likely to report them and doctors more easily diagnose them than in male patients. But for all of these theories, there is little consensus on how they actually play into the mechanism of brain injuries in girls and women.

This makes it difficult to know the best way to prevent concussions in girls and women. Do female athletes need better equipment, more neck strength training,

better referee calls, or stricter rules to prevent dangerous play? Hockey and lacrosse leagues have taken the latter approach, placing limits on body checking for young players and banning checking to the head and neck area at all levels. There are other sports that can institute similar protections. A great example is girls' soccer. We know that girls' neck muscles are not fully developed until age 14. If heading were eliminated for girls below that age, that would prevent concussion without negatively affecting later elite competition prospects. Some schools have begun instituting such rules, and more should follow suit.

But there's a lot of dispute over rule changes, and we need more action now to protect female athletes. First, we need more public awareness about this problem. The Women's Sports Foundation has made this a priority, holding a congressional briefing with athletes and medical experts last week.[8] In the way that Super Bowl champion Ben Utecht and Christopher Nowinski have spoken up on the need for better safety for male athletes, we need champion female athletes to do the same for girls and women in sports.[9]

The federal government must play a role in this national issue, as well. Congress has failed to act on childhood concussions, allowing the much-needed ConTACT Act (Concussion Treatment and Care Tools Act) to languish for six years without a vote into law. The ConTACT Act calls for the Centers for Disease Control and Prevention to adopt national guidelines for identifying possible concussions in young athletes, and strict rules about when and under what circumstances injured players should participate in practices and games. This way, all schools would be held to the same high standards to ensure student athletes receive proper care for concussions. We need to build a culture of support that centers on athlete safety rather than winning the game or a college scholarship.

These rules appropriately would apply to all players, regardless of gender. But we need to go a step further. We have some evidence that the brains of female athletes are more susceptible—or, at least, react differently—to injury compared to their male counterparts. We should stop assuming that concussions are a men's issue. We shouldn't simply accept that the best practices for boys' and men's sports will protect girls and women in the same way. The bodies of female athletes are different and their brains deserve just as much attention.

Notes

Links in the original online version of this article have been turned into endnotes.

1. Jennifer M. Hootman, Randall Dick, and Julie Agel, "Epidemiology of Collegiate Injuries for 15 Sports: Summary and Recommendations for Injury Prevention Initiatives," *Journal of Athletic Training* 42, no. 2 (April–June 2007): 311–319.

2. Andrew E. Lincoln et al., "Trends in Concussion Incidence in High School Sports: A Prospective Eleven-Year Study," *American Journal of Sports Medicine* 39, no. 5 (May 2011): 958–963.

3. Catherine Matusow, "What Makes a Successful Athlete Retire at the Age of Twenty-One?" *Houstonia,* December 31, 2013, www.houstoniamag.com/articles /2013/12/31/what-makes-a-successful-athlete-retire-at-the-age-of-21-january-2014.

4. Cristy L. Collins et al., "Neck Strength: A Protective Factor Reducing Risk for Concussion in High School Sports," *Journal Primary Prevention* 35, no. 5 (October 2014): 309–319.

5. Tracey Covassin and R. K. Elbin, "The Female Athlete: The Role of Gender in the Assessment and Management of Sport-Related Concussion," *Clinics in Sports Medicine* 30, no. 1 (January 2011): 125–131.

6. Kathryn Wunderle et al., "Menstrual Phase as Predictor of Outcome after Mild Traumatic Brain Injury in Women," *Journal of Head Trauma Rehabilitation* 29, no. 5 (September–October 2014): E1–8.

7. Covassin and Elbin, "The Female Athlete."

8. Women's Sports Foundation, "Game On! WSF Leaders Gather on Capitol Hill to Highlight the Importance of Concussion Safety in Schools in Support of the Twenty-ninth Annual National Girls and Women in Sports Day" (press release), February 4, 2015, www.womenssportsfoundation.org/media-center/press-releases/press-release -february-4-2015.

9. "Ben Utecht to Senate, 'It Took Losing My Mind to Care about My Mind,'" August 3, 2014, www.ben-utecht.com/ben-utecht-to-senate-it-took-losing -my-mind-to-care-about-my-mind; Concussion Legacy Foundation, https:// concussionfoundation.org.

WOMEN'S SPORT

What Everyone Needs to Know

Jaime Schultz | 2018

Excerpted from Jaime Schultz, *Women's Sport: What Everyone Needs to Know* (New York: Oxford University Press, 2018). Reproduced by permission of Oxford University Press.

Athletes have always used performance-enhancing drugs (PEDs) to gain a competitive edge. Athletes in ancient Greece used hallucinogenic mushrooms, sesame seeds, alcoholic concoctions, and animal hearts and testicles in their

efforts to boost performance. Since then, athletes of all ages, and at all levels of sport, have doped.

For the first part of the twentieth century, there were no laws prohibiting the use of PEDs. A mix of brandy, egg whites, and strychnine sulfate propelled Thomas Hicks across the finish line to take the gold medal in the 1904 Olympic marathon (after officials disqualified top finisher Fred Lorz for riding in an automobile for 11 miles of the race). In 1928, the International Association of Athletics Federations (IAAF) became the first international organization to ban doping, but there were no tests to detect it yet.

It wasn't until the 1960s, after the amphetamine-related deaths of cyclists Knud Jensen (1960) and Tom Simpson (1967), that sports authorities began to wage serious anti-doping efforts. The IOC established its Medical Commission in 1967 with the purpose of testing for doping and to verify the sex of female competitors. Faced with the ever-increasing prevalence and sophistication of doping techniques, in 1999 the IOC established the World Anti-Doping Agency (WADA) as an independent, international organization involved in research, education, and the development and monitoring of anti-doping codes.

Each year, WADA updates its list of prohibited substances. The most common PEDs athletes take are stimulants, anabolic-androgenic steroids, human growth hormone and growth factors, erythropoietin, diuretics, and beta blockers. WADA's 2016 data showed that more than four times as many male athletes tested positive for PED violations as female athletes, but doping remains a significant problem in women's sport.

Stimulants affect the central nervous system to speed up the brain and increase heart rate, blood pressure, body temperature, and metabolism. Athletes use stimulants to reduce fatigue, increase aggressiveness and alertness, improve endurance, increase aerobic performance, and suppress their appetites in order to lose weight. At the turn of the twentieth century, athletes ingested strychnine, nitroglycerine, and cocaine. As pharmacology advanced, competitors experimented with any number of drugs, including Benzedrine, bromantane, ephedrine, and Adderall, which is prescribed for patients with attention-deficit/hyperactivity disorder and related conditions. The use of stimulants is associated with several risks, including irritability, insomnia, dehydration, heart palpitations and rhythm abnormalities, heatstroke, circulatory problems, stroke, and heart attack.

Anabolic-androgenic steroids (AAS) are synthetic derivatives of testosterone that promote the growth of skeletal muscle. They can increase strength and muscle mass, reduce body fat, and help athletes train harder and recover more quickly from strenuous workouts. For women, the side effects of AAS can include menstrual irregularities, deepened voice, acne, increased facial hair, male pattern

baldness, small breasts, clitoromegaly (enlargement of the clitoris), sterility, high blood pressure, liver damage, heart attack, and stroke. Some of these side effects may be irreversible even after an athlete stops taking AAS.

Male athletes, notably weight lifters, began experimenting with steroids in the 1950s, and female athletes followed soon after. In the 1960s and 1970s, observers noted the strong physiques of Eastern bloc women who dominated international swimming and track and field competitions. The athletes were particularly conspicuous at the 1976 Summer Olympics, as East German women won 11 of the 13 swimming events, although all women passed their drug tests. It was not until after the fall of the Berlin Wall that the world learned of the East German government's massive doping program, which affected an estimated 10,000 athletes. Competitors as young as age twelve years, often unbeknownst to them or their parents, received the anabolic steroid Oral Turinabol. German officials specifically targeted girls and women for the drug because it had a more dramatic effect on their bodies than it did for boys and men. The doping program rocketed East Germany to the upper echelon of the Olympic medal count, but it has had significant and long-lasting consequences to the athletes' health. According to one advocacy group, 90 percent of the athletes recognized as doping victims have serious health issues, including cancer, heart enlargement and heart attack, malfunction of lungs and kidneys, infertility, ovarian cysts, joint and bone problems, and psychological trauma.[1]

The Russian government similarly engaged in a state-sponsored doping program, as a WADA-commissioned report detailed in 2016. Attorney Richard McLaren determined that between 2011 and 2015, more than 1,000 Russian athletes were involved in an institutionalized, systematic conspiracy to conceal positive drug tests. The fallout from this has been severe, resulting in a ban of the Russian track and field team from the 2016 Summer Olympic Games, and bans of the entire Russian delegation from the 2018 Winter Olympic Games and the 2016 and 2018 Paralympic Games, although "clean" athletes can compete under a neutral flag as "Olympic athletes from Russia."

Another high-profile doping scandal occurred in 2003 when journalists Lance Williams and Mark Fainaru-Wada revealed that the Bay Area Laboratory Co-Operative (BALCO) had developed a powerful and, at the time, undetectable steroid called tetrahydrogestrinon (THG or "The Clear"). The BALCO scandal implicated numerous high-profile male and female athletes, including cyclist Tammy Thomas and track and field athletes Regina Jacobs, Zhanna Block, Kelli White, and Marion Jones.

With effects similar to AAS, human growth hormone (hGH) poses yet another problem for anti-doping authorities. The pituitary gland produces the hormone,

which stimulates the growth of muscle, bone, and cartilage. Natural production peaks in adolescence and declines with age. Initially, athletes doped with hormones extracted from human cadavers. In the 1980s, scientists synthesized the hGH through genetic engineering, and the IOC banned its use in 1989. Potential side effects of hGH include muscle, joint, and bone pain; accelerated osteoarthritis; and excessive growth of hands, jaw, liver, kidneys, and heart, putting individuals at greater risks for heart disease and certain types of cancer.

Athletes similarly seek ways to boost their bodies' production of red blood cells, which carry oxygen to the muscles to delay fatigue, making it popular in endurance sports. One technique to do this is through the use of Erythropoietin (EPO), which a number of top women marathoners have been caught using, including Liliya Shobukhova, Rita Jeptoo, and Jemima Sumgong, winner of the 2016 Olympic marathon. Athletes can achieve similar effects through blood doping, a process that involves drawing and storing one's blood while the body naturally regenerates red blood cells. Just before competition, athletes re-inject the stored blood into their bodies for a rush of oxygen-carrying red blood cells. The risks associated with EPO and blood doping include thickened blood, which can lead to heart disease, stroke, and cerebral or pulmonary embolism, and both practices are banned by WADA and other authorities.

Diuretics, which increase urination, also fall under the category of banned substances. Athletes take them to lose weight and to mask other drugs in their urine. Another type of doping includes beta blockers, which impede the effects of adrenaline to reduce blood pressure, heart rate, muscle tremors, and anxiety. These outcomes are useful in sports that require a calm and steady hand, such as pistol shooting, billiards, and archery.

It is difficult to keep up with the constantly evolving development and use of PEDs in sport. Detection typically involves reactive tests—that is, first identifying a particular drug in a laboratory and then looking for its presence in an athlete's blood or urine. As an alternative, testers have developed an Athlete Biological Passport, which establishes an athlete's baseline of biological markers and looks for variances in that baseline. The passport is effective, but it is also expensive and not yet widely used.

Further complicating the issue of doping is that WADA and other organizations allow "therapeutic use exemptions" for athletes with illnesses or conditions that require medical treatment with a banned substance. Soon after the 2016 Olympic Games, a Russian cyber espionage group hacked into WADA's database, likely in retaliation for the ban of Russian Olympians and Paralympians. The group, which went by the name "Fancy Bear," publicized information that several American athletes, including Serena Williams and gold medal gymnast Simone

Biles, had tested positive for banned substances. Both women subsequently revealed that WADA had granted them therapeutic use exemptions and they were therefore not in violation of anti-doping policy.

WADA's list of prohibited substances and methods includes anything that meets two of the following three criteria:

1. It has the potential to enhance or enhances sport performance;
2. It represents an actual or potential health risk to the Athlete;
3. It violates the spirit of sport (this definition is outlined in the Code).[2]

Based on this principle, sport organizations must deal with issues of "technology doping," which refers to sports equipment (e.g., hydrodynamic swimsuits, motors hidden in bicycles, and certain prosthetic limbs) that may provide an unfair advantage. The criteria also spurred parasport officials to ban "boosting," which involves intentionally injuring a part of the body in which an athlete with impairment has no feeling. Examples include breaking a toe, the use of electric shock, allowing one's bladder to overfill, or over-tightening one's leg straps. These techniques "boost" the athlete's blood pressure and heart rate, potentially dangerous responses believed to improve athletic performance. Finally, gene doping is a significant concern for sport authorities, particularly because the editing or manipulation of one's genetic makeup may be impossible to detect. WADA first banned gene doping in 2003 and in 2018 amended its policy to include "the use of gene editing agents designed to alter genome sequences and/or the transcriptional or epigenetic regulation of gene expression."[3] This refers to tweaking an athlete's existing genes (through methods such as CRISPR), in addition to adding new ones, as was the case with earlier forms of gene doping.

Notes

1. Elisabeth Braw, "East Germany's Steroid Shame," *Newsweek,* June 8, 2014, www.newsweek.com/2014/06/13/east-germanys-steroid-shame-253840.html.

2. World Anti-Doping Agency, "Prohibited List Q&A," www.wada-ama.org/en/questions-answers/prohibited-list-qa#item-391.

3. World Anti-Doping Agency, "Prohibited List, 2018," www.wada-ama.org/sites/default/files/prohibited_list_2018_en.pdf.

FEMALE ATHLETES DOPE, TOO

Ian McMahan | 2016

From *Outside*, January 29, 2016, www.outsideonline.com/2035591/female-athletes
-dope-too. Reprinted with permission.

This year, for the first time, the World Anti-Doping Agency released a gender breakdown of PED violations. According to the data, more than four times as many male athletes tested positive for PED as female athletes. But this number seems to suggest that women are far less likely to turn to performance enhancing drugs, which may not be the whole story.

Measured against relative performance gains, there is actually little basis for the argument that women are less likely to use PEDs. Because women have lower baseline levels, they often benefit more from small doses of steroids, which gives them a greater boost in performance. "For females, the effects of anabolic steroids are greater, and the old files of the German Democratic Republic have shown that their official doping plan targeted females, as those effects had more impact than they did on their male counterparts," says Olivier de Hon, scientific expert at the Anti-Doping Authority of the Netherlands.

Instead, the differentiation may come down to a flaw in the testing pool. WADA technical documents specifically outline the selection of athletes for testing using "an all-inclusive assessment of risk of a sport or discipline in relation to doping that considers a wide range of risk factors in addition to physiological risk. Such factors may include doping history, financial gain, gender, age, status of the sport within a country, etc." In other words, testing is focused on those athletes that are deemed statistically more likely to dope. Under this formula, female athletes have been labeled as lower risk, meaning they aren't tested as often as men, explains Daniel Eichner, president of the Sports Medicine Research and Testing Laboratory, a WADA accredited lab. When asked to comment, a WADA representative offered only: "Our statistics do not identify tests by male and female athletes."

Of course, news that female athletes are doping isn't a surprise. Just as the IAAF documents indicate that doping among World Championship and Olympic track and field athletes is far more widespread than previously thought, recent high profile positive tests—including three-time Chicago Marathon champion Liliya Shobukhova and three-time Boston Marathon winner Rita Jeptoo—suggest

that female athletes may be doping at similar rates to their male counterparts.[1]

"We know that the win-at-all-costs culture exists in all sports, at all levels, and that the temptation to use performance-enhancing drugs to cheat your competitor isn't limited by gender," says Annie Skinner, a spokeswoman for the United States Anti-Doping Association. Which means that as long as there is a desire to win, doping will continue to be a problem among both men and women.

Note

A link in the original online version of this article have been turned into an endnote.

1. Peter Gambaccini, "Liliya Shobukhova Gets Two-Year Doping Ban," *Runner's World,* April 28, 2014, www.runnersworld.com/newswire/liliya-shobukhova-gets-two -year-doping-ban; Peter Gambaccini, "Rita Jeptoo Drug Case: What's Next, How Does It End?" *Runner's World,* February 2, 2015, www.runnersworld.com/newswire/rita -jeptoo-drug-case-whats-next-how-does-it-end.

PART III *Psychological Issues*

Part 3 focuses on the psychological dimensions of sport and the ways that athletic competition can increase self-confidence and self-esteem or, quite the opposite, lead to confusion, doubt, and emotional pain. Because athletic contests typically produce winners and losers, questions of success and failure in sport may seem self-evident. But psychological benefit and harm do not necessarily correspond with the contest's final score. The agony of defeat can prove every bit as valuable as the joy of winning, while some athletes pay a high emotional cost even when victorious.

The first reading, an excerpt from the Women's Sports Foundation's 2015 report "Her Life Depends on It," outlines some of the psychological benefits of athletic participation. In particular, playing sport can help protect girls and women against a number of mental health concerns, including depression, low self-esteem, anxiety disorders, and health compromising behaviors. For the most part, this holds true for girls across racial and ethnic groups, according to the second report in this section, "Sports Participation and Positive Correlates in African American, Latino, and White Girls." Still, it is important to note that correlation is not the same as causation: the study shows evidence that self-worth, body attractiveness, and athletic competence increase alongside sports participation, but not that sports participation necessarily produces those increases. As so many reports conclude, more research is required to better understand the connection.

Certainly, participating in sport can bring a number of mental health benefits, but as the Women's Sports Foundation report shows, it can also contribute to

disordered eating habits. In fact, the study details how female athletes show a higher rate of pathogenic weight loss behavior than their nonsporting peers. In addition to social pressures to maintain a particular body shape, athletes must contend with additional pressures from coaches and teammates. As D'Arcy Maine discusses, female rowers are especially susceptible to pressures to cultivate the "perfect rower body." Simply put, the lighter the boat, the faster it goes. As a result, athletes must try to balance their power-to-weight ratios—becoming as light as possible without sacrificing strength and energy—which can lead to unhealthy eating practices.

Gendered stereotypes present another psychological issue with which female athletes must contend. In an open letter to the heads of USA Swimming, coach Kelsey Theriault criticizes the organization's Foundations of Coaching course for perpetuating false beliefs about girls' need for "consistent affirmation in their competence" while simultaneously commenting on boys' innate competitiveness and aggression. Pulling specific examples from the section of the course titled "Gender and the Young Athlete," Theriault argues that the instructions reinforce pernicious stereotypes that damage both male and female swimmers. Consequently, she urges changes to the manual that would "recognize the needs of individual swimmers, rather than making coaching choices based on gender" so that coaches "can teach our athletes that girls and boys are both capable of achieving the same success."

Finally, the excerpt from Nicole M. LaVoi's research report, "Trends in Gender-related Research in Sport and Exercise Psychology," looks more broadly at the field from an academic perspective. Guided by two theoretical frameworks, cultural studies and ecological systems theory, LaVoi surveys the existing literature on the gendered physical activity gap, females in positions of power, and gender "differences" in coaching science and proposes future directions for gender-related work in sport and exercise psychology.

MENTAL HEALTH AND WELL-BEING

E. J. Staurowsky, M. J. DeSousa, K. E. Miller, D. Sabo, S. Shakib, N. Theberge, P. Veliz, A. Weaver, and N. Williams | 2015

Excerpted from *Her Life Depends on It III: Sport, Physical Activity, and the Health and Well-Being of American Girls and Women* (East Meadow, NY: Women's Sports Foundation, 2015). Reprinted with permission.

Given the physical nature of athletic pursuits, we may at times be inclined to overlook their impact on less-tangible mental health outcomes. Researchers do not yet have a good understanding of the interrelated effects of depression, low self-esteem, and distorted body image on health-compromising behaviors, such as suicide attempts or pathogenic weight control. However, growing numbers of studies are exploring how sports participation may serve to protect girls and women against some of these health risks while considering how it can exacerbate others. All other things being equal, athletes tend to enjoy a greater sense of self-esteem and feel less depression than their sedentary peers. Logically one could deduce that their activities generate a higher level of physical fitness that allows them to feel greater satisfaction with their own bodies than non-athletes. Yet, perhaps because they hold themselves to a more demanding physical standard, athletes are also at greater risk for eating disorders. Moreover, frequent exercise or sports activity may, in some cases, be a red flag for depression, low self-esteem, poor body image, or even suicidality when over-exercise is used as a coping mechanism or a strategy for weight loss. In essence, sports participation in moderation enhances mental health; in excess, it may (literally) be overkill.

Depression

BACKGROUND

Depression is a treatable illness. Symptoms may include persistent feelings of sadness, hopelessness, and worthlessness; loss of ability to experience pleasure; loss of interest in activities one usually enjoys; difficulty concentrating; and changes in sleep, appetite, weight, and energy levels. Depression has multiple variations, in which people can also suffer from manic episodes in addition to the depressive episodes (Marcus et al., 2012). Though often dismissed or trivialized as "the blues," the annual economic burden of depression in the United States in the early 2000s exceeded $83 billion in medical treatment costs, lost productivity, and mortality (Greenberg et al., 2003). Costs to healthcare plans and employers can be considerable. Some drugs, such as Abilify, can cost more than $1,000 per month alone, with other prescriptions increasing expenses. On an annual basis, employers may pay more than $350,000 per thousand employees for depression-related health concerns (Knopf, 2014). Women are twice as likely as men to suffer depression.

Reproductive hormones may play a causal role, particularly after [giving] birth or during menopause. Women may also be more prone to depression than men due to differences in how they respond to stressful life situations, such as conflicting work and family responsibilities. Women are also more likely to experience poverty and sexual or physical abuse, which has adverse effects for mental health (NIMH, 2008).

- Each year, 12 million women in the United States experience clinical depression. Although most can be treated successfully with medication and/or psychotherapy, less than half of these depressed women ever seek treatment (Mental Health America, 2008a).
- An estimated 73 million adult women worldwide experience a major depressive episode each year, and mental disorders following childbirth are estimated to affect about 13% of the women (World Health Organization, 2009).
- There is a higher prevalence of major depression for women who report sexual and emotional abuse as children than for men (Arnow et al. 2011).
- There are common misconceptions that depression is not an illness but a normal part of childbirth, menopause, and aging, and that strong people can "snap out of it." These misconceptions may discourage some women from seeking help (Mental Health America, 2008a, 2008b).

- Approximately half of depressed women in the United States seek treatment for depression (Ko et al., 2012).
- Women's depression frequently co-exists with other serious illnesses, such as eating disorders or post-traumatic stress disorder (Devane et al., 2005; Kessler et al., 2003). Depression is also a complicating factor in chronic medical conditions, such as diabetes, cancer, or heart disease (Cassano & Fava, 2002; Katon & Ciechanowski, 2002).
- The World Health Organization (2001) predicts that depression will be the most prevalent cause of disability among women worldwide by the year 2020. Depression is estimated to affect 350 million people, and the burden of depression is about 50% higher for women. (Marcus et al. 2012).
- Though the rates of depression are comparable among boys and girls in early childhood, by middle adolescence girls are twice as likely as boys to have experienced major depression. This gender gap continues until menopause (Cyranowski et al., 2000; Hyde, Mezulis, & Abramson, 2008).
- Women suffering from depression hesitate to tell other people about what they are experiencing. In a 2012 study the tendency of women who were self-stigmatizing, meaning they had low self-esteem and self-worth, was found to affect their beliefs about disclosing feelings of sadness or depression. Eighty percent of the women in this study indicated they would not disclose feelings of depression to healthcare professionals, nearly 40% indicated they would do what they could to keep their depression a secret (Oakley et al., 2012).
- In 2007, 12% of girls between the ages of 12 and 17 suffered a major depressive episode, two-thirds of whom suffered severe impairment as a result of her depression. More than half of the girls who experience depression received treatment, counseling, or medication for depression (SAMHSA, 2008).
- Teenage girls are especially vulnerable to depression due to biological and hormonal changes at puberty. Parental conflicts, unrealistic standards of beauty and femininity, and new social expectations related to reaching adolescence also contribute to depression among teenage girls (Mayo Clinic, 2008; NIMH, 2008).

FACTS AND RESEARCH FINDINGS

Across numerous studies and with rare exception, physical activity has been found to be an anti-depressant (Sallis, Pochaska, & Taylor, 2000; Teychenne,

Ball, & Salmon, 2008). For both biochemical and psychological reasons, exercise elevates mood and creates a sense of happiness and well-being (Craft, 2005; Cripps, 2008). Moreover, it appears that moderate levels of sports activity can significantly enhance social and psychological functioning in ways that buffer against depression. The evidence for exercise as a treatment for clinical depression remains promising although still inconclusive due to methodological flaws in much of the research to date (Cripps, 2008; Lawlor & Hopker, 2001; Mazure, Keita, & Blehar, 2002).

- Data drawn from a sample of 8,950 women between the ages of 50–55 revealed that those who sat for more than seven hours a day and did not meet daily physical activity (PA) standards were more likely to exhibit depressive symptoms than women who sat for less than four hours a day and met PA standards (van Uffelen et al., 2010).
- The combination of increased preoccupation with screen time (watching television, computer, and electronics use) and sedentary behavior was found to negatively affect depression levels among minority females (Breland et al., 2013).
- Aerobic exercise, toning, and resistance training can each reduce depressive symptoms (Ahmadi et al., 2002; Dunn et al., 2005; Taliaferro et al., 2008).
- Positive effects of exercise on depression apply across the life span, helping children (Sallis et al., 2000), teens (Dishman et al., 2006), young adults (McKercher et al., 2009), the middle-aged (Brown et al., 2005), and the elderly (Strawbridge et al, 2002).
- Lower levels of physical activity in childhood have been linked to increased likelihood of depression in adulthood (Jacka et al., 2011).
- Women who are at risk of depression and have low self-efficacy are less likely to participate in physical activity (Azar et al., 2011).
- Reasons for exercising matter. In a nationwide assessment of more than 40,000 students by the American College Health Association, college women who exercised were less likely to report feeling hopeless or depressed—except for those who exercised frequently to lose weight (Taliaferro et al., 2008).
- Adolescent and young adult women who participate in organized sports report lower levels of depression. Possible reasons include greater levels of parental and peer emotional support (Gore, Farrell, & Gordon, 2001), as well as greater social acceptance (Boone & Leadbeater, 2006), social connectedness and self-esteem (Armstrong & Oomen-Early, 2009), and

improved physical self-concept and body satisfaction (Dishman et al., 2006).

- High school seniors who played sports three to six hours per week were less depressed than those who played less often. More frequent participation had no such protective effect, perhaps due to the detrimental effects of overtraining (Sanders et al., 2000).
- Young women who walked at least 7,500 steps a day were 50% less likely to be depressed than sedentary women. However, very high levels of physical activity were associated with greater risk of depression (McKercher et al., 2009).
- Sports involvement may have long-lasting effects on mental health. Female college athletes were less likely to be clinically depressed than their non-athlete peers (Wyshak, 2001).
- Women with major depression who participated in some physical activity were less likely to experience excessive guilt and/or make a suicide plan than inactive women with major depression (McKercher et al., 2013).
- There is an inverse relationship between physical activity and depression symptoms among U.S. women. (Loprinzi, Fitzgerald, & Cardinal, 2012). This relationship is also true of women who may be pregnant (Mikkelsen et al., 2010).
- Women who participate in physical activity as adolescents have better control over anxiety and depression (World Health Organization, 2009).
- There have been discussions about including the measurement of depression and anxiety symptoms on activity diaries as a way to enhance the adherence of exercise (Stroehle, 2009).
- People with mobility impairments (for example, muscular dystrophy, multiple sclerosis, or spinal cord injury) experience much higher rates of depression than the overall U.S. population. The more physically active individuals with mobility impairments are, however, the less depression they experience (Rosenberg, 2013).
- Data analyzed from the Canadian National Health Population Survey revealed that women who were divorced, separated, or widowed were more vulnerable to depression and that low intensity physical activity was found to influence the likelihood of depression occurrence in those groups of women (Wang et al., 2011).
- There is a decreased risk of depression when a person is physically active for more than 90 minutes a day and watches five or fewer hours of television per week (Lucas et al., 2011).

- When women participated in moderate cardiorespiratory fitness activity they demonstrated a 44% lower rate of depressive symptoms. It was 54% lower when they participated in high cardiorespiratory fitness activity (Sui et al., 2009).

While participation in physical activity and sport clearly has a positive effect on mental outlook and health, there is a growing body of work that suggests that assumptions regarding athletic participation alone as an immunizer against depression and other illnesses are not correct. In studies examining mental health issues among athletes, female athletes exhibit higher tendencies for disorders such as depression than male athletes. The pressures of the athletic environment itself may trigger certain mental health crises or conditions for athletes.

From this emerging area of research here are some findings to consider:

- Among elite swimmers who competed in the Canadian and World Championships, 68% self-reported experiencing one major depressive episode, with more female athletes than male athletes reporting that they had experienced depression. The prospect and reality of failure and the pressure to succeed may contribute to the depression that both female and male athletes experience (Hammond et al., 2013).
- In a survey of former NCAA Division I athletes, findings indicated that injuries sustained during their collegiate playing careers negatively affected their quality of life after their playing days were over, increasing the likelihood of difficulties with physical functioning, suffering from depression and anxiety disorders, sleep disturbances, and necessitating pain interventions. While the study did not focus specifically on female athletes, female athletes were a part of the population studied (Simon & Docherty, 2014).

Anxiety Disorders

BACKGROUND

Anxiety disorders are the most common form of mental disorders in the general population and can include phobia, panic disorder, generalized anxiety disorder, post-traumatic stress disorder, and separation anxiety disorders (CDC, 2011). Most disorders are more prevalent in women than men and can last from a year to a lifetime of symptoms (CDC, 2011).

- Physical activity has helped to reduce the effects anxiety sensitivity has on binge eating when a person does moderate levels of physical activity, but does not mediate the effect of eating as a coping mechanism (De-Boer et al., 2012).
- It has been reported that physical activity may help women with anxiety disorders in an indirect way by increasing self-esteem and self-concept (Herring, O'Connor, & Dishman, 2014).
- Physical activity has helped increase social interaction and provides a protector barrier to the onset of anxiety disorders (Pasco et al, 2011).
- Physical activity helps to significantly decrease anxiety in women, a finding which does not appear in men (Brunes, Augestad, & Gud-mundsdottir, 2013).
- Women who are overweight and obese had a greater likelihood of anxiety and were less likely to work out on a regular basis (De Mello et al., 2013).
- Obese women show more symptoms of anxiety disorders than men do, especially agoraphobia, panic disorder, and mood disorders. (Mather et al, 2009).
- Much like depression, anxiety disorders are treatable. For most anxiety disorders, physical activity helps to moderate the onset of anxiety symptoms; however, it appears in some cases (i.e., elite-level female athletes) exercise may increase the amount of panic disorders (Strohle, 2009).

Suicide

BACKGROUND

It is impossible to calculate the intangible cost of suicide, and suicide attempts, in terms of human sorrow; however, the economic costs to society (including medical costs, lost productivity, and lost wages) exceed $15.4 billion annually in the United States (Institute of Medicine, 2002). Each suicide leaves an average of six survivors, those family members and friends intimately affected by the death. Suicide is the third-leading cause of death among American teenagers and young adults aged 15–24, accounting for one of every eight deaths in this age group (American Association of Suicidology, 2006; CDC, 2008). Suicide is the seventh-leading cause of death globally for women between the ages of 20–59, the fifth-leading cause of death for women 25–44, and the second-leading cause of death in low- and middle-income countries in the Western Pacific Region (World Health Organization, 2009).

Women are three times as likely to attempt suicide as men, but men are four times as likely to succeed (American Association of Suicidology, 2006). One reason for this difference is that men are more likely to use firearms, whereas women are more likely to use potentially reversible methods, such as poisoning or suffocation (CDC, 2007; Institute of Medicine, 2002).

- According to the Centers for Disease Control and Prevention, 36% of high school girls reported strong and persistent feelings of sadness or hopelessness in the past year, 19% seriously considered suicide, 13% made a suicide plan, and 9% actually tried to kill themselves. One in 50 of those attempts resulted in an injury, poisoning, or overdose that had to be treated by a doctor or nurse (CDC, 2008).
- The Centers for Disease Control and Prevention identified Hispanic girls as being at especially high risk for suicidal ideation and behavior; 42% felt sad or hopeless, 21% considered suicide, 15% made a suicide plan, 14% attempted suicide; and 1 in 25 attempts required treatment by a health professional (CDC, 2008).
- After doubling between the 1950s and the late 1970s, female adolescent suicide rates have declined slightly since 1980 (American Association of Suicidology, 2008; National Adolescent Health Information Center, 2006).
- Suicide attempts are especially common among adolescents; for every completed youth suicide, there are an estimated 100–200 attempts. In a typical American high school classroom, it is likely that one girl and two boys have tried to kill themselves in the past year (American Association of Suicidology, 2006).

Adolescent and young adult suicidal ideation and attempts are often linked to other high-risk behaviors. These include substance use (tobacco, marijuana, cocaine, and other illegal drugs), sexual risk-taking, vehicular risk-taking, delinquency, and interpersonal violence (Bae et al., 2005; Barrios et al., 2000; Hallfors et al., 2004; Schilling et al., 2009; Thompson, Kingree, & Ho, 2006).

- Suicide attempts tended to be higher for women with higher body mass index (BMI), especially for unmarried women (Mukamal & Miller, 2009).
- Higher rates of suicide attempts were most common for white women between the ages of 18–24 and 25–44; however, black women 18–24 were at the highest risk of suicide attempts (Baca-Garcia et al., 2010).
- Women who are obese are more likely to commit suicide, in part due to the trend of greater psychopathology in obese women (Mather et al., 2009).

Although the relationship between overall physical activity and female suicidality depends partly on the motive for exercise, multiple studies have confirmed that women who participate in sports are less likely to consider, plan, or attempt suicide (Brown & Blanton, 2002; Brown et al., 2007; Ferron et al., 1999; Harrison & Narayan, 2003; Oler et al., 1994; Page et al., 1998; Sabo et al., 2005; Taliaferro et al., 2008a; Tomori & Zalar, 2000; Unger, 1997). Unlike exercise alone, sports participation generally takes place within the context of a social network of coaches, teammates, parents, and others that fosters pro-social behavior and provides a therapeutic emotional support base.

- Physical activity can be protective against suicidality (Taliaferro et al., 2008b). In adolescents and young adults who made nearly lethal suicide attempts, one study found far lower levels of physical activity, even after controlling for explanatory factors, such as depression and alcoholism (Simon, Powell, & Swann, 2004).
- Exercise alone is not necessarily protective against suicidality for women; in fact, girls and women who engage in frequent exercise may have an elevated risk of suicidal behavior, possibly because they seek to lose weight in order to compensate for poor body image, low self-esteem, and depression (Brown & Blanton, 2002; Taliaferro et al., 2008b; Thome & Espelage, 2004).
- Female college students who don't participate in organized sports are two-thirds more likely to report suicidal behavior than female college athletes (Brown & Blanton, 2002).
- Girls who consider sport an important part of a healthy life, and as a useful coping behavior during times of distress, are less likely to be suicidal (Tomori & Zalar, 2000). A study showed that college women with depression were less likely to have a suicide plan when they were physically active (McKercher et al., 2013).
- In one nationwide study, high school girls who participated in organized sports were significantly less likely to report feeling hopeless or suicidal, or to report planning a suicide or having made multiple suicide attempts (Taliaferro et al., 2008a).
- A second nationwide study found the protective effect of sports against suicidal thinking to be strongest for girls who participated on three or more sports teams (Sabo et al., 2005).
- Another nationwide study found that female high school athletes were less likely to attempt suicide even after controlling for physical activity levels (Brown et al., 2007).

- Having a sport-related identity influences the relationship between sports participation and suicidality. Compared to college students who do not see themselves in sport-related terms, self-identified athletes are half as likely to attempt suicide—whereas self-identified jocks are twice as likely to do so (Miller & Hoffman, 2009). In this study, the term "jock" was assessed using the degree of agreement on two statements—"I tend to see myself as a jock" and "Other people tend to see me as a jock." The term "athlete" was used to refer to someone who had participated in a sport or on a team and referred to themselves as an "athlete."

Body Image

BACKGROUND

One of the most pervasive and unchallenged prejudices in U.S. culture is the prejudice against fat people. By the age of 5, children have absorbed the cultural bias against overweight people (Musher-Eizenman et al., 2003). Popular imagery in media, literature, and advertising emphasizes a vision of female physical perfection that is unrealistically thin (Kilbourne, 2004; Lamb & Brown, 2006; Wolf, 2002). To the extent that girls and young women internalize such consistent messages (some subtle, some quite blatant), they are apt to make unfavorable comparisons between this idealized, unrealistic form and their own bodies (Groesz et al., 2002; Yamamiya et al., 2005). Although boys also experience dissatisfaction with their bodies, more commonly revolving around being insufficiently muscular, girls are especially vulnerable to developing and investing in a negative body image (Cash & Pruzinsky, 2002). While the active male body has traditionally been judged on its ability to accomplish desired goals, the objectified female body has traditionally been judged on its sexual attractiveness to men (Smolak, 2004). Negative body image often is associated with disordered eating (Ackard et al., 2002; Ricciardelli & McCabe, 2001), depression (Bearman & Stice, 2008; Brausch & Gutierrez, 2009), poor self-esteem (Clay et al., 2005; Tiggemann, 2005), and even abuse of substances with appetite-suppressing qualities, such as cocaine, amphetamines, and, especially, cigarettes (Clark et al., 2005; Parkes et al., 2008). Body dysmorphia disorder (BDD) is a pathological disorder, which has similarities to obsessive-compulsive disorder for which people are focused on imagined physical defects typically on a specific area of the body (Paven et al., 2008).

- The U.S. weight-loss industry has grown rapidly in recent years; it represented approximately $30 billion in 1992, $46 billion in 2004, and is

forecasted to exceed $60 billion before the end of the current decade (Adams, 2005; U.S. Food and Drug Administration, 1992). Well over 90% of American girls own at least one Barbie doll (Dittmar et al., 2006; Norton et al., 1996; Rogers, 1999). In one experiment, girls aged 5 to 8 who played with a Barbie doll reported lower body-esteem and a greater desire to be thinner than girls who played with a doll that had more realistic body proportions. According to one estimate, only .001% of women match Barbie's large-breasted, narrow-hipped physical proportions (Anchutz & Engles, 2010).

- In one recent study, about half of girls 9–12 rated their own bodies as too heavy; although fewer than 15% were objectively overweight (Clark & Tiggemann, 2006).

- Women were found to have body uneasiness as a factor for wanting to control weight (Segura-Garcia et al., 2010; Grossbard et al., 2009).
- The body mass index (BMI) scores of women are negatively correlated with the women's body image (Erbil, 2013).
- Body dissatisfaction in American girls emerges by the age of 6 and is well-established by the age of 9 (Davison et al., 2000; Lowes & Tiggemann, 2003; Sands & Wardle, 2003).
- Only 12% of women (but twice as many men) think they look good in a swimsuit; moreover, 31% of women are so uncomfortable that they avoid wearing a swimsuit in public, while that is true for only half as many men (Frederick et al., 2006).
- Due to societal differences in body image perception, women currently being sampled in surveys tend to show less body dissatisfaction compared to their peers from 10–20 years ago (Lydecker et al., 2014).
- Body dismorphia disorder (BDD) can affect anywhere between 2.5% to 5.3% of the female populace, and those affected have 78% lifetime frequency of suicidal ideation and attempted suicide at the rate of 27.5% (Paven et al., 2008).
- In a study looking at the personality traits among obese women, body dissatisfaction played a significant role especially with those who have a higher level of neuroticism (Provencher et al, 2008).
- The motivation of how to change women's body dissatisfaction is important, since if it is appearance-based rather than health-based, there could be a high emergence of eating regulation (Verstuyf et al., 2012).
- Body image disturbance can be a stronger mediator of sociocultural pressures in girls than in boys (White & Halliwell, 2010).

- Women who have higher physical activity levels are drawn towards images related to exercise and physical activity, while women who do not work out were attracted to the images like a vacuum or cleaning (Berry et al., 2011).
- Cultural ideals of femininity as represented in television images are internalized by women. Once internalized, women often develop anxiety regarding their physical appearance and develop the habit of measuring themselves against those ideals in a way that can be detrimental (Hall et al., 2011).
- Among both teen and preteen girls, weight concern is a powerful motivator for tobacco use. Girls who are dissatisfied with their bodies are more likely to smoke as a means of weight control (Austin & Gortmaker, 2001; Kendzor et al., 2007; Neumark-Sztainer & Hannon, 2000).

FACTS AND RESEARCH FINDINGS

Research on links between female body image and sports and exercise has been somewhat inconsistent. Physical activity can build feelings of competence and self-esteem; it also boosts metabolism, thus improving physical conditioning and, therefore, appearance (Hausenblas & Downs, 2001). However, several studies have found that female athletes and/or exercisers have poorer body images than their less active peers (Parsons & Betz, 2001; Prichard & Tiggemann, 2008). Social physique anxiety can lead girls and women to either become more active in order to improve their appearance or to avoid social situations where their bodies will be on display (Hausenblas et al., 2004; Niven et al., 2009). For example, discomfort with wearing a swimsuit may be a barrier to swimming (James, 2000). The relationship between athletic participation and body image also depends on the sport; conventionally "feminine" sports may reinforce girls' acceptance of conventional cultural standards of female beauty, whereas non-traditional sports may ease the pressure to conform to those older standards.

- Exercise tends to have a positive effect on body image over time. In one study, college women who participated in a 12-week program of either aerobic exercise or circuit strength training reported significant improvements in body image compared to a non-exercising control group (Henry et al., 2006).
- The promotion of exercise as a way to lose weight is not optimal for women in midlife in terms of motivation and sustainable participation. "Daily well-being" might be a better frame to promote positive body image and exercise to women in midlife who are overweight.

This was not found to be true for men (Segar, Eccles, & Richardson, 2011).

- Intervention programs emphasizing physical activity can serve as effective tools for reducing body dissatisfaction and improving body-esteem (Ciccomascolo & Grossi, 2008; Huang et al., 2007).
- Sports participation tends to have a positive effect on body image over time. In one study, women who participated in organized sports prior to college reported having a significantly better sense of positive body image while in college (Richman & Shaffer, 2000).
- In a recent study, aerobic exercise yielded significantly greater improvements in social physique anxiety than strength training for women. However, both aerobic exercise and strength training will lead to significant improvement to overall body image concerns for women with pre-existing conditions (Martin Ginis et al., 2014).
- Girls who participate in sports or athletic activities traditionally considered "feminine" or aesthetic, such as cheerleading, dance, or gymnastics, are more likely to report being ashamed of their bodies, feeling overweight, and actively trying to lose weight than girls who don't participate in sports (Crissey & Honea, 2006; Parsons & Betz, 2001).
- On average, female athletes are more likely to have a positive body image and less likely to consider themselves overweight than female non-athletes (Hausenblas & Downs, 2001; Miller et al., 2000).
- According to Sabo and Veliz (2008), girls participating in three or more sports per year are more likely to have high scores on body-esteem measurements at all grade levels.
- According to McVey et al. (2010), preliminary findings have shown that if peer health educators could have a positive influence on how students view their bodies, they could help boost student's resilience and help prevent the onset of eating disorders.
- The type of physical activity can actually matter for women; an increased participation in yoga has a negative association with self-objectification, but cardio-based workouts were positively linked to self-objectification (Lovemark, 2009).
- Placing more emphasis on health reasons helps buffer self-objectification in women and encourages better adherence to exercise programs (O'Hara et al., 2014).

There are positive links between positive body image and engaging in moderate exercise. Another positive link exists between engaging in exercise and healthy eating habits that boost the body image (Wood-Barcalow et al., 2010).

Self-Esteem

BACKGROUND

Self-esteem, a positive or negative evaluation of one's own worth, is a key indicator of psychological well-being (Rosenberg, 1989). Self-esteem is a product of two factors: a sense of competence or self-efficacy based on our performance or accomplishments and an awareness of how others perceive us (McGee & Williams, 2000). Research on the health and behavioral consequences of self-esteem has been hampered by methodological weaknesses and should not be considered conclusive (McGee & Williams, 2000); some researchers argue that the relationships in question have been significantly exaggerated in popular perception (e.g., Goodson et al., 2006). However, some studies have found links between low self-esteem and substance use (Boden et al., 2008; Swaim & Wayman, 2004; Wild et al., 2004a); sexual risk-taking (Ethier et al., 2006; Spencer et al., 2002); depression and suicidality (Orth et al., 2008; Wild et al., 2004b); and unhealthy eating behavior (Martyn-Nemeth et al., 2009). Women, especially in adolescence, consistently suffer from lower self-esteem than their male peers, particularly in specific areas relating to appearance and physical competence (Gentile et al., 2009, Quatman & Watson, 2001).

- In Western cultures, girls tend to experience a significant decline in self-esteem over the course of adolescence, with the most severe loss found in white girls (Baldwin & Hoffmann, 2002; Biro et al., 2006).
- One important reason for low female self-esteem is that advertising, media in general, and popular culture pervasively sexualize girls and young women (American Psychological Association, 2007).
- For many girls, low self-esteem is linked to negative perceptions of weight, body fat, and body mass (Dunton, Jamner & Cooper, 2003).
- The link between self-esteem and sexual behavior differs considerably by gender; one study found that boys were more than twice as likely to be sexually precocious if they had high self-esteem, while girls were three times as likely to be sexually precocious if they had low self-esteem (Spencer et al., 2002).
- Links between low self-esteem and depression are particularly strong. Both can be buffered by social support and social connectedness (Orth et al., 2008; Williams & Galliher, 2006).
- College women between the ages of 18 and 25 with higher body mass indices (BMI) and body fat tend to base their self-worth on appearance more than women reporting lower body weights. Self-esteem was found

to be lower among college women who had higher body weights (Moncur et al., 2013).

FACTS AND RESEARCH FINDINGS

Research is divided on whether exercise and physical activity have positive impacts on women's self-esteem (e.g., Fox, 2000) or not (e.g., Tiggemann & Williamson, 2000). This is due, in part, to a shortage of randomized, carefully controlled research studies that successfully isolate the influence of exercise itself from other factors that influence self-esteem, such as family dysfunction and/or poverty. Studies of the influence of sports participation on overall self-esteem also have had mixed results. One key area in which women and men differ is in athletic or physical self-esteem, a difference that can be seen early in the life span.

Among children who play sports, boys report higher athletic self-esteem and perceived athletic competence than girls, a gender gap that increases during adolescence (Jacobs et al., 2002; Klomsten et al., 2004). The strongest findings suggest that sport affects girls' global self-esteem in indirect ways: by influencing other psychosocial factors that, in turn, contribute to a sense of physical and overall self-worth. For example, the relationship between sports participation and global self-esteem may be mediated by peer acceptance (Daniels & Leaper, 2006), sport self-concept (Slutzky & Simpkins, 2009), social connectedness (Armstrong & Oomen-Early, 2009), attachment to school (Tracy & Erkut, 2002), enjoyment of sports (Shaffer & Wittes, 2006), physical competence (Bowker, 2006), positive body image, and gender-role flexibility (Richman & Shaffer, 2000).

- Research shows that sports participation is positively associated with self-esteem in elementary school girls (McHale et al., 2005), 12th-grade girls (Dishman et al., 2006), and college women (Armstrong & Oomen-Early, 2009). There is also evidence that noncompetitive physical activity has the capacity to positively impact self-esteem in girls (Eddy, 2014).
- Tensions over gender-appropriate behavior can complicate the link between sports participation and self-esteem because female athletes risk being perceived as masculine by their peers (Daniels & Leaper, 2006; Richman & Shaffer, 2000). In one study, 11th-grade girls who endorsed a strongly feminine gender-role orientation had lower self-esteem if they played competitive sports but higher self-esteem if they played recreational sports that were more socially oriented and less competitive (Bowker et al., 2003).
- The more time girls spend participating in team sports, the better they feel about their athletic abilities and the higher their level of self-esteem.

The same link has not been found for individual sports (Pedersen & Seidman, 2004; Slutzky & Simpkins, 2009).

- Positive links between sports participation and girls' self-esteem have been found for white, African-American, and Hispanic girls (Erkut & Tracy, 2002; Schmalz et al., 2007; Tracy & Erkut, 2002; Simona et al., 2010).

- The indirect impact of sports participation on self-esteem has a shelf life of at least several years. In one study, preadolescent girls who played sports (ages 9–11) reported higher self-esteem two years later (Schmalz et al., 2007); in another study, women's pre-college sports participation predicted their self-esteem during the college years (Shaffer & Wittes, 2006).

- In a study of Dutch adolescent girls between the ages of 13 and 18 (n = 140), more than 80% reported participating in sport for a variety of reasons. Girls who were motivated to participate in sport because of weight reduction reasons had lower self-esteem and higher body dissatisfaction than girls who participated in sport for other reasons (enjoyment of the sport, for example) (de Bruin et al., 2009).

- Research shows that girls who exhibit low self-esteem paired with depression may stop playing sports due to increased doubt in playing ability (Jerstad et al., 2010).

- Female college students who were learning how to swim for the first time exhibited an increase in self-esteem during the learning process (Muhamad et al., 2013).

- In middle-aged women, increases in physical activity help to increase self-efficacy and overall self-worth. This also mediates the changes caused by menopause (Elavsky, 2010).

- Data indicates that both self-esteem and self-concept will increase as a consequence of exercise treatment for women (Garcia-Martinez et al., 2012).

Pathogenic Weight Loss Behavior

BACKGROUND

Eating disorders are on the rise in the United States, affecting as many as 10 million Americans (National Eating Disorders Association, 2009), more than 90% of whom are female (Hoek & van Hoeken, 2003; Mitchell & Bulik, 2006). About 1% of women meet the diagnostic criteria for anorexia nervosa, a condition in which distorted body image and intense fear of gaining weight lead

to voluntary starvation. Bulimia nervosa, a cyclical pattern of binge eating and purging, affects 1–2% of women. More than 3% of women suffer from a recently recognized third condition, binge eating disorder (Hudson et al., 2007).

Far more common is a subclinical but maladaptive pattern of disordered eating that includes the use of dangerous weight-control techniques, such as self-induced vomiting; fasting; use of laxatives, diuretics, or diet pills; and excessive exercise (CDC, 2008; Neumark-Sztainer, 2005). Pathogenic weight control is associated with nutritional deficiencies, chronic fatigue, decreased bone density, erosion of tooth enamel, menstrual and reproductive abnormalities, lowered self-esteem, anxiety, and depression (Academy for Eating Disorders, 2009; Courtney et al., 2008; Fairburn & Harrison, 2003). For individuals with eating disorders, compulsive exercise may render treatment more difficult because compulsive exercise can be a sign of relapse when the exercise is being done in order to control weight (Meyer et al., 2011; Taranis & Meyer, 2011; Halmi, 2013).

Eating disorders are most common among adolescent and young adult women; 86% of cases report onset by age 20, and some girls have been diagnosed as young as age 7 (National Association of Anorexia Nervosa and Associated Disorders, 2004; Ricciardelli & McCabe, 2001).

- Anorexia nervosa has the highest mortality rate of any mental illness; as many as 20% of cases end in death, according to some estimates (Eating Disorders Coalition, 2009).
- Unhealthy weight control behaviors are common among young women who are not eating-disordered. Nearly half of the college women in [one study] reported attempting to compensate for the effects of eating by fasting (11.3%), exercising vigorously (16.3%), or both (15.4%) in the past month (LePage et al., 2008).
- More than half of adolescent girls use health-compromising weight-control techniques, such as skipping meals, fasting, smoking cigarettes, vomiting, and taking laxatives (Neumark-Sztainer, 2005). Overweight girls are especially prone to use these strategies (Neumark-Sztainer et al., 2007).
- High school girls are more likely than boys to report that in the past month they have fasted for 24 hours or longer (16.3% vs. 7.3%); used diet pills, powders, or liquids without a doctor's advice (7.5% vs. 4.2%); or vomited or taken laxatives (6.4% vs. 2.2%) to lose or avoid gaining weight (CDC, 2008).
- African-American women are at lower risk for anorexia and bulimia than white women, in part because they are less likely to adopt exces-

sively thin beauty ideals (Perez & Joiner, 2003; Striegel-Moore et al., 2003). However, women of color are at no less risk for binge eating disorder and some pathogenic weight-control techniques (Crago & Shisslak, 2003; Taylor et al., 2007).

FACTS AND RESEARCH FINDINGS

Female athletes are at elevated risk for pathogenic weight control behavior. In conjunction with amenorrhea and osteoporosis, eating disorders are part of a "Female Athlete Triad" that undermines health and (ironically) athletic performance (American College of Sports Medicine, 2007; Manore et al., 2007). Sports participation may be a risk factor for eating disorders because unique pressures to maintain a specific body weight and shape; personality traits commonly found in athletes, such as perfectionism, competitiveness, and compulsiveness; as well as competition-related anxiety may play a role in disordered eating (de Bruin et al., 2009; Gulker et al., 2001; Holm-Denoma et al., 2009; Hopkinson & Lock, 2004). Pathogenic weight-control techniques may even be perceived as "normal" within an athletic context, such as ballet dancers who routinely purge or gymnasts who stop menstruating due to self-imposed dietary restrictions.

- Eating disorders are most common in aesthetic sports that are scored on appearance or form (e.g., dancing, figure skating, or gymnastics); after puberty, the small-breasted, narrow-hipped ideal for these sports is difficult to attain without pathogenic weight-control techniques (Bonci et al., 2008; Engel et al., 2003; Greydanus & Patel, 2004; Ryan, 1995; Sundgot-Borgen & Torstveit, 2004).
- Lean sports (e.g., running, swimming, or cycling) may also invite pathogenic weight-control behaviors. Adult women have about 25% body fat; elite female distance runners, 12–16%; and elite female sprinters, 8–10% (Greydanus & Patel, 2004). One recent study found 3% of non-lean-sport athletes at high risk for disordered eating but a much greater percentage (25%) of lean-sport athletes were at risk (Reinking & Alexander, 2005).
- Athletes often face significant social or financial pressure to regulate their body weight or shape. Failure may be noted and sanctioned by coaches, spectators, judges, and the athlete herself (Beals & Manore, 2002; Muscat & Long, 2008).
- Unsurprisingly, the most common weight-control behavior used by female college athletes is exercise. In one study, one-fourth of athletes exercised at least two hours a day for weight-related reasons—in addition to their sport training (Greenleaf et al., 2009).

- Elite athletes are at greater risk for pathogenic weight-control behavior than those who compete at a lower level or participate in recreational sports only (Sundgot-Borgen & Torstveit, 2004; Smolak et al., 2000).
- An NCAA study found that 9% of female college athletes have clinically significant problems with bulimia and 3% have clinically significant problems with anorexia. Weekly binge eating is reported by 11%, while 5.5% reported purging through self-induced vomiting, laxatives, or diuretics (Johnson et al., 1999).
- Among Division III female athletes who completed a survey assessing their eating behaviors (binging, purging, restrictive food choices), exercise behaviors, and attitudes toward body image and weight reduction, 27.7% exhibited risky eating behaviors that could develop into eating disorders. The responses of over a quarter of the female athletes in the study (n = 436) situated them on a continuum of risky eating. Nearly 6% of female athletes who completed the survey had a clinical eating disorder (Sears et al., 2012).
- Pathogenic weight control also occurs in younger athletes. In one study, 19.6% of female high school athletes reported disordered eating in the past month (Pernick et al., 2006). A second study found middle and high school girls to be at least twice as likely to use vomiting, laxatives, or steroids if they participated in weight-sensitive sports (Vertalino et al., 2007).
- In a study, 24% of the figure skaters studied that showed a greater risk of eating pathology. Those skaters tended to be older and had higher body mass indices (BMIs) than the skaters without elevated risk to eating pathology (Dwyer et al., 2012).
- Some pathological eating habits become normalized in elite sporting cultures since it is believed that a certain diet or weight will give the athlete an edge (Williams, 2012).
- Physical activity levels of women who recovered from anorexia did not differ from women who showed no history of pathological eating; however, the BMIs of the recovered women were typically 2 points lower (Dellava et al, 2011).
- While the vast majority of female college athletes in the sports of gymnastics and swimming and diving (n = 414) were found in a study by Petrie et al. (2009) not to display signs of disordered eating, a third of those athletes did report some level of eating disturbance.
- A study using the *Diagnostic and Statistical Manual of Mental Disorders* (DSM-IV) to define eating disorders found that such disorders were present in 31% of elite female athletes in "thin-build" sports (such as

gymnastics and distance running), compared with 5.5% of non-athletes (Byrne & McClean, 2002).

References

When possible, the editors have supplied source listings missing from the original in brackets.

DEPRESSION

Ahmadi, J., Samavat, F., Sayyad, M., & Ghanizadeh, A. (2002). Various types of exercise and scores on the Beck Depression Inventory. *Psychological Reports, 90*(3), 821–822.

Armstrong, S., & Ooman-Early, J. (2009). Social connectedness, self-esteem, and depression symptomatology among collegiate athletes versus non-athletes. *Journal of American College Health, 57*, 521–526.

Azar, D., Ball, K., Salmon, J., & Cleland, V. (2011). Individual, social, and physical environmental correlates of physical activity among young women at risk of depression. *Journal of Physical Activity and Health, 8*, 133–140.

Boone, E. M., & Leadbeater, B. J. (2006). Game on: Diminishing risks for depressive symptoms in early adolescence through positive involvement in team sports. *Journal of Research on Adolescence, 16*, 79–90.

Breland, J. Y., Fox, A. M., & Horowitz, C. R. (2013). Screen time, physical activity and depression risk in minority women. *Mental Health and Physical Activity, 6*(1), 10–15. doi:10.1016/j. mhpa.2012.08.002

Brown, W. J., Ford, J. H., Burton, N. W., Marshall, A. L., & Dobson, A. J. (2005). Prospective study of physical activity and depressive symptoms in middle-aged women. *American Journal of Preventive Medicine, 29*, 265–272.

Cassano, P., & Fava, M. (2002). Depression and public health, an overview. *Journal of Psychosomatic Research, 53*, 849–857.

Craft, L. L. (2005). Exercise and clinical depression: Examining two psychological mechanisms. *Psychology of Sport and Exercise, 6*, 151–171.

Cripps, F. (2008). Exercise your mind: Physical activity as a therapeutic technique for depression. *International Journal of Therapy and Rehabilitation, 15*, 460–465.

Cyranowski, J. M., Frank, E., Young, E., & Shear, M. K. (2000). Adolescent onset of the gender difference in lifetime rates of major depression: A theoretical model. *Archives of General Psychiatry, 57*(1), 21–27.

Devane, C. L., Chiao, E., Franklin, M., & Kruep, E. J. (2005). Anxiety disorders in the 21st century: Status, challenges, opportunities, and comorbidity with depression. *American Journal of Managed Care, 11*, S344–S353.

De Mello, M. T, de Aquino Lemos, V., Atunes, H. K. M, Bittencourt, L., Santos-Silva, R., & Tufik, S. (2013). Relationship between physical activity and depression and anxiety symptoms: A population study. *Journal of Affective Disorders, 149*, 241–246.

Dishman, R. K., Hales, D. P., Pfeiffer, K. A., Felton, G., Saunders, R., Ward, D. S.,

Dowda, M., & Pate, R. R. (2006). Physical self-concept and self-esteem mediate cross-sectional relations of physical activity and sport participation with depression symptoms among adolescent girls. *Health Psychology, 25*, 396–407.

Dunn, A. L., Trivedi, M. H., Kampert, J. B., Clark, C. G., & Chambliss, H. O. (2005). Exercise treatment for depression: Efficacy and dose response. *American Journal of Preventive Medicine, 28*, 1–8.

Gore, S., Farrell, F., & Gordon, J. (2001). Sports involvement as protection against depressed mood. *Journal of Research on Adolescence, 11*(1), 119–130.

Greenberg, P. E., Kessler, R. C., Birnbaum, H. G., Leong, S. A., Lowe, S. W., Berglund, P. A., & Corey-Lisle, P. K. (2003). The economic burden of depression in the United States: How did it change between 1990 and 2000? *Journal of Clinical Psychiatry, 64*, 1465–1475.

Hammond, T., Gialloreto, C., Kubas, H., & Davis, H. (2013). The Prevalence of Failure-Based Depression Among Elite Athletes. *Clinical Journal of Sport Medicine, 23*(4), 273–277.

Hyde, J. S., Mezulis, A. H., & Abramson, L. Y. (2008). The ABCs of depression: Integrating affective, biological, and cognitive models to explain the emergence of the gender difference in depression. *Psychological Review, 115*, 291–313.

Jacka, F. N., Pasco, J., Williams, L., Leslie, E., Dodd, S., Nicholson, G., Kotowicz, M., & Berk, M. (2011, May). Lower levels of physical activity in childhood associated with adult depression. *Journal of Science and Medicine in Sport, 14*(3), 222–226.

Jerstad, S. J., Boutelle, K. N., Ness, K. K., & Stice, E. (2010). Prospective Reciprocal Relations Between Physical Activity and Depression in Female Adolescents. *Journal of Consulting and Clinical Psychology, 78* (2), 268–272.

Johnson, C. C., Murray, D. M., Elder, J. P., Jobe, J. B., Dunn, A. L., Kubik, M., Voorhees, C., & Schachter, K. (2008). Depressive symptoms and physical activity in adolescent girls. *Medicine & Science in Sports & Exercise, 40*, 818–826.

Katon, W., & Ciechanowski, P. (2002). Impact of major depression on chronic medical illness. *Journal of Psychosomatic Research, 53*, 859–863.

Kessler, R. C., Barker, P. R., Colpa, L. J., Epstein, J. F., Gfroerer, J. C., Hiripi, E., Howes, M. J., Normand, S. L., Manderscheid, R. W., Walters, E. E., & Zaslavsky, A. M. (2003). Screening for serious mental illness in the general population. *Archives of General Psychiatry, 60*, 184–189.

Knopf, A. (2014). Could depression treatment help cure medical cost woes? *Behavioral Healthcare, 34*, 1, 26–29.

Ko, J. K, Farr, S. L. Dietz, P. M. Robbins, C. L. (2012). Depression and treatment among U. S. pregnant and nonpregnant women of reproductive age, 2005–2009. *Journal of Women's Health, 21*(8), 830–836.

Lawlor, D. A., & Hopker, S. W. (2001). The effectiveness of exercise as an intervention in the management of depression: Systematic review and meta-regression analysis of randomised controlled trials. *British Medical Journal, 322*, 1–8.

Loprinzi, P. D., Fitzgerald, E. M., & Cardinal, B. J. (2012). Physical activity and depression symptoms among pregnant women from the national health and nutrition examination survey 2005–2006. *Journal of Obstetric, Gynecologic, & Neonatal Nursing, 41*, 227–235.

Lucas, M., Mekary, R., Pan, A., Mirzaei, F., O'Reilly, E. J., Willett, W. C., Koenen, K., Okereke, O L., & Ascherio, A. (2011). Relationship between clinical depression risk and physical activity and time spent watching television in older women: a 10-year prospective follow-up study. *American Journal of Epidemiology. 174*(9), 1017–1027.

Marcus, M., Yasamy, M. T., van Ommeren, M., Chisholm, D., Saxena, S. (2012) *Depression: A Global Public Health Concern*. NY, NY: World Health Organization.

Mayo Clinic. (2008). Depression in women: understanding the gender gap. Retrieved 2008 from http://www. mayoclinic.com/health/depression/MH00035

Mazure, C. M., Keita, G. P., & Blehar, M. C. (2002). *Summit on women and depression: Proceedings and recommendations*. Washington, DC: American Psychological Association.

McKercher, C. M., Schmidt, M. D., Sanderson, K. A., Patton, G. C., Dwyer, T., & Venn, A. J. (2009). Physical activity and depression in young adults. *American Journal of Preventive Medicine, 36*, 161–164.

McKercher, C., Patton, G. C., Schmidt, M. D., Venn, A. J., Dwyer, T., & Sanderson, K. (2013). Physical activity and depression symptom profiles in young men and women with major depression. *Psychosomatic Medicine, 75*, 366–374.

Mental Health America. (2008a). Do you know the facts? Breaking down the myths about depression. Retrieved September 16, 2009, from http://www. mentalhealthamerica.net

Mental Health America (2008b). *Fact sheet: Depression in women*. Retrieved September 16, 2009, from http://www.mentalhealthamerica.net

Mikkelsen, S. S., Tolstrup, J. S., Flachs, E. M., Mortensen, E. L., Schnohr, P. & Flensborg-Madsen, T. (2010). A cohort study of leisure time physical activity and depression. *Preventive Medicine. 51*, 471–475.

National Institute of Mental Health. (2008). *Women and depression: Discovering hope*. (NIH Publication No. 00-4779). Bethesda, MD: National Institute of Mental Health, National Institutes of Health, U. S. Department of Health and Human Services.

Oakley, L. D., Kanter, J. W., Taylor, J. Y., & Duguid. M. (2012). The self-stigma of depression for women. *International Journal of Social Psychiatry. 58*(5), 512–520.

Rosenberg, D. E., Bombardier, C. H., Artherholt, S., Jensen, M. P., & Motl, R. W. (2013). Self-reported depression and physical activity in adults with mobility impairments. *Archives of Physical Medicine and Rehabilitation, 94*, 731–736.

Sallis, J. P., Prochaska, J. J., & Taylor, W. C. (2000). A review of correlates of physical activity of children and adolescents. *Medicine & Science in Sports & Exercise, 32*, 963–975.

Sanders, C. E., Field, T. M., Diego, M., & Kaplan, M. (2000). Moderate involvement in sports is related to lower depression levels in adolescents. *Adolescence, 35*(140), 793–797.

Simon, J., Docherty C. (2014). Current Health-Related Quality of Life Is Lower in Former Division I Collegiate Athletes Than in Non-Collegiate Athletes. *American Journal of Sports Medicine, 42*(2): 423–442.

Strawbridge, W. J., Deleger, S., Roberts, R., & Kaplan,G. A. (2002). Physical activity reduces the risk of subsequent depression for older adults. *American Journal of Epidemiology, 156*, 328–334.

Strohle, A. (2009). Physical activity, exercise, depression and anxiety disorders. *Journal Neural Transmission 116*, 777–784.

Substance Abuse and Mental Health Services Administration. (2008). *Results from the 2007 National Survey on Drug Abuse and Health: National findings* (Office of Applied Studies, NSDUH Series:H-34, DHHS Publication No. SMA 08-4343). Rockville, MD: Substance Abuse and Mental Health Services Administration.

Sui, X. Laditka, J. N., Church, T. S., Hardin, J. W., Chase, N., Davis, K., & Blair, S. N. (2009). Prospective study of cardiorespiratory fitness and depressive symptoms in women and men. *Journal of Psychiatry Res. 43(5)*, 546–552.

Taliaferro, L. A., Rienzo, B. A., Pigg, M., Jr., Miller, M. D., & Dodd, V. J. (2008). Associations between physical activity and reduced rates of hopelessness, depression, and suicidal behavior among college students. *Journal of American College Health, 57*, 427–435.

Teychenne, M., Ball, K., & Salmon, J. (2008). Physical activity and likelihood of depression in adults: A review. *Preventive Medicine, 46*, 397–411.

Teychenne, M., Ball, K., & Salmon, J. (2010). Physical activity, sedentary behavior and depression among disadvantaged women. *Health Education Research, 25* (5), 632–644.

Van Beek, Y., Hessen, D. J., Hutteman, R., Verhulp, E. E., & van Leuven, M. (2012). Age and gender differences in depression across adolescence: real or 'bias'? *Journal of Child Psychology and Psychiatry. 53*, 973–985.

[van Uffelen, J. G. Z., Wong, J., & Chau, J. Y. (2010). Occupational sitting and health risks: a systematic review. *American Journal of Preventive Medicine, 39*, 379–388.]

Wang, F., DesMeules, M., Luo, W., Dai, S., Lagace, C., & Morrison, H., (2011). Leisure-time physical activity and marital status in relation to depression between men and women: a prospective study. *Health Psychology, 30(2)*, 204–211.

World Health Organization. (2001). *World health report 2001: Mental health: New understanding, new hope.* Geneva, Switzerland: World Health Organization.

World Health Organization. (2009). *Women and health: Today's evidence tomorrow's agenda.* Geneva, Switzerland: World Health Organization.

Wyshak, G. (2001). Women's college physical activity and self-reports of physician-diagnosed depression and of current symptoms of psychiatric distress. *Journal of Women's Health & Gender-Based Medicine, 10*, 363–370.

ANXIETY DISORDERS

Brunes, A., Augestad, L. B., & Gudmundsdottir, S. L. (2013). Personality, physical activity, and symptoms of anxiety and depression: the HUNT study. *Social Psychiatry and Psychiatric Epidemiology. 48*, 745–756.

Centers for Disease Control and Prevention (2011). *Burden of Mental Illness.* Retrieved June 8, 2014, from http://www.cdc.gov/mentalhealth/basics/burden.htm

DeBoer, L. B., Tart, C. D., Presnell, K. E., Powers, M. B., Baldwin, A. S., Smits, J. A. J. (2012) Physical activity as a moderator of the association between anxiety sensitivity and binge eating. *Eating Behaviors, 13*, 194–201.

Herring, M. P., O'Connor, P. J., & Dishman, R. K. (2014). Self-esteem mediates associations of physical activity with anxiety in college women. *Medicine & Science in Sports & Exercise.*

Pasco, J. A., Williams, L. J., Jacka, F. N., Henry, M. J., Coulson, C. E., Brennan, S. L., ... Berk, M. (2011), Habitual physical activity and the risk for depressive and anxiety disorders among older men and women. *International Psychogeriatrics, 23*(2), 292–298.

SUICIDE

American Association of Suicidology. (2006). *Youth suicide fact sheet.* Retrieved September 16, 2009, from http://www.suicidology.org.

Arnow, B. A., Blasey, C. M., Hunkeler, E. M., Lee, J., & Hayward, C. (2011). Does gender moderate the relationship between childhood maltreatment and adult depression? *Child Maltreatment, 16*(3), 175–183.

Baca-Garcia, E., Perez-Rodriguez, N, M., Keyes, K. M., Oquendo, M. A., Hasin, D. S., Grant, B. F., & Blanco, C. (2010). Suicidal ideation and suicide attempts in the United States: 1991–1992 and 2001–2002. *Molecular Psychiatry, 15,* 250–259.

Bae, S., Ye, R., Chen, S., Rivers, P., & Singh, K. (2005). Risky behaviors and factors associated with suicide attempts in adolescents. *Archives of Suicide Research, 9,* 193–202.

Barrios, L. C., Everett, S. A., Simon, T. R., & Brener, N. D. (2000). Suicide ideation among U.S. college students: Associations with other injury risk behaviors. *Journal of American College Health, 48,* 229–233.

Brown, D. R. & Blanton, C. J. (2002). Physical activity, sports participation, and suicidal behavior among college students. *Medicine & Science in Sports & Exercise, 34*(7), 1087–1096.

Brown, D. R., Galuska, D. A., Zhang, J., Eaton, D. K., Fulton, J. E., Lowry, R., & Maynard, L. M. (2007). Physical activity, sport participation, and suicidal behavior: U.S. high school students. *Medicine & Science in Sports & Exercise, 39,* 2248–2257.

Centers for Disease Control and Prevention. (2008). Youth risk behavior surveillance, United States, 2007. *Morbidity and Mortality Weekly Report Surveillance Summaries, 57*(SS-4), 1–131.

Centers for Disease Control and Prevention. (2007). Suicide trends among youths and young adults aged 10–24 years, United States, 1990–2004. *Morbidity and Mortality Weekly Reports, 56*(35), 905–908.

Ferron, C., Narring, F. C., Cauderay, M., & Michaud, P.-A. (1999). Sport activity in adolescence: Associations with health perceptions and experimental behaviors. *Health Education Research: Theory & Practice, 14,* 225–233.

Fulton, J. E., Lowry, R., & Maynard, L. M. (2007). Physical activity, sport participation, and suicidal behavior: U.S. high school students. *Medicine & Science in Sports & Exercise, 39,* 2248–2257.

Hallfors, D. D., Waller, M. W., Ford, C. A., Halpern, C. T., Brodish, P. H., & Iritani, B. (2004). Adolescent depression and suicide risk: Association with sex and drug behavior. *American Journal of Preventive Medicine, 27*(3), 224–230.

Harrison, P. A., & Narayan, G. (2003). Differences in behavior, psychological factors, and environmental factors associated with participation in school sports and other activities in adolescence. *Journal of School Health, 73,* 113–120.

Institute of Medicine. (2002). *Reducing suicide: A national imperative.* Washington, DC: National Academies Press.

Mather, A. A., Cox, B. J., Enns, M. W., & Sareen, J. (2009). Associations of obesity with psychiatric disorders and suicide behaviors in a nationally representative sample. *Journal of Psychosomatic Research, 66,* 277–285.

McKercher, C., Patton, G. C., Schmidt, M. D., Venn, A. J., Dwyer, T., & Sanderson, K. (2013). Physical activity and depression symptom profiles in young men and women with major depression. *Psychosomatic Medicine, 75,* 366–374.

Miller, K. E., & Hoffman, J. H. (2009). Mental well-being and sport-related identities in college students. *Sociology of Sport Journal, 13,* 209–216.

Mukamal, K. J., & Miller, M. (2009). BMI and risk factors for suicide: Why is BMI inversely related to suicide? *Articles Epidemiology, 17*(3), 532–538.

National Adolescent Health Information Center. (2006). *Fact sheet on suicide: Adolescents & young adults.* San Francisco, CA: National Adolescent Health Information Center.

Oler, M. J., Mainous, A. G., III, Martin, C. A., Richardson, E., Haney, A., Wilson, D., & Adams, T. (1994). Depression, suicidal ideation, and substance use among adolescents: Are athletes at less risk? *Archives of Family Medicine, 3,* 781–785.

Page, R. M., Hammermeister, J., Scanlan, A., & Gilbert, L. (1998). Is school sports participation a protective factor against adolescent health risk behaviors? *Journal of Health Education, 29*(3), 186–192.

Sabo, D., Miller, K. E., Melnick, M. J., Farrell, M. P., & Barnes, G. M. (2005). High school athletic participation and adolescent suicide: A nationwide study. *International Review for the Sociology of Sport, 40,* 5–23.

Schilling, E. A., Aseltine, R. H., Glanovsky, J. L., James, A., & Jacobs, D. (2009). Adolescent alcohol use, suicidal ideation, and suicide attempts. *Journal of Adolescent Health, 44,* 335–341.

Simon, T. R., Powell, K. E., & Swann, A. C. (2004). Involvement in physical activity and risk for nearly lethal suicide attempts. *American Journal of Preventive Medicine, 27,* 310–315.

Substance Abuse and Mental Health Services Administration. (2008). *Results from the 2007 National Survey on Drug Abuse and Health: National findings.* (DHHS Publication No. SMA 08-4343). Office of Applied Studies, NSDUH Series: H-34, Rockville, MD: Substance Abuse and Mental Health Services Administration.

Taliaferro, L. A., Rienzo, B. A., Miller, M. D., Pigg, R. M., Jr., & Dodd, V. J. (2008a). High school youth and suicide risk: Exploring protection afforded through physical activity and sport participation. *Journal of School Health, 78,* 545–553.

Taliaferro, L. A., Rienzo, B. A., Pigg, R. M., Jr., Miller, M. D., & Dodd, V. J. (2008b). Associations between physical activity and reduced rates of hopelessness, depression, and suicidal behavior among college students. *Journal of American College Health, 57,* 427–435.

Thome, J., & Espelage, D. (2004). Relations among exercise, coping, disordered eating, and psychological health among college students. *Eating Behavior, 5,* 337–351.

Thompson, M. P., Kingree, J. B., & Ho, C. (2006). Associations between delinquency and suicidal behaviors in a nationally representative sample of adolescents. *Suicide and Life-Threatening Behavior, 36*(1), 57–64.

Tomori, M. & Zalar, B. (2000). Sport and physical activity as possible protective factors in relation to adolescent suicide attempts. *International Journal of Sport Psychology, 31,* 405–413.

Unger, J. B. (1997). Physical activity, participation in team sports, and risk of suicidal behavior in adolescents. *American Journal of Health Promotion, 12,* 90–93.

BODY IMAGE

Ackard, D. M., Croll, J. K., & Kearney-Cooke, A. (2002). Dieting frequency among college females: Association with disordered eating, body image, and related psychological problems. *Journal of Psychosomatic Research, 52,* 129–136.

Adams, M. (2005). U. S. weight loss market worth $46. 3 billion in 2004—forecast to reach $61 billion by 2008. *Natural News, 3/30/05.* Retrieved April 9, 2009, from http://www.naturalnews.com/006133.html

Anschutz, D., & Engles, R. (2010). The effects of playing with thin dolls on body image and food intake in young girls. *Sex Roles, 63,* 621–630.

Austin, S. B., & Gortmaker, S. L. (2001). Dieting and smoking initiation in early adolescent girls and boys: A prospective study. *American Journal of Public Health, 91,* 446–450.

Bearman, S. K., & Stice, E. (2008). Testing a gender additive model: The role of body image in adolescent depression. *Journal of Abnormal Child Psychology, 36,* 1251–1263.

Berry, T., Spence, J., & Stolp, S. (2011). Attentional bias for exercise-related images. *Research Quarterly for Exercise and Sport, 82*(2), 302–309.

Brausch, A. M., & Gutierrez, P. M. (2009). The role of body image and disordered eating as risk factors for depression and suicidal ideation in adolescents. *Suicide and Life-Threatening Behavior, 39,* 58–71.

Cash, T. F., & Pruzinski, T. (Eds.). (2002). *Body image: A handbook of theory, research, and clinical practice.* New York: Guilford Press.

Ciccomascolo, L. E., & Grossi, L. M. (2008). The effect of an 8-week educational curriculum and physical activity program on attitudes toward physical activity and body image of urban adolescent girls. *Women in Sport and Physical Activity Journal, 17,* 17–23.

Clark, M. M., Croghan, I. T., Reading, S., Schroeder, D. R., Stoner, S. M., Patten, C. A., & Vickers, K. S. (2005). The relationship of body image dissatisfaction to cigarette smoking in college students. *Body Image, 2*263–270.

Clark, L., & Tiggemann, M. (2006). Appearance culture in nine- to 12-year-old girls: Media and peer influences on body dissatisfaction. *Social Development, 15,* 628–643.

Clay, D., Vignoles, V. L., & Dittmar, H. (2005). Body image and self-esteem among adolescent girls: Testing the influence of sociocultural factors. *Journal of Research on Adolescence, 15,* 451–477.

Crissey, S. R., & Honea, J. C. (2006). The relationship between athletic participation and perceptions of body size and weight control in adolescent girls: The role of sport type. *Sociology of Sport Journal, 23,* 248–272.

Davison, K. K., Earnest, M. B., & Birch, L. L. (2002). Participation in aesthetic sports and girls' weight concerns at ages 5 and 7 years. *International Journal of Eating Disorders, 31,* 312–317.

Dittmar, H., Halliwell, E., & Ive, S. (2006). Does Barbie make girls want to be thin? The effect of experimental exposure to images of dolls on the body image of 5- to 8-year-old girls. *Developmental Psychology, 42,* 283–292.

Erbil, N. (2013). The relationships between sexual function, body image, and body mass index among women. *Sexuality and Disability 31,* 63–72.

Frederick, D. A., Peplau, L. A., & Lever, J. (2006). The swimsuit issue: Correlates of body image in a sample of 52,677 heterosexual adults. *Body Image, 3,* 413–419.

Groesz, L., Levine, M. P., & Murnen, S. K. (2002). The effect of experimental presentation of thin media images on body satisfaction: A meta-analytic review. *International Journal of Eating Disorders, 31,* 1–16.

Grossbard, J. R., Lee, C. M., Neighbors, C., & Larimer, M. E. (2009). Body image concerns and contingent self-esteem in male and female college students. *Sex Roles 60,* 198–207.

Hausenblas, H. A., Brewer, B. W., & Van Raalte, J. L. (2004). Self-presentation and exercise. *Journal of Applied Sport Psychology, 16,* 3–18.

Hausenblas, H. A., & Downs, D. S. (2001). Comparison of body image between athletes and nonathletes: A meta-analytic review. *Journal of Applied Sport Psychology, 13,* 323–339.

Henry, R. N., Anshel, M. H., & Michael, T. (2006). Effects of aerobic and circuit training on fitness and body image among women. *Journal of Sport Behavior, 29,* 281–303.

Huang, J. S., Norman, G. J., Zabinski, M. F., Calfas, K., & Patrick, K. (2007). Body image and self-esteem among adolescents undergoing an intervention targeting dietary and physical activity behaviors. *Journal of Adolescent Health, 40,* 245–251.

James, K. (2000). You can feel them looking at you: The experiences of adolescent girls in swimming pools. *Journal of Leisure Research, 32,* 262–280.

Kendzor, D. E., Copeland, A. L., Stewart, T. M., Businelle, M. S., & Williamson, D. A. (2007). Weight-related concerns associated with smoking in young children. *Addictive Behaviors, 32,* 598–607.

Kilbourne, J. (2004). "The more you subtract, the more you add": Cutting girls down to size. In Kasser, T., & Kanner, A. D. (Eds.), *Psychology and Consumer Culture,* (pp. 251–270). Washington, DC: American Psychological Association.

Lamb, S., & Brown, L. (2006). *Packaging girlhood: Rescuing our daughters from marketers' schemes.* New York: St. Martin's Press.

Lowes, J., & Tiggemann, M. (2003). Body dissatisfaction, dieting awareness, and the impact of parental influence in young children. *British Journal of Health Psychology, 8,* 135–147.

Lydecker, J. A., Cotter, E., & Mazzeo, S. E. (2014). Body checking and body image avoidance: Construct validity and norms for college women. *Eating Behaviors, 15*(1), 13–19.

Martin Ginis, K. A., Strong, H. A., Arent, S. M., Bray, S. R., & Bassett-Gunter, R. L. (2014). The effects of aerobic-versus strength-training on body image among young females with pre-existing body image concerns. *Body Image, 11,* 219–227.

McVey, G. L., Kirsh, G., Maker, D., Walker, K. S., Mullane, J., Laliberte, M., Ellis-

Claypool, J., Vorderbugge, J., Burnett, A., Cheung, L., & Banks, L. (2010). Promoting positive body image among university students: A collaborative pilot study. *Body Image, 7*(3), 200–204.

Miller, K. E., Sabo, D. F., Melnick, M. J., Farrell, M. P., & Barnes, G. M. (2000). *Women's Sports Foundation report: Health risks and the teen athlete*. East Meadow, NY: Women's Sports Foundation.

Musher-Eizenman, D., Holub, S., Edward-Leeper, L., Persson, A., & Goldstein, S. (2003). The narrow range of acceptable body types of preschoolers and their mothers. *Applied Developmental Psychology, 24*, 259–272.

Neumark-Sztainer, D., & Hannon, P. J. (2000). Weight-related behaviors among adolescent girls and boys. *Archives of Pediatrics & Adolescent Medicine, 154*, 569–577.

Niven, A., Fawkner, S., Knowles, A.-M., Henretty, J., & Stephenson, C. (2009). Social physique anxiety and physical activity in early adolescent girls: The influence of maturation and physical activity motives. *Journal of Sports Sciences, 27*, 299–305.

Norton, K. I., Olds, T. S., Olive, S., & Dank, S. (1996). Ken and Barbie at life size. *Sex Roles, 34*, 287–294.

Parkes, S. A., Saewyc, E. M., Cox, D. N., & MacKay, L. J. (2008). Relationship between body image and stimulant use among Canadian adolescents. *Journal of Adolescent Health, 43*, 616–618.

Parsons, E. M., & Betz, N. E. (2001). The relationship of participation in sports and physical activity to body objectification, instrumentality, and locus of control among young women. *Psychology of Women Quarterly, 25*, 209–222.

Paven, C., Simonato, P., Marini, M., Mazzoleni, F., Pavan, L., & Vindigni, V. (2008). Psychopathologic aspects of body dysmorphic disorder: A literature review. *Aesthetic Plastic Surgery 32*(3), 473–484.

Prichard, I., & Tiggemann, M. (2008). Relations among exercise type, self-objectification, and body image in the fitness centre environment: The role of reasons for exercise. *Psychology of Sport and Exercise, 9*, 855–866.

Provencher, V., Bégin, C., Gagnon-Girouard, M. P., Tremblay, A., Boivin, S., Lemieux, S. (2008). Personality traits in overweight and obese women: Associations with BMI and eating behaviors. *Eating Behaviors, 9*, 294–302

Ricciardelli, L. A., & McCabe, M. P. (2001). Children's body image concerns and eating disturbance: A review of the literature. *Clinical Psychology Review, 21*, 325–344.

Richman, E. L. & Shaffer, D. R. (2000). "If you let me play sport": How might sport participation influence the self-esteem of adolescent females? *Psychology of Women Quarterly*, 24: 189–199.

Rogers, A. (1999). *Barbie culture*. Thousand Oaks, CA: Sage.

Sabo, D., & Velez, P. (2008). *Go Out and Play: Youth Sports in America*. Eisenhower Park, NY: Women's Sports Foundation.

Sands, E. R., & Wardle, J. (2003). Internalization of ideal body shapes in 9–12-year-old girls. *International Journal of Eating Disorders, 33*, 193–204.

Segal, M., Eccles, J., & Richardson, C. (2011). Rebranding exercise: Closing the gap between values and behavior. *International Journal of Behavioral Nutrition and Physical Activity*, 94–102.

Segura-Garcia, Ammendolia, A., Procopio, M. C., Sinopoli, F., Bianco, C., DeFazio, P., & Capranica, L. (2010). Body uneasiness, eating disorders, and muscle dysmorphia in individuals who overexercise. *Journal of Strength and Conditioning Research 11*, 3098–4014.

Smolak, L. (2004). Body image in children and adolescents: Where do we go from here? *Body Image, 1,* 15–28.

Tiggemann, M. & Williamson, S. (2000). The effect of exercise on body satisfaction and self-esteem as a function of gender and age. *Sex Roles, 43,* 119–127.

U.S. Food and Drug Administration. (1992). *The facts about weight loss products and programs.* (DHHS Publication No. 92–1189). Washington, DC: Department of Health and Human Services.

Verstuyf, J., Patrick, H., Vankeenkiste, M., & Teixeira, P. (2012). Motivational dynamics of eating regulation: A self-determination theory of perspective. *International Journal of Behavioral Nutrition and Physical Activity,* 21–42.

White, J., & Halliwell, E. (2010). Examination of a sociocultural model of excessive exercise among male and female adolescents. *Body Image,* 227–233.

Wolf, N. (2002). *The beauty myth: How images of female beauty are used against women.* New York: William Morrow. (Original publication, 1991.)

Yamamiya, Y., Cash, T. F., Melnyk, S. E., Posavac, H. D., & Posavac, S. S. (2005). Women's exposure to thin-and-beautiful media images: Body image effects of media-ideal internalization and impact-reduction interventions. *Body Image, 2,* 74–80.

SELF-ESTEEM

American Psychological Association, Task Force on the Sexualization of Girls. (2007). *Report of the APA Task Force on the Sexualization of Girls.* Washington, DC: American Psychological Association.

Armstrong, S., & Ooman-Early, J. (2009). Social connectedness, self-esteem, and depression symptomatoloty among collegiate athletes versus nonathletes. *Journal of American College Health, 57,* 521–526.

Baldwin, S. A. & Hoffman, J. P. (2002). The dynamics of self-esteem: A growth-curve analysis. *Journal of Youth and Adolescence, 31,* 101–113.

Biro, F. M., Striegel-Moore, R. H., Franko, D. L., Padgett, J., & Bean, J. A. (2006). Self-esteem in adolescent females. *Journal of Adolescent Health, 39,* 510–507.

Boden, J. M., Fergusson, D. M., & Horwood, L. J. (2008). Does adolescent self-esteem predict later life outcomes? A test of the causal role of self-esteem. *Development and Psychopathology, 20,* 319–339.

Bowker, A. (2006). The relationship between sports participation and self-esteem during early adolescence. *Canadian Journal of Behavioural Science, 38,* 214–229.

Bowker, A., Gadbois, S., & Cornock, B. (2003). Sports participation and self-esteem: Variations as a function of gender and gender role orientation. *Sex Roles, 49,* 47–58.

Daniels, E., & Leaper, C. (2006). A longitudinal investigation of sport participation, peer acceptance, and self-esteem among adolescent girls and boys. *Sex Roles, 55,* 875–880.

deBruin, A. P., Woertman, L., Bakker, F., & Ouedejans, R. (2009). Weight related sport

motives and girls' body image, weight control behaviors, and self-esteem. *Sex Roles, 60*, 628–641.

Dishman, R. K., Hales, D. P., Pfeiffer, K. A., Felton, G., Saunders, R., Ward, D. S., Dowda, M., & Pate, R. R. (2006). Physical self-concept and self-esteem mediate cross-sectional relations of physical activity and sport participation with depression symptoms among adolescent girls. *Health Psychology, 25*, 396–407.

Dunton, G. F., Jamner, M. S. & Cooper, D. M. (2003). Physical self-concept in adolescent girls: Behavioral and physiological correlates. *Research Quarterly for Exercise and Sport, 74*, 360–365.

Eddy, M. (2014, November). Promoting self-esteem in overweight and obese girls. *Women's Healthcare*, 32–37.

Elavsky, L. (2010). Longitudinal examination of the exercise and self-esteem model in middle-aged women. *Journal of Sport and Exercise Psychology, 32*(6), 862–880.

Ethier, K. A., Kershaw, T. S., Lewis, J. B., Milan, S., Niccolai, L. M., & Ickovics, J. R. (2006). Self-esteem, emotional distress and sexual behavior among adolescent females: Inter-relationships and temporal effects. *Journal of Adolescent Health, 38*, 268–274.

Fox, K. R. (2000). Self-esteem, self-perceptions and exercise. *International Journal of Sport Psychology, 31*, 228–240.

Garcia-Martinez, DePaz, J. A., & Marquez, S. (2012). Effects of an exercise programme on self-esteem, self-concept and quality of life in women with fibromyalgia: a randomized controlled trial. *Rheumatological Interventions, 32*, 1869–1876.

Gentile, B., Grabe, S., Dolan-Pascoe, B., Twenge, J. M., Wells, B. E., & Maitino, A. (2009). Gender differences in domain-specific self-esteem: A meta-analysis. *Review of General Psychology, 13*, 34–45.

Goodson, P., Buhi, E. R., & Dunsmore, S. C. (2006). Self-esteem and adolescent sexual behaviors, attitudes, and intentions: A systematic review. *Journal of Adolescent Health, 38*, 310–319.

Jacobs, J. E., Lanza, S., Osgood, D. W., Eccles, J. S., & Wigfield, A. (2002). Changes in children's self-competence and values: Gender and domain differences across grades one through twelve. *Child Development, 73*, 509–527.

Jerstad, S. J., Boutelle, K. N., Ness, K. K., & Stice, E. (2010). Prospective reciprocal relations between physical activity and depression in adolescent females. Journal of Consulting and Clinical Psychology, *78*, 268–272

Klomsten, A. T., Skaalvik, E. M., & Espnes, G. A. (2004). Physical self-concept and sports: Do gender differences still exist? *Sex Roles, 50*, 119–127.

Martyn-Nemeth, P., Penckofer, S., Gulanick, M., Velsor-Friedrich, B., & Bryant, F. B. (2009). The relationships among self-esteem, stress, coping, eating behavior, and depressive mood in adolescents. *Research in Nursing & Health, 32*, 96–109.

McGee, R., & Williams, S. (2000). Does low self-esteem predict health-compromising behaviors among adolescents? *Journal of Adolescence, 23*, 569–582.

McHale, J. P., Vinden, P. G., Bush, L., Richer, D., Shaw, D., & Smith, B. (2005). Patterns of personal and social adjustment among sport-involved and noninvolved urban middle-school children. *Sociology of Sport Journal, 22*, 119–136.

Moncur, B., Bailey, B. W., Lockhart, B., LeCheminant, J., & Perkins, A. (2013). The

relationship of body size and adiposity to source of self-esteem in college women. *American Journal of Health Education, 44,* 299–305.

Muhamad, T. A. B., Sattar, H., Abadi, F. H., & Haron, Z. (2013). The effect of swimming ability on the anxiety levels of female college students. *Asian Social Science Journal, 9*(15), 108–114.

Orth, U., Robins, R. W., & Roberts, B. W. (2008). Low self-esteem prospectively predicts depression in adolescence and young adulthood. *Journal of Personality and Social Psychology, 95,* 695–708.

Pedersen, S., & Seidman, E. (2004). Team sports achievement and self-esteem development among urban adolescent girls. *Psychology of Women Quarterly, 28,* 412–422.

Quatman, T., & Watson, C. M. (2001). Gender differences in adolescent self-esteem: An exploration of domains. *Journal of Genetic Psychology, 162,* 93–117.

Richman, E. L. & Shaffer, D. R. (2000). "If you let me play sport": How might sport participation influence the self-esteem of adolescent females? *Psychology of Women Quarterly, 24,* 189–199.

Rosenberg, M. (1989). *Society and the adolescent self-image.* Revised edition. Middletown, CT: Wesleyan University Press.

Schmalz, D. L., Deane, G. D., Birch, L. L., & Davison, K. K. (2007). A longitudinal assessment of the links between physical activity and self-esteem in early adolescent non-Hispanic females. *Journal of Adolescent Health, 41,* 559–565.

Shaffer, D. R., & Wittes, E. (2006). Women's precollege sports participation, enjoyment of sports, and self-esteem. *Sex Roles, 55,* 225–232.

Simon, J. (2010). *Adapting and implementing a social capital survey for urban youth in an after-school science 4-H club.* Unpublished doctoral dissertation. Cornell University, Ithaca, NY.

Slutzky, C. B., & Simpkins, S. D. (2009). The link between children's sport participation and self-esteem: Exploring the mediating role of sport self-concept. *Psychology of Sport and Exercise, 10,* 381–389.

Spencer, Jennifer M., Zimet, G. D., Aalsma, M. C., & Orr, D. P. (2002). Self-esteem as a Predictor of Initiation of Coitus in Early Adolescents. *Pediatrics 109*(4), 581–584.

Swaim, R. C. & Wayman, J. C. (2004). Multidimensional self-esteem and alcohol use among Mexican American and White Non-Latino Adolescents: Concurrent and prospective effects. *American Journal of Orthopsychiatry, 74*(4), 559–570.

Tiggemann, M. & Williamson, S. (2000). The effect of exercise on body satisfaction and self-esteem as a function of gender and age. *Sex Roles, 43,* 119–127.

Tracy, A. J., & Erkut, S. (2002). Gender and race patterns in the pathways from sports participation to self-esteem. *Sociological Perspectives, 45,* 445–466.

Wild, Lauren G., Fisher, A. J., Bhana, A., & Lombard, C. (2004a). Associations among Adolescent Risk Behaviours and Self-Esteem in Six Domains. *Journal of Child Psychology and Psychiatry, 45*(8):1454–1467.

Wild, L. G., Flisher, A. J., & Lombard, C. (2004b). Suicidal ideation and attempts in adolescents: Associations with depression and six domains of self-esteem. *Journal of Adolescence, 27,* 611–624.

Williams, K. L., & Galliher, R. V. (2006). Predicting depression and self-esteem from

social connectedness, support, and competence. *Journal of Social and Clinical Psychology, 25,* 855–874.

PATHOGENIC WEIGHT LOSS

Academy for Eating Disorders. (2009). About eating disorders. Retrieved April 10, 2009, from http://www.aedweb.org

American College of Sports Medicine. (2007). Position stand: The female athlete triad. *Medicine & Science in Sports & Exercise, 39,* 1867–1882.

Beals, K. A., & Manore, M. M. (2002). Disorders of the female athlete triad among collegiate athletes. *International Journal of Sport Nutrition and Exercise Metabolism, 12,* 281–293.

Bonci, C. M., Bonci, L. J., Granger, L. R., Johnson, C. L., Malina, R. M., Milne, L. W., Ryan, R. R., & Vanderbunt, E. M. (2008). National Athletic Trainers' Association position statement: Preventing, detecting, and managing disordered eating in athletes. *Journal of Athletic Training, 43,* 80–108.

Byrne, S., & McLean, N. (2002). Elite athletes: effects of the pressure to be thin. *Journal of Science and Medicine in Sport, 5,* 80–94.

Centers for Disease Control and Prevention. (2008). Youth risk behavior surveillance—United States, 2007. *Morbidity and Mortality Weekly Report Surveillance Summaries, 57*(SS-4), 1–131.

Courtney, E. A., Gamboz, J., & Johnson, J. G. (2008). Problematic eating behaviors in adolescents with low self-esteem and elevated depressive symptoms. *Eating Behaviors, 9,* 408–414.

Crago, M., & Shisslak, C. M. (2003). Ethnic differences in dieting, binge eating, and purging behaviors among American females: A review. *Eating Disorders, 11,* 289–304.

De Bruin, K. A. P., Bakker, F. C., & Oudejans, R. R. D. (2009). Achievement goal theory and disordered eating: Relationships of disordered eating with goal orientations and motivational climate in female gymnasts and dancers. *Psychology of Sport and Exercise, 10,* 72–79.

Dellava, J. E., Hamer, R. M., Kanodia, A., Reyes-Rodriquez, M. L., & Bulik, C. M. (2011). Diet and physical activity in women recovered from anorexia nervosa. *International Journal of Eating Disorders, 44*(4), 37–382.

Dwyer, J., Eisenberg, A., Prelack, K., Song, W., Sonneville, K., & Ziegler, P. (2012). Eating attitudes and food intakes of elite female figure skaters: A cross-sectional study. *Journal of the International Society of Sports Nutrition, 9,* 53–59.

Eating Disorders Coalition. (2009). Eating disorders fact sheet. Retrieved April 10, 2009, from http://www.eatingdisorderscoalition.org

Engel, S. G., Johnson, C., Powers, P. S., Crosby, R. D., Wonderlich, S. A., Wittrock, D. A., & Mitchell, J. E. (2003). Predictors of disordered eating in a sample of elite Division I college athletes. *Eating Behaviors, 4,* 333–343.

Fairburn, C. G., & Harrison, P. J. (2003). Eating disorders. *The Lancet, 361,* 407–416.

Greenleaf, C., Petrie, T. A., Carter, J., & Reel, J. J. (2009). Female collegiate athletes: Prevalence of eating disorders and disordered eating behaviors. *Journal of American College Health, 57,* 489–495.

Greydanus, D. E., & Patel, D. R. (2004). Medical aspects of the female athlete at puberty. *International Sports Medicine Journal, 5*, 1–25.

Gulker, M. G., Laskis, T. A., & Kuba, S. A. (2001). Do excessive exercisers have a higher rate of obsessive-compulsive symptomatology? *Psychology, Health & Medicine, 6*, 387–398.

Halmi, K. (2013). Perplexities of treatment resistance to eating disorders. *BMC Psychiatry*, 292–305.

Hoek, H. W., & van Hoeken, D. (2003). Review of the prevalence and incidence of eating disorders. *International Journal of Eating Disorders, 34*, 383–396.

Holm-Denoma, J. M., Scaringi, V., Gordon, K. H., Van Orden, K. A., & Joiner, T. E. (2009). Eating disorder symptoms among undergraduate varsity athletes, club athletes, independent exercisers, and nonexercisers. *International Journal of Eating Disorders, 42*, 47–53.

Hopkinson, R. A., & Lock, J. (2004). Athletics, perfectionism, and disordered eating. *Eating and Weight Disorders, 9*, 99–106.

Hudson, J. I., Hiripi, E., Pope, H. G., & Kessler, R. C. (2007). The prevalence and correlates of eating disorders in the national comorbidity survey replication. *Biological Psychiatry, 61*, 348–358.

Johnson, C., Powers, P. S., & Dick, R. (1999). Athletes and eating disorders: The National Collegiate Athletic Association study. *International Journal of Eating Disorders, 26*, 179–188.

LePage, M. L., Crowther, J. H., Harrington, E. F., & Engler, P. (2008). Psychological correlates of fasting and vigorous exercise as compensatory strategies in undergraduate women. *Eating Behaviors, 9*, 423–429.

Manore, M. M., Kam, L. C., & Loucks, A. B. (2007). The female athlete triad: Components, nutrition issues, and health consequences. *Journal of Sports Sciences, 25*, S61–S71.

Meyer, C. (2011). Compulsive exercise and eating disorders. *European Eating Disorders Review*, 174–189.

Mitchell, A. M., & Bulik, C. M. (2006). Eating disorders and women's health: An update. *Journal of Midwifery & Women's Health, 51*, 193–201.

Muscat, A. C., & Long, B. C. (2008). Critical comments about body shape and weight: Disordered eating of female athletes and sport participants. *Journal of Applied Sport Psychology, 20*, 1–24.

National Association of Anorexia Nervosa and Associated Disorders (2009). *General information: Facts about eating disorders.* Retrieved April 10, 2009, from http://www.anad.org

National Eating Disorders Association. (2009). *Statistics: Eating disorders and their precursors.* Retrieved April 10, 2009, from http://www.nationaleatingdisorders.org

Neumark-Sztainer, D. (2005). *I'm, like, SO fat!* New York: Guilford Press.

Neumark-Sztainer, D., Wall, M. M., Haines, J. I., Story, M. T., Sherwood, N. E., & van den Berg, P. (2007). Shared risk and protective factors for overweight and disordered eating in adolescents. *American Journal of Preventive Medicine, 33*, 359–369.

Perez, M., & Joiner, T. E. (2003). Body image dissatisfaction and disordered eating in black and white women. *International Journal of Eating Disorders, 33*, 342–350.

Pernick, Y., Nichols, J. F., Rauh, M. J., Kern, M., Ji, M., Lawson, M., & Wilfley, D. (2006). Disordered eating among a multi-racial/ethnic sample of female high-school athletes. *Journal of Adolescent Health, 38,* 689–695.

Reinking, M. F., & Alexander, L. E. (2005). Prevalence of disordered-eating behavior in undergraduate female collegiate athletes and nonathletes. *Journal of Athletic Training, 40,* 47–51.

Ricciardelli, L. A., & McCabe, M. P. (2001). Children's body image concerns and eating disturbance: A review of the literature. *Clinical Psychology Review, 21,* 325–344.

Ryan, J. (1995). *Little girls in pretty boxes: The making and breaking of elite gymnasts and figure skaters.* New York: Warner Books.

Sears, L., Tracy, K., & McBrier, N. (2012). Self-esteem, body image, internalization, and disordered eating among female athletes. *Athletic Training & Sports Health Care, 4*(1), 29–37.

Smolak, L., Murnen, S. K., & Ruble, A. E. (2000). Female athletes and eating problems: A meta-analysis. *International Journal of Eating Disorders, 27,* 371–380.

Striegel-Moore, R. H., Dohm, F. A., Kraemer, H. C., Taylor, C. B., Daniels, S., Crawford, P. B., & Schreiber, G. B. (2003). Eating disorders in white and black women. *American Journal of Psychiatry, 160,* 1326–1331.

Sundgot-Borgen, J., & Torstveit, M. K. (2004). Prevalence of eating disorders in elite athletes is higher than in the general population. *Clinical Journal of Sport Medicine, 14,* 25–32.

Taranis, L., Touyz, S., & Meyer, C. (2011). Disordered eating and exercise: Development and preliminary validation of the compulsive exercise test (CET). *European Eating Disorders Review, 19*(3), 256–268.

Taylor, J. Y., Caldwell, C. H., Baser, R. E., Faison, N., & Jackson, J. S. (2007). Prevalence of eating disorders among blacks in the National Survey of American Life. *International Journal of Eating Disorders, 40,* S10–S14.

Vertalino, M., Eisenberg, M. E., Story, M., & Neumark-Sztainer, D. (2007). Participation in weight-related sports is associated with higher use of unhealthful weight-control behaviors and steroid use. *Journal of the American Dietetic Association, 107,* 434–440.

William, O. (2012). Eating for excellence: Eating disorders in elite sport—inevitability and "immunity." *European Journal of Sport and Society, 9,* 33–55.

SPORTS PARTICIPATION AND POSITIVE CORRELATES IN AFRICAN AMERICAN, LATINO, AND WHITE GIRLS

Susan C. Duncan, Lisa A. Strycker,
and Nigel R. Chaumeton | 2015

Excerpted from Susan C. Duncan, Lisa A. Strycker, and Nigel R. Chaumeton, "Sports Participation and Positive Correlates in African American, Latino, and White Girls," *Applied Developmental Science* 19, no. 4 (Fall 2015): 206–216, doi:10.1080/10888691.2015.1020156. Reprinted by permission of the publisher, Taylor & Francis Ltd.

Physical activity (PA) and sports participation, in particular, have been related to numerous positive outcomes during late childhood and early adolescence (Slutzky & Simpkins, 2009). About 44 million boys and girls aged 5–18 years old in the United States participate in organized sport activities each year (National Council of Youth Sports, 2008). For example, approximately 58% of high-school-aged students report having played on at least one school or community sports team during the past year (Eaton et al., 2012). The sports domain is an especially important developmental context for youth because it provides opportunities for learning interpersonal and athletic skills, building peer relationships, and developing positive self-perceptions (Holt, 2008; Madsen, Hicks, & Thompson, 2011; Mahoney, Larson, & Eccles, 2005; Smith, 2003). Youth sports participation and PA have been linked to less depression (Johnson & Taliaferro, 2011) and higher participation in other extracurricular activities (Duncan, Duncan, Strycker, & Chaumeton, 2002). Nonetheless, only limited research has been done to determine whether associations differ for subgroups at increased risk for low levels of PA and sports participation, such as girls and ethnic minorities.

In general, girls of all ages participate in less PA and sports than boys (Hobin et al., 2012), and there is evidence to suggest that PA patterns differ by ethnicity as well as gender (Centers for Disease Control and Prevention, 2005; Pate, Dowda, O'Neill, & Ward, 2007). Differences in PA across ethnic groups might be expected based on theories of ecological health behavior which posit that health behaviors are influenced by intrapersonal, social, cultural, and physical environment variables, and that the variables likely interact (Sallis & Owen,

1996, 1999). Variations across ethnic groups in PA behavior might occur as a result not only of different cultural influences (Wolf et al., 1993), but also differences in demographic, individual, family, social, and environmental variables, all of which have been shown to influence youth PA and sports participation. For example, youth from different social and cultural backgrounds may have different intrapersonal beliefs and self-perceptions, and receive varying levels of family and peer support for PA and sports participation (e.g., Kelly et al., 2010). Given possible cultural and social differences across ethnic groups and their potential influence on PA and sports involvement, it is likely that not only levels of sports participation vary across ethnic groups, but also that relationships between sports participation and other variables (e.g., intrapersonal beliefs and self-perceptions) might vary. The current study focused specifically on relations between intrapersonal variables and sports participation. Documenting and understanding differences in PA and sport participation between girls from different ethnic groups, as well as relations between such behavior and other variables, can aid in the design of more effective, culturally sensitive and competent interventions to increase PA participation for ethnically diverse girls (Kelly et al., 2010; Perry, Rosenblatt, & Wang, 2004).

Unfortunately, research exploring racial differences is lacking in all aspects of youth PA (Azzarito & Solomon, 2006)—most studies in this area have been conducted with predominantly White samples—especially during early adolescence (Zarrett et al., 2009). Little is known about possible ethnic differences in relations between sports participation and intrapersonal positive correlates, beyond theoretical predictions of their existence. To address this research gap, the current study drew on a multi-ethnic sample of early adolescent girls, and focused on associations between sports participation and the following intrapersonal positive correlate variables: self-perceptions (self-worth, body attractiveness, and athletic competence), depression, and extracurricular activity.

Positive Self-Perceptions

Children's and adolescents' self-perceptions, including self-worth, are of interest because of their proposed links to mental well-being, motivational states, and behavior (Whitehead, 1996). Self-worth appears to be related to both youth exercise (Annesi, 2005) and team sports participation (Slutzky & Simpkins, 2009). Annesi showed that preadolescents participating in an exercise program experienced significant improvements in self-concept, and Slutzky and Simpkins showed that children who spent more time in team sports reported higher self-concept and self-esteem. These authors recommended that future research examine whether girls' self-esteem and self-worth are tied to sports

participation at different stages of adolescence, and whether associations with sports participation vary across ethnic groups.

Studies have shown that, as children become adolescents, their self-worth differentiates into more-distinct areas of perceived competencies or adequacies, which are then related to more-global perceptions of self-worth (Harter, 1985). Perceptions of body attractiveness and athletic competence are two key components of global self-worth, which are likely related to sport participation among young adolescent girls. While relations between sport participation and self-worth are generally found to be positive, findings for the relationships between sport participation and body image have been less consistent (Crissy & Honea, 2006; Gill, 2007). For example, some researchers have found positive relations between PA or sport involvement and body satisfaction indicators (e.g., Daley, 2002; Kololo, Guszkowska, Mazur, & Dzielska, 2012), whereas others have found higher levels of body dissatisfaction among athletes versus nonathletes, or more negative relations (Cox & Thompson, 2000; Parsons & Betz, 2001). Despite the importance of body attractiveness perceptions to self-worth, and the potential influence of sports participation on such perceptions, relatively little is known about how these perceptions and relationships might vary across girls from different ethnic groups.

Similarly, among ethnically diverse girls there is a paucity of research relating perceptions of athletic competence to sport participation. Boone and Leadbeater (2006) proposed that team sports, in particular, provide opportunities for adolescents to develop athletic skills and competence. Donaldson and Ronan (2006) found that increased levels of sport participation were related not only to global self-worth, but also to perceived competence among young adolescents (ages 11–13 years). Perceptions of athletic competence are important because they influence youth PA participation, and may be related to self-worth and positive mental health in adolescence (Baker & Davison, 2011; Humbert et al., 2006). In order to explore associations between sport participation and positive self-perceptions in ethnically diverse girls, the current study examined relations between sport participation and self-worth, body attractiveness, and athletic competence. In addition, because of possible relations between sport participation, self-perceptions, and mental health, this study also examined relations with depression.

Depression

Late childhood and adolescent depression is a serious public health concern; an estimated 15–30% of youth experience an episode of depression during adolescence (Dishman et al., 2006). The prevalence of depression increases during

early to mid-adolescence, with the most dramatic increases evident for girls (Garber, Keiley, & Martin, 2002; Hankin, 2006). Research during this developmental period is limited (Larun, Nordheim, Ekeland, Hagen, & Heian, 2006), but some studies suggest a negative relationship between depression and PA in adolescence (Birkeland, Torsheim, & Wold, 2009; Boone & Leadbeater, 2006; Crews, Lochbaum, & Landers, 2004; Donaldson & Ronan, 2006; Duncan, Seeley, Gau, Strycker, & Farmer, 2012; Harris, Cronkite, & Moos, 2006; Jerstad, Boutelle, Ness, & Stice, 2010). Other studies have failed to find a significant association between early adolescent PA and depression (e.g., Schmitz et al., 2002), and there is limited evidence to suggest that relations are prospective (Birkeland et al., 2007; Larun et al., 2006). Even less research is available among ethnically diverse girls regarding the associations between sports participation and depression, or between depressive symptoms and positive self-perceptions. The current study includes examination of relationships between sport participation and depression symptoms, and self-perceptions and depression symptoms, across African American, Latino, and White girls.

Extracurricular Activities

Besides PA and sports, youth participate in numerous other organized extracurricular activities. Examples of such activities include participation in religious or volunteer activities or programs, school clubs, student governance, and music programs. Studies have found positive relationships between both cumulative effects and specific effects of different types of extracurricular activities and adolescent psychological outcomes (Fredricks & Eccles, 2006; Linver, Roth, & Brooks-Gunn, 2009). Research indicates that youth who are more physically active and who take part in more organized sports also participate more in other extracurricular activities (Duncan et al., 2002). However, research in this area among early adolescent girls and across different ethnicities is scarce. The current study examined relations between sports participation and extracurricular activities as well as relations between extracurricular activities, positive self-perceptions and depression, across African American, Latino, and White girls.

The overall purpose of this study was to examine the relations between participation in organized sports and hypothesized positive correlates, including self-perceptions, depression, and engagement in extracurricular activities—and determine whether these associations differed, as would be expected based on ecological health behavior theory, across African American, Latino, and White girls. Specifically, the objectives were to determine: (a) the relations between organized sports participation and self-worth, athletic competence, body attrac-

tiveness, depression, and extracurricular activities; (b) the relations between self-worth, athletic competence, body attractiveness, depression, and extracurricular activities; and (c) whether relations differed across African American, Latino, and White early adolescent girls. Because of known effects of age and income on PA and sports participation (Centers for Disease Control and Prevention, 2005; Santos, Esculcas, & Mota, 2004; Taylor & Lou, 2011; Whitt-Glover et al., 2009), these variables were controlled for in all analyses.

Method

SAMPLE AND PARTICIPANT SELECTION

Data are from the first year of a longitudinal study of 372 African American (n 128), Latino (n 120), and White (n 124) girls residing in a northwest U.S. metropolitan area. As part of the study design, families having a 10-, 12-, or 14-year-old girl were randomly recruited from 41 socioeconomically diverse neighborhoods using telephone, door-to-door, and word-of-mouth methods. Of eligible families, approximately 67.8% recruited by phone or door-to-door methods agreed to participate. The target girl and a parent completed surveys in their home. Girls younger than 12 years of age were administered the survey as an interview. Spanish-language surveys were provided for Spanish-speaking participants. Surveys were translated by an experienced Spanish translator—a native Argentinian with a doctorate degree from a U.S. university and experience in the United States as a translator and Spanish teacher—and were back-translated by the project's Spanish-fluent Research Assistants.

Approximately equal numbers of African American, Latino, and White girls were recruited from each age cohort. Mean age was 12.06 years (SD 1.69). The annual household income for the sample was 30% >$20,000, 40% from $20,000–$60,000, and 30% >$60,000.

ASSESSMENTS AND MEASURES

Survey visits lasted about 30–75 minutes. Participants completed individual surveys in private, away from other family members, to enhance confidentiality. Girls were paid $50 to complete the assessment; parents were paid $30. This study was approved by an Institutional Review Board. All adult participants gave informed written consent and all girls gave informed written assent prior to study participation. In addition to written informed consent procedures, project Research Assistants orally encouraged girls to be honest in their responses to questions, reiterated that personal information would be kept private and not shared with parents, indicated that girls did not have to answer any questions

that made them feel uncomfortable, and stated that they could stop at any time without penalty.

These procedures, which we have successfully used in past research, were designed to ensure that girls did not feel they had to answer in a certain way to please the investigators, and to thus reduce socially desirable responding. [. . .]

Results

Means and variances for variables in the model are shown in Table 1.

The values in Table 1 suggest that, on average, girls participated in one to two sports teams in the past year, and took part in an organized sports activity approximately once a month. On average, girls reported they were not very confident with how their body looked, had low to moderate levels of perceived athletic competence, had fairly high levels of self-worth, and reported low levels of depression. They were involved, on average, either in multiple extracurricular activities occasionally, or in one to two extracurricular activities regularly (approximately once a week). The most frequently reported physical activities across ages and ethnicities were walking, running, dancing, swimming, and bicycling. African American girls reported more participation in basketball and volleyball than the other groups, and Latino girls participated in less rollerblading and weight training than African American and White girls (all p < .05).

TABLE 1 **Descriptive Statistics of Variables in the Models**

	African American Mean (SD)	Latino Mean (SD)	White Mean (SD)
Age (years)	12.03 (1.81)	12.06 (1.66)	12.14 (1.61)
Income per capita (6-point scale divided by # family members)	.75 (.46)	.65 (.49)	1.11 (.45)
# sports teams past year	1.69 (1.46)	1.05 (1.53)	1.22 (1.30)
Self-report sports activity	3.55 (2.00)	2.43 (1.86)	3.65 (2.16)
Parent report sports activity	3.63 (2.01)	2.47 (2.02)	3.65 (2.07)
Attractive body	3.17 (.73)	2.83 (.79)	2.98 (.79)
Athletic competence	2.82 (.80)	2.49 (.77)	2.71 (.74)
Self-worth	3.56 (.55)	3.49 (.51)	3.48 (.61)
Depression symptoms	5.82 (4.10)	6.25 (3.97)	4.79 (3.63)
Extracurricular activities	14.80 (6.59)	12.32 (5.13)	13.99 (5.26)

MODEL SPECIFICATION

Figure 1 illustrates the model, in which participation in sports was hypothesized to relate to the positive correlates of self-worth, body attractiveness, athletic competence, less depression, and extracurricular activities. The positive correlate variables also were covaried with each other.

As shown in Figure 1, the sports participation latent factor comprised three items (# sports teams in the past year, youth self-reported organized sports, parent-reported organized sports) described in the Measures section. To set the scaling for the latent sports factor, the loading of one variable (# sports teams in the past year) was set at 1. The three survey items loaded significantly on the sports latent factor ($p > .001$), indicating it was a viable and reliable factor. To determine mean differences across groups on the variables of interest, a preliminary multiple-group unconditional model (without regression effects) was tested. This model revealed significant differences across groups for the mean of the sports factor (African American girls had higher levels than Latino and White girls), depression (White girls reported less depression than African American and Latino girls), and income (White girls had higher incomes than African American and Latino girls). In addition, Latino girls had significantly lower means than African American and [White] girls in their reports of body attractiveness, athletic competence, and participation in extracurricular activities. [. . .]

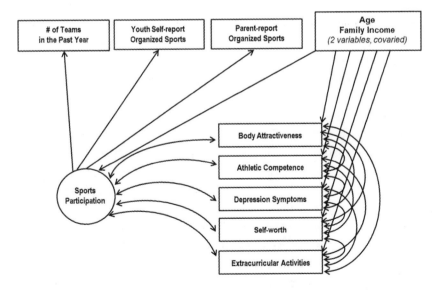

FIGURE 1

Significant correlations and ethnic differences are presented in Table 2. The sports factor significantly positively covaried with perceived body attractiveness, athletic competence, and self-worth, and, for Latino and White girls only, significantly negatively related to depression. The sports factor also significantly positively covaried with extracurricular activities across all three groups. Perceived body attractiveness, athletic competence, and self-worth were all significantly positively interrelated. Self-worth and body attractiveness were negatively related to depression, as was athletic competence, but only for Latino and White girls. Self-worth and athletic competence were significantly and positively related to extracurricular activities across all three groups, but the relationship between depression and extracurricular activities was significant and negative only for White girls.

Discussion

The current study explored relations between sports participation and positive self-perceptions, depression, and extracurricular activities during the late elementary and early middle school years across African American, Latino, and White girls. PA during early adolescence is underexplored (Zarrett et al., 2009), yet this is an important period in the development of self-perceptions. Because sports may be the most popular organized activity in which youth engage (Holt, 2008), it is important to understand how sports participation relates to positive correlates, especially in girls from different ethnic groups who are at increased risk for low PA.

Some significant mean differences emerged across ethnic groups. The higher mean income levels for White girls' families compared to African American and Latino girls' families is in line with prior research (Santos et al., 2004; Whitt-Glover et al., 2009). On average, African American girls had significantly higher sports participation than Latino and White girls. These data appear to run counter to prior results showing that African American youth are less active than White youth (Taylor & Lou, 2011); one explanation may be that past research has focused primarily on general PA across ethnic groups rather than specific participation in sports, thus it is possible that sports participation differs across ethnic groups but overall PA participation does not.

Mean ethnic group differences in depression, body attractiveness, athletic competence, and participation in extracurricular activities are also noteworthy. On average, White girls in this study reported less depression overall than Af-

TABLE 2 **Significant Correlations and Differences Across Ethnic Groups in the Final Model**

	African American Corr. (r)	Latino Corr. (r)	White Corr. (r)
Sports with:			
Attractive body	.158*	.143*	.158*
Athletic competence	.501**	.501**	.501**
Depression	*.154*	-.200*	-.234*
Self-worth	.204**	.204**	.204**
Extracurricular activities	.351**	.430**	.430**
Attractive body with:			
Athletic competence	.380**	.344**	.380**
Depression	-.309**	-.281**	-.363**
Self-worth	.629**	.571**	.629**
Athletic competence with:			
Depression	*.014*	-.224**	-.262**
Self-worth	.426**	.426**	.426**
Extracurricular activities	.181**	.222**	.222**
Depression symptoms with:			
Self-worth	-.378**	-.378**	-.444**
Extracurricular activities	.074	.091	-.265**
Self-worth with:			
Extracurricular activities	.107*	.131*	.131*

Note. Correlations denoted by *and **are significant at p < .05 and p < .001, respectively. Those in *italic* type denote a significant difference between that group and other groups (equality constraint relaxed).

rican American and Latino girls; Latino girls, compared to African American and White girls, reported less body attractiveness, athletic competence, and extracurricular activity. Research in this area is extremely limited, although there is some prior evidence that Latino girls may have higher rates of depression (e.g., Tienda & Kleykamp, 2000) than other ethnic groups. Body image issues have been found to be similar across adolescents from diverse ethnic groups, but social, cultural, and economic risk factors specific to ethnically and racially diverse groups are believed to play a role in the development of body image (George & Franko, 2009). Ethnic differences in perceptions of athletic competence and participation in extracurricular activities have not been studied. Clearly, further research is needed among ethnically diverse girls to determine consistencies in mean differences and to explicate these findings.

Despite some mean differences between ethnic groups, results of this study provide evidence that sports participation relates to greater perceived self-worth, body attractiveness, and athletic competence regardless of ethnic group. That is, African American, Latino, and White girls who participate in more sports also perceive more self-worth, body attractiveness, and athletic competence. This finding is consistent with literature showing that sports participation can be associated with both positive (e.g., goal setting, persistence, problem solving, teamwork, managing emotions, and time) and negative (e.g., stress, negative peer dynamics, and inappropriate coach behavior) developmental experiences (Larson, Hansen, & Moneta, 2006). The findings of this study point to a positive relationship between sports participation and self-worth, body attractiveness, and athletic competence self-perceptions that goes beyond any ethnic or cultural differences (Annesi, 2005; Kololo et al., 2012; Marsh & Kleitman, 2003; Suris & Parera, 2005). Slutzky and Simpkins (2009) found that youth in team sports had higher self-concept and self-esteem, and Donaldson and Ronan (2006) found that increased levels of sports participation were related not only to global self-worth, but also to perceived competence among young adolescents (ages 11–13 years). The present study provides evidence of a positive relationship between sport involvement and perceptions of body attractiveness across African American, Latino, and White girls, but results of past studies in this regard have been more equivocal (Crissy & Honea, 2006; Gill, 2007). It may be that the potential link between sports participation and body attractiveness or body image is influenced more by the particular sport in which girls participate (e.g., gymnastics, basketball) than by ethnic group.

The positive relationship of sports participation with extracurricular activities may be expected because sports participation can be considered a form of extracurricular activity, with structure, supervision, adult leaders, opportunities for personal development, emotional regulation, and teamwork (Larson et al., 2006). Research has shown that youth who participate in one kind of organized activity often participate in others (Linver et al., 2009). Furthermore, the PA participation literature indicates that, while youth sports participation is often a positive experience that carries positive developmental outcomes, it may be particularly positive when combined with participation in other organized out-of-school activities (Bartko & Eccles, 2003; Linver et al., 2009; Zarrett et al., 2009). Therefore, this study and others suggest that participation in a mixture of positive activities may lead to the most beneficial outcomes for youth. Future studies of longitudinal relations between youth sports, extracurricular activity participation, and positive outcomes across different ethnic groups would help increase understanding of these relationships and the specific mechanisms linking them (Bartko & Eccles,

2003). Future research might also move beyond mere participation assessments to measure the extent to which youth are engaged in physical activities—and to consider the quality of coaching or climates created by coaches, as these have been linked to positive youth development in several studies (e.g., Gould & Carson, 2011; Gould, Flett, & Lauer, 2012; Zarrett et al., 2007).

In this study, greater sports participation related to significantly less depression only for Latino and White, not African American, girls. It is unclear why this relationship was not significant for African American girls. Cultural, individual, or family variables might explain the difference; it may be that ethnic groups hold different cultural beliefs about the nature or value of sports participation. Further research is needed to replicate and help explain this finding.

In this study, the three ethnic groups had similar patterns of relationships among the positive correlates, with higher levels of one related to higher levels of the other. Greater self-worth was related to greater perceived body attractiveness and athletic competence, and greater body attractiveness to higher perceived athletic competence. These findings support prior research documenting associations between self-worth, perceived physical appearance, and athletic competence in adolescent girls (Craft, Pfeiffer, & Pivarnik, 2003), and between self-esteem and body image (Morin, Maïano, Marsh, Janosz, & Nagengast, 2011). This study also found that greater self-worth and athletic competence were significantly related to more extracurricular activity across all three groups, whereby girls participating in more organized extracurricular activities also had higher levels of self-worth and athletic competence. The lack of significant differences in these relations across the three groups is an important result, suggesting that positive associations between PA and correlates transcend ethnic or cultural differences.

A few ethnic differences emerged with regard to relationships between depression and positive correlates. Across all three ethnic groups, higher self-worth and perceived body attractiveness were significantly related to less depression, a finding that supports previous research (Dishman et al., 2006). However, greater athletic competence was significantly related to less depression only for Latino and White girls. The similar finding for the relationship between sports participation and depression (nonsignificant for African American girls) suggests that the relationship between depression and sports (participation and perceptions) might be different for different subgroups and should be examined separately across ethnically diverse groups of girls.

Future studies should include potential individual or family (e.g., importance of sport participation; family support) variables that might help to explain this difference. More extracurricular activity was related to less depression only for

White girls. Prior work in this area has generally not examined associations across different ethnic groups, or specifically for girls; thus, the reasons for this finding are unknown, but may relate to differing perceptions of extracurricular activities that occur in schools, places of worship, and the community in general. In addition, the extracurricular activities variable was a combination of multiple activities; future research investigating individual activities and their relationship to depression might shed some light on differences across ethnic groups.

As expected, there were significant age effects, but not for the sports factor, perhaps because of the restricted age range (10–14 years). Older girls had lower perceptions of athletic competence and self-worth, and reported more depression. For Latino and White girls only, older girls perceived less body attractiveness. Prior research indicates a cultural difference in body attractiveness or body image, whereby African American girls may view their bodies differently than other ethnic groups (Perry et al., 2004), generally selecting a larger ideal body size. It may be that African American girls' perceived body attractiveness varies less as they age compared to Latino and White girls. Higher household income was related to both greater participation in organized sports and more positive perceptions of body attractiveness. Across all ethnic groups, greater income is likely to enable participation in a variety of sports and may provide more opportunities to make oneself feel more attractive (e.g., by purchasing more expensive, fashionable clothes), and is likely related to other variables that influence perceived body attractiveness (e.g., healthy eating, opportunities to be physically active).

The current study had several limitations, including moderate correlations among the three variables comprising the youth sports participation latent variable and the use of cross-sectional data, which did not permit directional hypothesis testing of the predictive effects of sports participation on positive correlates. Also, the positive correlate variables analyzed represent only a few of many potential outcomes important for early adolescent girls. The analyses controlled for known effects of age and household income, but there are likely more factors (e.g., physical maturation, body mass index) and other confounding variables that were not controlled for in the analyses. Due to the potential cultural, demographic, individual, family, social and environmental differences that might affect sports participation and relations between participation and other variables across ethnic groups, it is important that future research include hypothesized influential variables from all these domains, to help explain differences in means and associations across ethnic groups. The current study included only demographic and intrapersonal variables. Thus, future research should include additional potential ecological variables (e.g., family, school, neighborhood environment) to more thoroughly examine ecological health behavior theoretical

influences. The inclusion of such variables could be in the form of control variables, interactions, or moderating or mediating variables. Strengths of the study include the use of multiple informants, multiple measurement methods, and a latent factor representing sports participation; the randomly recruited sample; and a design that documented similarities and differences across African American, Latino, and White early adolescent girls. Future research should continue to recruit ethnically diverse groups; to examine similarities and differences across these groups on sports participation, general PA, and positive self-perceptions, activities and behaviors; and to explore how relations change with age.

Overall, the findings of the present study support the existence of significant relationships between sports participation and positive self-perceptions and activities among early adolescent African American, Latino, and White girls. It has been suggested that self-perceptions, such as perceived athletic competence and body image, may be central to adolescents' feelings of self-worth (Barnett, Morgan, van Beurden, & Beard, 2008). Sports participation may help to increase these self-perceptions, or, as has been shown in reviews of other studies (e.g., Biddle, Whitehead, O'Donovan, & Nevill, 2005), it may be that girls with higher levels of these self-perceptions are more likely to choose and/or continue in sports and those with lower levels are more likely to self-select out of sports participation. It is quite likely that at least some of these relationships are reciprocal or bidirectional. Most reported studies have been cross-sectional, thus future longitudinal studies are needed to try to understand possible directional and bidirectional relationships. There also appears to be a relationship between sports and other extracurricular activity participation across African American, Latino, and White early adolescent girls, and between sports participation and less depression in White and Latino girls. Despite a few ethnic differences in mean levels and relationships between variables, however, the current study reveals more similarities than differences. Because sport participation and PA patterns, and their relations with self-perceptions and other activities, remain poorly understood in early adolescent girls from different ethnic groups, further research is needed to continue to improve our understanding of these relationships, and to learn how change occurs over time at different stages of childhood and adolescence.

References

Annesi, J. J. (2005). Improvements in self-concept associated with reductions in negative mood in preadolescents enrolled in an after-school physical activity program. *Psychological Reports, 97,* 400–404. doi:10.2466/PR0.97.6.400-404

Azzarito, L., & Solomon, M. A. (2006). A poststructural analysis of high school students' gendered and racialized bodily meanings. *Journal of Teaching in Physical Education, 25*, 75–98.

Baker, B. L., & Davison, K. K. (2011). I know I can: A longitudinal examination of precursors and outcomes of perceived athletic competence among adolescent girls. *Journal of Physical Activity and Health, 8*, 192–199.

Barnett, L. M., Morgan, P. J., van Beurden, E., & Beard, J. R. (2008). Perceived sports competence mediates the relationship between childhood motor skill proficiency and adolescent physical activity and fitness: A longitudinal assessment. *International Journal of Behavioral Nutrition and Physical Activity, 5*, 40. doi:10.1186/1479-5868-5-40

Bartko, W. T., & Eccles, J. S. (2003). Adolescent participation in structured and unstructured activities: A person-oriented analysis. *Journal of Youth and Adolescence, 32*, 233–241.

Biddle, S. J. H., Whitehead, S. H., O'Donovan, T. M., & Nevill, M. E. (2005). Correlates of participation in physical activity for adolescent girls: A systematic review of recent literature. *Journal of Physical Activity and Health, 2*, 423–434.

Birkeland, M. S., Torsheim, T., & Wold, B. (2009). A longitudinal study of the relationship between leisure-time physical activity and depressed mood among adolescents. *Psychology of Sport and Exercise, 10*, 25–34. doi:10.1016/j.psychsport.2008.01.005

Boone, E. M., & Leadbeater, B. J. (2006). Game on: Diminishing risks for depressive symptoms in early adolescence through positive involvement in team sports. *Journal of Research on Adolescence, 16*, 79–90. doi:10.1111/j.1532-7795.2006.00122.x

Centers for Disease Control and Prevention. (2005). *Physical activity for everyone: Recommendations. Are there special recommendations for young people?* Retrieved from www.cdc.gov/nccdphp/dpna/physical/recommendations/young.html

Craft, L. L., Pfeiffer, K. A., & Pivarnik, J. M. (2003). Predictors of physical competence in adolescent girls. *Journal of Youth and Adolescence, 32*, 431–438. doi:10.1023/A:1025986318306

Crews, D. J., Lochbaum, M. R., & Landers, D. M. (2004). Aerobic physical activity effects on psychological well-being in low-income Hispanic children. *Perceptual and Motor Skills, 98*, 319–324. doi:10.2466/pms.98.1.319-324

Crissy, S. R., & Honea, J. C. (2006). The relationship between athletic participation and perceptions of body size and weight control in adolescent girls: The role of sport type. *Sociology of Sport Journal, 23*, 248–272.

Cox, B., & Thompson, S. (2000). Sportswomen, soccer and sexuality. *International Review for the Sociology of Sport, 35*, 5–20.

Daley, A. J. (2002). Extra-curricular physical activities and physical self-perceptions in British 14–15-year-old male and female adolescents. *European Physical Education Review, 8*, 37–49. doi:10.1177/1356336X020081003

Dishman, R. K., Hales, D. P., Pfeiffer, K. A., Felton, G. A., Saunders, R., Ward, D. S., . . . Pate, R. R. (2006). Physical self-concept and self-esteem mediate cross-sectional relations of physical activity and sport participation with depression symptoms among adolescent girls. *Health Psychology, 25*, 396–407. doi:10.1037/0278-6133.25.3.396

Donaldson, S. J., & Ronan, K. R. (2006). The effects of sports participation on young adolescents' emotional well-being. *Adolescence, 41,* 369–389.

Duncan, S. C., Duncan, T. E., Strycker, L. A., & Chaumeton, N. R. (2002). Relations between youth antisocial and prosocial activities. *Journal of Behavioral Medicine, 25,* 425–438.

Duncan, S. C., Seeley, J. R., Gau, J. M., Strycker, L. A., & Farmer, R. F. (2012). A latent growth model of adolescent physical activity as a function of depressive symptoms. *Mental Health and Physical Activity, 5,* 57–65. doi:10.1016/j.mhpa.2012.03.001

Eaton, D., Kann, L., Kinchen, S. A., Shanklin, S., Flint, K. H., Hawkins, J., . . . Wechsler, H. (2012). Youth risk behavior surveillance—United States, 2011. *Morbidity and Mortality Weekly Report, 61*(SS04), 1–162.

Fredricks, J. A., & Eccles, J. S. (2006). Extracurricular involvement and adolescent adjustment: Impact of duration, number of activities, and breadth of participation. *Applied Developmental Science, 10,* 132–146. doi:10.1037/0012-1649.42.4.698

Garber, J., Keiley, M. K., & Martin, N. C. (2002). Developmental trajectories of adolescents' depressive symptoms: Predictors of change. *Journal of Consulting and Clinical Psychology, 70,* 79–95. doi:10.1037/0022-006X.70.1.79

George, J. B. E., & Franko, D. L. (2009). Cultural issues in eating pathology and body image among children and adolescents. *Journal of Pediatric Psychology, 35,* 231–242. doi:10.1093/jpepsy/jsp064

Gill, D. L. (2007). Gender and cultural diversity. In G. Tenenbaum & R. C. Eklund (Eds.), *Handbook of sport psychology* (pp. 823–844). Hoboken, NJ: Wiley & Sons.

Gould, D., & Carson, S. (2011). Young athletes' perceptions of the relationship between coaching behaviors and developmental experiences. *International Journal of Coaching Science, 5*(2), 3–29.

Gould, D., Flett, R., & Lauer, L. (2012). The relationship between psychosocial developmental and the sports climate experienced by underserved youth. *Psychology of Sport and Exercise, 13*(1), 80–87. doi:10.1016/j.psychsport.2011.07.005

Hankin, B. L. (2006). Adolescent depression: Description, causes, and interventions. *Epilepsy & Behavior, 8,* 102–114. doi:10.1016/j.yebeh.2005.10.012

Harris, A. H. S., Cronkite, R., & Moos, R. (2006). Physical activity, exercise coping, and depression in a 10-year cohort study of depressed patients. *Journal of Affective Disorders, 93,* 79–85. doi:10.1016/j.jad.2006.02.013

Harter, S. (1985). *Manual for the self-perception profile for children.* Denver, CO: University of Denver.

Hobin, E. P., Leatherdale, S. T., Manske, S., Dubin, J. A., Elliott, S., & Veugelers, P. (2012). A multilevel examination of gender differences in the association between features of the school environment and physical activity among a sample of grade 9 to 12 students in Ontario, Canada. *BMC Public Health, 12,* 74. doi:10.1186/1471-2458 -12-74

Holt, N. L. (2008). *Positive development through sport.* New York, NY: Routledge.

Humbert, M. L., Chad, K. E., Spink, K. S., Muhajarine, N., Anderson, K. D., Bruner, M. W., . . . Gryba, C. R. (2006). Factors that influence physical activity participation among high-and low-SES youth. *Qualitative Health Research, 16,* 467–483. doi:10.1177/1049732305286051

Jerstad, S. J., Boutelle, N., Ness, K. K., & Stice, E. (2010). Prospective reciprocal relations between physical activity and depression in female adolescents. *Journal of Consulting and Clinical Psychology, 78*, 268–272. doi:10.1037/a0018793

Johnson, K. E., & Taliaferro, L. A. (2011). Relationships between physical activity and depressive symptoms among middle and older adolescents: A review of the research literature. *Journal for Specialists in Pediatric Nursing, 16*, 235–251. doi:10.1111/j.1744-6155.2011.00301.x

Kelly, E. B., Parra-Medina, D., Pfeiffer, K. A., Dowda, M., Conway, T. L., Webber, L. S., ... Pate, R. R. (2010). Correlates of physical activity in Black, Hispanic and White middle school girls. *Journal of Physical Activity and Health, 7*, 184–193.

Kololo, H., Guszkowska, M., Mazur, J., & Dzielska, A. (2012). Self-efficacy, self-esteem and body image as psychological determinants of 15-year-old adolescents' physical activity levels. *Human Movement, 13*, 264–270. doi:10.2478/v10038-012-0031-4

Larson, R. W., Hansen, D. M., & Moneta, G. (2006). Differing profiles of developmental experiences across types of organized youth activities. *Developmental Psychology, 42*, 849–863. doi:10.1037/0012-1649.42.5.849

Larun, L., Nordheim, L. V., Ekeland, E., Hagen, K. B., & Heian, F. (2006). Exercise in prevention and treatment of anxiety and depression among children and young people. *Cochrane Database of Systematic Reviews, 2006*(3), CD004691. doi:10.1002/14651858. CD004691

Linver, M. R., Roth, J. L., & Brooks-Gunn, J. (2009). Patterns of adolescents' participation in organized activities: Are sports best when combined with other activities? *Developmental Psychology, 45*, 354–367. doi:10.1037/a0014133

Madsen, K. A., Hicks, K., & Thompson, H. (2011). Physical activity and positive youth development: Impact of a school-based program. *Journal of School Health, 81*, 462–470. doi:10.1111/j.1746-1561.2011.00615.x

Mahoney, J. L., Larson, R. W., & Eccles, J. S. (Eds.). (2005). *Organized activities as contexts of development: Extracurricular activities, after-school and community programs*. Mahwah, NJ: Lawrence Erlbaum and Associates.

Marsh, H., & Kleitman, S. (2003). Consequences of sport participation in high school. *Journal of Applied Sport Psychology, 25*, 205–228.

Morin, A. J. Maïano, C., Marsh, H. W., Janosz, M., & Nagengast, B. (2011). The longitudinal interplay of adolescents' self-esteem and body image: A conditional autoregressive latent trajectory analysis. *Multivariate Behavioral Research, 46*, 157–201. doi:10.1080/00273171.2010.546731

National Council of Youth Sports. (2008). *Report on trends and participation in organized youth sports*. Retrieved from http://www.ncys.org/pdfs/2008/2008-ncys -market-research-report.pdf

Parsons, E. M., & Betz, N. E. (2001). The relationship of participation in sports and physical activity to body objectification, instrumentality, and locus of control among young women. *Psychology of Women Quarterly, 25*, 209–222. doi:10.1111/1471-6402.00022

Pate, R. R., Dowda, M., O'Neill, J. R., & Ward, D. S. (2007). Change in physical activity participation among adolescent girls from 8th to 12th grade. *Journal of Physical Activity & Health, 4*, 3–16.

Perry, A. C., Rosenblatt, E. G., & Wang, X. (2004). Physical, behavioral, and body image characteristics in a tri-racial group of adolescent girls. *Obesity Research, 12,* 1670–1679. doi:10.1038/oby.2004.207

Sallis, J. F., & Owen, N. (1996). Ecological models. In K. Glanz, F. M. Lewis, & B. K. Rimer (Eds.), *Health behavior and health education: Theory, research, and practice* (2nd ed.) (pp. 403–424). San Francisco, CA: Jossey-Bass.

Sallis, J. F., & Owen, N. (1999). *Physical activity and behavioral medicine.* Thousand Oaks, CA: Sage.

Santos, M. P., Esculcas, C., & Mota, J. (2004). The relationship between socioeconomic status and adolescents' organized and nonorganized physical activities. *Pediatric Exercise Science, 16,* 210–218.

Schmitz, K. H., Lytle, L. A., Phillips, G. A., Murray, D. M., Birnbaum, A. S., & Kubik, M. Y. (2002). Psychosocial correlates of physical activity and sedentary leisure habits in young adolescents: The teens eating for energy and nutrition at school study. *Preventive Medicine, 34,* 266–278. doi:10.1006/pmed.2001 .0982

Slutzky, C. B., & Simpkins, S. D. (2009). The link between children's sport participation and self-esteem: Exploring the mediating role of sport self-concept. *Psychology of Sport and Exercise, 10,* 381–389. doi:10.1016/j.psychsport.2008.09.006

Smith, A. L. (2003). Peer relationships in physical activity contexts: A road less traveled in youth sport and exercise psychology research. *Psychology of Sport and Exercise, 4,* 25–39. doi:10.1016/S1469- 0292(02)00015-8

Suris, J. C., & Parera, N. (2005). Don't stop, don't stop: Physical activity and adolescence. *International Journal of Adolescent Medicine and Health, 17,* 67–78. doi:10.1515/IJAMH.2005.17.1.67

Taylor, W. C., & Lou, D. (2011). *Do all children have places to be active? Disparities in physical activity environments in racial and ethnic minority and lower-income communities.* Research Synthesis. Active Living Research. Retrieved from www .activelivingresearch.org

Tienda, M., & Kleykamp, M. (2000). *Physical and mental health status of Hispanic adolescent girls: A comparative perspective.* Office of Population Research Princeton University, Working Paper Series, Working Paper No. 2000-3.

Whitehead, J. R. (1996). A study of children's physical self-perceptions using an adapted physical self-perception profile questionnaire. *Pediatric Exercise Science, 7,* 132–151.

Whitt-Glover, M. C., Taylor, W. C., Floyd, M. F., Yore, M. M., Yancey, A. K., & Matthews, C. E. (2009). Disparities in physical activity and sedentary behaviors among US children and adolescents: Prevalence, correlates, and intervention implications. *Journal of Public Health Policy, 30,* S309–S334. doi:10.1057/ jphp.2008.46

Wolf, A. M., Gortmaker, S. L., Cheung, L., Gray, H. M., Herzog, D. B., & Colditz, G. A. (1993). Activity, inactivity, and obesity: Racial, ethnic, and age differences among schoolgirls. *American Journal of Public Health, 83,* 1625–1627. doi:10.2105/ ajph.83.11.1625

Zarrett, N., Fay, K., Li, Y., Carrano, J., Phelps, E., & Lerner, R. M. (2009). More than

child's play: Variable- and pattern-centered approaches for examining effects of
sports participation on youth development. *Developmental Psychology, 45*, 368–382.
doi:10.1037/a0014577

Zarrett, N., Lerner, R. M., Carrano, J., Fay, K., Peltz, J. S., & Li, Y. (2007). Variations in
adolescent engagement in sports and its influence on positive youth development.
In N. L. Holt (Ed.), *Positive youth development through sport* (pp. 9–23). Oxford,
UK: Routledge.

THE PRESSURE OF PULLING
YOUR OWN WEIGHT IN ROWING

D'Arcy Maine | 2017

From "Body Image Confidential," ESPNW, May 3, 2017, www.espn.com/espn/feature
/story/_/id/19232937/espnw-body-image-confidential. Bracketed insertions are part of
the original publication.

One in three college rowers ESPNW surveyed said they have had an eating
disorder. What makes them so vulnerable? The answer could lie in the nature
of the sport itself.

Kayleigh Durm was a junior in high school and a coxswain on the school's
lightweight 8 rowing team in 2005, when her coaches started jokingly asking
her a question during team dinners.

"Oh, Kayleigh, do you *really* need to eat that extra breadstick?" they would say.
She was 4-foot-11 and weighed 95 pounds.

While she says her coaches made the comments in a teasing and good-natured
way, the words stuck with her, and she started to question her own weight and
eating habits and how they would affect her team during races.

"I became hyperaware of what I was eating and would always say, 'I'm full,
I don't need any more food,' even when I was starving," she says. "I just didn't
want to get to that point when I was adding more stress to my boat, where I was
the coxswain who weighed 100 pounds and not 90."

After coxing for a year at Syracuse University, Durm left the team after feeling
"burnt out." She ultimately transferred to Ohio State, where she didn't row, and
graduated in 2011. She's now the director of rowing operations at Columbia
University, after spending three years as a volunteer coach at MIT. She had

rediscovered her passion for rowing in 2012, posting about the sport on her social media accounts and quickly becoming an accessible resource for high school coxswains. That same year, she founded the blog Ready All Row blog.

However, it didn't take long before Durm discovered a dangerous trend. Over and over, she received one simple question from high school-aged coxswains, both male and female: "What laxatives do you recommend to lose weight?"

In a survey of 201 Division I college athletes by ESPNW, 32 percent of rowers answered "yes" when asked if they've ever had an eating disorder. (That compares to 14 percent of all athletes surveyed.) Fifty-four percent of the rowers said they have a teammate with an eating disorder.

And the rate of eating disorders among rowers outpaces that among women in general. According to a 2006 study from the Multi-Service Eating Disorders Association,[1] 15 percent of women ages 17 to 24 have an eating disorder, and a study published in the National Center for Biotechnology Information found that 13.5 percent of women undergraduates have an eating disorder.[2]

So what is it about rowing that seems to foster disordered eating? Much of it seems built into the nature of the sport itself.

Rowers fall into two categories: lightweight and openweight (also known as heavyweight). Lightweight, traditionally for shorter, smaller athletes, commands a maximum weight of 130 pounds for female rowers, and the average weight for everyone in a boat can't exceed 125 pounds. Openweight has no official weight restrictions. In both divisions, the coxswain, who leads the team and steers the boat but does not actually row, must weigh at least 110 pounds, or otherwise must bring weight, such as sandbags or water, with them in the boat to make up the difference.

While openweight rowing is an official NCAA sport with championships in Varsity 8, Second Varsity 8 and Varsity 4, lightweight rowing is not, and only a handful of colleges have teams for women. Both divisions, however, are featured in the Olympic Games and in many high schools across the country.

Lightweight rowers are weighed on race day and can potentially lose their seat in the boat if they don't make the requirement, so some live in constant fear of not making weight. And it can become an all-encompassing obsession.

"I've been in environments with [lightweights] where weight and food is the sole thing they talk about in the run-up to racing," says Ruth Whyman, a former rower at the University of Washington and a member of Great Britain's national team. "They segregate themselves from heavyweights because it's easier not to eat around them, but *all* they talk about is food.

"Imagine how stressful that must be? You've been training for years and you might miss out because you're not at the ideal weight." Openweight rowers experience a different—but equally demanding—kind of pressure. From feeling

the need to look a specific way to being measured using an ergometer (which determines how much energy one is using in comparison to their weight), open-weight rowers are constantly thinking about their weight in terms of maximum efficiency in the boat. The best rowers are typically tall and lean because they have the best power-to-weight ratio—a formula that divides a rower's energy output in watts by their weight to determine a specific score. As heavier rowers add more weight and drag to the boat, those individuals are expected to contribute more power to compensate.

"There is such a specific body type that people aim for in rowing," Whyman says. "But I do think that a lot of that pressure comes from within the squad itself. I have never felt pressure from a single one of my coaches. Whether it's my national team or for Washington, I've never felt pressure from them to lose weight."

While every team relies on power-to-weight metrics differently, with some putting more emphasis on it than others, many rowers put great stock in their own numbers—as many college-level and professional athletes do—and work to improve in this regard. The lighter the overall boat is, the faster it will go, and this concept is not ignored.

"The pressure for having the perfect rower body came from me, because I knew what I wanted," Whyman says. "I was comparing myself to a lot of other women constantly, and it's extremely different to be in the changing room and be self-conscious if someone else has what you're striving for, and you don't have it, and thinking that affects you as an athlete. Thinking, 'Maybe if I was just five pounds lighter, I could go a second quicker.' There's a lot of pressure put on me by me."

While other sports, such as gymnastics, seem to favor particular body types and focus on appearance and physique, rowing is unique in its emphasis on weight and numbers on the scale, regardless of division.

"The tough part about rowing in particular is that you are literally pulling your own weight," says two-time Olympic gold medal–winning rower Susan Francia. "If a rower is overweight they are literally weighing down the boat. In rowing, your power-to-weight ratio is pretty important, so it's a fine balance between encouraging athletes to be at their ideal weight and pushing them into body image issues, which control their eating habits."

Durm says that she did skip meals during her junior year in high school, which greatly affected her energy level at practice. (Her decision to cut back on eating was short-lived when she saw the effect it was having on her performance.) However, she remembers watching teammates and opposing crews go to drastic lengths before weigh-ins on race day to make the necessary weight.

"Everyone kind of experimented with losing weight," she says. "Especially when we were at a race, and we were an hour from weigh-in, you would see

girls putting sweatpants and trash bags on when it was 84 degrees out—that was some of the more obvious stuff. But there were other girls who would disappear into the bathroom for a while and come out, and you knew they had been in there making themselves throw up. But you couldn't directly say that to them without it causing a problem."

Coaches, on the other hand, must walk a thin line, says Meghan O'Leary, a member of the 2016 U.S. Olympic rowing team, as they might need to instruct rowers to lose weight without shaming or encouraging bad habits. According to ESPNW's survey, rowers said they've been called fat by a coach at the same rate as respondents overall—about one in five.

According to the *Seattle Times*, the University of Washington fired Bob Ernst, its longtime women's rowing coach, in 2015 after he reportedly made disparaging remarks about women on the team and their weight and performance.[3] Rowers voiced concerns about pressure to skip class in order to meet a weekly quota of time-trial workouts, undergoing forced weigh-ins (which violated a school policy) and living with a general sense of fear, according to the *Seattle Times*. The school does not have a lightweight women's program.

Whyman, who graduated from Washington in 2014, said she never experienced anything like the complaints she read about, and she said she was surprised by the news. A spokesman for Washington declined to comment.

Coaches should be required to take classes focused on eating disorders so they know how to deal with athletes who are struggling, how to ensure they aren't doing anything to foster such behaviors and how to recognize warning signs, says Elizabeth Avery, a Boston-based nutritionist who works with student-athletes at Emerson College as well as in her own private practice.

"With some athletes, I might say, 'That's not a safe weight for you to be, so let's just forget that goal and be happy where you are and just try to get you to perform the best you can,'" Avery says. "What I always do with athletes, instead of focusing on their weight or their appearance, I talk about nutrition expressly around performance optimization."

Athletes can stop viewing eating as a negative, but rather as a necessity and an essential part of training, if they focus exclusively on how they can use food as the proper fuel for their sport, says Avery, who also helps athletes determine appropriate eating times for the ultimate benefit.

Avery, who rowed for Colgate University, says the risks caused by lightweight weigh-ins at the high school and college levels outweigh the benefits of having a class for smaller athletes who might be attracted to rowing.

"A lot of teams have an A and B boat, like varsity and junior varsity, and the bigger programs have a C and a D boat, and they should all be openweight," Avery says. "If you don't have the power to make the A boat, it's OK to be in

the C or D boat, but you shouldn't have to worry about your weight. Because I think what may start out as simply trying to make weight can often lead to something much deeper, like a body image problem."

The NCAA, for its part, has recently made mental health, including eating disorders, a priority. In 2016, the organization worked with mental health professionals and organizations to develop a set of guidelines and best practices that have since been distributed to all member institutions on how to recognize, treat and prevent disordered eating habits, as well as other conditions.[4]

"We know that there are a lot of benefits to sports, whether it's building self-esteem or promoting an active lifestyle throughout one's lifespan, or teaching skills and teamwork and character traits that are wonderfully positive," says Dr. Jessica Mohler, the coordinator of sport psychology services at the United States Naval Academy and a member of the NCAA's Committee on Competitive Safeguards and Medical Aspects of Sports. "Sports have the ability to provide that experience for our student-athletes, but we know that athletic competition also has some risks and it can also be stressful—both psychologically and physically.

"And certainly the pressures of sport competition, the pressure to perform at a high level added to sports' body types and size—sports that potentially emphasize thinness or certain body types related to performance—those athletes have an increased risk to develop really disordered eating behaviors."

The NCAA also sent out modules to all coaches on recognizing the signs and symptoms for a number of mental health disorders in hopes of providing education for those who work with student-athletes on a daily basis, Mohler adds.

But for Durm, the first line of defense is teammates looking out for each other.

"Your No. 1 athlete could be doing some of this stuff that an athlete with a known eating disorder is doing, and you're not paying attention to her because she's pulling good ERG scores and looks healthy," Durm says. "You need to say, 'We can't have this—it's not good for you, first of all, but also it's not good for others in the sport. We don't need to be perpetuating these behaviors.'"

Notes

Links in the original online version of this article have been turned into endnotes.

1. "Eating Disorders among College Students," Walden Center for Education and Research, www.waldencenter.org/popular-searches/eating-disorders-among-college -students.

2. Daniel Eisenberg, Emily J. Nicklett, Kathryn Roeder, and Nina E. Kirz, "Eating Disorder Symptoms among College Students: Prevalence, Persistence, Correlates, and

Treatment-Seeking," *Journal of American College Health* 59, no. 8 (September 2011): 700–707.

3. Geoff Baker, "UW Crew Legend Bob Ernst's Firing Came after Showdown with Rowers," *Seattle Times*, December 3, 2015, www.seattletimes.com/sports/uw-huskies /firing-of-uw-crew-legend-bob-ernst-came-after-showdown-with-rowers-sources-say.

4. *Inter-association Consensus Document: Best Practices for Understanding and Supporting Student-Athlete Mental Wellness* (Indianapolis: NCAA Sport Science Institute, 2016). Available at www.ncaa.org/sites/default/files/HS_Mental-Health-Best -Practices_20160317.pdf.

SHOUTS FROM THE STANDS

A Letter to USA Swimming about Gender Stereotypes

Kelsey Theriault | 2015

From SwimSwam, January 25, 2015, https://swimswam.com/shouts-from-the-stands -letter-usa-swimming-gender-stereotypes. Reprinted with permission. Bracketed insertions are part of the original publication.

The following is an open letter shared with SwimSwam by Kelsey Theriault, a coach with Palo Alto Stanford Aquatics. Theriault wrote to the heads of USA Swimming to express her disagreement with a coaching certification course called "Foundations of Coaching 201." The Foundations of Coaching course included a section titled "Gender and the Young Athlete," which Theriault found to reinforce harmful gender stereotypes. Her full letter to USA Swimming outlining her reasoning is below:

Dear Mr. Chuck Weilgus, Ms. Susan Woessner, and USA Swimming,

My name is Kelsey Theriault. I am a high school teacher and a swim coach. Working with and educating youth is my both my career and my passion. One reason why I am an educator is to help students and athletes recognize and effectively remove barriers on the road to success. As an educator and a coach,

I feel that it is incredibly important to send the message to girls that they are capable of the same success and achievement as boys. One major barrier to success for females is the messages conveyed in our gendered culture. These messages, such as "females are less competitive" or "females value relationships more and need constant approval," explicitly and implicitly tell female athletes that they should act, train, and compete differently than males.

Many psychological studies have been conducted that have disproven these theories and stereotypes commonly accepted by our society. Science has proven that the brains of males and females are essentially the same. For example, Dr. Lise Eliot, professor at the Chicago Medical School, has researched this topic in-depth and explains, "There are basic behavioral differences between the sexes, but we should note that these differences increase with age because our children's intellectual biases are being exaggerated and intensified by our gendered culture. Children don't inherit intellectual differences. They learn them. They are a result of what we expect a boy or a girl to be." Boys and girls learn these gender stereotypes from a young age. They see these stereotypical gender expectations in school, at home, with friends, and reinforced in popular culture. It is my goal, as an educator, to not only stop perpetuating these stereotypes, but to explicitly combat these sexist gender expectations.

Recently, I was in the process of updating my USA Swimming coaching credential by taking the course "Foundations of Coaching 201." I am seriously concerned by one section of this course: "Gender and the Young Athlete." USA Swimming is an institution that is committed to promoting success for all, regardless of race, gender, sexual orientation, etc., through the sport of swimming. I take issue with the way gender is presented to coaches in the way that they should coach young male and female athletes.

As the "Gender and the Young Athlete" section points out, and I agree, biologically, there are differences between males and females. Females, on average, tend to hit puberty earlier than males. Because of this, females may have slightly different training needs between the ages of eleven and fourteen. It is my belief that these slight differences can be addressed within coed training groups.

I find serious issue, though, with the following examples of advice given to coaches in the way that they should go about treating male and female athletes differently:

1. On page 19 of 25 of the course "Gender and the Young Athlete," it states: "[You can] help females bolster their perceived competence by recognizing and appreciating their skill development, training milestones and improvement. [You can] help males by allowing them to prove their competence by achieving success at practice and at meets."

This seems to send the message that female athletes need consistent affirmation in their competence as an athlete, whereas male athletes need to assert their aggression and competence through competition. Some female athletes need affirmation of their skills and development to improve self-confidence and some females need to see their improvements through achieving success with an outcome goal. The same goes for male athletes. To make broad and stereotypical claims about girls and boys could lead coaches to perpetuate the harmful gendered expectations of our society.

2. On page 22 of 25 of "Gender and the Young Athlete," it states: "Recognize that young females have greater needs for affiliation and are often motivated to participate for social reasons, while young males tend to be more motivated by competition. Girls are generally more team focused, so be sure to provide a team environment."

Proposing that young female athletes need more support from peers and coaches than their male counterparts seems to spread the stereotype that females are more dependent and that they need constant approval from authority figures (coaches) and peers. In my experience as a coach, I have seen many athletes motivated to participate for social reasons and athletes who are motivated by competition. First, I do not believe that these are mutually exclusive. Many athletes who are motivated by social reasons also enjoy the sport for the competition. I have coached many female athletes who are fierce competitors and many male athletes who enjoy and are motivated by the social aspect of the sport.

In addition, this also brings to issue the belief that boys are more "competitive" and aggressive and should be treated as such in the pool. This suggestion that boys are more competitive could lead to coaches treating male athletes as though they need to be this way to be successful in the pool. The hyper-masculine society in which we live sends the message to boys that they need to exhibit these qualities to "be a man." If young male athletes don't exhibit these qualities, whether in the pool or outside of the pool, they are seen as "girly" and often called derogatory names for females. This impacts female athletes in a negative way as well, making it seem as though being a female is innately negative. It is not.

Despite what I am sure is an effort for coaches to acknowledge the needs of all swimmers, this message could easily lead to coaches perpetuating hyper-masculinity in boys and submission and need for approval in girls. What we need, instead, is to instill skills of independence and self-confidence. We need to teach girls to be strong and independent.

3. Again, on page 22 of 25 of "Gender and the Young Athlete," it suggests: "Single gender training groups may help meet social affiliation needs. Alternately, single gender training lanes can accomplish the same objective."

The social development that occurs during the age range suggested (9 to 13) is critical in the development of gender ideas in adolescents. To separate girls and boys during this critical time of development sends the message that girls and boys are different, that they have different needs, different skills, and different ways of acting. So much so, that they must be separated. This can only add to the messages they are receiving in school and from peers about the differences in gender.

4. Finally, on page 25 of 25, it states: "Never stereotype the training and development of female and male athletes."

I completely agree. Yet, the way the information in this section was presented could easily be interpreted as suggesting that young female and male athletes think, act, and train in different ways and therefore have different needs based on gender. If a coach were to interpret the information this way, it would lead to stereotyping. This suggestion, to never stereotype based on gender, seems to be in conflict with the practices suggested in the section "Gender and the Young Athlete."

It is really important that all swimmers have their needs recognized and addressed. Many of the recommendations that USA Swimming has made throughout this course are good practices for coaches. It is incredibly important, though, to recognize and change the recommendations based on gender. Some female athletes need what has been recommended for male athletes, and vice versa. To make broad recommendations based on gender only strengthens stereotypical beliefs about males and females. It also implicitly encourages female athletes to take a more submissive, less competitive role. Instead of the current recommendations in the USA Swimming course "Foundations of Coaching 201," let us acknowledge that every athlete, regardless of gender, has different needs. Instead of educating coaches on the different ways to treat male and female athletes, I propose that USA Swimming teach its coaches to recognize, assess, and respond to the needs of individual athletes. By taking this approach, coaches acknowledge that each swimmer has individual needs and approaches for success. This encourages self-motivation, confidence, and independence in all athletes.

As a certified USA Swimming coach, I have had the privilege of working with swimmers of different age ranges and abilities. Through coaching, I have been able to help develop skills in young athletes that will help them be successful in whatever they pursue in life. I believe that the messages that USA Swimming and the sport of swimming send to young swimmers have helped young athletes achieve success in swimming, school, and the "real world."

That said, I propose that USA Swimming use its power as an authority in the swimming community to explicitly promote gender equality. I believe that

this is already a goal of USA Swimming, but the way in which gender has been presented in the coaching course "Foundations of Coaching 201" will not help that cause. As an institution, USA Swimming needs to promote fair and equal treatment of male and female athletes. By educating coaches to recognize the needs of individual swimmers, rather than making coaching choices based on gender (as presented in this course), we can teach our athletes that girls and boys are both capable of achieving the same success. As I pointed out earlier, these perceptions of differences in the behavior of males and females are learned. As an institution that educates youth, let us be the ones who break these stereotypes, the ones who teach girls to be confident and independent, and the ones who are actively and explicitly engaged in promoting equality of males and females.

I appreciate you taking the time to read this letter outlining my concerns and I look forward to hearing from you soon.

Sincerely,
Kelsey E. Theriault
M.A. Education, Stanford University
Assistant Swim Coach—Palo Alto Stanford Aquatics

TRENDS IN GENDER-RELATED RESEARCH IN SPORT AND EXERCISE PSYCHOLOGY

Nicole M. LaVoi | 2011

Excerpted from Nicole M. LaVoi, "Trends in Gender-Related Research in Sport and Exercise Psychology," *Revista iberoamericana de psicología del ejercicio y el deporte* 6, no. 2 (2011): 269–282.

To begin, it is important to outline what gender-related research is—and is not. A common error researchers often make is to conflate sex and gender as the same constructs. To distinguish between the two constructs is imperative. According to the American Psychological Association (2011), sex refers to the biological aspects of being male or female (i.e., sex chromosomes, internal reproductive organs, external genitalia), while gender refers to the attitudes, behaviors, feelings, experiences and characteristics associated with being male and female.

Examining gender pertains to how socially constructed and arbitrary conceptions of masculinity and femininity influence the sport and exercise experiences of all athletes. Gender-related research also pertains to how the structure of sport has traditionally privileged men and masculinity, and problematized or marginalized females in sport contexts.

Gender-related aspects of SEP [sport and exercise psychology] have predominately focused on girls and women in sport, and three lines of research will be summarized later in the paper. In 1988 sport sociologist Ann Hall argued that in North America the tendency is to think "gender" means "woman," and this remains mostly true in SEP two decades later. The experiences, correlates and outcomes for females in sport are worthy topics of inquiry and may, but should not be assumed to, differ from the experiences of males due to social and cultural context of participation, historic influences, and gender socialization. Gender-related trends in the U.S. should be used to guide research outside the U.S., but SEP researchers and practitioners are advised to use and apply the information in this paper in culturally competent ways, resist generalizations across cultures, and ask research questions that do not reify gender stereotypes. Certainly the norm of masculinity and femininity differs across cultures. [. . .]

In this paper, gender-related trends and areas of inquiry will be outlined that forward productive examination of gender that leads to social change, awareness, and positive outcomes for participants.

Two frameworks that are potentially helpful in moving gender-related SEP research forward include 1) Cultural Studies and 2) Bronfenbrenner's Ecological Systems Theory.

Engaging Cultural Studies in Sport and Exercise Psychology

Given that historically SEP researchers have embraced a limited approach to examining gender, a blurring of disciplinary boundaries is necessary if this area of inquiry is to progress. A discipline that encourages and embraces "open analytic, critical and political conversations by encouraging people to push the dialogue into fresh, uncharted territory" (Taylor & Francis, 2011) is needed. Arguably, the academic field of Cultural Studies may help expand gender-related research in SEP. Cultural Studies provides a space for scholarly dialogues that draw on theory and methods from several disciplines: anthropology, history, literary studies, philosophy, political economy, media/communication/film studies, feminist studies, and sociology. But whereas the traditional disciplines tend to produce stable objects of study, research in Cultural Studies attempts to account for cultural objects (i.e., athletes, coaches, teams) under conditions

constrained by power and defined by contestation, conflict, and change (George Mason University, 2011). Researchers concentrate on how a particular medium, message or social institution relates to ideology, social class, nationality, ethnicity, sexuality, and/or gender, rather than investigating a particular culture or area of the world. Recently, a loosely aggregated and emergent group of scholars who study power, power relations, the body and physical culture located their work in what they term Physical Cultural Studies (PCS; see Andrews & Silk, 2011).

Cultural Studies, and specifically PCS, offers a way for SEP researchers to study and integrate gender within their work, as gender is located on and performed by the physical body. Gender, an arbitrary construct of what it means to be masculine and feminine in a particular historical time and space, is part of a negotiated and subjective identity that influences optimal performance, experience and development of an individual—in sport and physical activity contexts. Silk and Andrews (2011) state in Cultural Studies it is "assumed that societies are fundamentally divided along hierarchical ordered lines of differentiation (i.e., gender) and are realized through the operations of power and power relations with social formation" (p. 10). Indeed gender is performed, engaged and interpreted on the physical body as a fluid, dynamic category. For example, what it means to be both "feminine" and an "athlete" has changed over time, and varies culturally. However, what has not changed is that the feminine remains secondary and marginalized to the masculine. Even with a record number of girls and women competing in sports at all levels in the U.S. due to the landmark federal law Title IX, female sport participation, the feminine, and the female athletic body remain contested.

In short, Cultural Studies blurs and dismantles disciplinary boundaries, where no one truth, way of knowing, or methodology reigns supreme, but where integrated knowledge that leads to complex understandings which make a difference to the communities and marginalized groups or individuals who need it most is desired and encouraged (Silk & Andrews, 2011). Cultural Studies is "aggressively non-reductionist" and researchers recognize and embrace the multiple factors which impact an individual actor, outcome or variable; and therefore reject the possibility of reducing causality to one factor. Reconstructing SEP by infusing Cultural Studies has not been widely used or accepted in Sport Psychology (Fisher, Roper, Butryn, 2009), nor gone uncontested. In sum, a scholarly approach that challenges the current "hyper-fragmentation and hyper-specialization" within human movement science would encourage transcending "intellectual boundaries and exclusivities" (Andrews, 2008) that are currently normative in SEP research. Another theoretical model that may help challenge non-reductionistic research has its origins in developmental psychology.

The Ecological Systems Theory

The Ecological Systems Theory (Bronfenbrenner 1977, 1979, 1993) posits human development reflects the influence of several environmental systems including individual, social, environmental, societal and cultural. This seminal theory has influenced how researchers approach the study of human beings and their environments, which varies from culture to culture. In combination, the Ecological System Theory and Cultural Studies may provide a comprehensive understanding of any one gender-related phenomenon. Using the issue of the physical activity of females as an example, this approach will be illustrated.

In a report titled *Developing Physically Active Girls: An Evidence-Based Multidisciplinary Approach*, three trends of girls' physical activity were summarized (Wiese-Bjornstal & LaVoi, 2007). First, adolescent girls participate in a broader array of physical activities, ranging from informal, play-like environments to the pressure-cooker world of Olympic sports, more than ever before in U.S. history. Second, girls' participation in moderate-to-vigorous physical activity or MVPA (the level of activity needed to accrue and maintain health benefits) outside of organized sports is declining, and declines are greater for girls of color and low-income girls. Third, girls' participation rates and behaviors in all types of physical activity—from organized sports, to outdoor recreation, to youth clubs, to physical education—consistently lag behind those of boys. Male participants outnumber their female peers, girls are less physically active than boys, and girls participate with less intensity than boys. While a gendered gap in physical activity exists (Wiese-Bjornstal & LaVoi, 2007), it is also clear that geography, gender, class, and race intersect in complex ways that prohibit or make it challenging for underserved girls to be physically active. Girls of color and girls from low-income communities have limited sport opportunities (Sabo et al., 2004), therefore it is not surprising that underserved girls are one of the least active populations in the United States and become increasingly inactive as they move from childhood through adolescence.

A wide variety of barriers for girls' physical activity at all levels of the environment have been identified by researchers across disciplines. Sport and Exercise Psychology (SEP) researchers have studied the gendered gap in physical activity using individual-level factors (i.e., self-perceptions, values, beliefs, motivation). Based on the data, girls who report lower levels of self-confidence, self-efficacy, and physical self-competence are less likely to participate in or persist at physical activity. However, girls' "choices," "lack of interest," or comparatively "low" self-perceptions fails to acknowledge that values, choices, expectations, effort, interest, and enjoyment are also shaped by the cultural and societal values and

beliefs, and social and physical environments in which girls live (Wiese-Bjornstal & LaVoi, 2007).

SEP researchers also study social factors such as parental influence. Underserved girls in studies around the U.S. report low levels of physical activity participation because they lack time due to family obligations; some parents believe "sports are for boys," value physical activity to a lesser extent for their daughters, provide fewer opportunities for girls to be active, or feel girls are less interested in sports than boys. Sport Sociologists examine the gendered physical activity gap by critically questioning and interrogating societal structures (i.e., political, legal, financial structures of power), societal norms (i.e., stereotypes, taken for granted ways of thinking and behaving, how girls are expected to conform to feminine norms, how values and expectations around what it means to be a girl influence physical activity participation) and cultural factors (i.e., shared behaviors, values, and traditions passed down [through] generations). Scholars in Public Health and Epidemiology examine individual, social and environmental (i.e., existence of green space, proximity of house to parks, safety) factors in concert, but often leave out motivation or how gendered beliefs impact physical activity and increase likelihood of obesity. Scholars in Sport History might study barriers over time that have prevented girls from engaging in sport and physical activity in the first place—barriers such as stereotypes about girls' inherent physical capacities, policies and laws, and inequities in funding priorities—and continue to limit girls' ability to reach their full potential. There are other academic sub-disciplines in which researchers study the phenomenon of girls' inactivity, but by highlighting the fragmentation of a select few disciplines I hope to shed light on how to advance gender-related SEP research.

By using an Ecological Systems approach to examine and illuminate multi-level and complex factors, along with opening up academic boundaries as suggested within Cultural Studies, a more complex understanding of gender-related phenomena is possible—as is the potential to make a difference to the communities, marginalized groups or individuals who need it most. For example, Thul and LaVoi (2011) recently published an article about reducing physical inactivity in East African immigrant adolescent girls in which they employed the Ecological Systems Model, and merged the literatures of SEP, Developmental Psychology, Prevention Science, and Public Health to argue for and ultimately develop culturally relevant physical activity programming. Combining two robust theoretical frameworks will stimulate interdisciplinary research and help all researchers understand the gendered physical activity gap. In the following section, two additional gender-related areas of inquiry will be summarized.

Sport and Exercise Psychology Gender-Related Areas of Inquiry Lack of Females in Positions of Power

Many assume the rise in participation opportunities for female athletes in the U.S. since the passage of the federal law Title IX in 1972 has translated into increasing numbers of females in positions of power in sport—an assumption that has proven to be false. Despite the fact that female athletic participation at all levels of sport is at a historic high, females in positions of power at all levels and in nearly all positions have declined since 1972 and remain a scarce minority. This surprising and counterintuitive trend is often referred to as an "unintended consequence" of Title IX. In fact in the most visible and arguably most important positions of power in sport—head coaches, athletic administrators, and sport editors—women remain marginalized and in many cases are statistical tokens (i.e., a member of a demographic category who occupies less than 15% of the workforce population). Tokens and marginalized groups are often alienated, highly visible and subjected to scrutiny, have to overperform to gain credibility, feel pressure conform to organizational norms, and are at increased risk for gender discrimination in the forms of sexual harassment, wage inequities, and limited opportunities for promotion.

A by-the-numbers analysis paints a bleak picture of the landscape for females in positions of power in U.S. sport. In their longitudinal report, Acosta and Carpenter (2008) indicate that only 20.6% of all college teams are coached by a female head coach and the number of female head coaches of women's teams (42.8%) is lower than at any time in history except for 2006 (42.4%). No national data exists for the percentage of females in positions of power for interscholastic sport, yet preliminary analysis in 2011 by researchers affiliated with The Tucker Center for Research on Girls & Women in Sport at the University of Minnesota suggest numbers are similar to or worse than the collegiate data (LaVoi & Kamphoff, in progress). At the youth sport level data is also scarce, but based on numbers from one state level youth soccer association, LaVoi (2009) found females seldom occupied head coach (15.1%) and assistant coach (18.9%) positions and were marginalized by being clustered within the less prestigious and less visible position of team manager and the less prestigious teams (i.e., younger age groups, less competitive recreational levels). The 2011 number for athletic directors is more bleak, only five of 120 (4%) athletic director positions in Division I-A—the biggest and most prominent programs—were occupied by females. Based on the data, 19% of collegiate athletic directors across all divisional levels are female, a number that has declined from the early 1970s when

over 90% of females oversaw female athletics programs. The data pertaining to Associated Press sports editors are no better; 94 percent are men.

Recognizing the need for female representation both at the international and national level, the International Olympic Committee mandated that by December 31, 2005, all National Olympic Committees must reserve 20% of positions involving decision-making for women (including coaches). Current data is not available to ascertain if U.S. National Governing Bodies (NGBs) of Olympic sports are in compliance with the IOC mandate. However, data from around the globe consistently indicate that women are underrepresented in coaching at the highest levels (Fasting & Pfister, 2000), including the professional and Olympic levels.

To address this issue, the International Working Group on Women and Sport (IWG) created the Sydney Scoreboard (http://www.sydneyscoreboard.com), a legacy of the 5th IWG World Conference, with the aim to increase the number of women on the boards/management committees of all sport organizations at the international, regional, national and local level. The Sydney Scoreboard operates as a powerful online tool through which women in leadership roles within sport organizations can be tracked both nationally and internationally. The site provides an internationally accessible, interactive and real time means of tracking progress and showcasing good practices with regards to the boards of sport organizations. Based on current data, in the U.S. very few (2.86%) of all Chief Executive Officers of sport organizations are women. No Sydney Scoreboard data currently exists for Spain.

Scholars have documented the many complex and dynamic societal, structural, familial, social and personal barriers that impede and influence the lack of females in power positions in sport. The many barriers, as well as supports, for U.S. female coaches are summarized within an ecological model by Dutove and LaVoi (2011). Yet in this post Title IX moment in the U.S., the role of personal agency—"a woman's right to choose"—is often left out of the discussion. Is something afoot that influences women not to choose, to seek, or to desire high-powered positions in sport? Perhaps women are "opting out" of demanding, high profile, time consuming, stressful positions and choosing to remain in supporting roles such as assistant coaches, associate and assistant athletic directors, and assistant sports editors where work-life balance and quality of life is more likely. Arguably the factors that facilitate and impede a woman's pursuit of positions of power in sport are complex, vary culturally, and cannot be adequately addressed by only using traditional SEP frameworks.

Gender "Differences" in Coaching Science

Coaching Science encompasses many sub-disciplines of human movement studies, and articles about the coach-created motivational climate, coach feedback and instruction, coach goal orientation and its effect on athlete outcomes, and qualities of the coach-athlete relationship, for example, regularly appear in SEP journals. As mentioned in the beginning of this paper, gender differences in coaching are often constructed or discussed in ways that "other" or marginalize female athletes and coaches. Recently, LaVoi and Hamilton (under review) did a meta-analysis of the SEP literature on male and female athlete perceptions of coach variables in order to provide evidence of whether or not empirical differences existed based on the sex of athletes. Based on the data, males and females largely preferred the same coach behaviors and few differences emerged. If this is true, then perceptions that coaching males and females requires different knowledge and different application of coaching science is just that—a perception, not an evidence-based reality. This finding based on the SEP literature challenges tacit assumptions of researchers and practitioners. It also supports the contention that a broader range of ecological factors and the application of a Cultural Studies perspective should be considered, evaluated and researched—especially given that coaching is a study in power and power relations. Without a blurring of disciplinary lines, and additional research, it is premature to claim that coaching males and females is different.

References

Acosta, R. V., & Carpenter, L. J. (2008). *Women in intercollegiate sport: A longitudinal, national study thirty-one year update.* Retrieved from http://webpages.charter.net/womeninsport.

American Psychological Association (2011). *Definition of terms: Sex, gender, gender identity, sexual orientation.* Retrieved from http://www.apa.org/pi/lgbt/resources/sexuality-definitions.pdf

Andrews, D. L. (2008). Kinesiology's *Inconvenient Truth* and the physical cultural studies imperative. *Quest, 60,* 45–62.

Andrews, D. L., & Silk, M. L. (2011). Toward a physical cultural studies. *Sociology of Sport Journal, 28* (1), 4–35.

Bronfenbrenner, U. (1977). Toward an experimental ecology of human development. *American Psychologist, 22,* 513–531.

Bronfenbrenner, U. (1979). *The ecology of human development: Experiments by nature and design.* Cambridge, MA: Harvard University Press.

Bronfenbrenner, U. (1993). The ecology of cognitive development: Research models and fugitive findings. In R. H. Wozniak & K. W. Fisher (Eds.), *Development in*

context: Activity and thinking in specific environments (pp. 3–24). Hillsdale, NJ: Erlbaum.

Dutove. J. K., & LaVoi, N. M. (2011). *Barriers and supports for female coaches: An evidence-based ecological model.* Retrieved from http://www.cehd.umn.edu/ tuckercenter/conference/posters/32.pdf

Fasting, K., & Pfister, G. (2000). Female and male coaches in the eyes of elite female soccer players. *European Physical Education Review, 6,* 91–110.

Fisher, L. A., Roper, E. A., & Butryn, T. M. (2009). Engaging cultural studies and traditional sport psychology. In R. J. Schinke & S. J. Hanrahan (Eds.), *Cultural sport psychology* (pp. 23–44). Champaign, IL: Human Kinetics.

George Mason University (2011). *What is cultural studies?* Retrieved from http:// culturalstudies.gmu.edu/whatiscs.htm

LaVoi, N. M. (2009). Occupational sex segregation in a youth soccer organization: Females in positions of power. *Women in Sport & Physical Activity Journal, 18*(2), 25–37.

LaVoi, N. M., & Hamilton, M. (under review). Gender Differences and Similarities: The Evidence Regarding Coaching Males and Females.

LaVoi, N. M., & Kamphoff, C. (in progress). Females in positions of power in high school athletics. A grant project funded by AAHPERD.

Sabo, D., Miller, K. E., Melnick, M. J., & Heywood, L. (2004). *Her life depends on it: Sport, physical activity and the health and well-being of American girls.* East Meadow, NY: Women's Sports Foundation.

Silk, M. L., & Andrews, D. L. (2011). Physical cultural studies: Engendering a productive dialogue. *Sociology of Sport Journal, 28*(1), 1–3.

Taylor & Francis (2011). *Cultural Studies: Aims and scope.* Retrieved from http://www .tandf.co.uk/journals/routledge/09502386.html

Thul, C. M., & LaVoi, N. M. (2011). Reducing physical inactivity and promoting active living: From the voices of East African adolescent girls. *Qualitative Journal of Sport & Exercise, 3*(2), 211–237.

Wiese-Bjornstal, D. M., & LaVoi, N. M. (2007). Girls' physical activity participation: Recommendations for best practices, programs, policies, and future research. In *The 2007 Tucker Center Research Report, Developing physically active girls: An evidence-based multi-disciplinary approach* (pp. 63–90). University of Minnesota, Minneapolis, MN: Tucker Center for Research on Girls & Women in Sport. Retrieved from http://www.cehd.umn.edu/tuckercenter/projects/TCRR/2007 -Tucker-Center-Research-Report.pdf

PART IV *Sex, Gender,
and the Rules of Inclusion*

Part 4 concerns sex segregation in sport. Should we separate boys from girls? Men from women? Why and in which sports? And what criteria we should use to identify who gets to compete in which categories? The answers to these questions are not as easy as they might seem.

In the first reading, Alice Sanders asks, "Is gender segregation in sports necessary?" The most common argument against integration, she notes, is that men are typically stronger than women. She sets out to explore that idea by assessing the "performance gap" between men and women. Sanders concludes that sex segregation in sport "is harmful to gender relations and society." It's a controversial proposition, the benefits and consequences of which merit careful analysis.

One of the economic effects of gender segregation, it should be noted, is the tremendous wage disparity between male and female athletes. Tennis is among the few sports to award equal prize money to both sexes, at least at grand slam events. England's historic Wimbledon tennis tournament was the last holdout, waiting until 2007 to equalize pay, and only after significant pressure from Venus Williams, one of the sport's marquee players. As part of her campaign, in 2006 Williams wrote an open letter in which she explained that "the home of tennis is sending a message to women across the world that we are inferior." Equal pay is about more than money—it tends to represent what a society values.

If we maintain sex segregation in sport, how do we determine who "counts" as a woman? Most recently, testosterone levels have been the deciding factor, as Jaime Schultz describes in "So What If Some Female Olympians Have High

testosterone? Specifically, sports officials have turned from "sex tests" that look at chromosomes to tests for "hyperandrogenism" (elevated levels of naturally occurring testosterone) as the latest technique to ensure that women athletes are "true" women. But why should high testosterone disqualify an athlete from competing as a woman when sport is riddled with physical, genetic, and social conditions that give one athlete an advantage over another?

Physiologist Ross Tucker takes up this question in his interview with Joanna Harper, who describes herself "as a scientist first, an athlete second and as a transgender person thirdly." Contrary to Alice Sanders's position on integration, Harper argues, "One cannot have women's equality without women's sport. In order to make women's sport meaningful, women must compete only against other women." At the same time, she acknowledges that "biology does not neatly divide human beings into two sexes." To this end, Harper is in favor of setting limits on women's testosterone levels in the context of sport—both for hyperandrogenic and trans women athletes. In fact, a number of organizations have adopted policies for trans athletes that use the same testosterone thresholds as hyperandrogenism policies.

Yet rules for trans athletes are inconsistent and often controversial. Some organizations adopt policies that require athletes to compete as the sex assigned at their birth; other organizations allow for self-determination; still others take into consideration the individual's age of transition, sex assigned at birth, and use of hormone therapy. The final reading in part 4 is an excerpt from *On the Team: Equal Opportunities for Transgender Student Athletes*, a report cosponsored by the National Center for Lesbian Rights and the Women's Sports Foundation initiative It Takes a Team! The authors discuss the importance of thoughtful, nondiscriminatory policies at the high school and collegiate levels as they take into account issues of competitive equity and the potential consequences of noninclusive policies and practices. As the readings in this part show, the question of sex segregation necessarily requires consideration about how and why we determine sex in the first place.

IS GENDER SEGREGATION
IN SPORTS NECESSARY?

Alice Sanders | 2016

From *How We Get to Next,* July 13, 2016, https://howwegettonext.com/is-gender
-segregation-in-sports-necessary-dc188150f242. Reprinted with permission.

"In contests involving strength, speed and reactive ability,
women are nowhere near as good as men."
ROD LIDDLE | writing in *The Spectator,* 2012[1]

"So, Kuper baited me: 'The top women can't take on the top men.'
He continued by making assertions like: women are slower than men;
women are weaker than men."
JENNIFER DOYLE | (speaking with sports writer Simon Kuper),
reported on her blog TheSportSpectacle, 2014[2]

This is the most common argument against gender integration in sports: integrated sports teams shouldn't exist because men are stronger than women.

But is that actually true? And even if it *is* true, does it mean that a woman shouldn't play on the same team as a man?

We accept, and expect, gender integration almost everywhere else—at work, in social spaces, and we're even coming around to the idea of non–gender specific

bathrooms. Yet sports remain segregated, and it's worth examining what the social cost of that separation is.

But first, the science. A 2010 study in *The Journal of Sports Science and Medicine* which examined the year-by-year improvement in world records and top 10 performances across 82 different sports since 1896 (the beginning of the modern Olympic era), found that women are not as fast, nor as strong, as men.[3] Genetic and hormonal factors between men and women affect "height, weight, body fat, muscle mass, aerobic capacity or anaerobic threshold," the authors note.

The data that they collected and examined showed that, on average, men outperform women by a 10 percent gap. That's an average, so the differences can be more or less pronounced depending on the sport—the lowest differences are in 800-meter freestyle swimming, for example (5.5 percent), and the highest in weightlifting (36.8 percent). Women typically do best relative to men in events based around aerobic stamina, like long-distance running. Andy Lane, a sports psychologist at the University of Wolverhampton, confirmed this to me when I spoke with him. "There are physical differences between males and females, typically around strength," he explained.

That general point obscures a more interesting one, though, in that the historical data show that, for a while, women seemed to be catching up. Over the last century, women's times have improved more than men's. This is mainly because women have increasingly had more access to the things that athletes need to better themselves—like more invitations to major events, and better equipment, training, and coaching. Social politics has influenced sports performances, going right back to when women were enfranchised in the early 20th century, through periods of increasing personal freedom and income that have made it more and more possible for women to become professional athletes.

That said, the data also show that this constant progress slowed in more recent decades—from 1983 onwards, the gender gap stabilized, and women's records started to consistently come to roughly 90 percent of the men's records. The best men and the best women have been getting better at the same rate ever since.

Could that change? Could women start catching up with men again? After all, people used to say women were unable to handle political office. Even the slowest-converging lines eventually do merge; the truth is nobody knows for sure if that's the case here. The history of women in sports is a history of being gradually allowed access to social privileges which have made them better athletes, and there could yet be undiscovered factors at play that could make the gap smaller.

Here's how the gender gap might start closing again, if it's ever going to.

For a start, history tells us that improvements in sports science and technology are more likely to close the gap, not widen it. Right now, top-level training is becoming more and more specific, for example—not just to the sport, not just to the general gender of an athlete, but tailored to each individual person.

Lane said: "Effective training is specific. There is a great deal of individual difference and so gender is of less importance. An individualized training program is the most effective and, as such, gender differences will blur."

David Epstein, author of *The Sports Gene*, makes a similar point—he argues that, as more and more has been discovered about the human genome, training programs can be tailored to specific types of genes related to athletic ability. "We're finding genes that make some people more trainable to particular training programs than others," he writes. "Not only genes, but actually direct physiology—whether it's properties of muscle fibers or things like that—that can help you figure out what the best training plan is for an individual."[4]

Of course, these advances are going to aid all genders in terms of better training. But almost all major sports—particularly team sports like football, basketball, baseball, and soccer—have been historically dominated by men, and I warrant that tailored training is much more likely to help women. Scientific studies in general focus more on men as subjects instead of women, and this includes medicine, health, and sports science.[5] Much sports research and training was specifically designed with men in mind—women should have more to gain from training specificity.

The second big advancement in the next few decades, particularly in team sports, will be augmentation—that is, using technology to physically alter and improve the human body. This is going to take many forms, and will be controversial, but some degree of it is inevitable—as will be the changes of our current ideas of what sports are.

We're going to start seeing new ways for athletes to be fed information while they're on the field or the track—think Google Glass–style data displays in contact lenses or goggles, or discreet earpieces, broadcasting everything from play formations to projections about where a ball will land. Even bio-augmentation might end up permitted, where athletes can physically upgrade their bodies, from better limbs to better brains for tactical decisions. (Doping, arguably, is already a crude form of this.) Gene editing may produce humans with every gene for athletic performance emphasized. Many of the newest sports—like e-sports—don't require any physicality at all, where mental strength is most important.[6]

In this world, differences in gender end up a minor irrelevance compared to all of the other factors which will determine sporting prowess.

"When girls like football, I think it's OK. But I think that the level of women's football is too low to take it seriously."

ANDREY ARSHAVIN | professional soccer player

"Women should be in the discotheque, the boutique, and the kitchen, but not in football."

RON ATKINSON | former soccer player and manager

This all assumes something else, of course—that physical attributes are the most important thing when it comes to sports. Yet for team sports, that's just not true.

It's certainly not just strength and speed that make a good player, and it doesn't necessarily follow that team sports should be segregated, even now, because of those specific attributes. There are variations of speed and strength among male players in all team sports; there are positions where strength is much less important; and others where speed is not so integral. If it was all about physicality, then players would be judged and recruited around edge case statistics like the fractions of seconds to reaching a ball—in reality, those are just one of myriad such stats that coaches look at.

Sure, it helps if you *can* make it to that ball quicker, but other skills are equally if not more important. In soccer, say, controlling the ball, tactical understanding, off-the-ball movement, teamwork, and cooperation—these are all vital parts of the game. What's more, women are already good, yet underrated, at endurance and stamina in events that last longer than two hours, the one area where there is evidence that they actually are able to outperform men—thanks to smaller bodies radiating heat more efficiently, and more efficient conversion of body fat into energy.[7]

It's funny, isn't it, that even though women have some advantageous biology, and are stereotypically thought of as being better than men in the key skills for team sports—think cooperation, multi-tasking—you'll never hear, "the thing is men just aren't as good at soccer, they can't play as part of a team like women can."

Social politics have hugely affected women's sporting performance over the last century—but what if sports could affect change in social politics?

All-male sports teams exist largely within a system run by men who went through the system themselves—men who end up as coaches, officials, and members of boards. It's a system that teaches men that a version of masculinity, that is both toxic and hierarchical, is among the most important traits to have. Eric Anderson, professor of sports, masculinities, and sexualities at the University of Winchester, defines this as "orthodox masculinity" in a 2008 study.

He argues that it's responsible for men's team sports cultivating a culture of misogynistic and homophobic attitudes.[8]

"It is a resilient system that reproduces a more conservative form of gender expression among men, helping make sport a more powerful gender regime," he explains. Ultimately, an athlete's own choices matter less and less, as they're encouraged to see everyone else through the lens of orthodox masculinity. More often than not, men who play to a high level in an all-male sports team also socialize mainly with their teammates, meaning that the bonds they form with people outside of that sporting universe—and especially women—are colored by the masculinity they have to live every day.

This means there is a higher chance of men having negative attitudes about women—objectifying them, for example. Anderson explains: "Male athletes (in general) and team sport athletes (in particular) have been shown to objectify women—often viewing them as sexual objects to be conquered." The statistics on campus rape in America are pretty terrifying; a three-year study by researchers Jeff Benedict and Todd Crosset in the mid-1990s showed that while male student-athletes comprise 3.3 percent of student populations in the United States, they made up 19 percent of sexual assault perpetrators and 35 percent of domestic violence perpetrators.

Integrating team sports could do a significant amount to change this. In his study, Anderson followed heterosexual male university cheerleaders, who had all previously played high school football. Before they started cheerleading almost all of them reported that they viewed the world through the prism of orthodox masculinity—they held misogynistic views, both about women as athletes, and also in a more general sense.

Overwhelmingly, the men who participated in sports with women had their minds changed. They perceived women as good athletes: strong, capable and skillful. David, one participant in Anderson's study, said: "I used to think women were weak, but now I know that's not true. I never thought women were so athletic before. I hated women's sports. But these women are athletes. They do stuff I'd never be able to do and I bet there are a lot of sports women can do better in." [. .]

It didn't stop there. "All but a handful reported that they had learned to see women as more than sex objects," Anderson explains. "All the athletes reported having learned to respect and value women as friends, teammates, and competent leaders. Thus in the sex-integrated sport of collegiate cheerleading, once sexist and misogynistic men were able to witness the athleticism of women, befriend them in ways that they were previously unable to, and to learn of their gendered narratives, it humanized them in the process."

Segregation in sports, it turns out, is harmful to gender relations and society. We worry that women might twist an ankle or break a leg if they were to play mixed sports, when in fact, the consequences of segregation are much, much more costly to women.

I hope that one day Marta will play on the same team as Messi; that gender segregation in team sports will end, and humanity will be better for it.

Notes

Links in the original online version of this article have been turned into endnotes.

1. R. Liddle, "This sexist assumption that women are weaker. It's right, isn't it," *Spectator*, July 28, 2012, www.spectator.co.uk/2012/07/this-sexist-assumption-that-women-are-weaker-its-right-isnt-it.

2. J. Doyle, "On the Sexism of Football Stars and Sports Critics," *SportSpectacle*, May 12, 2014, https://thesportspectacle.com/2014/05/12/on-the-sexism-of-football-scholars-and-sports-critics.

3. V. Thibault, M. Guillaume, G. Berthelot et al., "Women and Men in Sport Performance: The Gender Gap Has Not Evolved since 1983," *Journal of Sports Science & Medicine* 9, no. 2 (June 2010): 214–223.

4. David Epstein, *The Sports Gene: Talent, Practice, and the Truth about Success* (New York: Random House, 2014).

5. M. W. Moyer, "Drug Problem: Women Aren't Properly Represented in Scientific Studies," *Slate*, July 28, 2010, www.slate.com/articles/health_and_science/medical_examiner/2010/07/drug_problem.html.

6. D. Geere, "Why Everyone Is Suddenly into E-Sports (and How You Can Be, Too)," *How We Get to Next*, July 12, 2016, https://howwegettonext.com/why-everyone-is-suddenly-into-e-sports-and-how-you-can-be-too-9e8ce9d9401e.

7. G. Crowther, "Gender and Endurance Performance," *Northwest Runner* 29, no. 8 (August 2001): 15–16. Available at https://faculty.washington.edu/crowther/Misc/RBC/gender.shtml.

8. Eric Anderson, "'I Used to Think Women Were Weak': Orthodox Masculinity, Gender Segregation, and Sport," *Sociological Forum* 23, no. 2 (2008): 257–280.

WIMBLEDON HAS SENT ME A MESSAGE:
I'M ONLY A SECOND-CLASS CHAMPION

Venus Williams | 2006

The time has come for it to do the right thing: pay men and women equal prize money.

Have you ever been let down by someone that you had long admired, respected and looked up to? Little in life is more disappointing, particularly when that person does something that goes against the very heart of what you believe is right and fair.

When I was a little girl, and Serena and I played matches together, we often pretended that we were in the final of a famous tournament. More often than not we imagined we were playing on the Centre Court at Wimbledon. Those two young sisters from Compton, California, were "Wimbledon champions" many times, years before our dreams of playing there became reality.

There is nothing like playing at Wimbledon; you can feel the footprints of the legends of the game—men and women—that have graced those courts. There isn't a player who doesn't dream of holding aloft the Wimbledon trophy. I have been fortunate to do so three times, including last year. That win was the highlight of my career to date, the culmination of so many years of work and determination, and at a time when most people didn't consider me to be a contender.

So the decision of the All England Lawn Tennis Club yet again to treat women as lesser players than men—undeserving of the same amount of prize money— has a particular sting.

I'm disappointed not for myself but for all of my fellow women players who have struggled so hard to get here and who, just like the men, give their all on the courts of sw19. I'm disappointed for the great legends of the game, such as Billie Jean King, Martina Navratilova and Chris Evert, who have never stopped

fighting for equality. And disappointed that the home of tennis is sending a message to women across the world that we are inferior.

With power and status come responsibility. Well, Wimbledon has power and status. The time has come for it to do the right thing by paying men and women the same sums of prize money. The total prize pot for the men's events is £5,197,440; for the women it is £4,446,490. The winner of the ladies' singles receives £30,000 less than the men's winner; the runner-up £15,000 less, and so on down to the first-round losers.

How can it be that Wimbledon finds itself on the wrong side of history? How can the words *Wimbledon* and *inequality* be allowed to coexist? I've spent my life overcoming challenges and those who said certain things couldn't be achieved for this or that reason. My parents taught me that dreams can come true if you put in the effort. Maybe that's why I feel so strongly that Wimbledon's stance devalues the principle of meritocracy and diminishes the years of hard work that women on the tour have put into becoming professional tennis players.

I believe that athletes—especially female athletes in the world's leading sport for women—should serve as role models. The message I like to convey to women and girls across the globe is that there is no glass ceiling. My fear is that Wimbledon is loudly and clearly sending the opposite message: 128 men and 128 women compete in the singles main draw at Wimbledon; the All England Club is saying that the accomplishments of the 128 women are worth less than those of the 128 men. It diminishes the stature and credibility of such a great event in the eyes of all women.

The funny thing is that Wimbledon treats men and women the same in so many other respects; winners receive the same trophy and honorary membership. And as you enter Centre Court, the two photographs of last year's men's and women's champions are hung side by side, proudly and equally.

So why does Wimbledon choose to place a lesser value on my championship trophy than that of the 2005 men's winner, Roger Federer? The All England Club is familiar with my views on the subject; at Wimbledon last year, the day before the final, I presented my views to it and its French Open counterparts. Both clearly gave their response: they are firmly in the inequality for women camp.

Wimbledon has argued that women's tennis is worth less for a variety of reasons; it says, for example, that because men play a best of five sets game they work harder for their prize money.

This argument just doesn't make sense; first of all, women players would be happy to play five sets matches in grand slam tournaments. Tim Phillips, the chairman of the All England Club, knows this and even acknowledged that women players are physically capable of this.

Secondly, tennis is unique in the world of professional sports. No other sport has men and women competing for a grand slam championship on the same stage, at the same time. So in the eyes of the general public the men's and women's games have the same value.

Third, athletes are also entertainers; we enjoy huge and equal celebrity and are paid for the value we deliver to broadcasters and spectators, not the amount of time we spend on the stage. And, for the record, the ladies' final at Wimbledon in 2005 lasted 45 minutes longer than the men's. No extra charge.

Let's not forget that the US Open, for 33 years, and the Australian Open already award equal prize money. No male player has complained—why would they?

Wimbledon has justified treating women as second class because we do more for the tournament. The argument goes that the top women—who are more likely also to play doubles matches than their male peers—earn more than the top men if you count singles, doubles and mixed doubles prize money. So the more we support the tournament, the more unequally we should be treated! But doubles and mixed doubles are separate events from the singles competition. Is Wimbledon suggesting that, if the top women withdrew from the doubles events, that then we would deserve equal prize money in singles? And how then does the All England Club explain why the pot of women's doubles prize money is nearly £130,000 smaller than the men's doubles prize money?

Equality is too important a principle to give up on for the sake of less than 2 per cent of the profit that the All England Club will make at this year's tournament. Profit that men and women will contribute to equally through sold-out sessions, TV ratings or attraction to sponsors. Of course, one can never distinguish the exact value brought by each sex in a combined men's and women's championship, so any attempt to place a lesser value on the women's contribution is an exercise in pure subjectivity.

Let's put it another way: the difference between men's and women's prize money in 2005 was £456,000—less than was spent on ice cream and strawberries in the first week. So the refusal of the All England Club, which declared a profit of £25 million from last year's tournament, to pay equal prize money can't be about cash. It can only be trying to make a social and political point, one that is out of step with modern society.

I intend to keep doing everything I can until Billie Jean's original dream of equality is made real. It's a shame that the name of the greatest tournament in tennis, an event that should be a positive symbol for the sport, is tarnished.

SO WHAT IF SOME FEMALE OLYMPIANS HAVE HIGH TESTOSTERONE?

Jaime Schultz | 2016

From the *Conversation*, August 15, 2016, https://theconversation.com/so-what-if
-some-female-olympians-have-high-testosterone-62935.

On August 12, Dutee Chand became just the second female sprinter to represent India at the Olympic Games. Her road to Rio has been anything but easy.

In 2014, the International Association of Athletic Federations banned her from competition on the grounds that her body naturally produced too much testosterone, a condition called hyperandrogenism. It wasn't her fault, the organization explained. But her condition gave her an unfair edge over other female athletes, according to the IAAF policy.

Chand appealed the ruling, and in July 2015, the Court of Arbitration for Sport determined that the IAAF "was unable to conclude that hyperandrogenic female athletes may benefit from such a significant performance advantage that it is necessary to exclude them from competing in the female category."[1]

Arbitrators gave the IAAF two years to produce enough evidence to justify its policy. Until then, the organization must suspend the hormone test. The International Olympic Committee also complied, allowing Chand and other hyperandrogenic women to compete at the 2016 Olympic Games without having to lower their hormone levels.

The Chand case is the just the latest chapter in the long history of sex-testing female athletes in elite sport, something I've been studying for a while. Although the tests have changed over the years, the intent—to ensure that female athletes are sufficiently female—has not.

With all due respect, I think asking if elevated levels of testosterone give female athletes a competitive advantage is the wrong question. Instead, we should ask: "So what?"

The Long History of Sex-Testing Female Athletes

As the prestige of international athletics grew during the 20th century, critics worried that male athletes might commit "gender fraud" in pursuit of sporting

glory. In 1946, for example, the IAAF required female competitors to submit medical certificates to verify their sex.[2]

At the European Athletics Championship in 1966, the IAAF subjected female competitors to a "nude parade" past three gynecologists. This was because, as *Life* magazine reported, "there had been persistent speculation through the years about women who turn in manly performances."[3] That same year female athletes at the Commonwealth Games had to undergo gynecological exams to prove their sex. British pentathlete Mary Peters would later refer to it as "the most crude and degrading experience I have ever known in my life."[4]

In 1967 the IAAF turned to a "simpler, objective and more dignified" laboratory-based chromosome assessment, typically obtained by swabbing the inside of every female athlete's cheek (the IOC followed suit for the 1968 Olympic Games).[5] An XX result effectively established femaleness. Anything else spelled an end to the woman's career. But there are a host of genetic and biological variations that complicate the seemingly tidy split between male and female.

Polish sprinter Ewa Klobukowska, for instance, was summarily dismissed from sport in 1967 because she had "one chromosome too many." The IAAF nullified all of her victories, struck her name from the record books, and rescinded her medals, including the gold and bronze from the 1964 Olympics, all because of a naturally occurring condition that probably had little bearing on her success.

At 21 years old, her athletic career was over. "It's a dirty and stupid thing to do to me," she said at the time. "I know what I am and how I feel."

Then there are women with XY chromosomes, such as Spanish hurdler María José Martínez-Patiño. She successfully challenged her 1985 disqualification on the grounds that she also has androgen insensitivity syndrome, a condition in which her body cannot respond to testosterone, either natural or synthetic.[6]

Objections to Mandatory Testing Grow

The results of the tests are supposed to be confidential, so we don't know exactly how many women have been drummed out of sport as a result. Researchers estimate that between 1972 and 1990, sex-testing procedures disqualified approximately one in 504 elite athletes.[7] An untold number of women competing at the lower levels of sport met a similar fate, or else abandoned competition altogether based on fears that they might not meet the standards for femaleness.

From the beginning, there were protests about the ethics, validity and reliability of the tests. By the early 1990s, objections had reached a fever pitch and, in May 1992, the IAAF announced an end to systematic chromosomal testing.[8] The IOC did the same in 1999. However, both organizations reserved the right to

examine athletes if someone were to "challenge" their femaleness. The ostensibly progressive protocol ultimately discriminates against women who do not look or perform in accordance with certain "feminine" ideals. This is what happened to South African runner Caster Semenya in 2009 and to Dutee Chand in 2014.

Caster Semenya and Dutee Chand

Just hours before Semenya cruised to victory in the finals of the 800-meter race at the 2009 World Championships in Athletics, the IAAF confirmed "concerns that she does not meet the requirements to compete as a woman."[9]

Never clarifying what those requirements were, officials requested Semenya abstain from competition. She obliged for a disquieting 11 months, during which experts worked to determine her sex.[10] She was noticeably slower upon returning to the track (although she won a silver medal in the women's 800 meter at the London Games in 2012), leading to speculation that she must have undergone some intervention to lower her testosterone. The IAAF's subsequent policy on hyperandrogenism bolstered those opinions.[11]

This new policy ruled any female athlete exhibiting 10 or more nanomoles of functional testosterone per liter of blood (which they consider the lower end of "normal" male range) ineligible for competition.[12]

Women could apply for reinstatement if they sufficiently reduced their testosterone levels below the 10 nanomole threshold. This can be done surgically, often through the removal of internal testes, with hormone-suppressing medication or through a combination of both. Women with androgen insensitivity syndrome are exempt from this policy.

These guidelines took the place of the earlier "gender verification policy." Indeed, the IAAF, IOC and affiliated federations erased all mention of sex-testing from their rule books and instead initiated the hormone test "to protect the health of the athlete."

It's worth noting that male athletes don't seem to need similar protection. There is no upper limit to the levels of natural testosterone allowed in their bodies. In fact, male athletes with low testosterone can apply for a "Therapeutic Use Exemption" that allows them to take medically prescribed steroids to augment their androgen levels.[13]

The Court of Arbitration for Sport's decision in Dutee Chand's case suspends, at least for the 2016 Olympic Games, any testing or exclusion of women on the basis of hyperandrogenism. This creates an incredible amount of interest in the performances of Chand and Semenya and, quite possibly, any female athlete who does not conform to the traditional standards of femininity.

Question of Testosterone Is Missing the Point

Dutee Chand did not win a medal in Rio, but Caster Semenya, who has grown increasingly faster in past months, is an odds-on favorite to take home the gold in the 800-meter race.

So does excess testosterone actually confer a competitive advantage?

My question is if it does, so what?

Elite sport is built on the back of inequality. We love the myth of a level playing field, but it doesn't exist. Of the 207 nations competing in Rio, 75 have never won a medal. Wealthy, powerful countries dominate the Olympic Games, while conflicted, war-torn, impoverished countries simply lack the resources to promote sport to the level that will produce Olympic champions. That's a clear disparity that raises little outcry.

But what we're talking about in the case of hyperandrogenism is an innate condition that potentially enhances athletic performance. And, as scientists are just beginning to understand, elite sport is riddled with similar endowments.

Researchers associate physical performance with over 200 different genetic variations. More than 20 of those variants relate to elite athleticism.[14] These performance-enhancing polymorphisms—PEPS—can affect height, blood flow, metabolic efficiency, muscle mass, muscle fibers, bone structure, pain threshold, fatigue resistance, power, speed, endurance, susceptibility to injury, psychological aptitude, and respiratory and cardiac functions, to name just a few.

We don't disqualify athletes with these types of predispositions. We celebrate them.

With seven Olympic medals, Finland's Eero Mäntyranta, for example, is among the all-time greats of Nordic skiing. It's a sport that requires incredible stamina—a trait assisted by an abundance of red blood cells, which carry oxygen to the muscles. That's why so many endurance athletes try to boost their hemoglobin by training at high altitudes, sleeping in altitude chambers, or through illegal measures like blood doping or taking a synthetic version of the hormone erythropoietin (EPO).

Mäntyranta, who died in 2013, didn't need any of that. He had a condition called primary familial and congenital polycythemia, associated with a variation in the EPOR gene, which caused his body to produce 65 percent more red blood cells than the average male. David Epstein, author of *The Sports Gene*, calls Mäntyranta's EPOR variant a "gold medal mutation."[15]

How is this different from a woman's body that naturally produces more testosterone? Why is primary familial and congenital polycythemia a genetic gift and hyperandrogenism a disqualifying curse? Unless athletic authorities want

to take on all conditions that might result in an unfair advantage—biological, genetic, social or otherwise—it seems arbitrary to focus on testosterone in female athletes.

Notes

1. Court of Arbitration for Sport, "CAS Suspends the IAAF Hyperandrogenism Regulations," July 27, 2016, www.tas-cas.org/fileadmin/user_upload/Media_Release_3759_FINAL.pdf.

2. Vanessa Heggie, "Testing Sex and Gender in Sports; Reinventing, Reimagining and Reconstructing Histories," *Endeavor* 34, no. 4 (2010): 157–163.

3. "Are Girl Athletes Really Girls?" *Life*, October 7, 1966, 63.

4. Mary Peters, *Mary P.: An Autobiography* (London: Paul, 1974), with Ian Wooldridge.

5. Eduardo Hay, "Sex Determination in Putative Female Athletes," *JAMA* 221, no. 9 (1972): 998–999.

6. María José Martínez-Patiño, "Personal Account: A Woman Tried and Tested," *Lancet* 366 (2005): S38.

7. Malcolm A. Ferguson-Smith and Elizabeth A. Ferris, "Gender Verification in Sport: The Need for Change?," *British Journal of Sports Medicine* 25, no. 1 (March 1991): 17–20.

8. Jaime Schultz, "Caster Semenya and the 'Question of Too': Sex Testing in Elite Women's Sport and the Issue of Advantage," *Quest* 63, no. 2 (February 2011): 228–243.

9. Quoted in Jaime Schultz, *Qualifying Times: Points of Change in U.S. Women's Sport* (Urbana: University of Illinois Press, 2014), 118.

10. "Rio Olympics 2016: Caster Semenya Ditches 400m to Focus on 800m," BBC Sport, August 5, 2016, www.bbc.com/sport/olympics/36991646.

11. International Association of Athletics Federations, "IAAF to Introduce Eligibility Rules for Females with Hyperandrogenism," IAAF News, April 12, 2011, www.iaaf.org/news/iaaf-news/iaaf-to-introduce-eligibility-rules-for-femal-1.

12. International Association of Athletics Federations, "IAAF Comments on Interim Award Issued by the CAS on the IAAF's Hyperandrogenism Regulations," IAAF News, July 27, 2015, www.iaaf.org/news/press-release/hyperandrogenism-regulations-cas-dutee-chand.

13. "Therapeutic Use Exemption," World Anti-Doping Agency, www.wada-ama.org/en/what-we-do/science-medical/therapeutic-use-exemptions.

14. Lisa M. Guth and Stephen M. Roth, "Genetic Influence on Athletic Performance," *Current Opinion in Pediatrics* 25, no. 6 (December 2014): 653–658.

15. David Epstein, *The Sports Gene: Talent, Practice, and the Truth about Success* (New York: Random House, 2014).

HYPERANDROGENISM AND WOMEN VERSUS WOMEN VERSUS MEN IN SPORT

A Q&A with Joanna Harper

Ross Tucker | 2016

Excerpted from Ross Tucker, "Hyperandrogenism and Women vs Women vs Men in Sport: A Q&A with Joanna Harper," *Science of Sport*, May 23, 2016, https://sportsscientists.com/2016/05/hyperandrogenism-women-vs-women-vs-men-sport-qa-joanna-harper. Reprinted with permission.

Below you will find what I think is a fascinating, exhaustive interview on hyperandrogenism in female athletes with Joanna Harper, who you will meet in the interview, but who describes herself as a "scientist first, an athlete second, and a transgender person third." Harper is unique in the sense that she speaks on this incredibly complex topic from all three aspects—science/physiology, performance and as a transgender person herself. She has been, and is, part of the various panels and groups that are exploring the issue, and so offers insights with authority and experience on what is likely to be one of Rio's, if not sport's, greatest ever controversies. [...]

I hope that you find it as enlightening as I did. My questions are in bold, Harper's answers in plain text. [...]

Perhaps to begin, you're the best person to introduce yourself, your history, your current involvement, and why you are both passionate and knowledgeable about these issues.

My name is Joanna Harper, and perhaps more than anyone on the planet, I live and breathe gender and sports. It is a world of science, human rights and athletic performance; it is complicated, controversial, contradictory and wonderful. Welcome to my world.

Science, sports and gender have always been the three cornerstones of my life, however, for most of my years they occupied distinct sectors within my existence.

I was doing fourth grade math before I started kindergarten, and as soon as I passed the Dick and Jane book stage, I started reading books about science. My love for science and my mathematical aptitude led me to a satisfying career as a medical physicist.

As a male-identified child growing up in Canada, it was expected that I would love hockey. I did not. On the other hand, I was good at a many less-violent sports, and by the time I reached adulthood, distance running became the sport to define me as an athlete.

It dawned on me fairly early in life that while I saw myself as a girl, others did not. This gender-based dissonance shaped the ways in which I interacted with the world, and eventually, led me to make some fairly serious changes in my life.

It was not, however, until after my gender transition that science, sports and gender came together for me. After I started on Hormone Replacement Therapy (a testosterone blocker and estrogen), my ability to run fast took a major hit. This unsettling loss of speed led me to examine the science of sports performance and how we look at gender within the sports world.

I became the only person ever to publish a scientific paper on transgender athletic performance. My study and my interests have opened some rather amazing doors for me; I am the only transgender person in history to be part of the team to advise the International Olympic Committee (IOC) on gender-based issues. [. . .]

And I'm very grateful for your willingness to speak up on it, as I hope readers will be too, irrespective of their opinion on this issue. I hope people can appreciate the unique perspective you bring as a result of the intersection of all the issues into one voice. And as we get into this, I just want to remind everyone reading that the objective is never to have the final word, but rather the first one, and so I hope that this interview ignites good discussion on this matter!

And on that note . . . Let's get to it . . . We have an issue that is clearly complex, and you've published on it (some of the science), you've advised on it (the legal, social & ethical component) and you've lived it (your own gender transition from male to female). We could attack it from any one of those directions, and we will, but maybe you can start by trying distill the matter as simply as possible, get to the heart of the matter?

For most of humanity's existence, sport was for men only. However, I would hope that it would be self-evident that one cannot have women's equality without women's sport. In order to make women's sport meaningful, women must compete only against other women, as they are overmatched by men at the highest levels of most sports.

Unfortunately, biology does not neatly divide human beings into two sexes. There are tens of millions of people on the planet who don't fit easily into our standard definition of male or female—they are either intersex or transgender. Intersex and transgender people have rights too, including the right to compete in sport. Many intersex or transgender athletes wish to compete in women's sport, since they see themselves as women.

And this is heart of the matter. How do we support and protect women's sport and, at the same time, honor the rights of a marginalized segment of humanity?

Ok, so let's go back to the beginning, as far as possible, to briefly learn the path that has led us to here. I'm well aware that the intention of the authorities has not always been noble, and cheating has entered the equation, but history holds some important lessons in this regard? [. . .]

While DNA hadn't been sequenced in the thirties, scientists knew about "hermaphrodites" back then. Prior to 1936, there were two intersex athletes who had competed as female and then changed to living as male—Mark (formerly Mary Louise Edith) Weston and Zdenek (formerly Zdenka) Koubkova—who were cited by Avery Brundage when he called for sex verification rules in 1936. At the time, the two intersex athletes of that era that are well-known in 21st century, Stella Walsh and Dora (later Heinrich) Ratjen, weren't on the radar.

Of course, what Brundage and others were really worried about was men invading women's sport. And that is still the case today. I have been accused of "really" being a man who wants to profit in women's sport, and there are several morons on the letsrun message board who continue to insist that Semenya is a man. Hence, the notion that 21st century followers of sport are more enlightened than those of the 1930s is seriously flawed.

The suggestion that men have ever cheated to get into women's sport is completely unfounded. Ratjen was intersex and the Press sisters [Soviet track stars Tamara and Irina Press] probably were too. In fact, there has never been a proven instance of any man ever competing in women's sport. But that has never stopped the accusations.

The furor that has erupted over the new IOC transgender guidelines that don't require surgery is just one more example of the continuing myth that men are somehow itching to invade women's sport. [. . .]

Just for readers to follow some of the more technical terms, "virile" basically means "of a man," which is to say, a person who has masculine characteristics. This is the result of androgenic hormones. If I'm playing devil's advocate (not for the last time—there'll be others), to what extent does a lot of this controversy exist simply because we react to women who do not conform to what society tells us is "normal" for women? We see masculine characteristics—muscle, strength, shape of the skeleton, perhaps we hear the deeper voice—and we infer performance, perhaps unfairly? I guess what I'm asking is whether our action should be driven by what we see, as opposed to what we measure (in the blood, or maybe with a stopwatch? Your testosterone levels are too high, your performances are too good?).

This is a very important point. The higher T levels of hyperandrogenic women cause virilization, and we can see this virilization in physical features that we

normally associate with men. But masculine features, by themselves, should not be used to label a woman. There are a wide range of appearances, and many women with typical female T levels have some masculine features. But when obvious signs of virilization are combined with unusual athletic performance, then it is reasonable to conclude that the athlete is possibly hyperandrogenic. It is a very fine line between legitimate determination of a high-T athlete and stigmatism based on stereotyping. Unfortunately, the press and public often use the obvious physical characteristics of some intersex athletes for cruel purposes.

I would also like to note that the HA rules had a reasonable process beyond the simple determination of high T values. If an athlete was suspected of being hyperandrogenic, then a blood sample was taken. If the sample confirmed high T, then the IAAF launched a thorough medical investigation to determine the cause of the HA. The IAAF would only require the athlete to lower her T if the investigation proved that she gained a large advantage from her high T. [. . .]

Ok, so an HA system was put in place. It no longer is. Let's complete the history that brings us to the present day.

The HA system wasn't perfect by any means. Many intersex activists thought it was wrong to force women to alter their bodies to compete in sports. Even some of the people who helped design the HA system thought it needed tweaking. Then, in 2014, an Indian sprinter named Dutee Chand was "outed" as intersex by people in her country. Her case attracted the attention of many human rights advocates. Her advisors convinced her to challenge the HA rules through the Court of Arbitration for Sport (CAS).

In July 2015, CAS issued a temporary ruling suspending the HA rules of the IAAF; the federation has two years from the time of the ruling to make a better case for the HA regulations or CAS will abolish them.

While human rights advocates are deliriously happy over the CAS ruling, those who love women's sport are mortified. Those intersex athletes who previously used medications to reduce their T are now off of those medications, and are running faster. Allowing these athletes to compete in women's sport with their serious testosterone-based advantage threatens the very fabric of women's sport.

Ok, so that's a super strong statement, perhaps the crux of your position on this specific issue. You're saying women's sport is threatened by the situation as it stands, and that's something I want to really interrogate. However, before that, I must ask you a more personal question, if I may? And to do that I want to just relate a short story for readers. When you and I "met," way back in 2009 around the time that Caster Semenya was a global story for this very issue, I found out a little bit about your background and before

you'd ever voiced an opinion to me on the participation of intersex individuals as women, I confess that I jumped to the wrong assumption that you would, by default, be of the opinion that any exclusion of females for any reason was wrong. I totally expected you to be on the side of this debate that argues that women should be allowed to self-identify and compete where they wish, as women, without any intervention. I'm the first to admit that I was wrong to do that.

But given that you've just nailed your colors to the mast about the testosterone policy, have you ever felt that you're going against the grain? Somehow betraying a "constituency"? I ask because other transgender athletes have placed themselves very, very firmly in the CAS/Dutee Chand camp, and I'm fascinated that you don't. And have you been criticized and condemned for taking this position? Or is yours a common position even among transgender individuals?

The transgender community is split over the question of whether or to use T or to use gender identity for eligibility for women's sport. But if you think of me as only a trans person, then you would miss much of what is important about me. I define myself as a scientist first, an athlete second and as a transgender person thirdly, and the vast majority of scientists support the HA rules.

I would also like to relate a two-part epiphany that I had after my transition. In 2005, nine months after starting HRT, I was running 12% slower than I had run with male T levels; women run 10–12% slower than men over a wide range of distances. In 2006 I met another trans woman runner and she had the same experience. I later discovered that, if aging is factored in, this 10–12% loss of speed is standard among trans women endurance athletes. The realization that one can take a male distance runner, make that runner hormonally female; and wind up with a female distance runner of the same relative capability was life-changing for me.

I would admit that I sometimes feel like a bit of an "Aunt Jemima" in the transgender community. I am, however, more deeply entwined with the athletics community than the transgender community, and many people in the sports world still feel that it is wrong to allow transgender or intersex women into women's sport under any conditions. Hence, I am condemned by people in both the running and the transgender community for my middle-ground opinions. [. . .]

I want to ask you a couple of questions arising out of that answer. First, you've said "your middle-ground opinion." Correct me if I'm wrong—the two extreme opinions would be:

1. Allow all athletes to compete where they wish, as females, with no regulation.

2. No intersex individuals should be allowed to compete as women

Perhaps this is a good time to define what "middle ground" means to you, especially given that you mentioned earlier that allowing the participation of "athletes in sport with their serious testosterone-based advantage threatens the very fabric of women's sport." What is the fine print that pulls your view back to the middle, is what I'm asking?

First of all, to your first extreme option, I'd say, "allow all athletes to compete where they wish, as females, with no regulation of naturally produced advantages." And to the second option, I'd add transgender to the intersex category.

That out the way, I don't think that either of the "extreme" points of view are totally unreasonable if one understands the individuals who believe them.

If one believes that women's sports are vitally important, and one has little regard for the rights of a small segment of humanity, then suggesting that women's sport should only be for those who are 100% female is not unreasonable.

On the other hand, if one is passionate about the rights of marginalized minorities such as intersex or transgender women, and one is not as invested in the benefits of sport to all women, then it is not unreasonable to suggest that anyone who considers herself female should be allowed to compete as nature made her.

Since I believe in both the vital importance of women's sport and the rights of intersex and transgender women, then I am forced to consider a compromise position, one virtually identical to that espoused by the IAAF and the IOC.

Both of the "extreme" arguments are simple to explain and defend, often passionately. It is much harder to inspire passion over a compromise position that is painstakingly put together by a committee of divergent views. But this compromise position has been embraced by many people who value well-reasoned logic.

Now let's look at the epiphany you mentioned. You change your T from male to female levels, and pretty much immediately, you're 10 to 12% slower. Then you meet others, and that's the origin of your paper on this issue. That obviously gave you a personal experience, married to science (backed by theory), for your position. Is there any chance that for some, this performance change doesn't happen? That say, Maria Patino with AIS [androgen insensitivity syndrome] had very high testosterone levels, but got no such 10 to 12% advantage because her cells couldn't use the testosterone? I guess this is what [medical researchers] La Chapelle and Ljungqvist might have argued in her defense.

How does one deal with this category of individuals? Should we even try to manage a condition that creates a continuum of physiological outcomes rather than a binary one? Or is it about the principle of advantage, not the marginal scale? And let's say that many intersex individuals we see now are in the category of having the androgenic hormone but being unable, or less able, to use it—are they not in danger of being wrongly grouped with those who do benefit from testosterone?

Clearly, those with insensitivity to androgens have to be dealt with differently than everyone else. And to make matters more complex, some are partially insensitive to T. Making rules for those with PAIS [partial androgen insensitivity syndrome] is extraordinarily difficult, and I really don't want to get into the complexities involved. So, yes if one creates rules based on testosterone levels, or if one went back to chromosome-based rules, or even rules that were based on whether or not someone possesses testes, then people with resistance to androgens must be in their own little category.

OK, so let's look ahead a little bit. Rio, less than 100 days away, and already this year Caster Semenya, perhaps the most famous case of the intersex controversy, has run some eye-popping times (all on one day) and has returned to world-class levels having really drifted back in the last three years. There is so much allegation and suspicion over her (what changed?) and to be fair, a few other athletes too. How do you see this playing out on the Olympic stage?

I fear that that much of the anticipation for the upcoming Rio Olympics will be overshadowed by the specter of intersex athletes dominating some events in women's athletics, the premier sport of the games. It is also unfortunate that many people will blame the medal-winning intersex athletes whose only crime is to compete with the gifts that nature gave them. The real problem is that sports need some policy governing intersex athletes and currently there is none.

I want to dissect that a little more—you've mentioned the possibility that intersex athletes will dominate some events. I've heard, from some quarters, the accusation that this is "scare-mongering," that it's really just one or two athletes, and that they should be celebrated for gifts they are born with in the same way we celebrate Usain Bolt for his. So two questions. First, do you see this situation being prevalent enough to matter, or is one athlete in one event enough? How big might it be? And second, what is your take on the [argument] "elite sport is elite, and these athletes are 'lucky' in some kind of genetic lottery, so let them compete, just like we allow Bolt, or 6'10" basketballers to dominate"?

While Caster Semenya has gotten most of the media attention, she is far from the only presumably intersex athlete to have competed at a very high level in

athletics. In fact, two of the three medalists in the 800-meter race at the recent indoor world championships are probably intersex. It is very possible that we could see an all intersex podium in the 800 in Rio, and I wouldn't be surprised to see as many as five intersex women in the eight-person final. There are potential intersex medalists in other running events too. The mutations that we are talking about are very rare, and these women are hugely over-represented.

I think that comparing intersex women to extraordinarily tall basketball players misses a key point. It is not important to protect shorter male "ballers" from taller ones. It is fundamentally important to protect female athletes from those athletes who undergo male-type puberty. The most essential element of women's sport is that it is practiced by testosterone-challenged athletes. Even the CAS panel that suspended the IAAF's HA regulations "has accepted that testosterone is the best indicator of performance difference between male and female athletes."

I believe that you called the HA regulations "an imperfect solution to a complex problem" and I whole-heartedly agree. I don't, however, believe that in 2016 we have a better solution for the problem of determining who should be allowed to compete in women's sport. Furthermore, I believe that billions of potential female athletes deserve the right to compete with some semblance of a level playing field, and that requiring all women to compete within a given testosterone range is the best way we currently have to create such a playing field.

I want to go back to something you said previously: "And this is heart of the matter. How do we support and protect women's sport and, at the same time, honor the rights of a marginalized segment of humanity?"

What would you say to the following argument? "It's a simple numbers game—the number of women affected by the exclusion of intersex/hyperandrogenic individuals is relatively tiny. The number of women affected by their *inclusion* is much, much higher. That is, if it is about protection, then you protect more women by restricting (or perhaps regulating through testosterone) the participation of intersex individuals than by removing the testosterone (or alternative) limit." Is that a justified position, in your opinion?

While there is some validity to the argument that the rights of the many outweigh the rights of the few, I would counter that we can still maintain the integrity of women's sport if we allow only those intersex and transgender women who compete with typical female T levels into women's sport. Any advantages that intersex or transgender women might still maintain after lowering their T are small enough that they will not create an overly unbalanced playing field.

And then how about this one, which is me adopting the completely opposing position, but I do so to gauge your feeling on it:

"The participation of intersex or hyperandrogenic individuals in sport without requiring medical interventions, as Dutee Chand argued at CAS, is a human right. Or rather, it's a human right to be identified and compete (live, in a sporting sense) as a woman without needing any treatment. The participation and possible success of other women in sport is not a human right, and one person's rights in this instance supersede another. So it's not about numbers, as my previous question suggests, but rather that 'right' is right no matter how few or many people it affects in sport."

What would you say to that?

I would suggest that Dutee Chand, or anyone else who sees themselves as a woman, should be allowed to live as one. I believe that social gender should be entirely determined by self-identification. I was proud to be part of the IOC panel that recommended support for gender self-identification.

I do, however, support the right of athletic federations such as the IOC or IAAF to create a de facto athletic gender by preventing those athletes who carry a large testosterone-based advantage from competing against the vast majority of women.

I would further suggest that, while it might not be a right, success in sports is one of the greatest advancements in women's lives. If we value women's equality, it is imperative that we protect the ability of all women to succeed in sports.

What's the worst that could happen from here? Maybe there are two levels at which I can ask this question. First, we already discussed the upcoming Olympics and you pointed out that the Games may be overshadowed by the specter of intersex athletes, with blame and unfair accusation on those athletes. So scenario 1 is to look beyond the Games, maybe 5 years from now, perhaps even further, to three generations from now. Does women's sport look totally different if the status quo is retained—the end of women's sport as we know it, as some have said? Or is that too dramatic? What are we headed towards in women's sport? And then the second level, does that look different in sport compared to society? I guess I'm asking you to predict the range of possible outcomes, assuming the status quo remains as it is now.

There are a couple of very bad scenarios that are possible if there is no regulation of naturally produced advantages for female athletes. Some background information is necessary in order to understand the first undesirable outcome. There are a variety of intersex conditions or DSDs (differences of sexual development). The DSD that probably imparts the largest athletic advantage is called 5-alpha reductase deficiency or 5-ARD. Children born with 5-ARD have a Y chromosome, but have a deficiency in the enzyme that is used to convert testosterone to dihydrotestosterone or DHT. In turn, DHT is responsible for the development of external male genitalia, hence babies with 5-ARD are often assigned female

gender at birth. After puberty, girls with 5-ARD have T in the low-normal male range, and hence have a huge athletic advantage over other women.

5-ARD is extremely rare in the general population, but there are isolated pockets around the world where it is not uncommon. 5-ARD is an autosomal recessive condition, and so both parents must carry the gene for it in order for a child to be affected. In those remote areas where 5-ARD and consanguinity (inbreeding) are both common, a significant percentage of the population will carry the gene for 5-ARD. Given the globalization of sport, it is possible that those interested in developing the next generation of women's sports stars will look to these areas to find girls with 5-ARD, and aid in their athletic progress. This would be an extremely bad scenario for the rest of the women in the world who care about sporting success.

The other undesirable scenario I foresee is that transgender women might also be allowed to compete with unaltered testosterone levels. Most trans women desperately want to lower their T levels, but a minority of trans women would be willing to compete against other women with male levels of testosterone. I have seen other trans women argue that if intersex women can compete unaltered, then we should get to do the same thing. This would be a nightmare, not only for the world's female athletes, but also for those trying to increase acceptance for trans people everywhere.

Final question, and thanks again so much for your time. I really expect your thoughts to make a significant impact, shedding a lot of light on this issue. What's the solution? You've said, and I agree 100% with you, that the IAAF's previous position is "virtually identical" to the compromise position you'd espouse. That position is now gone, wiped away by CAS' decision unless they can provide evidence of unfair advantage with hyperandrogenism. My personal feeling is that they won't be able to provide this—the law and science don't co-operate the way people would like or expect—so I want to find out whether a) you'd agree with me on that, and if so, then b) what is the process from here? Will it take a different approach? Is this how sport is destined to be run, with no policy? What are you going to be involved in over the coming months (assuming you can talk about it?) and how does this get resolved, if at all?

The CAS decision in the Chand case is a temporary one; the IAAF and their lawyers are working to reverse that verdict. Since I am involved with the case, I will have no further comment on it. If the IAAF ultimately loses the case, I believe they will try to come up with some other way to place limits on who gets to compete in women's sport. I don't care to speculate publicly on what that method might be.

ON THE TEAM *Equal Opportunity*
for Transgender Student Athletes

Pat Griffin and Helen J. Carroll | 2010

Excerpted from Pat Griffin and Helen J. Carroll, "On the Team: Equal Opportunities for Transgender Student Athletes," a report cosponsored by the National Center for Lesbian Rights and It Takes a Team!, an initiative of the Women's Sports Foundation, October 4, 2010.

What Does Transgender Mean?

"Transgender" describes an individual whose gender identity (one's internal psychological identification as a boy/man or girl/woman) does not match the person's sex at birth. For example, a male-to-female (MTF) transgender person is someone who was born with a male body, but who identifies as a girl or a woman. A female-to-male (FTM) transgender person is someone who was born with a female body, but who identifies as a boy or a man.[1]

Some transgender people choose to share the fact that they are transgender with others. Other transgender people prefer to keep the fact that they transgender private.

It is important that other people recognize and respect the transgender person's identification as a man or a woman. In order to feel comfortable and to express their gender identity to other people, transgender people may take a variety of steps: changing their names and self-referencing pronouns to better match their gender identity; choosing clothes, hairstyles, or other aspects of self-presentation that reflect their gender identity; and generally living, and presenting themselves to others, consistently with their gender identity. Some, but not all, transgender people take hormones or undergo surgical procedures to change their bodies to better reflect their gender identity.

Some people are confused by the difference between transgender people and people who have intersex conditions. The key feature of being transgender is having a psychological identification as a man or a woman that differs from the person's sex at birth. Apart from having a gender identity that is different than their bodies, transgender people are not born with physical characteristics that distinguish them from others. In contrast, people with intersex conditions (which may also be called "Differences of Sex Development"), are born with

physically mixed or atypical bodies with respect to sexual characteristics such as chromosomes, internal reproductive organs and genitalia, and external genitalia.[2] An estimated one in 2,000 people are born with an anatomy or chromosome pattern that doesn't seem to fit typical definitions of male or female. The conditions that cause these variations are sometimes grouped under the terms "intersex" or "DSD" (Differences of Sex Development).[3]

Most people with intersex conditions clearly identify as male or female and do not have any confusion or ambiguity about their gender identities. In fact, most intersex conditions are not visible, and many intersex people are unaware of having an intersex condition unless it is discovered during medical procedures. Though there may be some similar issues related to sports participation between transgender and intersex individuals, there are also significant differences. This report will focus on the participation of transgender people in sports.

Why Must We Address Transgender Issues in School Athletic Programs?

Educators must address transgender issues in athletics for several reasons. First and foremost, core values of equal opportunity and inclusion demand that educational leaders adopt thoughtful and effective policies that enable all students to participate fully in school athletic programs. Over the course of many years, schools have learned and continue to appreciate the value and necessity of accommodating the sport participation interests of students of color, girls and women, students with disabilities, and lesbian, gay, and bisexual students. These are all issues of basic fairness and equity that demand the expansion of our thinking about equal opportunity in sports. The right of transgender students to participate in sports calls for similar considerations of fairness and equal access.

Additionally, as more states, localities, and schools add gender identity and expression to their non-discrimination policies, and as more courts hold that sex discrimination laws protect transgender people, transgender students and their parents are increasingly empowered to insist that athletic programs accommodate transgender students. To avoid decision-making that perpetuates discrimination, school leaders must be proactive in adopting policies that are consistent with school non-discrimination policies and state and federal laws prohibiting discrimination based on gender identity or expression.

Though the number of transgender students is small, research indicates that their number is growing.[4] As the number of people who come out as transgender as teenagers and children increases, so too do the numbers of parents who support their transgender children and advocate for their rights to safety and

fair treatment in schools. In response to these demands, K-12 school and college leaders must be prepared to accommodate the educational needs and protect the rights of trans-identified students.

To respond to these realities, sport governing organizations and individual schools are well advised to proactively adopt policies that provide equal opportunities for transgender students to participate on school sports teams. Moreover, in the spirit of encouraging sports participation for all, it is the right thing to do.

In order to design effective policies, educators must understand that gender is a core part of everyone's identity and that gender is more complex than our society generally acknowledges.

Learning about the experience of transgender people can help us to see more clearly how gender affects all of our lives, and to put that knowledge into practice in order to better serve all students.

Addressing the needs of transgender students is an important emerging equal opportunity issue that must be taken seriously by school leaders. Because a more complex understanding of gender may be new and challenging for some people, there is a danger that misinformation and stereotypes will guide policy decisions rather than accurate and up-to-date information. Athletic leaders who are charged with policy development need guidance to avoid inscribing misconceptions and misinformation in policies that, ultimately, create more problems than they solve.

Why Focus on High School and College Athletics?

Providing equal opportunities in all aspects of school programming is a core value in education. As an integral part of educational institutions, high school and college athletic programs are responsible and accountable for reflecting the goals and values of the educational institutions of which they are a part. It follows that school athletic programs must reflect the value of equal opportunity in all policies and practices.

Athletic programs affiliated with educational institutions have a responsibility, beyond those of adult amateur or professional sports programs, to look beyond the value of competition to promote broader educational goals of participation, inclusion, and equal opportunity. Because high schools and colleges must be committed to those broader educational goals, they should not unthinkingly adopt policies developed for adult Olympic and professional athletes. Recognizing the need to address the participation of transgender athletes, a few leading international and professional sport governing organizations have developed policies based on overly stringent, invasive, and rigid medical requirements.

These policies are not workable or advisable for high school and college athletes for a number of reasons.

For example, in 2004 the International Olympic Committee (IOC) developed a policy addressing the eligibility of transgender athletes to compete in IOC sanctioned events.[5] While the IOC deserves credit for its pioneering effort to address the inclusion of transgender athletes, medical experts have identified serious flaws in the IOC policy, especially its requirement of genital reconstructive surgery, which lacks a well-founded medical or policy basis. Most transgender people—even as adults—do not have genital reconstructive surgery.[6] In addition, whether a transgender person has genital reconstructive surgery has no bearing on their athletic ability. The IOC policy also fails to provide sufficient protections for the privacy and dignity of transgender athletes. Because of these serious flaws, high schools and colleges should not adopt or look to the IOC policy as a model.[7]

There are additional reasons for high schools and colleges to create their own policies rather than adopt policies developed for adults. High school- and college-aged student athletes have developmental needs that differ from those of adults. For example, a core purpose of high school and college is to teach students how to participate and be good citizens in an increasingly diverse society and how to interact respectfully with others. In addition, high school and college athletic programs impose limits on how many years a student athlete can compete that do not exist in adult sporting competitions, where athletes can compete as long as their performances are viable or, in the case of most amateur sports, as long as they wish to.

It is also advisable that high school athletic programs adopt a different policy for including transgender student athletes than college athletic programs. Specifically, this report recommends that high schools permit transgender athletes to play on teams consistent with the student's gender identity, without regard to whether the student has undertaken any medical treatment. In contrast, the report recommends a more nuanced policy for collegiate athletics that is based, in part, upon whether a student athlete is undergoing hormone therapy.

The need for distinct high school and collegiate policies is based on several considerations. First, in high school settings, students are guaranteed the availability of a high school education and a corresponding opportunity to participate equally in all high school programs and activities. At the high school level, the focus should be on full participation in athletics for all students, within the limits of school resources to provide participation opportunities.

Second, intercollegiate sports are governed differently than high school sports. Intercollegiate athletics are regulated nationally by governing bodies that spon-

sor national competitions and oversee such functions as the random testing of student athletes for the use of banned substances thought to enhance athletic performance. Because testosterone is a banned substance under the current rules for intercollegiate competition, the inclusion of transgender student athletes in college sports must be consistent with those rules.

Third, high school student athletes are still growing and developing physically, cognitively, and emotionally. Because high school–aged students are still growing and maturing, they present a broader range of physical characteristics than collegiate student athletes do, and these differences should be taken into account in developing a policy for high school students.

Finally, high school-aged and younger transgender students are subject to different medical protocols than adults because of their age and physical and psychological development.[8] The World Professional Association for Transgender Health (WPATH) has established guiding medical protocols for transitioning—the process by which a transgender person lives consistently with their gender identity—which may include treatments to have the person's physical presentation more closely align with their identity. Those protocols vary based on the age and psychological readiness of the young person.[9] For children and youth, transition typically consists entirely of permitting the child to dress, live, and function socially consistently with the child's gender identity.

For youth who are approaching puberty, hormone blockers may be prescribed to delay puberty in order to prevent the youth from going through the traumatic experience of acquiring secondary sex characteristics that conflict with his or her core gender identity. For older youth, cross-gender hormones or even some sex-reassignment surgeries may be prescribed.

All of these factors point to the need to develop policies for the inclusion of transgender student athletes in high school and college programs that take the relevant differences between the two settings into account. In the high school and college policies recommended below, we have attempted to take account of these differences.

Should the Participation of Transgender Student Athletes Raise Concerns about Competitive Equity?

Concern about creating an "unfair competitive advantage" on sex-separated teams is one of the most often cited reasons for resistance to the participation of transgender student athletes. This concern is cited most often in discussions about transgender women or girls competing on a women's or girls' team. Some advocates for gender equality in high school and college sports are concerned

that allowing transgender girls or women—that is, male-to-female transgender athletes, who were born male but who identify as female—to compete on women's teams will take away opportunities for other girls and women, or that transgender girls or women will have a competitive advantage over other non-transgender competitors.

These concerns are based on three assumptions: one, that transgender girls and women are not "real" girls or women and therefore not deserving of an equal competitive opportunity; two, that being born with a male body automatically gives a transgender girl or woman an unfair advantage when competing against non-transgender girls and women; and three, that boys or men might be tempted to pretend to be transgender in order to compete [. . .] with girls or women.

These assumptions are not well founded. First, the decision to transition from one gender to the other—to align one's external gender presentation with one's internal sense of gender identity—is a deeply significant and difficult choice that is made only after careful consideration and for the most compelling of reasons. Gender identity is a core aspect of a person's identity, and it is just as deep seated, authentic, and real for a transgender person as for others. Male-to-female transgender women fully identify and live their lives as women, and female-to-male transgender men fully identify and live their lives as men. For many transgender people, gender transition is a psychological and social necessity. It is essential that educators in and out of athletics understand this.

Second, while some people fear that transgender women will have an unfair advantage over non-transgender women, it is important to place that fear in context. When examined carefully, the realities underlying this issue are more complex than they may seem at first blush. The basis of this concern is that transgender girls or women who have gone through male puberty may have an unfair advantage due to the growth in long bones, muscle mass, and strength that is triggered by testosterone. However, a growing number of transgender youth are undergoing medically guided hormonal treatment prior to puberty, thus effectively neutralizing this concern. Increasingly, doctors who specialize in treating transgender people are prescribing hormone blockers to protect children who clearly identify as the other gender from the trauma of undergoing puberty in the wrong gender and acquiring unwanted secondary sex characteristics. When the youth is old enough to make an informed decision, he or she can make the choice of whether to begin cross-gender hormones. Transgender girls who transition in this way do not go through a male puberty, and therefore their participation in athletics as girls does not raise the same equity concerns that might otherwise be present.

In addition, even transgender girls who do not access hormone blockers or cross-gender hormones display a great deal of physical variation, just as there is a great deal of natural variation in physical size and ability among non-transgender girls and boys. Many people may have a stereotype that all transgender girls and women are unusually tall and have large bones and muscles. But that is not true. A male-to-female transgender girl may be small and slight, even if she is not on hormone blockers or taking estrogen. It is important not to over generalize. The assumption that all male-bodied people are taller, stronger, and more highly skilled in a sport than all female-bodied people is not accurate.[10] This assumption is especially inaccurate when applied to youth who are still developing physically and who therefore display a significantly broader range of variation in size, strength, and skill than older youth and adults.[11]

It is also important to know that any athletic advantages a transgender girl or woman arguably may have as a result of her prior testosterone levels dissipate after about one year of estrogen therapy. According to medical experts on this issue, the assumption that a transgender girl or woman competing on a women's team would have a competitive advantage outside the range of performance and competitive advantage or disadvantage that already exists among female athletes is not supported by evidence.[12] As one survey of the existing research concludes, "the data available does not appear to suggest that transitioned athletes would compete at an advantage or disadvantage as compared with physically born men and women."[13]

Finally, fears that boys or men will pretend to be female to compete on a girls' or women's team are unwarranted given that in the entire 40 year history of "sex verification" procedures in international sport competitions, no instances of such "fraud" have been revealed.[14] Instead, rather than identifying men who are trying to fraudulently compete as women, "sex verification" tests have been misused to humiliate and unfairly exclude women with intersex conditions.[15] The apparent failure of such tests to serve their stated purpose of deterring fraud—and the terrible damage they have caused to individual women athletes—should be taken into account when developing policies for the inclusion of transgender athletes.

Rather than repeating the mistakes of the past, educators in high school and collegiate athletics programs must develop thoughtful and informed policies that provide opportunities for all students, including transgender students, to participate in sports. These policies must be based on sound medical science, which shows that male-to-female transgender athletes do not have any automatic advantage over other women and girls. These policies must also be based on the educational values of sport and the reasons why sport is included

as a vital component of the educational environment: promoting the physical and psychological well-being of all students, and teaching students the values of equality, participation, inclusion, teamwork, discipline, and respect for diversity.

What Are the Benefits of Adopting Inclusive Policies and Practices regarding Transgender Student Athletes?

All stakeholders in high school and collegiate athletics will benefit from adopting fair and inclusive policies enabling transgender student athletes to participate on school sports teams. School-based sports, even at the most competitive levels, remain an integral part of the process of education and development of young people, especially emerging leaders in our society. Adopting fair and inclusive participation policies will allow school and athletic leaders to fulfill their commitment to create an environment in which all students can thrive, develop their full potential, and learn how to interact with persons from diverse groups.

Many schools and athletic departments identify diversity as a strength and have included sexual orientation and gender identity/expression in their non-discrimination policies. Athletic departments and personnel are responsible for creating and maintaining an inclusive and non-discriminatory climate in the areas they oversee. Adopting inclusive participation policies provides school athletic leaders with a concrete opportunity to fulfill that mandate and demonstrate their commitment to fair play and inclusion.

Moreover, when all participants in athletics are committed to fair play, inclusion, and respect, student athletes are free to focus on performing their best in athletic competition and in the classroom. This climate promotes the well-being and achievement potential of all student athletes. Every student athlete and coach will benefit from meeting the challenge of overcoming fear and prejudice about social groups of which they are not members. This respect for difference will be invaluable to all student athletes as they graduate and enter an increasingly diverse workforce in which knowing how to work effectively across differences is a professional and personal asset.

What Are Harmful Potential Consequences of Failure to Adopt Transgender-Inclusive Policies and Practices?

When schools fail to adopt inclusive participation policies, they are not living up to the educational ideals of equality and inclusion, and may reinforce the

image of athletics as a privileged activity not accountable to broad institutional and societal ideals of inclusion and respect for difference. Moreover, this failure puts schools, athletic conferences, and sport governing organizations at risk of costly discrimination lawsuits and negative media attention.

Failing to adopt transgender-inclusive participation policies is hurtful to and discriminates against transgender students because they may be denied the opportunity to participate in school sports. School sports programs are integral parts of a well-rounded education experience. The benefits of school sports participation include many positive effects on physical, social, and emotional well-being. All students, including those who are transgender, deserve access to these benefits.[16]

Failure to adopt inclusive participation policies also hurts non-transgender students by conveying a message that the values of non-discrimination and inclusion are less important than values based on competition and winning. Schools must model and educate about non-discrimination values in all aspects of school programming, not only for students, but for parents and community members as well.

Last but not least, failure to adopt policies that ensure equal opportunities for transgender student athletes may also result in costly and divisive litigation. A growing number of states and localities are adopting specific legal protections for transgender students. In addition, state and federal courts are increasingly applying sex discrimination laws to prohibit discrimination against transgender people.

Several studies show that schools are often hostile places for transgender students and other students who do not conform to stereotypical gender expectations.[17] These students are frequently subjected to peer harassment and bullying, which stigmatizes and isolates them. This mistreatment can lead to feelings of hopelessness, depression, and low self-esteem. When a school or athletic organization denies transgender students the ability to participate in sports because of their gender identity or expression, that condones, reinforces and affirms their social status as outsiders or misfits who deserve the hostility they experience from peers.

Finally, the absence of transgender-inclusive policies and practices reinforces stereotypes and fears about gender diversity. When transgender students are stigmatized and excluded, even non-transgender students may experience pressure to conform to gender-role stereotypes as a way to avoid being bullied or harassed themselves.

Notes

Note numbers and callouts have been changed from the original article.

1. Gender Spectrum, "A Word about Words," available online at http://www .genderspectrum.org/images/stories/Resources/Family/A_Word_About_Words.pdf.

2. Intersex Society of North America, "What's the Difference between Being Transgender or Transsexual and Having an Intersex Condition?" Available online at http://www.isna.org/faq/transgender.

3. Advocates for Informed Choice, General Brochure, available online at http:// aiclegal.files.wordpress.com/2010/02/aic-brochure.pdf.

4. See, e.g., Emily A. Greytak, Joseph G. Kosciw, and Elizabeth M. Diaz, Gay Lesbian Straight Education Network, *Harsh Realities: The Experiences of Transgender Youth in Our Nation's Schools* (2009). Available online at http://www.glsen.org/binary -data/GLSEN_ATTACHMENTS/file/000/001/1375-1.pdf. Despite this evidence of growing numbers, the decision to provide equal opportunity should not be based on the number of transgender students who want to play sports. Even the smallest minority of students deserves the opportunity to participate in all school-sponsored programs.

5. International Olympic Committee, *Statement of the Stockholm Consensus on Sex Reassignment in Sport* (2003), http://www.olympic.org/Documents/Reports/EN /en_report_905.pdf.

6. Lisa Mottet, National Gay and Lesbian Task Force Policy Institute, and National Center for Transgender Equality, "Preliminary Findings of the National Transgender Discrimination Survey" (2010).

7. Alice Dreger, "Sex Typing for Sport," Hastings Center Report (March–April 2010).

8. Stephanie Brill and Rachel Pepper, *The Transgender Child: A Handbook for Families and Professionals* (San Francisco: Cleis Press, 2008).

9. World Professional Association for Transgender Health, *The Harry Benjamin International Gender Dysphoria Association's Standards of Care for Gender Identity Disorders, Sixth Version* (2001). Available online at http://www.wpath.org/documents2 /socv6.pdf.

10. In addition, what counts as a competitive advantage may shift dramatically depending on the sport. What is an advantage in one context may be a disadvantage in another. For example, factors such as height, weight, reaction time, and proportion of fast-twitch muscle fibers all affect competitive advantage depending on the sport. A female volleyball player may be very tall, and yet few people would consider that to be an unfair competitive advantage in her sport. Similarly, a male swimmer may have a naturally high hemoglobin count enabling him to take in more oxygen, but he is not barred from swimming for that reason. Sarah Teetzel, "On Transgendered Athletes, Fairness and Doping: An International Challenge," *Sport in Society: Cultures, Commerce, Media, Politics,* 1743–0445, Volume 9, Issue 2 (2006), Pages 227–251.

11. Assuming that boys have an automatic advantage over girls is particularly false with respect to prepubescent children, where gender plays virtually no role in determining relative athletic ability. For that reason, we strongly recommend that

school and recreational sports adopt the policy recommended by the Transgender Law and Policy Institute and endorsed by Gender Spectrum. Transgender Law and Policy Institute, *Guidelines for Creating Policies for Transgender Children in Recreational Sports* (2009).

12. Brenda Wagman, Promising Practices: Working with Transitioning/ Transitioned Athletes in Sport Project, AthletesCAN, Canadian Association for the Advancement of Women in Sport, and the Canadian Centre for Ethics in Sport, *Including Transitioning and Transitioned Athletes in Sport: Issues, Facts and Perspectives* (2009). Available online at http://www.caaws.ca/e/resources/pdfs/Wagman _discussion_paper_THE_FINAL.pdf.

13. Michaela C. Devries, "Do Transitioned Athletes Compete at an Advantage or Disadvantage as Compared with Physically Born Men and Women: A Review of the Scientific Literature" (May 18, 2008). Including Transitioning and Transitioned Athletes, supra note 13. Available online at http://www.caaws.ca/e/resources/pdfs /Wagman_discussion_paper_THE_FINAL.pdf.

14. Erin Buzuvis, "Caster Semenya and the Myth of the Level Playing Field." *Social Science Research Network* (2009). Available online at http://papers.ssrn.com/sol3 /papers.cfm?abstract_id=1521674.

15. Joe Leigh Simpson et al, "Gender Verification in the Olympics," *JAMA* (2000); 284: 1568–1569; see also Sex Typing for Sport, *supra* note 8.

16. Kirk Mango, "The Benefits of Competitive Athletic Sports Participation in Today's Sports Climate," *Chicago Now* (February 16, 2010). Available online at http:// www.chicagonow.com/blogs/athletes-sports-experience/2010/02/the-benefits-of -competitive-athletic-sports-participation-in-todays-sports-climate.html.

17. Harsh Realities, *supra* note 3.

PART V *Athletes Performing Masculinities and Femininities*

Part 5 explores a central issue in the history of women in sport. Historically, sport has been what scholars call a "male preserve," that is, a place where boys and men could cultivate, perform, and prove their masculinity. What message does that convey to girls and women who want to play sports and, in turn, to the greater society about sportswomen? Do women become less feminine, less womanly, when they take up sport? Or are women who gravitate toward sport, especially more successful athletes, less feminine to begin with? Any answer to these questions must first grapple with the issue of what, exactly, the terms *masculine* and *feminine* mean.

As editors, our perspective is that sport is neither inherently masculine nor inherently feminine. Sports are games that require, nourish, and reward a variety of human qualities within both women and men. But the fact that popular perceptions of sport as masculine have made women's athletic involvement controversial suggests that there are larger issues at stake. After all, what does it matter if women take on culturally defined masculine qualities like strength, speed, power, or unconcealed ambition, qualities men are rewarded for on and off the playing fields? The persistent social, cultural, and political resistance to women's full and equitable participation in sport shows that it does matter.

At least two issues are at stake here. First, there is the threat to the traditional social and cultural practice of differentiating *woman* from *man* by assigning a cluster of descriptors to each sex, with the expectation that every woman will be feminine and every man masculine. The effects of this threat can be seen in

the All-American Girls Professional Baseball League's rules of conduct, which reveal a cultural concern for sportswomen's potential loss of femininity. A careful look at the list of required and prohibited behaviors provides useful insight into midcentury beliefs about gender and sport. If a woman can be too masculine, perhaps even more masculine than the man who disdains sports and prefers cooking over football, for instance, then what do these categories really mean? If culturally assigned norms of gender have no necessary association with biological sex, then we must ask what gender really describes and what purpose it serves. If we argue that gender is an erroneous assignment of human attributes to two falsely dichotomized biological classes, the so-called opposite sexes, then why preserve the categories of masculinity and femininity at all?

AAGBL rules may have required women to "look like girls," but did those high-caliber players also "throw like girls"? This insult has been used to denigrate girls and women and, even more, boys and men, throughout the history of sport. Is there any truth to the idea that the "effeminate" way of throwing is rooted in biology? Or is "throwing like a girl" just a myth? Jenn Savedge sets out to answer this question in the second reading in this part.

"Insulting male athletes for playing 'too womany,'" argue law professors Joanna L. Grossman and Deborah L. Brake, "is an ungrammatical variation on an old theme, the time-tested insult that a boy 'throws like a girl.'" The prevalence of "feminine" insults in sport reminds us that it is a gendered institution that continues to privilege a particular version of masculinity, one that may cause "collateral damage," such as violence, aggression, and sexual assault. "Learning to respect all athletes, both male and female," the authors argue, "could go a long way toward inoculating male athletes against the more problematic aspects of male sports culture."

The threat, real or imagined, that sport presents to conventional femininity remains an issue for today's collegiate sportswomen, even as they revel in the physical power and personal confidence they have developed through athletic engagement. That much is evident in some of the interview responses Vikki Krane and colleagues record in "Living the Paradox," which explores how female athletes reconcile conflicting social expectations surrounding femininity and athleticism. Jaime Schultz raises some of these same themes in "Something to Cheer About?" as she discusses the history of cheerleading's transition from a male-dominated activity to a feminized auxiliary to men's sports to, more recently, a (contested) sport in its own right. Part 5 thus raises the twin issues of gendered difference and power, themes that will reappear throughout the book because they are so fundamental to the experience of sport in the United States

ALL-AMERICAN GIRLS PROFESSIONAL BASEBALL LEAGUE RULES OF CONDUCT, 1943–1954

All-American Girls Professional Baseball League | 1943

From the official website of the AAGPBL Players Association, www.aagpbl.org/index.cfm/pages/league/18/league-rules-of-conduct.

The Rules of Conduct for Players as Set Up by the All-American Girls Professional Baseball League

The management sets a high standard for the girls selected for the different clubs and expects them to live up to the code of conduct which recognizes that standard. There are general regulations necessary as a means of maintaining order and organizing clubs into a working procedure.

1. ALWAYS appear in feminine attire when not actively engaged in practice or playing ball. This regulation continues through the playoffs for all, even though your team is not participating. AT NO TIME MAY A PLAYER APPEAR IN THE STANDS IN HER UNIFORM, OR WEAR SLACKS OR SHORTS IN PUBLIC.
2. Boyish bobs are not permissible and in general your hair should be well groomed at all times with longer hair preferable to short hair cuts. Lipstick should always be on.
3. Smoking or drinking is not permissible in public places. Liquor drinking will not be permissible under any circumstances. Other intoxicating

drinks in limited portions with after-game meal only, will be allowed. Obscene language will not be allowed at any time.

4. All social engagements must be approved by chaperone. Legitimate requests for dates can be allowed by chaperones.

5. Jewelry must not be worn during game or practice, regardless of type.

6. All living quarters and eating places must be approved by the chaperones. No player shall change her residence without the permission of the chaperone.

7. For emergency purposes, it is necessary that you leave notice of your whereabouts and your home phone.

8. Each club will establish a satisfactory place to eat, and a time when all members must be in their individual rooms. In general, the lapse of time will be two hours after the finish of the last game, but in no case later than 12:30 a.m. Players must respect hotel regulations as to other guests after this hour, maintaining conduct in accordance with high standards set by the league.

9. Always carry your employee's pass as a means of identification for entering the various parks. This pass is NOT transferable.

10. Relatives, friends, and visitors are not allowed on the bench at any time.

11. Due to shortage of equipment, baseballs must not be given as souvenirs without permission from the Management.

12. Baseball uniform skirts shall not be shorter than six inches above the knee-cap.

13. In order to sustain the complete spirit of rivalry between clubs, the members of different clubs must not fraternize at any time during the season. After the opening day of the season, fraternizing will be subject to heavy penalties. This also means in particular, room parties, auto trips to out of the way eating places, etc. However, friendly discussions in lobbies with opposing players are permissible. Players should never approach the opposing manager or chaperone about being transferred.

14. When traveling, the members of the clubs must be at the station thirty minutes before departure time. Anyone missing her arranged transportation will have to pay her own fare.

15. Players will not be allowed to drive their cars past their city's limits without the special permission of their manager. Each team will travel as a unit via method of travel provided for the league.

FINES OF FIVE DOLLARS FOR FIRST OFFENSE, TEN DOLLARS FOR SECOND, AND SUSPENSION FOR THIRD, WILL AUTOMATICALLY BE IMPOSED FOR BREAKING ANY OF THE ABOVE RULES.

DEBUNKING THE "THROW LIKE A GIRL" MYTH

Jenn Savedge | 2015

From *Mother Nature Network,* June 1, 2015, www.mnn.com/family/family-activities
/blogs/debunking-the-throw-like-a-girl-myth.

Do you remember that "Like a Girl" ad that captivated the world during the
Super Bowl and for weeks afterward? It's the one where the men, women and
young boys who were asked to run or throw "like a girl" responded by perform-
ing the motion in mock parody. Of course, when the young girls were asked to
run, jump or throw "like a girl," they gave it their all. As one little girl expresses,
running like a girl means to "run as fast as you can."

The video posed a question: When did doing something "like a girl" become
an insult?

Does the insult have any credence? That question was tackled in an episode
of "Mythbusters." On the show, Adam Savage and Jamie Hyneman attempted
to determine whether the phrase "throws like a girl" has any real basis. In other
words: Do girls throw more poorly than boys? The team was looking for an
experimentally provable difference between the way that men and women
throw a ball.

Using eight test subjects from four different age groups, the "Mythbusters"
team analyzed each participant's technique, speed and style while throwing a
ball. In the initial round of testing, they found that the throwing technique was
slightly different for young girls and women than it was for boys and men, with
the male participants' throws more closely resembling those of professional
pitchers.

But, Savage and Hyneman wondered, is this because boys are naturally better
at throwing a ball, or is it a cultural basis that has developed around the notion
that boys and men simply practice this technique more than girls? In other
words, are boys genetically better at throwing a ball than girls, or is this a learned
behavior that could apply to both girls and boys equally?

To test this theory, the mythbusters asked their eight participants again to
throw a ball—but this time using their left, non-dominant hand. This test,
they reasoned, would cancel out any additional practice that boys might have
throwing a ball than girls. Because no matter how many times you have thrown

a ball with your right hand, that skill won't automatically transfer over to your left hand without additional practice.

And that is the meat of the matter—without practice, are boys naturally better at throwing a ball than girls? The answer is no. The experiments showed that the while the boys' throws were slightly more accurate than the girls, the girls' throws were actually faster than the boys'. And when males and females throw with their non-dominant hand, their form is almost identical.

That indicates that any advantage that males gain in throwing a ball is learned—not genetic. It's simply a matter of practice. Males who practice ball throwing get better at it. And the same holds true for girls.

So, to use the term "throws like a girl" as an insult is a myth—and really more of an outdated notion than an insult. Just ask Little League baseball star Mo'ne Davis [who in 2014 was the first girl to earn a win (and pitch a shutout) in the Little League World Series].

PLAYING "TOO WOMANY" AND THE PROBLEM OF MASCULINITY IN SPORT

Joanna L. Grossman and Deborah L. Brake | 2013

From *Verdict*, September 17, 2013, https://verdict.justia.com/2013/09/17/playing
-too-womany-and-the-problem-of-masculinity-in-sport. Some of the ideas
in this column are developed in more detail in Deborah L. Brake, "Sport and
Masculinity: The Promise and Limits of Title IX," in *Masculinities and the Law:
A Multidimensional Approach*, ed. Frank Rudy Cooper and Ann C. McGinley
(New York: NYU Press, 2012).

With forty years under its belt, Title IX is rightfully lauded for having not just leveled but transformed the playing field for women and girls. Title IX, passed as part of the Education Amendments of 1972, provides that "no person in the United States shall, on the basis of sex, be excluded from participation in, be denied the benefits of, or be subjected to discrimination under any education program or activity receiving Federal financial assistance." Simply put, Title IX bans sex discrimination by educational institutions that take federal money.

Congress's aim in passing Title IX was to provide women and girls with equal opportunity in education in an era when they were blatantly discriminated against in terms of admission, especially to professional schools; had their numbers capped; or were admitted but were subjected to entirely different (and worse) treatment.

Title IX indeed has changed the face of education. It has been invoked to protect students against sexual harassment by teachers and peers, to ensure fair treatment of pregnant and parenting students, to remove obstacles to women's education in non-traditional fields like science and math, and to curtail the use of single-sex education that was rooted in stereotype. But Title IX is most known for its impact on athletics, even though that was probably the furthest thing from the legislators' mind when they enacted it. (The legislative history suggests little more than some chuckling over the prospect of co-ed football and co-ed locker rooms.)

Title IX's transformative effect on women's sports is undeniable. One year before Title IX's passage, there were fewer than 300,000 female high school athletes. Today, there are more than three million. A girl's likelihood of playing high school sports has gone from one in twenty-seven to nearly one in two. Female college sports have seen dramatic growth as well—from 32,000 women playing in 1971 to over 200,000 playing today.

There is no question that sports have changed women. Female sports participation has proven positive effects that are related to academic achievement; job success; positive self-esteem; reduced incidence of self-destructive behaviors like smoking, drugs, sex at a young age, and teen pregnancy; and physical and mental health benefits. By and large, sports have been empowering and have even changed, in fundamental ways, what it means to be a woman.

But have women changed sports? Why is it that despite the widespread participation of women and girls in sports, a team of ten-year-old boys would be told by their male coach (as recently happened to one of our sons) that the reason they lost their soccer game is because they "played too womany"? And why is it that this remark strikes so few people as offensive? Has women's participation in sports changed the norms of femininity for women, but not the norms of masculinity for men?

The Masculine Origins of Sport

Sports have always been a place where masculinity is learned and practiced. Sports were introduced in American schools out of fear that boys were becoming too womanly when the shift from an agrarian to an industrial labor force, along

with limits on child labor, left them at their mothers' apron strings rather than their fathers' boots. For athletic boys, sports are a path to success and popularity. Conversely, too, boys who lack athletic interest or ability risk remaining on the periphery of masculinity. Indeed, sports are so typed as masculine that they are sometimes pushed as a cure for homosexuality in the pseudo-psychological/religious programs designed—on false pretenses, of course—to supposedly turn gay kids straight. The same message surfaces in more mainstream programs as well. As reported in one lawsuit, when a student complained to the principal that he was experiencing anti-gay harassment, the principal reassured him, "You can learn to like girls. Go out for the football team." The message is endemic to American boyhood: an athletic boy is a real boy.

Sport is a rite of passage for boys, and an institution that reinforces a hierarchy of masculinity. The very nature of sports, as developed in schools and at other competitive levels, is associated with core tenets of masculinity—physicality, aggression, competition, and winning. The more a sport revolves around these features, the more masculine it is perceived to be. And the more it emphasizes violence, aggression, or brute strength over aesthetics, the more masculine it is perceived to be. The more masculine it is, the more money gets poured into it, the more fans it has, and the more it reinforces traditional norms of masculinity. No one would, for example, question the relative placement of football or basketball to diving or gymnastics on the masculinity scale.

The Cost of Prizing Masculinity in Sport

The reinforcement of traditional norms of masculinity through sport has its costs. For example, the allocation of resources to the most masculine male sports—football and basketball—consumes the lion's share of most institutional athletic budgets, leaving all other men's sports to scramble for the leftovers. Recent data shows that Division I colleges and universities spent about 88 percent of their total men's sports budget on football and basketball. (And despite conventional wisdom, the vast majority of these sports do *not* generate a profit, especially when all costs and expenditures are actually accounted for.) The huge rosters for football also take spots from "less masculine" sports. With 70–80 or more football players on the roster, there are fewer resources to fund other teams.

The money devoted to football and basketball has a cost for all such "less masculine" sports—both men's and women's. With no end in sight to their bloated budgets, the over-allocation has to be taken from somewhere. Women's sports, along with the less masculine men's sports (the so called non-revenue sports), take the hit. Title IX offers little resistance. It does *not* require equal funding of men's and women's sports; funding is just one factor in a qualitative comparison

of the overall men's and women's programs. Even then, actual equality is mostly a pipe-dream at the highest competitive levels. Regardless of how winning or well-known a women's team is, it is unlikely to receive the perks that are taken for granted in the most-valued men's sports. Women's teams rarely, if ever, see the luxury of hotel accommodations on nights before home games, high-tech video and digital display equipment in locker rooms, travel by chartered jet, being coached by someone paid more than the university president, and money lavished on recruits.

There are other costs, as well, to a system that encourages and rewards extreme performances of masculinity in male athletes. With masculinity comes a presumption of heterosexuality, and an expectation of unfettered sexual access to women. The culture of men's sports creates an atmosphere of entitlement in which sex is one of the perks. This sets up a dynamic in which men who do not live up to these norms are hazed or harassed; and other men feel entitled to behave in sexually aggressive, even assaultive, ways. Indeed, there have been several recent cases showing how expectations of sexual access can be part and parcel of a high-profile men's sports program, which we discuss below.

Masculinity's Collateral Damage

In one of the more notorious of these cases (although it is more of a variation on a theme than a breaking of the mold), the University of Colorado was sued for collaborating in a football recruiting program that supplied female students as euphemistically named "ambassadors" to show high-school senior football recruits a good time during their visits to campus. The lawsuit arose from the gang-rape of two female students by football players and recruits during one of these visits. In *University of Colorado v. Simpson*, a federal court of appeals held that the university was accountable for failing to supervise its recruiting program, despite its knowledge of the risk of sexual assault.

In a similarly egregious case against the University of Georgia, a female student alleged that she was gang-raped by a group of football and basketball players. Again, a federal appeals court allowed the suit to proceed based on the university's knowledge, prior to admitting him, that the athlete who led the gang-rape had committed prior sexual assaults and harassment. The university also displayed deliberate indifference in taking a full *eight months* after receiving the police report to conduct an investigation. And, in the end, the university never punished the assailants.

Other cases involve male athletes whose hyper-masculine aggression is not reserved for women. In several cases, schools have been sued for their inadequate responses to cases of male-on-male hazing and assault. In one of the earlier cases,

Seamons v. Snow (1996), a male high school football player was tied, naked, to a horizontal towel bar with athletic tape; his former girlfriend was then invited in to see him. The coach viewed this as a normal part of athletic culture—"Boys will be boys"—and when the victim complained, the coach accused him of betraying the team. The victim should have, the coach explained, "taken it like a man." The victim was told to apologize to the team for tattling, and, when he refused, he was dismissed from the team. Unfortunately, the federal appellate court reviewing this case upheld the dismissal of the complaint, concluding that the "qualities Defendants were promoting, team loyalty and toughness, are not uniquely male." And there was no proof, the court noted, that a female victim would have been treated better. More recent cases have done a better job discerning sex stereotyping in such hyper-masculine performances in male locker-room culture, and have allowed Title IX claims to proceed. These cases show some promise in using Title IX to challenge the extreme excesses of male sports culture. But their impact so far has been limited.

What all these cases have in common is the exaltation of men's athletics to the point where it becomes untouchable by the rest of the university, however outrageous the behavior being condoned. The phenomenon of "what happens in athletics, stays in athletics" is far too prevalent in the big-time men's sports programs, where ranks close to preserve the privilege and status of the program above all else. Even the worst examples of bad behavior being covered up fail to provoke the kind of momentum necessary to truly change the culture of privilege in the university that the most elite men's programs enjoy. We have previously written about one of the most reprehensible examples of this phenomenon, the Sandusky sex abuse scandal at Penn State.[1]

It is not just women and less privileged boys and men who pay the price of a male sport culture gone awry. The masculinity of sport has costs even for the men who attain the highest privilege in sports. Sport sociologists have identified a "toxic jock" identity that men in the highest-status sports often assume, which leads to an over-identification with the role of athlete, and an indulgence in harmful and dangerous high-risk behaviors. Men who over-identify with sport prioritize athletics over academics, which leaves many of them with little education and dim job prospects. Needless to say, most college athletes do not go on to be professional athletes.

The Challenges of Changing Sport Culture

While female athletes have made great strides under Title IX, their success has done little to change the masculine culture of sport. And yet, this is a challenge

that Title IX must take up if women are ever to attain equal status in sport. The masculinity that sport confers on boys and men depends too much on separating the masculine, which is prized, from the feminine (whether it appears in girls or less masculine boys), which is reviled. Insulting male athletes for playing "too womany" is an ungrammatical variation on an old theme, the time-tested insult that a boy "throws like a girl." The language can be updated in myriad ways, and for extra punch, accompanied by vulgar references to female anatomy, but the underlying message is the same as it was in the pre–Title IX era. And remarkably, the adults who are entrusted to teach sports to our boys see little problem with that message (except perhaps in its most vulgar linguistic form).

In asking what, if anything, Title IX can do about this state of affairs, one possibility might be to rethink the law's allowance of sex-separate competition. The insult of playing like a girl might lose its sting if boys grew up learning to fear a female opponent who bends the ball like a young Julie Foudy. While we would not advocate radical changes to Title IX's baseline of allowing sex-separate teams, which has placed crucial pressure on schools to expand girls' and women's sports in order to keep up with their growing interest, we see no reason why community sports programs, especially in the younger years, shouldn't encourage more co-ed play. Learning to respect all athletes, both male and female, at a young age could go a long way toward inoculating male athletes against the more problematic aspects of male sports culture that we have addressed here.

Even greater inroads might be made if boys had greater exposure to women as coaches. Most of the attention to the underrepresentation of women in coaching has focused on women's sports. The trajectory for women coaches is a mirror image of that of female athletes in the post–Title IX era: While women used to be well over 90% of the coaches of women's sports, they are now just over 40%. The turnaround is staggering, and is often lamented as an unintended consequence of Title IX. In fact, the causes are complex, but as women's sports gained greater resources, the coaching jobs became more desirable to men, and the old-boy networks in athletics worked to their advantage. But the story of women coaches in men's sports is one of continuity, not change: The percentage of female coaches of men's sports has held constant, at a meager 2–3%. With the legions of accomplished female athletes and teachers out there, surely "the best man for the job" of coaching boys' and men's teams is not always, necessarily, a man. If more women coached male athletes—and more male coaches interacted with them as colleagues and competitors—perhaps a way could be found to motivate male athletes that did not depend on de-valuing or de-humanizing half the human race in the name of coaching.

Note

A link in the original article has been turned into an endnote.

1. Joanna L. Grossman and Deborah L. Brake, "The Penn State Scandal: Why Is No One Talking about Title IX?," parts 1 and 2, *Verdict*, November 14–15, 2011, https://verdict.justia.com/2011/11/14/the-penn-state-scandal-why-is-no-one-talking-about-title-ix and https://verdict.justia.com/2011/11/15/the-penn-state-scandal-why-is-no-one-talking-about-title-ix-2.

LIVING THE PARADOX *Female Athletes*

Negotiate Femininity and Muscularity

Vikki Krane, Precilla Y. L. Choi, Shannon M. Baird, Christine M. Aimar, and Kerrie J. Kauer | 2004

Excerpted from Vikki Krane, Precilla Y. L. Choi, Shannon M. Baird, Christine M. Aimar, and Kerrie J. Kauer, "Living the Paradox: Female Athletes Negotiate Femininity and Muscularity," *Sex Roles* 50, no. 5–6 (March 2004): 315–329. Copyright © 2004 Plenum Publishing (an imprint of Springer). Reprinted with permission of Springer. Bracketed insertions are part of the original publication.

Physically active women and girls face an intriguing paradox: Western culture emphasizes a feminine ideal body and demeanor that contrasts with an athletic body and demeanor. Sportswomen, therefore, live in two cultures, the sport culture and their larger social culture, wherein social and sport ideals clash. This lived paradox may have a multitude of effects on female athletes, and the research provides varied accounts of their body image, eating behaviors, self-presentation, and self-esteem. Some researchers have found that female athletes have a more positive body image, healthier eating patterns, and are less likely to become pregnant accidentally than their nonathletic peers (Marten-DiBartolo & Shaffer, 2002; Miller, Sabo, Farrell, Barnes, & Melnick, 1999). Yet, other researchers have found that the sport environment creates pressures that lead to unhealthy practices such as disordered eating, excessive exercising, and training through injuries (e.g., Duquin, 1994; Johns, 1996; Krane, Greenleaf, & Snow, 1997).

To comprehend the sporting experiences of female athletes it is important to consider the cultural influences that can potentially alter their experiences, behaviors, and psychological states. [. . .]

An important cultural ideal that affects all women, and especially athletic women, is femininity. Femininity is a socially constructed standard for women's appearance, demeanor, and values (Bordo, 1993). There are multiple permutations of femininity; femininity is bound to historical context (i.e., it changes over time), and "acceptable" femininity may be perceived differently on the basis of, for example, race and sexual orientation (Chow, 1999). Although there are multiple femininities in the Western world, there also is a privileged, or hegemonic, form of femininity (Choi, 2000; Krane, 2001a; Lenskyj, 1994). This hegemonic femininity is constructed within a White, heterosexual, and class-based structure, and it has strong associations with heterosexual sex and romance (Ussher, 1997). Hegemonic femininity, therefore, has a strong emphasis on appearance with the dominant notion of an ideal feminine body as thin and toned. [. . .]

Within the context of the masculine domain of sport, sportswomen are expected to perform hegemonic femininity while distancing themselves from behavior perceived as masculine (Choi, 2000; Krane, 2001). However, negotiating the performance of hegemonic femininity while avoiding masculine behaviors becomes problematic for these physically active women. They face the contradiction that to be successful in athletics they must develop characteristics associated with masculinity (e.g., strength, assertiveness, independence, competitiveness), which contradict hegemonic femininity (Krane, 2001a). Female athletes learn what behaviors and appearances are privileged, and femininity is "performed" to gain social acceptance and status. For example, professional female boxers (Halbert, 1995) and elite ice hockey players (Etu & Williams, 1996) often present a feminine image even during competition (e.g., wearing pink).

It is evident that the privilege, and concomitant power, afforded sportswomen who adhere to the social expectations for women (i.e., perform hegemonic femininity) eludes masculine-perceived female athletes. As female athletes who perform femininity correctly accrue power and privilege, female athletes perceived as masculine are labeled as social deviants (Blinde & Taub, 1992), and they experience discrimination (Crawley, 1998; Krane, 1997). Feminine women in sport reap benefits such as positive media attention, fan adoration, and sponsorship (Kolnes, 1995; Krane, 2001a; Pirinen, 1997). As these feminine athletes gain acclaim, they become spokespeople for their sport (e.g., Mia Hamm for professional soccer, Lisa Leslie for the Women's Professional Basketball League). They also garner respect for their ability to be successful athletes while remaining true to their gender. As these feminine female athletes are highlighted by the

media and receive financial and political clout, they reinforce the socially constructed expectations for feminine behavior and appearance of sportswomen.

A problematic expression of hegemonic femininity for female athletes is the presentation of a feminine body. Ideally, sportswomen have toned bodies, yet they also must avoid excessive, masculine-perceived, muscular bodies. Successful athletes must be powerful and strong, yet obvious signs of this power are construed negatively, as contradicting hegemonic femininity. Consequently, female athletes struggle with the contradiction of the desire to be strong and successful, but not to develop "oversized" musculature (Wright & Clarke, 1999; Young, 1997). Muscle development for athletes, therefore, creates a paradox in which a tight, toned body is perceived as ideal, yet large muscles symbolize strength and masculinity (Bordo, 1993).

Two recent studies clearly showed the contradiction between the performance of hegemonic femininity and sport performance in female athletes. Krane, Waldron, et al. (2001) interviewed American college athletes, who revealed that they had conflicting body images. As athletes, the women had developed strong, muscular bodies to meet their aspirations in sport; however, their muscular physiques were a source of personal concern in social settings. This manifestation of concern was tied to their knowledge that their bodies did not fit the cultural ideal of a toned but not-too-muscular female body. Similarly, Russell (2002), in a study of British female rugby, cricket, and netball players, identified tensions between the "sporting body" and the "social body." The women in Russell's study were satisfied with their sporting bodies as strong, useful, and admired while participating in their sport, yet they expressed dissatisfaction with their bodies when they considered social contexts. In addition, Krane, Waldron, et al. found that athletes who wore revealing athletic uniforms (e.g., swimmers, gymnasts), expressed concern about how they looked in their uniforms. Their worries that they would be perceived as fat or too big, in some cases, led to unhealthy behaviors (e.g., dieting, excessive exercise, disordered eating).

The findings of those two studies (Krane, Waldron, et al., 2001; Russell, 2002) piqued our interest to understand further how female athletes negotiate social expectations of femininity and their athleticism. Specifically, we investigated relationships among body image and perceptions of muscularity and femininity in female collegiate athletes. Our research question was: How do female athletes negotiate and reconcile the social expectations of femininity with their muscularity and athleticism?

Method

PARTICIPANTS

Female athletes who were competing for a midwestern NCAA Division I university participated in this study (n = 21). The college varsity athletes included three cross-country distance runners, two track athletes, one soccer player, two volleyball players, two gymnasts, one swimmer, one basketball player, three softball players, and three tennis players. Club sport athletes included one rugby player and two ice hockey players. One of the volleyball players also competed in club hockey. The athletes averaged 20.48 (SD = 1.83) years of age, had an average of 9.36 years of experience (SD = 4.31) in their current sport, and had been on their current team for an average of 2.76 years (SD = 1.26). Body size varied among these women, but, overall, they were quite fit with low body fat. Their average self-reported height was 66.88 in. (SD = 2.94) and weight was 141.7 lbs (SD = 21.03). Body mass index (BMI) averaged 22.22 (SD = 2.20, range 18.6–26.6); all but three athletes had a BMI of less than 24. All of the athletes were White. We did not ask them about their sexual orientation, but all of the athletes presented a heterosexual stance (i.e., no one identified as lesbian, bisexual, or transgendered). [. . .]

Results

INFLUENCE OF HEGEMONIC FEMININITY

The theme "the influence of hegemonic femininity" addressed the ramifications of constant comparison to the cultural ideal of femininity. As the athletes contrasted their bodies with feminine bodies, the following data categories emerged: "the ideal body," "femininity defined," "muscular but not too muscular," and "uniform concerns."

The Ideal Body It is important to understand how these athletes constructed the ideal body, their own bodies, and femininity. Their discussion of these topics reflected the influence of hegemonic femininity. These women expressed a narrow rendering of femininity—that from a White, heterosexual perspective. Perhaps this is partly an effect of their social environment at a university with a predominantly White student body and because none of the athletes acknowledged an identity other than heterosexual in the interviews.

The cultural ideal body that the athletes described was "perfect" and "real good looking and they don't have much muscle," but they have "definition." The ideal body is exemplified by "people in magazines," actresses, and models. A volleyball player said:

You're surrounded by it. Like in the media, you're shown this perfect image, . . . you know the Barbie doll, and models and everything. And then you see the female athletes, all the popular athletes, and they've got like the athletic physique and now that's becoming more popular.

A hockey player responded to this comment as follows:

How many people would rather look like Rachel Hunter [a model] rather than Mia Hamm [a soccer player]? Because Rachel Hunter is this little skinny thing, waif-like person and then Mia Hamm's thicker, and that's not as cool. I still think that's not gonna change.

The athletes also acknowledged that the cultural ideal body was unrealistic: "all the perfect people and like no one looks like that, they're all air brushed and stuff."

In the focus groups, the athletes discussed their personal ideal bodies. Each woman identified something that could be different such as "longer legs," "smaller stomach," "smaller rear end," and "smaller thighs." Overall, they lamented their size and muscularity. Distance Runner 1 stated: "I wish I was littler. . . . Sometimes I just wish I had like a regular size body." Volleyball 1 concurred: "we have our muscle and I don't like it, I'd rather not have that." Still, most of the athletes wanted more muscular definition, but without muscular bulk. As they said: "I would be more defined," and "I always wanted to have a six pack [well defined abdominals]."

Femininity Defined Discussion regarding femininity was intriguing; their definitions of femininity typically were based on contrasting it with athleticism. "You lose all femininity when you put on a hockey uniform." In general, their definitions of femininity concerned being "petite and dainty" and engaging in specific behaviors. For example, femininity was defined as "having a gentle spirit," "more laid back," "having proper etiquette," "being clean," and "being girly." Generally, it was easier for the athletes to state what femininity was not: "not sweaty," "opposite of being a tomboy," "not wearing baggy jeans," and "like hitting the weight room is not feminine." The following exchange further expressed these beliefs:

GYMNAST 2: When you think of being feminine, you don't think of the person being like really outgoing, it's really reserved.
VOLLEYBALL PLAYER 1: Yeah and like grunting. You know how like people grunt in the weight room.
ALL: laughter

VOLLEYBALL PLAYER 1: Farting and belching are definitely not feminine. . . .
Making noises is not.

DISTANCE RUNNER 1: [I am not feminine] because I grunt, I fart, I burp.
(laughter) I'm loud, I'm obnoxious, I swear worse than any guy you'll
probably ever meet. I don't have the body structure, I don't act like it, I'm . . . I
dunno, aggressive.

The athletes reconciled their perceived lack of femininity by saying that it
was not essential to being athletic. As two athletes said:

HOCKEY PLAYER 1: It doesn't count [on the ice], nobody is going to give me
points for having my hair done or whatever. No way, I'm looking to be
the toughest person out there, the meanest person out there, the dirtiest
person, whatever I can get away with, all I get away with, whatever. That's
not feminine, that's not feminine at all, and I spit and hack and cuss and
everything that you're not supposed to do when you're a girl.

VB/HOCKEY PLAYER: When you're sitting in pre-game, we're having our locker
room talk or whatever, you're not thinking about "ok we need to go out there
and cross our legs when we sit on the bench because that's the feminine thing
to do, we need to sit up straight." We're not trying to look like women out
there because that's not the whole point of why we're playing the sport. We're
out there 'cause we enjoy it, we want competition and we're out there to beat
the crap out of somebody. I mean it's just not a focus at all.

Most of the athletes believed that being soft, girly, dainty, and clean implied
femininity, whereas being aggressive, outgoing, and sweaty implied being an
athlete. Further, being athletic was equated with being masculine. Feminine was
socially acceptable, and athletic was not. The athletes consistently expressed this
conflict throughout the focus groups.

Muscular but Not Too Muscular The athletes struggled with their perceptions
of their own bodies. They recognized the cultural ideal body as one shape, and
they viewed their own bodies as contrary to that ideal. These athletes clearly
were in great physical condition with low body fat, yet their muscularity was a
source of consternation. Having or building muscles was associated with being
unfeminine or "like men." Gymnast 1 said: "You don't feel feminine when you're
big and buff." By building "excess" muscle the athletes were being "like guys."
Soccer 1, when talking about working out in the weight room, said: "I feel like
when I am in there like we are getting . . . we're being like men or something
like that."

The participants described a seemingly arbitrary line that demarcated too

much muscle from attractive muscle tone in women. Once women surpassed this subjective limit of musculature, they were no longer perceived as feminine. As Distance Runner 2 said: "Muscle tone, yeah that's sexy. But, I guess I don't want to get too big or anything." Similarly, Softball Player 2 stated: "I like muscle a lot, [but] I mean, there is a point . . ." Concern about becoming too big often was expressed. The Basketball player noted, "I wouldn't want to be like real big and buff." Softball 3 elaborated on that point:

> I like the way I feel when I get the muscle . . . but yet, in the back of my mind I get scared that I'm gonna get big and people are gonna look at me like "oh my god." . . . I get scared of looking too much like a guy, like having too much muscle.

In addition to being conscious of how much muscle mass they were building, the women were concerned with their body weight. Not only did they perceive themselves as too muscular, they interpreted their body weight negatively regardless of their low body fat. When describing her first reaction to her weight gain from muscle development Tennis Player 3 said:

> When I came in my freshman year and started lifting, it was weird because then you develop and you're like "whoa!" You're very self-conscious about getting bigger and "oh, I'm getting fat or I'm getting too big there."

The following interaction shows how the athletes sometimes misinterpreted body weight:

> VB/HOCKEY PLAYER: Me being 5'11", I weigh 187 and so I look at the number on the scale and I'm like "holy crap I'm fat," but then [laughter] we get our fat tested and we find out you're like 15,16,17 percent body fat and you're like "oh, okay maybe I'm not that fat." Sometimes you just need that reinforcement, you know that reinforcement behind it just to be like "okay, I'm not fat" right, cause you look at the numbers and you're like "Oh God."
>
> SWIMMER: I agree with her [laughing].
>
> RUGBY PLAYER: You pretty much summed it up [laughing].

The athletes in this study initially felt that their increased body weight was traumatic. They didn't like getting bigger because it detracted from femininity and contradicted the cultural ideal body.

Uniform Concerns Uniform concerns emerged as a unique category for those athletes who wore "revealing" uniforms (e.g., track, gymnastics, swimming, and volleyball). Uniforms were considered revealing when they were tight and exposed the shape of the women's bodies. These athletes were concerned with

how they looked in revealing uniforms, and two different perspectives emerged: (a) they looked too big and (b) they were sexualized in their uniforms.

Athletes described their revealing uniforms in a variety of ways. The runners described their uniform as "butt-huggers, like basically underwear. And then like, a real tight tank top." Gymnast 2 explained that their uniforms were like bathing suits. The tennis players described one of their uniforms as:

TENNIS PLAYER 3: Like a miniskirt

TENNIS PLAYER 2: 8 inches above your knees, like barely covering your butt.

The volleyball team wore spandex shorts and "short sleeve jerseys which they're starting to get tighter as the years go on."

In these tight and revealing uniforms, the athletes felt "exposed." Distance Runner 2 said: "I was so scared when I saw them. Ours is like a one-piece swimsuit. I was so scared the first time I wore this, I'm like, 'my butt's gonna be jiggling all over the place." Similarly, VB/Hockey Player said:

First day of practice, my coach hands me this pair of spandex about this big [indicating very small] and she's like, "here fit your butt into those." And I'm like, "I can't even fit my hand into those let alone my entire butt." [laughing] Okay, and I almost cried and I put those things on, I walked out, and I'm like, "I don't feel comfortable at all."

Track Athlete 3 best articulated the general feelings of discomfort associated with these uniforms when she said: "you feel completely naked . . . your butt's right there."

Ironically, although the athletes thought that their "excessive" size and musculature was exposed in their uniforms, they also acknowledged that they were perceived as sexy in their revealing uniforms. Generally they stated that men attended their sporting events just to see them in their revealing uniforms: "Guys, like you know, 'Oh yeah, come to gymnastics, girls in leotards," and "Yeah, we've had comments like, 'oh you wear those spandex, I'll come to your games'" (Volleyball). Distance Runner 1 explained:

Guys will come to our races because we wear those things. They're like, "You guys wear those? Oh my gosh, we're coming!" . . . Of course nobody would come see a cross-country race unless they knew we wore those things.

The women complained that they were sexualized rather than appreciated for their athletic achievement. To minimize feeling exposed and reduce being sexualized, the athletes tended to wear additional clothes over their uniforms when not competing. Gymnast 2 explained:

After you compete, you put something on, like even if it's just a T-shirt or if it's something else. The only time you're really standing around with your leotard on is if you're about to go out there or if you're competing. Usually we don't really just sit around. . . . I personally just don't like to stand around in it [laughter] because people are constantly looking at you. I just feel uncomfortable if that happens.

Distance Runner 1 stated: "we definitely don't wear our [uniforms] until we're racing. . . . We don't run around in those things. No way." A tennis player agreed: "I usually just put my sweatpants on [when not playing]."

The athletes knew that their bodies differed from the feminine ideal body. This incompatibility negatively affected their body image (i.e., a desire to be less muscular) and resulted in concerns about how others perceived them, even during competitions. Their uniforms were a unique source of stress because of the exposure of their bodies in front of an audience. Yet immediately prior to competing, the athletes were able to shift their focus from body image concerns to performance. Distance Runner 1 said: "When I'm racing I'm not caring what I'm looking like at all, if it's like sexual or not. I'm just out there to feel comfortable in my uniform and race." The athletes articulated that they became used to wearing their revealing uniforms.

GYMNAST 2: How do I feel about them? I've been in them all my life. Umm, I don't know.

VOLLEYBALL PLAYER 1: Well I'm comfortable in them now because we've worn them for a long time and you just get used to them.

VB/HOCKEY PLAYER: You grow into it 'cause you have to wear them every day.

The athletes also seemed to have incorporated wearing their uniforms into their competitive mental preparation routines. They described wearing their uniforms as putting on "your game face" and feeling ready to compete. This sentiment was expressed in the following interaction among the track athletes:

TRACK ATHLETE 3: I feel faster when I put on my little bathing suit. . . . I feel like I'm ready to race, I'm in like a certain mode.

TRACK ATHLETE 2: Yeah, plus you're in the right like mind set, like—

TRACK ATHLETE 3: Yeah

TRACK ATHLETE 2: When you're wearing your uniform it feels like a lot different, like mentally almost than when you're just running in like a T-shirt and shorts.

TRACK ATHLETE 2: To me it does.

Although the athletes noted that their uniforms were a source of trepidation, they also had learned to cope with them and to refocus their attention during competition.

ATHLETE AS "OTHER"

The higher order theme of "athlete as 'other'" emerged from the women's descriptions of female athletes as marginalized and perceived as different from "normal girls." Within the context of the interviews, "normal" was used to refer to nonathletic girls and women. The participants were aware that as athletes they differed from women who were not athletes in (un)feminine appearance and behavior. The most common description of this perception was they were "like guys," or "like men" and particularly as "not girls." They often made comments such as "I wish I was a girl," "I want to look like a girl," and "sometimes I'm just not like a girl." All of the participants agreed with the basketball player's statement, "I just feel so different than everybody else." Additional indications of "other" status were supported by the data categories of *discrepancy, clothes, (not) doing femininity, social attention*, and *dating*.

Discrepancy This data category highlights the conflict the athletes had between being athletic and being feminine. The athletes clearly distinguished between their identities as a woman and as an athlete. [...]

Their strength and muscularity are acceptable in a sport environment, but a more feminine demeanor and image is desired in a social setting. The athletes recognized these different identities and distinguished between fitting into the different environments. As Rugby Player 2 stated: "if you're an athlete, then you have to like transform into entirely someone else when you come off the field or the ice or whatever." A softball player said:

> In sports I don't really think about my body that much. Or when like I'm in my uniform and everything, it's pretty much, it's irrelevant, you know? I think that people look at us and how good do we play our sports, but when we're out [socially], you know, like just using like chest size for example. I like feel really self-conscious about it, like if you see the girls that have big chests and little stomachs, and do that sort of stuff. And when you're out at that scene, out of the athletic scene, you know you're just a person that doesn't really have that good of a body. . . . Well I don't really care that I don't have big boobs, I can still throw a ball way harder than you can [laughs] you know what I mean, but I definitely, I mean I can see a difference between the two settings. I think about that a lot actually. (Softball Player 2)

Thus, the athletes constantly juxtaposed their athletic behaviors with "being a girl" (i.e., being feminine). Gender and femininity, therefore, have to be put aside in order to focus on the task at hand (i.e., sport). This may not seem surprising or important until one takes into account why gender is being put aside—because sport is not consistent with hegemonic femininity.

Clothes Attempts to find clothes that fit their muscular bodies were a constant reminder that the athletes were different from nonathletic women. The following interaction expresses this concern:

> VOLLEYBALL PLAYER 1: I hate shopping for pants and also when I shop for jeans, because my thighs are bigger [laughter] and it's from squatting, like if I didn't squat [an exercise with weights for strengthening leg muscles] I could probably fit into like three sizes smaller. But it's frustrating because like here I am fitting into the size like 12, 14, whatever when I never used to be that before I came to college.
>
> GYMNAST 2: It's so frustrating to go shopping for any type of clothing because, like I'd have to have it too big or like, my size, just can't get into shirts and stuff like that, especially jeans. It's just so tight like, around your thighs.
>
> DISTANCE RUNNER 2: And your quads . . .
>
> GYMNAST 2: And then the rest is just loose. Like you can be sitting down and be bulging out you know. You have no control over it. So . . .
>
> VOLLEYBALL PLAYER 1: My roommates are athletes too. One plays softball, and the two other ones play volleyball, and last year they were talking about opening a "Big Buns and Big Guns" clothing store for athletes [laughter] because, like we have bigger, like arms and then bigger butts. [laughter] We don't fit in normal clothes.

Not only was finding clothes problematic, but the women were not happy with the way they looked in skirts and dresses because of their muscular bodies. Their descriptions of themselves reiterate their other status (i.e., not a normal woman). For example, "I've got huge arms, and like you like wear a dress or you dress up or something and you feel like a monkey" (Gymnast 1) and "[in a dress] you don't look like a girl" (Distance Runner 2). Distance Runner 1 remarked: "It's kinda like an oxymoron, you're like you have these little skirts on and then you have this body. And it looks kind of funny." She later added:

> I look so stupid in a dress. It's like my dress, and then I have these legs.
> [laughter] They just don't match. Like it looks so weird. Like I have fancy shoes on, and I have these legs that are just like muscles, and they look really weird.

The clothes problem was merely pragmatic, yet a deeper issue remains. Athletes do not fit into regular clothes and, consequently, they were reminded about how they differ from "normal" women.

Social Attention Another reminder that female athletes were perceived as different came through the social attention that the athletes received. As the athletes said:

I don't feel like less of a girl [because of my muscles] but I feel like other people think I'm less of one. (Track Athlete 1)

Some people that don't [know that I'm an athlete], they'll come up to me like, "what the heck is she?" (Distance Runner 1)

Social attention from men particularly reinforced that athletes differed from other women. [. . .] "When I dress up or anything it's like 'wow, you are a girl.' . . . even my boyfriend comes up and is like 'oh my gosh, you're all done up'" (Gymnast 2). All of the athletes described situations when friends and other people acted surprised when they wore feminine attire.

Dating The distinction between being a "normal girl" and an athlete also was acknowledged during discussions about attractiveness and dating. All references to dating were in a heterosexual context and were consistent with the script of hegemonic femininity as heterosexual. The athletes explained that to be attractive to men, it was important to act in an "appropriate" manner. As Hockey Player 2 stated: "If you want to attract a guy, then you have to be [feminine] sometimes." VB/Hockey Player explained:

If you're trying to attract a guy, you're not gonna be like [laughs] punching them in the shoulder, be like "did you catch the game Friday?" You're gonna be, you know, tiny, cute, demure, and whatever. Not that I can pull off the demure thing, but I mean you're gonna want to act more like a female than a male or, you know, than more so a female than an athlete.

Similarly, Tennis Player 1 stated: "[it's important to be feminine] when you go out and you want to, you know, look nice and impress the boys [laughs]."

The athletes also complained that men were not attracted to women with large, athletic bodies. A hockey player said: "it's really hard to date around here, if you're not like this big [gestures making hands in small box]. . . . The ones that get chased after all the time it always seems to be like the little itty bitty girls." VB/Hockey Player agreed, "I'm so tall and big and it's hard to get a date."

(Not) Doing Femininity With the constant reminders that athletes were something other than normal women, these women engaged in behaviors to reinforce the notion that "we can be athletes and feminine too." vb/Hockey Player stated:

> We don't look very feminine when we're out there playing, and you know just to grasp on to that one last thing that makes us a girl, we'll put a ribbon in our hair. We do it to remind all you people in the stands, we are still girls. We're athletes first, but just remind everybody that we're girls too.

The athletes engaged in many typical behaviors to enhance their femininity: "doing my hair, putting makeup on," "putting on nice clothes," "wearing the latest trends," and "wearing French braids." Ironically, although well-fitting clothes were a source of contention, "wearing normal clothes" and "dressing up" were essential for appearing feminine. The athletes stressed that they could be feminine: "I can be more girly." [. . .]

Throughout the discussions, appearing feminine was equated with being a "normal girl." As Softball 3 stated: "I like doing my hair, putting makeup on so people know that I'm not just an athlete, like I am a girl too." The traditional script of femininity is incongruous with sport, so these athletes also constructed a feminine appearance to be perceived as normal women.

It is interesting that the athletes also equated eating with unfeminine behavior. Because of their physical activity, these women ate more than their nonathletic peers, which further reinforced their other status. Apparently, feminine women do not eat large amounts of food, as indicated in the following conversation:

> HOCKEY PLAYER 1: In season at our house, you can't keep enough food in there. Oh my god, last year, three of us were playing hockey and [vb/Hockey Player] was playing volleyball and hockey, and we'd eat like you would not believe in that house. Everything in the place was a mess. The fridge was constantly stocked full of stuff. That makes me feel very unfeminine, but you're hungry you just keep eating.
>
> [Everyone nods in agreement]
>
> vb/HOCKEY PLAYER: You're wolfing down food and you eat like seven times a day.
>
> HOCKEY PLAYER 1: every three hours.
>
> vb/HOCKEY PLAYER: yeah, like every three hours you're stuffing your face with something.
>
> RUGBY PLAYER: Your friends go all day with just one meal and you're just like . . .
>
> vb/HOCKEY PLAYER: I'm hungry again.

Other athletes also noted that their eating differentiated them from their nonathletic peers. Their nonathlete female friends often commented about how much they ate compared to normal women. For example, Distance Runner 2 described that friends stated: "I'll go out to dinner with [nonathlete friends] and I'll have like three big plates and they'll have like one little one, and I'll be done with everything and they're still eating."

Through many different avenues, the athletes were reminded that they were different. They were larger, more assertive, more muscular, and they ate more than normal women. The athletes also were not considered feminine because of their body shape and their casual attire. To be considered socially acceptable, they sometimes created an alternate identity from athlete—that of a feminine woman.

PHYSICALITY

An intriguing higher order theme emerged related to the *Physicality of Sport*. Although the athletes struggled with the conflict between being perceived in a socially desirable manner and excelling in their sport, they also discussed the benefits of their sport participation. The data categories of *function, pride*, and *empowerment* described some of these benefits.

Function One mechanism of reconciling the contradiction between having a culturally ideal body and being athletic women was their focus on the function of their size and strength. To be competitive, it was essential that they were strong and muscular. Throughout the interviews, they stated that they gained much muscle size because of their weight lifting. Yet, they also described the benefits of weight lifting as "it does make me stronger," "it makes me hit harder and maybe even quicker" (tennis player), and "help[s] you take off more on the ice if you want to pick your legs up faster" (hockey player). [. . .]

Pride The athletes discussed the pride they felt in their athletic achievements. These sportswomen worked hard to be competitive at the college level. Their commitment and effort resulted in pride in being an athlete. Distance Runner 2 stated: "I think girl athletes are sexy. . . . I think it's cool that we go out there and do that." Although these athletes acknowledged that models portray the culturally ideal body, the following interaction shows how they reconciled the difference between being valued for one's looks versus being valued for one's skill:

TRACK ATHLETE 3: I would rather be an athlete; I'd rather not be a model out there getting pictures taken just for her body, I'd rather have muscles, you know, and do the sport, and be recognized for it and know that I'm doing something good for myself.

SOCCER PLAYER: I think that people look up to athletes more than they look up
to models. . . . They give them more respect.

TRACK ATHLETE 1: I'd rather be respected for running rather than my looks.

SOCCER PLAYER: 'Cause it's something you can control.

Part of becoming a successful athlete is developing a strong muscular body.
They recognized that the cultural ideal exemplified a smaller physique, yet these
athletes were proud of their strong, developed bodies. As a rugby player stated:

It doesn't bug me to see people a lot smaller than me or whatever because I know
I'm healthy and I know most of it's muscle. Like when I work out and stuff, like I
can just see the muscles when I move, like them flexing. And I think if someone
says "you're thick" and "you're like a healthy muscular," and it's more muscle
than fat, then it's cool.

[. . .] The essence of this data category was exemplified by VB/Hockey Player,
who explained:

I used to be like more self-conscious about my size, but I mean I look around
and I see so many more athletes around on campus that are big, you know, but
they're built like Mack trucks. I don't think it's anything to be ashamed about.
I'm very proud that I'm a big girl.

These athletes appeared to redefine what it meant to be a muscular woman.
They focused on how they are strong and healthy even if they are different than
other women. They were proud of their status as athletes and the bodies they
developed through training and competition.

Empowerment Not only were these women proud of being athletic, they also
felt empowered because of their strength and skill. As they discussed, being an
athlete "helps your self-esteem," "it gives us more of a sense of time management
and confidence," "you feel stronger and you feel independent," and it leads to
"self-respect." These feelings of empowerment generalized beyond the sport
context and helped the women to feel self-sufficient:

I know people won't mess with me. "You mess with me and look you gotta
deal with this." Like in the real world I think it will help me out in the long run
because I don't think people will mess with me, you know. . . . Whether it be on
a job or like walking down New York City in the middle of the night and I think
my chances of getting mugged will be lower than some waif-like person walking
around. (VB/Hockey Player)

A hockey player expressed the same sentiment:

I feel more, this is gonna sound cheesey, but I feel more independent. I feel like I can take care of myself rather than if I was just some weakling. I feel like I could run away from someone if I had to, or whatever, you know what I mean. I don't need somebody to take care of me.

Although there were constant reminders that female athletes were not considered normal women, these athletes savored the benefits of their athletic participation. They were accomplished, confident, independent women in both athletic and social situations.

Discussion

The findings of this study illustrate how, because of the influence of hegemonic femininity, sportswomen live a paradox of dual and dueling identities. The athletes in our study recognized the status and privilege of "normal girls" that contrasted with their "other" or marginalized position. This circumstance reinforced the importance of portraying a heterosexually feminine appearance in social settings and sometimes in sport settings. Consistent with previous research (Krane, Waldron, et al., 2001), the athletes described the ideal feminine body as small, thin, and model-like. As expected, their description of the ideal female body was consistent with media portrayals of feminine women (Bordo, 1993; Duncan, 1994).

The athletes considered their muscular bodies as the primary hindrance to being perceived as heterosexually feminine in social settings. When they considered their athletic bodies in comparison to "normal girls" or the culturally ideal body, the athletes felt "different." They were larger and more muscular, and they did not fit into trendy clothing. Even though they embraced the function of their bodies, being too muscular was disconcerting. It was an unwanted source of social attention, a constant reminder that they were different from other women. [. . .]

As we pursued the examination of perceptions of muscular bodies, we found as much pride as consternation in athletic bodies. The athletes acknowledged the positive distinctiveness of the athletic female body, yet each athlete also expressed some desire to look different—that is, normal. Further, several athletes noted that when they came to college and began intensive weight lifting, they were not sure how to interpret the changes in their bodies. Weight gain initially was perceived negatively and was assumed to be due to increased body fat. However, the athletes appeared to have learned to focus on the function of their musculature and size, which resulted in satisfaction and pride. They worked hard to be strong and successful and were proud of their efforts. This

was consistent with previous studies that revealed that female athletes expressed empowerment, satisfaction, and enjoyment through physically assertive sport (Baird, 2001; Hargreaves, 1993; Rail, 1992; Russell, 2002; Theberge, 1997). Although these women were reminded in many ways that they did not conform to the culturally accepted, hegemonic script of femininity, they were able to highlight the benefits associated with sport performance. They enjoyed their sport participation and gained strength and confidence that positively affected them outside of sport as well as in the athletic environment.

It appears that, in negotiating and reconciling the social expectations of femininity with athleticism, sportswomen develop two identities—athlete and woman. Sometimes these two contrasting identities are kept separate but at other times they merge. This can be seen in their different performances of femininity and gender. Drawing on Ussher's (1997) scripts of doing girl, being girl, resisting girl, and subverting girl, Choi (2000) suggested that "being girl" is unlikely to be common among sportswomen, whereas "resisting girl" is likely to be prevalent. The athletes in this study understood that being feminine was important for feeling like normal women, but they were unanimous in the view that, as athletes, they did not have the time required to work on their appearance on a daily basis. Being feminine in our society is an effortful exercise, but so too is being athlete. These women's priorities as athletes did not include taking time to use makeup, style their hair, and dress nicely. Femininity, therefore, had to be "put aside" and resisted when they were being athletes as opposed to "girls." The athletes in our study simply displaced femininity with their "game face" or competitive zeal and left "doing girl" for social situations. This type of performance also was found in female rugby players who constantly negotiated being highly competitive (i.e., masculine) on the rugby pitch with being "real women" (i.e., feminine) in social contexts (Baird, 2001).

For some athletes, "doing girl" was seen as important in sport, such as when the volleyball players wore bows in their hair to remind people that although they were athletes, they were still women. [. . .] These findings illustrated that the position of "doing girl" can be taken up at the same time as "resisting girl." The two identities of athlete and woman are not, or perhaps cannot, always be kept separate because of the requirements of hegemonic femininity. This conflict also emerged from the athletes' concerns about how other people perceived their bodies. The athletes who wore revealing uniforms thought that their bodies were sexualized while in their uniforms, which was a source of discomfort. [. . .] The imposition of this perception upon the female athlete prevents the two identities of athlete and woman from being kept completely separate, as the unwanted attention from men is a reminder that she is a woman and subject to the male gaze.

Although the athletes' descriptions of the ideal feminine body were consistent

with the dominant ideal as portrayed in the media, it is important to situate this within a White, heterosexual prototype, or what Dewar (1993) referred to as the "generic sporting woman." All of the athletes in this study were White and presented as heterosexual. It is very likely that athletes of color and lesbian or bisexual athletes may not aspire to this same ideal. Yet, as Dewar noted, these other women are rendered invisible in sport and hegemonic femininity is privileged. For this reason, it also is important to note that although the athletes presented as heterosexual, it is possible that some of them identify as lesbian or bisexual. However, as Braun (2000) pointed out, focus groups offer many benefits, but they also may perpetuate heterosexism. The dominant heterosexual focus within the groups with discussions of dating and being attractive to men may have created an environment where women were not comfortable revealing another identity. How to challenge and not collude in heterosexism is an important issue for researchers to consider (Braun, 2000).

It also is important to point out that although there were commonalities among these athletes' construction of femininity and its consequences, they were not a wholly homogeneous group. In general, the tennis players were more concerned with portraying a traditionally feminine appearance and the rugby and hockey players most pushed the boundaries of femininity. Ice hockey and rugby were club sports, organized or managed by the women on the team. They were not governed within the traditional male-dominated sport setting, and the women were not compelled to adhere to hegemonic standards. Also of interest is that these athletes revealed positions contrary to popular beliefs. For example, although gymnasts and distance runners are stereotyped to be excessively thin, the women in this study were just as concerned about being too muscular as the athletes more commonly expected to be large and muscular (e.g., basketball, softball, and soccer players).

In conclusion, this study has extended our understanding of female athletes' perceptions of their bodies and their selves in sport and society. Rather than simply being passive victims of hegemonic femininity however, women can actively choose how the paradox of dueling identities is lived through different gender and femininity performances. Our study has illustrated the complexity of this process as women move among scripts as well as perform different scripts simultaneously. Moreover, "choices" are not always freely chosen. The complexity of living this paradox might lead to negative behaviors such as poor body image, disordered eating, and low self-esteem, although this did not seem to be the case for the women in our study. Indeed, through their negotiations of femininity they redefined the acceptable female body and behavior, reveling in their self-descriptions of their "nonfeminine" behaviors such as being noisy, assertive, competitive, and tough, as well as swearing, sweating, and eating.

Although the athletes noted that other people may not consider this acceptable feminine behavior, for them it was normal, and being an athlete was reconciled by the many physical and psychological benefits that empowered them both inside and outside of the sport context.

References

Baird, S. (2001). *Femininity on the pitch: An ethnography of women's rugby.* Unpublished master's thesis, Bowling Green State University, Ohio.

Blinde, E. M., & Taub, D. E. (1992). Women athletes as falsely accused deviants: Managing the lesbian stigma. *Sociological Quarterly, 33,* 521–533.

Bordo, S. (1993). *Unbearable weight: Feminism, Western culture, and the body.* Berkeley: University of California Press.

Braun, V. (2000). Heterosexism in focus group research: Collusion and challenge. *Feminism and Psychology, 10,* 133–140.

Choi, P. Y. L. (2000). *Femininity and the physically active woman.* London: Routledge.

Chow, R. (1999). When Whiteness feminizes . . . : Some consequences of a supplementary logic. *Differences, 11*(3), 137–168.

Crawley, S. L. (1998). Gender, class and the construction masculinity in professional sailing. *International Review for the Sociology of Sport, 33,* 35–41.

Dewar, A. (1993). Would all the generic women in sport please stand up? Challenges facing feminist sport sociology. *Quest, 45,* 211–229.

Duncan, M. C. (1994). The politics of women's body images and practices: Foucault, the panopticon, and *Shape* magazine. *Journal of Sport and Social Issues, 18,* 48–65.

Duquin, M. E. (1994). The body snatchers and Dr. Frankenstein revisited: Social construction and deconstruction of bodies and sport. *Journal of Sport and Social Issues, 18,* 268–281.

Etu, E., & Williams, M. K. (1996). *On the edge: Women making hockey history.* Toronto: Second Story Press.

Halbert, C. (1995). Tough enough and woman enough: Stereotypes discrimination and impression management among women professional boxes. *Journal of Sport and Social Issues, 21,* 7–36.

Hargreaves, J. A. (1993). *Sporting females: Critical issues in the history and sociology of women's sports.* New York: Routledge.

Johns, D. (1996). Fasting and feasting: Paradoxes of the sport ethic. *Sociology of Sport Journal, 15,* 41–63.

Kolnes, L. J. (1995). Heterosexuality as an organizing principle in women's sport. *International Review for Sociology of Sport, 30,* 61–79.

Krane, V. (1997). Homonegativism experienced by lesbian collegiate athletes. *Women in Sport and Physical Activity Journal, 6*(1), 141–163.

Krane, V. (2001a). "We can be athletic and feminine," but do we want to? Challenges to femininity and heterosexuality in women's sport. *Quest, 53,* 115–133.

Krane, V., Greenleaf, C., & Snow, J. (1997). Reaching for gold and the price of glory: A motivational case study of a former elite gymnast. *The Sport Psychologist, 11,* 53–71.

Krane, V., Waldron, J., Michalenok, J., & Stiles-Shipley, J. (2001). Body image and

eating and exercise behaviors: A feminist cultural studies perspective. *Women in Sport and Physical Activity Journal, 10*(1), 17–54.

Lenskyj, H. J. (1994). Sexuality and femininity in sport context: Issues and alternatives. *Journal of Sport and Social Issues, 18*, 356–376.

Marten-DiBartolo, P., & Shaffer, C. (2002). A comparison of female college athletes and nonathletes: Eating disorder symptomatology and psychological well-being. *Journal of Sport and Exercise Psychology, 24*, 33–41.

Miller, K. E., Sabo, D. F., Farrell, M. P., Barnes, G. M., & Melnick, M. J. (1999). Sports, sexual behavior, contraceptive use, and pregnancy among female and male high school students: Testing cultural resource theory. *Sociology of Sport Journal, 16*, 366–387.

Pirinen, R. M. (1997). The construction of women's positions in sport: A textual analysis of articles on female athletes in Finnish women's magazines. *Sociology of Sport Journal, 14*, 290–301.

Rail, G. (1992). Physical contact in women's basketball: A phenomenological construction and contextualization. *International Review for the Sociology of Sport, 27*, 1–27.

Russell, K. (2002). Women's participation motivation in rugby, cricket, and netball: Body satisfaction and self identity. Unpublished doctoral dissertation, Coventry University, Coventry, UK.

Theberge, N. (1997). "It's part of the game:" Physicality and the production of gender in women's hockey. *Gender and Society, 11*, 69–87.

Ussher, J. M. (1997). *Fantasies of femininity: Reframing the boundaries of sex.* New Brunswick, NJ: Rutgers University Press.

Wright, J., & Clarke, G. (1999). Sport, the media and the construction of compulsory heterosexuality. *International Review for the Sociology of Sport, 34*, 227–243.

Young, K. (1997). Women, sport, and physicality. *International Review for the Sociology of Sport, 32*, 297–305.

SOMETHING TO CHEER ABOUT?

Jaime Schultz | 2014

Cheerleading has a long and varied history in the United States. Perhaps no other activity in the annals of physical culture has been so completely regendered,

sexualized, commercialized, and sportified. In its original nineteenth-century expression, it was an activity solely for male college students. [. . .]

There was a good degree of prestige associated with being a "cheer leader" at the time. Faculty committees, physical education departments, and student-body groups typically selected the distinction. The *Nation* described the prominence associated with holding the position in 1911: "As a title to promotion in professional or public life, it ranks hardly second to that of having been a quarter-back."[1] For the first few decades, many football cheerleaders were the captains of other varsity sports.[2] As scholar Mary Ellen Hanson contends, "The first cheerleaders, privileged college men, were seen as heroic figures, part of the masculine world of sport and competition. Fellow warriors with players on the field, these cheerleaders exemplified leadership and athleticism."[3] [. . .]

Eventually, the appearance of girls and women along the sidelines began to alter the cheerleader's status.[4] Around the 1930s, there were scattered reports of "dimpled-kneed coeds" at southern universities, though women were not eligible for election to the All-American squad.[5] Neither were they welcomed at many schools. The University of Pittsburgh, for example, remained stalwart until 1954 and only decided to take the "big step . . . to have girl cheer leaders" after a poll showed that 87 percent of students supported integration.[6] [. . .]

By the mid-1970s, an estimated 95 percent of all cheerleaders were female.[7] [. . .]

Before legal and cultural shifts provided greater opportunities for girls and women, cheerleading was one of the few sanctioned outlets for those who craved a modicum of physical activity. It also provided occasions to develop leadership and social skills, as well as to travel with the teams they supported. But as new sporting venues became available, the number of cheerleading participants declined.[8] And so, gradually, officials adapted the activity to accommodate those who wanted greater physicality. As *Washington Post* journalist Amy Argetsinger put it, "Cheerleading might have vanished. Instead, it harnessed the spirit of the times, evolving into a melange of highflying acrobatics and show-biz flair that required more athleticism than before."[9] Leaders of the emerging "spirit industry" re-athleticized cheer, a move that proved profitable, for they could offer training, camps, and clinics at which to teach these new skill sets as well as contests at which competitors could test their mettle.

Among the leaders of this burgeoning trade was Lawrence Herkimer. "Herkie," a former Southern Methodist University cheerleader, began conducting clinics and camps in the late 1940s. He went on to found the National Cheerleaders Association (NCA), a company that diversified to sell uniforms, pompoms, and other equipment. His protégé, Jeffrey Webb, left the NCA to found

the rival Universal Cheerleaders Association (UCA) in 1975, and developed strategies to incorporate more stunts and gymnastics into what had stagnated into a relatively undemanding activity. Today there are more than seventy-five organizations that currently regulate cheerleading in the United States, although the NCA and UCA remain the largest and most influential. And while the two retain their separate identities and competitions, both currently belong to the same parent company, Varsity Brands, Inc., a billion-dollar business for which Webb serves as chief executive officer (CEO).[10]

Beyond the Cheers

This new competitive type of cheerleading became wildly popular at both the high school and the collegiate levels. CBS televised the first high school cheerleading competition in 1978. ESPN followed suit in 1983 and, the next year, broadcast the national collegiate competition.[11] That same year, Herkimer opened the first "cheer gym" (Cheerobics Center, Inc.) singularly devoted to cheerleader instruction. This sparked a wave of private, for-profit "all-star" gyms where girls and boys train arduously and year-round for the chance to compete against other squads at local, regional, national, and now international levels. Movies like *Bring It On* (2000) and competitions broadcast by ESPN International have begun to globalize the sport. The International Federation of Cheerleaders, a nonprofit group, recently petitioned the IOC for recognition as an Olympic sport. Not to be outdone, Varsity Brands established its International Cheerleading Union and started to assert its dominance over other worldwide organizations. Cheerleading is no longer a "peculiarly American custom."

Many of the all-star gyms originally served as gymnastic training centers—their transformation a corollary of gymnastics' steady and unfortunate decline since the 1970s. The high cost of gymnastic equipment and insurance needed to sponsor a team, rumors of corrupt and abusive coaches, as well as an unexplained reduction in those who express interest in the sport have left few scholastically based programs in the United States. One result of this trend, argues journalist Kate Torgovnick, is that a "large number of homeless gymnasts channeled their energy into cheerleading."[12] Those who might otherwise direct their talents toward gymnastics have found an outlet in competitive cheer, raising the bar for all competitors and converting the sport into a new hybridized form.

Thus, by 2009, as one researcher acknowledged, "Cheerleading is a gymnastic activity, and why it is still called *cheerleading* is not quite clear. It is a competitive contact sport that involves all types of gymnastic stunts, pyramids, and partner stunts as well as throwing flyers high in the air and catching them (we hope)."[13]

A related consequence of the heightened prowess and intrepidity of all-stars has been the soaring number of those hurt during practices and contests. Between 1979 and 1989, the federal government's Consumer Product Safety Commission found that the injury rate in cheerleading jumped 133 percent.[14] Between 1990 and 2002, the number of cheerleading-related hospital emergency room visits more than doubled.[15] Data from the National Center for Catastrophic Sports Injury Research determined that, in 2010, females in high school and collegiate cheerleading accounted for 64.5 and 71.4 percent, respectively, of all catastrophic injuries reported for girls and women.[16]

Those who hope to see their sport promoted to varsity status cite these alarming statistics to justify their cause. The sporting ethos, the undergirding logic suggests, is premised on the potential to do damage to one's body. Recognizing cheer as a sport would also help reduce the number of injuries by mandating specialized certifications for coaches and ensuring the athletes have safe and equal access to training facilities and equipment.[17] It would provide support from athletic departments that applies to all sports, including funding, travel, insurance, medical assistance, academic support, strength and conditioning coaching, and, in the case of some colleges and universities, the potential for scholarship money. Although this seems like a sound proposal, many members of the cheer community are reluctant to move toward sport status.

In its official position statement, the American Association of Cheerleading Coaches and Administrators (AACCA) determined that "cheerleading is in a new, developing category called 'athletic activity'" and not a sport. It explains that classifying cheerleading as a sport brings a host of unwelcome restrictions that would take away from their mission: "The primary purpose is not competition, but that of raising school unity through leading the crowd at athletic functions." The classification would also require regulations that many are loath to adopt, including limitations placed on recruiting, eligibility, training, and season duration. The organization would, however, like to see cheerleaders recognized as "student athletes," which would provide "opportunities for academic honors and even coverage under the athletic catastrophic insurance policy carried by the school or state athletics or activities association."[18] Instead of creating a new sport, the AACCA hopes to create a new category for recognizing the standing of cheerleaders.

There is a corporate imperative that the AACCA does not acknowledge. A nonprofit organization designed to promote safety education at all levels of cheerleading, the AACCA is a subsidiary of the very-much-for-profit Varsity Brands, and the promotion of cheer to a varsity sport would take money away from the powerful conglomerate. Scholastic programs could opt out of the camps, clinics, and competitions, as well as the membership, training, and sanc-

tioning agendas that Varsity Brands provides. Athletes might buy their uniforms and accessories elsewhere. It would mean contestation for the monopolistic stranglehold that Varsity Brands currently has over cheerleading, and so there is a financial incentive to resist recognizing it as a sport. In fact, in the Biediger v. Quinnipiac University trial about whether the school violated Title IX by promoting competitive cheer to varsity sport status as it dropped the women's volleyball team, Varsity Brands' CEO Jeff Webb testified that cheerleading was not a sport, which hurt the school's case. But larger cultural and economic currents seem to inevitably navigate toward sportification, and, not to be left behind, USA Cheer, also an affiliate of Varsity Brands, recently created a new category of competition it calls "Stunt" (USA Cheer likes to write it in all capital letters: STUNT, though it does not appear to be an acronym).

In September 2010, USA Cheer announced its "NCAA Emerging Sport Initiative"—a plan that serves as a precursor to full-fledged championship-level, NCAA-sanctioned sporthood.[19] Stunt, the sport's website describes, "removes the crowd-leading element and focuses on the technical and athletic components of cheer."[20] Competitions, called "games," are made up of four quarters: partner stunts, jumps and group tumbling, tosses and pyramids, and a two-and-a-half-minute team routine (the traditional routine of competitive cheerleading; see table 1 for a clarification of the rules of Stunt, A&T [acrobatics and tumbling], and competitive cheer). In 2011 twenty-two teams competed in USA Cheer's first national tournament, staged at the annual NCA championship in Daytona, Florida. As of 2012, Stunt hosts national championships for Division I and Division II institutions and is developing programs for high schools.

Like USA Cheer, the NCATA [National Collegiate Acrobatics and Tumbling Association] is up front about its mission to achieve NCAA emerging-sport and, eventually, championship-sport status. Part of this process has been a deliberate divorce from the corporatized vise grip of Varsity Brands. In a bold move, the NCATA eschewed the prestigious NCA national tournament in 2011 and instead held its own championship on the same weekend. Each participating school recognizes A&T as a varsity-level sport, and the student athletes are subject to the same perks and restrictions as members of any other athletic team. A&T athletes may not participate on spirit or sideline cheerleading squads, a stipulation the NCATA requires to remain within Title IX compliance and "protect" sideline cheer, as opposed to threatening its existence. In September 2010, the organization announced its partnership with USA Gymnastics, which sanctions their events and provides insurance policies for athletes, coaches, and officials.

There is an obvious struggle for power over competitive cheer's newest derivations. At one point, USA Cheer and the NCATA discussed the possibility of joining forces, yet USA Cheer advertised its sponsorship of Stunt just one week

after the NCATA disclosed its partnership with USA Gymnastics, clearly meaning to challenge the NCATA's control. USA Cheer offered irresistible incentives for many teams and solicited both sideline and competitive squads to compete in Stunt events. The organization provided teams with free uniforms (designed suspiciously like those worn in A&T), travel and hotel accommodations to Stunt events across the country, and paid their registration fees for Stunt's national competition. In all, Oregon A&T coach Felecia Mulkey "guestimates," as she put it, that USA Cheer/Varsity Brands shelled out somewhere in the neighborhood of two million dollars to create the appearance of a well-established sport.[21]

Those who agreed to participate in Stunt were banned from competing in any NCATA event. USA Cheer justifies the prohibition by explaining that A&T has "no formal association with cheerleading." This is a proposition with which John Blake, executive director of the NCATA, does not entirely disagree: "It's not gymnastics and it's not competitive cheerleading, but truly a new sport.... It's a chance for a very popular skill set that combines a variety of activities and sports to be recognized and easily integrated into an athletic program."[22] Betwixt and between, advanced and embryonic, only time will tell who or what will win out.[23]

It seems imminent that one group or another will succeed and the NCAA will officially recognize some hybridized progeny of cheerleading and gymnastics in the future. The Women's Sports Foundation and the American Association of University Women have both expressed provisional support for NCAA recognition, so long as the version in question meets the qualifications of legitimate sport. In addition, there are so many girls who currently participate in some derivative of competitive cheer that there will inevitably be a demand for formal organization at the collegiate level. The 2010–11 data from the National Federation of State High School Associations determined that competitive cheerleading was the ninth most popular sport among girls and that popularity grows exponentially each year (see table 2).[24] This vastly underestimates the number of participants because it considers only those states that recognize competitive cheer as a varsity sport and discounts the legions of those who compete for private gyms.

At the same time, the nature of competitive cheer brings issues associated with race and social class that continue to plague girls' and women's sports. As the NCATA website advertises, 89 percent of participants in A&T come from cheer gyms, indicating an undeniable class bias. One journalist broke down the cost of participation as it stood in 2010: cheer gym membership ($2,000 to $3,000 per year), cheer camps ($200 to $300 for a week of training), uniforms ($50), customized warm-ups ($45), poms ($15), and hair ribbons ($4).[25] This is just the tip of the iceberg, but the point is that the financial burden associated with competitive cheer may place the sport outside the reach of many families.

TABLE 1 **Differences between Acrobatics, Tumbling and Stunt, and Competitive Cheer**

	Competitive cheer (collegiate level)	Acrobatics & tumbling	Stunt
Competition limits	16–20, depending on sponsoring organization	35–40 on roster; game-day roster of 28. 3 positions: base (main and secondary), back base, flyer	Minimum 20 for game play; maximum 30 on roster. 3 positions: bases, tops, and backspots
Season	Year-round	Spring sport beginning in February	Spring sport beginning in February
Minimum number of contests	N/A	6	8
Competition format	Each team performs one two-and-a-half-minute routine	2–4 teams compete at meets composed of 6 events (compulsory, stunts, pyramids, basket tosses, tumbling, team routine)	Head-to-head games with four quarters (Stunts, jumps and tumbling, tosses and pyramids, team performance)
Projected competition length	Dependent on the number of competing teams, though each team's performance is limited to two and-a-half minutes	2 hours (for 2 teams)	1 hour, 15 minutes (for 2 teams)

	Schools Number		Participants Number
Basketball	17,767	Track and field—outdoor	475,265
Track and field—outdoor	16,030	Basketball	438,933
Volleyball	15,497	Volleyball	409,332
Softball—fast pitch	15,338	Softball—fast pitch	373,535
Cross-country	13,839	Soccer	361,556
Soccer	11,047	Cross-country	204,653
Tennis	10,181	Tennis	182,074
Golf	9,609	Swimming and diving	160,881
Swimming and diving	7,164	Competitive spirit squads	96,718
Competitive spirit squads	4,266	Lacrosse	74,927

An attendant concern is the lack of racial diversity within all manifestations of cheerleading. As Adams and Bettis assess, "No official statistics are kept on the racial composition of cheerleaders in the United States. Yet, a visit to almost any cheerleading camp, a glance through *American Cheerleader*, cheerleading brochures promoting camps and competitions, any catalog selling cheerleading products, or a look at the nationally televised cheerleading championships reveals that cheerleading squads throughout the country are primarily white." Efforts to recognize competitive cheer (in any format) as an NCAA sport may increase athletic opportunities for white, middle-class girls and women but continue to disadvantage those of color. This has been an unfortunate pattern in the history of Title IX. Scholars determine that "interscholastic athletic access and participation opportunities for females are unevenly distributed along racial lines."[26] The newest and fastest-growing sports, such as rowing and soccer, are sports predominantly populated by white females, which further restricts athletic scholarship opportunities—and, therefore, access to higher education—for racial and ethnic minority females. More important, fewer athletic opportunities for girls and women of color denies them the health and social benefits of sports participation. Promoting competitive cheer to varsity status contributes to this problem.

Nothing to Cheer but Cheer Itself

Consider cheer's multiple points of change: from an enclave that once promoted the "big man on campus" to an athletically masculine pursuit, a feminized social activity, a sexualized aspect of the postmodern sports spectacle, a highly commercialized athletic activity, and, ultimately, a sport form divorced from its sideline roots, each one of cheerleading's descendants normalizes a particular gendered subjectivity. In competitive or all-star cheerleading, for example, there are certain pedagogies in place that instruct girls and women about appropriate femininity in the context of competition. Their presentations, in turn, influence cultural perceptions about the athletes.

This femininity is decidedly not "apologetic," as the 1970s theory suggested. Girls and women are not compensating for their participation in a masculine sporting domain because cheerleading has been so thoroughly feminized over the course of the past sixty years that certain gendered performances are not only commonplace but required. The engendering process is not hypodermic, but if one looks at the All-Star scoring sheet used at the NCA nationals, there are certain elements for which the judges look. "Crowd Appeal," described as "Facial Expression, Eye Contact, Energy," for example, counts for 10 percent of a teams' final score. There is also a category titled "Overall Impression" worth another 20 percent. The magazine *Girls' Life* instructs cheerleaders that part of "doin' it right" includes looking "like you're having a blast. . . . [I]t can be tough to look like you're genuinely stoked. So rehearse your game face in the mirror before brushing your teeth. Your smile will be bigger, and you'll perfect that 'tude-filled head toss. Wink!" In this context, smiling is not "a spontaneous emotional response," argue Adams and Bettis; "rather smiling is part of disciplining the body."[27] Cheerleaders' emotional labor constitutes a significant part of what they do.

Makeup, hairstyles, glitter, and costumes also contribute to the hyper-feminine personae of competitive female cheerleaders. The embellishments help them play to the crowd and enhance their uniformity in the eyes of the judges. At the same time, it is important to remember that a number of Varsity Brands' subsidiaries saturate the culture with this merchandise so that athletes are inculcated with the imperatives of consumerism. Cheerleading competitions, magazines, camps, clinics, magazines, and catalogs create integrated spaces of consumption that promote ways of behavior and modes of appearance as normal and natural in the sport, all of which require the purchase of commercial products.

Critics often note the bubbly aesthetic ingrained in competitive cheer in their rationale for discounting it as serious sport. This explains why NCATA and USA

Cheer officials have worked hard to rid their sports of the conventional femininity so prevalent in cheerleading—markers that color cultural perceptions about what the athletes do. Stunt and A&T competitors wear uniforms distinct from those of their predecessors, and NCATA rules prohibit skirts and bare midriffs. "Teams are not judged on looks, choreography and uniforms, but instead on how well they execute their athletic discipline," reads the answer to an "FAQ" on the organization's website. Former Maryland head coach Jarnell Bonds insisted on purging her squad of laboriously styled "pageant hair." The heavy stage makeup was out too, as were the glitter and pom-poms. "We want them to pay attention to what we're doing, not how we look," she explained. One accoutrement proved especially difficult for Bonds to convince her athletes to abandon: "Hair bows. They love those hair bows. That's how they grew up with the sport."[28]

Here is an interesting twist. In the past, women athletes have employed strategies to assert their femininity in the context of sport in order to gain acceptance. At least, that has been integral to my argument. [. . .] Historically, athletic women, encouraged by various arbiters of gender normativity, have perpetuated conventional performances of femininity in ways that tempered any radical reformations of our perceptions of athleticism and womanhood. In the case of A&T, however, women must forsake the accessories of emphasized femininity in order to be taken seriously as athletes. Does this newest sport form expand our definition of athleticism? Of femininity? Or have the participants found a way to negotiate the persistent tension between the two categories? Better yet, does that tension even exist for them and, by extension, for other women athletes in contemporary U.S. sport? [. . .]

In her study of a girls' all-star squad, Amy Moritz found that, for participants, "cheerleading provides a place where they do not have to choose between femininity and athleticism—they can be both simultaneously and in a fluid moving context."[29] Other scholars contend that critics of the sport fail to understand that times have changed and that femininity no longer connotes weakness and oppression but rather conveys a range of gendered options from which contemporary girls now have the freedom to choose. In their extensive research on cheerleading, for instance, Adams and Bettis determined that "cheerleading offers a critical space for certain girls to take risks, to try on different identities, to delight in the physicality of their bodies, and to control and revel in their own power and desire. In this sense cheerleading does not have to be read as a debilitating discourse of victimization and exploitation, as typically interpreted by feminists."[30] These are arguments that have come to characterize third-wave feminism. That is, that girls and women have control over the making and shaping of their self-presentations. That there is power

and pleasure in the feminine, and to admit as much does not require some kind of consciousness raising on the part of the "girlies," but for those so quick to condemn their performativity.[31]

I do not mean to conflate all-star with A&T and Stunt, but my concern is that the former feeds into the latter. More specifically, my concern is that by participating in competitive cheer during their formative years, by the time they become varsity athletes these women will have been inundated with particular messages about how they should look and behave with regard to femininity—messages that will be hard to shake. Then again, I am cognizant of those who may find this critique misguided. Perhaps femininity no longer signifies vulnerability or passivity but rather signals strength and power. Individuals might "do gender" with a sense of playfulness and fluidity, creating performances specific to certain contexts in ways that signify agency and empowerment.

In *Sports in America*, James Michener denounced the activity of cheerleading as he assessed it in the mid-1970s. "I cannot comprehend why parents, and particularly mothers, prefer their daughters to be cheerleaders and pompon girls rather than athletes. This relatively recent development is a perversion of the human instinct for play and makes of a young girl a blatant sex object rather than a human being in her own right." He continued with his hopes for what sport might offer in the future: "I want our society to produce real women concerned with their own activities rather than giddy cheerleaders whose lives revolve around what the boys do in football. But I fear that in this contest the cheerleaders are bound to win, and the other night I found myself arguing, 'Well, twenty years from now, when we have a new society and a new type of girl, they'll be interested in their health and their physical fitness rather than cute miniskirts.'"[32] We are now almost forty years away from Michener's original observations. Cheerleading is no longer performed exclusively for others; participants are concerned with their own activities. And there is a new type of girl who may be simultaneously interested in health, physical fitness *and* cute miniskirts. For her, the choices may not be contradictory or mutually exclusive. Perhaps, in the end, this does give us something to cheer about, though let us do so with reserve and, if possible, without the hair bows.

Notes

Note numbers and callouts have been changed from the original article.

1. "Organized Cheering," 5–6; Mary Ellen Hanson, *Go! Fight! Win! Cheerleading in American Culture*, 13.
2. Arturo F. Gonzales, "The First College Cheer," 103.

3. Hanson, *Go! Fight! Win!*, 121.

4. Hanson, *Go! Fight! Win!*, 15; Marisa Walker, "Great Dates in Cheer," 42. Historically, as Verne Bullough notes in *The Subordinate Sex*, as women have entered particular professions, such as clerical work, elementary school teaching, and nursing, men have vacated those vocations for more powerful positions within those fields (employer, principal, physician).

5. "Sport: All-America."

6. "Girl Cheer Leaders for Pitt," *New York Times*, April 18, 1954, S7.

7. Randy Neil, *The Encyclopedia of Cheerleading*, 75; Hatton and Hatton, "The Sideline Show," 27; L. Davis, "Male Cheerleading and the Naturalization of Gender."

8. Judy Klemesrud, "Still the Rah-Rah, but Some Aren't Cheering," *New York Times*, 11 October 1971, 44.

9. Amy Argetsinger, "When Cheerleaders Are the Main Event," *Washington Post*, 10 July 1999.

10. Adams and Bettis, *Cheerleader: An American Icon*, 111.

11. Laura Grindstaff, "Hold that (Gender) Line! Cheerleading on ESPN."

12. Kate Torgovnick, *Cheer! Inside the Secret World of College Cheerleaders*, xvii.

13. Frederick O. Mueller, "Cheerleading Injuries and Safety," 565.

14. Sonja Steptoe, "The POM-POM Chronicles."

15. Brenda J. Shields and Gary A. Smith, "Cheerleading-Related Injuries to Children 5 to 18 Years of Age: United States, 1990–2002." In a subsequent study, Shields and Smith determined that the rate of injury in cheerleading may be overreported and sensationalized. Shields and Smith, "Cheerleading-related Injuries in the United States: A Prospective Surveillance Study."

16. Frederick O. Mueller and Robert C. Cantu, "Catastrophic Sports Injury Research: Twenty-Eighth Annual Report, Fall 1982–Spring 2010," http://www.unc.edu/depts/nccsi.

17. See Council on Sports Medicine and Fitness, "Cheerleading Injuries: Epidemiology and Recommendations for Prevention."

18. American Association of Cheerleading Coaches and Administrators, "Position Paper: Addressing the Issue of Cheerleading as a Sport," http://aacca.org/content.aspx?item=Resources/Test.xml.

19. For more on NCAA Emerging Sports, see NCAA, "Emerging Sports for Women," http://www.ncaa.org.wps/portal/ncaahome?WCM_GLOBAL_CONTEXT=/ncaa/NCAA/About+The+NCAA/Diversity+and+Inclusion/Gender+Equity+and+Title+IX/New+Emerging+Sports+for+Women.

20. College Stunt Association, http://www.collegeStunt.org/index/php.

21. Mulkey interview.

22. "NCA College Nationals Eligibility FAQ's," http://nca.varsity.com/college_nationals.aspx; "Two Cheers."

23. The NCAA recently recommended that the two organizations work together to promote one version of their sport, but USA Gymnastics will not work with a division of Varsity Brands, while Varsity Brands is loath to acquiesce control over its cheer dominion. The coming months, perhaps years, will undoubtedly bring even more controversy.

24. National Federation of State High School Associations 2010–2011 Athletics Participation Summary, http://www.nfhs.org/content.aspx?id=3282.

25. NCATA official website, http://www.thencata.org/index.html; Alissa Figueroa, "Cheerleading May Not Be a Sport, but It Is an Industry," *Christian Science Monitor*, 22 July 2010, http://www.csmonitor.com/Business/new-economy/2010/0722/Cheerleading-may-not-be-a-sport-but-it-is-an-industry.

26. Adams and Bettis, *Cheerleader: An American Icon*, 92; Moneque Walker Pickett, Marvin P. Dawkins, and Jomills Henry Braddock II, "The Effect of Title IX on Participation of Black and White Females in High School Sports: Evidence from National Longitudinal Surveys," 88; Sarah K. Fields, "Title IX and African-American Female Athletes."

27. Katie Abbondanza, "Bring It On"; Pamela Guice Adams and Pamela J. Bettis, "Alpha Girls and Cheerleading: Negotiating New Discourses with Old Practices," 159.

28. "FAQ," NCATA official website, http://www.thencata.org/home-2/faq/; Jarnell Bonds, interview with the author, March 9, 2010, College Park, MD.

29. Amy Moritz, "Cheerleading: Not Just for the Sidelines Anymore," 668. See also Molly Quinn, "Getting Thrown Around."

30. Adams and Bettis, "Alpha Girls and Cheerleading," 161.

31. See, for example, Leslie Heywood and Jennifer Drake, *Third Wave Agenda: Being Feminist, Doing Feminism*; Jennifer Baumgardner and Amy Richards, *Manifesta: Young Women, Feminism, and the Future*; and Leslie Heywood and Shari L. Dworkin, *Built to Win: The Female Athlete as Cultural Icon*.

32. James A. Michener, *Sports in America*, 141–2.

References

Abbondanza, Katie. "Bring It On." *Girls' Life* 14 (April–May 2008): 70–72.

Adams, Natalie Guice, and Pamela J. Bettis. "Alpha Girls and Cheerleading: Negotiating New Discourses with Old Practices." *Girlhood Studies* 2 (2009): 148–66.

———. *Cheerleader: An American Icon*. New York: Palgrave Macmillan, 2003.

Baumgardner, Jennifer, and Amy Richards. *Manifesta: Young Women, Feminism, and the Future*. New York: Farrar, Straus, and Giroux, 2000.

Bullough, Verne. *The Subordinate Sex*. Baltimore: Penguin Books, 1974.

Council on Sports Medicine and Fitness. "Cheerleading Injuries: Epidemiology and Recommendations for Prevention." *Pediatrics* 130, no. 5 (2012): 966–71.

Davis, Laurel R. "Male Cheerleading and the Naturalization of Gender." In Messner, Michael A., and Donald F. Sabo (eds.), *Sport, Men, and the Gender Order: Critical Feminist Perspectives*. Champaign, IL: Human Kinetics, 1990.

Fields, Sarah K. "Title IX and African-American Female Athletes." In Lomax, Michael (ed.), *Sports and the Racial Divide: African American and Latino Experience in an Era of Change*. Jackson, MS: UP of Mississippi, 2008.

Gonzales, Arturo F. "The First College Cheer." *American Mercury* (November 1956): 101–4.

Grindstaff, Laura. "Hold that (Gender) Line! Cheerleading on ESPN." *Contexts* (Summer 2005): 71–3.

Hanson, Mary Ellen. *Go! Fight! Win! Cheerleading in American Culture*. Bowling Green, Ohio: Bowling Green State University Popular Press, 1995.

Hatton, Charles Thomas, and Robert W. Hatton. "The Sideline Show." *Journal of the National Association of Women's Deans, Administrators, and Counselors* 41 (1978): 23–28.

Heywood, Leslie, and Jennifer Drake, *Third Wave Agenda: Being Feminist, Doing Feminism*. Minneapolis, MN: University of Minnesota Press, 1997.

Heywood, Leslie, and Shari L. Dworkin. *Built to Win: The Female Athlete as Cultural Icon*. Minneapolis, MN: University of Minnesota Press, 2003.

Michener, James A. *Sports in America*. New York: Random House, 1976.

Moritz, Amy. "Cheerleading: Not Just for the Sidelines Anymore." *Sport and Society* 14 (2001): 660–69.

Mueller, Frederick O. "Cheerleading Injuries and Safety." *Journal of Athletic Training* 44 (2009): 565–6.

Mueller, Frederick O., and Robert C. Cantu. "Catastrophic Sports Injury Research: Twenty-Eighth Annual Report, Fall 1982–Spring 2010," http://www.unc.edu/depts/nccsi.

Neil, Randy. *The Encyclopedia of Cheerleading*. Shawnee Mission, Kans.: International Cheerleading Foundation, 1975.

"Organized Cheering," *Nation*, January 5, 1911, 5–6.

Pickett, Moneque Walker, Marvin P. Dawkins, and Jomills Henry Braddock II. "The Effect of Title IX on Participation of Black and White Females in High School Sports: Evidence from National Longitudinal Surveys." *Journal of Race and Policy* 5 (2009): 79–90.

Quinn, Molly. "Getting Thrown Around." *Taboo* 7 (Fall–Winter 2003): 7–24.

Shields, Brenda J., and Gary A. Smith. "Cheerleading-related Injuries in the United States: A Prospective Surveillance Study." *Journal of Athletic Training* 44 (2009): 567–77.

———. "Cheerleading-related Injuries to Children 5 to 18 Years of Age: United States, 1990–2002." *Pediatrics* 17 (2006): 122–29.

"Sport: All-America." *Time*, December 11, 1939. http://www.time.com/time/magazine/article/0,9171,763027,00.html.

Steptoe, Sonja. "The POM-POM Chronicles." *Sports Illustrated*, January 6, 1992, 40–46.

Torgovnick, Kate. *Cheer! Inside the Secret World of College Cheerleaders*. New York: Touchstone, 2008.

Walker, Marisa. "Great Dates in Cheer." *American Cheerleader*, February 2005, 42.

Part 6 takes a closer look at the complex relationships between sexuality, sex, and sport. Why would one's sexual identity be any more important in sport than in other cultural pursuits, such as learning a language or singing in a choir? The physicality of sport, its associations with the revealed body (especially in sports such as track, volleyball, and swimming, where uniforms expose much of the body), and the images of unleashed, raw, or primal passions stirred by "naked competition" mirror qualities we associate with sexuality. Sport also promotes physical closeness among teammates, encouraging forms of personal—even intimate—contact (such as hugging or patting the butt of another player) that, in a different context, the general public might perceive as inappropriate displays of public affection, especially between athletes of the same sex. In its most insidious form, physical contact between athletes, coaches, and physicians can cross the line into assault.

The first two readings in this section underline the reach of that broader culture. Paul Gallico, one of the most popular sports columnists of the 1930s, exhibited a combination of contempt and bewilderment regarding female athletes in much of his work. In his 1936 article "Women in Sports Should Look Beautiful," Gallico argues that there are only eight sports in which women "do not manage to look utterly silly." In all other sports (seventeen, by his estimation), women make unattractive spectacles of themselves. "It is a lady's business to look beautiful," Gallico argued, "and there are hardly any sports in which she seems able to do it." For this reason, women should stick to sports like fishing, aviation, figure skating or ice dancing, and back-stroke swimming—sports in which they can look pretty, graceful, and wear "pretty cute costumes. . . . That's

what little girls were made for," the acclaimed journalist maintained, albeit somewhat facetiously.

Gallico's opinions continue to play out decades later in what Laura Pappano identifies as a "sharp (even bitter) debate: Female athletes' bodies and how they use them." Should women athletes rely on sex appeal to market themselves and their sport, or does this type of strategy undercut their legitimacy? In "Athletes and Magazine Spreads: Does Sexy Mean Selling Out?" Pappano argues that no matter where one lands on the controversial subject, "much of the debate is a distraction to the fundamental challenge of getting to a more fair place" when it comes to women's sports.

The next two articles show the wide-reaching effects of sexualizing women athletes. C. Ramsey Fahs, a staff writer for the *Harvard Crimson*, describes the Harvard men's soccer team's tradition of circulating sexually explicit scouting reports of incoming women soccer players. In response, some of the women who were the subject of that report issued a critical but ultimately gracious response. In "Stronger Together," the women first describe the "embarrassment, disgust, and pain" they felt after the story broke. In the end, however, they ask women and men to join forces against sexualizing practices and their dehumanizing effects.

The subsequent reading transitions from the hyper-heterosexualization of women athletes to issues of homophobia, both of which have to do with a broader culture of sexism. In her 1992 article "Changing the Game," sport scholar and activist Pat Griffin explores several manifestations of homophobia in sport and, especially, the ways in which these manifestations continue to "control and intimidate women." Griffin published this important work more than a quarter century ago. To what extent do we still see issues of silence, denial, apology, the promotion of a heterosexual image, attacks on lesbians, and a preference for male coaches in women's athletics today?

According to Allie Grasgreen in "Gag Orders on Sexuality," silence and denial continue to characterize the contemporary sporting landscape when it comes to issues of sexuality. Specifically, Grasgreen discusses these manifestations of homophobia in relation to basketball star Brittney Griner, who publicly came out (almost nonchalantly) just after her number-one selection in the 2013 WNBA draft. Griner later revealed that her former coach at Baylor University, Kim Mulkey, forbade lesbian athletes from talking publicly about their sexuality, fearing that they would damage the program's reputation. Commenting on the issue, Pat Griffin characterizes Mulkey's policy as "nothing new." What is "new," Griffin continues, "is that Brittney Griner has the courage to not only come out but to call the game."

The final selection presents the darkest side of sex and sport: sexual violence

Specifically, journalist Lindsay Gibbs explores USA Gymnastics' (USAG) involvement in what she calls "the biggest sex abuse scandal in American sports history." The scandal broke in December 2016, when the *Indianapolis Star* reported that, over the course of the previous two decades, at least 368 gymnasts had alleged that coaches, gym owners, and other adults working within the sport had sexually abused them. As the *Star* calculated: "That's a rate of one every 20 days. And it's likely an undercount."[1]

Since that initial story, Gibbs explains, former federal prosecutor Deborah J. Daniels investigated USAG and determined that the organization repeatedly failed—at every level—to safeguard the health and safety of its athletes, opting instead to prioritize winning medals and to preserve its reputation. Chief among the horrific charges are those against Dr. Larry Nassar, a longtime team physician for USAG and sports programs at Michigan State University. As of 2017, more than 140 girls and women have accused Nassar of sexual assault and rape, including 2012 Olympic gold medalist McKayla Maroney, who revealed that the abuse started when she was 13 years old and did not stop until she left the sport.

Together, the readings in this section speak to the centrality of sexuality in women's experience of sport. Sexuality, in turn, cannot be separated from the power dynamics that shape women's place in the sporting world and larger society.

Note

1. Tim Evans, Mark Alesia, and Marisa Kwiatkowski, "A 20-Year Toll: 368 Gymnasts Allege Sexual Exploitation," *Indianapolis Star,* December 16, 2016, ww.indystar.com /story/news/2016/12/15/20-year-toll-368-gymnasts-allege-sexual-exploitation/95198724.

WOMEN IN SPORTS
SHOULD LOOK BEAUTIFUL

Paul Gallico | 1936

From *Reader's Digest*, August 1936, 12–14.

Of some 25 sports in which ladies of today indulge publicly with vehemence and passion there are only eight in which they do not manage to look utterly silly. Definitely interdicted, and never again to be performed before my eyes, is any sport in which women stick out places when they play, wear funny clothes, get out of breath, or perspire. It is a lady's business to look beautiful, and there are hardly any sports in which she seems able to do it.

Ladies have no business playing squash, or any of its derivatives. They can't take it, or rather they can't take it gracefully. I am reminded particularly of an international match in which two gals played themselves into a state of absolute popeyed exhaustion, so that between games they sat panting on the floor of the court, their legs spread out, backs to the wall, tongues hanging out, faces beet-red, hair damp and scraggly, shorts and blouses wet and clinging. Come, come, girls. We simply cannot be having that sort of thing.

Ladies think they look beautiful and graceful playing tennis, but they do not. The girl has not yet been built who can run attractively—girls do something funny with their feet, or their knees go the wrong way. And the hippity-skippity sort of jig they do from side to side to cover court is just about as elegant as a giraffe in a great hurry. And besides, they get hot, and puff out their cheeks, and some of them stick out their tummies when about to lay into a forehand drive.

Females who don track shorts and jerseys and run and jump in track meets

are just wasting their time and ours, because they can't run fast enough or jump high enough or throw things far enough to matter, and besides they weren't built for that sort of costume. The upper part of their legs go in at the wrong places; they carry too much weight from the waist up unless they are built like boys (in which case this doesn't count, because then they aren't ladies); and finally they ought to get a look at their faces as they break the tape at the finish of the 100-yard dash, twisted and contorted and pitted with the gray lines of exhaustion.

Basketball and baseball played right are games for men, and good tough ones, and if you don't play it right, why play at all? If girls played basketball under men's rules, they would be taken away on stretchers after five minutes. Be quiet. I know I'm being unreasonable. You can write me indignant letters when I'm through.

Badminton sounds like a lady's game, but it isn't, because one hard set of badminton, well played, is more exhausting than three sets of tennis and I have already made the point that cuties should never, never go all out so they breathe audibly and get mustaches of perspiration.

Golf was never meant for women. If you don't believe it just think back, if you are a gentleman reader, to some of the instructions given you by your professional as to what to do with your Whatsit and your Whosit when you swing. A girl just can't do those things and still be a lady.

Fencing calls for the most absurd and unflattering posture in which a female could be asked to twist herself, and besides, the clothes most of them wear are utterly ridiculous and unsuited to the figure. The only time a girl fencer looks graceful and feminine is in the lunge when perfectly executed.

Girls don't look well swimming freestyle or breast stroke, because their hips are too wide and they wear those dreadful tight-fitting bathing caps to keep their hair from getting wet. Why don't they *let* their hair get wet? Georgia Coleman, the great diving champion, used to go off the 10-foot board and the high tower without a cap, and there was nothing prettier than to see her swimming back with her short yellow hair, wet and slick, streaming behind her.

Handball is simply no game for girls, and neither is polo, and any lady who permits herself to be lured into an eight-oar barge to pull a 12-foot sweep, or sculls, ought to have her head examined. It's a murderous sport and nothing for females.

I am now happy to arrive at the sports that have my approval for public performance, beginning with angling. Somehow it is pleasing and stimulating to see a girl hooked into a fish and playing him well, and except when she puts on waders to go into trout streams, she can get herself up in some pretty cute costumes. Look out for sunburn, darlings. Uncle Gallico doesn't like blistered and peeling noses. Somehow, too, a lady can manage to look most fetching shooting a bow and arrow. Archery is a calm, contemplative sport, as well, and the movements are all graceful.

Nor is there anything prettier than to watch a good girl flier—they're all good or they don't live long—circle her bright-colored bird down out of the sky and set it down on the field neatly and smoothly, roll to a stop, and reach for her handbag and powder her nose and touch up her lips before she scrambles out of the cockpit all aglow with the fun and excitement of it. Flying costumes are most becoming, too.

Riding and shooting are on the "Yes" list. So is back-stroke swimming. It is graceful and full of rhythm and the girls swim, face up, their features wreathed and softened by the white foam they churn up in the green waters.

Speed and figure skating are permitted, especially the latter, which is the female figure in the dance, but freed by the steel blades from the ordinary pull of gravity and lethargy of friction. An entire arena is her dance floor, and there is no costume lovelier or more graceful than the figure-skating dress with its short flared skirt, and the jaunty caps to match. Watch Sonja Henie Maxie Heber, or Maribel Vinson loose on the ice to a rhumba or a fox-trot, and you will see what I mean. That's what little girls were made for.

Skiing is on the doubtful list not because the gals don't look simply magnificent in ski clothes and graceful as wheeling gulls when they do it well, but they are always running into trees, or getting water on the knee, or twisting their ankles, which makes them practically useless as dancing partners, and they hobble around looking woeful, and I am too tender-hearted for that sort of thing. And they do get themselves into the most ridiculous positions when they fall.

It is to be hoped that this is all clear. It's my last warning on this matter.

ATHLETES AND MAGAZINE SPREADS

Does Sexy Mean Selling Out?

Laura Pappano | 2012

Excerpted from *On the Issues*, Spring 2012, www.ontheissuesmagazine.com /2012spring/2012spring_Pappano.php.

As a blogger and reader of women's sports blogs, I've learned that one subject reliably spurs sharp (even bitter) debate: Female athletes' bodies and how they use them. Whether the occasion is the *Sports Illustrated* swimsuit issue, bare-all

ESPN magazine spreads or even NCAA softballers planning time for hair and make-up to play in televised championships, it hits a well-worn nerve.[1]

The arguments line up as neatly as opposing soccer teams before the starting whistle. Some point out that women athletes with fabulous bodies and appealing looks should take advantage. If sex appeal broadens name recognition and brings attention, why not call in a little cheesecake to build the fan base? But others argue that pursuit of sexiness undercuts the status of women as serious athletes and, by extension, women's sports as legitimate, compelling athletic events. You don't look to lingerie football for great play. If tuning into women's sports is about watching not for skills but for skin, isn't that a problem?

The stark division, in other words, comes down to this: When female athletes lean on sex appeal, they either 1) are doing what they must to compete in a noisy and unfair world, or 2) are succumbing to a sexist value system that pushes women's sports to the margins and would rather treat women as sex objects than acknowledge their talent. Neither of these ideas is new. In fact, their constancy has gotten annoying. Can't we move the conversation forward?

We are stuck, I think, for three reasons: 1) Despite Title IX and "progress," we are still unsure what the job description "female athlete" entails; 2) Sports and sex appeal are linked, but that link is more fraught for women; 3) Women's bodies are still not, culturally speaking, their own.[2]

Let's take these in order [. . .]

Playing like Ladies

Look at "bad" behavior—say, the famous ponytail pull or Serena's cussing at an umpire at the U.S. Open—to be reminded of the narrow range of acceptable comportment for female athletes. The reason treatment of women in *Mad Men* is so funny is because women are now the majority of college graduates and earning more advanced degrees than men. Title IX helped women move from the sidelines onto the field, but advancement is slow. In a growing number of households, women are the big earners. In sports, they are still fighting for fans, pay and media coverage. When a female athlete plays up to male heterosexual desires, it looks like an inside job to thwart equity.

Yet—to get to point number two—on some level all commercial sport is about sex appeal. NFL quarterbacks are the sexy face of the franchise in a league marketing to women (pink gear aside) as well as to men.[3] Sex appeal is all over men's sports, from the NBA to NASCAR, MLS and tennis. Guys take off their shirts before crowds (and not just because it's too warm for comfort). For female athletes, the matter is more charged. How to differentiate between sex appeal that is part of the package and sex appeal that *is* the package? Sadly, lots of ink

has been spilled debating whether Danica Patrick is earning attention because she's a promising driver or because she's "sexy," a word she reportedly doesn't like being called.

At the root of the conflict is that organized sports are gendered as "masculine," invented to prepare boys for "manhood" as women trained to rule the home. Victorians believed that the future of society depended on men and women occupying "separate spheres." Football with its helmets and taking of territory taught boys lessons their fathers learned on the Civil War battlefield. So even though women took to basketball almost as soon as it was invented in 1891, the first games drew outrage: Aggressive female play was "mannish" and might drive players to take on male characteristics. (Solution: restrictive girl's rules.)

By the 1950s female basketball players and track athletes wore make-up and short-shorts to "prove" their femininity (and heterosexuality). Fear of developing "ugly muscles" kept many girls from sports altogether. During the Cold War, the U.S. was trounced by the Soviet Union in Olympic Medal counts—with women to blame. At the 1960 Olympics, Soviet women earned 28 medals to American women's 12. A 1963 *Sports Illustrated* article featured an attractive Russian female athlete and asked, "Why Can't We Beat This Girl?" The article said the reason American girls can't run faster is that "most won't even try."

Women Deserve Bodily Control

We may not consider this history today, but its influence lingers. For female athletes, the cultural context in which they play has changed some, but not enough, since the 1960s. Female beauty is today less Twiggy and more Serena, but we still feel conflict around physical performance and physical attractiveness. Patriots QB Tom Brady can frolic with farm animals, yet no one doubts his intentions when he steps up to throw. But U.S. World Cup team player Brandi Chastain's act of celebratory zest still gets read as a striptease. When female athletes appear in the *Sports Illustrated* swimsuit issue, do we see the beauty of the female athlete's body—or another victim of the bottomless appetite for fresh, sexy images? How many who ogle the female athletes in *Sports Illustrated* have seen them play with clothes on? Is it different when a household-name athlete like Serena is the subject? Is she sharing with the world just how beautiful and powerful her body is? Or is she just playing nasty? We never know intention—just as we don't understand how sexy images of women athletes are received.

Part of the matter—to address the third point—is that women's bodies are not really their own. One might read the decision to market one's sex appeal, particularly in the context of the revived political debate over contraception,

as the quest for a woman to control the use of her own body. Consider that for generations women's reproductive role has been subject to regulation by governments, courts and sports organizations under the guise of "protecting" women to insure the future population. It kept menstruating women in Victorian times from law school (blood needed for study would go to the brain, leaving a barren womb), and, later, girls from Little League (they would get hurt) until 1973, just to name two. It has taken years and loads of energy to challenge these views.

Females want to be in charge of their bodies, whether it's deciding to wrestle on the middle school team or to become a parent. If access to birth control has been critical to women's rising rates of education, salaries and career advancement, isn't the ability to command a magazine cover just another vehicle for increasing economic power?

The "right" to market one's sex appeal may not be of equal weight to the right to reproductive freedom, but we should recognize that athletes who pose nude or employ sex appeal are not necessarily subverting female power or the goal of advancing gender equity in sport. In the past, I have expressed disappointment to see sultriness where I'd hoped for competitive sass.[4] There is still plenty of sexiness that is mostly about titillation (read: NASCAR's Cope twins). But much of the debate is a distraction to the fundamental challenge of getting to a more fair place. We spar now because women's sports still feels fragile and temporary (will WPS—Women's Professional Soccer—really come back?) Certainly, we will always reserve admiration for athletes—male or female—who are strong role models and good people. But seeking real equity for female athletes means learning to appreciate female athletes' performances on their own. We may be desperate for role models for daughters and want proper, PR-friendly, sunny-dispositioned stars. But equality means not making girl-next-door comportment a condition of our support.

Notes

Links in the original online version of this article have been turned into endnotes.

1. "Sports Illustrated 2010 Swimsuit Cover Model, Brooklyn Decker," CNBC, February 11, 2010, www.cnbc.com/business-model-sports-illustrated; "Hope Solo and Other Athletes to Bare All in *ESPN the Magazine* 'Body' Issue," ESPN Radio website, October 5, 2011, http://1045theteam.com/hope-solo-and-other-athletes-to-bare-all-in-espn-the-magazine-body-issue.

2. "About Title IX," Gender Equity in Sports, http://bailiwick.lib.uiowa.edu/ge/aboutRE.html.

3. Alex Weprin, "NFL Launches Women-Centric Website," *TVNewser*, September 27, 2010, www.adweek.com/tvnewser/nfl-launches-womens-website/87313.

4. Laura Pappano, "Sarcasm Over, *SI*: Time for Real Pics of Female Athletes," *Fair Game News*, February 13, 2010, http://fairgamenews.com/2010/02/sarcasm-over-si-time-for-real-pics-of-female-athletes.

2012 HARVARD MEN'S SOCCER TEAM PRODUCED SEXUALLY EXPLICIT "SCOUTING REPORT" ON FEMALE RECRUITS

C. Ramsey Fahs | 2016

From the *Harvard Crimson*, October 25, 2016, www.thecrimson.com /article/2016/10/25/harvard-mens-soccer-2012-report. Bracketed insertions are part of the original publication.

In what appears to have been a yearly team tradition, a member of Harvard's 2012 men's soccer team produced a document that, in sexually explicit terms, individually assessed and evaluated freshmen recruits from the 2012 women's soccer team based on their perceived physical attractiveness and sexual appeal.

The author and his teammates referred to the nine-page document as a "scouting report," and the author circulated the document over the group's email list on July 31, 2012.

In lewd terms, the author of the report individually evaluated each female recruit, assigning them numerical scores and writing paragraph-long assessments of the women. The document also included photographs of each woman, most of which, the author wrote, were culled from Facebook or the Internet.

The author of the "report" often included sexually explicit descriptions of the women. He wrote of one woman that "she looks like the kind of girl who both likes to dominate, and likes to be dominated."

Each woman was assigned a hypothetical sexual "position" in addition to her position on the soccer field.

"She seems relatively simple and probably inexperienced sexually, so I de-

cided missionary would be her preferred position," the author wrote about one woman. "Doggy style," "The Triple Lindy," and "cowgirl" were listed as possible positions for other women.

The author also assigned each woman a nickname, calling one woman "Gumbi" because "her gum to tooth ratio is about 1 to 1."

"For that reason I am forced to rate her a 6," the author added.

"She seems to be very strong, tall and manly so, I gave her a 3 because I felt bad. Not much needs to be said on this one folks," the author wrote about another woman.

Concluding his assessment of one woman, the author wrote, "Yeah . . . She wants cock."

The "report" appears to have been an annual practice. At the beginning of the document, the author writes that "while some of the scouting report last year was wrong, the overall consensus that" a certain player "was both the hottest *and* the most STD ridden was confirmed."

Several members of the 2012 men's team declined to comment on the document, including whether subsequent men's soccer teams continued to create similar "reports."

Before the document was sent out to the team, an older member had emailed the list ordering that "someone man up and send out a proper scouting report on the incoming freshman [*sic*] for girl's team." Responding to that email, another teammate addressed the author, writing "what the fuck where are you on this?"

When the document was sent, several members of the team responded to the email. One member expressed approval of the document, writing "hahahahaha well done."

The document and the entire email list the team used that season were, until recently, publicly available and searchable through Google Groups, an email list-serv service offered through Google.

Director of Athletics Robert L. Scalise viewed the document for the first time Monday and said he had been unaware of the document until then.

Directly after seeing the document, he said, "Any time a member of our community says things about other people who are in our community that are disparaging, it takes away from the potential for creating the kind of learning environment that we'd like to have here at Harvard."

He added: "It's very disappointing and disturbing that people are doing this."

Scalise said the document reflects issues that extend far beyond Harvard's campus.

"We're not insulated from these types of things," he said. "These things exist in our society. Society hasn't figured out a way to stop these things from happening."

"Whenever you have groups of people that come together there's a potential for this to happen," Scalise added.

"It could be an individual, it could be a group, it could be a rooming group, it could be an athletic team," he said.

Pressed on whether the "scouting report" affected campus culture beyond impacting "the kind of learning environment" that Scalise described, he said, "I don't have a comment on that right now. I have to think about it a little."

"We need a little bit of time to just think about it and not rush to anything," Scalise said. "But it's totally inappropriate and disturbing."

Though Scalise said his first steps for responding to the document would "certainly" include speaking to coaches of both men's and women's athletic teams, he added that "there's a role for the administration at the College to also play in this" in addition to the athletics department.

Any reaction to the document, though, should be "an internal Harvard matter," Scalise said.

"This is not a media thing," Scalise said. "This is something that should be looked at by us in the administration to figure out what our steps are, but we shouldn't do anything more with the media on this other than 'thank you for letting us know about this, okay. We need to look at it.'"

First contacted about the document late Friday afternoon, Dean of the College Rakesh Khurana did not respond to multiple requests for an in-person meeting to view the document. College spokesperson Rachael Dane wrote in an email that Khurana was unavailable for an in-person interview. Khurana instead emailed a statement, after Dane had viewed the document herself in person.

"As a human being, and a member of the Harvard College community, I am always profoundly disturbed and upset by allegations of sexism, because I feel it is wrong and antithetical to this institution's fundamental values," Khurana wrote. "No one should be objectified. In light of all the attention that has been given to issues of inclusion, gender equity, and personal integrity at Harvard and elsewhere, we must work together to build a community of which we can all be proud."

Khurana also wrote that because "I was not Dean of Harvard College in 2012 and do not have knowledge of this particular email, I cannot speak to the alleged conduct of these particular students."

Evelynn M. Hammonds, who was the Dean of the College in 2012, deferred comment to Dane.

"When I first heard of this report from the Crimson, I was shocked and disgusted," wrote current Men's Soccer Coach Pieter S. Lehrer in a statement provided by Director of Athletic Communications Tim Williamson. "I will take

this opportunity to address this document from 2012 with my current athletes. I hope their seeing how offensive and hurtful this is will be a valuable lesson for everyone involved with this program."

Neither Lehrer, who was not the men's soccer coach at the time of the 2012 email, nor the team's current captains responded directly to inquiries as to whether there were "reports" produced after 2012.

"The information contained in this document from 2012 is unacceptable, and I am saddened to see this level of disrespect shown to these women," wrote Women's Soccer Coach Christopher P. Hamblin in an emailed statement, adding that "since Coach Lehrer's hire in 2013, I have seen a huge shift in the culture of the men's soccer program at Harvard."

The document, though written four years ago, surfaces amid a year at Harvard defined, in many ways, by campus discourse about gender equity and campus sexual harassment. It also comes at a time in which national conversations on the current presidential campaign focus on the same subject. After the surfacing of a 2005 tape in which Republican presidential nominee Donald J. Trump boasts about groping women, Trump dismissed his comments as "locker-room banter."[1]

In March, a University-wide task force on sexual assault prevention released a report aiming to address what University President Drew G. Faust called a "troubling" climate of sexual misconduct on campus.[2]

Notes

Links in the original online version of this article have been turned into endnotes.

1. David A. Fahrenthold, "Trump Recorded Having Extremely Lewd Conversation about Women in 2005," *Washington Post,* October 8, 2016, www.washingtonpost.com /politics/trump-recorded-having-extremely-lewd-conversation-about-women-in -2005/2016/10/07/3b9ce776-8cb4-11e6-bf8a-3d26847eeed4_story.html.

2. Andrew M Duehren and Daphne C. Thompson, "Grappling with Campus Sexual Assault, Harvard Looks to Expand Prevention Efforts," *Harvard Crimson,* March 9, 2016, www.thecrimson.com/article/2016/3/9/sexual-assault-prevention-report; Theodore R. Delwiche and Mariel A. Klein, "Survey Reveals 'Troubling' Sexual Assault Climate at Harvard, Faust Says," *Harvard Crimson,* September 21, 2015, www.thecrimson.com/article/2015/9/21/sexual-assault-climate-results.

STRONGER TOGETHER

Kelsey Clayman, Brooke Dickens, Alika Keene, Emily Mosbacher, Lauren Varela, and Haley Washburn | 2016

From the *Harvard Crimson*, October 29, 2016, www.thecrimson.com/article/2016 /10/29/oped-soccer-report. Brooke Dickens '16, Kelsey Clayman '16, Alika Keene '16, Emily Mosbacher '16, Lauren Varela '16, and Haley Washburn '16 are the six members of the Harvard Women's Soccer recruiting class of 2012.

On Monday, October 24, *The Crimson* published a story detailing a "scouting report" written by members of the 2012 men's soccer team regarding incoming female recruits on the women's soccer team.

We are these women, we are not anonymous, and rather than having our comments taken, spun, and published behind the guise of a fake anonymity offered to us by numerous news outlets, we have decided to speak for ourselves.

When first notified of this "scouting report" each of us responded with surprise and confusion, but ultimately brushed off the news as if it didn't really matter. As if we weren't surprised men had spoken of us inappropriately. As if this kind of thing was just "normal."

The sad reality is that we have come to expect this kind of behavior from so many men, that it is so "normal" to us we often decide it is not worth our time or effort to dwell on. Yet as the media has taken advantage of the Harvard name once more, it has become increasingly difficult to evade the pervasiveness of this story, harder still to elude the abhorrent judgment of our peers and the outrageous Internet commentary of the public, and hardest to subdue the embarrassment, disgust, and pain we feel as a result.

In all, we do not pity ourselves, nor do we ache most because of the personal nature of this attack. More than anything, we are frustrated that this is a reality that all women have faced in the past and will continue to face throughout their lives. We feel hopeless because men who are supposed to be our brothers degrade us like this. We are appalled that female athletes who are told to feel empowered and proud of their abilities are so regularly reduced to a physical appearance. We are distraught that mothers having daughters almost a half century after getting equal rights have to worry about men's entitlement to bodies that aren't theirs. We are concerned for the future, because we know that the only way we can truly move past this culture is for the very men who perpetrate it to stop it in its tracks.

Having considered members of this team our close friends for the past four years, we are beyond hurt to realize these individuals could encourage, silently observe, or participate in this kind of behavior, and for more than four years have neglected to apologize until this week.

We have seen the "scouting report" in its entirety. We know the fullest extent of its contents: the descriptions of our bodies, the numbers we were each assigned, and the comparison to each other and recruits in classes before us. This document attempts to pit us against one another, as if the judgment of a few men is sufficient to determine our worth. But, men, we know better than that. Eighteen years of soccer taught us that. Eighteen years—as successful, powerful, and undeniably brilliant female athletes—taught us that.

We know what it's like to get knocked down. To lose a few battles. To sweat, to cry, to bleed. To fight so hard, yet no matter what we do, the game is still out of our hands. And, even still, we keep fighting; for ourselves, yes, but above all for our teammates. This document might have stung any other group of women you chose to target, but not us. We know as teammates that we rise to the occasion, that we are stronger together, and that we will not tolerate anything less than respect for women that we care for more than ourselves.

While at Harvard, our coaches taught us that the only thing we can control in life is ourselves—our own attitude and effort—ultimately, our own actions and our own words. The actions and words displayed by members of the 2012 men's soccer team have deeply hurt us. They were careless, disgusting, and appalling, but an aberrant display of misogyny such as this does not reflect the type of environment Harvard Athletics cultivates. Harvard Athletics, specifically Harvard Women's Soccer, succeeds because despite any atmosphere of competition, we know how to be a team—to lift each other up and bring out the best in those around us to achieve our goals. With these recent events, we have seen this firsthand through our support for and empathy of one another above ourselves.

"Locker room talk" is not an excuse because this is not limited to athletic teams. The whole world is the locker room. Yet in it we feel blessed to know many men who do not and would never participate in this behavior out of respect for us—out of respect for women. To them we are grateful, and with them we strive to share a mutual respect through our own actions and words.

As women of Harvard Soccer and of the world, we want to take this experience as an opportunity to encourage our fellow women to band together in combatting this type of behavior, because we are a team and we are stronger when we are united.

To the men of Harvard soccer and to the men of the world, we invite you to join us, because ultimately we are all members of the same team. We are human beings and we should be treated with dignity. We want your help in combatting

this. We need your help in preventing this. We cannot change the past, but we are asking you to help us now and in the future.

We are hopeful that the release of this report will lead to productive conversation and action on Harvard's campus, within collegiate athletic teams across the country, and into the locker room that is our world. But ultimately, we hope this will catalyze the cultivation of an environment and a culture that strives to lift up all of its members.

Finally, to the men of Harvard Soccer and any future men who may lay claim to our bodies and choose to objectify us as sexual objects, in the words of one of us, we say together: "I can offer you my forgiveness, which is—and forever will be—the only part of me that you can ever claim as yours."

CHANGING THE GAME *Homophobia, Sexism, and Lesbians in Sport*

Pat Griffin | 1992

From *Quest* 44 (1992): 251–265, https://doi.org/10.1080/00336297.1992.10484053. Copyright © National Association for Kinesiology in Higher Education (NAKHE), www.nakhe.org. Reprinted by permission of Taylor & Francis Ltd., www.tandfonline .com, on behalf of NAKHE.

Throughout the history of Western culture, restrictions have been placed on women's sport participation. These restrictions are enforced through sanctions that evolved to match each successive social climate. Women caught merely observing the male athletes competing in the early Greek Olympic Games were put to death. When Baron DeCoubertin revived the Olympic tradition in 1896, women were invited as spectators but barred from participation. Even in the present-day Olympic Games, women may compete in only one third of the events.

Although the death penalty for female spectators was too extreme for the late 19th and early 20th centuries, an increasingly influential medical establishment

warned white upper-class women about the debilitating physiological effects of vigorous athleticism, particularly on the reproductive system. Women were cautioned about other "masculinizing effects" as well, such as deeper voices, facial hair, and overdeveloped arms and legs. The intent of these warnings was to temper and control women's sport participation and to keep women focused on their "natural" and "patriotic" roles as wives and mothers (Lenskyj, 1986).

During the 1920s and 1930s, as the predicted dire physical consequences proved untrue, strong social taboos restricting female athleticism evolved. Instead of warnings about facial hair and displaced uteruses, women in sport were intimidated by fears of losing social approval. Close female friendships, accepted and even idealized in the 19th century, became suspect when male sexologists like Freud "discovered" female sexuality in the early 20th century (Faderman, 1981, 1991; Katz, 1976). In the 1930s, as psychology and psychiatry became respected subfields in medicine, these doctors warned of a new menace. An entire typology was created to diagnose the "mannish lesbian," whose depraved sexual appetite and preference for masculine dress and activity were identified as symptoms of psychological disturbance (Newton, 1989). Social commentators in the popular press warned parents about the dangers of allowing impressionable daughters to spend time in all-female environments (Faderman, 1991; Smith-Rosenberg, 1989).

As a result, women's colleges and sports teams were assumed to be places where mannish lesbians lurked. Women in sport and physical education especially fit the profile of women to watch out for: they were in groups without men, they were not engaged in activities thought to enhance their abilities to be good wives and mothers, and they were being physically active in sport, a male activity. Because lesbians were assumed to be masculine creatures who rejected their female identity and roles as wives and mothers, athletic women became highly suspect.

The image of the sick, masculine lesbian sexual predator and her associations with athleticism persists in the late 20th century. The power of this image to control and intimidate women is as strong today as it was 60 years ago. What accounts for the staying power of a stereotype that is so extreme it should be laughable except that so many people believe it to be accurate? Whose interests are served by stigmatizing lesbians and accusing women in sport of being lesbian? Why does sport participation by women in the late 20th century continue to be so threatening to the social order? How have women in sport responded to associations with lesbians? How effective have these responses been in defusing concern about lesbians in sport?

The purpose of this article is to discuss the issue of lesbians in sport from a

feminist perspective that analyzes the function of socially constructed gender roles and sexual identities in maintaining male dominance in North American society. I share the perspective taken by other sport feminists that lesbian and feminist sport participation is a threat to male domination (Bennett, Whitaker, Smith, and Sablove, 1986; Birrell and Richter, 1987; Hall, 1987, Lenskyj, 1986; Messner and Sabo, 1990). In a sexist and heterosexist society (in which heterosexuality is reified as the only normal, natural, and acceptable sexual orientation), women who defy the accepted feminine role or reject a heterosexual identity threaten to upset the imbalance of power enjoyed by white heterosexual men in a patriarchal society (Bryson, 1987). The creation of the mannish lesbian as a pathological condition by early 20th-century male medical doctors provided an effective means to control all women and neutralize challenges to the sexist status quo.

To understand the social stigma associated with lesbian participation in sport, the function of homophobia in maintaining the sexist and heterosexist status quo must be examined (Lenskyj, 1991). Greendorfer (1991) challenged the traditional definition of homophobia as an irrational fear and intolerance of lesbians and gay men. In questioning how irrational homophobia really is, Greendorfer highlighted the systematic and pervasive cultural nature of homophobia. Fear and hatred of lesbians and gay men is more than individual prejudice (Kitzinger, 1987). Homophobia is a powerful political weapon of sexism (Pharr, 1988). The lesbian label is used to define the boundaries of acceptable female behavior in a patriarchal culture: When a woman is called a lesbian, she knows she is out of bounds. Because lesbian identity carries the extreme negative social stigma created by early 20th-century sexologists, most women are loathe to be associated with it. Because women's sport has been labeled a lesbian activity, women in sport are particularly sensitive and vulnerable to the use of the lesbian label to intimidate.

How Is Homophobia Manifested in Women's Sport?

Manifestations of homophobia in women's sport can be divided into six categories: (a) silence, (b) denial, (c) apology, (d) promotion of a heterosexy image, (e) attacks on lesbians, and (f) preference for male coaches. An exploration of these manifestations illuminates the pervasive nature of prejudice against lesbians in sport and the power of the lesbian stigma to control and marginalize women's sport.

SILENCE

Silence is the most consistent and enduring manifestation of homophobia in women's sport. From Billie Jean King's revelation of a lesbian relationship in

1981 to the publicity surrounding Penn State women's basketball coach Rene Portland's no-lesbian policy (Lederman, 1991; Longman, 1991), the professional and college sports establishment responds with silence to eruptions of public attention to lesbians in sport. Reporters who attempt to discuss lesbians in sport with sport organizations, athletic directors, coaches, and athletes are typically rebuffed (Lipsyte, 1991), and women in sport wait, hoping the scrutiny will disappear as quickly as possible. Women live in fear that whatever meager gains we have made in sport are always one lesbian scandal away from being wiped out.

Even without the provocation of public scrutiny or threat of scandal, silent avoidance is the strategy of choice. Organizers of coaches' or athletic administrators' conferences rarely schedule programs on homophobia in sport, and when they do, it is always a controversial decision made with fear and concern about the consequences of public dialogue (Krebs, 1984; Lenskyj, 1990). Lesbians in sport are treated like nasty secrets that must be kept locked tightly in the closet. Lesbians, of course, are expected to maintain deep cover at all times. Not surprisingly, most lesbians in sport choose to remain hidden rather than face potential public condemnation. Friends of lesbians protect this secret from outsiders, and the unspoken pact of silence is maintained and passed on to each new generation of women in sport.

Silence has provided some protection. Keeping the closet door locked is an understandable strategy when women in sport are trying to gain social approval in a sexist society and there is no sense that change is possible. Maintaining silence is a survival strategy in a society hostile to women in general and lesbians in particular. How effectively silence enhances sport opportunities for women or defuses homophobia, however, is open to serious question.

DENIAL

If forced to break silence, many coaches, athletic directors, and athletes resort to denial. High school athletes and their parents often ask college coaches if there are lesbians in their programs. In response, many coaches deny that there are lesbians in sport, at least among athletes or coaches at *their* schools (Fields, 1983). These denials only serve to intensify curiosity and determination to find out who and where these mysterious women are. The closet, it turns out, is made of glass: People know lesbians are in sport despite these denials.

In some cases, parents and athletes who suspect that a respected and loved coach is a lesbian either deny or overlook her sexual identity because they cannot make sense of the apparent contradiction: a lesbian who is competent, loved, and respected. In other instances, a respected lesbian coach is seen as an exception because she does not fit the unflattering lesbian stereotype most people accept as accurate. The end result in any case is to deny the presence of lesbians in sport.

The third manifestation of homophobia in sport is apology (Felshin, 1974). In an attempt to compensate for an unsavory reputation, women in sport try to promote a feminine image and focus public attention on those who meet white heterosexual standards of beauty. Women in sport have a tradition of assuring ourselves and others that sport participation is consistent with traditional notions of femininity and that women are not masculinized by sport experiences (Gornick, 1981; Hicks, 1979; Locke and Jensen, 1970). To this end, athletes are encouraged, or required in some cases, to engage in the protective camouflage of feminine drag. Professional athletes and college teams are told to wear dresses or attend seminars to learn how to apply makeup, style hair, and select clothes ("Image Lady," 1987). Athletes are encouraged to be seen with boyfriends and reminded to act like ladies when away from the gym (DePaul University's 1984 women's basketball brochure).

The Women's Sports Foundation (WSF) annual dinner, attended by many well-known professional and amateur female athletes, is preceded by an opportunity for the athletes to get free hairstyling and makeup applications before they sit down to eat with the male corporate sponsors, whose money supports many WSF programs. The men attending the dinner are not offered similar help with their appearance. The message is that female athletes in their natural state are not acceptable or attractive and therefore must be fixed and "femmed up" to compensate for their athleticism.

Femininity, however, is a code word for heterosexuality. The underlying fear is not that a female athlete or coach will appear too plain or out of style, the real fear is that she will look like a dyke or, even worse, is one. This intense blend of homophobic and sexist standards of feminine attractiveness remind women in sport that to be acceptable, we must monitor our behavior and appearance at all times.

Silence, denial, and apology are defensive reactions that reflect the power of the lesbian label to intimidate women. These responses ensure that women's sport will be held hostage to the *L* word. As long as questions about lesbians in sport are met with silence, denial, and apology, women can be sent scurrying back to our places on the margins of sport, grateful for the modicum of public approval we have achieved and fearful of losing it.

New Manifestations of Homophobia in Women's Sport

In the last 10 years, three more responses have developed in reaction to the persistence of the association of sport with lesbians. These manifestations have

developed at the same time that women's sport has become more visible, potentially marketable, and increasingly under the control of men and men's sport organizations. Representing an intensified effort to purge the lesbian image, these new strategies reflect a new low in mean-spirited intimidation.

PROMOTION OF A HETEROSEXY IMAGE

Where presenting a feminine image previously sufficed, corporate sponsors, professional women's sport organizations, some women's college teams, and individual athletes have moved beyond presenting a feminine image to adopting a more explicit display of heterosex appeal. The Ladies Professional Golf Associations' 1989 promotional material featured photographs of its pro golfers posing pin-up style in swimsuits (Diaz, 1989). College sport promotional literature has employed double entendres and sexual innuendo to sell women's teams. The women's basketball promotional brochure from Northwestern State University of Louisiana included a photograph of the women's team dressed in Playboy bunny outfits. The copy crowed "These girls can play, boy!" and invited basketball fans to watch games in the "Pleasure Palace" (Solomon, 1991). Popular magazines have featured young, professional female athletes, like Monica Seles or Steffi Graf, in cleavage-revealing heterosexual glamour drag (Kiersh, 1990).

In a more muted attempt to project a heterosexual image, stories about married female athletes and coaches routinely include husbands and children in ways rarely seen when male coaches and athletes are profiled. A recent nationally televised basketball game between the women's teams from the University of Texas and the University of Tennessee featured a half-time profile of the coaches as wives and mothers. The popular press also brings us testimonials from female athletes who have had children claiming that their athletic performance has improved since becoming mothers. All of this to reassure the public, and perhaps ourselves as women in sport, that we are normal despite our athletic interests.

ATTACKS ON LESBIANS IN SPORT

Women in sport endure intense scrutiny of our collective and individual femininity and sexual identities. Innuendo, concern, and prurient curiosity about the sexual identity of female coaches and athletes come from coaches, athletic directors, sports reporters, parents of female athletes, teammates, fans, and the general public (South, Glynn, Rodack, and Capettini, 1990). This manifestation of homophobia is familiar to most people associated with women's sport. Over the last 10 to 12 years, however, concern about lesbians in sport has taken a nasty turn.

Though lesbians in sport have always felt pressure to stay closeted, coaches and

athletic directors now openly prohibit lesbian coaches and athletes (Brownworth, 1991; Figel, 1986; Longman, 1991). In a style reminiscent of 1950s McCarthyism, some coaches proclaim their antilesbian policies as an introduction to their programs. Athletes thought to be lesbians are dropped from teams, find themselves benched, or are suddenly ostracized by coaches and teammates (Brownworth, 1991). At some schools, a new coach's heterosexual credentials are scrutinized as carefully as her professional qualifications (Fields, 1983). Coaches thought to be lesbians are fired or intimidated into resigning. These dismissals are not the result of any unethical behavior on the part of the women accused but simply because of assumptions made about their sexual identity.

Collegiate and high school female athletes endure lesbian-baiting (name-calling, taunting, and other forms of harassment) from male athletes, heterosexual teammates, opposing teams, spectators, classmates, and sometimes their own coaches (Brownworth, 1991; Fields, 1983; Spander, 1991; Thomas, 1990). Female coaches thought to be lesbians endure harassing phone calls and antilesbian graffiti slipped under their doors. During a recent National Collegiate Athletic Association (NCAA) women's basketball championship, it was rumored that a group of male coaches went to the local lesbian bar to spy on lesbian coaches who might be there. Another rumor circulated about a list categorizing Division I women's basketball coaches by their sexual identity so that parents of prospective athletes could use this information to avoid schools where lesbians coach. Whether or not these rumors are true doesn't matter: The rumor itself is intimidating enough to remind women in sport that we are being watched and that if we step out of line, we will be punished.

Negative recruiting is perhaps the most self-serving of all the attacks on lesbians in sport. Negative recruiting occurs when college coaches or athletic department personnel reassure prospective athletes and their parents not only that there are no lesbians in this program but also that there *are* lesbians in a rival school's program (Fields, 1983). By playing on parents' and athletes' fear and ignorance, these coaches imply that young women will be safe in their programs but not at a rival school where bull dykes stalk the locker room in search of fresh young conquests.

Fears about lesbian stereotypes are fueled by a high-profile Christian presence at many national championships and coaches' conferences. The Fellowship of Christian Athletes, which regularly sponsors meal functions for coaches at these events, distributes a free antihomosexual booklet to coaches and athletes. Entitled *Emotional Dependency: A Threat to Close Friendships,* this booklet plays into all of the stereotypes of lesbians (Rentzel, 1987). A drawing of a sad young woman and an older woman on the cover hints at the dangers of close

female friendships. Unencumbered by any reasonable factual knowledge about homosexuality, the booklet identifies the symptoms of emotional dependency and how this "leads" to homosexual relationships. Finally, the path out of this "counterfeit" intimacy through prayer and discipline is described. The booklet is published by Exodus, a fundamentalist Christian organization devoted to the "redemption" of homosexuals from their "disorder."

By allowing the active participation of antigay organizations in coaches' meetings and championship events, sport governing bodies like the NCAA and the Women's Basketball Coaches' Association are taking an active role in the perpetuation of discrimination against lesbians in sport and the stigmatization of all friendships among women in sport. In this intimidating climate, all women in sport must deal with the double burden of maintaining high-profile heterosexual images and living in terror of being called lesbians.

PREFERENCE FOR MALE COACHES

Many parents, athletes, and athletic administrators prefer that men coach women's teams. This preference reflects a lethal mix of sexism and homophobia. Some people believe, based on gender and lesbian stereotypes, that men are better coaches than women. Although a recent NCAA survey of female athletes (NCAA, 1991) indicated that 61% of the respondents did not have a gender preference for their coaches, respondents were concerned about the images they thought male and female coaches had among their friends and family: 65% believed that female coaches were looked upon favorably by family and friends whereas 84% believed that male coaches were looked on favorably by family and friends.

Recent studies have documented the increase in the number of men coaching women's teams (Acosta and Carpenter, 1988). At least part of this increase can be attributed to homophobia. Thorngren (1991), in a study of female coaches, asked respondents how homophobia affected them. These coaches identified hiring and job retention as problems. They cited examples where men were hired to coach women's teams specifically to change a tarnished or negative (read *lesbian*) team image. Thorngren described this as a "cloaking" phenomenon, in which a team's lesbian image is hidden or countered by the presence of a male coach. Consistent with this perception, anecdotal reports from other female head coaches reveal that some believe it essential to hire a male assistant coach to lend a heterosexual persona to a women's team. The coaches in Thorngren's study also reported that women (married and single) leave coaching because of the pressure and stress of constantly having to deal with lesbian labels and stereotypes. Looking at the increase in the number of men coaching women's

teams over the last 10 years, it is clear how male coaches have benefited from sexism and homophobia in women's sport.

Suspicion, Collusion, and Betrayal among Women in Sport

The few research studies addressing homophobia or lesbians in sport, as well as informal anecdotal information, have revealed that many women have internalized sexist and homophobic values and beliefs (Blinde, 1990; Griffin, 1987; Guthrie, 1982; Morgan, 1990; Thorngren, 1990, 1991; Woods, 1990). Blinde interviewed women athletes about the pressures and stress they experienced. Many talked about the lesbian image women's sport has and the shame they felt about being female athletes because of that image. Their discomfort with the topic was illustrated by their inability to even say the word *lesbian*. Instead, they made indirect references to *it* as a problem. Athletes talked in ways that clearly indicated they had bought into the negative images of lesbians, even as they denied that there were lesbians on their teams. These athletes also subscribed to the importance of projecting a feminine image and were discomforted by female athletes who didn't look or act feminine.

Quotes selected to accompany the NCAA survey and the Blinde study illustrate the degree to which many female athletes and coaches accept both the negative stigma attached to lesbian identity and the desirability of projecting a traditionally feminine image:

The negative image of women in intercollegiate sport scares me. I've met too many lesbians in my college career. I don't want to have that image. (NCAA)

Well, if you come and look at our team, I mean, if you saw Jane Doe, she's very pretty. If she walks down the street, everybody screams, you know, screams other things at her. But because she's on the field, it's dykes on spikes. If that isn't a stereotype, then who knows what is. (Blinde, p. 12)

Homosexual females in this profession [coaching] definitely provide models and guidance in its worst for female athletes. I'd rather see a straight male coach females than a gay woman. Homosexual coaches are killing us. (NCAA)

I don't fit the stereotype. I mean the stereotype based around women that are very masculine and strong and athletic. I wouldn't say I'm pretty in pink, but I am feminine and I appear very feminine and I act that way. (Blinde, p. 12)

These attempts to distance oneself from the lesbian image and to embrace traditional standards of femininity set up a division among women in sport that

can devastate friendships among teammates, poison coach–athlete relationships, and taint feelings about one's identity as an athlete and a woman. Some women restrict close friendships with other women to avoid the possibility that someone might think they are lesbians. Other women consciously cultivate high-profile heterosexual images by talking about their relationships with men and being seen with men as often as possible. As long as our energy is devoted to trying to fit into models of athleticism, gender, and sexuality that support a sexist and heterosexist culture, women in sport can be controlled by anyone who chooses to use our fears and insecurities against us.

Underlying Beliefs That Keep Women in Sport from Challenging Homophobia

The ability to understand the staying power of the lesbian stigma in sport is limited by several interconnected beliefs. An examination of these beliefs can reveal how past responses in dealing with lesbians in sport have reinforced the power of the lesbian label to intimidate and control.

A WOMAN'S SEXUAL IDENTITY IS PERSONAL

This belief is perhaps the biggest obstacle to understanding women's oppression in a patriarchal culture (Kitzinger, 1987). As long as women's sexual identity is seen as solely a private issue, how the lesbian label is used to intimidate all women and to weaken women's challenges to male-dominated institutions will never be understood. The lesbian label is a political weapon that can be used against any woman who steps out of line. Any woman who defies traditional gender roles is called a lesbian. Any woman who chooses a male-identified career is called a lesbian. Any woman who chooses not to have a sexual relationship with a man is called a lesbian. Any woman who speaks out against sexism is called a lesbian. As long as women are afraid to be called lesbians, this label is an effective tool to control all women and limit women's challenges to sexism. Although lesbians are the targets of attack in women's sport, all women in sport are victimized by the use of the lesbian label to intimidate and control.

When a woman's lesbian identity is assumed to be a private matter, homophobia and heterosexism are dismissed. The implication is that these matters are not appropriate topics for professional discussion. As a result, the fear, prejudice, and outright discrimination that thrive in silence are never addressed. A double standard operates, however, for lesbians and heterosexual women in sport. Although open acknowledgment of lesbians in sport is perceived as an inappropriate flaunting of personal life (what you do in the privacy of your home

is none of my business), heterosexual women are encouraged to talk about their relationships with men, their children, and their roles as mothers.

Magazine articles about such heterosexual athletes as Chris Evert Mill, Florence Griffith Joyner, Jackie Joyner-Kersey, Joan Benoit, Nancy Lopez, and Mary Decker Slaney have often focused on their weddings, their husbands, or their children. Heterosexual professional athletes are routinely seen celebrating victories by hugging or kissing their husbands, but when Martina Navratilova went into the stands to hug *her* partner after winning the 1990 Wimbledon Championship, she was called a bad role model by former champion Margaret Court. Although heterosexual athletes and coaches are encouraged to display their personal lives to counteract the lesbian image in sport, lesbians are intimidated into invisibility for the same reason.

CLAIMING TO BE FEMINIST IS TANTAMOUNT TO CLAIMING TO BE LESBIAN

Claiming to be feminist is far too political for many women in sport. To successfully address the sexism and heterosexism in sport, however, women must begin to understand the necessity of seeing homophobia as a political issue and claim feminism as the unifying force needed to bring about change in a patriarchal culture. Part of the reluctance to embrace the feminist label is that feminists have been called lesbians in the same way that female athletes have and for the same reason: to intimidate women and prevent them from challenging the sexist status quo. Women in sport are already intimidated by the lesbian label. For many women, living with the athlete, lesbian, and feminist labels is stigma overload.

By accepting the negative stereotypes associated with these labels, women in sport collude in our own oppression. Rather than seeking social approval as a marginal part of sport in a sexist and heterosexist society, we need to be working for social change and control over our sport destinies. The image of an unrepentant lesbian feminist athlete is a patriarchal nightmare. She is a woman who has discovered her physical and political strength and who refuses to be intimidated by labels. Unfortunately, this image scares women in sport as much as it does those who benefit from the maintenance of the sexist and heterosexist status quo.

THE PROBLEM IS LESBIANS IN SPORT WHO CALL ATTENTION TO THEMSELVES

People who believe this assume that as long as lesbians are invisible, our presence will be tolerated and women's sport will progress. The issue for these people is

not that there are lesbians in sport but how visible we are. Buying into silence this way has never worked. Other than Martina Navratilova, lesbians in sport are already deeply closeted (Bull, 1991; Muscatine, 1991). This careful camouflage of lesbians has not made women's sport less suspect or less vulnerable to intimidation. Despite efforts to keep the focus on the pretty ones or the ones with husbands and children, women in sport still carry the lesbian stigma into every gym and onto every playing field.

Women in sport must begin to understand that it wouldn't matter if there were no lesbians in sport. The lesbian label would still be used to intimidate and control women's athletics. The energy expended in making lesbians invisible and projecting a happy heterosexual image keeps women in sport fighting among ourselves rather than confronting the heterosexism and sexism that our responses unintentionally serve.

LESBIANS ARE BAD ROLE MODELS AND SEXUAL PREDATORS

This belief buys into all the unsavory lesbian stereotypes left over from the late 19th-century medical doctors who made homosexuality pathological and the early 20th-century sexologists who made female friendships morbid. In reality, there are already numerous closeted lesbians in sport who are highly admired role models. It is the perversity of prejudice that merely knowing about the sexual identity of these admired women instantly turns them into unfit role models.

The sexual-predator stereotype is a particularly pernicious slander on lesbians in sport (South et al., 1990). There is no evidence that lesbians are sexual predators. In fact, statistics on sexual harassment, rape, sexual abuse, and other forms of violence and intimidation show that these offenses are overwhelmingly heterosexual male assaults against women and girls. If we need to be concerned about sexual offenses among coaches or athletes, a better case could be made that it is heterosexual men who should be watched carefully. Blinde (1989) reported that many female athletes, like their male counterparts, are subjected to academic, physical, social, and emotional exploitation by their coaches. When men coach women in a heterosexist and sexist culture, there is the additional potential for sexual and gender-based exploitation when the unequal gender dynamics in the larger society are played out in the coach–athlete relationship.

It is difficult to imagine anyone in women's sport, regardless of sexual identity, condoning coercive sexual relationships of any kind. Even consensual sexual relationships between coaches and athletes involve inherent power differences that make such relationships questionable and can have a negative impact on the athlete as well as on the rest of the team. This kind of behavior should be

addressed regardless of the gender or sexual identity of the coaches and athletes involved instead of assuming that lesbian athletes or coaches present a greater problem than others.

BEING CALLED LESBIAN OR BEING ASSOCIATED WITH LESBIANS IS THE WORST THING THAT CAN HAPPEN IN WOMEN'S SPORT

As long as women in sport buy into the power of the lesbian label to intimidate us, we will never control our sport experience. Blaming lesbians for women's sports' bad image and failure to gain more popularity divides women and keeps us fighting among ourselves. In this way, we collude in maintaining our marginal status by keeping alive the power of the lesbian label to intimidate women into silence, betrayal, and denial. This keeps our energies directed inward rather than outward at the sexism that homophobia serves. Blaming lesbians keeps all women in their place, scurrying to present an image that is acceptable in a sexist and heterosexist society. This keeps our attention diverted from asking other questions: Why are strong female athletes and coaches so threatening to a patriarchal society? Whose interests are served by trivializing and stigmatizing women in sport?

Women in sport need to redefine the problem. Instead of naming and blaming lesbians in sport as the problem, we need to focus our attention on sexism, heterosexism, and homophobia. As part of this renaming process, we need to take the sting out of the lesbian label. Women in sport must stop jumping to the back of the closet and slamming the door every time someone calls us dykes. We need to challenge the use of the lesbian label to intimidate all women in sport.

WOMEN'S SPORT CAN PROGRESS WITHOUT DEALING WITH HOMOPHOBIA

If progress is measured by the extent to which we, as women in sport, control our sporting destinies, take pride in our athletic identities, and tolerate diversity among ourselves, then we are no better off now than we ever have been. We have responded to questions about lesbians in sport with silence, denial, and apology. When these responses fail to divert attention away from the lesbian issue, we have promoted a heterosexy image, attacked lesbians, and hired male coaches. All of these responses call on women to accommodate, assimilate, and collude with the values of a sexist and heterosexist society. All require compromise and deception. The bargain struck is that in return for our silence and our complicity, we are allowed a small piece of the action in a sports world that has been defined by men to serve male-identified values.

We have never considered any alternatives to this cycle of silence, denial, and

apology to the outside world while policing the ranks inside. We have never looked inside ourselves to understand our fear and confront it. We have never tried to analyze the political meaning of our fear. We have never stood up to the accusations and threats that keep us in our place.

What do we have to pass on to the next generation of young girls who love to run and throw and catch? What is the value of nicer uniforms, a few extra tournaments, and occasional pictures in the back of the sports section if we can't pass on a sport experience with less silence and fear?

Strategies for Confronting Homophobia in Women's Sport

What, then, are the alternatives to silence, apology, denial, promoting a hetero-sexy image, attacking lesbians, and hiring male coaches? How can women in sport begin confronting homophobia rather than perpetuating it? If our goal is to defuse the lesbian label and to strip it of its power to intimidate women in sport, then we must break the silence, not to condemn lesbians but to condemn those who use the lesbian label to intimidate. Our failure to speak out against homophobia signals our consent to the fear, ignorance, and discrimination that flourish in that silence. If our goal is to create a vision of sport in which all women have an opportunity to proudly claim their athletic identity and control their athletic experience, then we must begin to build that future now.

INSTITUTIONAL POLICY

Sport governing organizations and school athletic departments need to enact explicit nondiscrimination and antiharassment policies that include sexual orientation as a protected category. This is a first step in establishing an orga-nizational climate in which discrimination against lesbians (or gay men) is not tolerated. Most sport governing organizations have not instituted such policies and, when asked by reporters if they are planning to, avoid taking a stand (Brownworth, 1991; Longman, 1991). In addition to nondiscrimination policies, professional standards of conduct for coaches must be developed that outline behavioral expectations regardless of gender or sexual orientation. Sexual ha-rassment policies and the procedures for filing such complaints must be made clear to coaches, athletes, and administrators. As with standards of professional conduct, these policies should apply to everyone.

EDUCATION

Everyone associated with physical education and athletics must learn more about homophobia, sexism, and heterosexism. Conferences for coaches, teach-ers, and administrators should include educational programs focused on un-

derstanding homophobia and developing strategies for addressing homophobia in sport.

Athletic departments must sponsor educational programs for athletes that focus not only on homophobia but on other issues of social diversity as well. Because prejudice and fear affect the quality of athletes' sport experience and their relationships with teammates and coaches, educational programs focused on these issues are appropriate for athletic department sponsorship and should be an integral part of the college athletic experience.

VISIBILITY

One of the most effective tools in counteracting homophobia is increased lesbian and gay visibility. Stereotypes and the fear and hatred they perpetuate will lose their power as more lesbian and gay people in sport disclose their identities. Although some people will never accept diversity of sexual identity in sport or in the general population, research indicates that, for most people, contact with "out" lesbian and gay people who embrace their sexual identities reduces prejudice (Herek, 1985).

The athletic world desperately needs more lesbian and gay coaches and athletes to step out of the closet. So far only a handful of athletes or coaches, most notably Martina Navratilova, have had the courage to publicly affirm their lesbian or gay identity (Brown, 1991; Brownworth, 1991; Bull, 1991; Burke, 1991; Muscatine, 1991). The generally accepting, if not warm, reaction of tennis fans to Martina's courage and honesty should be encouraging to the many closeted lesbian and gay people in sport. Unfortunately, the fear that keeps most lesbian and gay sportspeople in the closet is not ungrounded. Coming out as a lesbian or gay athlete or coach is a risk in a heterosexist and sexist society (Brown 1991; Brownworth 1991; Burton-Nelson, 1991; Hicks, 1979; Muscatine, 1991). The paradox is that more lesbian and gay people need to risk coming out if homosexuality is to be demystified in North American society.

Another aspect of visibility is the willingness of heterosexual athletes and coaches, as allies of lesbian and gay people, to speak out against homophobia and heterosexism. In the same way that it is important for white people to speak out against racism and for men to speak out against sexism, it is important for heterosexual people to object to antigay harassment, discrimination, and prejudice. It isn't enough to provide silent, private support for lesbian friends. To remain silent signals consent. Speaking out against homophobia is a challenge for heterosexual women in sport that requires them to understand how homophobia is used against them as well as against lesbians. Speaking out against homophobia also requires that heterosexual women confront their own

discomfort with being associated with lesbians or being called lesbian because that is what will happen when they speak out. The lesbian label will be used to try and intimidate them back into silence.

SOLIDARITY

Heterosexual and lesbian women must understand that the only way to overcome homophobia, heterosexism, and sexism in sport is to work in coalition with each other. As long as fear and blame prevent women in sport from finding common ground, we will always be controlled by people whose interests are served by our division. Our energy will be focused on social approval rather than on social change, and on keeping what little we have rather than on getting what we deserve.

PRESSURE TACTICS

Unfortunately, meaningful social change never happens without tension and resistance. Every civil and human rights struggle in the United States has required the mobilization of political pressure exerted on people with power to force them to confront injustice. Addressing sexism, heterosexism, and homophobia in women's sport will be no different. Taking a stand will mean being prepared to use the media [and] college petitions, lobby officials, picket, write letters, file official complaints, and take advantage of other pressure tactics.

Conclusion

Eliminating the insidious trio of sexism, heterosexism, and homophobia in women's sport will take a sustained commitment to social justice that will challenge much of what has been accepted as natural about gender and sexuality. Addressing sexism, heterosexism, and homophobia in women's sport requires that past conceptions of gender and sexuality be recognized as social constructions that confer privilege and normalcy on particular social groups: men and heterosexuals. Other social groups (women, lesbians, and gay men) are defined as inferior or deviant and are denied access to the social resources and status conferred on heterosexual men.

Sport in the late 20th century is, perhaps, the last arena in which men can hope to differentiate themselves from women. In sport, men learn to value a traditional heterosexual masculinity that embraces male domination and denigrates women's values (Messner and Sabo, 1990). If sport is to maintain its meaning as a masculine ritual in a patriarchal society, women must be made to feel like trespassers. Women's sport participation must be trivialized and

controlled (Bennett et al., 1987). The lesbian label, with its unsavory stigma, is an effective tool to achieve these goals.

If women in sport in the 21st century are to have a sport experience free of intimidation, fear, shame, and betrayal; then, as citizens of the 20th century, we must begin to reevaluate our beliefs, prejudices, and practices. We must begin to challenge the sexist, heterosexist, and homophobic status quo as it lives in our heads, on our teams, and in our schools. A generation of young girls—our daughters, nieces, younger sisters, and students—is depending on us.

References

Acosta, V., and Carpenter, L. (1988). Status of women in athletics: Causes and changes. *Journal of Health, Physical Education, Recreation and Dance,* 56(6), 35–37.

Bennett, R., Whitaker, G., Smith, N., and Sablove, A. (1987). Changing the rules of the game: Reflections toward a feminist analysis of sport. *Women's Studies International Forum,* 10(4), 369–380.

Birrell, S., and Richter, D. (1987). Is a diamond forever? Feminist transformations of sport. *Women's Studies International Forum,* 10(4), 395–410.

Blinde, E. (1989). Unequal Exchange and exploitation in college sport: The case of the female athlete. *Arena Review,* 13(2), 110–123.

Blinde, E. (1990, March). *Pressure and stress in women's college sports: Views from Athletes.* Paper presented at the annual convention of the American Alliance for Health, Physical Education, Recreation and Dance, New Orleans.

Brown, K. (1991). Homophobia in women's sports. *Deneuve,* 1(2), 4–6, 29.

Brownworth, V. (1991, June 4). Bigotry on the home team: Lesbians face harsh penalties in the sports world. *The Advocate: The National Gay and Lesbian Newsmagazine,* pp. 34–39.

Bryson, L. (1987). Sport and the maintenance of male hegemony. *Women's Studies International Forum,* 10(4), 349–360.

Bull, C. (1991, December 31). The magic of Martina. *The Advocate: The National Gay and Lesbian Newsmagazine,* pp. 38–40.

Burke, G. (1991, September 18). Dodgers wanted me to get married. *USA Today,* p. 10C.

Burton-Nelson, M. (1991). *Are we winning yet?* New York: Random House.

Diaz, J. (1989, February 13). Find the golf here? *Sports Illustrated,* pp. 58–64.

Faderman, L. (1981). *Surpassing the love of men: Romantic friendship and love between women from the Renaissance to the present.* New York: Morrow.

Faderman, L. (1991). *Odd girls and twilight lovers: A history of lesbian life in twentieth-century America.* New York: Columbia University Press.

Felshin, J. (1974). The triple option . . . for women in sport. *Quest,* 21, 36–40.

Fields, C. (1983, October 26). Allegations of lesbianism being used to intimidate, female academics say. *Chronicle of Higher Education,* pp. 1, 18–19.

Figel, B. (1986, June 16). Lesbians in the world of athletics. *Chicago Sun-Times,* p. 119.

Gornick, V. (1981, May 18). Ladies of the links. *Look,* pp. 69–76.

Greendorfer, S. (1991, April). *Analyzing homophobia: Its weapons and impacts.* Paper

presented at the annual convention of the American Alliance for Health, Physical Education, Recreation and Dance, San Francisco.

Griffin, P. (1987, August). *Lesbians, homophobia, and women's sport: An exploratory analysis.* Paper presented at the annual meeting of the American Psychological Association, New York.

Guthrie, S. (1982). *Homophobia: Its impact on women in sport and physical education.* Unpublished master's thesis, California State University, Long Beach.

Hall, A. (Ed.) (1987). The gendering of sport, leisure, and physical education [Special issue]. *Women's Studies International Forum,* 10(4).

Herek, G. (1985). Beyond "homophobia": A social psychological perspective on attitudes toward lesbians and gay men. In J. DeCecco (Ed.), *Bashers, baiters, and bigots: Homophobia in American society* (pp. 1–22). New York: Harrington Park Press.

Hicks, B. (1979, October/November). Lesbian athletes, *Christopher Street,* pp. 42–50.

Image lady. (1987, July). *Golf Illustrated,* p. 9.

Katz, J. (1976). *Gay American History,* New York: Avon.

Kiersh, E. (1990, April). Graf's dash. *Vogue,* pp. 348–353, 420.

Kitzinger, C. (1987). *The social construction of lesbianism.* Newbury Park, CA: Sage.

Krebs, P. (1984). At the starting blocks: Women's athletes' new agenda. *Off our backs,* 14(1), 1–3.

Lederman, D. (1991, June 5). Penn State's coach's comments about lesbian athletes may be used to test university's new policy on bias. *Chronicle of Higher Education,* pp. A27–28.

Lenskyj, H. (1986). *Out of bounds: Women, sport, and sexuality.* Toronto: Women's Press.

Lenskyj, H. (1990). Combatting homophobia in sports. *Off our backs,* 20(6), 2–3.

Lenskyj, H. (1991). Combatting homophobia in sport and physical education. *Sociology of Sport Journal* 8(1), 61–69.

Lipsyte, R. (1991, May 24). Gay bias moves off the sidelines. *New York Times,* p. B1.

Locke, L. F., and Jensen, M. (1970, Fall). Heterosexuality of women in physical education. *The Foil,* pp. 30–34.

Longman, J. (1991, March 10). Lions women's basketball coach is used to fighting and winning. *Philadelphia Inquirer,* pp. 1G, 6G.

Messner, M., and Sabo, D. (Eds.) (1990). *Sport, men, and the gender order: Critical feminist perspectives.* Champaign, IL: Human Kinetics.

Morgan, E. (1990). *Lesbianism and feminism in women's athletics: Intersection, bridge, or gap?* Unpublished manuscript, Brown University, Providence.

Muscatine, A. (1991, November/December). To tell the truth, Navratilova takes consequences. *Women's SportsPages,* pp. 8–9. (Available from Women's SportsPages, P.O. Box 15134, Chevy Chase, MD 20825)

National Collegiate Athletic Association. (1991). *NCAA study on women's intercollegiate athletics: Perceived barriers of women in intercollegiate athletic careers.* Overland Park, KS: Author.

Newton, E. (1989). The mannish lesbian: Radclyffe Hall and the new woman. In M. Duberman, M. Vicinus, and G. Chauncey (Eds.), *Hidden from history: Reclaiming the gay and lesbian past* (pp. 281–293). New York: New American Library.

Pharr, S. (1988). *Homophobia: A weapon of sexism.* Inverness, CA: Chardon Press.

Rentzel, L. (1987). *Emotional dependency: A threat to close friendships.* San Rafael, CA: Exodus International.

Smith-Rosenberg, C. (1989). Discourses of sexuality and subjectivity: The new woman, 1870–1936. In M. Duberman, M. Vicinus, and G. Chauncey (Eds.). *Hidden from history: Reclaiming the gay and lesbian past* (pp. 261–280). New York: New American Library.

Solomon, A. (1991, March 20). Passing game. *Village Voice,* p. 92.

South, J., Glynn, M., Rodack, J., and Capettini, R. (1990, July 31). Explosive gay scandal rocks women's tennis. *National Enquirer,* pp. 20–21.

Spander, D. (1991, September 1). It's a question of acceptability. *Sacramento Bee,* pp. D1, D14–15.

Thomas, R. (1990, December 12). Two women at Brooklyn College file rights complaint. *New York Times,* p. 22.

Thorngren, C. (1990, April). *Pressure and stress in women's college sport: Views from coaches.* Paper presented at the annual convention of the American Alliance for Health, Physical Education, Recreation and Dance, New Orleans.

Thorngren, C. (1991, April). *Homophobia and women coaches: Controls and constraints.* Paper presented at the annual convention of the American Alliance for Health, Physical Education, Recreation and Dance, San Francisco.

Woods, S. (1990). The contextual realities of being a lesbian physical education teacher: Living in two worlds (Doctoral dissertation, University of Massachusetts, Amherst, 1989). *Dissertation Abstracts International, 51*(3), 788.

GAG ORDERS ON SEXUALITY

Allie Grasgreen | 2013

From *Inside Higher Ed,* May 23, 2013, www.insidehighered.com/news/2013/05/23 /baylors-gag-order-athletes-sexuality-reveals-homophobia-still-prevalent-womens. Copyright © *Inside Higher Ed.*

Female college athlete comes out as gay and no one bats an eye—until it's learned her coach told her not to. The case of Brittney Griner at Baylor is indicative of the culture of women's sports.

When Brittney Griner, Baylor University's star basketball player and one of the most celebrated athletes in the history of the sport, came out publicly as gay last month, she was rather nonchalant about it. She didn't write a *Sports Illustrated* cover story—à la professional basketball player Jason Collins, a few weeks

later—she just sort of mentioned it in media interviews. Griner is "someone who's always been open," she said, with family, friends and teammates.

But, as Griner revealed a few weeks later, she wasn't allowed to be open as much as she might have liked.[1] That's because Baylor head coach Kim Mulkey told her and her teammates not to talk publicly about their sexuality.

"It was a recruiting thing," Griner told ESPN. "The coaches thought that if it seemed like they condoned it, people wouldn't let their kids come play for Baylor."[2]

Griner's account followed on the heels of speculation that her coming out signaled a new age at Baylor—a private Christian university whose nondiscrimination policy does not cover sexual orientation and whose student handbook entry for "sexual misconduct" includes as examples of inappropriate actions "homosexual behavior" and participation in "advocacy groups which promote understandings of sexuality that are contrary to biblical teaching."[3]

But the news about Baylor's gag order was a sobering reminder that while lesbian, gay, bisexual, trans and queer advocates have made progress in college sports—and the National Collegiate Athletic Association is actively pushing an LGBT inclusion campaign—they still have a long way to go.

"Most of the athletes who are in her situation never say anything, but it's not a new situation," said Pat Griffin, a scholar on LGBT issues and author of *Strong Women, Deep Closets: Lesbians and Homophobia in Sport*. "What's new is that Brittney Griner has the courage not only to come out, but to call the game."[4]

Baylor's unofficial rule against talking openly might seem like an outdated if not outright ridiculous concept at a time when states are legalizing same-sex marriage, the general public is more accepting of homosexuality than ever, and 7 in 10 incoming college students believe same-sex couples should have the right to marry.[5]

And college sports have not been immune from those cultural shifts, to be sure. Rene Portland, the former and extremely successful women's basketball coach at Pennsylvania State University, made no secret of her disdain for homosexuality, at least on her team—"I will not have it in my program," she told the media. The brazen discrimination continued until 2007, when Portland resigned after settling a lawsuit with a former Penn State player who said the coach made her miserable and threw her off the team because of suspicions she was gay.

Such open hostility would be hard to find these days. (Coaches of men's teams arbitrarily shouting homophobic slurs at athletes during practice, however, is another matter.[6]) But women's sports have a storied history of "negative recruiting," whereby coaches try to steer athletes away from other programs by suggesting they tolerate or condone homosexuality. It's often a subtle nudging:

emphasizing the "family values" at the coach's own program, or telling parents they wouldn't be comfortable with the "lifestyle" on other teams.

The practice speaks to the gender stereotypes that still pervade sports, despite social progress. Negative recruiting is basically nonexistent in men's athletics, where it's assumed (wrongly, of course) that everyone is straight. But it lingers in women's sports, where the assumption is the opposite. In part, that is why the reaction to Griner's coming out was rather muted compared to Collins'. (Collins is also the only athlete in a major professional sport to come out as gay. No male college athletes in a major sport—football, basketball, baseball or hockey—have done so.)

The same "don't ask, don't tell" culture that keeps athletes from speaking out keeps coaches in the closet as well. In their case, it's not an explicit decree from up the chain of command, but that same fear that having a lesbian at the helm will hurt a program's ability to recruit. Among coaches, the fear is "endemic," Griffin said.

Sherri Murrell, the only Division I women's basketball coach to publicly come out as gay, did so much the same way Griner did—Portland State University asked if she wanted a family photo in the athletics media guide, and she said yes. But that picture of Murrell, her partner and their two children transformed the coach into an icon and beacon of hope for the athletes and coaches who—whether for fear of retaliation or public scrutiny—haven't been able to be so open.

Just the other day, Murrell got an e-mail from a coach at a non–Division I institution whose athletic director told her to hire more men to help with recruiting so the program had more "straight" representation.

"People are still fearful for their jobs. . . . If athletic directors are forcing people to be in the closet, then you've got some issues," Murrell said. "What matters is that we are morally and ethically doing the right thing as coaches and teaching players that this has nothing to do with anything."

In addition to more education on the issue for athletic directors, Murrell sees a need for more straight allies to step up in support of gay athletes. But there is a paradox at play in women's sports: more lesbian athletes are coming out, but fewer straight athletes are speaking out (again, the opposite is true in men's sports).

"It continues to be difficult to have strong female voices talking about respect and inclusion," said Hudson Taylor, founder of Athlete Ally and a former wrestler at the University of Maryland at College Park. Part of that is a perception that it's easier for female athletes to come out. (Griner, in fact, was taunted and bullied about her "masculinity" and her sexuality for years.) But—as evidenced by Mulkey and Baylor—there are still some very real obstacles.

"When athletes come out, it puts the spotlight on what the current climate is actually like," Taylor said. "At the end of the day, if we're going to make meaningful change to our athletic community, we'll do it by educating a generation of allies to start speaking out."

Taylor worked with Griffin to write a resource guide on inclusion of LGBTQ athletes and staff in college sports, which was commissioned by the NCAA's LGBTQ subcommittee.[7] They presented on the topic and the report (published in March) at the annual NCAA convention, and the NCAA has an entire summit devoted to inclusion.

All NCAA member institutions have access to the resource guide. But "inclusion" means "being open to them being open," Griffin said—not saying, You can be out but not publicly out.

"It's an environment where people can just live their truth—they don't have to be afraid that if they reveal themselves to their teammate, to their coaches, to their fans, to whomever, that it will be bad," Griffin said. "Athletes and coaches can be as open as they choose to be about who they choose to love or how they identify themselves."

Many athletes, raised to put their sport above all else, segment their person—they might identify as gay, but they also identify as athletes, and the latter takes precedent.

"Sport culture is unique in that respect—you are forced to kind of privilege above all else your sport identity because that's what they're told they have to do to succeed," said Kristine Newhall, co-founder and contributor to the Title IX blog.[8] "You hear the same kind of discourse coming from these female athletes who are saying, yes, I'm coming out to you, the world, but I was always out."

But Griner's announcing her sexual orientation—nonchalant as it may have been—shows that in today's world, to today's athletes, it's really not a big deal, Murrell said.

"The bottom line is the kid's an outstanding basketball player and brought home some championships to Baylor. That's a special thing, and they need to embrace everything, not just her rebounding, not just her shooting—but the fact that Brittney is a wonderful person who identifies as a lesbian," Murrell said. "I think there's going to be a lot of good positives to come from it."

Notes

Links in the original online version of this article have been turned into endnotes.

1. Allie Grasgreen, "Baylor Coach Told Players to Keep Sexuality Quiet, Star Says," *Inside Higher Ed*, May 21, 2013, www.insidehighered.com/quicktakes/2013/05/21/baylor-coach-told-players-keep-sexuality-quiet-star-athlete-says.

2. "Griner: No Talking Sexuality at Baylor," ESPN, May 28, 2013, www.espn.com /wnba/story/_/id/9289080/brittney-griner-says-baylor-coach-kim-mulkey-told -players-keep-quiet-sexuality.

3. Samuel G. Freedman, "'Griner Effect' May Change the Game at Baylor," *New York Times*, May 17, 2013, www.nytimes.com/2013/05/18/us/griner-baylor-lesbian-college -sports.html.

4. Pat Griffin, *Strong Women, Deep Closets: Lesbians and Homophobia in Sport* (Champaign, IL: Human Kinetics, 1998).

5. Allie Grasgreen, "Live and Let Live (and Study)," *Inside Higher Ed*, January 26, 2012, www.insidehighered.com/news/2012/01/26/survey-finds-freshmen-more -liberal-leaning-academically-focused.

6. Allie Grasgreen, "A Question of 'Cause,'" *Inside Higher Ed*, April 8, 2013, www. insidehighered.com/news/2013/04/08/rutgers-says-it-didnt-have-cause-fire-rice -contract-suggests-otherwise.

7. *Champions of Respect: Inclusion of LGBTQ Student-Athletes and Staff in NCAA Programs* (Indianapolis: NCAA, 2012), www.ncaapublications.com/p-4305 -champions-of-respect-inclusion-of-lgbtq-student-athletes-and-staff-in-ncaa -programs.aspx.

8. Erin Buzuvis and Kristine Newhall, *Title IX Blog*, http://title-ix.blogspot.com.au.

DEVASTATING REPORT DETAILS TOXIC CULTURE THAT LED TO THE WORST SEX ABUSE SCANDAL IN U.S. SPORTS

Lindsay Gibbs | 2017

From *ThinkProgress*, June 28, 2017, https://thinkprogress.org/report-gymnastics-abuse-6099c92098c2.

The system is broken. And the people who broke it are still at the helm.

It takes a village of incompetence and downright depravity to facilitate the biggest sex abuse scandal in American sports history. A new report issued this week details the myriad ways that USA Gymnastics misstepped over the past few decades and ultimately failed to protect its athletes from sex abuse.

Last December, the *Indianapolis Star* reported that over the span of 20 years,

368 gymnasts alleged sexual abuse or exploitation by coaches and other authority figures, many of whom were alleged to have been associated with USA Gymnastics as members.[1] A significant amount of those allegations had not been investigated or reported by USA Gymnastics.

Most of the coverage of this scandal has centered around Larry Nassar, the former USA Gymnastics coach who has been accused of sexual abuse by more than 80 people and who is currently on trial in Michigan.

But the Daniels Report, which was commissioned by USA Gymnastics in late 2016 and authored by former federal prosecutor Deborah J. Daniels, makes it clear that this not the work of a lone wolf. Rather, this scandal is the result of a system that failed, on almost every conceivable level, to protect its athletes—predominantly young, impressionable girls in a sport that is built on trust.

The report offers 70 recommendations in 10 primary areas to help USA Gymnastics move forward. But the takeaway from the horrifying 146-page report is just how preventable—and familiar—this scandal is.

"If you like the way the Catholic hierarchy handles sex abuse you'll love USA Gymnastics, I guess," John Manly, an attorney for several of Nassar's victims, told the *Orange County Register* after the report came out.[2]

The problems within USA Gymnastics stem from a top-heavy administration that prioritized winning medals [above] all else, and a decentralized membership program for coaches, instructors, athletes, and clubs that had little-to-no accountability to the sport's governing body. There are currently over 3,500 private clubs around the country that are affiliated with USA Gymnastics, some of which train among 5,000 athletes.

Here are some of USA Gymnastics' most striking oversights—accidental and otherwise—that propagated the culture of abuse.

Abuse Allegations Were Not Taken Seriously by the Board of Directors for USA Gymnastics

There is an "Ethics, Grievance and Safe Sport" committee on the USA Gymnastics Board of Directors. However, even though the history of allegations against gymnastics coaches goes back decades, and the spotlight on sex abuse in the sport has been getting larger and larger in recent years, the Daniels Report found "no existence" of talk about sexual abuse in the minutes of either this committee or the Board at large. Rather, the "Ethics, Grievance and Safe Sport" committee spent most of its time reviewing "compensation arrangements" of Board members and figuring out if they were official conflicts of interest.

At a testimony in front of a U.S. Senate committee in March 2017, one former

Board member, a former three-time national champion rhythmic gymnast who has alleged sexual abuse by the team physician at the National Team Training Center, said that Board discussions were usually about "money and medals," and that any talk about abuse allegations centered around the accused coach's reputation.

The President of USA Gymnastics Had Far Too Much Control over What Happened with Official Complaints

Article 10 of the Bylaws required that all reports of sexual abuse or misconduct had to be filed in writing with the president. Then, the president had the power to select the employee who would conduct an investigation. Then, the president had the power to determine the outcome of a complaint.

This was a recipe for disaster. As Daniels wrote, "a president who was not inclined to take reports of misconduct seriously, or who was concerned about tarnishing the reputation of the organization, or who was a friend of the respondent in the matter, would have the authority to dismiss the complaint, or choose not to pursue it, without the involvement of others."

There Was Shockingly Poor Training on and Enforcement of the Organization's Existing Child Abuse Prevention Policies

According to the Daniels Report, "it appears that little, if any, formal training of staff has been provided relating to child abuse prevention and the dynamics of child abuse, including the developmental and other factors that hinder reporting of abuse by victims."

While USA Gymnastics did establish Safe Sport guidelines focused on child abuse prevention and athlete safety, it believed that since member clubs were private, it could only encourage its member clubs to enforce those policies, and couldn't make it a requirement.

USA Gymnastics Established a Permanently Ineligible Membership List for Coaches in 1990, But It Was Horrifically Ineffective

According to the *Indianapolis Star*, in some cases coaches were convicted criminally of child sex abuse but not banned by USA Gymnastics.[3] For example, Ray Adams coached at at least 12 clubs in four states despite being fired multiple times and even charged with criminal offenses for sexual abuse four times. The Daniels Report says that Adams "left a trail of anguish in his path, in the form

of over 15 abused girls whose lives were damaged—but clubs continued to hire him, either because they were unaware of the abuse, or, in the case of at least one club, reportedly knew but promised to 'watch' him."

The Permanently Ineligible list was not routinely published or easily accessible, so many USA Gymnastics clubs would be unaware they were employing coaches who were banned.

Those on the Permanently Ineligible list were also still permitted to work at USA Gymnastics–affiliated clubs, as long as they weren't working directly with athletes training for USA Gymnastics–sanctioned competitions. For example, in one case someone on the Permanently Ineligible list found work at a USA Gymnastics–affiliated club coaching cheerleading, which is not an Olympic sport and therefore not subjected to USA Gymnastics rules.

"In addition, such a person would theoretically be permitted to coach recreational gymnastics, available to young children who do not expect to compete but simply wish to learn tumbling or other aspects of gymnastics," notes the Daniels Report. "In that sense, the coach could become even more dangerous, permitted to coach even younger children while operating outside the jurisdiction of USA Gymnastics."

The System for Reporting Abuse Seemed Designed to Discourage and Downright Ignore Complaints

Prior to 2013, a written complaint from either the alleged victim, or if the alleged victim was a minor, their parent, was required in order to even initiate the grievance process for sexual abuse. Even when that rule was changed four years ago, it was not properly communicated to USA Gymnastics members.

Of course, even when written complaints were made, they often went nowhere. Why? Well, because "USA Gymnastics has not historically required member clubs, or any other members of USA Gymnastics, to report any type of abuse, including sexual misconduct, to USA Gymnastics or law enforcement authorities." Yeah.

The Daniels Report is filled with many more rage-inducing details about the corrupt culture of USA Gymnastics, including a scathing indictment about the lack of oversight at the Karolyi Ranch, the home of coaching legends Bela and Martha Karolyi, which served as the central training location for National Team members and elite gymnasts and where much of Nassar's alleged abuse took place.

The recommendations that Daniels makes in the report for the future of USA Gymnastics are practical and positive steps that would no doubt make the sport a much safer place. The fact that the Board unanimously decided to implement those recommendations on Tuesday is another good sign—although they no-

tably offered no timeline or accountability process for that implementation.[4]

But a culture this broken isn't fixed in 146 pages, and it's certainly not fixed without a drastic change in leadership. While former USA Gymnastics President Steve Penny finally resigned in March—with a $1 million severance in hand—Paul Parilla, the chairman of the USA Gymnastics Board of Directors, unfathomably still has a job.

Parilla has been with the Board of Directors since 1999 and served as chairman since December 2015, and has overseen USA Gymnastics' inept, often even cruel, handling of the scandal—including waiting five weeks to inform FBI officials about allegations against Nassar.[5] On a conference call with reporters on Tuesday, Parilla said that he intended to remain in his position as chairman. (He also said that the media attention was the only reason the Daniels Report was commissioned.)

"This is the height of institutional arrogance," John Manly, an attorney for some of Nassar's victims, said. "If he had any sense of propriety or decency then Mr. Parilla would resign."

Now, with Nassar on trial and more victims coming forward—Daniels says in the report that the number of victims is already underreported—this scandal is only going to get worse. There is no reason to believe that the people who oversaw a program that turned a blind eye to victims for decades are the people who are capable of taking the proper steps to fix it.

Notes

Links in the original online version of this article have been turned into endnotes.

1. Tim Evans, Mark Alesia, and Marisa Kwiatkowski, "A 20-Year Toll: 368 Gymnasts Allege Sexual Exploitation," *Indy Star,* December 15, 2016, www.indystar.com/story /news/2016/12/15/20-year-toll-368-gymnasts-allege-sexual-exploitation/95198724.

2. Scott Reid, "Report Calls for Culture Change at USA Gymnastics in Wake of Sex Abuse Scandal," *Orange County Register,* June 27, 2017, www.ocregister. com/2017/06/27/report-calls-for-culture-change-at-usa-gymnastics-in-wake-of-sex -abuse-scandal.

3. Marisa Kwiatkowski, Tim Evans, and Mark Alesia, "How the USA Gymnastics Scandal Unfolded," *Indy Star,* March 16, 2017, www.indystar.com/story/news/2017 /03/16/indianapolis-star-indystar-usa-gymnastics-steve-penny-child-sexual-abuse /99270916.

4. USA Gymnastics Board of Directors, "Letter to Gymnastics Community," USA Gymnastics website, June 27, 2017, https://usagym.org/pages/post.html?PostID=20437.

5. Mark Alesia, Marisa Kwiatkowski, and Tim Evans, "USA Gymnastics Delayed Reporting Weeks," *Indy Star,* February 16, 2017, www.indystar.com/story /news/2017/02/16/larry-nassar-usa-gymnastics-fbi-child-sexual-abuse/98002452.

PART VII *Intersections of Race, Ethnicity, and Gender*

The category of *woman* is not homogenous. Sex always intersects with other axes of power, including gender, sexuality, religion, (dis)ability, social class, culture, geographic location, and, as we address in part 7, race and ethnicity. These intersections shape the experiences of athletes, both as individuals and collectively; they are differences that make a difference.

The first two items in this part look at the articulations between race, gender, and sport as they relate to African American women, femininity, and track and field. In the first, "'Cinderellas' of Sport: Black Women in Track and Field," Susan Cahn explores how athletes negotiated racialized and gendered expectations about their appearance, comportment, and behavior with their sport's presumed "masculine" character. Between 1936 and 1948, as Cahn discusses, black women became "the dominant force in track, a position they would maintain for decades." Their success, however "had a double edge." Even as sport offered athletes a host of opportunities for education, travel, and national recognition, their very success could reinforce disparaging stereotypes of black women as "less womanly or feminine than white women."

Lindsay Parks Pieper's subsequent essay on track star Florence Griffith-Joyner provides an interesting follow up to Cahn's piece. Specifically, Pieper analyzes "the interconnected nature of race, gender, and sexuality as expressed through the mediation of Florence Griffith-Joyner." Whereas the mainstream media virtually ignored sportswomen of color in the mid-twentieth century, journalists of the 1980s were fascinated with "Flo Jo's" sex appeal, long fingernails, and

singular outfits. This fixation, Pieper argues, "reaffirmed racial distinctions and maintained racialized order in sport."

African American women have been, and continue to be, overrepresented in track and field and basketball, and underrepresented in most other sports. Indeed, one of the unintended consequences of Title IX has been that girls and women of color have not reaped the same expansive benefits as their white peers. This is especially true at "heavily minority schools" (where 10 percent or less of the population identifies as white), which typically have fewer opportunities and resources for all students. According to the National Women's Law Center's report "Finishing Last," girls of color are "doubly disadvantaged" when it comes to high school sports by both sex and race/ethnicity. To that end, the report offers several strategies that federal, state, and local policies and communities might adopt in order to increase the opportunities for girls of color to play sports.

Gymnastics is one sport in which girls and women of color have been historically and significantly underrepresented. But as Celisa Calacal and Lindsay Gibbs point out, there may be signs that this is starting to shift. The five members of the 2016 Olympic women's gymnastics team included two African American athletes, Simone Biles and Gabrielle Douglas, as well as the first Latina gymnast to represent the U.S., Laurie Hernandez. Involvement in the sport has been slow and difficult for gymnasts of color, but this change is vitally important. "The idea of seeing someone that looks like you is so profound," remarked one woman interviewed for this story, "and it has such an impact on your understanding of what you potentially can be."

The "look" of an athlete, however, can also end up marginalizing girls and women of color. In figure skating, a sport where Asian American skaters have had some success in the last two decades, judges evaluate skaters on artistry, personality, and technical skill. Andi Zeisler's "All about Eve on Ice" criticizes the selection process for the 2014 Sochi Olympics. Zeisler smells "the whiff of racism" in the decision to leave national figure skating champion Mirai Nagasu off the team in favor of two skaters with "silky blond hair, white skin, snub noses, and lean willowy physiques." She asks us to consider how implicit bias operates in big market events like the Olympics: did media preference for familiar faces and narratives influence the decisions of ostensibly neutral athletic officials?

As we consider issues of race and ethnicity in this part, we must recognize that racial and ethnic identities are social identities mapped onto diverse groups of people, often in problematic ways. This is evident in the brief story about Filipino-American diver Victoria Manalo Draves. The failure to correctly identify Draves as the first Asian American gold medalist, argues journalist Devin Israel Cabanilla, has to do with both sexism and racism, as journalists typically

identify Korean American male diver Sammy Lee as the first Asian American Olympic champion. Even more, Cabanilla notes, the "effect of the preconceived notion of who belongs in 'Asian America' also can't be ignored." This article reminds us that racial identities are not self-evident and are never far removed from the gendered racial politics of a given historical moment.

There are important differences and distinctions within all racial and ethnic categories, but perhaps no group has been subjected to more disrespectful homogenization than Native Americans. In the last reading of this section, writer Ian Frazier tells the story of Oglala Sioux SuAnne Big Crow, a fourteen-year-old basketball phenomenon from South Dakota's Pine Ridge Reservation. In the face of racial taunting at a game against a non-Indian school, and in reaction to a long legacy of racism against the Oglala Sioux and other Native Americans, Big Crow performed what Frazier describes as "one of the coolest and bravest deeds I ever heard of."

In the end, however, it should not be incumbent upon marginalized groups and individuals to effect change. Rather, all advocates for women's sport must take into consideration how race and ethnicity—as well as economic inequality—continue to create disparate athletic experiences and opportunities for girls and women.

"CINDERELLAS" OF SPORT

Black Women in Track and Field

Susan Cahn | 2003

Excerpted from Susan Cahn, "'Cinderellas' of Sport: Black Women in Track and Field," in *Coming on Strong: Gender and Sexuality in Women's Sport*, 2nd ed. (Chicago: University of Illinois Press, 2015). Copyright © 1994, 2015 Susan Cahn. Bracketed insertions are part of the original publication.

After World War II forced the cancellation of the 1940 and 1944 Olympic Games, Olympic competition resumed in 1948, hosted by London. Although England remained in a state of grim disrepair, the performance of three female track-and-field athletes shone through the bleakness of the postwar European setting. Francina "Fanny" Blankers-Koen, competing for the Netherlands, won an astounding four gold medals with victories in the one hundred- and two hundred-meter sprints, the eighty-meter hurdles, and four hundred-meter relay. The Dutch athlete was heralded not only for her medals but for achieving her success as an adult married woman—a full-time housewife and the mother of two children. Among Europeans her fame was rivaled only by the French athlete Micheline Ostermeyer, winner of gold medals in the shot put and discus and a bronze in the high jump. Ostermeyer, in addition to her athletic excellence, was a concert pianist whose musical ability and middle-class background marked her as a "respectable" woman in a sport many perceived as unwomanly.[1] The third athlete was Alice Coachman, a high jumper from Albany, Georgia. As a track and basketball star for Tuskegee Institute, Coachman had established a reputation as the premier black woman athlete of the 1940s. Her single gold

medal in the high jump could not match the totals of Blankers-Koen or Oster-meyer. Nevertheless, it was historically significant, both as the only individual track-and-field medal won by U.S. women and, more important, as the first medal ever received by a woman of African descent.

The superlative performances of these three Olympic champions earned them only momentary glory in the United States. Their names quickly faded from public view, overshadowed by male Olympians and athletes like Barbara Ann Scott, the Canadian Olympic figure-skating champion, whose sport earned far more attention and approval than women's track and field. Track athletics, like basketball, had excited enormous public interest as a women's sport in the 1920s and early 1930s. But even more so than basketball, track had fallen victim to negative media coverage and organized efforts to eliminate it from school and international competition.

By midcentury the sport had a reputation as a "masculine" endeavor unsuited to feminine athletes. Few American women participated, and those who did endured caricatures as amazons and muscle molls. In this climate, despite the temporary enthusiasm inspired by the female champions of 1948, Olympic governing bodies of the 1950s once again considered eliminating several women's track-and-field events from the games because they were "not truly feminine."[2]

In the discussions that followed, Olympic official Norman Cox sarcastically proposed that rather than ban women's events, the International Olympic Committee (IOC) should create a special category of competition for the unfairly advantaged "hermaphrodites" who regularly defeated "normal" women, those less-skilled "child-bearing" types with "largish breasts, wide hips, [and] knocked knees."[3] This outrageous but prescient recommendation (the IOC instituted anatomical sex checks in 1967, followed by mandatory chromosome testing of women athletes) placed a new spin on a familiar argument. Cox's assertion that victorious women Olympians were most likely not biological females rested on the deep conviction that superior athleticism signified masculine capacities that inhered in the male body.

Among the athletes who withstood this kind of ridicule and continued to compete were African-American women, who by midcentury had come to occupy a central position in the sport of track and field. Beginning in the late 1930s, black women stepped into an arena largely abandoned by middle-class white women, who deemed the sport unsuitable, and began to blaze a remarkable trail of national and international excellence. But their preeminent position in the sport had a double edge. On a personal level success meant opportunities for education, travel, upward mobility, and national or even international recognition. The accomplishments of such Olympians as Alice Coachman, Mae Faggs, or

Wilma Rudolph also demonstrated to the public that African-American women could excel in a nontraditional yet valued arena of American culture. However, viewed through the lens of commonplace racial prejudices, African-American women's achievements in a "mannish" sport also reinforced disparaging stereotypes of black women as less womanly or feminine than white women.[4] [. . .]

As white women vacated the sport and amateur athletic organizations withdrew their support, black athletes stepped to the fore of women's track and field. Along with basketball, boxing, football, and baseball, track was one of the most popular sports in black communities during the interwar years. African-American men first gained fame as sprinters in the 1920s. Their reputation grew when Jesse Owens soundly defeated Hitler's vaunted Aryan super athletes in an astonishing quadruple performance at the 1936 Berlin Olympics. The success of Owens and other black Olympians, including Ralph Metcalfe, Archie Williams, and Cornelius Johnson, challenged assumptions of white superiority and further popularized track and field among black sport fans and young athletes, including girls.[5]

Although women's sport clearly played second fiddle to men's in black communities, a significant sector of the population demonstrated interest in women's athletics, whether as fans, recreation leaders, or athletic sponsors.[6] Additional encouragement came from African-American educators and journalists, who expressed an acceptance of women's sport rare for their day. In 1939 prominent black physical educator E.B. Henderson agreed with others in his profession that the first priority of girls' athletics should be health, not competition. But he went on to criticize "the narrowed limits prescribed for girls and women," arguing: "There are girls who ought to display their skill and national characteristic sport to a wider extent. These national exponents of women's sport are therefore to be commended for the prominence they have attained. . . The race of man needs the inspiration of strong virile womanhood."[7]

Black women's own conception of womanhood, while it may not actively have encouraged sport, did not preclude it. A heritage of resistance to racial and sexual oppression found African-American women occupying multiple roles as wageworkers, homemakers, mothers, and community leaders. In these capacities women earned respect for domestic talents, physical and emotional strengths, and public activism. Denied access to full-time homemaking and sexual protection, African-American women did not tie femininity to a specific, limited set of activities and attributes defined as separate and opposite from masculinity. Rather, they created an ideal of womanhood rooted in the positive qualities they cultivated under adverse conditions: struggle, strength, family commitment, community involvement, and moral integrity.[8]

Although these values were most often publicly articulated by women in positions of political and intellectual leadership, they were expressed in more mundane fashion by countless other women who helped build the infrastructure of black churches, community centers, club life, and entertainment—the institutions that sponsored athletic activities for girls and women. The work of earning a living and raising a family, often in near-poverty conditions, prevented the great majority of black women from participating in sport or any other time-consuming leisure activity. Yet by the 1930s and 1940s, as sport became a central component of African-American college life and urban community recreation, women were included as minor but nevertheless significant players.[9]

African-American interest in track and field and permissive attitudes toward women's athletics set the stage for the emergence of black women's track at the precise moment when the majority of white women and the white public rejected the sport as undignified for women. Tuskegee Institute formed the first highly competitive collegiate women's track team in 1929.[10] The school immediately added women's events to its Tuskegee Relays, the first major track meet sponsored by a black college, and soon thereafter began extending athletic scholarships to promising African-American high school girls. Coached by Clive Abbott, Christine Petty, and later Nell Jackson, the Tuskegee team matured into North America's premier women's track club during the 1930s and 1940s, capturing eleven of twelve AAU (Amateur Athletic Union) outdoor championships between 1937 and 1948.[11]

Tuskegee was not alone among black colleges in encouraging women's track and field. Prairie View A&M of Texas added women's events to its annual relays in 1936, followed by Alabama State College. Florida A&M, Alcorn College in Mississippi, and Fort Valley State College of Georgia were among the schools attending early Tuskegee meets. Tennessee A&I (later Tennessee State University, or TSU) first sent participants to the Tuskegee Relays in 1944 and established a permanent program in 1945 under the direction of Jessie Abbott, daughter of Tuskegee athletic director Clive Abbott. Collegiate programs drew primarily from southern high schools. Although travel costs and the scarcity of black high schools prohibited extensive interscholastic competition, high school girls from throughout the South trained hard for annual trips to Tuskegee or other college meets where they competed in special "junior" events organized for high schools from around the region.[12]

In the North independent and municipal track clubs provided initial training and encouragement for black girls interested in the sport. Tidye Pickett and Louise Stokes, a Boston track star, got their start on northern playgrounds and in 1936 became the first African-American women to compete on a U.S. Olympic

team.[13] In later years, the CYO (Catholic Youth Organization) Comets of Chicago and Police Athletic League of New York produced sprinters like Barbara Jones and Mae Faggs, who both went on to compete for Tennessee State and the U.S. Olympic team.

African-American track women compiled their record of excellence while suffering the constraints of racial and gender discrimination. In the late 1940s and early 1950s, efforts to end racial segregation in major league sports like baseball and basketball had made little impact on the extensive segregation in school, municipal, semipro, and minor league sport. The white press gave minimal coverage to black sports and seldom printed photographs of African-American athletes. Black women found that sex discrimination, in the form of small athletic budgets, halfhearted backing from black school administrators, and the general absence of support from white-dominated sport organizations, further impeded their development.

The AAU policy of sponsoring white-only meets, where southern state laws permitted, posed another barrier. Southern black women's teams, excluded from regional competitions, were limited to black intercollegiate meets and the AAU national championships. Tuskegee athletes typically competed in only three meets per year—the AAU indoor and outdoor championships and the Tuskegee Relays. Tennessee State University followed a similar pattern until the late 1950s and 1960s, when opportunities increased.[14] En route to these meets, teams faced the additional difficulties of traveling through the segregated South. The shortage of restrooms, restaurants, and motels available to black travelers meant that black athletes had to create makeshift accommodations and endure degrading, exhausting conditions.

Despite these obstacles black women's track survived and even thrived. World War II caused the cancellation of the 1940 and 1944 Olympic Games. In the interlude between 1936 and 1948, African-American women became the dominant force in track, a position they would maintain for decades. Commenting on the fact that white women held only two of the eleven slots on the 1948 U.S. national track team, E.B. Henderson surmised that "American [white] women have been so thoroughly licked over so many years by the Booker T. Washington Girls that they have almost given up track and field competition."[15]

African-American women had found an athletic niche, and when the Olympic Games resumed in 1948, black sport activists sensed a historic turning point. Fay Young of the *Chicago Defender* announced in bold type: "Negro Women Will Dominate 1948 U.S. Olympic Track Team." Young subtitled his commentary "Negro Womanhood on Parade," suggesting that the black public viewed athletics as a terrain of achievement with import beyond the immediate athletic realm.[16]

But what did it mean when "Negro womanhood" was "on parade" in a controversial, "mannish" sport? Throughout the 1950s African Americans made up more than two-thirds of American women chosen to compete in the track-and-field events of the Pan-American Games, international track meets and the Olympics.[17] Among athletes, amateur track leaders, and the broader public, the achievements of African-American women athletes could hold significantly different, even contradictory, meanings. Athletic successes which could, in one context, affirm the dignity and capabilities of African-American womanhood, could also appear to confirm derogatory images of both black and athletic women.

African-American women in their teens and twenties only dimly perceived the historical significance of their athletic achievements. They were far more aware of the personal opportunities and enjoyment they found in track and field. Yet in describing their experiences, athletes commented on the racial and gender barriers they faced, reflecting as well on their knowledge of athletics as a site for personal and social transformation.[18]

Lula Hymes (Glenn) and Leila Perry (Glover) both grew up in Atlanta, Georgia, ran track for Booker T. Washington High School in the 1930s and attended Tuskegee in the late 1930s and early 1940s on college track scholarships. Each won numerous honors in collegiate and AAU competition. Their teammate Alice Coachman (Davis) grew up in Albany, Georgia, and was recruited while still a high school student to attend Tuskegee Institute's secondary school and postsecondary trade school. An extraordinary athlete, Coachman dominated the high jump and sprinting events from 1939 to 1948. Her perseverance paid off in a gold medal for the high jump, the only bright spot for U.S. track women in the 1948 London Olympics.

Shirley Crowder (Meadows), Martha Hudson (Pennyman) and Willye White were part of the next cohort of track women. Crowder and Hudson grew up in Georgia in the 1940s and 1950s, attended Tennessee State University on track scholarships in the late 1950s, and competed in the 1960 Olympics in Rome.[19] Their Olympic teammate White won recognition as a high school sprinter and jumper in her home state of Mississippi. While a member of TSU and Chicago track teams, she competed in five successive Olympic Games from 1956 to 1972.[20]

All six athletes began by running high school track in segregated southern schools. By the 1940s most black high schools offered girls' track and basketball teams, providing at least a modicum of organizational support and coaching for promising young athletes. The women recalled that while it was still unusual for a girl to be heavily involved in sports, they were not lone competitors. Reinforced by teammates and coaches, young athletes also received support from friends and family members.

They were, however, aware that some contemporaries disapproved of female athletes. Willye White learned of these attitudes at an early age, when members of her rural Mississippi community questioned her tomboyish ways. Describing herself as a "tomboy" and an "outcast," she explained, "It was not acceptable in American society." Alice Coachman also met with criticism. Her parents repeatedly tried to prevent her from going to the playground where she played ball and raced with the boys. Coachman recalled that her parents as well as others in the community suspected that athletic girls would suffer injury and poor health: "The general feeling during that time—they just felt that girls were going to break their neck. . . . In my hometown, . . . they were always afraid of them getting hurt. . . . They weren't educated about women's track."

Yet, more often than not, athletes found fellow students and community members to be genuinely supportive, especially if they had an interest in sport or personal contact with the women involved. Shirley Crowder described the atmosphere at Tennessee State:

> If the person was not involved with sports as a participant or a spectator . . .
> they perhaps thought of it as being too masculine perhaps at that time. Because
> I've had some people say things like that to me. . . . I just credit it to the fact that
> some were jealous because we were constantly traveling. I just took it that way.
> But most of the people who were closer to us appreciated what we were doing.

At Tuskegee athletes rarely encountered criticism. The mannish image of women athletes occupied a remote corner in Leila Perry's mind, since, as she explained: "The people we encountered, you didn't have that kind of a stigma. Like at Tuskegee, everybody was proud of us. Because we were really outstanding. . . . It didn't touch me, because at Tuskegee it wasn't such. They were proud of their athletes."[21]

Insulated from wider cultural criticism by their immediate surroundings, athletes rejected interpretations that conflicted with their own. Lula Hymes reasoned, "They gonna think and talk and say what they want to say anyway, regardless of how you feel about it. I never pay any attention to what people say." Martha Hudson agreed: "I've heard the talk, but it didn't bother me." She explained that her TSU coach and teammates provided a layer of protection: "We were just so prepared for a lot of things—criticism—our coach would talk to us. Things that a lot of people worried about, we didn't. We would discuss it, we would talk about it, but it didn't bother us."

Like Hudson, athletes shielded from public rebuke felt free to participate and enjoy their sport to the fullest. Lula Hymes summarized her experience: "I just wanted to run and win during that time. . . . I was out there just enjoying

myself. Because I liked it; [it was] something I wanted to do!" Similarly Shirley Crowder concluded, "I was just always me. . . . I knew what I had to do and I'd do it regardless." Reflecting on the sheer pleasure of her youthful passion, Alice Coachman commented, "When I look back at it now, I just say, 'Lord, I sure was a running thing!'"

Beyond the elemental joy of competing, athletes also placed high value on the educational and travel opportunities that track and field made available. While several had planned to attend local colleges, athletic scholarships gave them the chance to go away to school and expand their horizons. Hymes, Perry, and Coachman especially appreciated the rich cultural and intellectual life of Tuskegee in the 1930s and 1940s: "They had all kinds of activities around the campus for you. And you just kind of grew as a person. You weren't just involved in athletics, you were involved in the happenings of the world. Because they brought the world to Tuskegee."

Athletes described their travels as a combination of painful and wondrous awakenings. Traveling across the South and into northern cities brought young athletes out of the protective fold of black institutions and communities. They encountered the harsh realities of southern segregation and the more confusing, unwritten rules of northern racism. Growing up in Atlanta's black community, Lula Hymes had not experienced segregation as burdensome or painful. "I wasn't aware until we started traveling," she recalled. On the road she found that "if we wanted to go to the bathroom, we had to stop and go in the woods. We couldn't go in the stores to buy anything. We had to go around. It was really hard, segregated." Alice Coachman described a similar contrast between student life at Tuskegee and traveling with the track team. Remarking on the difficulty of obtaining food, gas, and lodging on the road, she explained that travel with the team brought segregation into full view, especially compared to the relative safety of Tuskegee, where "you had your own little world." Although roadside picnics and stops at black colleges, restaurants, or rooming houses might make for pleasant travel, athletes understood the forces of racism that lay behind those "choices."

Young track women found that travel also offered positive experiences. As high school students spending the summer at Tuskegee's or tsu's junior training program, teenagers gained independence, new friends, and sometimes an escape from difficult work or family situations. After spending her first summer at Tuskegee, Alice Coachman begged her parents to let her return during the school year: "I had gotten a taste of traveling with the girls. . . . You know, going to big cities, and I had never been out of Albany, Georgia. And everybody was nice. I wanted to be with the group—I wanted to be there too!" Willye White

saw track as a ticket out of Greenwood, Mississippi. "It was my talent, and my ability. And with that I could do a lot of things. I could get away from my grandparents, I could travel throughout the state. . . . It allowed me freedom of movement." Describing escape from grueling work as her "main motivator," White explained: "I left [Mississippi] every May, and that meant I didn't have to go to the cotton fields and I came back in September. As far as what was traditional and nontraditional, I had no idea. All I knew was it was just an escape for me not to have to go to the cotton fields during the summer."

Travel to AAU and Olympic competitions opened even more vistas. Athletes recalled dancing at the Savoy Ballroom and the Cotton Club in New York City, being taken to historical sites like Mount Vernon, and encountering chop suey and chopsticks for the first time. Top black teams occasionally received celebrity treatment, although it might come with a racist twist. Martha Hudson told of being invited as part of the TSU track team to appear on Dick Clark's *American Bandstand* television program, only to find out afterward that they had been kept off camera nearly the entire show. In a similar vein Leila Perry recalled a ceremony honoring the Tuskegee team at the Atlantic City, New Jersey, city hall. Before being presented with the key to the city, the team was asked to sing for the crowd, because "as always, they think that black folks are supposed to be able to sing."

These racial slights were outweighed by profound moments of racial insight and pride. Recalling her first Olympic journey to Melbourne, Australia, Willye White described a life-altering experience: "That's when I found out there were two worlds, Mississippi and the rest of the world. I found that blacks and whites could eat together, sleep together, play together, do all these things together. And it was just eye opening. Had I not been in the Olympic Games, I could have spent the rest of my life thinking that blacks and whites were separate." For White and other African-American athletes, involvement in high-level track and field brought deep satisfactions and worldly knowledge.

Beyond its personal significance to individual athletes, the success of black women in track served as a broader symbol of pride and achievement for black communities. Black colleges and newspapers heralded women's track accomplishments, even when the mainstream press ignored them. When white officials or journalists did occasionally take note of black female athletic accomplishments, their praise represented momentary triumphs in the long struggle against racial oppression. Victorious homecoming ceremonies at which white politicians and reporters showered black Olympians with honors served as a powerful symbolic reversal of racial hierarchy. When the white mayors of Greenwood, Mississippi, and Clarksville, Tennessee, handed Willye White and

Wilma Rudolph the keys to their cities, it symbolized a door that could open for all African Americans. It granted due, if temporary, respect and nurtured the hope that racial justice might soon prevail.

Paradoxically, while black communities understood the athletic success of African-American women to be a measure of black cultural achievement, it held a very different meaning when interpreted through the lens of white America's prevailing racial and sexual beliefs. For the most part black women athletes were simply ignored by the white media and athletic establishment. Figures like Alice Coachman, the first black woman in history to win an Olympic medal, or Mildred McDaniel, the only American woman to win an individual gold medal in the 1956 Olympic track-and-field competition, did not become national celebrities, household names, or even the subject of magazine feature stories. The most striking feature of the historical record on black women athletes is neglect. This pattern is not surprising given the invisibility of minority cultures in mainstream discourse. Yet the historical roots of the silence surrounding black women athletes are complex. They [lie] deep in the traditions of Western thought, in which women of color have long been viewed as distant but definitive repositories of inferior, unfeminine qualities.[22]

For centuries European and Anglo-American art, science, and popular thought had constructed a normative ideal of white womanhood that relied on an opposing image of black women as the inferior "other." Specifically, images of female sexuality, femininity, and beauty were composed along racially polarized axes. North American and British scientists of the nineteenth century described black sexuality as lascivious and apelike, marked by a "voluptuousness" and a "degree of lascivity" unknown in Europe. Citing supposed physical distinctions between African and European women as empirical proof, they contrasted black women's presumed primitive, passionate sexuality to an ideal of asexual purity among highly "civilized" white women. These stereotypes continued to permeate American culture in the early twentieth century. Called "openly licentious" and "morally obtuse," black women posed a negative contrast to the presumed "lily-white" virtue of Anglo-American women.[23]

Theories of sexual inferiority and primitiveness found a corollary in standards of beauty. Early-twentieth-century sexologist Havelock Ellis argued that a scientifically objective chain of beauty ran parallel to the evolutionary chain of being. White European and Anglo-American women occupied the most highly evolved, beautiful end of the scale, while black women were assigned a place at the opposite end.[24] Ellis's "scientific" theory was rooted in popular racial assumptions that found another expression in dominant media standards of beauty. Advertisements, advice columns, and beauty magazines excluded

women of color, except for occasional portrayals as dark-skinned exotica from far-away lands.

Racialized notions of sexual virtue and feminine beauty were underpinned by another concept, that of the virile or mannish black female. African-American women's work history as slaves, tenant farmers, domestics, and wageworkers disqualified them from standards of femininity defined around the frail or inactive female body. Their very public presence in the labor force exempted African Americans from ideals of womanhood that rested on the presumed refinement and femininity of a privatized domestic arena. Failing to meet these standards, black women were often represented in the dominant culture as masculine females lacking in feminine grace, delicacy, and refinement.

The silence surrounding black athletes reflects the power of these stereotypes to restrict African-American women to the margins of cultural life, occupying a status as distant "others." In one sense the invisibility was not specific to athletes. With the exception of a few sensational stage performers like Josephine Baker or Lena Horne, African-American women were not generally subjects of white popular interest or adoration. There were, however, more specific causes for the lack of attention to black women's athletic accomplishments, reasons rooted in the striking intersection of racial and gender ideology in sport.

The long exclusion of both African-American women and female athletes from categories of acceptable femininity encouraged the development of analogous mythologies. References to imitative "animalistic" behavior had often been used to describe white female athletes, who by "aping" male athletic behavior were suspected of unleashing animal instincts. Charges of mimicry found an even deeper congruence with racist views of African Americans as simian and imitative. Similarly, the charge that sport masculinized women physically and sexually resonated with scientific and popular portrayals of mannishness and sexual pathology among black women. The assertion that sport made women physically unattractive and sexually unappealing found its corollary in views of black women as less attractive and desirable than white women.[25] The correspondence between stereotyped depictions of black womanhood and athletic females was nearly exact, and thus doubly resonant in the case of African-American women athletes.

The myth of the "natural" black athlete lent further support to the perception that African-American women were biologically suited to masculine sport. Early-twentieth-century education and social science journals, especially in the 1930s, were sprinkled with anthropometric studies of racially determined muscle length, limb size, head shape, and neurological responses. Experts in both science and sport labored to identify genetic factors, including a conditioned

"fear-response" and peculiar characteristics of African-American hands, ten-dons, muscles, joints, nerves, blood, thighs, and eye color, which might explain the fact that black athletes sometimes jumped higher or ran faster than whites.[26] This formulation of the "natural" black athlete represented black athletic accom-plishment as a by-product of nature rather than as a cultural attainment based on skill and knowledge. By maintaining the myth that people of European descent were cultured, intellectual and civilized, while those of African heritage were uncivilized beings guided by physical and natural impulses, it also converted black achievements into evidence of racial inferiority.[27]

A legacy of racist thought influenced the reception of black women track athletes. This kind of racism was rarely overt and probably not even intended by many sport enthusiasts. It was signaled primarily as an absence—the lack of popular interest, organizational support, media coverage, and public acclaim. White observers may have tacitly dismissed black women's accomplishments as the inevitable result of "natural," "masculine" prowess. By this logic black women's very success could appear to provide further evidence of track and field's un-feminine character. Advocates of women's track may have ignored black athletes because their existence ran contrary to the image of classic (white) femininity that officials so desperately wanted to convey.[28] While racism was only one factor contributing to the poor reputation of women's track and field, the confluence of powerful racial and athletic stereotypes could only reinforce the stigmatized status of track women in general, and African-American athletes in particular.

However, the situation changed after World War II, when the global conflict between the United States and the Soviet Union suddenly fixed national and international attention on women's track. As a small band of neglected, under-trained female athletes assumed the weight of the "free world" on their backs, sport advocates and journalists were forced to confront the image of women's track and its leading stars.

Concerned observers agreed that to improve women's performance, sport administrators must interest a larger number of girls and women in track and then provide adequate training programs to develop their abilities. The problem was how to popularize a sport deemed by many as unfeminine and undesirable for women. For sport advocates trying to revive popular interest in a dying sport, the commanding position of African-American women in track posed an especially vexing problem. To improve the image of track and field, promoters could either incorporate black track women into approved concepts of athletic womanhood, or they could minimize the presence and contributions of black women in order to create a more respectable image of the sport. Black and white athletic officials approached the dilemma with a variety of strategies.

African-American journalists, coaches, and athletic promoters consciously cultivated the feminine image of black women athletes. Tennessee State Coach Edward Temple instituted a dress code and prohibited photographers from taking postrace pictures until after his athletes had retreated to the locker room to touch up their hair and wash their faces. He wanted the visible signs of strain and sweat removed, creating a "public face" of composure. Asked about the masculine image of track athletes, Temple told a reporter, "None of my girls have any trouble getting boyfriends. I tell them that they are young ladies first, track girls second."[29]

Black educator and sports historian E.B. Henderson took pains to establish the femininity of black competitors, asserting in 1948 that "colored girl athletes are as a rule, effeminate. They are normal girls."[30] Contrasting "colored" athletes to those champions who "are more man than woman," one athlete declared that Coach Temple "wanted to show that we were ladies, respectable ladies. . . . They said negative things about athletes, about the way they dress and so on and so forth, so he wanted us to try to set an example that athletes were not what some of them thought we were—that we were ladies."[31]

This carefully composed image of athletic womanhood did double duty, debunking myths of the mannish woman athlete and of the natural black athlete. It also raised a wall of defense against misinformed or malicious representations of black women. By publicly asserting their femininity and sexual respectability, black athletes answered tacit denials of their womanhood and demanded inclusion in the realm of culture.[32]

The continued prominence of black women in the sport and the impact of the civil rights movement forced some change in media policy of the early 1960s. African-American women were more often featured and photographed. However, the few athletes who attained a visible presence were often treated as exceptional cases. In reporting on Wilma Rudolph's triple-gold-medal performance at the 1960 Rome Olympics, where she won the one hundred- and two hundred-meter sprints and anchored the four hundred-meter relay, *Time* magazine declared: "In a field of female endeavor in which the greatest stars have often been characterized by overdeveloped muscles and underdeveloped glands, Wilma (Skeeter) Rudolph has long, lissome legs and a pert charm."[33] In this view top women track athletes, who in the United States happened to be black, were masculine freaks of nature, and Rudolph was the exception. Even as they applauded her charm and speed, the press resorted to stereotypical images of jungle animals. They nicknamed Rudolph the "black gazelle."[34] Like other black athletes, she was represented as a wild beast, albeit a gentle, attractive creature who could be adopted as a pet of the American public.[35]

Constrained by segregation laws, inferior resources, limited competitive opportunities, discriminatory sport agencies, and media "blackouts," African-American women athletes faced tremendous barriers to participation. Sadly, when they surmounted these odds, their commanding presence in the "mannish" sport of track and field could appear to verify their absence from "true" (white) womanhood and athletic respectability.

The subtle interplay of racial and gender stereotypes surely did the greatest damage to African-American athletes, but it also indirectly constricted the athletic possibilities of other women. Sport advocates who stressed white norms of femininity and attempted to distance the sport from its black stars simply reinforced a definition of femininity that confined women physically, sexually, and athletically. They thereby subverted their own genuine interest in expanding women's athletic freedom. As long as the "mannish amazon" could be represented by the liminal figure of the black female track star, sport would remain an illegitimate activity for all women.

Notes

Note numbers and callouts have been changed from the original article.

1. On Blankers-Koen, see Richard Schaap, *An Illustrated History of the Olympics,* 2nd ed. (New York: Alfred A. Knopf, 1967), 241. On Blankers-Koen and Ostermeyer, see Guttmann, *Women's Sports: A History* (New York: Columbia University Press, 1991), 200.

2. Avery Brundage, Brundage Collection, Box 70 (Folder-Circular Letters to IOC's, NOC's, and IF's, 1952–54), University of Illinois Archives.

3. Brundage Collection, Box 115 (Folder-Athletics-Women), "IOC-Quotations for and against women's competition," no date (mid-fifties), University of Illinois Archives.

4. This stereotype has been discussed in much of the historical literature on African-American women. See, for example, Paula Giddings, *When and Where I Enter* (New York: William Morrow, 1984), chaps. 1, 2, 4; Barbara Hilkert Andolsen, *"Daughters of Jefferson, Daughters of Bootblacks": Racism and American Feminism* (Macon, GA: Mercer University Press, 1986); Patricia Hill Collins, *Black Feminist Thought* (Boston: Unwin Hyman, 1990), chaps. 4, 8.

5. On Owens, see William J. Baker, *Jesse Owens: An American Life* (New York: Free Press, 1986). On African Americans in track and field, see Arthur R. Ashe, Jr., *A Hard Road to Glory: A History of the African-American Athlete, 1919–1945* (New York: Warner Books, 1988), 73–91.

6. Linda D. Williams's study found that the black press between 1924 and 1948 gave significant and positive coverage to black women athletes. Williams concludes that there was "a more favorable environment for the sportswomen in the black community" and that black women benefited from a diverse and popular black sports culture during this period. See Linda D. Williams, "An Analysis of American

Sportswomen in Two Negro Newspapers: The *Pittsburgh Courier,* 1924–1948 and the *Chicago Defender,* 1932–1948" (Ph. D. diss., Ohio State University, 1987), 22, 114.

7. Henderson, *The Negro in Sports,* rev. ed. (Washington, DC: Associated Publishers, 1939), 218.

8. On black women's construction of womanhood, see Giddings, *When and Where I Enter,* 49, 85–94; Deborah K. King, "Multiple Jeopardy, Multiple Consciousness," *Signs* 14 (Autumn 1988): 43–72; Bonnie Thornton Dill, "The Dialectics of Black Womanhood," *Signs* 4 (Spring 1979): 543–5; Patricia Hill Collins, "Learning from the Outsider Within," *Social Problems* 33 (December 1986): 514–32; and Hazel V. Carby, *Reconstructing Womanhood: The Emergence of the Afro-American Woman Novelist* (New York: Oxford University Press, 1987).

9. There may have been class differences in the degree of support for women's sports. In "Organizing Afro-American Girls' Clubs in Kansas in the 1920s," *Frontiers* 9, 2 (1987): 69–72, Marilyn Dell Brady indicates that the largely middle-class National Association of Colored Women sponsored girls' clubs that included athletics among a variety of other cultural activities. But sport was not a major focus of these clubs. While golf and tennis were popular among black country club members, it is not clear whether wealthier African Americans approved of women's involvement in sports like basketball, bowling, or track, which had greater working-class constituencies.

10. *New York Age,* February 16, 1929, p. 6.

11. See Ashe, *A Hard Road to Glory,* 75–9, and annual reports of AAU track-and-field championships published in the *Amateur Athlete.*

12. On southern high school and collegiate women's track, see *Atlanta Daily World* sports pages from the 1930s and 1940s. On TSU, see Tennessee State University Tigerbelles Clippings Files, Tennessee State University Archives, Nashville, TN; TSU yearbooks; and Fatino Marie Clemons, "A History of the Women's Varsity Track Team at Tennessee State University," master's thesis (April 1975), Graduate Research Number 1766, TSU Archives.

13. On northern track meets, see the *Chicago Defender* and *Pittsburgh Courier* sports pages. Stokes, as well as Pickett, had been deprived of a place on the 1932 Olympic team despite her apparent qualifications. The American Olympic Committee's requirement that most women pay their own travel expenses nearly prevented their participation in the 1936 Berlin Games, until at the last minute money turned up. I was unable to determine how the money was raised, but for a partial explanation, see *Philadelphia Tribune* (August 13, 1936), p. 14. See also Davis, *Black American Women,* 130–3.

14. Interviews by the author, Lula Hymes Glenn and Alice Coachman Davis (Tuskegee, AL), May 7, 1992, Leila Perry Glover (Atlanta, GA), May 8, 1992, and Edward Temple (Nashville, TN), July 7, 1988; Clemons, "A History of the Women's Varsity," 22; and TSU clippings files at TSU Archives. In its first three years, TSU competed in only one meet per year, and in fifteen years never entered more than seven meets per year.

15. *Atlanta Daily World,* August 6, 1948.

16. *Chicago Defender,* May 22, 1948.

17. Black track athletes flourished throughout the postwar era. In the mid-1950s,

350 women competed at the Tuskegee Relays. Teams from Xavier, Albany State of Georgia, Alabama State, Prairie View A&M, TSU, Philander Smith of Arkansas, Bethune Cookman, and Chicago's Catholic Youth Organization (CYO) entered the senior division, while high schools from throughout the South sent girls to the junior division meet. During these years the Tennessee Tigerbelle team took the mantle from Tuskegee's fading program. TSU won the Tuskegee Relays in 1953 and began a string of AAU national championships. Between 1948 and 1968 Tennessee athletes claimed twenty-five of the forty Olympic track-and-field medals won by American women. See Ashe, *A Hard Road to Glory,* 73–91; Nolan A. Thaxton, "A Documentary Analysis of Competitive Track and Field for Women at Tuskegee Institute and Tennessee State University" (Thesis, Department of Physical Education, Springfield [Mass.] College, 1970); and news clippings from the *Chicago Defender,* Box 401, Claude Barnett Collection, Chicago Historical Society.

18. The following accounts are based on six oral-history interviews with women who competed at Tuskegee or Tennessee State University between the late 1930s and the early 1960s. Glenn interview; Glover interview; Davis interview; interviews by the author, Shirley Crowder Meadows (Atlanta, GA) December 15, 1991; Martha Hudson Pennyman (Griffin, GA) May 8, 1992; and Willye White (Chicago, IL), February 9, 1988. All the quotes that follow are from these interviews. Individual quotations will be cited only if the speaker is not clearly identifiable from the text.

19. Crowder competed but did not medal in the hurdles. Hudson won a gold medal in the 400-meter relay.

20. White won a silver medal in the long jump in 1956 and a second silver in the 400-meter relay in 1964.

21. Perry interview.

22. Sander L. Gilman, "Black Bodies, White Bodies: Toward an Iconography of Female Sexuality in Late Nineteenth-Century Art, Medicine and Literature," in Henry Louis Gates, Jr., ed., *"Race," Writing and Difference* (Chicago: University of Chicago Press, 1986), 223–61.

23. See John D'Emilio and Estelle Freedman, *Intimate Matters* (New York: Harper & Row, 1988), 87–93. Quote from Herbert G. Gutman, *The Black Family in Slavery and Freedom, 1750–1925* (New York: Pantheon Books, 1976), 536.

24. Gilman, "Black Bodies, White Bodies," 238.

25. Stereotypes about physical beauty and sexuality could be contradictory. Within the dominant white discourse, black women were represented as both unattractive sexual partners and wildly attractive, irresistible seducers of white and black men alike. Similarly, portrayals of the masculinized black woman might endow her body with a kind of virile sexual passion or with a muscular asexuality.

26. Phillip M. Hoose, *Necessities: Racial Barriers in American Sports* (New York: Random House, 1989), 4.

27. This myth had different implications for images of black men and women. While the notion of "natural," "virile" athleticism supported an image of the black man as a supermasculine, sexual, brawny, "stud" or "buck" figure, thus affirming the masculinity (if not the humanity) of black men, the ideology had the reverse effect for women. Notions of the "mannish," "primitive" black female athlete pushed African-

American women even further outside the parameters of femininity as defined by the dominant culture.

28. Since neither critics nor supporters of women's track and field commented publicly on these omissions, explanations are necessarily based on inference.

29. *Detroit News*, July 31, 1962, sec. B, p. 1, in Claude A. Barnett Collection, Box 402, Chicago Historical Society.

30. Edwin B. Henderson, "Sports Comments," *Atlanta Daily World*, August 4, 1948.

31. *Ebony* 10 (June 1955): 28, 32.

32. A single, inviolable image of respectability held white observers at a distance, creating a kind of buffer zone between public settings and less public African-American environments that may have allowed more personalized, flexible styles of femininity. Darlene Clark Hine makes a similar argument about black women's clubs in the Midwest during the early twentieth century. She argues that African-American women developed a "culture of dissemblance" that presented a public face of unimpeachable propriety and apparent openness to counter negative stereotypes, while they hid their inner pain and pleasures under a "self-imposed invisibility" to gain psychic space and freedom from public scrutiny. "Rape and the Inner Lives of Black Women in the Middle West: Preliminary Thoughts on the Culture of Dissemblance," *Signs* 14 (Summer 1989): 912–20.

33. *Time* 76 (September 19, 1960): 74–5.

34. Guttmann, *Women's Sports*, 204.

35. Patricia Hill Collins has argued that when white culture has accepted African Americans it has often been as "pets" rather than as equals, merely changing the terms of oppression from absolute subordination to subordination with affection. Collins, "Toward a Sexual Politics of Black Womanhood," guest lecture at the University of Minnesota (March 31, 1989). See also Collins, *Black Feminist Thought*, 74.

References

Andolsen, Barbara Hilkert. *"Daughters of Jefferson, Daughters of Bootblacks": Racism and American Feminism*. Macon, GA: Mercer University Press, 1986.

Ashe, Arthur R. *A Hard Road to Glory: A History of the African-American Athlete, 1919–1945*. New York: Warner Books, 1988.

Baker, William J. *Jesse Owens: An American Life* (New York: Free Press, 1986).

Brady, Marilyn Dell. "Organizing Afro-American Girls' Clubs in Kansas in the 1920s." *Frontiers* 9, no. 2 (1987): 69–72.

Carby, Hazel V. *Reconstructing Womanhood: The Emergence of the Afro-American Woman Novelist*. New York: Oxford University Press, 1987.

Clemons, Fatino Marie. "A History of the Women's Varsity Track Team at Tennessee State University." Master's thesis, April 1975, Graduate Research Number 1766, TSU Archives.

Collins, Patricia Hill. *Black Feminist Thought*. Boston: Unwin Hyman, 1990.

———. "Learning from the Outsider Within." *Social Problems* 33 (December 1986): 514–32.

———. "Toward a Sexual Politics of Black Womanhood." Guest lecture at the University of Minnesota, March 31, 1989.

D'Emilio, John, and Estelle Freedman. *Intimate Matters*. New York: Harper & Row, 1988.

Davis, Michael D. *Black American Women in Olympic Track and Field*. Jefferson, NC: McFarland: 1992.

Dill, Bonnie Thornton. "The Dialectics of Black Womanhood." *Signs* 4 (Spring 1979): 543–5.

Giddings, Paula. *When and Where I Enter*. New York: William Morrow, 1984.

Gilman, Sander L. "Black Bodies, White Bodies: Toward an Iconography of Female Sexuality in Late Nineteenth-Century Art, Medicine and Literature," in Henry Louis Gates, Jr., ed., *"Race," Writing and Difference* (Chicago: University of Chicago Press, 1986), 223–61.

Gutman, Herbert G. *The Black Family in Slavery and Freedom, 1750–1925*. New York: Pantheon Books, 1976.

Guttmann, Allen. *Women's Sports: A History*. New York: Columbia University Press, 1991.

Henderson, Edwin. *The Negro in Sports,* rev. ed. Washington, DC: Associated Publishers, 1939.

Hine, Darlene Clark. "Rape and the Inner Lives of Black Women in the Middle West: Preliminary Thoughts on the Culture of Dissemblance." *Signs* 14 (Summer 1989): 912–20.

Hoose, Phillip M. *Necessities: Racial Barriers in American Sports*. New York: Random House, 1989.

King, Deborah K. "Multiple Jeopardy, Multiple Consciousness." *Signs* 14 (Autumn 1988): 43–72.

Schaap, Richard. *An Illustrated History of the Olympics,* 2nd ed. New York: Alfred A. Knopf, 1967.

Thaxton, Nolan A. "A Documentary Analysis of Competitive Track and Field for Women at Tuskegee Institute and Tennessee State University." Thesis, Department of Physical Education, Springfield [Mass.] College, 1970.

Williams, Linda D. "An Analysis of American Sportswomen in Two Negro Newspapers: The *Pittsburgh Courier,* 1924–1948 and the *Chicago Defender,* 1932–1948." Ph. D. diss., Ohio State University, 1987.

ONE-LEGGED LEOTARDS AND
TIGER-STRIPED FINGERNAILS

Florence Griffith-Joyner and the Representation of Black Femininity

Lindsay Parks Pieper | 2015

During the 1984 Los Angeles Olympics, U.S. runner Florence Griffith (who later added the Joyner) burst onto the international scene. The relatively unknown sprinter earned two silver medals; however, the fame Griffith garnered actually stemmed more from her colorful, four-inch long fingernails and clothing decisions than her speedy feats. Four years later in the Seoul Olympics, the superstar, now Griffith-Joyner through marriage and nicknamed "Flo-Jo" by the media, again dazzled crowds, setting two world records. She also impressed with colorful, self-designed, one-legged bodysuits, and star-spangled fingernails.

As Christine Brennan of the *Washington Post* recounted, "With her long, painted fingernails, hand-made bodysuits, flowing hair and deep, mellow voice, Griffith-Joyner doesn't even need gold medals to make it big."[1] From her clothing choices to her fingernail colors, Flo-Jo's appearance fostered more public awe and scrutiny than did her athletic accomplishments.

This piece examines Griffith-Joyner's rise to fame and representation in popular culture. As Flo-Jo both embodied and challenged conventional gender and racial norms, she offers a unique opportunity to interrogate the mediation of black femininity in the United States. The predominantly white, male cultural gatekeepers regularly discussed Flo-Jo's nails, clothing, and sexuality, consequently deploying long-standing racial ideologies predicated on social signifiers of difference. Such mediation in popular culture consequently reaffirmed normative notions of race, gender, and sexuality. A case study of Flo-Jo's fame and legacy provides insight into the cultural understandings of female athletes of color.

Black Femininity in Sport

Due to the historical prohibitions of middle-class feminine norms in sport, few white women competed in track and field in the first half of the twentieth century. Any woman who did opt to participate in track and field frequently faced stigmatization as an "amazon" or a "muscle moll." As historian Susan Cahn explains, "black women stepped into an arena largely abandoned by middle-class white women . . . and began to blaze a remarkable trail of national and international excellence."[2] While black women such as Louise Stokes, Alice Coachman, and Wilma Rudolph helped dismantle certain racial prejudices, black females' victories in track and field simultaneously reinforced stereotypes of black women as less feminine than white women.

While black athletes participated in sports unabashedly in the first half of the century, white athletes sought to moderate activities with overt feminine tendencies. The victorious figure of the black female runner thus consequently fused together gender and racial stereotypes. Within this raced and gendered context, Griffith-Joyner emerged in athletics.

Born in Los Angeles, California, Florence Griffith grew up in the infamous Jordan Downs Housing Project, a public housing apartment complex in the historically volatile Watts neighborhood. One of eleven children, she started racing competitively at age seven and simultaneously demonstrated an early inkling for fashion. A stylish nonconformist, Griffith was once allegedly forced to leave a shopping mall for wearing her pet boa constrictor as an accessory.[3] After running track in high school, she attended the California State University at Northridge and was coached by Bob Kersee, her future brother-in-law. Griffith later followed Coach Kersee to UCLA, where she earned a bachelor's degree in psychology.

After a successful college career, Griffith entered the international track and field scene. In the 1980 Olympic trials, Griffith qualified for the 100-meter race. Yet, much to her disappointment, the U.S. government decided to boycott the Moscow Games due to Cold War embroilments. However, as previously mentioned, when the Olympics returned to Los Angeles in 1984, she earned two silver medals—one in the 200-meter race and one in the 4x400-meter relay—and the international spotlight focused on her unprecedented four-inch-long fingernails.[4]

Two years later, her fame was again enhanced by dual reports of six-and-a-half inch fuchsia nails and a marriage to Olympic triple jumper Al Joyner. Through marriage, Griffith-Joyner became sister-in-law to Olympic heptathlete Jackie

Joyner-Kersee. Moreover, during the 1988 Olympic Trials in Indianapolis, Flo-Jo set the world record for the 100 meters at 10.49 seconds, while wearing a purple one-legger with blue bikini bottoms and fashioned with lightning bolts. She then proceeded to break the world record in the 200 meters in Seoul, this time donning a white fishnet two-legger and one-inch, bright orange nails with stripes.

As Phil Hersh of the *Chicago Tribune* noted, "the glamorpuss who once wore 4-inch, curved, tiger-striped fingernails simply broke world records as if they were going out of style."[5] Similar accounts reverberated around the country, all primarily focusing on various aspects of Griffith-Joyner's appearance.[6] Accordingly, the ways in which Griffith-Joyner's nails and clothing were interpreted in popular culture offers an opportunity to interrogate the production and reproduction of black femininity in and through sport.

The Mediation of Flo-Jo

Flo-Jo's nails and outfits inspired a variety of public responses, from admiration to disgust. In such reports, she was treated as an Olympic abnormality, through subtle signifiers of racial difference. The reinforcement of blackness as the cultural "other" was fostered through the mediation of Griffith-Joyner's nails and clothing choices.

In 1988, Frank Litsky of the *New York Times*, a white, middle-aged sportswriter, penned a piece entitled "A Sprinter's Form Overtakes Her Fashion."[7] In this article, Litsky told his readers to "start with the fingernails." He then described Flo-Jo's colorful extremities, recalling that in 1984 her nails were four inches long and she painted three of them red, white, and blue. The fourth, the writer noted, was painted gold, the color of the medal Griffith-Joyner hoped to win. Similarly, Hersh reported in 1988 that "her nails, trimmed to a couple of inches long [...], were orange with stripes Saturday and fuchsia Sunday."[8]

When covering Flo-Jo's rise to fame and her international domination, few reporters could resist mentioning her fingernails. Oftentimes, the art on her fingers outshone the medals around her neck. The constant reporting of Flo-Jo's nails provides a significant cultural moment where race and gender intersect. Although Griffith-Joyner presented conventional femininity through the maintenance of her appearance, she did so in a way that explicitly expressed blackness. Nails are not only a reflection of individual aesthetic choice, but also an important vehicle that illustrates race and gender.

According to women's studies scholar Miliann Kang, an individual's manicure preference demonstrates embodied gender and racial difference. According to King, "women's choices of nail styles and services reflect the social construction

of beauty, which is not based on natural or biological traits but upon socially conditioned tastes that are deeply entrenched in gender, race and class differences."[9] In other words, regardless of intention, French manicures and pastel colors signal white, middle-class, heteronormative beauty. Long, sculptured, airbrushed nails, on the other hand, are markers of blackness, sexual deviancy, and marginalized femininity. Writers highlighted Flo-Jo's fingernails as both a source of intrigue and revulsion, subtly emphasizing racial differences. Because she preferred long, colorful nails, the runner was depicted as abnormal, deviant, and different. While blackness was never explicitly mentioned in such accounts, the focus on her nails normalized whiteness.

For example, Paddy Calistro of the *Los Angeles Times* posited that "even at a more manageable length, the runner's flamboyant fingernails have been discussed almost as much as her flat feet."[10] Her word choice suggests white normativity. The postulation of a manageable length stems from white feminine beauty norms. So, too, does the utilization of "flamboyant" as a descriptor. As another example, Patricia McLaughlin of the *Chicago Tribune* called them "dragon-lady fingernails" and declared that "long red nails look both dangerous and incapacitating."[11] Because Griffith-Joyner did not keep her nails short and monochromatic, cultural commentators, such as Litksy, Calistro, and McLaughlin, marked her as non-white and thus non-normative and intimidating.

Further reinforcing racial and gender difference, journalists resoundingly focused on Griffith-Joyner's athletic attire. Again, such reports ranged from approval to repugnance. Notably, Flo-Jo received a disproportionate abundance of media coverage, most rooted in stereotypes of black female sexual promiscuity. All competitors raced in form-fitting, aerodynamic spandex; however, Griffith-Joyner was constructed as a sexual oddity in lingerie.

As *Sports Illustrated* reporter Kenny Moore tantalizingly recounted in 1988, "Griffith-Joyner's electric-plum bodysuit caressed her from neck to ankle. Over it she wore a turquoise bikini brief. Yet her left leg was bare; somehow it appeared more naked than any other bare limb in the race."[12]

The uniqueness of Flo-Jo's self-designed adornments allowed the media to focus on her body and her sexuality. A majority of popular articles referenced her designs as bodysuits, eliciting images of scantily clad athletes, situated for erotic voyeurism. For example, Hersh described her lime green bodysuit as "one leg stretching to the ankle and the other cut off at the crotch."[13] More overtly sexual, after describing Griffith-Joyner's "shocking pink one-legger" in a different article, Hersh noted that her race was "run in a negligee—oops, negligible headwind."[14]

As historian Evelynn M. Hammonds explains, black women's sexuality has

been constructed in a binary opposition to that of white women's, rendered simultaneously invisible and hyper-visible.[15] Regarding the latter category, scholars Marilyn Yarbrough and Crystal Bennett note that the stereotype of the Jezebel exists in the white imagination as the alluring seductress with an insatiable sexual appetite.[16] Such stereotypes, as conveyed on the body of Griffith-Joyner, support the sexual exploitation and subjugation of black women, consequently reinforcing white privilege. The erotic undertones of the mediation surrounding Flo-Jo not only promoted a racialized binary of sexual difference, but implied a promiscuity rooted in blackness.

After the 1988 Olympics, Flo-Jo retired from competition. Although she attempted a comeback for the 1996 Atlanta Olympics, tendonitis in her right leg ended her aspirations. Sadly, two years later, on September 21, 1998, Griffith-Joyner died in her sleep at the age of 38. The cause of death was suffocation during an epileptic seizure. Despite her premature death, and the speculation that performance enhancing substances played a role, Flo-Jo's legacy remains significant.

By analyzing the interconnected nature of race, gender, and sexuality as expressed through the mediation of Florence Griffith-Joyner, one can see how popular lore represented her as the "other," contrasting her nails, outfits, and sexuality against conventional notions of white hetero-femininity. The media's fixation on her as different reaffirmed racial distinctions and maintained racialized order in sport.

Notes

1. Christine Brennan, "The Relative Power of Griffith Joyner," *Washington Post*, September 16, 1988, B3.

2. Susan K. Cahn, *Coming on Strong: Gender and Sexuality in Twentieth-Century Women's Sport* (Cambridge: Harvard University Press, 1994), 112.

3. Jere Longman, "Florence Griffith Joyner, 38, Champion Sprinter, Is Dead," *New York Times*, September 22, 1988, http://www.nytimes.com/1998/09/22/sports/florence-griffith-joyner-38-champion-sprinter-is-dead.html.

4. Kris Schwartz, "FloJo Made Speed Fashionable," *ESPN Classic SportsCentury Biography*, http://www.espn.com/classic/biography/s/Griffith_Joyner_Florence.html.

5. Phil Hersh, "Griffith-Joyner Nails 100-Meter Dash Final," *Chicago Tribune*, July 18, 1988, http://articles.chicagotribune.com/1988-07-18/sports/8801150917_1_one-legger-florence-griffith-joyner-stripes.

6. For examples, see: Linda Villarosa, "Speed Queen," *Runner's World* 23, no. 10 (1988), 79; Susan Reed, "Flashy Florence Griffith Joyner Will Be One to Watch—and Clock—in the Women's Sprints," *People Weekly* 30 (August 29, 1988): 60–63; Amby

Burfoot, "Flash Prance," *Runner's World* 23, no. 12 (1988), 48; and Kenny Moore, "Very Fancy, Very Fast," *Sports Illustrated* 69, no. 12 (1988): 158–164.

7. Frank Litsky, "A Sprinter's Form Overtakes Her Fashion," *New York Times*, July 18, 1988, http://www.nytimes.com/1988/07/18/sports/sprinter-s-form-overtakes-her-fashion.html.

8. Phil Hersh, "Fast Track: A Sprinter Finds That Sudden Fame Is Just Her Style," *Chicago Tribune*, July 22, 1988, http://articles.chicagotribune.com/1988-07-22/features/8801160748_1_one-legger-body-suit-lipstick.

9. Miliann Kang, *The Managed Hand: Race, Gender, and the Body in Beauty Service Work* (Berkeley: University of California Press, 2010), 98.

10. Paddy Calistro, "Strength, Not Length: Interest in Healthy Nails Grows, and So Do Sales for Treatment Products," *Los Angeles Times*, October 16, 1988, http://articles.latimes.com/1988-10-16/magazine/tm-6376_1_treatment-products.

11. Patricia McLaughlin, "Good Riddance: Fashion 'Innovations' that Deserve a Swift Burial," *Chicago Tribune*, November 27, 1988, http://articles.chicagotribune.com/1988-11-27/features/8802200356_1_pouf-fur-pieces-crinolines.

12. Moore, "Very Fancy, Very Fast," 158.

13. Hersh, "Griffith-Joyner Nails 100-Meter Dash Final."

14. Phil Hersh, "Griffith Sets U.S. Record in 200 in Style," *Chicago Tribune*, July 24, 1988, http://articles.chicagotribune.com/1988-07-24/sports/8801170454_1_world-class-ac-florence-griffith-joyner-meters.

15. Evelyn M. Hammonds, "Toward a Genealogy of Black Female Sexuality: The Problematic of Silence," in *Feminist Genealogies, Colonial Legacies, Democratic Futures*, ed. M. Jacqui Alexander and Chandra Talpade Mohanty (New York: Routledge, 1997), 170–182.

16. Marilyn Yarbrough and Crystal Bennett, "Cassandra and the 'Sistahs': The Peculiar Treatment of African American Women in the Myth of Women," *Journal of Gender, Race and Justice* 3, no. 2 (2000): 634–655.

FINISHING LAST *Girls of Color and*

School Sports Opportunities

National Women's Law Center and Poverty and Race Research Action Council | 2015

Originally published as *Finishing Last: Girls of Color and School Sports Opportunities* (Washington, DC: National Women's Law Center, 2015). Bracketed insertions are part of the original publication.

Introduction and Executive Summary

Our nation's schools remain highly segregated along racial and economic lines and schools with high concentrations of minority and low-income students generally have fewer resources for academic and extracurricular activities.[1] Opportunities to play sports, which provide valuable benefits, are diminished for all students at these schools, but are particularly limited for girls. In fact, when it comes to girls of color and chances to play school sports,[2] the reality is bleak: they receive far fewer opportunities—defined as spots on teams—than white girls, white boys, and boys of color.[3] It is an inequality that has gone largely undocumented due to limited research. This report uses an innovative research strategy—identifying high schools where the student body is either 90 percent or more white or 10 percent or less white—to show the lack of sports opportunities on the basis of race and gender.

While heavily minority schools[4] typically have fewer resources[5] and provide fewer spots on teams compared to heavily white schools, they also allocate those fewer spots unequally such that girls of color get less than their fair share. So even though girls overall still receive fewer opportunities to play sports than boys, girls in heavily minority schools are especially shortchanged. In fact, nationwide, 40 percent of heavily minority schools have large "female opportunity gaps," compared to only 16 percent of heavily white schools (see box [page 292] for explanation of Title IX requirements and what constitutes a large female opportunity gap).

These national inequities persist at the state level. Thirteen states have a substantial number (20 or more) of both heavily minority and heavily white high schools, which allows for a comparison of the relative opportunities offered to girls and boys in these schools. These thirteen states are Alabama, Illinois,

Methodological Note

Data on sports opportunities in high schools are National Women's Law Center calculations based on the U.S. Department of Education's Civil Rights Data Collection (CRDC) for school year 2011–2012. The CRDC data cover all of the nation's public school students.6

DEFINITIONS

Girls/Boys of Color: Students who do not fall into the racial category of White. The CRDC data use seven racial categories: American Indian/Alaskan Native, Asian, Hispanic/Latino of any race, Black/African American, White, Native Hawaiian and other Pacific Islander, and two or more races. The CRDC data treat Hispanic as a racial category.

High Schools: Schools are included in NWLC's calculations if they have a 10th grade, are co-ed, and provide interscholastic athletic opportunities.

Heavily White/Minority Schools: For this analysis, schools are defined as "heavily white" if 90 percent or more of enrolled students are white and "heavily minority" if 10 percent or less of enrolled students are white.[7]

Louisiana, Massachusetts, Michigan, Mississippi, North Carolina, New Jersey, New York, Ohio, Pennsylvania, Tennessee, and Texas. In all of them, a greater share of heavily minority high schools have large female opportunity gaps as compared to heavily white schools.

Focusing on the participation opportunities that schools choose to provide to girls is critical because the history of Title IX has shown that "If you build it, they will come." While schools sometimes claim that girls are not interested in sports to justify their providing more opportunities to boys, courts have consistently rejected such stereotypes as contrary to the purpose of Title IX.[8]

The systematic failure to treat girls, and especially girls of color, in an equitable manner deprives them of the many positive health, academic, and employment outcomes associated with playing sports. It is vitally important—and legally required by federal civil rights laws prohibiting sex (Title IX) and race (Title VI) discrimination[9]—that states and school districts provide students with equal opportunities to play sports in school. This report provides recommendations to help decision makers at the federal, state, and local levels fulfill their obligations to do so.

Title IX Requirements

Showing that the percentage of spots on teams allocated to girls is roughly equal to the percentage of students who are girls is one way that a school can demonstrate compliance with Title IX. The term "female opportunity gap" used in this report refers to the percentage point gap between the percentage of spots on teams allocated to girls and the percentage of students who are girls. For example, if at School A, girls are 45 percent of all students but only get 35 percent of all the spots on teams, then School A has a female opportunity gap of 10 percentage points. While there is no set gap that constitutes a violation of Title IX, gaps of 10 percentage points or more indicate that schools are likely not complying with the law.

See Office for Civil Rights, U.S. Dep't of Educ., *Clarification of Intercollegiate Athletics Policy Guidance: The Three-Part Test 4–5* (Jan. 16, 1996).

KEY FINDINGS

- 42 percent of our nation's public high schools are 90 percent or more white, or over 90 percent minority.
- 40 percent of heavily minority high schools have large female opportunity gaps compared to 16 percent of heavily white schools.
- In 8 of the 13 states identified in this report, the share of heavily minority schools with large female opportunity gaps is more than double the share of heavily white schools with large gaps.

Girls of Color Are Not Receiving Equal Opportunities to Play School Sports

Girls of color are doubly disadvantaged when it comes to opportunities to play sports in high school. First, over 40 percent of our nation's public high schools are either heavily white or heavily minority,[10] and there are far fewer opportunities to play sports at heavily minority schools than at heavily white high schools.[11] At the typical heavily minority high school, for every 100 students there are just 25 spots on sports teams. By contrast, at the typical heavily white high school, for every 100 students there are 58 spots.[12]

Second, while gender disparities are pervasive across schools,[13] they are worse at heavily minority schools. At the typical heavily white high school, girls have

only 82 percent of the opportunities to play sports that boys have: for every 100 female students there are 51 spots on teams, and for every 100 male students there are 62 spots on teams.[14] But at the typical heavily minority high school, girls have only 67 percent of the opportunities to play sports that boys have: for every 100 female students there are just 20 spots on sports teams, and for every 100 male students there are 30 spots.[15]

These data show that girls of color are doubly disadvantaged because heavily minority schools have fewer overall athletic opportunities and fail to distribute those limited opportunities equitably between boys and girls. As a result, girls at heavily minority high schools have:

- Only 39 percent of the opportunities to play sports as girls at heavily white schools do.
- Only 67 percent of the opportunities to play sports as boys at heavily minority schools do.
- Only 32 percent of the opportunities to play sports as boys at heavily white schools do.[16]

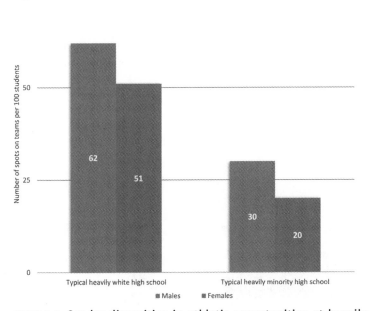

FIGURE 1 **Gender disparities in athletic opportunities at heavily white and heavily minority high schools** *Source:* NWLC calculations based on CRDC 2011–2012 data. Heavily white high schools have white enrollment of 90 percent or more. Heavily minority high schools have white enrollment of 10 percent or less. CRDC data treat Hispanic as a racial category.

Looking at the data another way, heavily minority schools are more than twice as likely to have large female opportunity gaps—defined as a gap of 10 percentage points or more between the percentage of students who are female and the percentage of athletic spots for girls[17]—which is a strong indicator of lack of compliance with Title IX. Forty percent of heavily minority high schools have large female opportunity gaps compared to 16 percent of heavily white schools.

(At the typical school with a large female opportunity gap of 10 percentage points or more, girls lose 91 opportunities to play sports. See box [page 295].) This means that girls in heavily minority schools receive far less than their fair share of the already limited opportunities to play sports.

This troubling national picture is reflected in the thirteen states where there are a substantial number of both heavily minority and heavily white schools.[18] In each of these states, the share of heavily minority schools with large female opportunity gaps is higher—more than double in 8 of 13 states—than the share of heavily white schools with large female opportunity gaps.[19] Some mid-Atlantic states show the largest disparities between opportunities for girls of color and white girls. In New York, for example, 40.1 percent of heavily minority high schools have large female opportunity gaps, which is almost nine times larger than the share of heavily white high schools with such gaps (4.5 percent). In New Jersey, 47.4 percent of heavily minority high schools have large female opportunity gaps—more than seven times larger than the share of heavily white high schools with such gaps (6.5 percent). The situation is particularly bad for girls

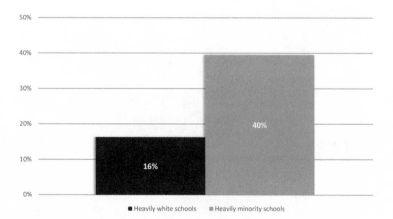

FIGURE 2 **Percentage of high schools with large female opportunity gaps in sports, by racial composition of school** *Source:* NWLC calculations based on CRDC 2011–2012 data. Heavily white high schools have white enrollment of 90 percent or more. Heavily minority high schools have white enrollment of 10 percent or less. CRDC data treat Hispanic as a racial category.

Large Female Opportunity Gaps = Many Lost Chances to Play Sports

At the typical school with a large female opportunity gap (gap of ten percentage points or more), girls lose 91 chances to play sports. At such a school, the typical number of boys' spots on teams is 185–twice the number of girls' spots (92). The typical enrollment for boys is 407–almost the same as girls' enrollment (402). For girls to have proportionally equal opportunities, the typical school with a large female opportunity gap would have to add 91 spots on teams for girls, bringing the total number of spots to 183. If the school did so, boys and girls would both have 46 spots on teams per 100 students (as compared to the current situation, in which boys have 46 spots on teams per 100 male students and girls have 23 spots per 100 female students).

of color in Alabama, Mississippi, and North Carolina, where about 80 percent of heavily minority schools have large female opportunity gaps.

School-Sponsored Sports Opportunities Are Particularly Important for Girls of Color, yet Schools Are Failing to Provide Them with Equal Chances to Reap the Many Benefits of Participation

Girls of color are less likely than white girls to participate in sports outside of school,[20] making school-sponsored opportunities that much more important.[21] By not providing them with equal opportunities to play sports, schools are denying girls the health, academic, and economic benefits that accompany participation.[22]

There are long-term health benefits of sports participation. Playing sports decreases a young woman's chance of developing heart disease, osteoporosis, breast cancer, and other health related problems.[23] Female student athletes also exhibit more responsible social behavior than their non-athletic peers. For example, studies have found that high school athletes are 25 percent less likely to smoke[24] and less likely to use cocaine (3.1 percent versus 7.2 percent) or psychedelic drugs (9.8 percent versus 18.1 percent).[25] And female student athletes have much lower rates of both high-risk sexual behavior and pregnancy compared to their peers who are not athletes.[26] A 1998 report found that high school female athletes were more likely to use a condom than non-athletes (53 percent versus 41 percent), and were less than half as likely to get pregnant as female non-athletes (5 percent versus 11 percent).[27] In addition, girls who play sports report better body image

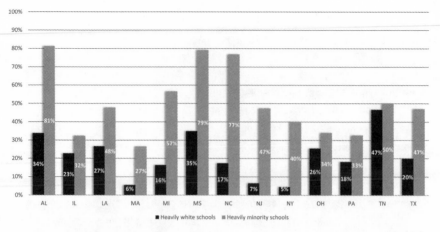

FIGURE 3 **Percentage of high schools with large female opportunity gaps in sports, by racial composition of school** *Source*: NWLC calculations using CRDC 2011–2012 data. Heavily white high schools have white enrollment of 90 percent or more. Heavily minority high schools have white enrollment of 10 percent or less. States have at least 20 schools in both categories. "Large female opportunity gaps" are defined as Title IX gaps of 10 percentage points or greater. CRDC data treat Hispanic as a racial category.

and an overall higher quality of life, compared to girls who don't play sports.[28] According to a 2008 report, only 35 percent of female non-athletes reported having high body esteem, compared to 43 percent of girls moderately involved in sports and 54 percent of girls highly involved in sports.[29]

With respect to obesity, research shows that women who were athletes while young had a seven percent lower risk of obesity 20 to 25 years later compared to those who were not. The study notes that "no other public health program can claim similar success."[30] This is significant because even though obesity rates have stabilized over the past decade, they remain extremely high for most children of color.[31] In 2013, 16.7 percent of African American and 11.4 percent of Hispanic high school girls were obese compared to 9.7 percent of white girls and 2.1 percent of Asian American girls.[32] High school boys' obesity rates were generally higher than those of their female counterparts, except among African American youth: 16.7 percent of African American girls were obese compared to 14.8 percent of African American boys.[33] These high obesity rates have dire health consequences, including increased risk for cardiovascular disease and diabetes, as well as a negative impact on self-esteem, relationships with peers, performance in school, and even earnings.[34]

While increasing physical activity is one of the keys to combating obesity,[35] girls of color not only have unequal opportunities in terms of school-based

sports, but also face obstacles to being physically active in their communities outside of school. So it is not surprising that girls of color are less physically active than their white peers. Over one-quarter of African American girls, one-fifth of Hispanic girls, and nearly one-fifth of Asian American girls report not being physically active for at least 60 minutes in the past week, while less than one-sixth of white girls do.[36]

Many neighborhoods where girls of color are disproportionately concentrated have higher rates of traffic, crime, and other factors that limit opportunities for girls to take part in physical activities outdoors.[37] Fewer parks, trails, bike paths, and recreational facilities also contribute to decreased physical activity.[38] Other structural issues, such as inadequate housing and environmental factors,[39] can also lead to increased instances of asthma and obesity that negatively affect the ability of girls of color to take advantage of any physical activity opportunities.

Providing school-based opportunities for girls of color to play sports is there-fore critical. In addition to the health benefits, playing sports leads to better aca-demic and employment outcomes. Although often overlooked, girls—particularly girls of color—drop out at high rates. In 2010, 22 percent of girls failed to graduate on time with a diploma, and the numbers were worse for girls of color: 49 percent of American Indian female students, 34 percent of black female students, and 29 percent of Hispanic female students failed to graduate on time.[40] Playing sports increases the likelihood that they will graduate from high school, have higher grades, and score higher on standardized tests.[41] And girls of color who play on sports teams experience higher levels of self-esteem[42] and are more likely to be involved in other extracurricular activities than minority girls who do not play sports.[43] Not to mention that the availability of an athletic scholarship can dramatically increase a young woman's ability to attend college and—if she gets multiple scholarship offers—her ability to choose from a wider range of schools.

Beyond helping students stay engaged in school, playing sports also has a pos-itive effect on employment outcomes. A study using state-level data concluded that an increase in female sports participation leads to an increase in women's labor force participation down the road and greater female participation in pre-viously male-dominated occupations, particularly high-skill, high-wage ones.[44] That same study showed that being a high school athlete was associated with 11 to 14 percent higher wages for women, even when controlling for demographic factors (e.g., age, race), family background (e.g., parental education attainment, family poverty status) and school characteristics (e.g., dropout and attendance rates).[45] In addition, more than four out of five executive businesswomen played sports growing up, and the vast majority reported that the lessons they learned on the playing field contributed to their success in business.[46]

The Disparate Sports Opportunities Provided to Girls at Heavily Minority versus Heavily White Schools Raise Questions under the Civil Rights Laws Prohibiting Gender and Race Discrimination

More than 40 years after the passage of Title IX of the Education Amendments of 1972, schools across the country continue to provide girls with fewer opportunities to play sports when compared to boys. The typical high school provides girls with 75 percent of the opportunities provided to boys.[47] And more than 50 years after the passage of Title VI of the Civil Rights Act of 1964, over 40 percent of our nation's public high schools are still either heavily white or heavily minority due to a variety of factors.[48] Heavily minority schools tend to have fewer resources overall and provide fewer opportunities to play sports to their students, particularly girls. These disparities between heavily minority and heavily white schools touch on both of these civil rights laws.

Although Title IX has been credited with dramatically increasing female athletic opportunities, it has also been criticized for not benefitting girls of color as much as white girls.[49] The available data, coupled with that presented in this report, support the need to increase opportunities for girls of color in particular. For example, according to a 2008 nationwide survey of 2,185 students in grades 3–12,[50] girls of color are less likely to be athletes than white girls.[51] Specifically, 36 percent of African American girls, 36 percent of Hispanic girls, and 47 percent of Asian American girls were non-athletes, compared to 24 percent of Caucasian girls.

The differences in girls' sports opportunities between heavily minority and heavily white high schools are borne out in the underrepresentation of women of color in college athletics. Women of color make up 25 percent of female college students, but only 15 percent of female college athletes.[52] By contrast, white women are 69 percent of the female student body and 77 percent of female college athletes; and men of color make up 22 percent of male college students and 22 percent of male college athletes.[53] In addition, black women in particular are concentrated in two sports: Nine out of ten participate in basketball or track and field.[54] This translates into fewer opportunities for athletic scholarships, especially since many colleges have added opportunities for women to play sports like volleyball, crew, and soccer.[55]

While Title IX and Title VI provide protection from overlapping race and sex discrimination, the law has had trouble handling such claims of "intersectionality."[56] Courts have tended to break these types of claims into separate race and sex components,[57] a practice that fails to account for and minimizes the unique harms and challenges that girls of color face.[58]

States and school districts, however, through their decisions about how to distribute resources to local schools, are in a prime position to address the unique factors that lead to girls of color receiving the fewest sports opportunities. The Department of Education's Office for Civil Rights, which enforces both Title IX and Title VI, recently issued guidance reminding states and school districts of their legal obligation under Title VI "to provide students with equal access to [educational] resources without regard to race, color, or national origin," and specifically addressed the issue of cross-district resource disparities. The guidance strongly encourages states and school districts to "take proactive steps to ensure that the educational resources they provide are distributed in a manner that does not discriminate against students on the basis of race, color, or national origin."[59] Because educational resources include extracurricular programs such as sports, the guidance supports increasing the quantity and quality of sports programs for students in heavily minority schools. States and school districts must further focus on girls in these intensely segregated and often under-resourced communities, analyzing their participation rates and adding opportunities as needed to comply with Title IX.

Policymakers and Communities Must Increase Their Efforts to Ensure That Girls of Color Receive Equal Opportunities to Secure the Advantages Associated with Playing Sports

There are a number of steps that federal, state, and local policymakers and communities should take to increase opportunities for girls of color to play sports and gain the benefits that accompany participation. The following list of recommendations—including expanding racially and economically integrated educational opportunities, stepping up enforcement of Title IX and Title VI, increasing data transparency, and addressing resource inequities facing communities of color—would help advance the ball.

FEDERAL POLICYMAKERS

- The Department of Education should investigate the states identified in this report (along with the schools in those states) under Title VI and Title IX to require them to provide equal athletic opportunities on the basis of race and gender.[60]
- The Department of Education should modify its Civil Rights Data Collection (CRDC) so that athletic participation data is collected not just by gender, but also by gender broken down by race/ethnicity, consistent with other key parts of the CRDC.
- Congress should pass the High School Data Transparency Act, which

would require schools to make publicly available information on the number of female and male students and athletes, broken down by race/ethnicity, as well as the expenditures by sports teams.

- The Department of Education should increase incentives for states to develop interdistrict school integration programs that will expand opportunities for all children to attend integrated schools (for example, by expanding the Magnet Schools Assistance Program and including diversity priorities in the Department's competitive grants).[61]

STATE POLICYMAKERS

- States should take steps to provide equitable educational resources, including athletic opportunities, to all school districts in their state and ensure that differences in resources among districts do not result in discrimination on the basis of race, consistent with their obligations under Title VI.[62]
- States should fund magnet schools and other interdistrict programs to expand racially and economically integrated educational opportunities for more children.
- States should monitor their school districts to ensure that they are providing equal athletic opportunities to boys and girls, consistent with their obligations under Title IX.
- States should assess barriers to girls' sports participation, particularly in racially isolated schools, by analyzing girls' participation rates and working with schools to add new teams or spots on teams as needed.
- States should require schools to collect and make publicly available data on the sports opportunities and resources provided to boys and girls, broken down by race/ethnicity.[63]
- States should assess the availability of parks, recreation centers, and other athletics resources for their various communities and take steps to increase access where opportunities to be physically active are lacking—for example, through support for shared use initiatives that allow community access to school facilities.

LOCAL GOVERNMENTS AND COMMUNITIES

- Local governments should use funds from the federal Community Development Block Grant program to improve recreational facilities, parks, and play equipment,[64] particularly in low-income, racially isolated neighborhoods.
- Local governments in low-income and minority communities should

review and change zoning laws to address infrastructure improvements and create areas that facilitate physical activity.[65]

- Local governments should institute policies to incentivize the development of parks, recreation facilities, or sidewalks and trails, such as allowing denser development in exchange for land set aside for public parks.[66]

- Communities with heavily minority high schools should partner with community-based and legal services organizations to secure more funding for physical activity resources and sports opportunities in school (for example, if a recreational facility is built in a heavily white area while a heavily minority community has significantly fewer recreational facilities, a Title VI challenge could be brought).[67]

- Communities should challenge the lack of access to public parks due to discriminatory siting of parklands or recreational facilities under the public trust doctrine—a common law doctrine requiring public entities owning and operating public parks to ensure equal access.[68]

- Communities should press local governments for improved designs and management of the built environment—including implementation of safety and violence prevention measures—to help increase physical activity in neighborhoods and parks.[69]

- Communities and local governments should enlist private sector support to strengthen youth sports leagues and similar activities for girls, to create a stronger youth pipeline for high school sports participation.[70]

- Communities should pool resources for the purpose of sharing the cost of sports equipment among all participants[71] and providing community-financed transportation to and from sports facilities.[72]

- To counteract barriers to participation such as obesity, communities should structure recreational-level practices and competitions in a manner that leads adolescents to progressively develop their skills and improve their fitness level.[73]

SCHOOL DISTRICTS

- School districts should evaluate the athletic opportunities they provide to students and ensure that they are not discriminating on the basis of race or gender or both.

- School districts should survey their female students, especially girls of color who are still not receiving their fair share of opportunities, to find out what sports they are interested in playing.

- School districts should pay special attention to the impact of discipline on girls' participation in physical activity and sports. The Department

of Education has found a significant disparity in disciplinary action taken against minority girls (particularly African American girls) versus white girls, which can include barring participation in school-sponsored sports events.[74]

- To take advantage of the importance of role models in sports participation,[75] schools should explore ways to expand parental involvement in girls' sports activities[76] and increase the visibility of older female athletes from the community who can provide training and guidance.[77]

- Schools should partner with community-based nonprofit organizations to introduce girls to various sports and teach core skills outside of school that they can apply to school sports.[78]

- Schools, through concerted community outreach, should create a high profile for physical activity and ensure recognition of physical activity, sports participation, and achievement.[79]

- Schools should ensure that students receive 150 minutes of physical activity per week during physical education class, since research indicates that the opportunity to participate in physically active sports increases a child's desire to play sports, which in turn affects future sports participation and overall rates of physical activity.[80]

- All schools receiving federal funding for school meals should fulfill their obligation to create and utilize school wellness policies and wellness policy councils, which should establish aspirational goals for and track girls' sports participation.[81]

- Schools should enter into joint use agreements with community organizations to provide additional space for physical activity, especially in communities where recreational facilities and parks are less common.[82]

Conclusion

Girls of color are finishing last when it comes to opportunities to play sports in school and missing out on the lifelong benefits that accompany athletic participation. While the playing field is far from level for girls in general, it is particularly uneven for girls in heavily minority schools. Tackling the problem will require policymakers at all levels—federal, state, and local—and communities to work together to increase opportunities for girls of color to play sports and be physically active. Doing so is not only required by law, but is also a critical investment in their future.

Notes

1. *See generally* GARY ORFIELD ET AL., THE CIVIL RIGHTS PROJECT, E PLURIBUS . . . SEPARATION: DEEPENING DOUBLE SEGREGATION FOR MORE STUDENTS (2012), *available at* http://civilrightsproject.ucla.edu/research/k-12-education /integration-and-diversity/mlk-national/e-pluribus...separation-deepening-double -segregation-for-more-students.

2. "Sports" refers to interscholastic sports. Office for Civil Rights, 2011–12 *Civil Rights Data Collection Questions and Answers*, U.S. DEP'T OF EDUC., http://www2.ed.gov /about/offices/list/ocr/docs/crdc-2011–12-factsheet.html (last visited Apr. 9, 2015).

3. Figures are relative to enrollment.

4. The UCLA Civil Rights Project refers to the increasing number of schools that have 90 percent or more minority enrollment as "intensely segregated schools." GARY ORFIELD ET AL., THE CIVIL RIGHTS PROJECT, BROWN AT 60: GREAT PROGRESS, A LONG RETREAT AND AN UNCERTAIN FUTURE 5 (2014), *available at* http:// civilrightsproject.ucla.edu/research/k-12-education/integration-and-diversity/brown -at-60-great-progress-a-long-retreat-and-an-uncertain-future/Brown-at-60-051814 .pdf. Based on Orfield's report, in the current report, the term "intensely segregated" is used interchangeably with the terms "heavily minority" and "racially isolated." For purposes of comparison this analysis applies the same 90 percent or more standard to schools which are 90 percent or more white or 10 percent or less white.

5. *See, e.g.*, ARY SPATIG-AMERIKANER, CTR. FOR AM. PROGRESS, UNEQUAL EDUCATION: FEDERAL LOOPHOLE ENABLES LOWER SPENDING ON STUDENTS OF COLOR (2012), *available at* https://cdn.americanprogress.org/wp-content/uploads /2012/08/UnequalEduation-1.pdf.

6. Data are from the CRDC flat file. All data in the CRDC are self-reported by school administrators. Single-sex schools are excluded from NWLC's calculations. For additional details, *see* Office for Civil Rights, *Civil Rights Data Collection (CRDC): 2011–12 CRDC*, U.S. DEP'T OF EDUC., http://www2.ed.gov/about/offices/list/ocr/data .html?src=rt/ (last updated Mar. 21, 2015). According to the CRDC FAQ, "The 2011–12 CRDC will collect data from a universe of all public schools and school districts, including juvenile justice facilities, charter schools, alternative schools, and schools serving students with disabilities."

7. Of the 6,703 schools, 4,633 are heavily white and 2,070 are heavily minority. Overall, they account for 42 percent of the 16,056 co-ed high schools that provide athletic opportunities. Twenty-nine percent of schools in the total sample are heavily white and 13 percent are heavily minority. *Id. See also* Office for Civil Rights, *CRDC FAQ*, U.S. DEP'T OF EDUC., http://ocrdata.ed.gov/FAQ (last visited Apr. 9, 2015).

8. *See* Cohen v. Brown Univ., 101 F.3d 155, 178–79 (1st Cir. 1996) ("To assert that Title IX permits institutions to provide fewer athletic participation opportunities for women than for men, based up on the premise that women are less interested in sports than are men, is . . . to ignore the fact that Title IX was enacted in order to remedy discrimination that results from stereotyped notions of women's interests and abilities."); *see also* Pederson v. La. State Univ., 213 F. 3d 858, 878–82 (5th Cir. 2000)

(noting that attitudes tying female interest in sports to stereotypes about femininity are archaic and discriminatory).

9. *See* Title IX of the Education Amendments of 1972, 20 U.S.C. §1681 (2012) (prohibiting sex discrimination in federally funded education programs and activities); Title VI of the Civil Rights Act of 1964, 42 U.S.C. § 2000d (2012) (prohibiting discrimination on the basis of race, color, and national origin in federally funded programs and activities).

10. In the CRDC data set, the most comprehensive data set of sports opportunities in U.S. public schools, data on sports participation are not available by race. Because of this shortcoming, racial composition of the student population is used to identify heavily white or heavily minority high schools.

11. The typical (median) high school has 614 students and 277 spots on sports teams. These figures translate into 45 athletic slots per 100 students. But focusing on the typical high school obscures important disparities. The typical mostly white high school has substantially fewer students (398) but not dramatically fewer spots on teams (229). These figures translate into 58 athletic slots per 100 students. At the typical mostly minority high school the situation is reversed: enrollment is higher (637 students) while participation is lower (160 spots on teams). These figures translate into just 25 athletic slots per 100 students. This means that the typical mostly minority high school has less than half (43 percent) of the athletic participation opportunities per 100 students that mostly white high schools have. In all cases, median enrollment and participation slots are calculated separately. Nat'l Women's Law Ctr. calculations based on Office for Civil Rights, *Civil Rights Data Collection (CRDC): 2011–12 CRDC, supra* note 6.

12. *See supra* note 11 for details on enrollment and athletic participation at these schools.

13. The typical (median) high school has 302 female students and 116 female spots on teams for girls. These figures translate into 38 spots on teams per 100 female students. By comparison the typical high school has 313 male students and 161 spots on teams for boys. These figures translate into 51 spots on teams per 100 male students. This means at the typical high school, girls are only receiving three-quarters of the participation opportunities that boys are, per hundred students. Nat'l Women's Law Ctr. calculations based on Office for Civil Rights, *Civil Rights Data Collection (CRDC): 2011–12 CRDC, supra* note 6. At the heavily white school the situation is more equitable (*see infra* note 14), while at the typical heavily minority high school it is worse (*see infra* note 15).

14. The typical (median) mostly white high school has 192 female students and 98 spots on teams for girls. These figures translate into 51 spots on teams per 100 female students. By comparison the typical mostly white high school has 202 male students and 125 spots on teams for boys. These figures translate into 62 spots on teams per 100 male students. This means at the typical mostly white high school, girls are only receiving 82 percent of the participation opportunities that boys are, per 100 students. Nat'l Women's Law Ctr. calculations based on Office for Civil Rights, *Civil Rights Data Collection (CRDC): 2011–12 CRDC, supra* note 6.

15. The typical (median) heavily minority high school has 318 female students and 65 spots on teams for girls. These figures translate into just 20 spots on teams per 100

female students. By comparison the typical heavily minority high school has 322 male students and 97 spots on teams for boys. These figures translate into 30 spots on teams per 100 male students. This means at the typical heavily minority high school, girls are only receiving two-thirds of the athletic participation spots that boys are, per 100 students. Nat'l Women's Law Ctr. calculations based on Office for Civil Rights, *Civil Rights Data Collection (CRDC): 2011–12 CRDC, supra* note 6.

16. *See supra* notes 14 and 15 for details on enrollment and athletic participation at these schools. Figures compare spots on sports teams per 100 students. Boys at the typical heavily minority high school receive just under half (48 percent) of the athletic participation opportunities that boys at the typical heavily white high school do (30 spots on teams per 100 students, compared to 62 spots on teams per 100 students).

17. *See* text box, *supra* [page 295].

18. A state must have a sufficient number of each type of high school—at least 20 schools in either category—to make this comparison. Nat'l Women's Law Ctr. parameters for analyzing data found in Office for Civil Rights, *Civil Rights Data Collection (CRDC): 2011–12 CRDC, supra* note 6.

19. These states are Alabama, Massachusetts, Michigan, Mississippi, North Carolina, New Jersey, New York, and Texas. Nat'l Women's Law Ctr. calculations based on Office for Civil Rights, *Civil Rights Data Collection (CRDC): 2011–12 CRDC, supra* note 1.

20. *See* WILSON SPORTING GOODS CO. & WOMEN'S SPORTS FOUND., THE WILSON REPORT: MOMS, DADS, DAUGHTERS AND SPORTS 5 (1988), *available at* http://www.womenssportsfoundation.org/home/research/articles-and-reports /mental-and-physical-health/moms-dads-daughters-and-sports.

21. *See* WOMEN'S SPORTS FOUND., HER LIFE DEPENDS ON IT II: SPORT, PHYSICAL ACTIVITY, AND THE HEALTH AND WELL BEING OF AMERICAN GIRLS AND WOMEN 56–60 (2009), *available at* http://www.womenssportsfoundation.org /home/research/articles-and-reports/mental-and-physicalhealth/~/media/PDFs /WSF%20Research%20Reports/Her_Life_II_Full.ashx (finding that "girls and their families [. . .] need program resources, safe venues, and opportunities to participate in school and community sports programs").

22. *See generally* ALEX POINSETT, CARNEGIE CORP. OF N.Y., THE ROLE OF SPORTS IN YOUTH DEVELOPMENT (1996), *available at* http://files.eric.ed.gov/fulltext /ED407376.pdf.

23. *See* WOMEN'S SPORTS FOUND., HER LIFE DEPENDS ON IT II, *supra* note 21, at 9–23.

24. Brian Castrucci et al., *Tobacco Use & Cessation Behavior among Adolescents Participating in Organized Sports*, 28 AM. J. HEALTH BEHAVIOR 63, 63 (2004).

25. Adam Naylor et al., *Drug Use Patterns among High School Athletes & Nonathletes*, 36 ADOLESCENCE 627, 634 (2001).

26. *See* WOMEN'S SPORTS FOUND., HER LIFE DEPENDS ON IT II, *supra* note 21, at 37–39 ("According to [a 2002] study, 10% of young adult women with a history of extensive sports involvement in high school [had] a child outside of marriage, while the number is 25% for those who had little or no involvement in high school sports."); T. Dodge & J. Jaccard, *Participation in Athletics and Female Sexual Risk Behavior: The Evaluation of Four Causal Structures*, 17 J. ADOLESCENT RES. 42 (2002); THE

PRESIDENT'S COUNCIL ON PHYSICAL FITNESS AND SPORTS, PHYSICAL ACTIVITY & SPORTS IN THE LIVES OF GIRLS 26–27 (1997), *available at* http://www .donaldcollins.org/administrators_school_officials/phys%20activity%20in%20 lives%20of%20girls.pdf.

27. THE WOMEN'S SPORTS FOUND., SPORT AND TEEN PREGNANCY 4–5 (1998), *available at* http://www.womenssportsfoundation.org/home/research/articles-and -reports/mental-and-physical-health/sport-and-teen-pregnancy.

28. *See* Women's Sports Found., Go Out and Play: Youth Sports in America 75–81 (2008), *available at* http://www.womenssportsfoundation.org/home/research/articles -and-reports/mental-and-physical-health/go-out-and-play (discussing the favorable contributions of sport and athletic contributions to body esteem for both boys and girls); *id.* at 96–109 (stating that girls and boys who play sports experience an increased quality of life, measured by their responses to statements that tap whether they feel positive about themselves and have positive relationships with friends and family members).

29. *Id.* at 79.

30. Tara Parker-Pope, *As Girls Become Women, Sports Pay Dividends*, N.Y. TIMES, Feb. 16, 2010, at D5, *available at* http://www.nytimes.com/2010/02/16/health/16well .html?emc=eta1; Robert Kaestner & Xin Xu, *Title IX, Girls' Sports Participation, and Adult Female Physical Activity and Weight*, 34 EVAL. REV. 52 (2010).

31. TRUST FOR AM.'S HEALTH & ROBERT WOOD JOHNSON FOUND., THE STATE OF OBESITY: BETTER POLICIES FOR A HEALTHIER AMERICA 3, 7 (2014), *available at* http://www.rwjf.org/content/dam/farm/reports/reports/2014/rwjf414829 (includes obesity rates for children by gender for whites, Latinos, and African Americans); *see also* Cynthia L. Ogden et al., *Prevalence of Childhood and Adult Obesity in the United States*, 2011–2012, 311 J. AM. MED. ASS'N TBL. 3 (2014), *available at* http://jama .jamanetwork.com/article.aspx?articleid=1832542 (includes additional data on non-Hispanic Asian American boys and girls, whose obesity rates are generally lower than those of other racial and ethnic groups).

32. *Youth Online: National Youth Risk Behavior Surveillance System*, CTRS. FOR DISEASE CONTROL & PREVENTION, http://nccd.cdc.gov/youthonline/App/Default .aspx (last visited Apr. 12, 2015). The share of all high school students who are obese is 13.7 percent in 2013, up from 10.6 percent in 1999. Note that this increase is not linear. The Centers for Disease Control and Prevention categorize a child as obese when his/ her Body Mass Index (BMI) is at or above the 95th percentile for children of same age and sex (based on sex- and age-specific reference data from the 2000 CDC growth charts). *Overweight and Obesity*, CTRS. FOR DISEASE CONTROL & PREVENTION, http://www.cdc.gov/obesity/childhood/basics.html (last visited Apr. 12, 2014).

33. *See* text and citations *supra* note 32. Nineteen percent of Hispanic boys were obese, compared to 16.5 percent of white boys and 9.9 percent of Asian American boys. The share of all high school students who are obese was 13.7 percent in 2013, up from 10.6 percent in 1999. Note that this increase is not linear.

34. *E.g.*, TRUST FOR AM.'S HEALTH & ROBERT WOOD JOHNSON FOUND., *supra* note 31, at 27–31; *see generally* S. Caprio et al., *Influence of Race, Ethnicity, and Culture on Childhood Obesity: Implications for Prevention and Treatment* 31 DIABETES CARE

2211 (2008), *available at* http://www.ncbi.nlm.nih.gov/pmc/articles/PMC2571048
/ (regarding cardiovascular disease and diabetes); MH Zeller et al., *Negative Peer
Perceptions of Obese Children in the Classroom Environment*, 16 OBESITY 755 (2008)
(regarding peer relationships); H. Taras & W. Potts-Datema, *Obesity and Student
Performance at School*, 75 J. of Sch. Health 291 (2005) (regarding school performance);
Joanna Venator & Richard Reeves, *Weight and Social Mobility: Taking the Long View
on Childhood Obesity*, BROOKINGS (Jan. 8, 2015, 3:03 PM), http://www.brookings.edu
/blogs/social-mobility-memos/posts/2015/01/08-childhood-obesity-social-mobility
-reeves (regarding earnings).

 35. CTRS. FOR DISEASE CONTROL & PREVENTION, OBESITY EPIDEMIC
AND THE UNITED STATES STUDENTS (2013), *available at* http://www.cdc.gov
/healthyyouth/yrbs/pdf/us_obesity_combo.pdf. The other three solutions are:
better health education, healthier school environments, and better nutrition
services.

 36. CTRS. FOR DISEASE CONTROL & PREVENTION, *Youth Online, supra* note 32.
Every group of girls report rates of inactivity higher than boys of the same race
/ethnicity do.

 37. Gary Bennett et al., *Safe to Walk? Neighborhood Safety and Physical Activity
among Public Housing Residents* 4 PLOS MEDICINE 1599 (2007), *available at* http://
www.plosmedicine.org/article/fetchObject.action?uri=info:doi/10.1371/journal.pmed
.0040306&representation=PDF; ROBERT GARCÍA ET AL., THE CITY PROJECT,
ECONOMIC STIMULUS, GREEN SPACE, AND EQUAL JUSTICE 8–9 (2009), *available
at* http://www.cityprojectca.org/blog/wp-content/uploads/2009/04/stimulus-green
-space-justice-200904294.pdf ("Almost half (48%) of Hispanic children under 18 in
central cities were kept inside as much as possible because their neighborhoods were
perceived as dangerous. The same was true for more than 39% of black children, 25%
of non-Hispanic white children, and 24% of Asian children.").

 38. BRISTOL-MYERS SQUIBB, ACTIVE LIVING BY DESIGN: LOW INCOME
POPULATIONS AND PHYSICAL ACTIVITY 2–3 (2012), *available at* http://www.bms
.com/documents/together_on_diabetes/2012-Summit-Atlanta/Physical-Activity-for
-Low-Income-Populations-The-Health-Trust.pdf; PA Estabrooks et al., *Resources
for Physical Activity Participation: Does Availability and Accessibility Differ by
Neighborhood Socioeconomic Status?*, 25 ANN. BEHAV. MED. 100 (2003) (High-,
medium-, and low-income communities report similar levels of pay-to-play physical
activity resources.).

 39. BRISTOL-MYERS SQUIBB, *supra* note 38, at 2.

 40. Nat'l Women's Law Ctr. calculations based on Educ. Counts Research Ctr.,
Data Indicators, EDITORIAL PROJECTS IN EDUC., http://www.edcounts.org
/createtable/step1.php (last visited Mar. 12, 2015) (retrieved from Custom Table
Builder). Graduation rates are reported by Editorial Projects in Education under the
Cumulative Promotion Index (CPI); *see generally* NAT'L WOMEN'S LAW CTR., WHEN
GIRLS DON'T GRADUATE, WE ALL FAIL: A CALL TO IMPROVE HIGH SCHOOL
GRADUATION RATES FOR GIRLS (2007), *available at* http://www.nwlc.org/resource
/when-girls-dont-graduate-we-all-fail-call-improve-high-school-graduation-rates
-girls; NAT'L WOMEN'S LAW CTR., UNLOCKING OPPORTUNITY FOR AFRICAN

AMERICAN GIRLS: A CALL TO EDUCATIONAL EQUITY 27 (2014), *available at* http://
www.nwlc.org/resource/unlocking-opportunity-african-american-girls-call-action
-educational-equity.

41. *See* DOUGLAS HARTMANN, LA84 FOUND., HIGH SCHOOL SPORTS
PARTICIPATION & EDUCATIONAL ATTAINMENT: RECOGNIZING, ASSESSING, &
UTILIZING THE RELATIONSHIP 6–7 (2008), *available at* http://library.la84.org/3ce
/HighSchoolSportsParticipation.pdf.

42. ANN ROSEWATER, TEAM-UP FOR YOUTH, PLAYING WELL: ORGANIZED
SPORTS AND THE HEALTH OF CHILDREN AND YOUTH 8 (2010) *available at*
https://0ea29dd9a16d63dcc571-314f1dcf5bee97a05ffca38f060fb9e3.ssl.cf1.rackcdn.com
/uploads/center_resource/document/251/Sports_and_Children_s_Health.pdf (citing
R.F. Valois et al., *Physical Activity Behaviors and Emotional Self-Efficacy: Is There a
Relationship for Adolescents?*, 78 J. SCH. HEALTH 321, 321–27 (2008)).

43. WOMEN'S SPORTS FOUND, MINORITIES IN SPORTS: THE EFFECT OF VARSITY
SPORTS PARTICIPATION ON THE SOCIAL, EDUCATIONAL, AND CAREER MOBILITY
OF MINORITY STUDENTS 7 (1989), *available at* http://www.womenssportsfoundation
.org/home/research/articles-and-reports/athletes-of-color/minorities-in-sports.

44. Betsey Stevenson, *Beyond the Classroom: Using Title IX to Measure the Return to
High School Sports* 18–20, 23–24 (Nat'l Bureau of Econ. Research, Working Paper No.
15728, 2010), http://www.nber.org/papers/w15728.pdf.

45. *Id.* at 4, 27.

46. WOMEN'S SPORTS FOUND., WOMEN'S SPORTS AND PHYSICAL ACTIVITY
FACTS AND STATISTICS 19 (2009), *available at* http://www.womenssportsfoundation
.org/home/research/articles-and-reports/athletes/~/media/PDFs/WSF%20research
%20Reports/WSF%20FACTs%20March%202009.ashx.

47. *See supra* note 13; *see generally* NAT'L COALITION FOR WOMEN & GIRLS IN
EDUC., TITLE IX AT 40: WORKING TO ENSURE GENDER EQUITY IN EDUCATION
14–15 (2012), *available at* http://www.ncwge.org/PDF/TitleIXat40.pdf (discussing
barriers girls still face in athletics and recommendations to help ensure greater
compliance with Title IX).

48. *See supra* note 7; *see generally* Gary Orfield et al., THE CIVIL RIGHTS PROJECT,
E PLURIBUS . . . SEPARATION, *supra* note 1.

49. *See* William C. Rhoden, *Black and White Women Far from Equal under Title IX*,
N.Y. TIMES, June 11, 2012, at D5, *available at* http://www.nytimes.com/2012/06/11
/sports/title-ix-has-not-given-black-female-athletes-equal-opportunity.
html?pagewanted=all&_r=0.

50. WOMEN'S SPORTS FOUND., GO OUT AND PLAY, *supra* note 28, at 2.

51. WOMEN'S SPORTS FOUND., GO OUT AND PLAY, *supra* note 28, at 16; *see also*
DEBORAH L. BRAKE, GETTING IN THE GAME: TITLE IX AND THE WOMEN'S
SPORTS REVOLUTION 117 (NYU Press, 2010).

52. WOMEN'S SPORTS FOUND., TITLE IX AND RACE IN INTERCOLLEGIATE
SPORT 8–9 (2003), *available at* http://www.womenssportsfoundation.org/home
/research/articles-and-reports/school-and-colleges/title-ix-and-race-in
-intercollegiate-sport. Per the source, "[F]igures do not add to 100% because non-
resident aliens and students of other/unknown races are not included." *Id.*

53. *Id.*

54. Lauren Smith, *Black Female Participation Languishes outside Basketball and Track,* THE CHRONICLE OF HIGHER EDUC., June 29, 2007.

55. *Id.*

56. *See generally* KIMBERLÉ CRENSHAW, DEMARGINALIZING THE INTERSECTION OF RACE AND SEX: A BLACK FEMINIST CRITIQUE OF ANTIDISCRIMINATION DOCTRINE, FEMINIST THEORY AND ANTIRACIST POLITICS (Univ. of Chi. L. Forum, 1989), *available at* http://politicalscience.tamu.edu/documents/faculty/Crenshaw -Demarginalizing.pdf (using the term "intersectionality" to describe how attitudes about race and gender interact to form a unique kind of discrimination against African American women).

57. The most analogous cases available are in the employment context. *See, e.g.,* DeGraffenreid v. General Motors Assembly Div., 413 F. Supp. 142, 143 (E.D. Mo. 1976), *aff'd in part, rev'd in part on other grounds,* 558 F.2d 480 (8th Cir. 1977) (holding that plaintiffs who alleged employer's hiring policies discriminated against them as black women could either assert race-based claim or sex-based claim, but not both); Lee v. Walters, CIV. A. No. 85–5383, 1988 WL 105887, *7 n.7 (E.D. Pa. 1988) (dismissing plaintiff's claim of sex and race discrimination for failure to show "direct evidence of anti-female or anti-asian [sic] animus").

58. *But see* Jeffries v. Harris Cnty. Cmty. Action Ass'n, 615 F.2d 1025, 1032 (5th Cir. 1980) ("We agree that discrimination against black females can exist even in the absence of discrimination against black men or white women").

59. Letter from Catherine E. Lhamon, Assistant Sec'y, U.S. Dep't of Educ. Office for Civil Rights, to Colleagues 1 (Oct. 1, 2014), *available at* http://www2.ed.gov/about /offices/list/ocr/letters/colleague-resourcecomp-201410.pdf.

60. *Id.* at 5.

61. *See* NAT'L COALITION ON SCH. DIVERSITY, REAFFIRMING THE ROLE OF SCHOOL INTEGRATION IN K-12 EDUCATION POLICY (2010), *available at* http:// school-diversity.org/pdf/DiversityIssueBriefStmt.pdf; *Advocacy Letters,* Nat'l Coalition on Sch. Diversity, www.school-diversity.org (last visited Apr. 15, 2015).

62. *See generally* EQUITY & EXCELLENCE COMM'N, U.S. DEP'T OF EDUC., FOR EACH AND EVERY CHILD—A STRATEGY FOR EDUCATION EQUITY AND EXCELLENCE (2013), *available at* https://www2.ed.gov/about/bdscomm/list/eec/ equity-excellence-commission-report.pdf. For information on how state funding mechanisms can penalize students in low-income school districts, *see, e.g.,* CHANGELAB SOLUTIONS, NOT MAKING THE GRADE: HOW FINANCIAL PENALTIES FOR SCHOOL ABSENCES HURT DISTRICTS SERVING LOW-INCOME CHRONICALLY ILL KIDS 9 (2014), *available at* http://changelabsolutions.org/sites/default/files /SchoolFinancing_StatePolicymakers_FINAL_09302014.pdf.

63. A few states already have adopted and implemented state laws and policies requiring high schools to submit annual reports with information regarding their athletic participation rates and expenditures by gender. *See* 702 KY ADMIN. REGS. 7:065 §§ 2(13)-(14) (2009); Georgia Equity in Sports Act, Ga. Code. Ann. § 20-2-315 (2010); School Athletics Equity Act, N.M. STAT. ANN. § 6.13.4.8 (2009); Equity in Interscholastic Athletics Disclosure Act, 24 PA. CONS. STAT. ANN. § 16-1604-C (West 2012).

64. THE FINANCE PROJECT, FINANCING CHILDHOOD OBESITY PREVENTION PROGRAMS: FEDERAL FUNDING SOURCES AND OTHER STRATEGIES 37 (2004), *available at* http://www.nlc.org/documents/Find%20City%20Solutions/IYEF /Community%20Wellness/fp-financing-obesity-prevention-gid-sep04.pdf.

65. EMILY THRUN ET AL., BRIDGING THE GAP, USING LOCAL LAND USE LAWS TO FACILITATE PHYSICAL ACTIVITY (2012), *available at* http://www.bridging thegapresearch.org/_asset/5q86hg/btg_land_use_pa_FINAL_03-09-12.pdf. For a comprehensive examination of the issues related to maximizing the health benefits of potential zoning changes, *see* RACHEL JOHNSON THORNTON ET AL., CTR. FOR CHILD & CMTY. HEALTH RESEARCH, JOHNS HOPKINS UNIV., ZONING FOR A HEALTHY BALTIMORE: A HEALTH IMPACT ASSESSMENT OF THE TRANSFORM BALTIMORE COMPREHENSIVE ZONING CODE REWRITE (2010), *available at* http:// www.hiasociety.org/documents/BaltimoreHIA_FullReport.pdf. For an examination of the potential impacts of zoning changes on adolescent obesity, see Jamie F. Chriqui et al., *Physical Activity-Oriented Zoning and Walkable Community Associations with Adolescent Obesity* (APHA Annual Mtg. & Expo., Conference Paper No. 312230, 2014), *recording of presentation available at* https://apha.confex.com/apha/142am/web program/Paper312230.html.

66. EMILY THRUN ET AL., *supra* note 65.

67. *See, e.g.*, ROBERT GARCÍA ET AL., THE CITY PROJECT, ECONOMIC STIMULUS, *supra* note 37, at 15.

68. *See, e.g.*, ROBERT GARCÍA ET AL., CTR. FOR LAW IN THE PUBLIC INTEREST, DREAMS OF FIELDS: SOCCER, COMMUNITY, AND EQUAL JUSTICE 26 (2002), *available at* http://www.cityprojectca.org/pdf/dreamsoffields.pdf. For a careful consideration of whether public parks are protected under the public trust doctrine, see Serena M. Williams, *Sustaining Urban Green Spaces: Can Public Parks Be Protected under the Public Trust Doctrine?*, 10 S.C. ENVIRONMENTAL L. J. 23 (2002), *available at*: http://works.bepress.com/serena_williams/2.

69. SANDY SLATER, NEIGHBORHOODS INITIATIVE & UIC HEALTHY CITY COLLABORATIVE, SHARING WHAT WE HAVE LEARNED: THE ASSOCIATION BETWEEN HOME AND NEIGHBORHOOD ENVIRONMENTS AND YOUTH PHYSICAL ACTIVITY AND OBESITY (2012), *available at* http://oceanhp.webhost.uic.edu/wp -content/uploads/2015/01/April-2012-Featured-Researcher-Slater.pdf; ROBERT GARCÍA ET AL., CTR. FOR LAW IN THE PUBLIC INTEREST, DREAMS OF FIELDS, *supra* note 68, at 16, *available at* http://www.cityprojectca.org/pdf/dreamsoffields.pdf.

70. For example, the Bay Area Women's Sports Initiative recruits female athletes for the purpose of "engaging, equipping and encouraging children on playgrounds to be active, self-confident change makers" through engagement in community service activities. *See* BAY AREA WOMEN'S SPORTS INITIATIVE, https://bawsi.org (last visited Apr. 12, 2015).

71. WOMEN'S SPORTS FOUND. UK & SPORTSCOTLAND, MAKING WOMEN AND GIRLS MORE ACTIVE: A GOOD PRACTICE GUIDE 29 (2005), *available at* http://www .scottishstudentsport.com/assets/downloads/making-women-and-girls-more-active .pdf.

72. *Id.* at 21; *see also* Femke De Meester et al., *Interventions for Promoting*

Physical Activity among European Teenagers: A Systematic Review 6 INT'L J. BEHAV. NUTRITION & PHYSICAL ACTIVITY 1, 7 (2009), *available at* http://www.ijbnpa.org /content/pdf/1479-5868-6-82.pdf.

73. Sandra Mandic et al., *Getting Kids Active by Participating in Sport and Doing It More Often: Focusing on What Matters*, 9 INT'L J. BEHAV. NUTRITION & PHYSICAL ACTIVITY 1, 5 (2012), *available at* www.ijbnpa.org/content/pdf/1479-5868-9-86.pdf.

74. In the 2011–12 school year, African American girls in grades pre-K–12 were suspended at six times the rate of white girls and at a higher rate than white, Latino, and Asian American boys. OFFICE FOR CIVIL RIGHTS, U.S. DEP'T OF EDUC., CIVIL RIGHTS DATA COLLECTION, ISSUE BRIEF NO. 1, DATA SNAPSHOT: SCHOOL DISCIPLINE 3 (2014), *available at* http://ocrdata.ed.gov/Downloads/CRDC-School -Discipline-Snapshot.pdf.

75. JO KIRBY, CHILD & ADOLESCENT HEALTH RESEARCH UNIT, UNIV. OF EDINBURGH, THE IMPORTANCE OF ROLE MODELS IN MAKING ADOLESCENT GIRLS MORE ACTIVE: A REVIEW OF THE LITERATURE 13 (2009).

76. Femke De Meester et al., *supra* note 72, at 7; MW Beets et al., *Parental Social Support and the Physical Activity-Related Behaviors of Youth: A Review*, 37 HEALTH EDUC. BEHAV. 621 (2010); V. Cleland et. al, *A Longitudinal Study of the Family Physical Activity Environment and Physical Activity among Youth*, 25 AM. J. HEALTH PROMOT. 159 (2011); *Motivating Kids in Physical Activity*, President's Research Digest (President's Council on Physical Fitness & Sports), Sept. 2000, Series 3, No. 11, *available at* https:// www.presidentschallenge.org/informed/digest/docs/200009digest.pdf.

77. *See* WOMEN'S SPORTS FOUND. UK & SPORTSCOTLAND, *supra* note 71, at 18. *See also* R. BAILEY ET AL., INT'L COUNCIL OF SPORT SCIENCE & PHYSICAL EDUC., WORLD HEALTH ORG., GIRLS' PARTICIPATION IN PHYSICAL ACTIVITIES AND SPORTS: BENEFITS, PATTERNS, INFLUENCES AND WAYS FORWARD 5 (2005), *available at* https://www.icsspe.org/sites/default/files/Girls.pdf (Older girls from the target *community* provide effective role models, as studies have found that "effective role models need not be the most outstanding sporting individuals, but rather, may come from within the school (other pupils or teachers) or at home (parents or siblings).").

78. WOMEN'S SPORTS FOUND. UK & SPORTSCOTLAND, *supra* note 71, at 30.

79. *See* WOMEN'S SPORTS FOUND. UK & SPORTSCOTLAND, *supra* note 71, at 17.

80. CAL. TASK FORCE ON YOUTH & WORKPLACE WELLNESS, PHYSICAL EDUCATION RESEARCH FOR KIDS (PERK) 18 (2010), *available at* http://www. childrennow.org/uploads/documents/bwlw2011_resource1.pdf ("Quality physical education also teaches fundamental movement skills that have been shown to predict higher levels of participation in organized physical activity in adolescents.").

81. *See* Healthy, Hunger-Free Kids Act of 2010, Pub. L. No. 111-296, § 204, 124 Stat. 3183, 3216 (2010).

82. *See, e.g.*, JEFFREY M. VINCENT, CTR. FOR CITIES & SCHOOLS, UNIV. OF CAL., BERKELEY, PARTNERSHIPS FOR JOINT USE: EXPANDING THE USE OF PUBLIC SCHOOL INFRASTRUCTURE TO BENEFIT STUDENTS AND COMMUNITIES (2010), *available at* http://citiesandschools.berkeley.edu/reports/Partnerships_JU_Aug2010 .pdf.

AMERICA'S PAINFUL JOURNEY FROM PREJUDICE TO GREATNESS IN WOMEN'S GYMNASTICS

Celisa Calacal and Lindsay Gibbs | 2016

From *ThinkProgress,* August 8, 2016, https://thinkprogress.org/americas-painful -journey-from-prejudice-to-greatness-in-women-s-gymnastics-a35c8e4eebb7. Bracketed insertions are part of the original publication.

Before 9:00 a.m. on a Tuesday morning in August, APEX Gymnastics in Leesburg, Virginia, is already filled with dozens of budding gymnasts. The three-year-olds, dressed in leotards still too big for them and with ponytails that won't stay up, bounce on the trampoline, while the intermediate-level girls laugh amongst themselves as they put chalk on their hands and prepare to tackle the daunting uneven bars or four-inch balance beams.

Meanwhile, the high school girls gather around the floor, casually knocking out complex, powerful tumbling passes while they wait for class to officially begin.

There's a palpable sense of excitement on this particular day, and it doesn't take long to figure out why. In just days—hours, even—Team USA is scheduled to start competing at the Rio Olympics. While most of these girls (and a handful of boys) are gymnastics fanatics and watch the sport year-round, the Olympics are the holy grail, and the Olympians are their heroes. Be it Shawn Johnson or Nastia Liukin, Gabby Douglas or Aly Raisman, Olympic gymnasts are the main reason most of these girls are here at all.

This is something their coach, Zerell Johnson Welch, relates to intimately.

Back in 1976, a 12-year-old Welch was couch-bound due to a broken ankle from a skateboarding accident. With nothing else to do, she found herself glued to that summer's Olympic Games in Montreal. She quickly became enamored with Romanian gymnast Nadia Comaneci, who effortlessly and gracefully flipped and twirled her way to three gold medals and a historic perfect 10.

"I think I can do that," Welch remembers telling herself. "I want to do that."

Her parents were supportive, and once her ankle healed, they immediately enrolled her in gymnastics, so Welch could chase her budding Olympic dream.

But reality quickly set in for Welch when she walked into her first class and realized nobody looked like her.

"I was probably the only black girl, African American, in my class," she told *ThinkProgress*. "It was very daunting . . . stressful, frustrating, isolating, and hurtful at times."

Welch stuck with the sport, but was constantly bombarded with reminders that she was different, particularly by coaches who were unfamiliar with hair and body types that didn't fall within the narrow confines of typical gymnasts.

"I remember [a male coach] making a comment about my rump, my bump, my butt," she said. "I didn't really become self-conscious of that until he actually brought it to my attention. And it was done in a joking way but it wasn't a joking way to me at all. Not at all."

Still, her love for the sport, hard work, and natural talent propelled Welch through the ranks. That is, until the "exorbitant" cost of competitive gymnastics simply became too much for her family and she was forced to quit at 17.

"It took my family out," Welch said of the financial burden.

Gymnastics is full of stories like Welch's. It's a cycle that has kept the sport white-washed for decades. People of color haven't traditionally been drawn to gymnastics because they don't see themselves represented in it. Those who do break the mold and have the opportunity to fall in love with the sport are further deterred by the crippling cost of competing at the top levels—a reality that makes it more difficult for low-income and even middle-income families, which are disproportionately African American and Hispanic, to rise through the ranks.

But this year's Olympic team might be a sign that the tide is turning. With two black women on the team—three-time world all-around champion Simone Biles and defending Olympic all-around champion Gabby Douglas—as well as the first Latina on the U.S. women's Olympic gymnastics team in over a decade, Laurie Hernandez, the gold medal favorites are now a majority-minority team.

Welch knows firsthand that this is far more than a symbolic victory.

"The idea of seeing someone that looks like you is so profound, and it has such an impact on your understanding of what you potentially can be," she said.

The United States gymnastics team first appeared in the Olympics in 1932. But for 60 years, only white women represented the country on the sport's biggest stage.

In 1992, Dominique Dawes and Betty Okino shattered the gymnastics color barrier, becoming the first African American gymnasts to compete in the Games and win an Olympic medal when the U.S. won bronze in the team competition.

(Though, notably, Luci Collins and Ron Gallimore would have broken the color barrier in 1980 had the U.S. not boycotted the Moscow games.)

Four years later in Atlanta, the iconic "Awesome Dawesome" was an integral part of the Magnificent Seven, becoming the first African American woman to win an individual gymnastics medal—a bronze on floor exercise. In the team event, she became the first black gymnast of either gender to win a gold medal.

Welch's gymnastics career was long over at that point, but the significance of Dawes' accomplishments in 1996 were certainly not lost on her. By then, Welch's two children were both gymnastics junkies, and Welch was thrilled that they would be able to see a prominent black woman reach the pinnacle of the sport.

"Being a mom, having my children see [Dawes], I was just ecstatic that they can actually have a sense of inclusion and belonging that I did not have," she said.

Over the next few years, a few other minority gymnasts were able to break through. Amy Chow, an Asian American gymnast, competed with Dawes and the rest of the Magnificent Seven in 1996, winning a silver medal on the uneven bars. And at the 2004 games, Annia Hatch, a Cuban-American, became the first American woman to medal in vault since Mary Lou Retton in 1984.

Despite the accomplishments of these groundbreaking women, the face of American gymnastics remained overwhelmingly white. A 2007 study conducted by USA Gymnastics found that the vast majority of gymnasts at the amateur level were white—a whopping 74 percent. In contrast, African Americans comprised just 6 percent of the 18,994 gymnasts surveyed; Hispanics just 3 percent.

Those odds didn't stop Gabby Douglas. Twenty years after Dawes burst onto the scene, a 16-year-old Douglas made history at the London Olympics in 2012 as the first African American woman to win the all-around competition.

Working as a Fox commentator at the time, Dawes broke down in tears after Douglas won gold, saying, "I'm so thrilled to change my website and take down the fact that I was the only African American with a gold medal."[1]

Biles, who just missed the age cutoff for the London Games, arrived right on Douglas' heels; the 4'9" powerhouse has won the last three world championships by a significant margin and clearly established herself as one of the best gymnasts—if not athletes—of all time.

Of course, it hasn't all been smooth sailing for the trailblazers. Change has never been easy.

Like Welch, Douglas faced racist and discriminatory behavior during her time as a young gymnast, a fact she revealed during an interview with Oprah Winfrey in 2012. Douglas shared that she had faced racially motivated bullying

during her years as a young gymnast at Excalibur, where she was the only African American student. In one instance, Douglas recalled teammates referring to her as their "slave."[2]

The comments didn't end when she became a household name; during her London breakout, Douglas was even subjected to racially-charged criticism about her hair.[3]

Douglas has always been open to discussing race and discrimination with the media, clearly considering it an integral part of her story. Biles, however, feels differently. She doesn't dwell on the fact that she was the first African American gymnast to win the world championships, a feat she's accomplished three times.[4] She wants to just be known as a gymnast, not a black gymnast.

But that's easier said than done. In 2013, following Biles' all-around victory at the 2013 World Championships, Italian gymnast Carlotta Ferlito said in a video interview that "next time we should also paint our skin black, so then we could win too."

Inflammatory comments from Italian Gymnastics Federation official David Ciaralli further exacerbated the issue. In a Facebook post, Ciaralli wrote, "Carlotta was referring to a trend in gymnastics at this moment, which is going towards a technique that opens up new chances to athletes of colour (well-known for power) while penalising the more artistic Eastern European style that allowed Russians and Romanians to dominate the sport for years."

While both Ciaralli and Ferlito apologized, their remarks reflect common racial stereotypes about black athletes that label them as powerful, nearly superhuman beings.

It's no secret that gymnastics has historically favored grace and European standards of beauty over power and athleticism. This idealized image of a graceful, lithe, and in most cases, white, gymnast can alienate girls of color, painting a picture of a sport that is not for them. But the success of Biles, Douglas, and now Hernandez is challenging the either/or notions of those standards.

"I'm still kind of realizing how much impact I have made," Douglas said in a February piece by USA Gymnastics.[5]

As the mother of two gymnasts, Alexandria Brown has seen firsthand the importance of representation in the sport.

Her daughters are half African American and half Hispanic, and Brown estimates that her 10-year-old daughter Sara has watched *The Gabby Douglas Story*, the made-for-TV movie about Douglas' life, over 100 times.

"You know, I remember seeing so many tears and all after she recognized the

hard work that Gabby Douglas had gone through," Brown said. "She learned a lot from the experience of this girl."

It wasn't just Douglas' race that connected with the Browns; it was her story of financial struggles and family sacrifice.

On average, classes for competitive gymnastics range from $180 to $300 a month, and that doesn't include the money spent on pricey gymnastics attire, coach's training fees, gymnastics summer camp, and travel expenses to go from meet to meet. The costs for leotards and warm-up suits alone can range from $300 to $500. Adding up all of these costs amounts to over $1,000 per month.

And that's just for gymnasts at the amateur level.

The financial burden for Olympic hopefuls is much higher. Forbes estimates the average cost of raising an Olympic-level gymnast is about $15,000 per year.[6] Multiply that by the five to eight years of training, and parents can find themselves shelling out around $120,000.

The financial commitment is a significant one for all families with children in costly sports like gymnastics, but that burden is often felt the most by African American and Hispanic communities, which have the highest poverty levels in the nation.

Brown did absolutely everything she could to keep up with the multiplying bills as her daughters' talent and interest in gymnastics grew. She bartered services, such as babysitting and house-sitting. She took a part-time cleaning job at the gym. The owner of APEX even provided her with a partial scholarship. But at the end of the day, it wasn't enough. If she was working too much, she couldn't be available to transport the girls to and from the classes. If she wasn't working, she couldn't afford the bills. It was too much to overcome.

"If we do not have the help, there's no way we can do it," Brown said. "There's no way. I would love for her to keep going but I don't think we can afford it."

Welch, who coached the "immensely talented" Sara at APEX, said seeing girls leave is particularly heartbreaking because gymnastics is more than just a sport—it's a social outlet and a second family for many of them. Plus, it was tough to see one of the few non-white families at the gym forced to walk away because of time and money.

"When one girl has to drop, I feel a lot of anguish," she said. "I also feel a lot for the parents."

Following Douglas' historic win at the 2012 Summer Olympics, Steve Penny, president of USA Gymnastics, thought, "If there's more Gabby Douglases out there, I want to find them."

Of course, acknowledging that is one thing. Actually going out and putting the necessary programs in place to attract more minorities to the sport is another.

In order to get more minorities involved in the sport in the grassroots level, it's important to build accessible, affordable facilities in their communities. But there also need to be grants and sponsorships available to help transition these gymnasts to the elite level if they have the talent and commitment.

Wendy Hilliard, an African American woman and former gymnast, has been working on the first part of this equation for decades. In 1996, she founded the Wendy Hilliard Foundation to bring gymnastics to children and families in Harlem, a predominantly black and Hispanic, low-income community.

The idea for the foundation was primarily borne out of Hilliard's personal experiences with the sport, when gymnastics was housed in schools and YMCAS in urban centers. Growing up in Detroit, Michigan, the quality of Hilliard's instruction was high—the Detroit Recreation Department had hired four coaches from Ukraine—while the costs remained low. The Detroit team found success on the national and international circuits, with its athletes even making two Olympic teams. And in 1978, Hillard herself became the first African American to represent the U.S. in international competitions.

Seeing the lack of minorities in the sport, Hilliard knew she wanted to give other children the same opportunities she had as a gymnast. Serving the Harlem community for nearly 20 years, Hilliard's Foundation has provided free and low cost gymnastics classes to well over 15,000 children—an average of 1,000 kids every year. Hilliard has found that her program has been successful in drawing more families from the community into the sport, and has also attracted older teens to learn how to teach gymnastics. She's now working on setting up a similar foundation in Detroit.

"It's almost like you gotta take the sport where the people are," she said.

USA Gymnastics, meanwhile, has a few grassroots initiatives in place, but is mainly focused on diversifying the sport through the media. Ron Galimore, now the Chief Operating Officer for USA Gymnastics, says that promoting successful gymnasts like Biles and Douglas is one way the organization can "take the sport to all ethnicities."

Though there has not been an updated study on diversity in the sport since 2007, Penny and Galimore both believe there has been a growth in diversity following the success of athletes like Biles and Douglas. A look at the elite level of the sport suggests that might indeed be the case. For instance, at the 2016 Secret U.S. Classic, eight of the 20 gymnasts in the junior division were either black or biracial. And among those that qualified for the junior national championships, 31 percent were black, 24 percent were Asian, and 8 percent were Hispanic.

But professor Rob Ruck, a sports historian at the University of Pittsburgh, wants to see more. He believes that every local sports club needs to make a conscious effort to bridge the affordability gap and increase minority participation in gymnastics.

"Where resources are invested, talent is developed," Ruck said. "When people make an effort, things change and happen."

Four years ago, Welch made the most difficult decision of her coaching career when she decided to stop commuting three hours a day to work at a gym in Maryland, which was very diverse, and start teaching at APEX, which is less so. But ultimately, she realizes that she can have an impact no matter where she goes.

"It is just as important for those who do not look like you to be exposed to you," she recalls her mother telling her when she made her decision. "Diversity goes both ways and exposure goes both ways."

Welch praises APEX for its efforts to diversify, which include offering scholarship programs and recruiting a diverse staff. But she still thinks more can be done.

For one, the cost of training has to decrease, she says. She also believes community support is key in making sure the sport is accessible to every child, such as the existence of local sponsors that are present in other sports like baseball and basketball.

"The community as a whole has to change their mindset and believe every child should have access," she said. "And then, when they understand that there's a lack of equity or accessibility, they come together and provide scholarships for children."

Ultimately, she wants the diversity on Team USA's women's gymnastics team in Rio—which is already being considered one of the most talented Olympic teams of all time—to be the rule, not the exception. She wants all races to have the chance to participate in a sport that has taught her discipline and friendship, hard work and, most importantly, fearlessness.

"[Gymnastics] forces you to deal with fear in such a way that if you can get through this, most of the time the encounters that you face after you leave this gym, you'll be able to say they're doable," Welch said.

"It forces you to actually have a conversation about what you thought was the impossible."

Notes

Links in the original online version of this article have been turned into endnotes.

1. Philip Hersh, "Simone Biles and Gabby Douglas Are Latest and Greatest Heroes in a Storied History of African-American Gymnasts," TeamUSA, February 29, 2016, www.teamusa.org/News/2016/February/29/Simone-Biles-and-Gabby-Douglas-are -latest-in-a-storied-history-of-African-American-gymnasts.

2. Joyce Chen, "Gabby Douglas to Oprah: I Was 'Bullied,' Called 'Slave' during Early Gymnastics Training in Virginia," *New York Daily News*, August 27, 2012, www .nydailynews.com/entertainment/tv-movies/olympic-gold-medalist-gabby-douglas -tells-oprah-called-slave-gymnastics-training-virginia-article-1.1145455.

3. Dodai Stewart, "Haters Need to Shut the Hell Up about Gabby Douglas' Hair," *Jezebel*, August 1, 2012, https://jezebel.com/5930785/haters-need-to-shut-the-hell-up -about-gabby-douglass-hair.

4. Lonnae O'Neal, "The Difficulty of Being Simone Biles," *The Undefeated*, 2016, https://theundefeated.com/features/the-difficulty-of-being-simone-biles.

5. Hersh, "Simone Biles and Gabby Douglas Are Latest and Greatest Heroes in a Storied History of African-American Gymnasts."

6. Tom Van Riper, "The Cost of Raising a Summer Olympian," *Forbes*, July 24, 2012, www.forbes.com/sites/tomvanriper/2012/07/24/the-cost-of-raising-a-summer -olympian/#308702104c80.

ALL ABOUT EVE ON ICE

Creating a New Olympic Rivalry

between Blonde Girls, Just in Time

Andi Zeisler | 2014

From *Bitch Media*, January 14, 2014, www.bitchmedia.org/post/all-about-eve-on-ice -creating-a-new-olympic-rivalry.

If you'd watched Mirai Nagasu's free skate this past Saturday night at the United States National Figure Skating Championships, you definitely would have believed you'd witnessed a triumphant finish to a figure-skating cliffhanger. Nagasu, who placed fourth at the 2010 Olympic Games in Vancouver, had an uneven

recent history in competition, with a messy long program at last year's Nationals and an 8th-place finish at the NHK Trophy in Tokyo, one of the key international competitions that make up the Grand Prix. But she skated two gorgeous, clean programs at this year's Nationals—the only one of the top-four skaters, in fact, to skate without a single fall—and the smile she flashed toward the end of her long program signaled relief and pride: If the judges' scores made the decision, she'd be getting a second chance for Olympic glory.

Unfortunately, that's not how U.S. Figure Skating—or the Olympic marketing machine—works. Though until this year the top-three finishers at an Olympic-year Nationals have gotten an automatic ticket to the Games, this year the selection procedure made a historic allowance for other criteria—specifically, the "body of work" of 4th-place finisher Ashley Wagner. She, rather than bronze medalist Nagasu, will be headed to Sochi along with the 1st- and 2nd-place finishers, Gracie Gold and Polina Edmunds.[1] I'm not the only one calling shenanigans.[2]

Wagner is a two-time national champion who missed qualifying for the 2010 Olympic team by a hair, a story that background commentary emphasized heavily in this year's Nationals. Her nerves were apparent at the Nationals, and her long program seemed irrevocably marred by two falls. But Wagner was a lock for the Olympic team for one crucial reason: what NBC, the network broadcasting the Olympics, needs more than a champion skater is a good story. Preferably one that showcases not only athletic competition but a more basic competition between two young women.

1994 gave us the Kerrigan-vs.-Harding saga, a perhaps-untoppable (let's hope, anyway) storm of media narrative recently unpacked brilliantly in *The Believer* on the occasion of the event's 20th anniversary;[3] four years later, there was a less violent rivalry on deck, that between the beloved Michelle Kwan and the unbearably perky 15-year-old newcomer Tara Lipinski.[4] This year, the story can be summed up as *All About Eve* on ice: Bubbly, 18-year-old Gold, with her made-for-headlines name, is poised to unseat 22-year-old Wagner. Even before the Olympic team members were announced, the Nationals were the Ashley-vs.-Gracie show. "Gracie Gold's Triumph is Ashley Wagner's Tragedy," lamented Yahoo! Sports;[5] "Ashley Wagner Falls Twice while Gracie Gold Shines in Free Program," gloated *USA Today*.[6]

U.S. women's figure skating has long been a marquee event for Olympics broadcasts, but no U.S. competitors medaled in 2010; as John Powers noted in a recent *Boston Globe* analysis, American women haven't topped the world skating scene since 2006.[7] The result, he and other analysts worried, was that NBC, without Americans on which to hang breathless, pre-Games coverage,

could simply shunt coverage of the women's competition to the sidelines. "With Lindsay Vonn out of the skiing competition with an injury, an absent Wagner would have left the United States—and the network—without another visible star and medal hopeful," noted the *New York Times'* Jere Longman in an article titled "Wagner on U.S. Team as Officials Choose Reputation over Result."[8] But a manufactured rivalry between the perennially hopeful Wagner and newly-crowned U.S. champion Gracie Gold? That's some must-see TV.

It's impossible to ignore the whiff of racism in the federation's decision to market its Olympic rivalry as one between two women who are skating dopple-gangers, sharing the silky blond hair, white skin, snub noses, and lean, willowy physiques of classic ice queens. Despite the fact that a number of its most vis-ible champions have been women of color—Kristi Yamaguchi, Debi Thomas, Kwan—figure skating has always been a sport defined by whiteness. The first-ever black pair in the history of the sport (France's Vanessa James and Yannick Bonheur) debuted at 2010 Olympics; the bronze medalists at those same Games were Germany's Aliona Savchenko and Robin Szolkowy, the first interracial pairs skaters. France's Surya Bonaly, a three-time world silver medalist and five-time European champion, was legendarily at odds with both judges and audiences due to her "aggressive" style and strongly muscled physique—Serena Williams before Serena Williams. And it's hard to forget that back in 1998, when Lipinski rocketed out of relative obscurity to win gold over Kwan, MSNBC chose the baffling, incorrect "American Beats Out Kwan" as its headline.[9]

In other words, the racial tenor of the decision to snub Nagasu for the 2014 team may not be overt, but contextualized in skating history, it's also not unprob-lematic. There was even something to the narrative that accompanied Nagasu's performance Saturday night that was decidedly othering. Commentators Scott Hamilton, Terry Gannon, and Sandra Bezic, among others, made repeated reference to the "meltdowns" that had plagued Nagasu's performances over the past several years—crying on the ice before her long program at the 2009 Nationals, frustrating her former coach with her stress even over being in the lead—and wondered aloud at her decision to compete without a coach. Nagasu, it was implied, was simply too much of a loose cannon to count on. Wagner, meanwhile, has her own history of close calls and struggles—she once called herself the "almost girl," and lamented after her scores were posted Saturday that "I'm embarrassed that I get so much media attention for the skater that I am, and then that skater doesn't even show up on the day that it counts."

But some underdogs, it seems, are better than others. In Wagner's case, there's also more invested in them—the skater has contracts with Nike, Cover Girl, Proctor & Gamble, and Pandora jewelry, among others, making her the most

endorsed non-Olympic medalist in skating history.[10] (Nagasu has no sponsorships; Gold is a fellow Cover Girl endorsee, deepening their perceived rivalry.) And despite the petition on Change.org addressed to the president of the U.S. Figure Skating Association, Patricia St. Peter, it's unlikely to change what the federation maintains is a justified decision. "The deliberations are confidential, but I can vouch for the fact it was a fair process," St. Peter stated after the team was announced.[11] But don't count on getting clarification over whether that means fair to the athletes—or to the sponsors.

Few winter sports are as emotionally charged a spectacle as women's figure skating, and it's one of the few where judges don't even pretend to not judge a competitor's personality almost as much as their technical proficiency. In the end, the Ashley-vs.-Gracie gambit will work—and even if it doesn't there's a built-in backup story in Nationals silver medalist Edmunds, the 15-year-old whose first international competition as a senior competitor is the Olympics (and whose own story is made broadcast-ready by the fact that her mother and coach is Russian by birth).[12] In skating in general, and the Olympics in particular, it's never been just about the skating. But it's too bad that it took Nagasu losing her rightful place at the Sochi games to finally make that all too apparent.

Notes

Links in the original online version of this article have been turned into endnotes.

1. John Powers, "Ashley Wagner on, Mirai Nagasu off Olympic Team," *Boston Globe*, January 13, 2014, www.bostonglobe.com/sports/2014/01/13/ashley-wagner-mirai -nagasu-off-olympic-figure-skating-team-here-why/ojuHqvjYXdlM28Ozef8UoO /story.html.

2. "Figure Skater Mirai Nagasu Snubbed for U.S. Olympic Team," *Angry Asian Man* (blog), January 13, 2014, http://blog.angryasianman.com/2014/01/figure-skater-mirai -nagasu-snubbed-for.html.

3. Sarah Marshall, "Remote Control: Tonya Harding, Nancy Kerrigan, and the Spectacles of Female Power and Pain," *Believer*, January 2014. Available at www .believermag.com/issues/201401/?read=article_marshall.

4. Kayla Webley, "Olympic Showdowns on Ice: Michelle Kwan and Tara Lipinski," *Time*, February 25, 2010, http://content.time.com/time/specials/packages /article/0,28804,1968197_1968201_1968195,00.html.

5. "Gracie Gold's Triumph Is Ashley Wagner's Tragedy at U.S. Figure Skating Championships," Yahoo Sports, January 11, 2014, https://sports.yahoo.com/ news/gracie-gold-s-triumph-is-ashley-wagner-s-tragedy-at-u-s--figure-skating- championships-043302700-olympics.html.

6. Maggie Hendricks, "Ashley Wagner Falls Twice While Gracie Gold Shines in Free Program," *USA Today*, January 11, 2014, http://sportswire.usatoday.com/2014/01/11 /sochi-olympics-figure-skating-long-gracie-gold.

7. John Powers, "US Figure Skaters Aren't Expected to Be Forces in Sochi," *Boston*

Globe, January 5, 2014, www.bostonglobe.com/sports/2014/01/05/for-men-and
-women-solo-skaters-gilded-age-past/HvkgIwPUy8Bhr6oCICgt2L/story.html.

8. Jeré Longman, "Wagner on U.S. Team as Officials Choose Reputation Over
Result," *New York Times,* January 13, 2014, www.nytimes.com/2014/01/13/sports/
olympics/klutz-over-lutz-wagner-stumbles-to-olympic-skating-berth.html.

9. Eric Sorensen, "Asian Groups Attack MSNBC Headline Referring to Kwan—
News Web Site Apologizes for Controversial Wording," *Seattle Times*, March 3, 1998,
http://community.seattletimes.nwsource.com/archive/?date=19980303&slug=2737594.

10. "Skater Wagner Covered in Sponsor Glory," *Chicago Tribune,* November 5, 2013,
www.chicagotribune.com/chi-skater-wagner-covered-in-sponsor-glory-20131105-
column.html.

11. Alice Park, "Why Fourth Place Is Good Enough to Make the Olympic Figure
Skating Team," *Time,* January 12, 2014, http://keepingscore.blogs.time.com/2014/01/12
/why-fourth-place-is-good-enough-to-make-the-olympic-figure-skating-team.

12. Nick Zaccardi, "Meet Polina Edmunds, Breakthrough Olympic Figure Skater,"
NBC Sports, January 12, 2014, http://olympics.nbcsports.com/2014/01/12/polina
-edmunds-makes-us-olympic-team-us-figure-skating-championships.

MEDIA FAIL TO GIVE *REAL* FIRST ASIAN AMERICAN OLYMPIC GOLD MEDALIST HER DUE

Devin Israel Cabanilla | 2016

From the *Seattle Globalist,* December 15, 2016, www.seattleglobalist.com/2016/12/15
/real-first-asian-american-olympic-gold-medalist-doesnt-get-due/60115.

Earlier this month, memorial stories started running which honored the passing
of the purported first Asian American Olympic gold medalist. Sammy Lee of
California was revered for his feats in diving.

Articles reflected on Lee's admirable determination during the 1948 London
games to challenge the discriminatory sports world as a Korean American. He
won his first gold medal on Aug. 5, 1948, and a bronze at the same Olympics.
He won another gold at the 1952 games in Helsinki.

Unfortunately, declarations of his groundbreaking feat for Asian Americans be-
came a matter—once again—of a man getting credit for something a woman did.

The first Asian American Olympic gold medalist was a Filipina American woman. Her name was Victoria Manalo Draves. Manalo Draves (Draves was her married name) was the first woman diver to win two golds in the same Olympics, and she won her first gold medal in springboard diving on Aug. 3, 1948—two days before Lee won his first gold medal in platform diving.[1]

"Obviously it's just wrong," said Shannon Urabe, the visitor services assistant manager at the Wing Luke Museum of the Asian Pacific American Experience, located in Seattle. "We shouldn't assume it's men who achieve in sports first. It's especially hard to find female Asian American heroes."

Vicki Manalo Draves, who died in 2010, went through the same trials of racial segregation as Lee did, with the additional difficulty of facing bias against women. At one point, Manalo Draves was forced to use her British mother's maiden name to gain access to swimming facilities that barred people of color.

The lack of celebration and recognition of women in the sports world is sadly commonplace. Many media outlets accepted that a man was first in an achievement and this misinformation spread.

We at the Seattle-based Filipino American National Historical Society (FANHS) took up the effort to ask major news outlets for a correction: the *New York Times*, NBC News and the *Los Angeles Times*. The *New York Times* and NBC News quickly made updates and corrections to their articles, but not the *Los Angeles Times*—which missed its own 2010 story on Manalo Draves' groundbreaking Olympic achievements.[2]

"I was disappointed by the dismissive response I received from the [*L.A. Times* reporter], whose technically narrow view of journalism did not seem to allow a more expansive and truthful historical context to his article," FANHS member Ador Yano said.

(The *L.A. Times* was also called out recently for its lack of editorial tact in publishing letters that seemingly validated and condoned the incarceration of Japanese Americans during WWII.)

The effect of the preconceived notion of who belongs in "Asian America" also can't be ignored.

Psychologist E.J.R. David points out that while Filipinos and South Asians compose half of all Asian Americans today, articles on "Asian Americans" often only include people with East Asian ancestry—those with Chinese, Japanese and Korean ancestry.[3]

Or, as he puts it bluntly: "The majority of Asian Americans today are *brown*, not yellow!"

No one is diminishing Sammy Lee's achievements—being the first Asian American man to win an Olympic gold medal is notable. In real life, Lee and

Manalo Draves were teammates who respected each other, good friends (Lee gave her away at her wedding), practiced the same sport, represented the same nation and succeeded in reaching gold together at the same Olympics.

"I think it's interesting that the attempt at a diversity story in sports ended up marginalizing women while trying to highlight ethnicity," said Emily Kutzler, who studies media research. "The story of both of them would have meant just as much."

That would have been a great story to tell.

Notes

Links in the original online version of this article have been turned into endnotes.

1. Doug Williams, "Vicki Manalo Draves Overcame Prejudice to Make Olympic History," TeamUSA, March 24, 2016, www.teamusa.org/News/2016/March/24/Vicki -Manalo-Draves-Overcame-Prejudice-To-Make-Olympic-History.

2. Charles Lam, "Sammy Lee, First Asian-American Man to Win Olympic Gold Medal, Dies at 96," NBC News, December 4, 2016, www.nbcnews.com/news/asian -america/sammy-lee-first-asian-american-win-olympics-gold-dies-96-n691746; Robert D. McFadden, "Sammy Lee, First Asian-American Man to Earn Olympic Gold, Dies at 96," *New York Times*, December 3, 2016, www.nytimes.com/2016/12/03/sports /sammy-lee-dies-asian-american-olympic-gold.html; Dennis McLellan, "Victoria Manalo Draves Dies at 85; Olympic Gold Medal Diver," *Los Angeles Times,* April 29, 2010, http://articles.latimes.com/2010/apr/29/local/la-me-victoria-draves-20100429.

3. E. J. R. David, "The Marginalization of Brown Asians," *Seattle Globalist*, October 25, 2016, www.seattleglobalist.com/2016/10/25/ejr-david-marginalization-brown -asians/57763.

ON THE REZ

Ian Frazier | 2001

Excerpted from *On the Rez* by Ian Frasier. Copyright © 2000 Ian Frazier; used by permission of the Wylie Agency LLC and Farrar, Straus and Giroux.

SuAnne Marie Big Crow was born on March 15, 1974, at Pine Ridge Hospital— the brick building, now no longer a hospital, just uphill from the four-way

intersection in town. Her mother, Leatrice Big Crow, known as Chick, was twenty-five years old. Chick had two other daughters: Cecelia, called Cee Cee, who was three, and Frances, called Pigeon, who was five. Chick had been born a Big Crow, and grew up in her Grandmother Big Crow's house in Wolf Creek, a little community about five miles east of Pine Ridge. Chick had a round, pretty face, dark eyes, a determined chin, and wiry reddish-brown hair. Her figure was big-shouldered and trim; she had been a good athlete as a girl. Now she worked as an administrative assistant for the tribal planning office, and she was raising her daughters with the help of her sisters and other kin. [. . .]

As strongly as Chick forbade certain activities, she encouraged the girls in sports. At one time or another they did them all—cross-country running and track, volleyball, cheerleading, softball, basketball. Some of the teams were at school and others were sponsored by organizations in town. [. . .]

In the West, girls' basketball is a bigger deal than it is elsewhere. High school girls' basketball games in states like South Dakota and Montana draw full-house crowds, and newspapers and college recruiters give nearly the same attention to star players who are girls as to those who are boys. There were many good players on the girls' teams at Pine Ridge High School and at the parochial Red Cloud School when SuAnne was little. SuAnne idolized a star for the Pine Ridge Lady Thorpes named Lolly Steele, who set many records at the school. On a national level, SuAnne's hero was Earvin "Magic" Johnson, of the Los Angeles Lakers pro team. Women's professional basketball did not exist in those years, but men's pro games were reaching a level of popularity to challenge baseball and football. SuAnne had big posters of Magic Johnson on her bedroom walls.

She spent endless hours practicing basketball. When she was in the fifth grade, she heard somewhere that to improve your dribbling you should bounce a basketball a thousand times a day with each hand. She performed this daily exercise faithfully on the cement floor of the patio; her mother and sisters got tired of the sound. For variety, she would shoot layups against the gutter and the drainpipe, until they came loose from the house and had to be repaired. As far as anyone knew, no girl in an official game had ever dunked a basketball—that is, had leaped as high as the rim and stuffed the ball through the hoop from above—and SuAnne wanted to be the first in history to do it. To get the feel, she persuaded a younger boy cousin to kneel on all fours under the basket. With a running start, and a leap using the boy's back as a springboard, she could dunk the ball.

Charles Zimiga, who would coach SuAnne in basketball during her high school years, remembers the first time he saw her. He was on the cross-country track on the old golf course, coaching the high school boys' cross-country team

(a team that later won the state championship), when SuAnne came running by. She was in seventh grade at the time. She practiced cross-country every fall, and ran in amateur meets, and sometimes placed high enough to be invited to tournaments in Boston and California. "The fluidness of her running amazed me, and the strength she had," Zimiga said. "I stood watching her, and she stopped right in front of me—I'm a high school coach, remember, and she's just a young little girl—and she said, 'What're you lookin' at?' I said, 'A runner.' She would've been a top cross-country runner, but in high school it never did work out, because the season conflicted with basketball. I had heard about her before, but that day on the golf course was the first time I really noticed her." [. . .]

By the time SuAnne was in eighth grade, she had grown to five feet five inches ("But she played six foot," Zimiga says); she was long-limbed, well-muscled, and quick. She had high cheekbones, a prominent, arched upper lip that lined up with the basket when she aimed the ball, and short hair that she wore in no particular style. She could have played every game for the varsity when she was in eighth grade, but Coach Zimiga, who took over girls' varsity basketball that year, wanted to keep peace among older players who had waited for their chance to be on the team. He kept SuAnne on the junior varsity during the regular season. The varsity team had a good year, and when it advanced to the district playoffs, Zimiga brought SuAnne up from the JV for the playoff games. She tended to get into foul trouble; the referees rule strictly in tournament games, and SuAnne was used to a more headlong style of play. She and her cousin Doni De Cory, a five-foot-ten-inch junior, combined for many long-break baskets, with Doni throwing downcourt passes to SuAnne on the scoring end. In the district play-off against the team from Red Cloud, SuAnne scored thirty-one points. In the regional playoff game, Pine Ridge beat a good Todd County team, but in the state tournament they lost all three games and finished eighth.

Some people who live in the cities and towns near reservations treat their In-dian neighbors decently; some don't. In Denver and Minneapolis and Rapid City police have been known to harass Indian teenagers and rough up Indian drunks and needlessly stop and search Indian cars. Local banks whose deposits include millions in tribal funds sometimes charge Indians higher interest rates than they charge whites. Gift shops near reservations sell junky caricature In-dian pictures and dolls, and until not long ago beer coolers had signs on them that said INDIAN POWER. In a big discount store in a reservation-border town a white clerk observes a lot of Indians waiting at the checkout and remarks, "Oh, they're Indians—they're used to standing in line." Some people in South

Dakota hate Indians, unapologetically, and will tell you why; in their voices you can hear a particular American meanness that is centuries old.

When teams from Pine Ridge play non-Indian teams, the question of race is always there. When Pine Ridge is the visiting team, usually the hosts are courteous and the players and fans have a good time. But Pine Ridge coaches know that occasionally at away games their kids will be insulted, their fans will feel unwelcome, the host gym will be dense with hostility, and the referees will call fouls on Indian players every chance they get. Sometimes in a game between Indian and non-Indian teams, the difference in race becomes an important and distracting part of the event.

One place where Pine Ridge teams used to get harassed regularly was the high school gymnasium in Lead, South Dakota. Lead is a town of about 3,200 northwest of the reservation, in the Black Hills. It is laid out among the mines that are its main industry, and low, wooded mountains hedge it around. The brick high school building is set into a hillside. The school's only gym in those days was small, with tiers of gray-painted concrete on which the spectator benches descended from just below the steel-beamed roof to the very edge of the basketball court—an arrangement that greatly magnified the interior noise.

In the fall of 1988, the Pine Ridge Lady Thorpes went to Lead to play a basketball game. SuAnne was a full member of the team by then. She was a freshman, fourteen years old. Getting ready in the locker room, the Pine Ridge girls could hear the din from the Lead fans. They were yelling fake Indian war cries, a "woo-woo-woo" sound. The usual plan for the pre-game warm-up was for the visiting team to run onto the court in a line, take a lap or two around the floor, shoot some baskets, and then go to their bench at courtside. After that, the home team would come out and do the same, and then the game would begin. Usually the Thorpes lined up for their entry more or less according to height, which meant that senior Doni De Cory, one of the tallest, went first. As the team waited in the hallway leading from the locker room, the heckling got louder. A typical kind of hollered remark was "Squaw!" or "Where's the cheese?" (the joke being that if Indians were lining up, it must be to get commodity cheese); today no one remembers exactly what was said. Doni De Cory looked out the door and told her teammates, "I can't handle this." SuAnne quickly offered to go first in her place. She was so eager that Doni became suspicious. "Don't embarrass us," Doni told her. SuAnne said, "I won't. I won't embarrass you." Doni gave her the ball, and SuAnne stood first in line.

She came running onto the court dribbling the basketball, with her teammates running behind. On the court the noise was deafening. SuAnne went right down the middle and suddenly stopped when she got to center court. Her teammates

were taken by surprise, and some bumped into each other. Coach Zimiga, at the rear of the line, did not know why they had stopped. SuAnne turned to Doni De Cory and tossed her the ball. Then she stepped into the jump-ball circle at center court, facing the Lead fans. She unbuttoned her warm-up jacket, took it off, draped it over her shoulders, and began to do the Lakota shawl dance. SuAnne knew all the traditional dances (she had competed in many powwows as a little girl), and the dance she chose is a young woman's dance, graceful and modest and show-offy all at the same time. "I couldn't believe it—she was powwowin', like, 'get down!'" Doni De Cory recalls. "And then she started to sing." SuAnne began to sing in Lakota, swaying back and forth in the jump-ball circle, doing the shawl dance, using her warm-up jacket for a shawl. The crowd went completely silent. "All that stuff the Lead fans were yelling—it was like she *reversed* it somehow," a teammate says. In the sudden quiet all they could hear was her Lakota song. SuAnne dropped her jacket, took the ball from Doni De Cory, and ran a lap around the court dribbling expertly and fast. The audience began to cheer and applaud. She sprinted to the basket, went up in the air, and laid the ball through the hoop, with the fans cheering loudly now. Of course, Pine Ridge went on to win the game. [. . .]

Because [this was] one of the coolest and bravest deeds I ever heard of, I would like to consider it from a larger perspective that includes the town of Lead, all the Black Hills, and 125 years of history.

Lead, the town, does not get its name from the metal. The lead the name refers to is a mining term for a gold-bearing deposit, or vein, running through surrounding rock. The word, pronounced with a long *e*, is related to the word "lode." During the Black Hills gold rush of the 1870s, prospectors found a rich lead in what would become the town of Lead. In April 1876, Fred and Moses Manuel staked a claim to a mine they called the Homestake. Their lead led eventually to gold and more gold—a small mountain of gold—whose wealth may be guessed by the size of the hole its extraction has left in the middle of present-day Lead.

In 1877, a mining entrepreneur from San Francisco named George Hearst came to the Hills, investigated the Manuels' mine, and advised his big-city partners to buy it. The price was $70,000. At the time of Hearst's negotiations, the illegal act of Congress that would take this land from the Sioux had only recently passed. The partners followed Hearst's advice, and the Homestake Mine paid off its purchase price four times over in dividends alone within three years. When George Hearst's only son, William Randolph, was kicked out of Harvard for giving his instructors chamber pots with their names inscribed on the inside, George Hearst suggested that he come West and take over his (George's) share in

the Homestake Mine. William Randolph Hearst chose to run the San Francisco *Examiner* instead. His father gave him a blank check to keep it going for two years; gold from Lead helped to start the Hearst newspaper empire. Since the Homestake Mine was discovered, it has produced at least $10 billion in gold. It is one of the richest gold mines in the world.

Almost from the moment that George Armstrong Custer's expedition entered the Black Hills, in 1874, to investigate rumors of gold, there was no way the Sioux were going to be allowed to keep this land. At Custer's announcement that the expedition had found "gold in the roots of the grass," the rush began. By 1875, the Dakota Territorial Legislature had already divided the Black Hills land into counties; Custer County, in the southern Hills, was named in that general's honor while he was still alive, and while the land still clearly belonged to the Sioux. Many people in government and elsewhere knew at the time that taking this land was wrong. At first, the Army even made halfhearted attempts to keep the prospectors out. A high-ranking treaty negotiator told President Ulysses S. Grant that the Custer expedition was "a violation of the national honor." One of the commissioners who worked on the "agreement" that gave paper legitimacy to the theft said that Custer should not have gone into the Hills in the first place, and with the other commissioners reminded the government that it was making the Sioux homeless and that it owed them protection and care. The taking of the Black Hills proceeded inexorably all the same.

Sioux leaders of Crazy Horse's generation began working to receive fair compensation for the Hills in the early 1900s. The Black Hills claim that the Sioux filed with the U.S. Court of Claims in the 1920s got nowhere. In 1946, the government established the Indian Claims Commission specifically to provide payment for wrongly taken Indian lands, and in 1950 the Sioux filed a claim for the Black Hills with the ICC. After almost twenty-five years [. . .], the ICC finally ruled that the Sioux were entitled to a payment of $17.5 million plus interest for the taking of the Hills. Further legal maneuvering ensued. In 1980 the Supreme Court affirmed the ruling and awarded the Sioux a total of $106 million. Justice Harry Blackmun wrote for the majority, "A more ripe and rank case of dishonorable dealings will never, in all probability, be found in our history"—which was to say officially, and finally, that the Black Hills had been stolen.

By the time of the Supreme Court ruling, however, the Sioux had come to see their identity as linked to the Hills themselves, and the eight tribes involved decided unanimously not to accept the money. They said, "The Black Hills are not for sale." The Sioux now wanted the land back—some or all of it—and trespass damages as well. They especially wanted the Black Hills lands still owned by the federal government. These amount to about 1.3 million acres, a small proportion of what was stolen. At the moment the chances that the Sioux will get these or

any other lands in the Black Hills appear remote. The untouched compensation money remains in a federal escrow account, where it, plus other compensation money, plus accumulated interest, is now more than half a billion dollars.

Inescapably, this history is present when an Oglala team goes to Lead to play a basketball game. It may even explain why the fans in Lead were so mean: fear that you might perhaps be in the wrong can make you ornerier sometimes. In all the accounts of this land grab and its aftermath, and among the many greedy and driven men who had a part, I cannot find evidence of a single act as elegant, as generous, or as transcendent as SuAnne's dance at center court in the gym at Lead.

For the Oglala, what SuAnne did that day almost immediately took on the status of myth. People from Pine Ridge who witnessed it still describe it in terms of awe and disbelief. Amazement swept through the younger kids when they heard. "I was, like, '*What* did she just do?'" recalls her cousin Angie Big Crow, an eighth grader at the time. All over the reservation, people told and retold the story of SuAnne at Lead. Anytime the subject of SuAnne came up when I was talking to people on Pine Ridge, I would always ask if they had heard about what she did at Lead, and always the answer was a smile and a nod—"Yeah, I was there," or "Yeah, I heard about that." To the unnumbered big and small slights of local racism that the Oglala have known all their lives, SuAnne's exploit made an emphatic reply.

Back in the days when Lakota war parties still fought battles against other tribes and the Army, no deed of war was more honored than the act of counting coup. To "count coup" means to touch an armed enemy in full possession of his powers with a special stick called a coup stick, or with the hand. The touch is not a blow, and serves only to indicate how close to the enemy you came. As an act of bravery, counting coup was regarded as greater than killing an enemy in single combat, greater than taking a scalp or horses or any prize. Counting coup was an act of almost abstract courage, of pure playfulness taken to the most daring extreme. Very likely, to do it and survive brought an exhilaration to which nothing else could compare. In an ancient sense that her Oglala kin could recognize, SuAnne counted coup on the fans of Lead.

And yet this coup was an act not of war but of peace. SuAnne's coup strike was an offering, an invitation. It gave the hecklers the best interpretation, as if their silly, mocking chants were meant only in good will. It showed that their fake Indian songs were just that—fake—and that the real thing was better, as real things usually are. We Lakota have been dancing like this for centuries, the dance said; we've been doing the shawl dance since long before you came, before you got on the boat in Glasgow or Bremerhaven, before you stole this land, and we're still doing it today. And isn't it pretty, when you see how it's supposed to

be done? Because finally what SuAnne proposed was to invite us—us onlookers in the stands, namely the non-Lakota rest of this country—to dance, too. She was in the Lead gym to play, and she invited us all to play. The symbol she used to include us was the warm-up jacket. Everyone in America has a warm-up jacket. I've got one, probably so do you, so did (no doubt) many of the fans at Lead. By using the warm-up jacket as a shawl in her impromptu shawl dance, she made Lakota relatives of us all.

"It was funny," Doni De Cory says, "but after that game the relationship between Lead and us was tremendous. When we played Lead again, the games were really good, and we got to know some of the girls on the team. Later, when we went to a tournament and Lead was there, we were hanging out with the Lead girls and eating pizza with them. We got to know some of their parents, too. What SuAnne did made a lasting impression and changed the whole situation with us and Lead. We found out there are some really good people in Lead."

America is a leap of the imagination. From its beginning people, had only a persistent idea of what a good country should be. The idea involves freedom, equality, justice, and the pursuit of happiness; nowadays most of us probably could not describe it much more clearly than that. The truth is, it always has been a bit of a guess. No one has ever known for sure whether a country based on such an idea is really possible, but again and again we have leaped toward the idea and hoped. What SuAnne Big Crow demonstrated in the Lead high school gym is that making the leap is the whole point. The idea does not truly live unless it is expressed by an act; the country does not live unless we make the leap from our tribe or focus group or gated community or demographic and land on the shaky platform of that idea of a good country which all kinds of different people share.

This leap is made in public, and it's made free. It's not a product or a service that anyone will pay you for. You do it for reasons unexplainable by economics—for ambition, out of conviction, for the heck of it, in playfulness, for love. It's done in public spaces, face-to-face, where anyone may go. It's not done on television, on the Internet, or over the telephone; our electronic systems can only tell us if a leap made elsewhere has succeeded or failed. The places you'll see it are high school gyms, city sidewalks, the subway, bus stations, public parks, parking lots, and wherever people gather during natural disasters. In those places and others like them, the leaps that continue to invent and knit the country continue to be made. When the leap fails, it looks like the L.A. riots, or Sherman's march through Georgia. When it succeeds, it looks like the New York

City Bicentennial Celebration in July 1976, or the Civil Rights March on Washington in 1963. On that scale, whether it succeeds or fails, it's always something to see. The leap requires physical presence and physical risk. But the payoff—in terms of dreams realized, of understanding, of people getting along—can be so glorious as to make the risk seem minuscule.

I find all this hopefulness, and more, in SuAnne's dance at center court in the gym in Lead. My high school football coach used to show us films of our previous game every Monday after practice, and whenever he liked a particular play, he would run it over and over again. If I had a film of SuAnne at Lead (as far as I know, no such film or video exists), I would study it in slow motion frame by frame. There's a magic in what she did, along with the promise that public acts of courage are still alive out there somewhere. Mostly I would run the film of SuAnne again and again for my own braveheart song. I refer to her, as I do to the deeds of Crazy Horse, for proof that it's a public service to be brave.

PART VIII *Women, Sport, and the Media*

Part 8 addresses the representations of women athletes in sport media, as well as the embattled history of women journalists. Media matters because of the commercial nature of big-time sports. Women's professional sport in the U.S., especially soccer, basketball, softball, and volleyball leagues, faces a conundrum. To gain popularity, a sport must be visible, which in our society means gaining television, print, and social media attention. But for networks to assume the cost of televising a sport, executives must be confident that advertisers will pay to promote their products during telecasts. Marketers base their decisions on the perceived popularity of the particular sport or league as they try to gauge market size and potential profits and losses. This becomes a vicious circle for promoters of women's sport: promoters need adequate media coverage to attract an audience, yet promoters cannot interest the media in covering a sport unless it is already widely popular.

Cheryl Cooky, Michael A. Messner, and Robin H. Hextrum's key article, "Women Play Sport, but Not on TV: A Longitudinal Study of Televised News Media," reveals that this coverage is lower in 2010 than it was 20 years ago. Consequently, news media "build audiences for men's sport while silencing and marginalizing women's sport," perpetuating the message that sport is for and about men.

Sport studies scholars Marie Hardin, Susan Lynn, and Kristie Walsdorf circumvent the usual silence and marginalization by focusing on the contents of women's sport and fitness magazines. Through their analysis, they argue that,

due to a powerful mix of sexism and ableism, women with impairments contend with "double exclusion," while women of color with impairments must also deal with systemic racism, putting them in a "triple bind." As a result, fitness publications directed toward female readers overwhelmingly foreground white, able-bodied sportswomen.

Lindy West continues the media critique by noting several sexist moments in the reportage of the 2016 Summer Olympic Games. Her article, "How to Talk about Female Olympians without Being a Regressive Creep—A Handy Guide" provides a tongue-in-cheek but nonetheless observant checklist for sport journalists who want to write respectfully about female athletes.

It seems that journalists covering Muslim sportswomen could use a "handy guide" of their own, as sport activist and journalist Shireen Ahmed makes clear. Too often reporters rely on overgeneralized tropes that perpetuate "gendered Islamophobia" while failing simply to recognize the women as athletes. Part of the problem, Ahmed maintains, is that the vast majority of sportswriters are "white, straight, able-bodied men." In fact, according to the 2017 Women's Media Center report, women make up just 11.3 percent of all American sport columnists and 12.6 percent of sport reporters. On television, men make up 95 percent of anchors and co-anchors and 96 percent of sport analysts, while women's highest representation came in at 14.4 percent of ancillary reporters. Women in sport media face attacks on their credibility, which have become even more aggressive, relentless, and anonymous with the advent of social media. And too often the vitriol spills into sexual harassment and threats of sexual violence, as Julie DiCaro explains in the final reading in this part.

WOMEN PLAY SPORT, BUT NOT ON TV

A Longitudinal Study of Televised News Media

Cheryl Cooky, Michael A. Messner,
and Robin H. Hextrum | 2013

Using quantitative and qualitative analysis, we examine the televised news media coverage on the local news affiliates in Los Angeles (KABC, KNBC, and KCBS) and on a nationally broadcast sports news and highlights show, ESPN's *SportsCenter*, to assess changes and continuities in the amount of coverage and the quality of coverage of men's and women's sports. We argue that both the amount of coverage of women's sports and the quality of that coverage illustrate the ways in which televised news media build audiences for men's sport while silencing and marginalizing women's sport. Moreover, the overall lack of coverage of women's sport, despite the tremendous increased participation of girls and women in sport at the high school, collegiate, and professional levels, conveys the message to audiences that sport continues to be by, for, and about men. [. . .]

Method

[. . .] The central aim of the current study was to compare the quantity and quality of televised news and highlights shows' coverage of women's and men's athletic events. [. . .]

We analyzed 6 weeks of television sports news, both the 6 p.m. segments and the 11 p.m. segments, on the three local network affiliates in Los Angeles (KNBC, KCBS, and KABC). As in the 1989, 1993, 1999, and 2004 studies, in order to ensure the sample included various sports seasons, we analyzed three 2-week blocks: March 15–28; July 12–25; and November 8–21. The codebook drew upon previous iterations of the study and included gender of sport (male, female, neutral), type of sport (basketball, football, golf, tennis, etc.), competitive level of the sport (professional, college, high school, youth, recreation, etc.), and time of the segment (measured from the beginning of an individual segment of coverage, reported in total minutes/seconds; segments were defined based on the type of sport covered). Codes were also included to quantify production values (coded as yes/no) including the use of music, the use of graphics, interviews, and the inclusion of game highlights. We analyzed the main coverage of the broadcast, as well as the scrolling ticker at the bottom of the screen (in cases where it was present). In addition to the above quantitative measures, we analyzed the quality of coverage in terms of visuals and verbal commentary.

In addition to the local affiliates, we analyzed 3 weeks[1] of the 1-hr 11 p.m. ESPN *SportsCenter* broadcasts. These 3 weeks corresponded with the first week of each of the three network news segments: March 15–21, July 12–18, and November 8–14. As mentioned above, we added *SportsCenter* to the study in 1999, which allows us the ability to compare the 2009 data with the 1999 and 2004 data. The same procedures used for the analysis of the local affiliates were followed for the analysis of *SportsCenter*. [. . .]

Analysis and Interpretation of Findings

The first "Gender and Televised Sports" report was issued in 1990, nearly two decades after Title IX fueled an explosion of girls' and women's athletic participation in the United States. The 1990 report heralded the recent surge of girls' participation in youth sports, the dramatic upswing of girls' and women's high school and college sports opportunities and participation, and the stirrings of growth in women's professional sports. The study concluded that since women's sports received only 5% of TV news coverage, people who get all or most of their information from television news would have little idea how dramatically sports had changed. One common response to the 1990 study was an optimistic view: Members of the public and many students with whom we discussed our findings assumed that TV news coverage was simply lagging behind the surging popularity of women's sports; they predicted that news media coverage would gradually catch up to the growing participation rates of girls and women in sport.

Twenty years later, this optimistic prediction of an evolutionary rise in TV news coverage of women's sports has proven to be wrong. During the ensuing two decades, girls' participation in youth sports has continued to rise (Sabo & Veliz, 2008; Staurowsky et al., 2009). In 1971, only 294,000 U.S. high school girls played interscholastic sports, compared with 3.7 million boys. In 1989, the first year of our sports media study, high school boy athletes still outnumbered girls, 3.4 million to 1.8 million. By 2009, the high school sports participation gap had closed further, with 4.4 million boys and 3.1 million girls playing (National Federation of State High School Associations, 2009). This trend is echoed in college sports. In 1972, the year Title IX was enacted, there were only a little over two women's athletics teams per college. By 2010, the number had risen to 8.64 teams per NCAA school (Carpenter & Acosta, 2010). Women's professional sports, including the WNBA (founded in 1996) has developed a somewhat stronger foothold in the larger professional sports marketplace. However, during the past two decades of growth in women's sports, the gap between TV news and highlights shows' coverage of women's and men's sports has not narrowed, rather it has widened. Women's sports in 2009 received only 1.3% of the coverage on TV news, and 1.3% on ESPN's *SportsCenter*.

This deepening silence about women's sports in mainstream televised news and highlights shows is of particular concern for sports studies scholars, especially when considered alongside the fact that the world of sports is no longer a "male preserve," in which boys and men enjoy privileged and exclusive access to sport participation opportunities (Messner, 2002). To be sure, there is an expanding array of media sources of sports information, including Internet websites, which fans of women's sports can tap for news about their favorite athletes or teams.[2] Though it is nowhere near the level of the seemingly 24/7-live broadcasts of men's sports across the TV dial, the number of live broadcasts of women's sports has also expanded over the past 20 years (in 2003, ESPN began broadcasting the women's NCAA basketball tournament in its entirety on its sister station, ESPN 2). But television news and highlights shows remain two extremely important sources of sports information. Their continued tendency to ignore or marginalize women's sports helps maintain the myth that sports are exclusively by, about, and for men.

How can we explain the growing chasm between coverage of women's and men's sports? We are cautious in interpreting why coverage of women's sports has nearly evaporated, based entirely on our content analysis of the programming. To answer this "why" question would require a study that also focuses on the production of news and highlights shows. What assumptions and values guide the decisions of producers, editors, and TV sports commentators on

what sports stories and events are important to cover, and how to cover them? When asked, producers, commentators, and editors will usually explain their lack of attention to women's sports by claiming that they are constrained by a combination of market forces and by their desire to give viewers "what they want to see." We understand programmers' desire to respond to market realities and viewer preferences. And while we recognize that ESPN and other media outlets conduct extensive marketing research to determine what to cover, when, and how, we wish to engage the question of how it is that the coverage or lack thereof builds audiences for men's sports. If ESPN's marketing research were to show that viewers are more interested in men's sports, our theoretical orientation leads us to examine how it is that this interest is socially constructed; the media are one institution among many that promotes men's sports while ignoring women's sports. Not acknowledging the important role the media play in promoting men's sport through their coverage of visually and aurally exciting highlights and commentary downplays the power media institutions have to provide exciting and pleasurable experiences, which enhance the interest in and consumption of men's sport.

The expansion of new media has been accompanied by shrinking revenues for traditional mass media, leading to tighter budgets and staff cuts for traditional news outlets. In a March 2010 editorial blog, *Los Angeles Times* sports editor Mike James responded to reader complaints about the newspaper's lack of coverage of college women's basketball and other smaller market sports:

> True, we haven't been covering a lot of women's basketball this season, aside from a couple of features, largely because women's basketball hasn't been a major draw in LA. . . . Consequently, we have to make the difficult decisions every day on what events and sports we do cover and those that we can't. Our decision has been to try to make sure we reach the greatest number of readers we can with resources available, and regrettably, that means that some areas don't get much regular coverage. (Edgar, 2010)

James' lament about the impact of recent staff cuts at the *LA Times* would surely be echoed by hundreds of newspaper editors across the nation. As reporters and other sports news staff are cut, newspapers play it safe and assign their remaining staff to big-market sports teams that, they assume, "the greatest number of readers" want to read about. However, it is unlikely that the well-documented financial decline of print journalism can explain the declining coverage of women's sports in television news. And it certainly cannot explain the lack of coverage on ESPN's *SportsCenter*. In its 2010 media guide published for potential advertisers, ESPN claims that it is the "most viewed ad supported cable channel"

and that the 2009 broadcast year was ESPN's "highest rated ever" (ESPN 2010, p. 5). Clearly, ESPN has no shortage of viewers, or presumably of advertising revenue, so in this case, the argument of shrinking budgets or budget cuts (e.g., which may be the case for newspapers) is not a convincing one. ESPN's decision to ignore women's sports must be due to other factors, which we discuss below.

ESPN tells potential advertisers that in 2009 it was the top cable network viewed consistently by men aged 18–54 and that it has been "men's favorite TV network since 1998" (ESPN, 2010, p. 5). Clearly, the ways in which ESPN targets its programming to male viewers is reflective of a larger trend, wherein TV producers carve out market niches that situate male viewers in the electronic equivalent of locker rooms characterized by male banter and ironic humor (Farred, 2000; Messner & Montez de Oca, 2005; Nylund, 2007).

A foundational assumption of those who create programming for men on programs like *SportsCenter* seems to be that the mostly male viewers want to think of women as sexual objects of desire, or perhaps as mothers, but not as powerful, competent, competitive athletes. This is a questionable assumption, especially given some of the latest data from the University of Minnesota's Tucker Center, which has found that across various demographic variables, including age and gender, when female athletes are portrayed as athletically competent, these images generated the greatest interest in women's sport, while the sexualized images of female athletes were the least likely to generate interest in women's sport (Kane & Maxwell, 2011). But even if this sexist assumption of male desire to see women as sex objects accurately captures the desires and values of a large swath of the U.S. male demographic that watches ESPN, it is probably inaccurate to operate from the same assumptions concerning viewers of evening TV news on their local affiliates. After all, a sports report on the evening and late night news is a short (2–5 min) segment embedded within a larger news report that is being viewed by a diverse audience. Presumably, a large proportion of TV news viewers are women, many of whom are unlikely to find the male-centric views of the locker room or its ironic, sexist banter to be very inviting. We wonder how many women—and indeed, how many men—simply tune out when the sports segment of the evening news begins.

In past iterations of this study, we pointed to the ways that sexist humor in sports commentary made fun of women and trivialized women athletes (and often women spectators at sporting events). We argued that this trivialization and sexualization of women in the news broadcasts served to marginalize women's sports, while also creating a viewing experience for male viewers that meshed neatly with the feeling of a locker room culture that affirms the centrality of men (Kane & Maxwell, 2011; Messner et al., 2003). In 2004, we noted a lessening

of this sort of trivialization and sexualization of women in the broadcasts. Our 2009 study revealed that these practices nearly disappeared.

It is a positive development that sports news and highlights viewers are less often seeing disparaging and sexist portrayals of women (Bernstein, 2002; Daniels, 2009; Daniels & LaVoi, 2012). However, this decline in negative portrayals of women has not been accompanied by an increase in respectful, routine news coverage of women's sports. Instead, when the news and highlights shows ceased to portray women athletes in trivial and sexualized ways, they pretty much ceased to portray them at all.

The "women's sports history" segments during the month of March on *SportsCenter* offer an intriguing glimpse into programmers' assumptions about how to present women's sports to male viewers who are used to being fed a steady diet of men's sports. While these special segments had high technical quality, and were produced in ways that were respectful of the accomplishments of the women athletes, two elements were notable. First, these features were placed in a liminal space between regular *SportsCenter* stories and ESPN commercial breaks. Clearly, they were meant to be viewed as something different, separate, and apart from the regular programming (which on most nights continued their normal coverage of mostly the "Big Three" men's sports). Second, one of the features was narrated by the voice-over of the male fiancé of the woman athlete being featured. We interpret this as a strategy to make a woman athlete recognizable and palatable to a presumably male audience: In (mostly) rejecting the past practices of making a woman athlete familiar and "consumable" to a male audience by sexualizing her, producers in 2009 packaged the woman athlete instead as a family member, in a familiar role as mother, girlfriend, or wife.

Viewing the woman athlete through the male gaze of sexualized humor is apparently (and thankfully) now discredited; instead, now women athletes are being repackaged to be seen through another male gaze—as family members. This repackaging of women athletes meshes with the larger commercial project of packaging women athletes as heterosexual mothers/wives (most recently seen in the marketing and broadcast coverage of the 2012 Olympics). This practice has been criticized both for the ways in which it renders lesbian and other women athletes marginal or invisible and for the ways in which it maintains the public view of women athletes from the vantage point of men's continued positions of centrality in social life.

Connected with the silencing of women athletes is the fact that the voices of women commentators continue to be entirely absent from the local affiliates' sports news broadcasts, and heard very rarely on *SportsCenter*. Unlike TV news

anchor, reporter, and weather announcer positions, the occupation of TV sports commentator continues to remain mostly sex segregated (Etling & Young, 2007; Sheffer & Schultz, 2007). Women have had a very difficult time breaking in to sports broadcasting, remaining relegated at best to marginal roles such as "sideline reporter" during an NBA or men's college basketball game. Viewers of sports news and highlights shows continue to receive a constant barrage of words and images about men's sports, narrated by a cacophony of men's voices.

In the absence of audience research, we must be cautious in drawing conclusions about the meanings that TV viewers make of sports news and highlights shows. However, we can speculate on these questions, based on our analysis of the trends over the past 20 years, and the dominant meanings that are conveyed in the patterns of gendered coverage of sports stories.

It has been known for many years that sports news and highlights shows do not simply "give viewers what they want," in some passive response to demand. Instead, there is a dynamic reciprocal relationship between commercial sports and the sports media. Media scholar Sut Jhally called this self-reinforcing monetary and promotional loop the "sports/media complex" (Jhally, 1984). When we add fans into this loop, we can see how information and pleasure enhancement are part of a circuit that promotes and actively builds audiences for men's sports, while simultaneously providing profits for men's sports organizations, commercial sponsors, and the sports media. Sports fans seek out news wraps and highlights of games—even of games they have already watched in their entirety—not simply for information, but because viewing these news broadcasts enhances and amplifies the feelings—the tension, suspense, and exhilaration—they may have enjoyed a few hours earlier.

As such, TV news and highlights shows do not simply "reflect" fan interest in certain sports, as sports commentators and editors often argue. They also help generate and sustain enthusiasm for the sports they cover, thus becoming a key link in fans' emotional connection to the agony and ecstasy of spectator sports. Fans of men's sports—especially the Big Three of football, basketball, and baseball—become accustomed to having this fix routinely delivered to their living rooms. This emotional enhancement is but one element of the larger role of TV sports news in building audiences for men's sports. Meanwhile, their silence, marginalization, and trivialization of women's sports ensure smaller audiences for women's sports, while keeping fans of women's sports on emotional life support.

We have noted in past studies how a comparison of coverage of women's and men's NCAA basketball offers an especially valuable window into TV news' audience-building functions (Messner et al., 1996). Our 2009 data enhance our

understanding of how audience-building works. As we noted above, far less time was devoted to reporting on the women's NCAA tournament than on the men's. What was most striking in the 2009 study was the amount of time all of the news and highlights shows spent on (and the enthusiastic, even excited tone within which they couched) reports about upcoming men's NCAA tournament seeds and matchups. Little or no such anticipatory reports on the women's games appeared on the broadcasts within our sample. Even after the tournament games started, reports on the women's games were, at best, typically relegated to the ticker. Meanwhile, the men's tournament was receiving significant coverage in every broadcast.

Audience-building for men's sports permeates the mass media in a seemingly organic manner. As such, these promotional efforts are more easily taken for granted and, ironically, may be less visible as promotion. News and highlights shows are two important links in an extensive apparatus of audience-building for men's sports. However, they rarely operate this way for women's sports.

Conclusion

Can these stubborn patterns of inequitable coverage of women's sports be broken or changed? Clearly, the longitudinal data from our study show that there is no reason to expect an evolutionary growth in media coverage of women's sports. To the contrary, our research shows that the proportion of coverage devoted to women's sports on televised news over the past 20 years has actually declined, and there is no reason to believe that this trend will reverse itself in the next 20 years unless producers decide that it is in their interests to do so. For this to happen in a substantial way, power relations and perceptions of gender will have to continue to change within sport organizations, with commercial sponsors who promote and advertise sports, and within the mass media. These shifts in perception will not come about by themselves but will involve changes and pressures from a number of directions.

One important source of such change within the mass media would involve an affirmative move toward developing and supporting more women sports reporters and commentators. While we should be cautious in assuming that women reporters will necessarily cover sports differently from the ways that men do, there is some evidence to suggest that women sports reporters are less likely to cover women athletes in disrespectful ways, and more likely to advocate expanding the coverage of women's sports (Hardin & Whiteside, 2008; Kian & Hardin, 2009; LaVoi, Buysse, Maxwell, & Kane, 2007; Staurowsky & DiManno, 2002).

Sports organizations too can contribute to change by providing the sports media with more and better information about women athletes. Indeed, a longitudinal study shows that university sports information departments have vastly improved their presentation of women's sports in their annual media guides (Kane & Buysse, 2005). Sports fans can also be an active part of this loop to promote change: Audience members can complain directly to the producers of sports programs—to tell them that they do not appreciate sexist treatment of women in sports news and highlights shows and that they want to see more and better coverage of actual women's sports. That is why, perhaps, they call it "demand."

Overall, we find the results of this study to be discouraging. Clearly, change has happened, but not in the direction of improved coverage of women's sports. In recent years, sports news and highlights shows have evidenced a retrenchment, expressed through a narrowed focus on a few commercially central men's sports.

Notes

Note numbers and callouts have been changed from the original article.

1. One reviewer noted the sampling method eliminated important women's sports events including the WNBA finals or Wimbledon. Here, the following weeks were selected to provide continuity with previous studies. The sampling dates originated in the 1989 data collection, nearly 10 years before the advent of the WNBA. In order to make consistent comparisons across time, the same time frames were sampled for every study. While we might expect to see more coverage following these events, the data itself would suggest otherwise. For example, our comparison between the NBA and WNBA showed that during the WNBA season (July), there was more coverage of the NBA, which was out of season during that 2-week sample period.

2. Shortly after the online release of the "Gender in Televised Sports" report, ESPN launched a new website devoted to "women sports fans," ESPNW.com. Here it is important to note that the website's goal is not to solely to cover women's sports, although the website aspires to be "your primary destination for women's sports." It also aims to cover sports in ways that appeal to women sports fans, as its tag, "an online destination for female sports fans and athletes" and its goal to "connect female sports fans to the sports they love," suggest (http://espn.go.com/espnw/about).

References

Bernstein, A. (2002). Is it time for a victory lap? Changes in the media coverage of women in sport. *International Review for the Sociology of Sport, 37,* 415–428.

Carpenter, L. J., & Acosta, V. (2010). *Women in intercollegiate sport: A longitudinal,*

national study, thirty-three year update. Retrieved from http://www.acostacarpenter.org/

Daniels, E. A. (2009). Sex objects, athletes and sexy athletes: How media representations of women athletes can impact adolescent girls and college women. *Journal of Adolescent Research*, 24, 399–423.

Daniels, E. A., & LaVoi, N. M. (2012). Athletics as solution and problem: Sports participation for girls and the sexualization of female athletes. In T. A. Roberts & E. L. Zubriggen (Eds.), *The sexualization of girls and girlhood* (pp. 63–83). New York, NY: Oxford University Press.

Edgar, D. (2010, March 12). Which sports to cover? It's a tough call. *Los Angeles Times*. Retrieved from http://latimesblogs.latimes.com/readers/2010/03/which-sports-to-cover-its-a-tough-call.html

ESPN. (2010). *2010 Pocket Guide*. ESPN Marketing and Sales. Retrieved from http://www.espncms.com/

Etling, L., & Young, R. (2007). Sexism and authoritativeness of female sportscasters. *Communication Research Reports*, 24, 121–130.

Farred, G. (2000). Cool as the other side of the pillow: How ESPN's *SportsCenter* has changed television sports talk. *Journal of Sport and Social Issues*, 24, 96–117.

Hardin, M., & Whiteside, E. (2008). Maybe it's not a 'generational thing': Values and beliefs of aspiring sport journalists about race and gender. *Media Report to Women*, 36, 8–16.

Jhally, S. (1984). The spectacle of accumulation: Material and cultural factors in the evolution of the Sports/Media Complex. *Critical Sociology*, 12, 41–57.

Kane, M. J., & Buysse, J. A. (2005). Intercollegiate media guides as contested terrain: A longitudinal analysis. *Sociology of Sport Journal*, 22, 214–238.

Kane, M. J., & Maxwell, H. D. (2011). Expanding the boundaries of sport media research: Using critical theory to explore consumer responses to representations of women's sports. *Journal of Sport Management*, 25, 202–216.

Kian, E. T. M., & Hardin, M. (2009). Framing sports coverage based on the sex of sports writers: Female journalists counter the traditional gendering of media coverage. *International Journal of Sport Communication*, 2, 185–204.

LaVoi, N. M., Buysse, J., Maxwell, H. D., & Kane, M. J. (2007). The influence of occupational status and sex of decision maker on media representations in intercollegiate athletics. *Women in Sport & Physical Activity Journal*, 15, 32–43.

Messner, M. A. (2002). *Taking the field: Women, men and sports*. Minneapolis: University of Minnesota Press.

Messner, M. A., Duncan, M. C., & Cooky, C. (2003). Silence, sports bras, and wrestling porn: The treatment of women in televised sports news and highlights. *Journal of Sport and Social Issues*, 27, 38–51.

Messner, M. A., Duncan, M. C., & Wachs, F. L. (1996). The gender of audience-building: Televised coverage of men's and women's NCAA basketball. *Sociological Inquiry*, 66, 422–439.

Messner, M. A., & Montez de Oca, J. (2005). The male consumer as loser: Beer and liquor ads in mega sports media events. *Signs: Journal of Women in Culture and Society*, 30, 1879–1909.

National Federation of State High School Associations (2009). *2008–09 High school athletics participation survey*. Retrieved from http://www.nfhs.org

Nylund, D. (2007). *Beer, babes and balls: Masculinity and sports talk radio*. New York: State University of New York Press.

Sabo, D. F., & Veliz, P. (2008). *Youth sport in America*. East Meadow, NY: Women's Sports Foundation.

Sheffer, M. L., & Schultz, B. (2007). Double standard: Why women have trouble getting jobs in local television sports. *Journal of Sports Media*, 2, 77–101.

Staurowsky, E. J., DeSousa, M. J., Ducher, G., Gentner, N., Miller, K. E., & Shakib, S., . . . Williams, N. (2009). *Her life depends on it II: Sport, physical activity, and the health and well-being of American girls and women*. East Meadow, NY: Women's Sports Foundation.

Staurowsky, E. J., & DiManno, J. (2002). Young women talking sports and careers: A glimpse at the next generation of women in sport media. *Women in Sport and Physical Activity Journal*, 11, 127–161.

DEPICTING THE SPORTING BODY

The Intersection of Gender, Race, and Disability in Women's Sport/Fitness Magazines

Marie Hardin, Susan Lynn, and Kristie Walsdorf | 2006

Excerpted from Marie Hardin, Susan Lynn, and Kristie Walsdorf, "Depicting the Sporting Body: The Intersection of Gender, Race, and Disability in Women's Sport/Fitness Magazines," *Journal of Magazine and New Media Research* 8, no. 1 (Spring 2006), with the permission of the Magazine Media Division of the Association for Education in Journalism and Mass Communication.

Even in light of Title IX and the growth of women's sport participation, it has been well documented that women's sports in the United States receive far less media coverage than do men's sports (Box scores, 2005; *Women's Sports & Fitness*, 2002). Male-dominated team sports rule, with women's sports receiving less than 10 percent of coverage (Box scores, 2005; *Women's Sports & Fitness*,

2002). Media presentations of female athletes reinforce the notion that women are, ideally, not suited for sport; they are "sexually different"—inferior to men (Duncan, 1990; Schell, 2003). Black female athletes are even further marginalized by media preferences to frame women as sexually different (Collins, 2000; Vertinsky & Captain, 1998).

Cultural critics assert that the boundaries around media coverage of female sport are defined by male hegemony, which reinforces a hierarchy topped by able-bodied men, considered the epitome of the "rugged individualism" (De-Pauw, 1997; Hahn, 1987). Marginalization of women in sport is centered on the body, where physicality is central (Blinde & McCallister, 1999; Hall 1996). The female body is considered "disabled" in a sexist culture. "Women and the disabled are portrayed as helpless, dependent, weak, vulnerable, and incapable bodies" (Garland-Thomson, 2002, p. 8). Disability sport is not viewed as legitimate, but instead as something less; the notion of "disabled sport" has been likened to the ideological paradox presented by the notion of "lesbian mother" (Cherney, 2003; DePauw & Gavron, 1995; Golden, 2002; Thompson, 2002).

Female athletes with a disability, then, face double exclusion; they are perceived by the culture as "polluting" by virtue that they do not fit neatly into social categories (Douglas 1966; Hall 1997). They are culturally rendered as "asexual," yet they are also perceived as "female"—passive, dependent and weak (Blinde & McCallister, 1999; Schell 1999; Thomas & Smith, 2003). In a triple-bind are disabled women of color: not white, not able-bodied, not male; they are also social misfits, a threat to social "purity" (Douglas, 1966; Hall, 1997).

Integrating Research on Gendered Media Images

Media criticism in regard to women and sport has been scrutinized in recent years for its tendency to focus on the experiences of white, able-bodied women as universal (Hall, 1996). Instead, feminist scholars are urged to "develop work that reflects the diversity of all women's lives and their struggles against multiple oppressions" (Hall, p. 44).

Beyond relationships between gender and race/ethnicity, feminist scholars have advocated a better understanding of the interrelationships between sexism and ableism (Garland-Thomson, 2002; Gerrschick, 2000). "Disability cannot be adequately understood if it is separated from the other axes of power with which it intersects" and vice versa (Maas & Hasbrook, 2001, p. 22). It seems that feminist-inspired scholarship must be sensitive to the whole of oppression; as such sensitivity is a hallmark of recent feminist thought and a key component of its possibilities for social transformation (Marston, 1997).

This research examines the relationship between images of sport, disability, gender and race in general-interest women's sport magazines. Women's sport and fitness magazines offer an outlet that should provide an empowering space for female athletes, and, by extension, to female athletes with a disability. This study critiques the photographic space provided to women in four such magazines. This analysis also ascertains how the magazines' positioning of female athletes as sexually different interacts with racialized depictions of female athletes with a disability. As might be expected in a culture where women and sport are not considered a natural pair, two of the three "new era" magazines have folded since the beginning of this research. However, the messages they contain provide important insight into the changing status of women on sport/media's "contested terrain"; further, an understanding of the content of these magazines can help us better assess and improve sporting depictions in future women's sports titles.

This study finds that female sport magazines, by failing to include athletes with a disability, have also failed to break free from a male/ableist hegemonic body standard. Nonwhite female athletes with a disability are almost invisible. However, the findings could also suggest that the more a magazine rejects the boundaries of male hegemony, the more likely it is to also (at least partially) reject ableism, serving feminist goals.

Sports/Media, Hegemony, and the Body

Cultural critics have indicted the sports/media complex for reinforcing cultural norms that create unequal power relationships based on binary oppositions: white/black, male/female, able-bodied/disabled, heterosexual/homosexual (Hall, 1997; Hargreaves, 1994; Jhally, 1989; Sage, 1990). It reinforces ideology that the "ideal body" is one fit and able to contribute to economic production (Hahn, 1988; Hargreaves, 1994). Hahn (1988) writes:

> The human body is a powerful symbol conveying messages that have massive social, economic and political implications. In order to perpetuate their hegemony, ruling elites have attempted to impose what might be termed a moral order of the body, providing images that subjects are encouraged to emulate. (p. 29)

Sport in its elite, commercial form reflects and projects itself on the surveillance and manipulation of the body. The sports/media complex reflects the body as a site of struggle over symbolic and material rewards between dominant and subordinate groups; the "moral order" places those bodies deemed most valuable to economic production (male, able-bodied) at the top; gender/sexuality, race and able-bodiedness are factors in what is deemed the "norm" versus the

"deviant" (Hahn, 1988; Hall, 1996; Hall, 1997). Disability, perhaps more than any other difference from the standard (such as femaleness) is considered deviant (Hahn, 1988). Douglas (1966) describes people with a disability as examples of cultural "misfits" that transgress symbolic boundaries and are thus deemed "polluting" in society.

HEGEMONY AND FEMALE ATHLETES

The most examined subordinate group in relation to the body, sport and male has been female athletes, and media framing of women in sport as sexually different has received considerable attention (Hall, 1996; Hardin, Lynn, Walsdorf & Hardin, 2002; Lynn, Hardin & Walsdorf, 2004). Sexual difference is the term used to describe the presentation of girls and women as *naturally* (biologically) less suited for sport than men. (The term "gender difference," also used in literature about women in sports, is often used in a way that is interchangeable with the term "sexual difference" (Davis, 1997).)

Sexual difference is signified by the female body, which has been commodified (Hall, 1996). For instance, sports are socially acceptable or unacceptable for women based on how they conform to traditional ideas about roles for the female body (Gniazdowski & Denham, 2003; Tuggle & Owen, 1999). Non-contact sports that emphasize feminine ideals of grace, beauty, and glamour, such as figure skating and gymnastics, receive more favorable coverage (Hardin, Lynn, Walsdorf & Hardin, 2002; Schell, 1999).

Although emphasis on sexual difference is emphasized through text and photographs, photographs are considered to be more potent influences (Rowe, 1999). The use of fewer photos of women (relative to men), downward camera angles, and photos that show women in passive poses can all reinforce sexual difference (Duncan, 1990; Duncan & Sayaovong, 1990; Lynn, Hardin & Walsdorf, 2004). Several studies point to the framing of women as sexually different, with an emphasis on the body aesthetic, in sports photographs (Cuneen & Sidwell, 1998; Duncan, 1990; Duncan & Sayaovong, 1990; Hardin, Lynn, Walsdorf & Hardin, 2002; Ryan, 1994). Even sports magazines designed for a female audience emphasize sexual difference in photographs. Schell's (1999) examination of *Women's Sports & Fitness* photos during the late 1990s and two studies that examined advertising photographs in *SI Women*, *Women's Sports & Fitness* and *Real Sports* found that sexual difference was reinforced in these magazines to varying degrees (Francis, 2003; Lynn, Walsdorf & Hardin, 2004).

THE MEDIA AND BLACK SPORTING WOMEN

Black sporting women have been marginalized by media depictions to a greater degree than have white women (Collins, 2000; Gordy, 2004; Hall, 1996; Hall,

2001; Vertinsky & Captain, 1998). Black women have been framed as both racially and sexually different/deviant; they do not meet white American standards of beauty and are "defeminized" (Hall, 1996; Hall, 2001; Vertinsky & Captain, 1998).

Black women in sport have also received less attention from media researchers than their white counterparts, but a handful of studies have been published. A study of sports magazines including *Sports Illustrated* and *Women's Sports & Fitness* found that Black women were scarce. When they were depicted, they were more likely than white women to be depicted in team sports, considered more masculine than individual sports (Davis & Harris, 1998). Schell's (1999) examination of photos in *Women's Sports & Fitness* during the late 1990s found that images of minority sporting women were rare, in favor of homogenized white, thin women. The only athletic Black role models in the magazine were basketball players and track athletes. Tennis players Venus and Serena Williams were covered in the magazine but were presented as self-centered and egoistic (Schell, 1999). Another study, a content analysis of feature stories in every issue of *SI for Women*, found that Black female athletes were often depicted as assertive and aggressive (Gordy, 2004).

HEGEMONY AND ATHLETES WITH A DISABILITY

The number of athletes with a disability in the United States has grown over the past few decades; participation rates during the 1990s were characterized as explosive by a writer for *Sports Illustrated* (Hoffer, 1995). Hoffer went on to acknowledge the competitive legitimacy of disabled athletics: "Really, the distinction between wheelchair racers and the Olympians is fading at these high levels" (p. 65). Although there is virtually no data about overall participation in sport by U.S. women with a disability, a 1997 report indicated that 31 percent of Canadian women with a disability considered themselves "quite or very" physically active (DePauw, 1997b, p. 225).

Despite the continuing progress in technology, legal rights and sports participation, men and women with a disability are also stigmatized because their bodies do not reflect the "norm" (Shapiro, 1993; Taub, Blinde & Greer 1999). Media coverage of disability athletics reflects this stigmatism through non-coverage or stereotypical coverage. For instance, the Paralympics, the most elite sports event for athletes with a disability and one of the largest sporting events in the world, receives scant coverage. Coverage of the Salt Lake City games in 2002, which took place after the winter Olympics, was virtually non-existent in U.S. media except for coverage by the A&E network (Golden, 2002). Golden, who interviewed sports reporters at both events, found that many American journalists did not view disabled sports as valid because the journalists believed the athletes could not be competitive.

Researchers have found little coverage of disability athletics in newspapers and sports magazines. A 2000 study of *Sports Illustrated for Kids* found that athletes with a disability were absent in that magazine, providing no positive disabled role models for children (Hardin, Hardin, Lynn & Walsdorf, 2001). Another study, by Maas and Hasbrook (2001), examined photos in golf magazines and found no representation of golfers with visible disabilities. Schell (1999) analyzed photographs published in *Women's Sports & Fitness* between 1997 and 1999. No women with a disability were depicted in the magazine.

A study that examined gendered depictions of disability assessed British newspaper coverage of the 2000 Paralympics. Thomas and Smith (2003) found that women were more often depicted in passive poses than men. More than half the photos studied appeared to hide athletes' impairments. Another study that examined gendered depictions of disability in *Sports 'n Spokes*, a magazine that covers wheelchair sports, found that women were depicted as active almost as often as were men, but that they were less likely to be presented as sports competitors (Hardin & Hardin, 2005).

Hahn (1987) and Shapiro (1993) assert that among media producers, advertisers may have the strongest motive to shun disability; advertising in a capitalist, consumer-driven culture must present the "ideal body," one that reminds consumers of their own need to correct their imperfections to reach visual standards presented by ads. When models with a disability are depicted in ads, only those with "pretty" disabilities, such as attractive models who are deaf or who use a wheelchair, appear; sports-minded wheelchair users are toward the top of the media hierarchy of acceptable disability images (Haller, 2000; Haller & Ralph, 2002; Schantz & Gilbert, 2001). Further, studies of advertising in sport-related magazines have also found that not a single image of disability appears (Hardin, Hardin, Lynn & Walsdorf, 2001; Schell, 1999).

A Description of Women's Sport/Fitness Magazines

Although several women's fitness magazines had been on newsstands for years, a new type of women's sport/fitness title emerged during the mid-to-late 1990s, mostly in response to the surge in women's sports around the 1996 Olympics (Granatstein, 2000). Three general interest magazines, *Women's Sports & Fitness*, *SI Women*, and *Real Sports*, were launched with fanfare during 1997–1998. The new magazines aimed to compete with established fitness-oriented titles such as *Shape* (Harvey, 1998). The magazine, launched in the early 1980s, has 1.5 million subscribers and offers workout, fitness, diet and beauty tips to readers. It does not report on sports events, although it occasionally features athletes who are women (Shape Print Advertising, 2002).

The newer magazines, which proclaimed a mission that involved a mix of stories on fitness and competitive sport, struggled to find an identity. *Sports Illustrated* launched *Sports Illustrated Women/Sport* in 1997, but within months, changed the magazine's name to *Sports Illustrated for Women*. In 2001, the magazine changed names again, to *SI Women*. The magazine published its last issue in December 2002. The Condé Nast magazine *Sports for Women* (launched in 1997) changed its name to *Women's Sports & Fitness* in 1998. The magazine folded in September 2000 with a circulation of about 650,000 (Wollenberg, 2000). *SI Women* and *Women's Sports & Fitness* presented beauty-oriented fitness features—much like those in *Shape*—along with material about sports (Hardin, Lynn & Walsdorf, 2005).

The only women's sports magazine without the aesthetic fitness angle is *Real Sports*, a magazine that has struggled to gain advertisers and has, in the past two years, moved to an e-zine format. Launched by Amy Love in 1998, *Real Sports* does not include beauty features, but instead focuses on coverage of a variety of sports. In print form, it had a peak circulation of around 150,000. Editorial content includes recaps and features on all levels of women's sports, from professional league play (WNBA, WUSA) to college and amateur ranks.

Studies of women in advertising and editorial photo images in these four magazines (without consideration of race or disability) has found that they fell on a continuum of sexual difference (Lynn, Hardin & Walsdorf, 2004; Hardin, Lynn, & Walsdorf, 2005). *Shape* presents women as passive and best suited for individual fitness routines designed to sculpt the body in the "ideal" feminine form. The other magazines fell behind *Shape* in their reinforcement of sexual difference. WSF also reinforced sexual difference, but to a slightly lesser degree. The magazine integrated strong images of sporting women with passive model photos. *SI Women* also sent mixed messages through its photos, but more often rejected sexual difference than did WSF by using action shots, and the magazine also provided strong images of active women in basketball, soccer and other team sports. *Real Sports* was at the far end of the continuum, providing a stark contrast from *Shape*.

Another study of three of the four magazines (all but *Shape*) found similar results; content analysis of features, covers and ads in *SI Women* and *Women's Sports & Fitness* found an emphasis on athletes in feminine roles in those magazines, while a similar content analysis of *Real Sports* found a focus "almost exclusively on the sport and the athlete's participation" (Francis 2003, p. 24).

Research Questions

This study examines photos in four women's athletic magazines to ascertain the inclusion of athletes with a disability and to determine if a relationship exists between their inclusion and the reinforcement of sexual and racial difference in magazine photographs. This study examines *Real Sports*, *SI Women* (siw), *Shape* and *Women's Sports & Fitness* (wsf) for the presence of athletes with a disability in photographs. *Real Sports*, siw and wsf were chosen as representative of the framing of women in the "new era" of women's sports, introduced during the 1990s (Messner, 2002); the images in these magazines are gauged against the more traditional images presented in *Shape*, launched a decade earlier. The time period for the study was chosen to best reflect the energy of the "new era" for women's sports after the new titles were introduced; the 1999 World Cup championships took place during this time period, and the summer 2000 Olympics also put attention on women's sports (Granatstein, 2000).

This study explores the relationship between the level of sexual difference and the inclusion of athletes with a disability in the magazines. Photographs were chosen because of their power as visual magnets and cultural communicators.

Coding categories were designed to answer three primary research questions:

1. To what extent do the magazines under study include images of athletic women with a disability?
2. How do *Real Sports*, siw, *Shape* and wsf differ with respect to their inclusion of athletes with a disability?
3. Do the magazines that provide stronger reinforcement of sexual difference, such as *Shape* and wsf, differ from the more sport-focused magazines in their depictions of disability (*Real Sports*, siw)?

Method

DATA COLLECTION

Content analysis was the research method chosen to answer the research questions presented. Commonly defined as an objective, systematic, and quantitative discovery of message content, content analysis has also been determined as an effective way to examine media images of minority or historically oppressed groups (Stacks & Hocking, 1998; Wimmer & Dominick, 1991).

Real Sports, siw, *Shape*, and wsf were the sampling unit for this study. Individuals in photos were coded separately and served as units of analysis. Advertising and editorial photographs in 6 issues of each magazine, from spring

1999 through summer 2000, were examined. Only photographs determined to include nonfamous and celebrity (human) models were studied; a total of 6,045 photo images were coded. [...]

Findings

INCLUSION OF DISABILITY

Of the more than 6,000 advertising and editorial images of women coded in the four magazines, only 22 were coded as possessing a discernible disability. No magazine reached one percent of its total images with those of athletes with a disability. [...]

Of the 22 images, two were of able-bodied women who were temporarily immobilized by illness or injury—leaving just 20 images of athletes [with] disabilities for analysis. [...] All images of athletes with a disability were in editorial photos; no images of athletes with discernible disabilities in advertising photos in any of the magazines were found.

Jean Driscoll, a white wheelchair racer with perhaps more name recognition than any other wheelchair athlete in the United States ("On a Roll," 2003), was depicted twice—once in two different magazines (WSF and *Real Sports*). Jami Goldman, a white double-amputee sprinter, also appeared in two magazines (SIW and *Real Sports*). Other athletes depicted included wheelchair basketball players, a Paralympic skier, an elite bicycle racer, a wheelchair tennis player and a Paralympic runner. Of the 20 women with a disability, only one Black athlete, a basketball player from Gallaudet University, was depicted.

EDITORIAL PHOTOS: DIFFERENCES
AMONG THE MAGAZINES AND SEXUAL DIFFERENCE

No magazine used disability images for even 1 percent of its editorial photo images; however, the magazines demonstrated slight differences in the number and types of disability images they used. *Shape*, a magazine that focuses on aesthetically oriented fitness in a frame of (white) traditional standards of femininity, did not use a single image of disability. WSF, which also framed women's sport in the boundaries of sexual difference, ran only one image of an athlete with a disability: white wheelchair racer Jean Driscoll. Driscoll was depicted crossing the finish line in the Boston Marathon.

SIW used the largest number of images: 13. However, all of the images were in one feature, a "No Limits" package in its Winter 1999–2000 issue that focused on disabled women. This feature included the one image of a Black athlete with a disability—a player in the group shot of the Gallaudet basketball team.

sɪw simultaneously presented images that reinforced and rejected sexual difference. [...]

Further, most of the images were of women passively posed for the camera instead of engaged in sport, indicating sexual difference (Duncan, 1990). For instance, a photo of white goalball player Jen Armbruster, depicted her in a passive pose, lying on a basketball floor. Armbruster is visually impaired. Another photo considered striking for its messages about disabled women in sports is that of Muffy Davis, a white paraplegic downhill skier. Davis is posed for the camera in a setting that depicts her skiing through clouds (instead of on a downhill snow slope, where she competes). The photo could be interpreted as trivializing her accomplishments as not "real."

The sɪw feature did, however, contain the only image of a Black athletic woman with a disability: Cassey Ellis. She was posed passively (standing, gazing at the camera) and represented a sport stereotypical for Black athletes: basketball. As such, the image simultaneously reinforced sexual difference and racial difference.

Real Sports ran fewer images of athletes with a disability than sɪw, but used them in more than one issue, integrating them with other feature photos. Every image was active, and none disguised the athlete's impairment. [...] *Real Sports*, however, fails to depict any Black women with a disability, reinforcing racist ableism by rendering sporting Black disabled bodies as invisible.

Discussion and Conclusions

This research implies a link between disabled sports and women's sports that should be explored, defined, refined and strengthened. In a wider sense, perhaps it suggests a stronger link between disability studies and feminist studies, the disabled rights movement and the women's rights movement. This idea is not a new one although in practice it has not been widely accepted (Blinde & McCallister, 1999; Garland-Thomson, 2002; Gerrschick, 2000; Marston, 1997).

The highly limited number of photos depicting disability makes it difficult to draw conclusions about differences among the magazines. However, the findings, read in light of previous studies and literature on disability, the body, sport and hegemony, support notions that: 1) Sport-related advertising continues to emphasize the hegemonically defined "ideal body" through exclusion of disability, perpetuating the "deviant" status of disability; and 2) Athletes with a disability, especially non-white athletes, have not been integrated adequately into editorial content. The results also invite speculation that the more the publication is willing to reject male hegemony, the more likely it seems to also reject ableist hegemony.

DISABILITY AND ADVERTISING

In light of the sport/media's role in perpetuating male, ableist hegemony, it is no surprise that advertisers in sport/fitness-related media would shun images related to disability in favor of an ideal body image. While feminists have criticized the ideal body standard for its disempowering role in women's lives, this standard also reinforces marginal status for people with a disability. Perhaps no other minority group in the United States is so marginalized in advertising, in relation to its actual proportion in the population. Unfortunately, the ideal body standard is a key force behind consumerism in the United States. The standard, however, must be reconfigured if people with a disability are to move from the margins; any inclusion would move them forward from their present status.

RACIALIZED (NON)DEPICTIONS OF DISABILITY

The second conclusion highlights the ableist orientation of sport media and their tendency to emphasize racial and sexual difference. Lack of attention from the media feeds a spiral of marginalization and exclusion for disabled women, emphasizing their already low social status and "keeping in their place" within U.S. culture. Further, the marginalization of athletic women with a disability robs disabled girls of positive role models. The population affected by the absence of positive images is substantial: The U.S. Census in 2000 indicated that 21.2 million people (8.2 percent of the population) reported having a physical or sensory disability. The percentage of females between 16 and 64 years of age in the U.S. with a physical or sensory disability is approximately 8.5 percent. Further, in every age category, non-white Americans report higher rates of disability than white Americans (Waldrop & Stern, 2003).

The complete invisibility of non-white disabled women was expected, in light of previous studies. Black disabled women are virtually guaranteed the bottom spot in the hegemonic hierarchy: because they do not conform to white standards of femininity, they are not perceived as sexually different ("feminine") enough to garner mainstream sport coverage. Their lack of able-bodiedness further marginalizes them.

Yet Black women are part of the "explosion" in competitive disability sports competition in the United States (Hoffer, 1995, p. 64). Examples of Black women who would easily fit on the pages of *Real Sports*, SIW or any women's sports magazine are April Holmes, a member of the USA Disabled Track Team, or Andrea Woodson, a member of the USA women's wheelchair basketball team and player for the Lady Texans (Runner's Amazing Comeback, 2003; Woodson, 2004). Others compete at elite levels in a variety of sports, including wheelchair basketball; minority participation in such sports in any part of the United States

often mirrors regional population demographics (Woodson, 2004). Further, sporting Black women with a disability could be role models for a large population; the highest disability rates in the United States are among the Black population (Waldrop & Stern, 2003).

One argument that might be made by sport/media decision makers is that potential readers should not dictate their coverage; instead, what is "newsworthy" ought to dictate coverage. However, unlike traditional men's sports media, the women's sport/fitness magazines in this study are not event driven; they do not provide coverage of events. Instead, coverage is subjective and based on such values as sport seasons and personalities. Disabled sports (such as able-bodied sports) offer these values.

Another argument is that disabled sports don't have enough of a following to justify coverage. But disabled athletics can't hope to gain a following when awareness of such sports remains so low because of media exclusion. As Cherney (2003) points out, the material values of sport make the exclusion of athletes with a disability more troubling; they are robbed, by an ableist culture and media, of the opportunity to be compensated for their skillful participation in sport.

Women's sport media, it was hoped, would be more inclusive of athletes with a disability—especially because women's sport media, by definition, addresses at least to a small degree the need to expand notions of the acceptable sporting body. It seems that women's sport/fitness media has simply jostled the existing hegemonic sports hierarchy without attempting to dismantle it. This falls far short of the feminist mission that would call for dismantling "dominations" of all kinds (Marston, 1997).

Perhaps women's sport producers and media fail to fully understand the nature of male hegemony; as long as the ideal body standard remains unchallenged, women's sports will never have the same stature as men's. The ideal body standard, and its role in sport, must be redefined. That redefinition must, by its very nature, be inclusive of disability. DePauw (2000) argues that with time, images of athletes with a disability can alter traditional views of the normal body, a change that would serve to flatten the "moral order" of the body.

REJECTION OF MALE HEGEMONY / REJECTION OF ABLEISM

The results of this research suggest that the more a magazine embraces sporting women, the more likely it is to accept athletes with a disability. It is almost paradoxical, considering the fact that traditional sports media remains staunchly ableist, that the stronger the sport orientation of a women's magazine, the less ableist it became. Rejection of sexual difference seems to be related to positive images of disabled sporting bodies.

Much of this acceptance may be a function of the cultural constructions of

disability and gender as related to the cultural anti-link between women's sport and gender norms. Traditional femininity requires adherence to heterosexual beauty and body ideals, and participation in sport requires a willingness to suspend or reject these ideals. As Gerrschick (2000) articulates, women with physical disabilities are already framed as "non-feminine," as they are never able to achieve the feminine body ideal. Thus, "women with a disability are less likely than their able-bodied counterparts to be limited by many of the gendered expectations and roles" (p. 1268). In other words, women with a disability are at the same time more and less suitable in mediated depictions of sport. While they can never hope to meet an able-bodied standard, their cultural status as "genderless" is fitting for representations of women's sport that seek to throw off the limits of hegemonic gender roles.

It is hoped, however, that the correlation between the magazines' sport orientation and the presentation of athletes with a disability indicates more: a realization that at some level, there is an understanding that the fate of women's and disability sports is linked, and that a true redefining of sport (reflected in sport media) must take place for women to experience sporting equality. This seems to reflect what Hargreaves (1994) has described as the use of oppositional ideas to subvert dominant/oppressive ones, potentially leading to slow but sure cultural change. It is interesting to note that the newest U.S. general-interest women's sports title—*HerSports*—has already integrated some images of women with a disability in its pages although it has published less than six issues.

Any effort to redefine sport—to dismantle it as a hegemonic institution—will have to be Herculean to succeed. The resistance to such effort is apparent in this research; two of the four women's sport magazines coded in this study have folded. It is interesting, however, that the two magazines that have ceased to exist are the magazines that tried to "straddle the fence," as it were—offering images that both rejected and reinforced sexual difference. It seems the lesson here is that going halfway is ultimately a losing game; there does not seem to be tolerance between the status quo and re-presentation of sport in ways that ultimately reject male (able-bodied) hegemony.

References

When possible, the editors have supplied source listings missing from the original in brackets.

Blinde, E.M., and McCallister, S.G. (1999). Women, disability, and sport and physical fitness activity: The intersection of gender and disability dynamics. *Research Quarterly for Exercise and Sport 70*, 303–312.

Box scores and bylines: A snapshot of the newspaper sports page (2005). Report

published by the Project for Excellence in Journalism. Online: http://www
.journalism.org/resources/research/reports/sports/default.asp.

Cherney, J. (2003). *Sport as Ableist Institution: "Body is Able," Casey Martin, and the PGA Tour, Inc.* Unpublished paper.

Collins, P.C. (2000). *Black Feminist Thought.* New York: Routledge.

Cuneen, J., and Sidwell, M.J. (1998). Gender portrayals in Sports Illustrated for Kids advertisements: A content analysis of prominent and supporting models. *Journal of Sport Management 12*, 39–50.

[Davis, L. R., & Harris, O. (1998). Race and ethnicity in U.S. sport media. In *MediaSport: Cultural Sensibilities and Sport in the Media Age*, L. A. Wenner (ed.). Boston: Routledge & Kegan Paul.]

DePauw, K. (1997). The (in)visibility of disability: Cultural contexts and "sporting bodies." *Quest 49*, 416–430.

DePauw, K. (2000). Social-cultural context of disability: Implications for scientific inquiry and professional preparation. *Quest 52*, 366.

DePauw, K., and Gavron, S. (1995). *Disability and Sport.* Champaign: Human Kinetics.

DePauw, K. (1997b). Sport and physical activity in the life-cycle of girls and women with a disability. *Women in Sport & Physical Activity Journal 6*, 225.

Douglas, Mary. (1966). *Purity and Danger.* New York: Praeger.

Duncan, M.C. (1990). Sports photographs and sexual differences: Images of women and men in the 1984 and 1988 Olympic Games. *Sociology of Sport Journal 7*, 22–42.

Duncan, M.C., & Sayaovong, A. (1990). Photographic images and gender in Sports Illustrated for Kids. *Play and Culture 3*, 91–116.

Francis, S. (2003). *Coverage of female athletes in women's sports magazines: A content analysis.* Paper presented to the Association for Education in Journalism and Mass Communication Annual Meeting, Miami.

Gniazdowski, L.A., & Denham, B.E. (2003, August). *Still photographs of female athletes featured in Sports Illustrated versus Sports Illustrated for Women.* Paper presented at the annual conference of the Association for Education in Journalism and Mass Communication, Kansas City, MO.

Garland-Thomson, R. (2002). Integrating disability, transforming feminist theory. *NWSA Journal 14*, 1–32.

Gerrschick, T. (2000). Toward a theory of disability and gender. *Signs 24*, 1263–1268.

Golden, A. (2002). *An analysis of the dissimilar coverage of the 2002 Olympics and Paralympics: Frenzied pack journalism versus the empty press room.* Paper presented to the Association for Education in Journalism and Mass Communication Annual Meeting, Miami, FL.

Gordy, L. (2004, October). *Females of color in Sports Illustrated for Women.* Presented to the annual meeting of the North American Society for the Sociology of Sport, Tucson, AZ.

Granatstein, L. (2000). Back in the game. *Mediaweek*, 31 January.

Hahn, H. (1987). Advertising the acceptably employable image: Disability and capitalism. *Policy Studies Journal 15*, 551–570.

Hahn, H. (1988). Can disability be beautiful? *Social Policy 18*, 26–31.

Hall, M.A. (1996). *Feminism & Sporting Bodies.* Champaign, IL: Human Kinetics.

Hall, R. (2001). Shaking the foundation: Women of color in sport. *The Sport Psychologist 15*, 386–400.

Hall, S. (1997). The spectacle of the "other." In *Representation: Cultural Representations and Signifying Practices*, edited by W. Hall. Thousand Oaks: Sage.

Haller, B. (2000). If they limp, they lead? News representations and the hierarchy of disability images. In *Handbook of Communication and People with Disabilities*, edited by D. Braithwaite. Mahwah, NJ: Lawrence Erlbaum Associates.

Haller, B. and Ralph, S. (2002). *Are disability images in advertising becoming bold & daring? An analysis of prominent themes in U.S. & U.K. campaigns.* Paper presented to the Association for Education in Journalism and Mass Communication Annual Meeting, Miami, FL.

Hardin, M., & Hardin, B. (2005). Performance or participation . . . pluralism or hegemony? Images of disability & gender in Sports 'n Spokes magazine. *Disability Studies Quarterly 25* (4). Online: www.dsq-sds.org.

Hardin, B., Hardin, M., Lynn, S., & Walsdorf, K. (2001). Missing in action? Images of disability in Sports Illustrated for Kids. *Disability Studies Quarterly 21*, 21–32.

Hardin, M., Lynn, S., & Walsdorf, K. (2005). Challenge and Conformity on "Contested Terrain": Images of Women in Four Women's Sport/Fitness Magazines. *Sex Roles 53* (1–2), 105–118.

Hardin, M., Lynn, S., Walsdorf, K. & Hardin, B. (2002). The framing of sexual difference in SI for Kids editorial photos. *Mass Communication and Society 5*, 341–360.

Hargreaves, J. (1994). *Sporting Females.* London: Routledge.

Harvey, M. (1998). Ad pages up for Conde Nast's reworked "fitness" title. *Folio 27*, 13.

Hoffer, R. (1995). Ready, willing and able. *Sports Illustrated*, 14 August.

Jhally, S. (1989). Cultural studies and the sports/media complex. In *Media, Sports & Society*, L. Wenner (ed.). Newbury Park: Sage.

Lynn, S., Hardin, M., & Walsdorf, K. (2004). Selling (out) the sporting woman: Advertising images in four athletic magazines. *Journal of Sport Management 18* (4), 335–349.

Lynn, S., Walsdorf, K., Hardin, M., & Hardin, B. (2002) Selling girls short: Advertising and gender images in Sports Illustrated for Kids. *Journal of Women in Physical Activity and Sport*, 11 (2), 77–100.

Maas, K.W., & Hasbrook, C.A. (2001). Media promotion of the paradigm citizen/golfer: an analysis of golf magazines' representations of disability, gender, and age. *Sociology of Sport Journal 18*, 21–36.

Marston, C.L. (1997). *Handling media research on disability: Toward including a feminist "exile" perspective on theory and practice.* Paper presented to the Association for Education in Journalism and Mass Communication Annual Meeting, New Orleans.

Media/Advertiser Resources. (2002). Real-Sports.com. Online: http://www.real-sports.com/about/about_mediaad.html.

Messner, M. (2002). *Taking the Field: Women, Men & Sports.* Minneapolis: University of Minnesota Press.

["On a Roll: The Anatomy of Wheelchair Marathon Cyclist." (2011). *Boston Magazine.* March 24, www.bostonmagazine.com/2011/03/24/on-a-roll-how-to-win-the-marathon-wheelchair-division.]

Rowe, David. (1999). *Sport, Culture and the Media*. Buckingham, UK: Open University.

Runner's amazing comeback no surprise to April. (2003). *Challenge Magazine*. Disabled Sports USA. Online: http://www.dsusa.org.

Ryan, L.T. (1994). Swimsuit models or victim stories, who will cover for me? *New York Times*, 20 February.

Sage, George. (1990). *Power and Ideology in American Sport: A Critical Perspective*. Champaign, IL: Human Kinetics.

Schantz, O., & Gilbert, K. (2001). An ideal misconstrued: Newspaper coverage of the Atlanta Paralympic games in France and Germany. *Sociology of Sport Journal 18*, 69–94.

Schell, L.A. (1999). Socially Constructing the Female Athlete: A Monolithic Media Representation of Active Women. Ph.D. diss., Texas Women's University, Denton.

Schell, B. (2003). (Dis)empowering images? Media representations of women in sport. Women's Sports Foundation Web Site. Online: http://www.womenssportsfoundation.org/cgibin/iowa/issues/media/article.html?record=881.

Shape Print Advertising. (2002). Shape.com. Online: http://www.shape.com/about/printads.jsp

Shapiro, J. (1993.) *No Pity: People with Disabilities Forging a New Civil Rights Movement*. New York: Times Books.

Stacks, D.W., & Hocking, J.E. (1998). *Communication Research*. New York, NY: Longman.

[Taub, D.E., Blinde, E.M., & Greer, K.M. (1999). Stigma management through participation in sport and physical activity: Experiences of male college students with physical disabilities. *Human Relations 52*, 1469–1483.]

[Thomas, N., & Smith, A. (2003). Pre-occupied with able-bodiedness? An analysis of the British media coverage of the 2000 Paralympic games. *Adapted Physical Activity Quarterly, 20(2)*, 166–181.]

Thompson, J. (2002). *Mommy Queerest: Contemporary Rhetorics of Lesbian Maternal Identity*. Amherst: University of Massachusetts Press, 2002.

Tuggle, C.A., & Owen, A. (1999). A descriptive analysis of NBC's coverage of the Centennial Olympics. *Journal of Sport & Social Issues 23*, 171–182.

Vertinsky, P., & Captain, G. (1998). More myth than history: American culture and representations of the black female's athletic ability. *Journal of Sport History 25*, 532–561.

Waldrop, J., & Stern, S. (2003). Disability Status: 2000. Washington, D.C.: U.S. Census Bureau.

Wimmer, R.D., & Dominick, J. (1991). *Mass Media Research: An Introduction*. Belmont, CA: Wadsworth Publishing.

Wollenberg, S. (2000). Owners close Sport, Women's Sports & Fitness magazines. DetNews.com. Online: http://detnews.com/2000/sports/0006/28/spots-82612.htm.

Women's Sports & Fitness Facts & Statistics. (2002). Women's Sports Foundation.

HOW TO TALK ABOUT FEMALE OLYMPIANS WITHOUT BEING A REGRESSIVE CREEP *A Handy Guide*

Lindy West | 2016

From the *Guardian*, August 9, 2016, www.theguardian.com/commentisfree/2016 /aug/09/female-olympians-guide-gaffes-athletes-sports-makeup-shorts-marital-status -lindy-west. Copyright © Guardian News & Media Ltd., 2017.

As ever, this year's Olympics—an international bacchanal of physical perfection and triumphant will swaddled in human rights abuses and environmental catastrophe—are providing fuel for public delight and scorn in abundance. Making a strong showing in the "scorn" category already is the press, which, less than a week in, has managed to insult, demean and erase female athletes in a cornucopia of bungles.

The *Chicago Tribune* announced American trap shooter Corey Cogdell-Unrein's medal win with the headline "Wife of a Bears' lineman wins a bronze medal today in Rio Olympics," not even bothering to mention her name. In the afterglow of Katinka Hosszu's world-record-breaking swim, NBC sportscaster Dan Hicks pointed out Hosszu's husband and gushed: "And there's the man responsible."[1] Another NBC commentator described the powerhouse US female gymnastics team as looking as though "they might as well be standing in the middle of a mall."[2] People Magazine called Simone Biles "the Michael Jordan of gymnastics," as though we can't possibly comprehend female greatness without a male proxy.[3] Rightwing media co-opted Ginny Thrasher's gold medal win in the 10-metre air rifle competition, dubbing her "a girl with a gun," as a cudgel in their crusade against gun safety. In a Twitter exchange that rapidly went viral, Dutch cyclist Annemiek van Vleuten lamented her injuries after a crash, inspiring some random man to explain to her how to ride a bike: "First lesson in bicycling, keep your bike steady . . . whether fast or slow."

The Olympics offer up women's bodies for public scrutiny on a massive scale, but to surprisingly constructive effect, relatively speaking: It's one of the only hit TV shows that celebrates female strength, skill and excellence without sexualising female existence. And it's not that I think the authors of the aforementioned

gaffes are vicious, deliberate misogynists. It's more that they were raised in a culture—as we all were—that has almost no idea how to process competent women (see also: America's current presidential election). You can feel a faint confusion pulsing behind every word. A girl . . . doing things!?

So, as a public service, here is a handy guide for how to talk and/or write about female Olympians without being a regressive creep who is constantly getting yelled at by feminists on the internet.

Do write about the sports they did! I've put together a quick and easy template for your basic reporting needs (cribbed and adapted from a piece I wrote about coverage of female politicians in 2014, because you could basically have this conversation about any industry, and I do):

NEWS REPORT: [Female Athlete] did [sports] today. [Describe sports.] THE END. Sportswriting accomplished!

Do write about female athletes the way you write about male athletes—i.e., without mentioning their gender except maybe in the name of the sport. Can you imagine if we brought up gender every time we wrote about men? "Perky male point guard Isaiah Thomas, stepping out in a flattering terrycloth headwrap, proves that men really can play ball and look cool-summery-sexy doing it!" See how unbearable that sounds? Chase that feeling.

Don't spend more time discussing female athletes' makeup, hairdos, very small shorts, hijabs, bitchy resting faces, voice pitch, thigh circumference, marital status and age than you spend analysing the incredible feats of strength and skill they have honed over a lifetime of superhuman discipline and restraint.

Don't refer to women in terms of men they know, are related to, work with or have sex with. Women are fully-formed, autonomous people who do things. We are not pets or gadgets or sex-baubles.

Do write about gender when it's relevant, such as when you're discussing gender discrimination—for instance, the pay gap in women's basketball and soccer, and the garbage way the media covers (or doesn't) women's sports.

Don't bring your sex feelings into it. And, yes, I am aware that there are more than several women on Twitter with passionate opinions about the shoulder-to-waist ratios of the piles of trapezoids on the men's swimming roster. But there is not currently a vacuum of serious, well-rounded coverage of men's sports. There is not a historic precedent of men's bodies eclipsing their accomplishments, and, in turn, undermining their credibility and hobbling their upward mobility in every major industry. It is OK to have sex feelings. Just watch where you're spraying them.

Of course, there is plenty of smart, nuanced, neutral Olympics coverage out there too, and live TV is hard, and people make mistakes. But the way we talk

about women—particularly women at the top of their fields, women whose power and prowess is undeniable—has a tangible impact on the way we treat female colleagues, female job interviewees and female presidents. This is not an accident. It is the system working as designed.

Athletes are athletes. If you care about sports, write about sports. If you care about gender equality, write about sports.

Notes

Links in the original online version of this article have been turned into endnotes.

1. Elle Hunt, "Commentators Take Gloss off Female Olympians' Efforts and Medals," *Guardian,* August 9, 2016, www.theguardian.com/sport/2016/aug/09/rio -2016-commentators-take-gloss-off-female-olympians-medals.

2. Lee Moran, "The Media Are Saying and Doing a Bunch of Sexist Stuff during the Olympics," *HuffPost,* August 8, 2016, www.huffingtonpost.co.uk/entry/rio-2016 -sexism-media_us_57a840dbe4b056bad215f03c.

3. Char Adams, "Why Simone Biles Is the Michael Jordan of Gymnastics—and How She's Still a Typical Teen," *People,* July 8, 2016, http://people.com/sports/simone -biles-gymnastics-olympic-trials-and-michael-jordan-comparison.

BREAKING: WOMEN IN HIJAB PLAY SPORTS

Shireen Ahmed | 2016

For the 2016 Olympic Games in Rio, Team USA presented the first hijab-wearing athlete. Ibtihaj Muhammad is an unapologetic Black Muslim woman and brilliant fencer who speaks candidly about the toxic American political climate while casually attempting to slay in world-class competition.[1]

The media attention around Muhammad is important—but the obsession about her clothing choices is tiresome. Female athletes are often subject to

incredulous amounts of misogyny, and in the case of Muhammad, gendered Islamophobia. Discussions from mostly male sportswriters on those issues are often lacking in nuance.

The coverage of Muslim women athletes often emphasizes their traditional roles in an exotic culture,[2] and makes their uniforms and veils into the topic of much fascination and tokenization.[3] According to a 2014 Women's Media Center report almost 90 percent of sportswriters are white, straight, able-bodied men.[4] Therein lies much of the problem. When stories on Muhammad emphasize that she is *not* an oppressed and subservient woman, it just reinforces the unfortunate myth that most Muslim women *are* meek and oppressed.

A few years ago, I created a BINGO card that could be used while following coverage of Muslim women in sports.[5] I pointed to the usual tropes that were used in articles about Muslim women including: their country of origin, their father's opinion of sport, and any particular incident of violence against women that was unrelated to the said athlete but mentioned anyway due to similar faith or culture.

It began as somewhat of a joke but quickly turned into something reminiscent of *The Onion* where it could be used to identify a formula that most sportswriters might adhere to.

I am an identifiable woman of color who focuses on sports. Of course there are more women like me.

There are so many opportunities for (sports) media outlets to reach out to Muslim women to write about . . . wait for it . . . Muslim women. It's appalling how infrequently this happens.

The stories about Muslim athletes are so filled with what I consider "fire over fact" it almost ignores the reality: Muslim women, both veiled and unveiled, have been competing at the highest levels of international sports for a very long time.[6]

Admittedly, the optics of a Black Muslim American woman geared up in Team USA gear are powerful. But the constant conversations about her headscarf and the clothes of other Muslim athletes are not.

When Egypt's Dooa El-Ghobashy and her teammate Nada Meawad played against Germany in beach volleyball, the internet exploded. There were incessant discussions of whether the chosen uniforms represented a "Clash of Cultures" or an intense "Burka vs Bikini" competition.[7] In fact, the German team wore specialized swimsuits and Egypt wore something from one of the booming modest sportswear lines.[8] These tropes are irresponsible as they not only pit women against women but are reductive.

First and foremost, these women are athletes who have trained for years and are now competing on the world's most important stage. The constant mentions

of their headscarves are not always relevant considering there have been incredible female athletes who have competed in headscarves before Muhammad. All one has to do is Google.

The headlines that scream about the accomplishment of a "Hijabi American" are unhelpful as they reduce an athlete to her outfit. It can be noted that we don't refer to any other athlete who observes a faith by a religious accessory, be it a necklace or tattoo featuring a cross, the Star of David, or a "Karma" symbol.

More than anything, there is passion, strength, resilience, and possibility and yes, the banality of constant training and dedication.

There are tremendous hurdles Muslim women may face in sport.[9] One of the most important issues nowadays is bans on headscarves that exclude incredible Muslim women athletes from the sports they love.[10]

It is important to recognize that the issue of those who have access to the platform of sportswriting is really as important as the topic itself.

When we see a very selective group of privileged men who create policy around women's clothing and then a selective group write of it—how much progress is being made?

The policing and fetishizations of women's bodies often collide, particularly in the world of sport.

Those are topics that ought to be highlighted in mainstream sports media instead of vacuous discussions of whether the chosen uniform of an athlete is appropriate or a novel concept from the lens of the sportswriter. The sooner that men realize that their opinion of what women wear is not required or necessary, the better off we shall be.

Women in hijab are so much more than their headscarves or turbans. We struggle, fall, recover, and thrive like all other people. There might not be any hijab-wearing athletes on the front pages, but it does not mean they do not exist. It simply means that one should broaden their viewpoint.

Finally, as much as sportswriters might want to engage in important discussions about Muslim women in sports, it is worth considering that Muslim women are completely capable of writing about themselves.

Notes

Links in the original online version of this article have been turned into endnotes.

1. Nico Hines, "Ibtihaj Muhammad, Hijab-Wearing Olympic Star: I'm Not Safe in the U.S.," *Daily Beast*, August 4, 2016, www.thedailybeast.com/ibtihaj-muhammad-hijab-wearing-olympic-star-im-not-safe-in-the-us.

2. Chuck Culpepper, "Marriage, Motherhood, Education, Maybe Sports: Female Muslim Athletes' Expected Priorities," *Washington Post*, July 13, 2016,

www.washingtonpost.com/sports/olympics/marriage-motherhood-education-maybe
-sports-female-muslim-athletes-expected-priorities/2016/07/13/a7f15a42-2f17-11e6
-9b37-42985f6a265c_story.html.

3. Teo Bugbee, "'The Tainted Veil': Muslim Women Confront the Power and Legacy
of the Hijab," *Daily Beast*, December 6, 2015, www.thedailybeast.com/the-tainted-veil
-muslim-women-confront-the-power-and-legacy-of-the-hijab; J. Weston Phippen,
"An American Hijab at the Olympics," *Atlantic*, February 4, 2016, www.theatlantic.
com/national/archive/2016/02/first-olympic-athlete-in-hijab/459933/.

4. Sara Morrison, "Media Is 'Failing Women'—Sports Journalism Particularly So,"
Poynter, February 19, 2014, www.poynter.org/news/media-failing-women-sports
-journalism-particularly-so.

5. Shireen Ahmed, "Muslim Women in Sports Bingo," Tales from a Hijabi
Footballer, November 8, 2014, http://footybedsheets.tumblr.com/post/102118817082
/i-created-a-bingo-card-that-is-helpful-when.

6. Shireen Ahmed, "Hijab in Sport and Unhelpful Media Biases," Muslimah Media
Watch, March 19, 2013, www.patheos.com/blogs/mmw/2013/03/hijab-in-sport-and
-unhelpful-media-biases.

7. Stephanie Webber, "Egyptian Women's Beach Volleyball Player Wears Hijab
against Bikini-Clad Opponents at Rio Olympics," *Us Weekly*, August 9, 2016, www
.usmagazine.com/celebrity-news/news/egyptian-volleyball-player-wears-hijab
-against-bikini-clad-opponents-w433523; "Hijabi Egyptian Volleyball Player
Compared to Bikini-Clad German," *Al Arabiya English*, August 9, 2016, http://english
.alarabiya.net/en/variety/2016/08/09/Hijabi-Egyptian-volleyball-player-compared-to
-bikini-clad-German.html.

8. Shireen Ahmed, "Sports Hijab Industry Wins—or Does It?," Muslimah Media
Watch, June 17, 2015, www.patheos.com/blogs/mmw/2015/06/sports-hijab-industry
-wins-or-does-it/.

9. "Saudi Arabia: Women Are 'Changing the Game,'" Human Rights Watch, August
4, 2016, www.hrw.org/news/2016/08/04/saudi-arabia-women-are-changing-game.

10. Shireen Ahmed, "The Intersection of Sports and Activism: Fighting for Cover,"
Shadow League, August 9, 2016, www.theshadowleague.com/story/the-intersection
-of-sports-and-activism-fighting-for-cover.

WOMEN IN SPORTS MEDIA FACE UNRELENTING SEXISM IN CHALLENGES TO THEIR EXPERTISE AND OPINIONS

Julie DiCaro | 2016

From the Women's Media Center, April 30, 2016, http://wmcspeechproject.com/2016 /04/30/women-in-sports-media-face-unrelenting-sexism-in-challenges-to-their -expertise-and-opinions. Reprinted by permission of the Women's Media Center and the author.

I was never truly aware of sexism until I started working in sports media. In the 13 years I spent as an attorney, I saw and felt a lot of injustice, but it was the kind I recognized: preference based on seniority, office politics or nepotism. It wasn't until I made the move to working full time in sports media that I really felt the soul-crushing, confidence-eroding, rage-inducing injustice of being considered "less" than my colleagues solely because of my gender. Today, I fully register the reality that I am treated differently every day because I am a woman.

In March of last year, an essay by Damon Young at *The Huffington Post* caused a fundamental shift in my worldview. In fact, it affected me so profoundly that it never really left me. I realized that men simply don't believe women, because we are women.

In his *HuffPo* piece, Young wrote:

> Trust. Well, the lack thereof. Generally speaking, we (men) do not believe things
> when they're told to us by women. Well, women other than our mothers or
> teachers or any other woman who happens to be an established authority figure.
> Do we think women are pathological liars? No. But, does it generally take longer
> for us to believe something if a woman tells it to us than it would if a man told
> us the exact same thing? Definitely![1]

I struggle with this reality every day.

Last year, I reported extensively on the Patrick Kane rape investigation. I was repeatedly accused of being biased and reporting only part of the story. Hundreds of men on Twitter demanded I reveal my sources and detail my vetting procedures publicly before they would accept my reporting as accurate. Even when

my reports were borne out by later events, I was accused of having an agenda and pushing a narrative. Though I pushed back, demanding to know how I was biased or what facts I was omitting, no one could ever really tell me. While I'd love to believe I was alone in this, women reporting on hot button issues (like Jane McManus on domestic violence in the NFL, and Jessica Luther on sexual assault in college sports) have been subjected to the same questions and accusations.

I've even had my credibility questioned when reporting easily verifiable information, like the World Series schedule or a starting lineup. I am routinely asked "Where did you get this information?" and "Who's your source?" Yet my male co-workers rarely experience these challenges. Sometimes it feels like even the most basic of facts must be confirmed by a male colleague before a certain portion of the audience will believe them to be true.

Part of the issue for women in sports media is that the industry is even more male-dominated than the rest of media. In part, the public is simply reacting to the lack of trust they see sports media putting in women professionals, who are often relegated to the role of sideline reporters or hosts, positions in which they are tasked with reporting on what men say or do, or asking them what they think.

Consider the reaction to ESPN's Jessica Mendoza being named an analyst on Sunday Night Baseball, where she is paid to give her own opinion rather than solicit them from men. Mendoza, who in addition to be a rising star at ESPN, was a former all-American softball star. During an October incident of harassment, she was reviled as a "*Woman Announcer*":

"Can this woman announcer stop talking," tweeted @Mike_Reda20.

"The fact that i have to listen to this woman announcer all night is making me lose my mind"—Wizard of Os.

"Really? A women's softball slugger as guest analyst on MLB Wildcard Game? Once again ESPN too frigging cute for their own good."—@mikebell929.

Mendoza's perceived lack of knowledge about the game was the target of much male ire, despite a myriad of male analysts on the same broadcast who didn't play pro ball.[2]

Perhaps the most disturbing aspect of the Mendoza backlash was not just that so many men refused to find her credible because she is a woman, but that so many men had no problem *saying openly* that they didn't find her credible because she was a woman. In this respect, sports media is the last bastion of sexism, one in which women are routinely excluded from major roles simply for being female—and in which it's acceptable to do so.

The perceived lack of credibility by female reporters leads to a far uglier

problem: online harassment. While a recent Pew study revealed that men are slightly more likely than women to experience online harassment, the harassment experienced by women tends to be disproportionately severe, involving sexual harassment and online stalking.[3] The online harassment women reporters face daily has a distinctly misogynistic bent, using, above all, the reporter's gender, in and of itself, as an insult.

> "@JulieDiCaro I feel sorry that you falsely accuse men of doing something they didn't. You are a fat, miserable white cunt"—@masterdon40

> "@88pkane Please slap this cunt @juliedicaro for slandering you and demeaning your character"—@masterdon40

> "@udpaule: @JulieDiCaro One of the Blackhawks player should beat you to death with their hockey stick like the WHORE you are. CUNT"

The message this gendered harassment conveys to women in sports media is clear: You don't belong here by virtue of your gender. You are not credible by virtue of your gender. And for those reasons, you are deserving of violence.

How, then, do women in sports media position themselves as reliable, credible, and trustworthy, in the face of such unfair and unjustifiable doubt? It begins with demanding a place at the grown-up table. By not being satisfied at being relegated to being "social media correspondents," sideline reporters, and glorified moderators for debates between men. When it comes to sports media, women, already viewed as "outsiders" by men who resent our influx into the industry, must insist on working in roles where our thoughts, analysis, and reporting are as valued as our looks, submissiveness, and sunny dispositions.

Notes

Links in the original online version of this article have been turned into endnotes.

1. Damon Young, "Men Just Don't Trust Women—and It's a Huge Problem," *HuffPost*, December 6, 2017, www.huffingtonpost.com/damon-young/men-just-dont -trust-women_b_6714280.html.

2. Jaclyn Hendricks, "Shock Jock Throws Sexist Twitter Tantrum over ESPN Analyst," *New York Post*, October 7, 2015, https://nypost.com/2015/10/07/shock-jock -throws-sexist-twitter-tantrum-over-espn-analyst.

3. Maeve Duggan, "Online Harassment," Pew Research Center, October 22, 2014, www.pewinternet.org/2014/10/22/online-harassment.

PART IX *Current Status and Recommendations for the Future*

We conclude this book with a series of readings that address the current status of women's sport. This assessment provides the occasion to look back—to see what has changed, consider what remains the same, and imagine how things can be different in the future.

The pioneers behind Title IX never intended that law to be just about athletic opportunities, but school sport is an educational program. This means that any elementary, junior high, high school, junior or community college, or college or university that receives any federal financial funding cannot discriminate on the basis of sex. This includes everything from discrimination in STEM (science, technology, engineering, and mathematics) education to protecting students against sexual harassment, abuse, and assault.

For most people, however, Title IX is synonymous with girls' and women's scholastic and intercollegiate sports. On the occasion of Title IX's forty-fifth anniversary, the National Coalition for Women and Girls in Education commissioned a report on the status of the law, excerpted here. The report reiterates a number of points made throughout this book, including the benefits of sports participation, the tremendous growth since 1972, and the continued need for more athletic opportunities for girls and women. The report also addresses common myths about Title IX, men's sports, and athletic funding.

A 2017 NCAA study, "The Status of Women in Intercollegiate Athletics," similarly reports that participation rates for girls in high school sports are more

than ten times higher than they were before the passage of Title IX. Still, inequalities persist. Boys make up 58 percent of all high school athletes. Women, and especially women of color, remain underrepresented at the intercollegiate level, too, and women's sports typically lack the funding and support enjoyed by men's programs. What is more, there is a significant lack of women in leadership positions, especially coaches, athletic directors, and conference commissioners.

For all its problems, Title IX has led to remarkable progress for U.S. girls and women. But what about those who live in countries where there is no law to ensure athletic opportunities? As the report from the World Health Organization (WHO) states, "Many girls around the world are not currently able to take advantage of the benefits of regular sports and physical activities due to inequitable access and opportunities." Consequently, the WHO offers ten possible strategies for initiating change around the world.

The global inequities in girls' and women's sport are obvious at the Olympic and Paralympic Games, especially in positions of leadership and governance. The 2016 Olympic Games in Rio de Janeiro, as the authors of "Women in the Olympic and Paralympic Games: An Analysis of Participation, Leadership, and Media Coverage" show, saw the highest ever delegation of female athletes, at 45 percent. On the U.S. team, almost 53 percent of all athletes were women, and they accounted for more than half the medals at the Olympic Games. Other countries, including China, Australia, Brazil, Cameroon, and Zimbabwe, also scored well with female representation on their Olympic delegations. Yet there were a number of nations where women's participation was either abysmally low or nonexistent. In fact, five countries competing in the 2016 Olympic Games in Rio did not include a single woman in their delegations.

Gender inequity was even more pronounced at the 2016 Paralympic Games, where women made up 38.6 percent of the athletes. What is worse, of the 159 national Paralympic committees represented at the Games, 42 did not include any women. Those women who did compete received significantly less media coverage than their Olympic counterparts.

Throughout this book, we have identified a number of problems that continue to affect girls and women in sport. The final reading offers ten solutions or strategies for change. This 1995 report from the Feminist Majority Foundation should be outdated, but it is clear that these strategies remain relevant today.

As we bring this book to a close, we ask readers to think about the many setbacks and triumphs in women's sport. It has been a long and difficult road from exclusion to acceptance. The journey is not complete. Too many women, for too many reasons, are turned away from sport or experience some form of discrimination when they do participate. As we repeatedly assert, women's sport

matters. Regardless of whether they are highly skilled professionals, recreational athletes, or somewhere in between, girls and women reap significant rewards from sport. Moreover, sport tells us much about the values and beliefs of our society, making the study of sport a rich and engaging endeavor.

TITLE IX AND ATHLETICS

Leveling the Playing Field Leads

to Long-Term Success

National Coalition for Women and Girls in Education | 2017

Excerpted from National Coalition for Women and Girls in Education (NCWGE), *Title IX at 45: Advancing Opportunity through Equity in Education* (Washington, DC: NCWGE, 2017). Available at www.ncwge.org/TitleIX45/Title%20IX%20at%2045 -Advancing%20Opportunity%20through%20Equity%20in%20Education.pdf.

At the 2016 summer Olympic Games in Rio de Janeiro, the U.S. Olympic team fielded a record 292 female athletes. These women not only outnumbered their male teammates, they formed the largest group of women ever to compete in Olympic history. The U.S. women earned 61 medals at the games, more than any other group—male or female—from any country. U.S. women performed similarly well in the Paralympic Games, earning 70 of Team USA's 115 medals.

In the wake of the games, many players, coaches, and commentators have noted the impact of Title IX on the success of U.S. women athletes. Figures from the past 45 years of international competition support this connection. In 1972, the year the legislation passed, the U.S. summer Olympic team's 400 athletes included just 84 women; the trend in female participation and success has been upward ever since.[1]

While most have lauded the new heights of achievement reached by U.S. women athletes, a few naysayers have resurrected the complaint that by granting female students equal access to school sports, Title IX somehow discriminates

Key Findings

1. Title IX has led to unprecedented participation and success for girls and women in sports. With more opportunities to play, the number of female high school athletes has risen more than tenfold in the past 45 years, while seven times as many women compete in college sports. These gains have helped elevate U.S. women's sports both nationally and internationally.

2. Participation in sports confers health and social benefits that extend well beyond school. Female athletes are less likely to develop health problems, less likely to engage in risky behavior, and more likely to do well in school than their non-athlete peers. They also develop leadership skills that can help them succeed professionally.

3. These gains have not come at the expense of male athletes. In fact, participation in sports among boys and men has continued to expand under Title IX, at both the high school and the college level.

4. Attacks on Title IX often spring from misconceptions about the law. In specifying equal opportunity for women and girls in sports, the law does not mandate quotas or lower opportunities for male athletes.

5. Despite many gains over the past 45 years, more needs to be done to address barriers for girls and women in sports. Greater enforcement of the law by the federal and state governments, self-policing of compliance by schools, and greater transparency of information on sports participation and spending will help bring about a truly level playing field that will benefit all.

against male athletes. In fact, the success of U.S. women in the global sports arena not only affirms the value of Title IX, it negates the claim that girls and women don't deserve equal access to athletics because they don't have the same level of interest as their male counterparts.

Although the athletic provisions of Title IX are probably the most well-known aspects of the legislation, myths about the requirements and impact of Title IX are prevalent. The law requires that schools treat the sexes equally with regard to participation opportunities, athletic scholarships, and the benefits and services provided to male and female teams. It does not require that schools spend the same amount on both sexes, nor has it resulted in reduced opportunities for boys and men to play sports.

Despite substantial gains since the passage of Title IX, the playing field is still not level for girls and women. Compared with their male counterparts,

girls are twice as likely to be inactive, enter into sports later in life, drop out of sports earlier in life, and have fewer opportunities to participate in both high school and college sports. Greater enforcement of Title IX and diligent efforts to advance women and girls in sports are still necessary to achieve truly equal opportunity on the playing fields.

Greater Opportunity = More Participation for Everyone

Opportunities for girls and women in athletics have increased exponentially since the passage of Title IX. During the 1971–1972 school year, immediately before the legislation passed, fewer than 300,000 girls participated in U.S. high school athletics. To put that number in perspective, just 7% of all high school athletes were girls. In 2015–2016, the number of female athletes had climbed more than tenfold to 3.3 million, or 42% of all high school athletes (Figure 1).[2]

Title IX has also had a huge impact on women's participation in college athletics. In 1971–1972, fewer than 30,000 women participated in college sports. In 2015–2016, that number exceeded 214,000—about 7 times the pre–Title IX rate (Figure 2).[3] In 1972, women received only 2% of schools' athletic budgets, and athletic college scholarships for women were nonexistent.[4] In 2013–2014, women received 47% of the athletic scholarship dollars at Division 1 schools, although their overall funding continues to lag.[5]

As the graphs show, greater female participation in school sports has not caused a decline among boys and men. In fact, male participation in both high school and college athletics has continued to *increase* since Title IX's enactment, and males continue to have more opportunities to participate in sports than females at all school levels.

The same is true of funding. As an example, in Division 1-FBS (the most competitive college division, formerly Division I-A), median expenditures have doubled for men as well as for women since 2004; expenditures for women are still less than half those for men ($10.6 million vs. $26.1 million). Moreover, median expenses per athlete in every category of Division I (FBS, FCS, and Division 1 without football) have increased more rapidly for men than for women over the past 10 years.[6]

Despite the gains over the past 45 years, much work remains to be done to ensure equal access to school sports. Girls' and women's participation still lags behind that of their male counterparts, and the sharp increases in female participation through the beginning of the decade have leveled off in recent years. Given the proven benefits of athletics, it is essential that women and girls be given equal opportunities to participate.

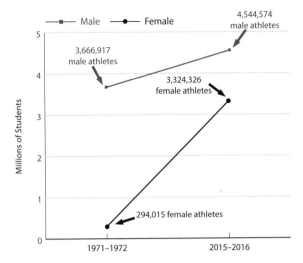

FIGURE 1 **Male and female participation in high school sports, 1972–2016** *Source*: National Federation of State High School Associations, 2016.

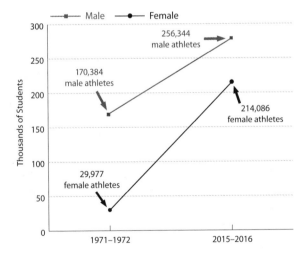

FIGURE 2 **Male and female participation in college sports, 1972–2016** *Source*: NCAA Sports Sponsorship and Participation Report, 1971–72 to 2011–12 and 1981–82 to 2015–16.

Health and Social Benefits of Sports

The benefits of participation in athletics for girls and women encompass both immediate and long-term health advantages. They also confer a range of academic and social benefits that can have a deep and lasting impact.

Many of the benefits linked to sports participation offer a positive trajectory for later physical, social, emotional, educational, and economic outcomes. These benefits apply beginning in elementary school and carry through to all points of entry into athletics during childhood and adolescence.

BETTER SHORT-TERM AND LONG-TERM HEALTH

Sports can have a major impact on girls' and women's health. It is well documented that regular physical activity can reduce the risk of obesity for adolescent girls, making it an important strategy for combating obesity-related health issues.[7] These benefits are long lasting; one study found that women who played sports while young had a 7% lower risk of obesity 20–25 years later, when women were in their late 30s and early 40s.[8] The study notes that while a 7% decline in obesity is modest, "no other public health program can claim similar success."

Obesity is a concern for all girls, but particularly for those of color. Of girls aged 2–19, obesity affects 15% of white girls, 21% of African American girls, and 22% of Hispanic girls.[9] Because girls of color often have limited out-of-school sports opportunities in their communities and face other challenges to participation (e.g., financial and transportation needs), they are more likely to participate in sports through school than through private organizations.[10] This makes it even more critical that they have equal access to school-sponsored sports to enable them to be physically active.

The long-term health benefits of participation in school athletics extend well beyond combating obesity. Regular physical activity also decreases a young woman's chance of developing a range of other diseases, including heart disease, osteoporosis, and breast cancer.[11] Given the high social and financial costs of such illnesses, the societal benefits of school sports programs can be enormous.

The direct health benefits of increased activity may come as no surprise, but participation in sports can have less obvious benefits as well. For example, girls and women who play sports have higher levels of confidence and self-esteem and lower levels of depression than those who don't. They also have a more positive body image and experience higher states of psychological well-being.[12]

Sports participation can also affect risk behaviors. High school athletes are less likely to smoke cigarettes or use drugs than their peers who don't play sports.[13] One study found that female athletes are 29% less likely to smoke than

non-athletes.[14] Given the high costs of smoking-related illnesses and deaths, these figures are significant. Moreover, adolescent female athletes have lower rates of both sexual activity and unintended pregnancy than their non-athlete counterparts.[15] This is true for white, African American, and Latina athletes.[16]

ACADEMIC AND PROFESSIONAL ACHIEVEMENT

Studies have found that female participation in sports offers a range of academic benefits. Young women who play sports are more likely to graduate from high school, have better grades, and score higher on standardized tests than non-athletes.[17] This pattern of greater academic achievement is consistent across community income levels. A statewide, three-year study by the North Carolina High School Athletic Association found that athletes achieved grade point averages that were nearly a full point higher than those of their non-athlete peers, in addition to higher graduation rates.[18]

These benefits are helping to close certain education gaps for girls and women. For example, female athletes are more likely to do well in science classes than their classmates who do not play sports.[19] In addition, female athletes of color consistently benefit from increased academic success throughout their education. Female Hispanic athletes, for example, are more likely than non-athletes to improve their academic standing, graduate from high school, and attend college.[20] Overall, female athletes have higher college graduation rates than their non-athlete peers.[21]

The lessons of teamwork, leadership, and confidence that girls and women gain from participating in athletics can help them after graduation as well as during school. A whopping 94% of female business executives played sports, with the majority saying that lessons learned on the playing field contributed to their success. Former female athletes also earn an average of 7% more in annual wages than their non-athlete peers.[22]

The Truth about Title IX and Athletics

Title IX opponents continue to try to undermine the law through media attacks, legal challenges, and appeals to Congress and the Executive Branch. The basic claim made by opponents is that women and girls are inherently less interested in sports than their male counterparts, and that providing females with equal opportunities therefore harms male athletes.

These criticisms are not supported by the facts, nor do they represent what the law says. They have been resoundingly rejected by all of the federal appellate courts that have considered them.[23]

Making the Most of Opportunities in Athletics

Increased participation by women and girls in sports since Title IX has led to a new generation of athletes and fans who pack stadiums and spend a growing number of consumer dollars on women's sports. Following are just a few examples of how expanded opportunity in athletics leads to greater participation and success.

- The U.S. women's basketball team won an unprecedented sixth straight gold medal during the 2016 Olympics, once again going undefeated and racking up a total of 49 straight Olympic match wins. The average margin of victory during the 2016 games was nearly 40 points.
- With a silver medal at the 2014 Winter Olympics, the U.S. women's ice hockey team continued its streak of medaling at every Olympics since the sport was introduced in 1998.
- Women's soccer has expanded rapidly as more girls and women have had a chance to participate. Girls now make up 48% of U.S. Youth Soccer membership, and the number of women's NCAA soccer teams has more than tripled over the past 25 years, from 318 in 1991 to 1,034 in 2016.
- Professional women's soccer also continues to grow in popularity. In 2015, the U.S. became the first women's team to win three World Cup titles when it defeated Japan in the final match. That game took the record as the most-watched soccer match—men's or women's—in U.S. history.
- In 2012, the 40th anniversary of Title IX, women outnumbered men on the U.S. Olympic team for the first time and garnered 58 medals, earning the games the media nickname "the Title IX Olympics." In 2016, U.S. women Olympians earned 61 medals—more than nearly all countries' combined men's and women's teams.

Source: Adapted from *The Battle for Gender Equity in Athletics in Colleges and Universities*, National Women's Law Center, 2015.

The latest attacks have targeted secondary school programs. In 2011, the American Sports Council filed a lawsuit against the U.S. Department of Education, claiming that Title IX should not apply to secondary schools. This case, like other similar cases, was dismissed. The court found that because the law does not require schools to reduce opportunities, the council could not show that Title IX caused the injuries at the base of the suit (described as the potential reduction of athletic opportunities for boys).[24]

WHAT THE LAW SAYS

Title IX requires that schools treat both sexes equally with regard to three distinct aspects of athletics: participation opportunities, athletic scholarships, and the benefits and services provided to male and female teams.

Participation. The Department of Education uses a "three-part test" to evaluate schools' compliance with the requirement to provide equal participation opportunities (see the boxed insert for details). This test was set forth in a Policy Interpretation issued by the Department's Office for Civil Rights (OCR) in 1979[25] and has withstood legal challenges.

Athletic Financial Assistance. Title IX requires that athletic scholarships be allocated in proportion to the number of female and male students participating in intercollegiate athletics.[26] OCR has made clear that schools will be found in compliance with this requirement if the percentage of total athletic scholarship dollars received for each sex is within one percentage point of their levels of participation.[27] In other words, if women comprise 42% of the athletes on campus, the school must provide between 41% and 43% of its athletic scholarship dollars to female athletes.

Other Benefits and Services. Title IX also requires equity in benefits and services. The law does not require that each men's and women's team get exactly the same benefits and services, but it does require that male and female athletes receive equal treatment overall in areas such as locker rooms, equipment, practice and game facilities, recruitment, academic support, and publicity.[28]

Debunking the Myths: No Cuts or Quotas

One feature the law does *not* include is any form of discrimination against or harm to male athletes. Despite this, myths abound about how Title IX affects athletics, particularly at the high school and college levels. Most of these myths reflect the unfounded fear that increasing athletics opportunities for girls and

The Three-Part Test

Under the three-part test, a school is in compliance with the law if:

1: The percentages of spots on teams allocated to males and females are substantially proportionate to the percentages of male and female students enrolled; *or*

2: It has a history and continuing practice of expanding athletic opportunities for the underrepresented sex; *or*

3: Its athletics program fully and effectively accommodates the interests and abilities of the underrepresented sex.

women will correspondingly decrease opportunities for boys and men. In fact, boys and men have continued to make gains in athletics as opportunities for their female counterparts have grown, with corresponding benefits for all students.

Myth 1: Title IX requires quotas. Title IX does not set quotas; it simply requires that schools allocate participation opportunities in a nondiscriminatory way. The three-part test is lenient and flexible, allowing schools to comply even if they do not satisfy the first part. The federal courts have consistently rejected arguments that Title IX imposes quotas.

Myth 2: Title IX forces schools to cut male sports. Title IX does not require or encourage the cutting of any sports. It does allow schools to make choices about how to structure their programs as long as they do not discriminate. Instead of allocating resources among a variety of sports, many college administrators are choosing to take part in the basketball and football "arms race" at the expense of other athletic programs. In Division I-FBS, for example, basketball and football consume 80% of total men's athletic expenses. Average expenditures on football alone in this division ($12+ million) still exceed average expenditures on *all* women's sports ($9+ million).[29]

Myth 3: Men's sports are declining because of Title IX. Opportunities for men in sports—measured by numbers of teams as well as athletes—have continued to expand since the passage of Title IX. Between the 1988–1989 and the 2015–2016 school years, National Collegiate Athletic Association (NCAA) member institutions added 4,045 men's sports teams and dropped 3,016, for a net gain of more than 1,000 men's teams. Women made greater gains over the same period, but

only because they started at such a deficit; 5,660 women's teams were added and 2,185 were dropped. During the 2015–2016 school year, NCAA member institutions actually dropped more women's teams than men's teams (44 vs. 35).[30]

Myth 4: Title IX requires equal spending on male and female sports. The fact is that spending does not have to be the same as long as the benefits and services provided to the men's and women's programs are equal overall. The law recognizes, for instance, that football uniforms cost more than swimsuits; therefore, a discrepancy in the amount spent on uniforms for men's and women's teams is not necessarily a problem. However, the school cannot provide men with top-notch uniforms and women with low-quality uniforms, or give male athletes home, away, and practice uniforms and female athletes only one set of uniforms. A large discrepancy in overall funding is a red flag that warrants further scrutiny.

Myth 5: Men's football and basketball programs subsidize female sports. The truth is that these high-profile programs don't even pay for themselves at most schools. Even among the most elite divisions, nearly half of men's football and basketball programs spend more money than they generate.[31]

Moving toward Equality: Recent Progress and Remaining Challenges

MAJOR STEPS FORWARD

In 2010, the Department of Education issued a new policy document revoking an earlier document from 2005 that weakened Title IX protections by allowing schools to gauge female students' interest in athletics by relying on responses (or lack of responses) to an email survey. The 2010 Clarification states that schools cannot rely solely on surveys to demonstrate that they are in compliance with part three of Title IX's participation test. Instead, schools must adhere to a longstanding policy requiring them to evaluate multiple indicators of interest to show that they are fully and effectively accommodating their female students' interests.[32]

In another step forward, courts have held that women's sports must adhere to certain criteria to count under Title IX. In 2010, after one university attempted to eliminate varsity women's volleyball and instead elevate the less expensive competitive cheerleading squad to varsity status, a federal district court in Connecticut held that competitive cheerleading is not yet a sport for the purposes of Title IX.

In its decision, the court cited cheerleading's lack of a central governing body, standardized rules, defined season, or post-season structure, among other issues.

While competitive cheerleading certainly requires athleticism of its participants, the court found that the opportunities provided were not consistent with a true varsity experience.[33] A federal appeals court upheld this decision in 2012.

CONTINUING BARRIERS FOR GIRLS AND WOMEN

Despite great gains over the past 45 years, barriers to true equality in school athletics still remain:

- Girls have 1.2 million fewer chances to play sports in high school than boys.[34] In addition, opportunities are not equal among different groups of girls. Fewer than two-thirds of African American and Hispanic girls play sports, while more than three-quarters of Caucasian girls do.

- Girls of color are doubly disadvantaged by race and gender when it comes to high school athletic opportunities. Schools that are heavily minority (90% or more) have fewer resources and often do not allocate athletic opportunities equitably; girls in these schools receive just 39% of the opportunities that girls in heavily white schools receive.[35]

- Three-quarters of boys from immigrant families are involved in athletics, while fewer than half of girls from immigrant families are.[36]

- In addition to having fewer participation opportunities, girls often endure inferior treatment in areas such as equipment, facilities, coaching, scheduling, and publicity. Such inferior treatment violates Title IX.[37]

- At the most competitive college level, Division I-FBS schools, women make up nearly 52% of students, yet they have only 47% of the opportunities to play intercollegiate sports. Female athletes at these schools receive 43% of the total athletic scholarship dollars, 31% of the dollars spent to recruit new athletes, and less than 30% of the total money spent on athletics.[38]

- Since Title IX passed, the proportionate role of female coaches has decreased dramatically. In 1972, 90% of women's college teams were coached by women, while as of 2014 just 43% were. Only 3% of men's teams are coached by women. As the number of women's teams has increased, the percentage of female coaches has continued to drop.[39]

NCWGE Recommendations

- Schools at all levels must monitor their athletic departments' compliance with Title IX to ensure that girls and women have access to school sports. This includes implementing measures to gauge interest as well as to allocate resources equitably.

- High schools should make data available on male and female participation in sports, including budgets and expenditures for each team. This information, which they already collect, would help dispel myths about Title IX and its impact on athletics.
- Transparency of information should be a priority for legislators as well as for individual schools and communities. One effective measure would be passage of the federal High School Athletics Transparency Bills,[40] which require high schools to make their existing data public (something colleges already have to do).[41] State legislatures should also consider passing such legislation, which would allow communities to be informed about the treatment of boys and girls in high school sports without creating an additional burden on schools.
- OCR must receive adequate funding and strengthen its efforts to enforce Title IX by initiating proactive compliance reviews at more educational institutions and providing technical assistance and guidance on emerging Title IX questions.
- Schools should seek to hire qualified women in positions of administrative authority. In addition to serving as role models, female administrators may help improve gender equity. For example, schools with female athletic directors have a higher percentage of women coaches.

Notes

1. See https://cronkitenews.azpbs.org/2016/08/16/title-ix-tipping-point-for -explosion-of-us-females-in-olympics/.

2. National Federation of State High School Associations (NFHS), *2015–16 High School Athletics Participation Survey,* 2016. See http://www.nfhs.org/ ParticipationStatistics/PDF/2015-16_Sports_Participation_Survey.pdf.

3. E. Irick, *NCAA Sports Sponsorship and Participation Rates Report: Student-Athlete Participation, 1981–82—2015–16.* National Collegiate Athletics Association (NCAA), 2016, p. 79. See http://www.ncaapublications.com/productdownloads/PR1516.pdf.

4. Remarks of Senator Stevens (R-AL), 130 Cong. Rec. S 4601 (daily ed. April 12, 1984).

5. *Revenues & Expenses, 2004–2014: NCAA Division 1 Intercollegiate Athletics Programs Report.* NCAA, 2015. See http://www.ncaa.org/sites/default/files/2015%20 Division%20I%20 RE%20report.pdf.

6. Ibid., pp. 18 and 24.

7. The President's Council on Physical Fitness and Sports, *Physical Activity & Sport in the Lives of Girls,* 1997. See http://www.cehd.umn.edu/tuckercenter/library/docs /research/pcpfs_report.pdf.

8. See T. Parker-Pope, "As Girls Become Women, Sports Pay Dividends," *New York*

Times, Feb. 16, 2010; R. Kaestner and X. Xu, "Title IX, Girls' Sports Participation, and Adult Female Physical Activity and Weight," *Evaluation Review,* 34(1), 2010.

9. Centers for Disease Control and Prevention, National Center for Health Statistics, *Prevalence of Overweight and Obesity among Children and Adolescents Aged 12–19 Years: United States, 1963–1965 through 2013–2014* (2016). Available at https:// www.cdc.gov/nchs/data/hestat/obesity_child_13_14/obesity_child_13_14.htm#table3.

10. *The Wilson Report: Moms, Dads, Daughters and Sports.* Women's Sports Foundation (WSF), 1988.

11. E. J. Staurowsky, M. J. DeSousa, K. E. Miller et al., *Her Life Depends on It III: Sport, Physical Activity, and the Health and Well-Being of American Girls and Women.* WSF, 2015. Available at https://www. womenssportsfoundation.org/research/article -and-report/health-research/her-life-depends-on-it-iii/.

12. D. Sabo and P. Veliz, *Go Out and Play: Youth Sports in America.* WSF, 2008. Available at https://www. womenssportsfoundation.org/research/article-and-report /health-research/go-out-and-play/.

13. E. J. Staurowsky et al., *Her Life Depends on It III.* WSF, 2015.

14. M. J. Melnick, K. E. Miller, D. Sabo et al., "Tobacco use among high school athletes and non-athletes: Results of the 1997 Youth Risk Behavior Survey." *Adolescence, 36,* 2001, 727–747.

15. See, e.g., T. Dodge and J. Jaccard, "Participation in Athletics and Female Sexual Risk Behavior," *Journal of Adolescent Research,* 17(1), 2002; D. Sabo et al., *Sport and Teen Pregnancy,* WSF, 1998; The President's Council on Physical Fitness and Sports, *Physical Activity & Sports in the Lives of Girls,* 1997.

16. D. Sabo et al., *Sport and Teen Pregnancy.* WSF, 1998. Available at https://www .womenssportsfoundation.org/research/article-and-report/health-research/sport -and-teen-pregnancy/.

17. NFHS, *The Case for High School Activities.* Available at https://www.nfhs.org /articles/the-case-for-high-school-activities/.

18. See http://www.nchsaa.org/whitley-study.

19. E. J. Staurowsky et al., *Her Life Depends on It III.* WSF, 2015.

20. D. Sabo, *Minorities in Sports: The Effect of Varsity Sports Participation on the Social, Educational, and Career Mobility of Minority Students.* WSF, 1989. Available at https://www.womenssportsfoundation.org/research/article-and-report/athletes-of -color/minorities-in-sports.

21. See data on athletics and graduation rates at http://www.ncaa.org/about /resources/media-center/news/graduation-success-rate-continues-climb and http:// web1.ncaa.org/app_data/GSR/nablus15/GSR_Fed_Trends.pdf.

22. See http://www.ey.com/gl/en/newsroom/news-releases/news-sport-is-a-critical -lever-in-advancing-women-at-all-levels-according-to-new-ey-espnw-report.

23. See, for example, *National Wrestling Coaches Association v. United States Department of Education,* 366 F.3d 930 (D.C. Cir. 2004); *Miami University Wrestling Club v. Miami University,* 302 F.3d 608, 612–13 (6th Cir. 2002); *Williams v. Sch. Dist. of Bethlehem,* 998 F.2d 168, 171 (3d Cir. 1993); *Pederson v. La. State Univ.,* 213 F.3d 858, 880 (5th Cir. 2000); *Chalenor v. Univ. of N.D.,* 291 F.3d 1042, 1046 (8th Cir. 2002); *Roberts v. Colo. State Univ.,* 998 F.2d 824, 828–29 (10th Cir. 1993), among others.

24. *American Sports Council v. United States Department of Education* (D.D.C.

2012). See https://www.gpo.gov/fdsys/pkg/USCOURTS-dcd-1_11-cv-01347/pdf
/USCOURTS-dcd-1_11-cv-01347-0.pdf.

25. 44 Fed. Reg. 71413 et seq (1979).

26. 34 C.F.R. § 106.37(c).

27. 34 C.F.R. § 106.41(c) and Norma V. Cantú, *Dear Colleague Letter: Bowling Green State University,* (U.S. Department of Education, Office for Civil Rights, July 23, 1998).

28. 34 C.F.R. § 106.41(c) (1–10).

29. *Debunking Myths about Title IX and Athletics.* National Women's Law Center (NWLC), 2015. Available at http://www.nwlc.org/resource/debunking-myths-about
-title-ix-and-athletics.

30. E. Irick, *NCAA Sports Sponsorship and Participation Rates Report: Student-Athlete Participation, 1981–82—2015–16.* NCAA, 2016, pp. 8–9.

31. D. Fulks, *NCAA Revenues & Expenses Report: 2004–2014.* NCAA, 2015.

32. *The Department of Education Puts the Teeth Back in Title IX by Revoking a Damaging 2005 Athletics Policy.* NWLC, 2010. Available at http://www.nwlc.org/sites
/default/files/pdfs/FactSheeton2010TitleIXPolicy.pdf.

33. See https://ecf.ctd.uscourts.gov/cgi-bin/show_public_doc?2009cv0621-171.

34. NFHS, *2015–16 High School Athletics Participation Survey,* 2016.

35. NWLC and Poverty & Race Research Action Council, *Finishing Last: Girls of Color and School Sports Opportunities* (2015). Available at https://nwlc.org/resources
/finishing-last-girls-color-and-school-sports-opportunities/.

36. D. Sabo and P. Veliz, *Go Out and Play: Youth Sports in America.* WSF, 2008.

37. See http://cdn.ca9.uscourts.gov/datastore/opinions/2014/09/19/12-56348.pdf.

38. U.S. Department of Education, *Equity in Athletics Data Analysis (EADA),* 2014. See https://ope.ed.gov/athletics/#/customdata/datafiltered.

39. V. R. Acosta and L. J. Carpenter, *Women in Intercollegiate Sport: A Longitudinal, National Study, Thirty-Seven Year Update, 1977–2014,* pp. 18–19. Available at http://
acostacarpenter.org/2014%20Status%20of%20Women%20in%20Intercollegiate%20
Sport%20-37%20Year%20Update%20-%201977-2014%20.pdf.

40. NWLC, *High School Athletics Transparency Bills of 2013.* Available at https://
nwlc. org/resources/high-school-athletics-transparency-bills-2013/.

41. See 20 U.S.C. Part 1092(g); the federal government reports this data through EADA, https://ope.ed.gov/athletics/#/.

Resources on Title IX and Athletics

Debunking the Myths about Title IX and Athletics. National Women's Law Center (NWLC), 2015. Available at http://nwlc.org/resources/debunking-myths-about
-title-ix-and-athletics/.

The Battle for Gender Equity in Athletics in Colleges and Universities. NWLC, 2015. Available at https://nwlc.org/wp-content/uploads/2015/08/bge_in_colleges_and
_universities_8.11.15.pdf.

The Battle for Gender Equity in Athletics in Elementary and Secondary Schools. NWLC, 2015. Available at http://nwlc.org/resources/battle-gender-equity-athletics
-elementary-and-secondary-schools/.

NCAA Gender Equity Report, 2004–2010. National Collegiate Athletic Association

(NCAA), 2012. Available at http://www.ncaapublications.com/productdownloads
/GEQS10.pdf.

Equity and Title IX in Intercollegiate Athletics: A Practical Guide for Colleges and
Universities. NCAA, 2012. Available at http://www.ncaapublications.com
/productdownloads/EQTI12.pdf.

Equity in Athletics Data Analysis. U.S. Department of Education. Available at https://
ope.ed.gov/athletics/#/.

Title IX Still Applies: The Battle for Gender Equity in Difficult Economic Times.
NWLC, 2015. Available at http://www.nwlc.org/resource/title-ix-still-applies
-gender-equity-athletics-during-difficult-economic-times.

Find Your Title IX Coordinator. American Association of University Women
(AAUW). Available at http://www.aauw.org/resource/find-your-title-ix
-coordinator/.

FORTY-FIVE YEARS OF TITLE IX

The Status of Women

in Intercollegiate Athletics

Amy S. Wilson | 2017

Excerpted from Amy S. Wilson, *45 Years of Title IX: The Status of Women in
Intercollegiate Athletics* (Indianapolis: National Collegiate Athletic Association, 2017).
Copyright © 2017 National Collegiate Athletic Association.

Participation

- Male and female student-athletes continue to set NCAA participation
 records each year; these numbers are at all-time highs. One trend to
 continue to monitor is the rate of growth of participation numbers by
 gender. In the 2000s, men's participation numbers in championship
 sports have slightly outpaced women's. From 2002–2016, male student-
 athletes gained just over 65,000 participation opportunities while female
 student-athletes garnered almost 58,000.

- Division I has the best participation rate for women with 46.7 percent
 female student-athletes and 53.3 percent male student-athletes. The gap

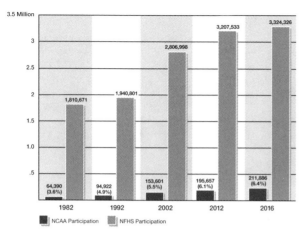

FIGURE 1 NCAA and high school female participation levels In 2015-16, more than 3.3 million female high school athletes were part of the recruiting pool to fill 209,472 roster spots on NCAA championship sport teams.

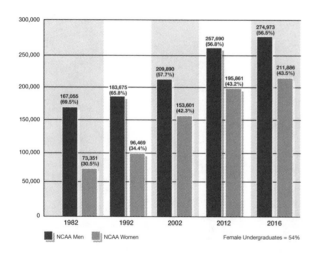

FIGURE 2 Championship sports participation: all divisions Since the early 2000s, men's championship participation opportunities have grown at a slightly faster rate than women's even though colleges and universities are fielding on average one more women's team than men's in their athletics programs. The overall undergraduate enrollment rate across all NCAA divisions is 46 percent males and 54 percent females; thus, with the female student-athlete participation rate at 43.5 percent, the women's overall sport participation rate is 10.5 percent lower than the average percentage of women undergraduates. *Source*: NCAA Sports Sponsorship and Participation Report

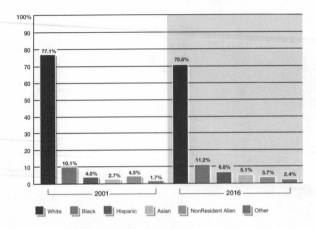

FIGURE 3 **NCAA Women's participation by race: all divisions**
The past 15 years reveal modest increases in female student-athlete diversity.
Black and Hispanic female student-athletes have experienced slight gains in
participation, up 1.1 and 2.8 percentage points, respectively. *Source*: NCAA
Sports Sponsorship, Participation and Demographics Search

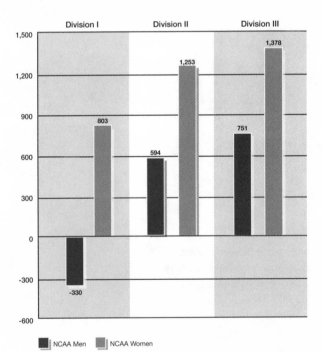

FIGURE 4 **Net outcome of NCAA added and dropped teams 1988–
2016** Since 1988, Division I has had a net loss of 330 men's teams. However,
an assessment of all NCAA divisions indicates a net gain for Divisions II and
III men's teams. *Source*: NCAA Sports Sponsorship and Participation Report

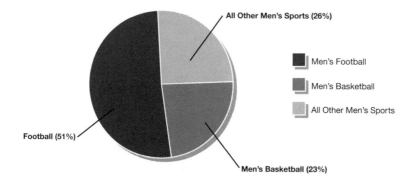

FIGURE 5 **Expenses by men's sport program: Division I** For Division I overall, 74 percent of the men's budget was allocated to football and basketball. *Source:* NCAA Financial Reporting System

between men's and women's participation opportunities is at double digits in favor of men in Division II (16.6 percent) and Division III (16.8 percent).

- The female student-athlete population across all NCAA Divisions is more racially and ethnically diverse in 2015–16 than it was in 2000–01. The number of minority student-athletes grew by over 6 percentage points, resulting in just over 29 percent of female intercollegiate student-athletes being minority women. The most recent data show that Division I (63.7 percent white/36.3 percent minority) has the most diversity among female student athletes, followed by Division II (68.1 percent white/31.9 percent minority) and Division III (80.1 percent white/19.9 percent minority).

Allocation of Resources

Over the past decade, expenditures for men's and women's athletics programs have doubled in all three Divisions.

Division I has the greatest gap in spending between men's and women's athletics programs. Analysis of median expenses indicates that Division I athletics departments are spending twice as much on their men's programs than on their women's programs with the widest gap at the Football Bowl Division (FBS).

Division II and Division III have more equitable spending on men's and women's athletics programs than Division I. Compared to the 20 percentage point difference in median expenses at Division I, Division II has a 9 percentage point spending gap between men's and women's programs, and Division III's gap is 8.

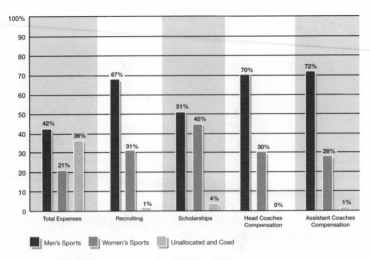

FIGURE 6 **Allocation of resources: Division I** Of the NCAA divisions, Division I has the greatest difference in expenditures on men's and women's athletics programs with the exception of scholarships. *Source*: NCAA Financial

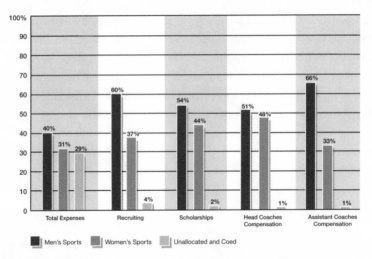

FIGURE 7 **Allocation of resources: Division II** Division II athletics programs allocate more resources for men in each category, but they provide the most equitable compensation for head coaches of the three divisions. *Source*: NCAA Financial Reporting System

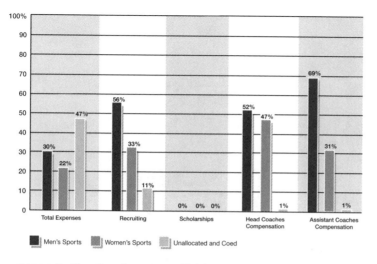

FIGURE 8 **Allocation of resources: Division III** Division III athletics programs provide the most overall equitable spending on men's and women's sports. *Source*: NCAA Financial Reporting System

In 2015, Division I spent more on each male student-athlete than female student-athlete: over $45,000 more at FBS; $5,500 more at FCS; and $3,200 more at Division I institutions without football. In contrast, Division II and Division III show slightly higher expenditures for each female student-athlete, results affected by the male advantage in participation opportunities.

Leadership Positions

- Since Title IX was passed in 1972, the numbers of female head coaches and female athletics directors (ADs) have declined. Over the past decade, the percentage of female coaches of women's teams has leveled off at around 40, and since 1980, the percentage of female ADs has remained around 20.
- Women hold approximately 23 percent of all NCAA head coaching, athletics director, and conference commissioner positions.
- As emphasized earlier in this report, in Title IX's 45th year, there is still much progress to be made for minority women's representation in leadership positions in intercollegiate athletics. In 2015–16, 13.8 percent of female head coaches of women's teams and 12.6 percent of female athletics directors were minority women. These percentages have decreased slightly from five years ago.

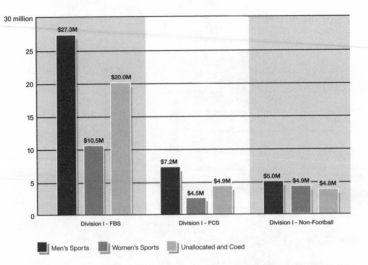

FIGURE 9 **Median total expenses in athletics programs: Division I**
At FBS institutions, the median budget for the men's athletics program is
more than 2.5 times the budget for the women's athletics program. *Source*:
NCAA Financial Reporting System

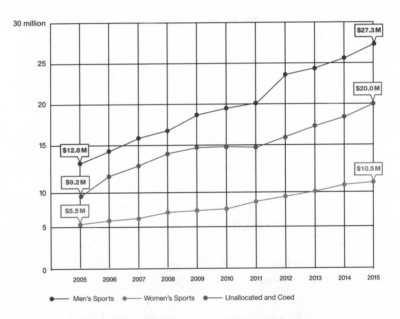

FIGURE 10 **Median total expenses: Division I FBS** Division I FBS
athletics programs have the largest spending gap between men's and women's
athletics programs. *Source*: NCAA Financial Reporting System

- Since Title IX was passed, men have gained many opportunities to coach female student-athletes; in 2015–16, men were head coaches of 59.8 percent of women' teams. In contrast, women have experienced meager increases in opportunities to coach men, holding only 4.6 percent of head coaching positions for men's teams.
- In 2015–16, more men (51 percent) than women (49 percent) were assistant coaches for women's teams.
- In 2015–16, women were 34.5 percent of associate athletics directors, a slightly lower percentage than 20 years ago. For assistant athletics director positions, women gained a mere 1.3 percentage points since 1996.
- In the past five years, women have outpaced men in acquiring conference commissioner positions. There were 27 female commissioners with no minority women in this role in 2010–11. In 2015–16, women are in 37 of the available 142 conference commissioners positions, including 2 minority women. [. . .]

Moving Forward

Title IX's 45th anniversary is a milestone that offers the opportunity to ask important questions: Are we succeeding at providing equitable intercollegiate athletics participation opportunities for women and men; at using resources to

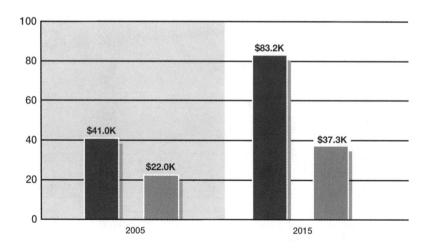

FIGURE 11 **Median expenses per athlete: Division I** Division I FBS institutions spend more than twice as much on each male student-athlete than on each female student-athlete. Expenditures for each male and female athlete are more balanced in the Division I FCS and Division I institutions without football. *Source*: NCAA Financial Reporting System

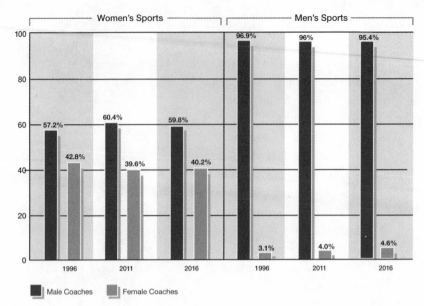

FIGURE 12 Head coaches by gender According to NCAA data, 60 percent of women's teams are now coached by men. While men are coaching women's teams in high numbers, only 4.6 percent of men's teams are coached by women, an increase of 1.5 percent over 20 years. *Source*: NCAA Sport Sponsorship, Participation and Demographics Search

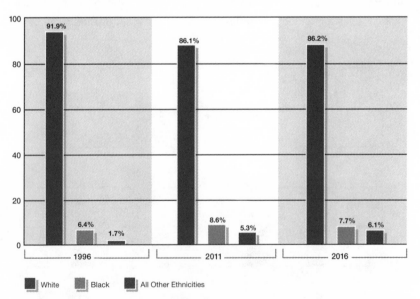

FIGURE 13 Female head coaches of women's teams by ethnicity Over the past five years, there has been no improvement in the percentage of minority women who are head coaches of women's teams. The percentage of black female head coaches has decreased by nearly a percentage point. *Source*: NCAA Sport Sponsorship, Participation and Demographics Search

create equitable experiences for all student-athletes; and at hiring and retaining diverse leaders who reflect the demographics of the student-athlete population and serve as impactful role models? This report shows that while some progress has been made, there remains much work to do. The NCAA will continue to lead initiatives such as those listed above that support and complement the work being carried out by membership schools and conferences. Achieving an equitable and inclusive experience for student-athletes and all who teach and lead them will require an ongoing and proactive commitment by the NCAA national office and the membership.

GIRLS' PARTICIPATION IN PHYSICAL ACTIVITIES AND SPORTS *Benefits, Patterns, Influences, and Ways Forward*

R. Bailey, I. Wellard, and H. Dismore | 2005

Excerpted from R. Bailey, I. Wellard, and H. Dismore, *Girls' Participation in Physical Activities and Sports: Benefits, Patterns, Influences and Ways Forward* (Geneva: WHO, 2005).

Recommendations

The benefits of participation in physical activities are great, and the potential costs of inactivity can be severe. Many girls around the world are not currently able to take advantage of the benefits of regular sports and physical activities due to inequitable access and opportunities.[1] Therefore, a central challenge facing governments, schools, sports groups and communities is to develop forms of physical activity that are sensitive to girls' needs and interests. But rather than focusing on "girl-friendly" sports,[2] we should be looking for ways to make sports and other physical activities more "child-friendly" and "youth-friendly."

Our reading of the research suggests a number of strategies that promote such "child-friendly" practices, facilitate regular physical activity, and are supportive of positive sporting experiences.

1. Girls do enjoy engaging in physical activities. Strategies should be implemented which build upon this enjoyment, and allow them to participate as fully as possible, in forms that offer them satisfaction and opportunities for achievement.

2. Practices should be established which recognise the importance of fun, health and social interaction in sports participation.

3. School physical education is a foundation of life-long physical activity. Fundamental movement skills need to be developed from an early age, for all children, with the emphasis on the individual body, rather than sporting outcomes.

4. Some girls regularly engage in sports and physical activities, as an integral part of their lifestyle. Any strategies concerned with raising participation among young people need to remember that neither girls nor boys are "the problem"; rather, the difficulty lies with the ways in which physical activities are constructed and presented.

5. It is important to examine and highlight the practices inherent within sports which might deter children from participating. Sports provision may need to be adapted to encourage and accommodate all young people.

6. It is necessary to listen to voices from outside mainstream sports, for example, dance, mixed ability, noncompetitive and co-operative activities.

7. Sports programmes should reflect local cultural needs if they are to engage and sustain girls' participation.

8. The organisation of sports groups and programmes should include women in key roles, such as coaching and mentors, and role models drawn from within local communities and schools. These should reflect differences in perspectives and interests, and develop close links with schools and communities, to ensure continuity of engagement in sports and physical activities throughout life.

9. More research is needed to explore sports and physical activities in the lives of young people, and this needs to reflect the diversity of experiences around the world, acknowledging both developed and developing countries.

10. The more opportunities that are available for girls to be physically active, the more they are active. Strategies need to be put in place that ensure activities, settings and facilities are easily accessible and safe.

Notes

Note numbers and callouts have been changed from the original article.

1. Sabo, D., Miller, K., Melnick, M. and Heywood, L. (2004) *Her life depends on it: Sport, physical activity and the health and well-being of American girls.* East Meadow, US: Women's Sports Foundation.

2. Kirk, D., Fitzgerald, H., Wang, J. and Biddle, S. (2000) *Towards Girl-Friendly Physical Education: The Nike/YSTGirls in Sport Partnership Project—Final Report.* Loughborough, UK: Institute for Youth Sport.

WOMEN IN THE OLYMPIC AND PARALYMPIC GAMES

An Analysis of Participation, Leadership, and Media Coverage

E. J. Houghton, L. P. Pieper, and M. M. Smith | 2017

Excerpted from E. J. Houghton, L. P. Pieper, and M. M. Smith, *Women in the 2016 Olympic and Paralympic Games: An Analysis of Participation, Leadership, and Media Coverage* (East Meadow, NY: Women's Sports Foundation, 2017). Available at www .womenssportsfoundation.org/research/article-and-report/elite-athletes/women -2016-olympic-paralympic-games.

The summer Olympic and Paralympic Games appear to be settings where female athletes have reached near parity with men. At the 2016 Olympic Games in Rio, female athletes accounted for 45% of the participants, an all-time high, achieving the goal set by former International Olympic Committee (IOC) President Jacques Rogge, which he predicted would occur by 2008. For Americans, the representation of female athletes at the 2016 Games was unprecedented, with 292 American women constituting the largest delegation of women at any Olympic Games. Their strength in numbers was matched by their notable sport performances, accounting for more than half of the nation's total medals (61 of 121) and 27 of the 46 gold medals (Myre, 2016). Similarly, for the first time, women

competed in the same number of Paralympic sports as men and constituted a large percentage of International Paralympic Committee (IPC) leadership roles. However, as one looks deeper into the number of participants, events, leadership opportunities, and media coverage provided to women, it is evident that women have only recently received increased opportunities. There is much work still to be done on the participation, leadership, and media fronts. [. . .]

The IOC has, over the past decade, made noteworthy attempts to support the inclusion of greater numbers of women in leadership positions in the international sporting scene. The percentage of women members of the IOC has grown from 15% in 2008 to 25% in 2016. The number of women on the 10-member IOC Executive Board has grown from one in 2008 to three in 2016. In February 2012, the IOC Women and Sport Commission hosted the 5th IOC World Conference on Women and Sport. However, the IOC action and rhetoric of gender equality has gained only minimal response from the National Olympic Committees (NOCs), the International Federations (IFs), and the International Paralympic Committee (IPC)—most of which still struggle to meet the IOC's request that women hold at least 20% of leadership positions. With so few women serving in leadership positions, it is difficult to maintain organizational focus on the need to support women both as athletes and as leaders. Moreover, despite hosting a World Conference on Women and Sport every four years since 1996, 2016 marked the first year the IOC did not host the event, leading many to question its commitment to the issues facing women in sport and leadership.

The opportunity to be an Olympian or Paralympian brings with it numerous rewards. It gives the athlete the chance to earn prize money, secure endorsement deals, and challenge herself against the greatest competitors in the world. More importantly, perhaps, is the fact that it gives unprecedented visibility to outstanding, elite female athletes. As international mega-events, the Olympic and Paralympic Games are widely covered by sport media. These media outlets are often responsible for reproducing and/or challenging gendered norms within sport and society. Media coverage of the Olympic and Paralympic Games, if done without gendered bias, has the capability to allow millions of young girls to watch role models who inspire sport participation. There are also abundant returns that come to women who serve in a leadership capacity in sport as coaches and sport administrators. And, although these women often work behind the scenes, they are an integral part of the team, actively advocating for women as athletes. We, therefore, view the issue of equitable participation for women as athletes and sport leaders as a basic issue of human rights. Sport is a valuable source of empowerment for girls and women. By limiting women's

access to highly competitive sport opportunities, media coverage, and leadership roles, we are restricting their basic human rights.[. . .]

Some of the major findings documented by this study are summarized below:

1. *Countries continue to exclude women in their Olympic delegations.* In 2012, for the first time ever, three countries that had never included women on their Olympic teams—Saudi Arabia, Qatar, and Brunei—sent female competitors to the Games. By 2016, both Saudi Arabia and Qatar again included women in their delegations, while Brunei did not attend the Games. Perhaps the great amount of pressure applied to Saudi Arabia in 2012 (Brennan, 2012; Shihab-Eldin, 2012) helped encourage the nation to continue to grow their female athletes' opportunities, doubling their number of female athletes to four in 2016. Qatar brought one female athlete in its delegation in 2016. However, five NOCs failed to include a woman in their athlete delegations: Iraq, Monaco, Nauru, Tuvalu, and Vanuatu. This is the second consecutive time that Nauru has failed to include a female athlete in its delegation (Verveer, 2012). Table 1 highlights several nations and their slow efforts to include female athletes in their delegations. It is clear that many of these nations are quite small and have limited budgets for elite sport, which leads to small Olympic team delegations that have historically excluded female athletes. However, as Table 1 also indicates, many of these nations continue to make steady and notable gains.

2. *The wealth gap continues to widen: in both the Olympic and Paralympic Games, wealthy nations bring larger delegations and win more medals than less financed nations.* In examining the participation numbers and percentages for all of the National Olympic Committees and National Paralympic Committees competing in the Olympic and Paralympic Games, it becomes clear that developed nations have significant structural advantages over smaller, less developed nations, which continue to struggle to field a team, often bringing only a handful of competitors, and in many cases only one or two athletes. Wealthy countries bring larger delegations and win more medals than their less financed competitors. For National Paralympic Committees, this divide becomes even more apparent, as developed nations typically offer greater opportunities for individuals with disabilities, which includes access to sport and recreation.

3. *Women have finally accounted for 45% of the overall participants in the Olympic Games.* Women made up 45% of the overall participants in the Olympic Games, which is up slightly from the percentage of women who competed in

TABLE 1 **NOCS that have failed to send at least one female participant to the Olympic Games since 1992 (with numbers of women they have sent each year)**

NOC	1992	1996	2000	2004	2008	2012	2016
Afghanistan	dnp**	0	dnp*	2	1	1	1
American Samoa	0	1	1	1	2	1	1
Aruba	1	0	2	1	0	1	4
Bahrain	0	0	2	3	3	8	15
Barbados	1	2	6	1	1	0	4
Botswana	0	0	0	1	2	1	3
British Virgin Islands	0	0	0	0	1	1	3
Brunei Darussalam	dnp*	0	0	0	dnp*	1	1
Burkina Faso	0	2	1	2	3	3	2
Cayman Islands	0	1	2	2	1	1	2
Cook Islands	0	1	1	1	1	5	5
Djibouti	0	0	1	dnp*	1	3	1
Federation of St. Kitts & Nevis	N/A	6**	1	1	3	1	1
Gambia	0	1	1	1	1	1	1
Grenada	1	0	1	2	5	4	2
Guinea-Bissau	dnp*	0	1	2	1	2	2
Haiti	0	0	2	1	4	2	3
Islamic Republic of Iran	0	1	1	1	3	8	9
Iraq	0	0	2	1	1	3	0
Kuwait	0	0	0	1	0	2	S‡
Lao People's Democratic Republic	0	1	1	2	2	1	2
Lebanon	0	0	2	2	2	7	5
Libyan Arab Jamahiriya	0	0	0	2	2	1	1
Liechtenstein	3	2	1	0	0	2	2
Malawi	1	0	1	2	2	2	2
Malaysia	0	3	8	8	14	13	15
Mauritania	0	0	1	1	1	1	1
Monaco	1	0	0	1	1	1	0
Nauru	dnp*	0	1	1	0	0	0
Netherland Antilles	1	0	1	0	0	Nd†	N/A
Niger	0	1	2	1	3	2	2
Oman	0	0	0	0	1	1	2
Pakistan	0	1	1	2	2	2	3
Palestine	dnp*	0	1	1	2	2	2
Panama	0	2	2	1	2	2	6
Papua New Guinea	1	0	3	2	4	4	2
Qatar	0	0	0	0	0	4	2
Rwanda	3	0	2	2	2	2	3
Samoa	0	1	1	1	2	3	3
Saudi Arabia	0	0	0	0	0	2	4
Senegal	2	0	19	10	7	7	16
Solomon Islands	0	1	1	1	2	2	2
Somalia	dnp*	0	1	1	1	1	1
Sudan	0	0	1	1	4	2	2
Swaziland	0	1	2	1	2	1	1
Tanzania	0	1	1	2	2	2	2
Togo	0	1	1	1	1	2	3
Trinidad and Tobago	0	4	5	9	11	10	10
Tuvalu	N/A	N/A	N/A	N/A	1**	1	0
United Arab Emirates	0	0	0	0	2	2	3
Uruguay	0	2	3	2	3	3	5
Vanuatu	2	1	1	1	2	2	0
Yemen	0	0	0	0	1	1	1

* Did not participate ** 1st Olympic appearance † Nation dissolved ‡ suspended

London in 2012. It represents the greatest percentage of female Olympians in modern Olympic history, and several nations had delegations with more women than men. The IOC, in its Olympic Agenda 2020, aims to achieve 50% female athlete participation in the Games. It remains to be seen how this increase in the percentage of female athletes will be achieved. In the sport of freestyle wrestling, additional weight classes were added so women and men had the same number of weight classes. However, inequities persist that make it structurally impossible for gender equity to be achieved. For example, in boxing, there are three weight classes for women and 10 weight classes for men. In the football and water polo tournaments, more men's teams participate, adding to the inequities. In Olympic Agenda 2020, there is one recommendation among 40 that specifically addresses gender equality. The IOC places the responsibility on International Federations. The report also suggests mixed-gender team events (IOC, 2015).

4. *For the second consecutive Olympic Games, women made up more than half of the U.S. Olympic athletes.* In Rio, for the second consecutive Olympic Games, women made up more than half of the U.S. team. This major accomplishment was celebrated in the American press, especially after the tremendous successes of the American women in their respective sports. Of 554 American athletes, 292 were women, accounting for 52.7% of the American delegation.

Yet, gender equity within the U.S. Olympic team continues to be subject to the success of teams qualifying for the Games. For example, in 2016 (as was the case in 2012), the men's football team did not qualify for Olympic competition, but the women's football team did, which helped maintain equity between the two genders. This balance could easily be lost if both teams qualified, as there are still more opportunities for male athletes in individual sports and events, accounting for the overall imbalance. Likewise, the women's field hockey team qualified and the men's team did not. These two women's teams accounted for 34 women competing unmatched by their male counterparts in the two sports. Relying on the inability of men's teams to qualify for the Olympic Games is hardly a strategy to utilize in achieving gender equity.

5. *American women continue to dominate team sport competition in the Olympic Games, in large measure due to the impact of Title IX. However, other nations are also benefitting from Title IX with many of their female athletes attending American colleges, leading their teams to victory over the Americans.* One result of the successful qualification of American women's teams for Olympic competition is the dominance of these American women's teams against their world opponents. They won gold medals in basketball, gymnastics, and rowing eights,

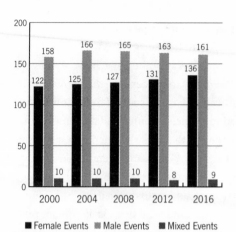

FIGURE 1 **The number of Olympic events by gender, 2000–2016**

■ Female Events ■ Male Events ■ Mixed Events

WOMEN AND SPORTS IN THE UNITED STATES

but were unable to defend their Olympic title in football. In 2016, it was reported that American women, if they were their own team, would have finished third among the overall medal standings (Longman, 2016). If the 2012 Games were dubbed the "Title IX Olympics," then the 2016 Games were a continuation of the celebration of the legislation's impact on American women's Olympic successes, as well as a contributing factor to the success of women around the world who have competed at American colleges and universities as a result of Title IX. Many of these international female athletes are attaining scholarships at American colleges and universities and developing their athletic skills and prowess, and then returning to their home nations to compete in the Olympic Games. For example, the majority of the Canadian women's football team attended American universities.

6. *Female athletes continue to have fewer participation opportunities, are relegated to shorter distances in certain sports, and face other structural obstacles to full equity in the Olympic and Paralympic Games.* In 2016, although women competed in an equal number of sports for the first time in Olympic history, they participated in 136 events compared to 161 events for men, with nine mixed events. As a result, while more than 11,000 athletes competed in the 2016 Games and the percentage of female athletes participating increased over previous years, female athletes still received fewer participation opportunities than their male counterparts did. One aim toward achieving gender equity in the Olympic Games will be for the IOC to offer 50% of participation "opportunities" to female athletes.

On a positive note, two new sports were reintroduced to the Olympic Games in 2016: golf and rugby sevens. Both sports offered the same number of participant opportunities to female and male athletes.

TABLE 2 **U.S. Olympic Team Totals, by Sport and Gender, 2016**

Sport	Females	Males	Totals	Percentage of Female Athletes	Percentage change from 2012 Games
Archery	1	3	4	25%	-25%
Artistic Gymnastics	5	5	10	50%	no change
Athletics	64	64	128	50%	no change
Badminton	4	3	7	57.1%	+24.8%
Basketball	12	12	24	50%	no change
Beach Volleyball	4	4	8	50%	no change
Boxing	2	6	8	25%	no change
Canoe Slalom	1	3	4	25%	+5%
Canoe Sprint	1	0	1	100%	+50%
Cycling BMX	2	3	5	40%	no change
Cycling Mountain Bike	2	1	3	66.7%	+16.7%
Cycling Road	4	2	6	66.7%	+22.3%
Cycling Track	5	2	7	71.4%	+4.7%
Diving	5	5	10	50%	-4.5%
Equestrian	6	6	12	50%	+3.8%
Fencing	9	6	15	60%	+10%
Field Hockey	16	0	16	100%	no change
Golf	3	4	7	42.9%	new sport
Handball	0	0	0	N/A	
Judo	3	3	6	50%	+10%
Marathon Swimming	1	2	3	33.3%	
Modern Pentathlon	2	1	3	66.7%	no change
Rhythmic Gymnastics	6	0	6	100%	N/A
Rowing	20	21	41	48.8%	+3.3%
Rugby	12	12	24	50%	new sport
Sailing	7	8	15	46.7%	+2.8%
Shooting	7	13	20	35%	+5%
Soccer	18	0	18	100%	no change
Swimming	22	25	47	46.8%	-4.2%
Synchronized Swimming	2	0	2	100%	N/A
Table Tennis	3	3	6	50%	-25%
Taekwondo	2	2	4	50%	-10%
Tennis	6	5	11	54.5%	+4.5%
Trampoline	1	1	2	50%	no change
Triathlon	3	3	6	50%	-10%
Volleyball	12	12	24	50%	no change
Water Polo	13	13	26	50%	no change
Weightlifting	3	1	4	75%	+8.3%
Wrestling	4	10	14	28.6%	+5.1%
Totals	292	262	554	52.7%	+1.9%

TABLE 3 U.S. Paralympic Team Totals, by Sport and Gender, 2016

Sport	Females	Males	Totals	Percentage of Female Athletes	Guides
Archery	2	6	8	25%	
Athletics	30	43	73	41.2%	
Boccia	0	0	0	N/A	
Canoe Sprint	3	0	3	100%	
Cycling Road	10	12	22	45.5%	
Equestrian	5	0	5	100%	
Football 5-a-side	0	0	0	N/A	
Football 7-a-side	0	14	0	0%	
Goalball	6	6	12	50%	
Judo	2	3	5	40%	
Powerlifting	0	1	1	0%	
Rowing	4	4	8	50%	1 female guide
Sailing	1	5	6	16.7%	
Shooting	4	4	8	50%	
Sitting Volleyball	12	12	24	50%	
Swimming	23	10	33	69.7%	
Table Tennis	1	1	2	50%	
Triathlon	7	3	10	70%	2 female guides
Wheelchair Basketball	12	12	24	50%	
Wheelchair Fencing	1	1	2	50%	
Wheelchair Rugby	0	12	12	0%	
Totals	124	154	278	44.5%	3 female guides

FIGURE 2 **The number of Paralympic events by gender, 2000–2016**

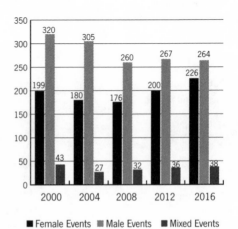

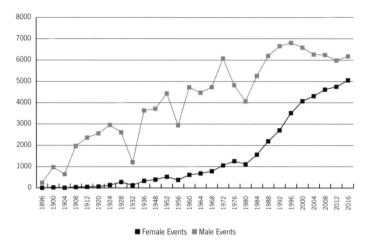

FIGURE 3 **The number of female and male athletes in the Olympic Games**

For the second consecutive Olympic Games, boxing offered only three weight classes for female boxers, as compared to 10 weight classes for male boxers. Despite competing in the 50km race walk in world championships, women are still denied the opportunity to compete in the event at the Olympic Games. Female swimmers compete in the 1,500m freestyle in other international swimming events, yet not at the Olympic Games, where it is an event reserved for the male swimmers. Women are relegated to swimming the 800m freestyle, though it can no longer be explained as an issue of ability, as women compete in the 10km marathon swimming event. In the sport of water polo, there are 12 men's team but only eight women's teams. These are just a few of the structural differences and inequities faced by female athletes at the Olympics Games that are discussed every Olympiad with no action taken by the IOC to rectify the imbalances.

Women have far fewer participation opportunities than men in the Paralympic Games. The 2016 Paralympic Games saw a slight improvement in the percentage of female athletes, with 38.6% of the athletes from the 159 National Paralympic Committees being women (1,669 female athletes), an increase from 35.4% of the athletes in London. However, 42 NPCs failed to include at least one woman in their athlete delegation, and seven NPCs failed to include at least one man in their athlete delegation. This is an improvement, as four years prior, 57 NPCs had failed to include a female athlete in their delegations. Eleven NPCs had delegations of at least 50% females, more than double the number of such delegations four years prior in London. These are good signs of progress that should be noted.

But competition opportunities for female Paralympians continue to lag

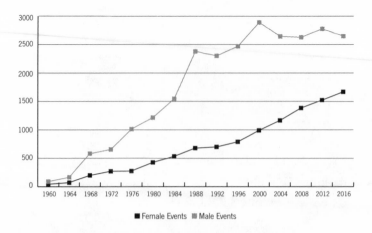

FIGURE 4 **Historic participation in Paralympic Games by gender**

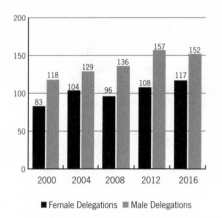

FIGURE 5 **Number of national delegations sending women to the Paralympic Games, 2000–2016**

behind their male counterparts. Female Paralympians compete in 20 of the 22 Paralympic sports (they are excluded from football 5-a-side and football 7-a-side) and compete in 226 events compared to 264 events for their male counterparts. Additionally, there are 38 mixed events.

In comparison with their female counterparts in the Olympic Games, female Paralympians have much ground to cover in achieving gender equity in the number of events and also the number and percentage of total participants. Female Paralympians accounted for only 38.6% of all Paralympians, despite having the opportunity to compete in 50% of the events (including women's and mixed events) for the first time in Paralympic Games history, something the Olympic Games has failed to achieve. Although the Paralympic Games began in 1960 and have a shorter history than the Olympic Games, the interest in sport for athletes

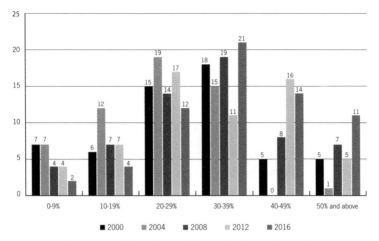

FIGURE 6 **Percentage of female participants for delegations of 10 or more, Paralympic Games, 2000–2016**

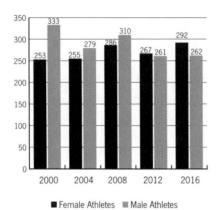

FIGURE 7 **U.S. female and male representation in the Olympic Games, 2000–2016**

with disabilities, both male and female, is still growing. Much of this interest is generated from the International Paralympic Committee and its website, which livestreams the Paralympic competitions. This is especially helpful when the events are marginalized by mainstream media outlets, including television.

7. *The* IOC *requested that women be provided with at least 20% of the leadership opportunities in international sport organizations by 2005; however, women continue to be minimally represented in leadership positions in Olympic governance.* IOC: Women have minimal opportunities to serve in leadership capacities within national and international sports structures. The International Olympic Committee (IOC) established a 20% threshold goal for the inclusion of women in National Olympic Committees (NOC), National Governing Bodies (NGB),

and International Federations (IF) by 2005. As of October 2016, 23 (25%) of the 92 members of the IOC are women. This is the second time the IOC reached its own 20% threshold and marks an increase from 2012 when the membership was only 20.8% female. Also for the second time, three female members again sit on the 15-member IOC Executive Committee. There has never been a female IOC President.

NOCs: Leadership positions within the 203 active NOCs are still largely dominated by men: women hold only 10.4% of such positions. Moreover, 162 (79.9%) NOCs have all-male leadership teams, 40 (19.7%) have male/female leadership teams, and one, Zambia, has an all-female leadership team. Although a slight improvement in female representation—85.3% of NOCs had all-male leadership teams in 2012—women still are notably underrepresented in leadership positions.

IFs: Leadership positions within the 28 summer Olympic IFs and seven winter Olympic IFs are also dominated by men. Only three summer IFs' executive boards meet or exceed the 20% threshold, a decline in female membership from 2012 when six summer IF boards exceeded the mark. Of the 469 summer IFs' executive board positions, women hold only 60 (12.8%) of them. Three winter IFs' executive boards meet or exceed the 20% threshold. Of the 85 winter IFs' executive board positions, women hold only 16 (18.8%) of them.

IPC: The International Paralympic Committee (IPC) has set a higher standard of 30% for gender equity in its leadership structures. As of September 2016, three women (20%) are part of the 15-member IPC Governing Board, a number that remains consistent from 2012. Twenty-six (15.3%) of 170 listed NPC presidents are women, an increase from 19 in 2012. Fifty-two (30.8%) of designated "main contacts" are women.

8. *The USOC continues to make strides towards organizational gender equity, but it is still well below a balanced 50/50 split in leadership positions. This is particularly true in the NGBs where women are woefully underrepresented in leadership positions.* The USOC exceeds the IOC-recommended 20% threshold for the inclusion of women, with 37.5% of its members being female. This is consistent from 2012. The Executive Team, which consists of 11 members, has only two female members, a decline from four in 2012. Only one woman, Chief Marketing Officer Lisa P. Baird, is among the top five highest-compensated members of the USOC. Likewise, only two of the 41 highest-paid members of NGBs are women.

TABLE 4 **NOC Presidents by Region**

NOCs by Region	Male	Female	Percent Female
ANOCA	49	4	7.6%
PASO	37	4	9.8%
OCA	43	0	0%
EOC	46	3	6.1%
ONOC	16	1	5.9%
Total	191	12	5.9%

TABLE 5 **NOC Secretary Generals by Region**

NOCs by Region	Male	Female	Percent Female
ANOCA	47	6	11.3%
PASO	33	8	19.5%
OCA	40	3	7%
EOC	41*	7*	17.0%
ONOC	11	6	35.3%
Total	172	30	14.9%

* The Montenegrin Olympic Committee did not list a secretary general.

TABLE 6 **NPC Leadership**

Region	President			Main Contact		
	Male	Female	Unidentified	Male	Female	Unidentified
Africa	42	6		34	10	4
Americas	19	9		17	13	
Asia	37	3		34	7	1
Europe	39	7		28	18	1
Oceania	7	1		4	4	
Total	144	26		117	52	6

Women are again underrepresented in leadership positions on the National Governing Bodies. Summer NGBs' boards of directors have 39 chairs listed, of which six (15.4%) are women. This is a slight increase from 2012. Of the 569 total board members, 157 (27.6%) are women. Fourteen of the 39 summer NGBs do not meet the 20% threshold for female membership, a significant increase from 2012 when only eight NGBs did not meet the mark. Winter NGBs' boards of directors have eight chairs listed, none of whom are women. Of the 126 total board members, 39 (31%) are women. Only USA Hockey falls below the 20% threshold for female representation. For both the summer and winter NGBs, men are frequently the highest-paid employee of the organization.

9. *Media coverage of female athletes in the Olympic Games far exceeds that of female athletes in the Paralympic Games, who receive very little online media coverage by major U.S. news sites.* With the increasing accessibility to and reliance on online newspaper coverage, female athletes in the Olympic Games receive an increased percentage of coverage during the two weeks of the Olympic Games in relation to previous reports. Part of what aided the quantity of coverage of female Olympians, however, was the inclusion of the ESPNW website in this study, as its focus on women's sport added to the total numbers of articles written about female Olympians. While many of the stories continue to reinforce the traditional tropes of femininity and requisite beauty, news coverage of female Olympians also focused on their sporting accomplishments and celebrated their successes. In comparison, despite the increased coverage of the Paralympic Games on NBC, as well as livestreaming on the IPC's website, there was limited online coverage of the Paralympic Games. This overall lack of media coverage marginalized the accomplishments of both female and male Paralympians.

References

Brennan, C. (2012, July 25). Finally: It's all about the women at the London Olympics. *USA Today*. Retrieved from http://usatoday30.usatoday.com/sports/story/2012 -07-25/London-Olympics-Brennan-women/56488526/1

International Olympic Committee (2015). *Olympic Agenda 2020: 20+20 Recommendations*. Retrieved from: https://stillmed.olympic.org/Documents /Olympic_Agenda_2020/Olympic_Agenda_2020-20-20_Recommendations-ENG .pdf.

Longman, J. (2016, August 22). For those keeping score, American women dominated in Rio. *New York Times*. Retrieved from: http://www.nytimes.com/2016/08/23/sports /olympics/for-those-keeping-score-american-women-dominated-in-rio.html

Myre, G. (2016, August 21). Olympic women are the biggest winners at the Rio Olympics. *NPR*. Retrieved from: http://www.npr.org/sections/thetorch /2016/08/21/490818961/u-s-women-are-the-biggest-winners-in-rio-olympics

Shihab-Eldin, A. (2012, July 27). Saudi Arabia's Olympic paradox: Insulting women, Islam and "prostitutes." *The Blog: HuffPost online.* Retrieved from http://www .huffingtonpost.com/ahmed-shihabeldin/saudi-arabias-olympic-par_b_1709873 .html

Verveer, M. (2012, August 20). London Olympics make the case for unleashing the potential of women and girls. *The Blog: HuffPost online.* Retrieved from http://www .huffingtonpost.com/melanne-verveer/olympics-women_b_1813414.html

STRATEGIES FOR CHANGE

Feminist Majority Foundation | 1995

Excerpted from "Empowering Women in Sports," a report in the Empowering Women series (Arlington, VA: Feminist Majority Foundation, 1995), available at www.feminist.org/research/sports/sports10.html. Reprinted by permission of Feminist Majority Foundation, copyright © 1995.

Gender equity will not happen by itself; we have to work for it and speak out against discrimination. The following are some strategies you can use to bring about gender equity in athletics. The strategies are organized in general from the least time and energy consuming to the most. Everything you can do will help.

STRATEGY 1: Support Women's and Girls' Sports

You can support women's athletics at any age. Participate in sports yourself. Attend women's and girls' sporting events. Earmark university contributions for women's athletic programs. Do not be taken in by stereotypes that negate women's athletic abilities and deride women who perform well in sports. Coach, athlete, fan and fundraiser are all roles that can build confidence and initiative, and promote women's leadership.

STRATEGY 2: Join a Women's Rights Organization

Title IX and other advances for women in athletics were won through feminist organizing. You can join (or organize) a feminist organization in your school,

university, or town. Sponsor programs on Title IX and gender equity, and call attention to policies that unfairly disadvantage women and girls in the sports arena. National Girls and Women in Sports Day, the first Thursday in February, is a great day to plan activities. [. . .]

STRATEGY 3: Challenge the Myths

Stereotypes unchallenged are stereotypes accepted. Familiarize yourself with the myths and point out the discrepancies between myth and reality about women and girls in sports. Arm yourself with the facts[. . .].

STRATEGY 4: Speak Out against Gender Inequity

Remember, you're in the majority! Breaking the silence has a tremendous impact. It puts women's issues at the forefront of everyone's mind and identifies them as legitimate topics to be addressed.

At every opportunity—in meetings, at conferences, and in the classroom—point out inequalities in women's athletics. Don't hesitate: feminists are the majority. In a 1986 *Newsweek*/Gallup poll, 71% of the women surveyed believe the women's movement has improved their lives. Three years later, a *Time* magazine poll found that 81% think the movement is still improving their lives.

With such data, it is clear that women's issues are supported and should be addressed by those in athletics.

STRATEGY 5: Encourage Other Women and Girls

Your visibility to women just starting out in athletics can make a critical difference in their future. Invite women and girls to informational meetings about athletics and the wonderful things they have to offer. Encourage them to see themselves as players, coaches—whatever role they would like to play. Offer advice on how they can get their athletic careers started and where to go for more information.

STRATEGY 6: Push for Gender Equity Policies

Gender equity in athletics applies to three basic areas: participation opportunities, athletic financial aid, and all other athletic benefits and opportunities.

Encourage local, state, and national policy makers to take steps towards ending gender bias by promoting and reinforcing gender equity policies and

practices in the Department of Education, federal education programs, and in educational funding and research. Write to the Office of Civil Rights, your members of Congress, your Governor, and members of your state legislature to let them know you want gender equity enforced.

STRATEGY 7: Speak Out against Homophobia

The silence and fear that goes with a climate of homophobia is harmful to all women. Speak out against anti-gay jokes or comments. Push your athletics department to adopt policies that prohibit discrimination against lesbians and gays. And take action when you think someone was fired for being a suspected lesbian (of course, check with that person first and work with her in planning what to do).

STRATEGY 8: Publicize Discrimination at Your School or University

Is your school, university, or college in violation of Title IX, the federal law that prohibits gender discrimination in education, including athletics? To find out, answer the following three questions:

- Are men's and women's athletic programs funded in proportion to the percentage of men and women students?
- Are opportunities for participation for women and men athletes proportional to enrollment?
- Is there an unmet need for a varsity women's sport (such as a club sport whose members want to upgrade to a varsity sport)?

If you can prove that participation is not proportional, and that there is an unmet need for more women's sports, and/or if you can prove that the funding is not proportional, your school is in violation of Title IX. Bring this up with the athletics administrators (who no doubt are already aware of it), and ask them what measures they intend to take to correct the inequity. Be sure to let them know about the numerous successful lawsuits women athletes and coaches have brought against schools in violation of Title IX.

Starting in 1996, colleges and universities will be required to disclose funding and participation statistics to anyone who asks, thanks to the Moseley-Braun/Kennedy Amendment to the 1994 Elementary and Secondary Education Act.

Beyond talking to the athletics administrators, you can also meet with college presidents and faculty concerning gender equity issues and the present status of

your institution, and place articles or write letters to the editor in school papers discussing facts about Title IX, your school in particular, and your feelings about the discrimination.

You might also want to read up on sex discrimination or contact women's organizations for information on not only how to recognize discrimination but also how to counter it effectively.

STRATEGY 9: Develop a Media Strategy

The media is vital to creating change. Never hesitate to contact the media and make them aware of actions, workshops, or other activities. Encourage reporters to cover women's athletics in your area. Local radio and TV talk shows should also be encouraged to devote programs to women's athletics.

Support women sports reporters and media coverage of women's sports. Similarly, you can call the media to task when they do not cover women's sports or do not have female reporters.

STRATEGY 10: Consider Legal Alternatives

Sometimes, despite the best efforts to correct a problem, the only recourse is to take legal action. Thus far, legal action and the threat thereof have been largely responsible for advances toward ending discrimination against women and girls in sports.

If you have been a victim of sex discrimination in athletics, try to settle your grievances with the institution personally; if your attempt is not successful, immediately contact the Office of Civil Rights at the U.S. Department of Education, and work through the regional office of the state in which the alleged discrimination occurred. Another option is to go to a private lawyer; either way, if Title IX violations are found and not remedied, the next step is to file suit.

INDEX

AACCA (American Association of Cheerleading Coaches and Administrators), 210–11

AAGPBL (All-American Girls Professional Baseball League), xvii–xviii, 179–80

AAS (anabolic-androgenic steroids), 61–63

ableism, 348–49, 356–59. *See also* disability

active aging, 11–20

adoption of Russian children, 23–28

African American women and sport, 103–15, 267–68, 275–79, 281n27, 282n35, 284–88, 350–51. *See also* black women in track and field

Ainsworth, Barbara, 12

All-American Girls Professional Baseball League (AAGPBL), xvii–xviii, 179–80

Allison, Rachel, 30–31, 33

American Association of Cheerleading Coaches and Administrators (AACCA), 210–11

anabolic-androgenic steroids (AAS), 61–63

Anderson, Eric, 144–45

anxiety disorders, 63, 74–75, 80–81, 85, 86

Asian American women and sport, 296–98, 323–25

Athlete Biological Passport, 63

athletic competence, 20, 80, 82–83, 105–15, 126–27, 174–75n11

audiences, 31–33, 337–45

Avery, Elizabeth, 123–24

BALCO (Bay Area Laboratory Co-Operative), 62

barriers to equality in school athletics, 386

barriers to participation, 132–33, 270–71, 279, 300–301

basketball, 325–33

Bay Area Laboratory Co-Operative (BALCO), 62

Bay Area Women's Sports Initiative, 310n70

beauty and women in sport, 224–30

benefits of sport participation, 3–8, 15, 52–53, 83, 380–81

Bennett, Crystal, 288

Berkeley Tennis Club (BTC), 18

Big Crow, SuAnne Marie, 325–33

black femininity, 268, 275–79, 284–88

black women in track and field, 266–79, 280–81n17–18. *See also* African American women and sport

body image: and disability, 357; of ethnic groups, 103–15; and femininity, 188–206; and mental health, 69, 78–81;

and pathogenic weight loss behavior, 84–88; and physical activity, 80–81; and rowing, 120–24; and self-esteem, 78–81, 83; and sport participation, 295–96, 380

boosting, 64

Boston Breakers, 10, 31–32

Brady, Marilyn Dell, 280n9

breast cancer, 4

Brennan, Christine, 284

Bronfenbrenner's Ecological Systems Theory, 12, 132–33

BTC (Berkeley Tennis Club), 18

Calistro, Paddy, 287

campus sexual violence, 145

Chand, Dutee, 150–54, 158–59, 163–64

cheerleading, 145, 207–17, 385–86

Civil Rights Data Collection (CRDC), 303nn6–7, 304nn10–15

civil rights movement, 278–79

class differences, 280n9

Clinton, Hillary, 13

coaching science, 136

Coachman, Alice, 266–67, 271–73, 275

Coleman, Kiana, 31

Collins, Patricia Hill, 282n35

Communication & Sport (journal), 30–31

Competing for Life: Older People, Sport and Ageing (Dionigi), 15–16

competitive environments, 7

competitive equity, 169–72, 174n10

concussions, 57–59

Concussion Treatment and Care Tools Act (ConTACT Act), 59

ConTACT Act (Concussion Treatment and Care Tools Act), 59

Cooky, Cheryl, 30–33

CRDC (Civil Rights Data Collection), 303nn6–7, 304nn10–15

Croft, Annabel, 46, 49–50

cultural studies, 130–31

Dane, Rachael, 232

Daniels, Deborah J., 259–62

David, E.J.R., 324

De Cory, Doni, 327–32

depression, 44, 69–74, 78, 82–85, 103–15, 173, 380

Developing Physically Active Girls: An Evidence-Based Multidisciplinary Approach, 132–33

DiGiulian, Sasha, 9

Dima Yakovlev Law, 23–28

Dionigi, Rylee, 15–16

disability, 23–28, 71, 347–59, 401–15

diuretics, 63

diversity in Olympic Games, 312–25

diving, 323–25

Douglas, Gabrielle (Gabby), 313–17

Draves, Victoria Manalo, 324–25

Durm, Kayleigh, 120–24

eating disorders, xxi, 78–81, 84–88, 120–24

Ecological Systems Theory, 132–33

Eichner, Daniel, 65

Eliot, Lise, 126

Elkins, Hollis, 29, 33

Ellis, Havelock, 275

employment outcomes, 291, 297

empowerment, 34–37, 41–42, 202–6

EPO (Erythropoietin), 61, 63, 153

Epstein, David, 143, 153

Ernst, Bob, 123

Erythropoietin (EPO), 61, 63, 153

ESPN's *SportsCenter*, 30, 337–42

ESPNW.com website, 345n2

Ethics, Grievance and Safe Sport committee, 259–60

ethnicity: and female head coaches, 398; and gymnastics, 312–18; and intercollegiate athletics, 393; and the Olympic Games, 312–25; and school-based sport, 290–302; and sport participation, 103–15

exercise psychology, 129–36

extracurricular activities, 106–15

Fainaru-Wada, Mark, 62

FANHS (Filipino American National Historical Society), 324

Faust, Drew G., 233
Federal Law of Russian Federation No. 272-FZ. *See* Dima Yakovlev Law
Female Athlete Triad, 54–55, 86
female leadership, 134–35, 187, 387, 395, 400, 412–14
feminine ideal, xvi, 152, 188, 196, 350
femininity: and African American women, 268, 275–79, 281n27, 282n32, 284–88; and body image, 188–206; and cheerleading, 215–17; and disability, 355, 357, 359; and gender-related research, 130–31; and hyperandrogenism, 152; and masculinity, xvii–xix, 44; and sex appeal, 226–29; and sexual identity, 240–41, 244–45; in swimming, 225–26; and Title IX, 131
feminism, xix, 28–33, 216–17, 246, 415–18
Feminist Majority Foundation, 415–18
figure skating, 226, 319–22
Filipino American National Historical Society (FANHS), 324
fitness magazines, 347–59
"Flo Jo." *See* Griffith Joyner, Florence

Gehrke, Kristen, 33
gender-based violence. *See* violence against women
gender differences in coaching, 136
gender discrimination: and female leadership, 134; and intersectionality, 298–99; and masculine-perceived female athletes, 189; and pay gap, xx–xxi, 9, 28–33, 35, 147–49; and racial discrimination, 266–79; strategies for change, 415–18; and sustainable development goals (SDGs), 34–37; and Title IX, xiv, xix, 291, 383–84; and transgender athletes, 166, 172–73; and turf lawsuit, 29–30, 35; and writing about sport, 364
gender equity: and campus sexual harassment, 230–36; and feminism, xix, 28–33; and the Olympic Games, 401–14; overview, xxi–xxii; and the

Paralympic Games, 401–14; and pay gap, xx–xxi, 9, 28–33, 35, 147–49; and school-based sport, 386; and sex appeal, 229; and sport media, 369–71; strategies for change, 415–18; and swimming, 125–29; and Title IX, 376–99; and transgender athletes, 169–70; and writing about sport, 363–65
"gender fraud," 150–54
gender identity, 159, 165–73
gender-related research, 129–36
gender segregation, 141–46
gender stereotypes, 34–37, 125–30, 256, 279
gene doping, 64
George, Andu Bobby, 49
Griffin, Pat, 255–57
Griffith Joyner, Florence ("Flo Jo"), 284–88
Griner, Brittney, 254–57
gymnastics, 209–12, 258–62, 312–18, 363

Hall, Ann, 130
Hamblin, Christopher P., 233
Hammonds, Evelynn M., 232, 287–88
Hanson, Mary Ellen, 208
harassment, 230–36
Harper, Joanna, 155–64
Harvard men's soccer team, 230–36
head coaches, 134, 243, 394–98
health and well-being. *See* mental health
Hearst, George, 329–30
hegemonic femininity, 189–206
Henderson, E. B., 268, 270, 278
Herkimer, Lawrence, 208–9
Hersh, Phil, 286–87
heterosexism, 205, 241, 245–51
hGH (human growth hormone), 62–63
hierarchical organization, 6
hijabs and sport, 365–67
Hilliard, Wendy, 317
Hine, Darlene Clark, 282n32
homophobia, 236–52
Hon, Olivier de, 65
human growth hormone (hGH), 62–63

hyperandrogenism, 150–64
hypermasculinity, 127, 185–86

ideal bodies, 114, 188, 191–97, 201–3, 349, 352, 356–58
inclusive participation policies and practices, 172–73
injuries, 52–59, 64, 210, 218n15
integration in sport, sex, 141–46
intercollegiate athletics, xviii–xix, 168–69, 383, 390–99
International Paralympic Committee (IPC), 402, 412
intersectionality, 12, 276, 298–99
intersex athletes, xxiii, 156–66, 171
IOC Medical Commission, 52, 55, 61
IPC (International Paralympic Committee), 402, 412

James, Mike, 340
JAPA (Journal of Aging and Physical Activity), 14–15
Jhally, Sut, 343
Journal of Aging and Physical Activity (JAPA), 14–15

Kang, Miliann, 286–87
Karp, Jason, 47–48
Keovathong, Anne, 50
Khurana, Rakesh, 232
kinesiology, 11–12, 19–20
Kutzler, Emily, 325
Kvitova, Petra, 49

Lane, Andy, 142–43
Latina women and sport, 103–15
leadership, 134–35, 187, 387, 395, 400, 412–14
Lee, Sammy, 323–25
Lehrer, Pieter S., 232–33
lesbians in sport, xix, 29, 236–57, 342, 417
Litsky, Frank, 286

Macleod, Hannah, 49
magazine spreads, 226–29

Magnitsky Act, 23–28
Manly, John, 259–62
Martin, Meagan, 9
masculinity: and African American women, 267–68, 276–78; and cheerleading, 215; and female athleticism, 237; and femininity, xvii–xix, 44; and gender, xiv; and gender-related research, 130–31; and hegemonic femininity, 189–90; hypermasculinity, 127, 185–86; and older men, 14; orthodox, 144–45; and sex appeal, 228; and sexual identity, 184–85; and Title IX, 182–87; and transgender athletes, 157–58; and UN Women, 35–36
masters athletes, 16–17. See also older women in sport
McFadden, Tatyana, 23–28
McLaren, Richard, 62
McLaughlin, Patricia, 287
media coverage: of African American women, 275–79, 287–88, 350–51; of Asian American women, 323–25; and feminine women, 189–90, 203–5; of Muslim women, 365–67; and older women, 14; and the Paralympic Games, 401–14; and sexism, 369–71; and the sporting body, 347–59; strategies for change, 418; study of televised news media, 337–45; and Title IX, 338–39; of women's sport, 30–37
mega sport events, 36–37
Mendoza, Jessica, 370
menstruation, 43–50
mental health: and anxiety disorders, 63, 74–75, 80–81; and body image, 69, 78–81; and depression, 44, 69–74, 78, 82–85, 103–15, 173, 380; overview, 69; and pathogenic weight loss behavior, 69, 84–88; and self-esteem, 82–84; and suicide, 75–78
Mertens, Maggie, 28–33
Michener, James, 217

Miller, Delaney, 9

Mohler, Jessica, 124

Moore, Kenny, 287

Moritz, Amy, 216

Mulkey, Felecia, 212

Mulkey, Kim, 255–56

Murrell, Sherri, 256–57

muscularity, 188–206

Muslim women and sport, 365–67

Mythbusters (television show), 181–82

Nagasu, Mirai, 319–22

NAK (National Academy of Kinesiology), 11–12

Nassar, Larry, 258–62

National Academy of Kinesiology (NAK), 11–12

National Coalition for Women and Girls in Education (NCWGE), 376–87

Native American women and sport, 325–33

Navratilova, Martina, 49, 246–47, 250

NCAA participation, 218n23, 390–93

NCWGE (National Coalition for Women and Girls in Education), 376–87

Newhall, Kristine, 257

news media, 337–45. *See also* media coverage

obesity, 75–76, 79, 296–97, 306n32, 380

"Old Beaches" basketball team, 18

older women in sport, 11–20

O'Leary, Meghan, 123

Olympic Games: and black women in track and field, 266–79, 280n13, 284–88; and cheerleading, 209; diversity in, 312–25; and female leadership, 135; and female participation, 228, 236; and gender equity, 401–14; and intersex athletes, 161–64; and Muslim women, 365–67; and performance enhancing drugs, 60–66; pre-Title IX, xvi–xviii; and role models, 8; and sex-testing female athletes, 150–54; and sustainable development goals (SDGs), 34–37; and Title IX, 376, 382, 405–6; and transgender athletes, 167–68; and writing about sport, 363–65

online harassment, 371

orthodox masculinity, 144–45

osteoporosis, 4, 52, 54, 86, 295, 380

PA (physical activity). *See* physical activity

Paralympic Games, 23–28, 62, 351–52, 355, 376, 401–14

participation. *See* sport participation

pathogenic weight loss behavior, 69, 84–88

pay gap, xx–xxi, 9, 28–33, 35, 147–49

performance-enhancing drugs (PEDS), 60–66

physical activity: and anxiety disorders, 75; and body image, 80–81; and cheerleading, 208; and community structure, 300–301; and depression, 71–74; and femininity, 200; IOC Medical Commission statement on, 52–56; and long-term health benefits, 380–81; and menstruation, 47; and obesity, 296–97; and older women, 12–13; and pathogenic weight loss behavior, 87; and positive correlates in African American, Latina, and white girls, 103–15; and self-esteem, 82–84; and sport and exercise psychology, 131–33; and strategies to promote participation in girls, 399–400; and suicide, 77

physical benefits of sport participation, 52–53

physicality, xix, 143–44, 184, 201–3, 208, 216, 348

Pike, Elizabeth, 16–17

Pine Ridge Reservation, 325–33

Portland Thorns, 32–33

Portland Timbers, 32–33

positive reinforcement, 7–8

positive self-perceptions, 103–6, 110, 115, 183. *See also* self-esteem

Powers, John, 320–21
psychosocial benefits, 15, 53, 83
Putin, Vladimir, 23–28

racial difference, 284–88, 349–59
racial discrimination, xvi, 266–79, 314–15, 324
racial diversity, 214, 290–302, 317
racial stereotypes, 275–79, 315
racism, 321
Radcliffe, Paula, 46–47, 49
recommendations, policy, 55–56, 128, 299–302, 386–87, 399–400
Reddy, Helen, 13
Reeves, Jazmine, 31–33
representation: of black femininity, 268, 275–79, 284–88; of disability, 351–52; and female leadership, 187, 395, 412–14; in the Olympic Games, 135, 401–14; of women of color, 278, 298–99, 312–18
risks of sport participation, 53–55. *See also* injuries
rock climbing, 8–10
role models: and disabled athletes, 352, 357–58; and female leadership, 387, 400; and lesbians in sport, 247–48; in media, 402; and mega sport events, 36; need for, 7–10, 58; and parental involvement, 302; and women of color, 351
Rose City Riveters, 33
Rosenblatt, Ben, 49
rowing, 120–24
Ruck, Rob, 318
rules of sport, 4–7

Scalise, Robert L., 231–32
school-based sport, xix–xx, 290–302, 376–87
scouting report, 230–36
SDGs (sustainable development goals), 34–37
Seattle Reign, 31
segregation of gender in sport, 141–46
self-esteem: and anxiety disorders, 75; and body image, 78–81, 83; and depression, 71–72; and empowerment, 202; and ethnic group study, 104–5, 112–15; overview, 82–84; and pathogenic weight loss behavior, 85; and psychosocial benefits of sport participation, 53; and school-based sport, 380; and suicide, 77; and transgender athletes, 173; and women of color, 296–97
self-worth, 6–7, 82–84, 104–6, 108–15
Semenya, Caster, 152–54, 157–62
senior athletes, 11–20
SEP (sport and exercise psychology), 129–36
sex appeal, 226–29, 241
sexism, 12, 205, 232, 236–52, 348, 369–71
sex-testing female athletes, 150–54
sexual difference, 288, 350, 353–59
sexual harassment, 230–36
sexual identity: and femininity, 240–41, 244–45; and harassment, 226–36; and ideas of beauty, 224–26; and lesbians in sport, 236–57; and magazine coverage, 226–29; and masculinity, 184–85; and women of color, 275–76, 284–88
sexual violence, 145, 247, 258–62
Shiraishi, Ashima, 9
Skinner, Annie, 66
soccer, xiv, xx–xxi, 9–10, 28–33, 34–36, 230–36, 382
social benefits of school-based sport, 380–81
spectatorship, 8–10
sport and exercise psychology (SEP), 129–36
sporting body, 347–59
sport media, 369–71
sport participation: benefits of, 3–8; and biological characteristics, 41–50; and body image, 295–96, 380; contributing to gender equity, 34–37; and disability inclusion, 23–28; and eating disorders, 120–24; and ethnic group study, 103–15;

and gendered stereotypes, 125–29; of
girls, 399–400; and mental health,
69–88; and older women, 11–20; and
performance enhancing drugs, 60–66;
physical benefits of, 52–53; risks of, 53–
55; and role models, 8–10; and school-
based sport, 295–302; and sex-specific
injury, 55–60; and Title IX, 376–87
sport sociology, 11–20
St. Peter, Patricia, 322
stereotypes: and body image, 205;
and disabled athletes, 351, 356; and
feminist focus, 415–16; in high-level
competition, xix; and lesbians in sport,
237, 239, 242–44, 246–47, 250, 256; and
masculinity, 186; and older women,
11, 14, 19; and performance enhancing
drugs, 158; and sport and exercise
psychology, 130, 133; and swimming,
125–29; and team sport, 144; and Title
IX, 183, 291; and transgender athletes,
158, 167, 171, 173; and UN Women,
35–36; of women of color, 268, 275–79,
281n25, 285, 287–88, 315, 356
Stewart, Dodai, 30
suicide, 75–78
sustainable development goals (SDGs),
34–37
swimming: and depression, 74;
empowerment of women, 41–42;
and femininity, 225–26; and gender
segregation in sport, 142; and gender
stereotypes, 125–29; and older women,
16–17; and the Olympic Games, 407–9;
and performance enhancing drugs, 62

Taylor, Hudson, 256–57
team sport, xxi, 83, 104–5, 112, 143–46,
347–48, 351, 405–6
teamwork, 4, 25, 112, 124, 144, 172, 381
technology doping, 64
television coverage, 7–8, 10, 14, 29, 80,
337–45
Templeton, Cathy, 36–37
tennis, 18–19, 35, 46, 49–50, 147–49, 224–26

testosterone, 61, 150–54, 156–64, 169–71
therapeutic use exemptions, 63–64, 152
Theriault, Kelsey, 125–29
Thompson, Inga, 50
throwing-like-a-girl myth, 181–82
Title IX: and cheerleading, 211, 214;
defined, xiv; and female leadership,
134–35; and femininity, 131; feminist
focus on, 415–18; and intercollegiate
athletics, 390–99; and masculinity,
182–87; and media coverage, 338–39;
and older women, 17–18; and
Olympic athletes, 376, 382, 405–6; and
policymakers, 299–300; requirements,
292; and school-based sport, xix–xx,
290–302, 376–87; and women of color,
xxiv–xxv, 290–302
Title VI of the Civil Rights Act of 1964,
291, 298–301, 304
Torgovnick, Kate, 209
track and field, xv–xviii, xxiv, 25, 62, 65,
266–79, 280–81n17–18, 298
transgender athletes, 155–64, 165–73
turf lawsuit, 29–30, 35
Tuskegee Institute, 269–74

UCLA Civil Rights Project, 303n4
unintended pregnancy, 3, 381
United States Tennis Association
(USTA), 18–19
UN Women, 35–36
Urabe, Shannon, 324
USTA (United States Tennis
Association), 18–19

Varsity Brands, 209–12, 215, 218n23
violence against women: on campus, 145;
connected to sport events, 35–36; and
feminist focus, 33; and masculinity,
184; and Muslim women, 366; and
sexual-predator stereotypes, 247; and
sport media, 369–71

WADA (World Anti-Doping Agency),
61–66

Wagner, Ashley, 320–21
water aerobics, 17–18
Watson, Heather, 46, 49–50
Webb, Jeffrey, 208–9, 211
Welch, Zerell Johnson, 312–18
Wendy Hilliard Foundation, 317
White, Susan, 48
Whyman, Ruth, 121–23
Williams, Lance, 62
Williams, Linda D., 279n6
Wimbledon, 147–49
WNBA (Women's National Basketball
 Association), 345n1
women's movement, xix, 29, 356, 416
Women's National Basketball Association
 (WNBA), 345n1
Women's Soccer is a Feminist Issue
 (Mertens), 28–33
Women's Sports and Fitness Foundation,
 10

Women's Sports Foundation (WSF), 3–8,
 59, 212, 240
work ethic, 7
work setting, 4–7
World Anti-Doping Agency (WADA),
 61–66
World Cup, xx, 8, 23, 28–33, 34–36, 228,
 354
World Professional Association for
 Transgender Health (WPATH), 169
writing about sport, 363–65
WSF (Women's Sports Foundation), 3–8,
 59, 212, 240

Yakovlev, Dima, 23–28
Yarbrough, Marilyn, 288
Young, Damon, 369

Zimiga, Charles, 326–27, 329
Zirin, Dave, 9

INDEX